NEW VISIONS
NEW PERSPECTIVES

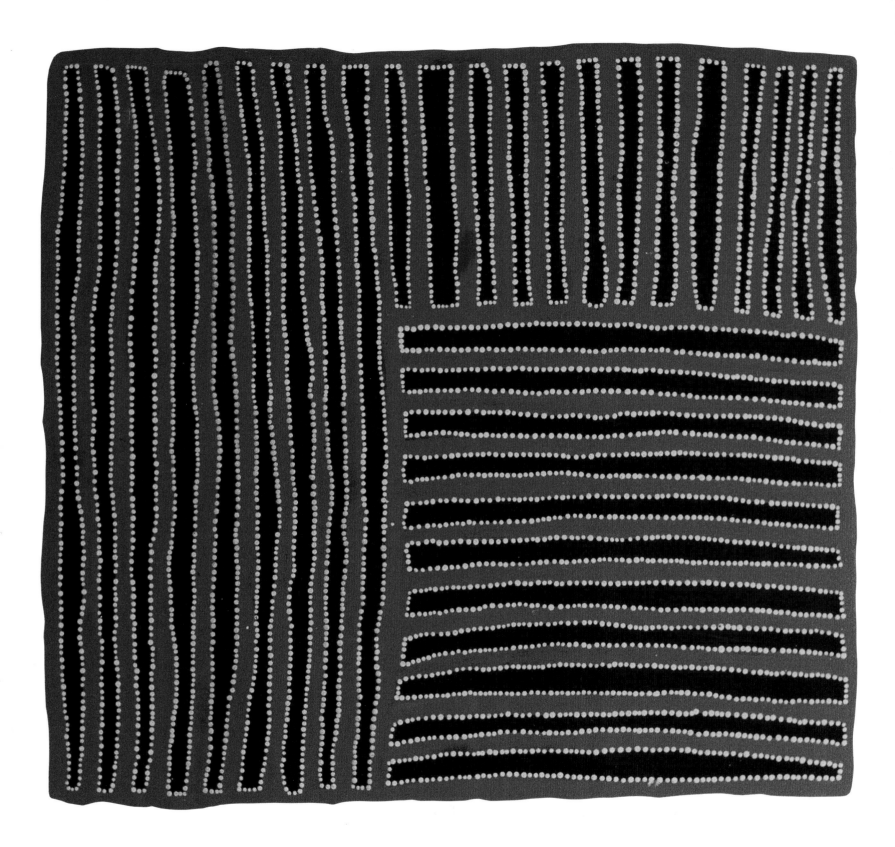

NEW VISIONS
NEW PERSPECTIVES

Voices of Contemporary Australian Women Artists

ANNA VOIGT

CRAFTSMAN HOUSE

G+B ARTS INTERNATIONAL

Dedicated to Mother Earth,
my mothers and grandmothers
and creative women everywhere
— those living, those passed on,
those yet to be born.

Distributed in Australia by Craftsman House,
20 Barcoo Street, Roseville East, NSW 2069
in association with G+B Arts International:
Australia, Canada, China, France, Germany, India,
Japan, Luxembourg, Malaysia, The Netherlands,
Russia, Singapore, Switzerland, United Kingdom
United States of America

ISBN 976 8097 92 2

Design Caroline de Fries and Anna Voigt
Cover Design Caroline de Fries and Anna Voigt
Printer Kyodo Printing Co., Singapore

Frontispiece: Gloria Petyarre, *Awelye*,
1993, polymer on linen, 75 x 81 cm,
Courtesy of Utopia Art, Sydney

Contents

Acknowledgments

E very creative act has its midwives and no story can be encompassed in one telling. In bringing to fruition this one book, composed of many stories, I am indebted to the generous contributions of more people than can be adequately or individually praised.

Foremost appreciation is extended to the artists who freely gave of their time, work and energy, making this project possible. Also to Nevill Drury for his support in publishing the book despite its 'shape-shift' over time.

Special thanks to those who assisted me with the Aboriginal artists and material: Manungka Manungka Women's Association; Zohl D'Ishtar with Mirlkitjungu; Chris Watson with Matingali; Chris Hodges with Gloria Petyarre.

To the owners and personnel of galleries who provided visual material, biographies and other information on request, particularly: Brenda May and Courtney Kidd of Access Contemporary Art Gallery, Sydney; Adrian Newstead of Coo-ee Aboriginal Art, Sydney; Brian Hooper and Jane Watters of Coventry Gallery, Sydney; Paul Greenaway of Greenaway Art Gallery, Adelaide; Bill Wright and Mark Hughes of Sherman Galleries Goodhope, Sydney; William Mora and Max Delaney of William Mora Gallery, Melbourne; all at Roslyn Oxley9 Gallery, Sydney; Australian Galleries, Melbourne and Sydney; Belinda Scott of the National Aboriginal and Torres Strait Islander Visual Artists Database; Rudolf Talmacs; Sue Rowley at Wollongong University.

To the public and private collectors who agreed to the reproduction of artworks in their care and to all the photographers who enabled that process.

To co-designer Caroline de Fries and Marg Bowman for thoughtful editorial comment on the manuscript.

To Barbara Makgill for her kindness and for massaging my tired limbs and aching body.

To women writers, historians, scholars, educators, mothers, activists, critics, artists and poets over the centuries without whose tireless commitment a book such as this would have never seen the light of day.

Preface

This book of *journeys* of the creative lives and processes of thirty-four women artists is in honour of the feminine principle in Nature and as expressed in Art.

New Visions New Perspectives is not intended as a definitive book or analytical statement but is rather an exploration into the protean sea of ideas and activity that is creative life. In a departure from the more conventional mode of art book, it is one celebratory offering — a contribution towards enabling the diversity of creative women's voices to be heard in the cultural mainstream.

No book is ever finished and most books are a compromise, especially when working intermittently to accommodate other work and life commitments and within specific deadlines which allow little time for reflection. A book unnaturally freezes information in time, and whereas the views expressed by artists (and author) were applicable at the time of speaking, 'the hound of heaven' impels the artist ever forward. What was said with clarity yesterday can become infused with doubt today and revised tomorrow — such are the vicissitudes of creativity in the stream of rapid change which is life in the universe we inhabit.

Inclusion and exclusion are difficult issues. The thirty-four women artists included in *New Visions New Perspectives* represent the organic shape that the book became. More artists were initially asked — a few didn't respond to correspondences, one preferred curatorial discourse to personal disclosure, a couple did not want to de-mythologise their 'image', one did not want to be in a 'gendered' book and then there was the odd 'political' obstruction. A handful of very competent others were not included because either circumstances such as other commitments made the time and communication necessary for participation in the book impossible or their work did not meet the arguable criteria of progressive work into the 1990s. Also, despite an over-accommodation on my part (which I humorously tell myself I will never repeat!), one cannot continuously extend deadlines for necessary material — a point arrives with a Stop sign and what is in the briefcase becomes the destined publication. There are unquestionably a number of other fine artists who could have alternatively constituted this book.

As this was conceived to be a book on *creative process* and the personal developmental *journey* of artists from *primary source* material, the artists included in the book were asked, when and where possible, basically the same questions — initially posed in a questionnaire. Occasionally distance and/or language precluded direct contact with an artist and other arrangements had to be made to obtain necessary information. The direct approach was conceptually designed to bring, hopefully, a more immediate as well as personal tone to the book, embracing the particular insights and *vitality* that women bring to their art.

The questionnaire was divided into sections broadly as follows:

- Details of the specific experiences, people, works, places, writings (or other) that have been inspirational and/or particularly important in each artist's creative development.
- Philosophies, struggles and concerns which motivated and guided the artists — they were invited to quote from sources that were influential or inspirational and/or to provide any precepts they may have formulated about their art or life.
- A general outline of each artist's *creative process* — including aspects such as what *moved* the artist from impulse or spark to realised form and how they *fed* into and structured their work ideas, time and space. Here were included such

details as emotions, moods, dreams and/or other *visions*, nature elements, music, sentiments, thoughts, as well as concrete/physical/technical details of the media and methods employed.
- A discussion of the general creative process in relation to the *journey of creation* — from idea to completed work — of each of the specific art works that were to be reproduced in the book.
- The meanings and significance of pictorial, symbolic, archetypal and meta-physical elements in the work, if applicable.
- Reflections on how being a woman has influenced the journey of being an artist and also the art work produced — both positively and negatively.
- The artist's comments on how they perceived their role as an artist and the function and purpose of their art.

Other questions were asked, where relevant — for example, in relation to the more intangible aspects of the 'spirit' in and of art, as this is an important dimension in art that I believed had become neglected in our more materialistic age and was resurfacing, albeit in different ways, in some women's art work.

All these, and other questions that emerged were then 'fleshed out' in supplementary personal interviews and follow-up correspondences to accommodate and include individual predilections such as:

- The specific importance of particular developmental influences and experiences in relation to the art work.
- The resistances to disclosure and/or acknowledgement of resources or influences.
- The further investigation of materials and methods in relation to the *ritual* dimensions of individual art practice.
- Expanding upon philosophical underpinnings and thematic concerns in an artist's work, again focusing on the *journey* of creative impulse: experience, feeling or concept into resolved form.

Although the artists were basically given the same opportunity for proffered material, there is considerable difference in the lengths of material/number of pages given to each artist. This is not a statement as to the greater or lesser importance of the artist or the skill involved in the art works. It is rather the willingness and time given to the task by the artists and also their disparate levels of ability to articulate ideas, feelings and experiences verbally. These artists have obviously chosen to express their ideas and visions in *images* and not words, as visual media enable, in many instances, an otherwise difficult self expression. These factors alone of course made this book a lengthy and arduous undertaking. Material filtered in via various telecommunications from all over Australia and overseas, usually in piecemeal fashion and in various forms — from scribbled handwritten notes, some like shopping lists, to clear, highly considered responses. Then there were the transcriptions of kilometres of tape — anyone who has translated spoken dialogue to cogent written form knows well that we do not speak the way English grammarians would have us believe. This was the almost overwhelming beginning.

However, over many months and within the constraints of the above-mentioned, I attempted to assemble, shape and edit these individual stories, simultaneously attempting to stay as close as possible to the idiosyncratic spirit of each artist's voice and vision and also to arrive at comprehensive, readable and interesting 'mini' but meaningful portraits. In this endeavour, I omitted some of my questions in the interest of longer uninterrupted passages of text and I varied others to tone necessary repetition. The overall shape of this oeuvre changed a number of times in the course of the making as I wrestled with unforeseen and new information, much like the enclosed artists' own work. Preconception rarely resembles post-partum.

Introduction

We tell beginnings: for the flesh and answer,
for the look, the lake in the eye that knows,
...in the love that gives us ourselves

Nourish beginnings, let us nourish beginnings.
Not all things are blest, but the
seeds of all things are blest,
The blessing is the seed.

Muriel Rukeyser

It is a curious thing that the introduction to a book is not written until the book is virtually complete, so in reality introduction is also conclusion and book's end is only a beginning.

Another beginning and ending for me is the recent news that my biological father is dying, his physical life, by one measure, now a handful of calendar months. I also have concern for my stroke-affected mother, whose considerable creativity has long been subsumed into caring for her husband, her children, her grandchildren, her garden, her beautiful needle and crochet work and, before that, her animal friends. A common woman's story. I find a strangely disquieting synchronicity in my approaching the concluding stages of writing a book on creative women (and co-authoring another on spirituality in art) and my father now dying of cancer — a father who was a typical product of his cultural time and place, who valued formal education and intellect over experience, 'logic' over emotions or feeling, sport over art and materiality over spirituality. I grapple with reconciling these concurrent private and public realities, as I am unable — or no longer willing, I am not sure — to separate them. I search for the connecting thread, the meaningful metaphor...

Another story common to women prior to the 1970s and 1980s was my struggle to overcome the cultural brainwashing which ascribed women to the domestic spheres and men to the public arenas of social life, to find my own creative vision and voice. There was not a single female creative role model, in terms of an authoritative public artist — either in person or in any of the many books I devoured, in my entire early formative years. I have only begun to realise fully the depths of this impact on my life and art and on that of other women.

Perhaps the seed which is the subject matter of this book was sown in those early years, when I naively determined not to suffer the fate of any of the women that I observed whilst 'growing-up'. It was to be a long and arduous journey. There were no maps and no guides.

THE JOURNEY

The more conscious genus of this book emerged during the 1980s when I was working as an art consultant (with the poet in me ever present). In my frequent meanders through art galleries, I noticed that I was becoming increasingly uninspired, disaffected and disengaged by the majority of the contemporary art I was seeing. Whilst not wishing to undermine the effort involved in producing this art, and knowing well the economic imperatives of survival, the work itself often seemed to me to be superficial, formulaic, commercially or academically directed and cold — lacking real originality or the tensions of 'felt' vision, strength of conviction, spirit and mystery. The dominance of the male vision, practice and principle and the comparative absence of the female vision and principle within my sphere at the time was still too frequently apparent, despite the new feminisms of the late 1960s and the women's art movement of the 1970s.[1]

At the same time, I found my interest in indigenous and tribal art and culture (or as some contemporary cultural geographers would call it — 'primitivism') — sparked during my nomadic travels of the 1970s — was resurrecting, deepening and gathering momentum. This was particularly so for African and Oceanic Art, Aboriginal Australian and Native American Indian art and artefacts and also the sacred art of certain spiritual traditions. I reflected on why much of the indigenous and sacred art I experienced was engaging, compelling, inspiring and exciting and why the contemporary art of that time — in overseas countries I visited as well as in Australia — for the most part, was not.

My summations are now more complex and flow into diverse tributaries too detailed to outline here. However, in the context of that time in the 1980s — and acknowledging that this is a simplistic overview (though not intended to be either reductionist or to espouse or fuel fantasies of purism or the 'noble savage') — I initially concluded that indigenous art contained and expressed a *cosmology* that even in its minutae, radiates an *embodied* sense of *spiritual presence* (or energy) and *primal power*. Simultaneously, this cosmology was rooted in the everyday experiences of its communal cultural members — an intertwining of the non-secular and secular or 'sacred' and 'profane' spheres in daily life.

The Earth-connected, animistic spirituality evoked in this art, which infused and melded with the cultural contexts of its participants, embraced in details of the particular and the universal a range of explicit references. It referred to domestic life and sexuality; fertility and procreative forces; the interior/exterior life of the spirit; and rites of passage in the eternal cycles within cycles of birth, life, death and rebirth. Nature was full of religious meaning and was accorded the highest respect as provider and destroyer of life. The art also expressed an awareness of multi-faceted reality and the co-existence of so-called opposites and paradoxes such as transience and permanence, male and female energies, flesh and spirit, reverence and irreverence, the interchange of the visible and non-visible worlds and the dark and light forces within all things physical and metaphysical. Despite the harsh physical realities of archaic life, there was no separation of art from life and Nature from religion — all were intertwined and everyone in the culture participated in the one cosmic reality.

I reflected on the costs of industrialisation, colonisation, the patriarchy, our Judeo-Christian and Anglo-Saxon heritages, mass communication technology, and the inherited Greek canon of an art of aesthetics rather than an art of culture. At the time I was mourning a loss of connection to the Earth and the natural world as well as the relative absence of mystery, magic and 'soul' in our extroverted, mechanistic and materialistic culture. These losses attended the 'advancement' of scientific explanation, technological 'development' and economic rationalism — in line with the worldwide industrial, political, military and trading nexus. I began to realise that within the cosmological expression that is indigenous art and culture was contained the metaphorical and symbolic languages of Nature and the sense of mystery and soul that I found to be missing in art (except for music and poetry). I found in indigenous art — art being the means by which these peoples expressed and conveyed knowledge — a *connecting force*, and I surmised that most white Eurocentric contemporary art, on the other hand, had lost connection with all of these dimensions and thus could not generate connection in a viewer. The terrain was not that black and white; there were/are many shades of grey, but, essentially, indigenous art was showing me languages of connection and *relationship* and the loss of it, while Eurocentric contemporary art was showing me languages of separation, disconnection and alienation — reflecting the malaises of the wider culture. Both were/are valuable in the dialectics of art and life.

As Lucy R. Lippard, that pre-eminent writer and commentator on contemporary art, expressed it in *Overlay*, 1983 (which, as its title suggests, discusses the overlays of human culture on nature):

'Despite the fact that many of the "movements" of modern art have been devoted to blurring the boundaries built up over the millenia to separate art and life, art is still overdefined in Western society, to the point where function is limited to decoration or status symbol…the social element of response, of exchange is crucial even to the most formalized objects or performances else culture remains simply one more manipulable commodity in a market society where even ideas and the deepest expressions of human emotion are absorbed and controlled.'[2]

The lost/forgotten connections to elemental forces which shape us, and their consequent lack of acknowledgement in our cultural and historical accounts, perturbed me greatly — in the same way as I am affected when reading commentaries about children who when asked to respond visually to questions about where milk or meat comes from draw cartons and packets bought at supermarkets or draw taps when locating the source of water. Such absences of knowledge of the physical points of origin, process, construction and production was, I felt, distorting our perceptions and severing our connection to the source in ways that were damaging to life enhancement and understanding — in and out of the arts. This, together with the proliferation of reproduced imagery projected from the mass media that daily assaults and numbs our senses, was obscuring the fact that works of art are effortfully made by the minds, eyes and hands of individual human beings.

I found myself increasingly shifting the focus of my interest from finished art 'product', so to speak, (to me, art had become increasingly commoditised, commercialised and corporatised) to the *journey* of art making — the creative–destructive process, I call it — which to me manifests itself in *everything* in the universe; indeed, creation arises out of destruction and vice versa. A curiosity and fascination with this primary mystery has been with me for as long as I can remember and underpins all of my endeavours in one form or another. Now it was becoming more formalised.

In the late 1980s I was commissioned by a private art collector to write some pieces on the construction of certain art works in their collection, and thus my focus on the creative–destructive process approach to art and art writing began. Concomitant with this approach was a felt need to debunk some of the prevailing romanticised attitudes towards the arts and artists. Making art, whilst having the potential to transform and transport, is often difficult, ugly and messy — like life — and these aspects are usually hidden from view in the name of aesthetic ideologies.

Also during this period, I was living and working with artists and observed the frequent chasms that existed between how artists spoke about their work and how many academics and critics framed and wrote about artists' work. There seemed to be two parallel worlds operating in visual arts — that of art practice and that of art text — with very little communication between the two. I encountered many instances where artists did not even understand what was being written — by others — about their own work. I had also recently completed a degree in Communications and found communications theory (which frequently finds its way into the arts) to be suffering the same indigestion of jargon and separation from subject matter. It was consequently not really communicating to anyone other than one's academic peers and included agendas that often had little to do with actual communication.

All of this echoed a story I once read about music criticism by Andre Previn, who said that he and another musician (I think it was Oscar Peterson, but am not entirely sure) would collect music reviews from the media, read the reviews to each other without mentioning the composer or performer/s names and see if they could guess who was being discussed. Previn said that *not once* were they correct in matching musician to music criticism. Similar observations could be applied to the visual arts, where density and complexity are often confused with profundity (and often used to disguise the lack of it) and simplicity and accessibility is often con-

fused with superficiality, weakness or a 'facile' nature. Nothing could be further from the truth.

Artificial separations, divisions, fragmentations, self-perpetuating hierarchies, intellectually dominated written language, the fictions of Eurocentric patriarchal history defining 'reality', form over feeling, style over meaning, absences, dualisms, binary oppositions, disconnections — these thoughts flashed in and out of my consciousness like neon lights. From all these seeds, this book was eventually born.

RETURN TO ORIGINS

I relate this story as a personal journey, and how and where it intersects and connects to the interpersonal, cultural and universal, is very much an area of exploration for many women artists everywhere. The deeply felt personal that is universal was an essential criterion in times past for assessing so called 'great art', as was a fresh or *renewed* vision. It was through my personal odyssey and excavations, and via indigenous art, that I began to understand not only myself and my art but many of the concerns currently being expressed by women artists all over this planet. Numerous creative women everywhere, in one way or another, in one form or another, are remembering and returning to their origins — both personal and ancestral-archaic. To return to origins is to return to the source and primal locations of life, to memory, to the body of self and Earth — to birth, growth stages, decay, death and rebirth in a ceaseless cycle — as arenas for the processes, forms and mysteries of existence.

The word 'art' is derived from the Latin root *ars*, which means 'to make'. In *The Transformative Vision*, 1975, Jose A. Arguelles stated that the root of the word 'archaic' comes from a verb meaning 'to begin'. As well as being a way of ordering the chaos of life in Nature, the making of forms by the artist is a way of relating to this existential mystery. Also, for the artist, a return to origins is a return to the origins of art and human culture itself as well as to a personal biographical story. In crafting and voicing their visions, these women artists are drawing *directly* from many well-springs: their personal, familial and cultural relationships and experiences; their natural eroticism, their pleasures and sensuous responses; their pain and joys; their losses and gains; their memories, reflections and intuitive ways of knowing; from the complex world of emotions and feeling; from explorations into the mysteries of existence and identity; from spiritual questings; from interactions with the Earth and the natural world; from myths and dreams; and from psychic journeys into information on the archaic world — *her*story and *his*tory.

During the course of these physical, psychological and spiritual journeys has come the recognition of our need for spiritual sustenance as well as material provision. As women relate their stories, the commonality of archetypes and mythologies arise, regardless of their personal and cultural backgrounds. Their connected mythic spiritual legacy is the cosmogonic Great Mother Goddess, in all her many aspects, awakened in the consciousness of contemporary daughters. As always, the seeds of new visions and new perspectives, whilst executed in the present with an eye to the future, are rooted in the past, spiralling through time.

Monica Sjöö and Barbara Mor, 1991, in *The Great Cosmic Mother*, emphasise that:

> '[it was from the] first inner circle of women — the campsite, the fire-site, the cave, the first hearth, the first circle of birth — that human society evolved. As hominids evolved into Paleolithic Homo sapiens, and then into settled and complex Neolithic village people on the time-edge of "civilisation," these tens of thousands of years of human culture were shaped and sustained by communities of creative, sexually and psychically active women — women who were inventors, producers, scientists, physicians, lawgivers, visionary shamans[3], artists. Women who were also the Mothers — receivers and transmitters of terrestrial and cosmic energy.'

The authors stress the importance for women to learn and understand 'the switch from primate estrus to human menstrual cycle, because this was the mechanism of female evolution'.[4]

Archaeologist and curator Marija Gimbutas, in the ground-breaking study *The Goddesses and Gods of Old Europe*, 1982 — which has had a wide-reaching and powerful impact on contemporary creative women, elucidates the discoveries of material concerning the mythical imagery of *Old Europe*: 'the culture called Old Europe was characterized by a dominance of woman in society and worship of a Goddess incarnating the creative principle as Source and Giver of All. In this culture the male element, man and animal, represented spontaneous and life-stimulating — but not life-generating powers.' The term *Old Europe*, she clarifies, is:

> '...applied to a pre-Indo-European culture of Europe, a culture matrifocal and probably matrilinear, agricultural and sedentary, egalitarian and peaceful. It contrasted sharply with the ensuing proto-Indo-European culture which was patriarchal, stratified, pastoral, mobile, and war-oriented, superimposed on all Europe except the southern and western fringes, in the course of three waves of infiltration from the Russian steppe, between 4500 and 2600 B.C.'[5]

The eminent scholar Jane Ellen Harrison[6] also holds this view of a peaceful Old European matrilinear culture, but there are other researchers, such as Camille Paglia[7], who insist that the power and turbulence of primeval nature which dominated the lives of this culture could not possibly be peaceable and that women held symbolic rather than real power.

There is also debate as to whether the manifestations of the Great Mother/Goddess were imaginal or intellectual archetypes or historical political reality — the latter view holding that this reality needs to be understood if we are to understand ancient mythology and iconography. It is important also, I feel, to understand that in the archaic world, unlike contemporary times, there was *no separation* between physical and imaginal worlds, between body, soul and spirit, between divine in Nature and embodied archetype.

Equally important in understanding prehistorical cultural connections to the workings of universal laws in Nature is the way in which meanings and relationships were/are expressed in mythopoeic (myth-making) languages of visual symbol, metaphor, pattern, sound and music, dance and ritual enactment, in countless forms. All of these expressions were aspects of an interwoven fluid reality and all were in communication with each other. Symbol was connected to Nature, to cosmogony, to myth, to living tradition and experience and was not just the line design that is contemporary art. The dependency on written, intellectually dominated language to define 'reality' — such as is the case today — is a relatively new construction, and a very limited and limiting one at that.

It is perhaps also relevant to the purposes of this discussion to realise that in our culture the word 'myth' has come to mean fantasy, lie or erroneous belief, whereas 'myths', as Joseph Campbell — the foremost geographer in this area — suggests, are the collective dreams of a culture, and dreams are the personal myths of an individual. I read somewhere once that all myths originate in a place of truth and end in a place of inexplicability. One cannot pin down myths with explanations and definitions; the scope is too vast and their divine notions change shape over time and space. Myths fundamentally reside in mystery, as they relate to archetypal expressions of the world of divine Reality. Myths and dreams are part of our paradoxical reality and have always been considered as such, except in the artificial divisions created by Western civilisation between material and imaginal worlds. One has only to look around today to see how visions, dreams, myths and archetypes, manifested through one technological form or another, are powerfully (and largely unconsciously) central in our culture. And so the dialogues and debates continue, zigzagging across the globe. Meanwhile, women continue to love and be inspired by the *Venus of Willendorf* (a stone figure dated at c. 25 000 BC), the Bird and Snake Goddess in her many guises, Botticelli's *Birth of Venus* (c. 1482), Frida Kahlo (1910–1954) and

the various *Madonnas* of history.

It is taught that Western civilisation began with the ancient Greeks, and it appears that this construction of history remained the accepted, virtually unchallenged, reality until recently. Surprisingly, curiosity as to what lay beyond this period, what shaped this Greek culture, appears to have lain largely dormant until the latter half of this century. However, the actual reality is that European civilisation was not created over a few centuries. It extends back much further in space and time — by about six to nine thousand years, on current estimates. And, as Gimbutas points out, it is becoming less possible to understand Greek civilisation without understanding the Minoan and Mycenaean world that preceded it. And to understand the Minoan world it is necessary to study what went before it, that is the culture of 'Old Europe'.

We, as a nation, are also now recognising that the roots of Aboriginal Australia (as it is now called) — in which women had important and recognised creative roles within their communities — extends as far back as forty to fifty thousand years ago and perhaps even earlier. This continent was not 'terra nullius'[8] and was not 'discovered' by European explorers, as was taught until recently in classroom history. To understand present day Australian culture, it is necessary to study all the legacies of European culture — down to 'Old Europe' and the Celtic influences — Aboriginality and, increasingly, Asian-Pacific cultures.

Since the documentation of Western history — including art history — woman has been omitted from its records. This patriarchal denial and oppression has rendered thousands of generations of women virtually powerless and culturally invisible — objects not subjects. Many contemporary women, as is now apparent, have effectively sought, and continue to seek, social and political change within their cultures. Also, as indicated earlier, a number of feminist research writers and artists have observed that having been denied any place in history — or having effectively been *buried* — women are now looking to available information on prepatriarchal, matrifocal cultures and religions for a sense of their true female identity, divinity and power. In their psychological and spiritual thirst, it is to evidence on archaic cultures — such as the 'Old Europe', richly documented by Gimbutas, the Greek and Celtic pantheons, and Oriental mythology — that many creative contemporary women have turned. In these ancient cultures, manifestations of the creative feminine principle are powerfully and centrally visible and the various archetypal expressions of the divine Great Mother/Goddess, as life-generating and health-sustaining forces, were supremely honoured in the interwoven sacred and secular daily life of these communities. Creative women are also looking to the art and artefacts of indigenous cultures such as Africa, New Guinea, Aboriginal Australia and Native American Indian, in their search to re-capture a sense of the primal in their lives and art.

There are many women writers and artists, such as Kate Briscoe, Lucille Martin and Anneke Silver, as examples in this book, who are consciously researching female archetypes, archaeological information and speculations on pre-literate, Earth-connected cultures and indigenous artefacts. There are others for whom it has not been so much a conscious decision to look to these earlier cultures to be able to articulate and frame their sensibilities but rather it was an organic impulse which led them there — artists such as Heather Ellyard, Inga Hunter and Wendy Stavrianos, in this book, and other women artists on similar journeys. In their explorations, all of these artists are attempting to bring forth meaningful visual statements that are relevant to contemporary culture now and in doing so, aim to forge new ground in art.

Certain aspects of life can only be understood in retrospect. It is only recently (and this is an area still in formation for me) that I began to see the connections between what women artists were seeking to restore — that is, art borne of personal experience and cultural connection — and expressions in indigenous art. However, in identifying the *reconnections* I see many women artists — though not all, and indeed some males also — attempting to make, I wish to emphasise that I do not equate their art practice and works with the art and artefacts of indigenous

peoples or other traditions. Nor do I equate them with contemporary culture's relentless pursuit of the 'exotic' or the 'primitive' form as a novelty with which to revivify a jaded spirit. The 'lost' connections to which I am referring have more to do with questions of perceived art (and human) values, existing hierarchies, connections and relationships with the natural world and with contemporary cultural life.

However, whether consciously, organically or a hybrid, the remembering of or returning to primal roots, to the origins of art and culture — to indigenous knowledge, to the cultures, religions, archetypes and symbols of the Great Goddess or Great Cosmic Mother — is a returning to a spiritual link with the Earth, to an identification with the energies of the feminine principle and to personal, social and ecological healing. And the fact is that this life-generating feminine principle, this universal Great Mother/Goddess, in her various symbolic, metaphoric and archetypal forms, is again breaking through into creative consciousness and is speaking through the work of many artists today — as is evidenced in the art and discussion of several artists in this book.

The universal and sacred Great Mother is at the heart and soul of all creation. It is from her womb that all life is birthed and it is to her that all life returns at death, like the cycles of the moon and the seasons of vegetation in eternal return. The life force that she signifies is an immanent power contained within the sphere of Nature rather than the transcendent external force of Western belief. One of the earliest significations of this female principle in what we define as 'art' today is the incisions and sculptural reliefs of vulvas from the Aurignacian period (c. 27 000–26 000 BC). Conceptually, they were intended to make corporate a symbol, were metaphorically mnemonic, and a feature signified the whole figure. For around thirty thousand years — from Paleolithic times, throughout the Neolithic (c. 7000–5500 BC), Chalcolithic (c. 5500–3500 BC) and Copper and Bronze Ages of southern Europe — the symbolism of the supernatural vulva, particularly as the triangle and as symbols of becoming — such as seeds, buds, sprouts, eggs, pregnant bellies, prominent buttocks and aquatic iconography — was universal throughout Europe. The magic vulva, rather than being an erotic symbol, appears to hold central significance as a symbol of birth and the life-generating powers of the world.

In our own times, New York artist Mary Beth Edelson, whose ritual-based performance art has influenced many Western contemporary women artists, has been described by Lucy R. Lippard as:

> '…the American artist most deeply immersed in the study of the Great Goddess, resurrected from prehistory as a medium between nature and humanity… For over a decade she has combined…Jungian psychology, feminism, dreams, fantasies, the collective unconscious, politics, and collaborative artmaking — into a body of work that combines many mediums and millenia… Her utterly serious (and equally humorous) battle cry has been *Your 5,000 Years Are Up!*'[9]

Edelson is said to exemplify the cross-fertilisation of poetics and politics — considered important in a revitalised vision of the world — in the 1977 works: *See For Yourself: Pilgrimage To A Neolithic Cave* and *Memorials to 9,000,000 Women Burned as Witches in the Christian Era*.'

Two other extraordinary living artists who exemplify the dialogue between past and present, between Nature, culture and art or between poetics, politics and the primal — expressed in vivid, earthy and sensuous ways — are sculptors Magdalena Abakanowicz and the legendary Louise Bourgeois. Both sculptors have influenced the perceptions of numerous contemporary women artists. Abakanowicz's *Group of 36 figures* from the *Ragazzi* series (1990) have a raw power which evokes memories of seething life and inevitable death in both, ultimately anonymous, modern and ancient human being. Bourgeois's exquisite 1989 sculpture *Untitled (With Hand)* shows with sublime simplicity the beauty and tragedy of the natural human cycle in Nature in eternal return — the finite within the infinite.

Arguably one of the most discussed contemporary art works among women artists is the cooperatively assembled monumental *Dinner Party* (1973–1979) by Judy Chicago and many others, which is a dedication to women's buried history in Western civilisation. The table settings range from 'places' for the Primordial Great Goddess and Ishtar, the Canaan Great Goddess, to the Indian Kali and the Celtic goddesses Boadicea and Saint Bridget. Judy Chicago has adopted as a personal signature the ancient universal motif of the butterfly — 'the witch's messenger'. It signifies the natural chrysalid's shape of metamorphosis into a winged adult, the butterfly of the Greeks and Aztecs and 'the flying flower' of the Nahuatl — all symbolic of the destiny of the human soul. The butterfly is perhaps an exemplary leitmotif of the transformational aspect of the Great Goddess, expressed in her epiphany in the shape of a caterpillar, chrysalis and butterfly. This symbol and its meanings and associations is again echoed (albeit not directly) in the wonderful butterfly mandala made by Elizabeth Gower in her recent installation exhibition of works that query the notion of the collector and collections. In the catalogue accompanying this exhibition, Gower emphasises the importance of continuing to examine 'the two dominant theories of our time, evolution or creation: chance or design'.

Another powerful visual expression of the archaic feminine principle that is erupting into contemporary creative consciousness is that of the Bird and Snake Goddess, and her manifold symbolism, which is linked to the aquatic sphere and the idea of the origins of life. Gimbutas discusses her all-pervasive presence in archaic culture as mistress/goddess of the life-giving waters and of air 'who is both one and two, assuming the shape of a snake, a crane, a goose, a duck a diving bird'. Her cosmic character is emphasised in a series of abstract compositions painted on Cucuteni vases and in the 'floating duck' of the famous Vinca *Hyde Vase* and what has been called the *Venus of Vinca*. (The Vincas were a people settled in Macedonia, peaking at c. 5000 BC.) 'The combination of a water snake and a water bird', says Gimbutas, 'is a peculiarity of the Old European symbolism representing divine ambivalence.' Parallel lines, V's, Chevrons (multiple V's), belts of zigzags and groups of parallel lines have been found consistently on figurine masks and bodies, anthropomorphic vases, miniature cult vessels and zoomorphic containers suggestive of a 'coherent system of symbolic expression and communication'. The meander symbol of cosmic waters was carved on figurines — often incised like a labyrinth — 'with bird-masks or bird-heads, snake-arms or snake-legs and on masks, cult vessels and altars in all cultural groups of Old Europe'.

The bisexuality, or fusion of the sexes, of the water-bird-snake-woman deity — apparently symbolising a strengthening of life powers — is represented in various schema such as in bird-shaped containers with a long neck, 'symbolically linked with the Phallus or the snake from Upper Palaeolithic times and onwards throughout many millenia'.[10] The epiphanies of the goddess were many and varied — although she generally appeared as a human female and often as a water bird, she also manifested as all the various species of snake, toad, owl and bear. Her powers permeated all of nature, human life, the animal world and all vegetation. All of the known symbols of this ancient universal Great Goddess are being employed by many women artists today in multiple modes and media.

The rhythm and symmetry of this prehistoric art has also been linked to dance and music — which resonates with tribal people's approach to dance as emanating from the movements of birds and other animals, with their sounds being the origins of music. In cosmogonic myths, rhythmic sound is at the root of all Creation. Inherent to or behind this cultural patterning is the idea of what the Neoplatonists called the 'Axis Mundi' (Axis of the World — often symbolised as a Cosmic Tree) — the still centrepoint around which the seeming chaos or movement of the universe revolves. It is not such a great leap from the branches of the 'Axis Mundi' to the ocean of 'Anima Mundi' (Soul of the World) — the inner/outer female animating force of the universe. The goddesses and gods (or God) are the channels through which the power of this life force manifests.

Lucy Lippard expressed the view that:

> 'The spiral, water meander, lozenge [denoting fertility — a diamond shape symbolizing the sown field often incised with a dot in the centre representing seed], zig-zag, and bird, snake, and egg motifs of this goddess-centred Old European culture turn up in different guises until (and into) Christian times… The androgynous bird-snake goddesses of Old Europe, with their phallic heads and fertile bodies were the predecessors of the Cycladic idols that inspired Constantin Brancusi (who was raised in Romania, in the heart of Old Europe) and Max Ernst, with his androgynous bird alter-ego — LopLop.'[11]

Both of these artists have been very influential in the history of modern art and upon many artists in this book. Aspects of this totemic sensibility are also found in the work of women surrealist artists like German collage artist Hannah Hoch (1889–1978), the French painter Leonor Fini (b. Buenos Aires, 1918) and significantly in Berlin-born Meret Oppenheim (1913). Oppenheim is notable for her words as well as her shape-shifting art works in such statements as: 'The mind is androgynous', and when it comes to art: 'There is no difference between man and woman: there is only artist or poet'.

The Bird Goddess archetype and/or her symbolism emerges in the works of Kate Briscoe, Wendy Stavrianos, Anneke Silver and Judi Singleton but is perhaps most graphically expressed in the shamanistic art work of multi-faceted artist Inga Hunter.

The aspects of air and water, bird and snake, flight, fluid nature and subterranean reality, and bisexual or androgynous nature has resonances with that archaic prototype of the artist, the shaman — about whom more will be discussed later.

The revered and feared Rainbow Serpent — creator and protector of life — of Aboriginal Australia, who is said to inhabit deep permanent waterholes, is still honoured in the ceremonial art, dances and songs of Aborigines throughout this continent. Aborigines also honour the sacrality of Mother Earth in all aspects of their lives and hold the view that all life descends from the Mother.

Aboriginal women and men, carrying forward and embodying the Law of their ancestors, hold highly sophisticated and complex maps of their country and related ceremonies in their mind's eye. This intimate experiential knowledge, which has helped them survive extremely harsh physical and spiritual conditions and to keep alive awesomely rich cultures for millenia, embraces past, present and future time and space in a seamless cosmological 'Tjukurrpa' — translated by Europeans as 'Dreamtime' but which has for Aborigines a meaning far greater, more akin to the quintessence of existence itself and comprising the land and the people. The seeming abstraction of contemporary Aboriginal art, or 'songline' journeys, is actually an extraordinarily detailed mapping of land and story, myths and ceremonies — an interwoven cosmological reality which is instantly recognisable to its cultural inhabitants.

A significant structure of traditional Aboriginal culture, which also emerges in their art, is the concept of 'women's business' and 'men's business', which denotes knowledge and responsibilities accorded to each group within a community. These groups contain clearly distinguishable characteristics and roles and although fulfilling separate functions, they are seen as integral, interdependent and complementary aspects of a cultural unit. With regard to 'women's business', it was not until the 1970s that women's stories began to be recorded by female anthropologists, educators and others in the field. Until this time, research on Aboriginal people and their cultures was dominated and documented by male anthropologists, and due to traditional requirements (generally speaking) that only men can deal with 'men's business' and only women can deal with 'women's business', it was only the men's stories that were being recorded. However, Aboriginal and Torres Strait Islander women have their own traditional legacy and have been making art, so to speak (there is no specific word for art in

Aboriginal cultures), for thousands of years. They have been doing their ceremonial body painting, making their traditional feathered head and arm bands, sand paintings and dance board paintings, weaving dilly bags, making tools and carving coolamons for hunting and gathering food and water for millenia. All of these creative endeavours have emerged in paintings by Aboriginal women from several communities, and their stories and creative works are now being increasingly recognised, recorded, published and painted.

Examples of this revolutionary contemporary art rooted in an archaic tribal tradition can be seen in the works of Matingali and Mirlkitjungu from Wirrimanu (aka Balgo Hills) and Gloria Tamerre Petyarre from Utopia. Matingali and Mirlkitjungu's works show various aspects of areas of this cultural mapping/Tjukurpa/Law for which they are custodians, as does the work of Gloria Tamerre Petyarre, which also draws from the 'paint-up' designs of 'Awelye', (Women's Law/ceremony) — or 'Yawulyu' to the Wirrimanu women. Aboriginal women and their art are particularly prominent in both the Wirrimanu and Utopia communities. Aboriginal art is also extraordinarily rich and prolific given the relatively small numbers of its practitioners.

All of the symbolic schema under discussion resonate in the art and architecture of many world cultures and religions throughout time — particularly the labyrinth/mandala, which is again gaining prominence not only with visual artists but also as a Jungian symbol of individuation and an archetypal meditative symbol of integration. It has been said that the history of art is the history of the world's religions and, more recently, that current spaces exhibiting art are subsuming formerly religious domains. The blueprint of sacred architecture is the female body. This is to say that unchanging, underlying divine realities of Nature, the interdependence and interconnectedness of all space and all time, the transmission of elements from one culture to another — and cumulative knowledge — has occurred throughout human history. Each evolution of human culture is overlaid upon that which preceded it and contains elements, albeit often in new personas, of earlier cultures. This has taken place whether we are conscious or unconscious of origins — both natural and cultural — and whether or not we forget our origins or are given cause to remember — as is the case today. Forgotten knowledge is not lost knowledge — all is held in the memory of body and land. When Nature needs, she reveals.

The precursor of the labyrinth is the spiral — the pre-eminent symbol, together with the circle, of the divine string of all life — exquisitely expressed in the double helix of DNA. The beauty of this vibrational patterning of nature is visible today in the meeting of natural law, mathematics and computer technology in the reproduced works of the visual science of fractal geometry.[12] Many artists today are looking to all the available areas of information on human and scientific consciousness and to their related symbolic realities to define their art and their place within it — as seen in the work of Marion Borgelt, Joan Brassil, Lyndall Milani and Anne Judell, for instance.

Another aspect of artists' work today is the way in which it directs our attention to the non-verbal, sensuous world of experiential reality, through the use of abstraction, such as in the work of Aida Tomescu and Lezlie Tilley or in the dreamscapes of Barbara Licha.

Many artists are shining beacons on the forces and subtle processes of contemporary cultural construction — artists such as Merilyn Fairskye, Pat Hoffie and Lucille Martin, who in all manner of creative ways attempt to engage and provoke their audiences into other ways of seeing and thinking. Gabriela Frutos, in her works, explores the conflicts between the natural world and human constructions on the landscape. Death, loss and redemption definitely has its place in art — in the work of Jutta Feddersen, Anne MacDonald, Kate Briscoe and Lindy Lee.

All life originated in the primal Oceanus of sea and womb — it is this dreaming of oneness, this unitary organisation, for which we all yearn and strive, and to which we all fear to return. Some artists are expressing this feminine dynamic in the revelatory insights revealed in the bodily life/death experience of childbirth, powerfully articulated in the near-death experience and work of Lyn Plummer. And others do this in the more day-to-day themes of motherhood,

of personal, familial and cultural relationships, of woman struggling to juggle all the roles demanded of her, as in the work of Davida Allen and Mona Ryder. As Allen expresses it: 'I am more interested in shining a congratulatory light on the woman in the house doing the nappies…on the woman struggling to maintain some sense of sexual self in her tired marital bed…' Other themes of celebrating the body and personifications of Woman herself are explored in the work of Annette Bezor, Joan Letcher, Vicki Varvaressos and Liz Williams.

In the context of understanding this reconnection to the feminine principle and to the body of self and Earth in many women and artists, it is perhaps important to consider that prior to the 'scientific revolution' which attended the age of Enlightenment in the 1700s, the entire planet — body and fluids — was apparently considered by most peoples to be *alive* and to be the Mother of life. Earthly forms and processes have long been associated with the human female body as well as with Earth herself as a living body — it was her skin/soil, her breath/ wind, her fresh water/ancestral blood, her children/all living species which gave and sustained life. This is eloquently expressed in the words of the great Chief Seattle (Sealth — born in 1790) in his now famous reply, on behalf of the Duwamish people and other Indian nations, to an offer in 1854 by the United States government to buy a large area of Indian land:

> 'Every part of the earth is sacred to my people. Every shining pine needle, every sand shore, every mist in the dark woods, every clearing and humming insect is holy in the memory and experience of my people. The sap which courses through the trees carries the memories of the red man… Our dead never forget this beautiful earth, for it is the mother of the red man. We are part of the earth and it is part of us.'

Chief Seattle, in closing his speech, prophesied '[t]he end of living and the beginning of survival'[13] due to exploitative Western attitudes towards life and the Earth. Seattle's words are echoed in the expressed relationships of Australian Aborigines to their animate ancestral land.

It is only since the scientific revolution that Mother Earth became earth and began to be perceived of as dead — like the machines and technology that science has produced ever since. Looked at in historical terms, the idea that the Earth is inanimate has existed for only a brief period, whereas the perception of a sacred universe with an interconnected and interdependent web of life has existed for millenia. Elizabeth Gower, on the processes of researching and collating the body of work for her recent *Chance or Design* exhibition, says: '[It] is evident to me that the natural world is a manifestation of precision, order, design and beauty of such complexity and ingenuity that it could not have come about through millions of chance accidents and random mutations'. There is also recent scientific information coming forward, such as the Gaia hypothesis, proposed by biologists Lynne Margulis and James Lovelock, which is again supporting the fact that the planet and the atmosphere is a unified biological entity, and there are now scientists who are prepared to argue the importance of conservation in light of this understanding. *Gaia* is an ancient Greek name for the Great Mother Creatrix — one of her many throughout time and cultural place-and science is only now echoing a truth long known, understood and respected by the indigenous peoples of the Earth.

Among the artists whose work specifically addresses the need for learning about, understanding and respecting Earth and the sacrality of natural law, and examining history and emphasising conservation in light of this understanding, are the Aboriginal artists Matingali, Mirlkitjungu, Gloria Temarre Petyarre and Fiona Foley and Sydney-based painter Hannah Kay. Mandy Martin, in a tangent to the modern understanding of mapping, is tracking the trails of 'artist as explorer' in retracing the steps of early European explorers through the Australian landscape.

The notion of the inherent sacrality of Cosmic Nature — and of the Earth and body as the location of divine earthly experience — is echoed today in the words and work of a number of

artists in this book. Lyn Plummer comments:

> 'Flesh as memory is embedded with the markings and scar of the culture's past behaviour patterns, lusts, ritual gratifications and punishments. The skin is the parchment on which the culture's collective memory has traced and incised a collection of patterns and images… The costume has become a metaphor for the skin… Woven into the garments of our rituals are the convolutions of basic instinctive behaviour which can be related to sexuality and power.'

And speaking about the archetypal work *Autumn Mantle*, Wendy Stavrianos says: 'She is a landscape. Her dress is her voice. Dress is always used in my work to convey meaning. Cloth has sacred associations for me.' As Heather Ellyard expresses it:'

> 'Women work from where we are, from where we can reach and touch. The personal is the starting point. We do not separate. We thrive on the "permeable boundaries". We make connections; we make allegiance to nature. Women know the cycles. We know how to wait the gestation out; how to prolong the kiss; how to relive the orgasm (and translate it); how to wipe tears and shit; how to clean wounds and bathe in soothing waters; how to share and how to dance and sing when alone. This knowing is organic without betraying the intellect, and resonant because it is both intimate and open.'

And so the images, stories within stories and themes within themes continue as creative women draw on elements of their ancient and contemporary lineage in building bridges into the future — which is the power and potential of art.

THE ARTISTS AND ART

As with so-called 'women's art' in general, much of the art work and practice discussed in *New Visions New Perspectives* is the flowering of 1970s and 1980s concerns about addressing the lost/ forgotten connections and absences in art and life, albeit in individual ways. The artists are focusing on terrains such as the female body as subject — as location of experiential memory, cyclic nature and sensual being and not just aesthetic object determined by the male gaze; the exploration and articulation of inner spatial reality, as well as exterior space, as a ground for one's experiencing; the reconciliation of sexuality and spirituality or flesh and spirit; the reintegration of physical, emotional, intellectual and spiritual relationships; the realms of the domestic and the intimate as part of our everyday lives — and thus as part of history and a legitimate art resource; individual identity within a cultural and multicultural context; the constructive nature of perception and culture; the *nature* of consciousness; the landscape not only as surface 'view' but as source, resource, sacred site of meaning; the use of performance ritual in art practice; death, loss and bereavement; and addressing the interconnectedness of all things.

Other areas of exploration by women artists are the exploration of the nexus between science and art — both through visual translations of theories of universal physical laws and by using the technologies that characterise our age and inverting and subverting their explicit and implicit processes; the use of ephemeral materials in their work, thus challenging existing Western art canons where art work is/should be on a 'grand' scale and designed to endure intact over time; and addressing concerns of the dominance of verbal language, and its existing historical and structural baggage, in articulating experience. At the heart of this is a groundswell shift of framework priorities from an academic art to an art of individual and cultural experience whilst retaining respect for artisan skills.

The artists in *New Visions New Perspectives* are addressing these concerns, amongst others, consciously and unconsciously, in a multitude of different visual modes and media — from painting, printmaking and sculpture to mixed media assemblages, photographic and photo-

copy collages and multi-media installations. The artists in this book encompass established, emerging and mid-career professional stages and are of widely divergent backgrounds and perspectives — from Aboriginal elders to women of European and Asian descent and relatively recent migrants — and this is reflected in their art work and practice. In a rich diversity of expressive styles, the women openly tell their stories of formative influences, inspirations, pivotal experiences, struggles, philosophies and concerns — all of which are transmuted and transformed through the skilful manipulation of their chosen media into individual creative visions. The artists also give detailed information on the processes involved in the creation of the reproduced images accompanying their testimonials. The spirit of openness with which the artists *directly* share their experiences and knowledge provides a wealth of lively, informative and at times challenging material which is often profoundly moving, inspirational and illuminating.

There has been, and continues to be, much debate as to whether or not there is a 'female sensibility' in the arts, and in the public sphere the jury is still out on this score. On the current face of it, a female sensibility does appear to exist: for instance, in biological life experience; value structure; content; ways of 'speaking'; in some instances, in the employment of particular (ephemeral) materials and their meanings; in the ways that women often move primarily from the *inside out* in expressing themselves rather than the *outside in*, which is common (though not exclusive) in the male vision; and in the reflective nature of much of their art. However, while the processes of redressing history and questioning what is inherently 'female' and what is cultural prescription are still afoot, the longer term view is difficult to determine — particularly as there seems to be some quiet *revolutions*[14] going on as to the whole nature of previously determined canons and categories of art — in much the same way as happened with Dadaism and more particularly the Surrealist movement, though on a much greater scale.

We are in the middle of a profound paradigm shift in human consciousness and, in terms of art, it appears to be women, indigenous people and those men who are creating from their feminine aspect who are at the vanguard of this fundamental shift in creatively and psychically leading us back to our origins on Earth, our biological basis of being and the life of spirit and soul in our embodied selves. What distinguishes current revolutions in contemporary art theory and practice is the powerful resurgence of the feminine principle in art and cultural life; the art of women and their positing of personal and cultural experience as art subject; the unveilings of ancient cultural knowledge and the re-awakening of mythic, archetypal and shamanic consciousness that all of the above has elicited.

Norma Broude and Mary D. Garrard, in *The Power of Feminist Art*, 1994, suggest that until the advent of the women's art movement in the 1970s and 'its now well-known slogan *the personal is the political* there had not yet existed a self-conscious and universalising female voice in art — self-conscious in articulating female experience from an informed social and political position and universalising in defining one's experience as applicable to the experience of other women'. Feminist (women's) art and history propelled by the women's art movement, say Broude and Garrard, helped to initiate postmodernism in America, tenets which now have currency throughout Western contemporary art practice.

> 'We owe to the feminist breakthrough some of the most basic tenets of postmodernism: the understanding that gender is socially and not naturally constructed; the widespread validation of non-"high art" forms such as craft, video and performance art; the questioning of the cult of "genius" and "greatness" in western art history; the awareness that behind the claim of "universality" lies an aggregate of particular standpoints and biases, leading in turn to an emphasis upon pluralist variety rather than totalizing unity.'[15]

These conclusions could be reached, it was suggested, because:

'…feminism had created a new theoretical position and a new aesthetic category — the position of female experience. In so doing it reduced what had previously been considered universal in art to its actual essence — the position of male experience (and usually white heterosexual male experience). And once any given work of art was understood to proceed out of and be shaped by specific conditions of gender, race, sexuality, or class, it became equally clear that audiences also responded to art out of their own conditioning i.e. the art that we find most compelling is art with whose maker we share a basis of common beliefs or experience.'[16]

In response to questions on the nature of art on an archetypal level, Camille Paglia, author of the influential, provocative, multi-disciplinary tome *Sexual Personae*, 1990, which has had a considerable impact on several artists in this book, asserts that 'Judeo-Christianity never did defeat the brutal pagan[17] forces of sex and nature which still flourish in art, eroticism, astrology and pop culture' and that 'the amorality, aggression, sadism, voyeurism and pornography in great art have been ignored or glossed over by most academic critics'. Sigmund Freud said that we pay for civilisation with our sexuality, and Paglia asserts that 'sexuality and eroticism are the intricate intersection of nature and culture' and that 'sex is a far darker power than feminism has admitted'. Paglia's theory, in response to contemporary culture's drive for sexual liberation, is that 'whenever sexual freedom is sought or achieved, sadomasochism will not be far behind. Romanticism always turns into decadence… Not sex but cruelty is the great neglected or suppressed item on the modern humanistic agenda.'[18]

Paglia, like a number of other writers, further extends the perennial culture versus Nature debate with the theory that Western personality and Western achievement are largely of the archetype Apollo — symbolising maleness and aspects such as the law, tradition, objectivism, cold separatism, fascism, voyeurism, principle of unity and order — whose great antagonist and rival is the archetype Dionysius — symbolising chthonian procreative femaleness (and transexuality), empathic and sympathetic emotionalism, energy, disorder, volatility, the new and the principle of pluralism. These two great Western cultural principles, Paglia asserts, 'govern sexual personae in life and art' — and art is about apollonian order. 'The westerner knows by seeing. Perceptual relations are at the heart of our culture, and they have produced our titanic contributions to art.' And she continues, 'From remotest antiquity, western art has been a parade of sexual personae, emanations of absolutist western mind. Western art is a cinema of sex and dreaming. Art is form struggling to wake from the nightmare of nature.'[19]

I imagine that Zeus — that archetypal sky god father who dominates Western institutional thought — could equally qualify for the position held by Apollo. But I ask, why two male gods (albeit a feminised god as in Dionysius) in the archetypal culture versus nature contest? What of the 'monstrous Venus' of cosmogonic myth — and her descendants such as the mythic personification of Gaia — the Genetrix of *all* Life — nature, human, animal and vegetation — and from whom all gods and goddesses spring. She, it seems to me, is central to this schema in her own right.

As fascinating as the constitution of archetypes may be, their constructive message is most usefully applied to deciphering what their divine energies have to reveal to us creatively about the cosmos, ourselves and the times in which we live — and to raising questions as to what personal and cultural need particular mythologies, archetypes and dreams are addressing and responding to when they arise. However, if we follow Paglia's, and others, precept of the intense ongoing rivalry between apollonian and dionysian forces of culture and nature, it would appear that at this time in history, Dionysius has really flung the proverbial gauntlet at Apollo's feet. And those beings who are principally manifesting the tensions between the Apollonian and Dionysian archetypes and the dionysian aspect in the arts arena are women artists (and those males most strongly creating from their feminine aspect).

As well as being identified with chthonic power and the femaleness and transexuality in nature, the Dionysian archetype, that mystical god and daemon[20] of vegetation, has often been called the androgynous god of ecstasy. The primal human being most associated with the ecstatic state (and often linked to Orpheus) is the *shaman* — said by many, as mentioned earlier, to be the archaic prototype of the artist — meaning the full spectrum of the *visionary* arts (not to be confused with *visual* arts). This archetypal, pre-political holy woman or man was also a pre-eminent healer in and for the tribal and prehistoric community, and shamanism has often been said to be the world's first religion — remembering that in ancient times there was no separation of art and culture, Nature, magic and religion.

It was this core quality of ecstasy that had gone missing in contemporary life and which I particularly noticed in the fields of contemporary art, religion and psychology, where one would expect, above all other exterior places (other than Nature), to find its presence. Before I encountered shamanism, I had defined this missing animating quality in contemporary cultural life as 'an absence of *joy*', as a corollary to the other side of the equation, pain.

THE ARTIST AS SHAMAN

One of the most fascinating lines of enquiry that has emerged alongside the current interest exhibited by contemporary artists and other cultural explorers and commentators in the archaic is the revitalised interest in the phenomenon of *shamanism* and in the notion of the *artist as shaman*. Considered by many to be the foremost scholar in this area, Mircea Eliade, in his book *Shamanism*, 1964, defines shamanism as *technique of ecstasy*. Generally, shamanism has co-existed with other forms of religion and, as Eliade says, 'The shamans have played an essential role in the psychic defense of the community'.[21] Shamanism has been described as a widespread religious tradition generally found in hunting and gathering cultures amongst people living in dispersed, often migratory groups. The shaman is differentiated from the magician, the medium and those in an ordinary ecstatic state in her/his individually unique method of purposeful journeying in an altered state of consciousness into inner spatial reality.

Shamanism had its emergence into consciousness in Paleolithic times, perhaps even extending into the Neanderthal era, and in visually returning to the so-called beginnings of Western art, we encounter not only what was the first known image-making by humankind in what is now known as Europe — in the cave art of Lascaux and Trois Freres in southern France and Altamira in northern Spain — but also the first known images of the shaman.

The opening sentences in Helen Gardner's long-time tertiary textbook *Art Through The Ages*, 1926, read:

> 'What Genesis is to the biblical account of the fall and redemption of man, early cave art is to the history of his intelligence, imagination, and creative power. In the caves of southern France and northern Spain, discovered only about a century ago [by accident]…we may witness the birth of that characteristically human capability that has made man master of his environment — the making of images and symbols.'

The authors continue:

> 'Like Adam, Paleolithic man gathered and named the animals, and the faculty of imagination came into being along with the concepts of identity and meaning… Our intellectual and imaginative processes function through the recognition and construction of images and symbols; we see and understand the world pretty much as we are taught to by the representations of it familiar in our time and place.'[22]

The Genesis version of Creation is no longer universally accepted, but amongst those acquainted with early art history and shamanism, there is still accord that the masked bearded

humanoid figure with antlers, tail and bear paws called the *Sorcerer* (c. 15 000–10 000 BC) at Trois Freres in the Pyrenees and the bird-headed, stick-like figure at Lascaux (which has come to be known at *the Sistine Chapel of pre-historic art*) are both the first figurative images of 'man' and the first known images of the ancient shaman. However, it has recently been scientifically validated by Dr Claudio Tuniz that the macropod track at Olary in South Australia has the oldest dated rock art engraving site in the world. It is dated at 34 000 years old.

The meanings of the content of this art engraving are yet to come to light.

Returning to the shaman, anthropologist Joan Halifax elucidates in *Shamanic Voices*, 1979:

> 'The shaman can be described not only as a specialist in the human soul but also as a generalist whose sacred and social functions can cover an extraordinarily wide range of activities. Shamans are healers, seers, and visionaries who have mastered death. They are poets and singers, they dance and create works of art. They are not only spiritual leaders but also…the repositories of the knowledge of the culture's history, both sacred and secular.'[23]

There are a number of women artists and writers who believe that the first shamans were women in holy relationship with the heartbeat of Earth and her seasons, of finite Nature within the infinite *chain of being*. Women also, through their universal biological connection to Nature and 'moon-mind', have a long history as healing mediatrixes. Though it can't be verified whether women were the first shamans or not: information on women's formerly suppressed history is still emerging — and being perhaps as old as human consciousness itself, the details of the shaman's existence are lost in the mists of time and can only be extrapolated from living mystery traditions. Also the perceptions of most Western anthropologists/scholars in this area are not akin to the perceptions of the shamans or shamanic cultures themselves.

In any case, what matters is that in the ecstatic religious visionary phenomena that is shamanism, both female and male shamans existed and continue to exist, and those shamans who were male were usually feminised — androgynous, bisexual, transsexual. Margaret Mead said in *Male and Female*, 1949: 'The more intricate biological pattern of the female has become a model for the artist, the mystic and the saint.'[24]

The shaman archetypally expresses that profoundly human need to fly 'like a bird', to form a bridge between the worlds of past, present and future and between the physical and spiritual realms, and to glimpse the numinous power of primary imaginal worlds revealed to us in moments of dream, in heightened experiences in Nature, in deep, empathic connection with other beings, in music and great works of art, thus transcending the treads of everyday or ordinary waking consciousness.

Using a ritual technique that often employs drama, dance, sound and song to induce an altered state of consciousness or 'ecstasy', the shaman journeys — at will — with a specific mission to retrieve knowledge from the inner planes of reality. Generally, a shamanic mission is for the purposes of restoring balance in an individual or the tribe/community, to retrieve lost 'objects' and/or to glean information of cosmic import. During this inner journey, the shaman is believed to leave her/his body and travel to the underworld and overworld — Earth being the middle world — contacting and interacting with the spirits and beings of Nature. A common task for the shaman is to retrieve a lost soul for s/he, working directly with the cosmos and its forces, is the geographer par excellence of this inner world of space and spirit. To the shaman, the practice of 'art' forms was a 'means' not an 'end'.

For the shaman to acquire this difficult and esteemed position in the culture, typically s/he had somehow been hurled into the dark waters of existence through illness or traumatic incident — the archetypal dark night journey of the soul. Defying death, the shaman-to-be, showing immense courage and endurance, recovers their physical, psychological and spiritual health and is reborn, so to speak. In the journey of self-healing, the wounded shaman has

acquired deep and detailed knowlege of the processes of dis-ease and the recovery of health. With this new-born wisdom, strength and, above all, awesome power, the shaman can access, see, navigate and communicate with normally invisible and subtle forces and, with that power, has the capacity to act as an intermediary and guide on behalf of others. The shaman is the intercessor between gods and human beings, who — in essence — on a voyage of flight, returns to the place of origin. To shamans, an energetic life force permeates all things and the cosmos is an interconnected vibrating whole, which enables them to move between worlds and operate effectively both in what Michael Harner, in *The Way of The Shaman*, 1980, calls Ordinary State of Consciousness and Shamanic State of Consciousness.[25]

The visionary tradition of shamanism, though diminished and diluted by scientific technology, is still actively practised in a number of places today, including Aboriginal Australia, surviving and adapting over the millenia through world migration and the resultant diversity amongst peoples. The shamanic spirit that is resurgent in contemporary consciousness is manifestly evident in the lives and occupations of many creative and healing people, as Joan Halifax says in *Shaman*, 1982: 'Today the role of the shaman takes many forms — healer, ceremonialist, judge, sacred politician, and artist, to name a few. The shaman lies at the very heart of some cultures, while living in the shadowy fringe of others.'[26]

We no longer live in a tribal way but are, for the most part, urban dwellers not in contact with ancient animistic cultural knowledge and thus cannot lay claim to being shamanesses or shamans. However, aspects of a shamanic spirit can arise spontaneously in a journey of healing trauma and transforming that knowledge into works of art or in acting as a healing or awakening agent for others. A shamanic spirit reverberates in the lives and work of a number of women across the spectrum of the contemporary arts and healing professions, including several in this book. Some of the aspects of this spirit which are prominent in art made by women are the transformation of visions and experiences — both painful and joyful — into works of art; the engagement of ritual in private and public art-making processes and the altered states that often accompany it; the retrieving of ancient knowledge and values, as is amply evidenced in this book's discussions; making manifest and visible ordinarily hidden, subtle and so-called invisible realms in exterior/interior space; the interaction with forces, iconography and value systems of contemporary cultural construction with the aim of reordering existing perceptions in order to enlighten.

The emphasis on the personal journey and inner experience as subject matter and the primal as a site of interest — which are prominent in contemporary women's art — resonates with the prophetic words of art critic Jack Burnham, writing in 1974. In his chapter on 'The artist as shaman' in *Great Western Salt Works*, Burnham says: 'Contemporary art has finally arrived at the critical stage of its crisis…at this most crucial and sensitive point the artist focuses upon the primal aspects of his own creative motivations…and it is the "trials" and psychodramas of the individual that provide us with our sense of direction.' He suggests that 'since all historic art-making is the sum-total of the individual's emotional potential, it is likely that art in its last stages constitutes a structural reversion to the infantile stages of human development. At this level art deals with those "nuclear" relationships established by a child in its first months of life.' This is of course a returning directly to our bodies and personal experiential memory — in other words, a psychic return to our origins in life. 'It is precisely those artists involved in the most naked projections of their personalities who will contribute most to society's comprehension of itself,' he states. Burnham considers that 'only by artistic means can the originally-sick man, the shaman invert the evils of his tribe', and in so doing, the shaman-artist has the potential to 'draw people away from substitute objects toward the ancient memories of life and productivity'.[27]

Michael Tucker, in *Dreaming With Open Eyes*, 1992, proposes that the 'synchronistic' (after Carl Jung) discoveries of the art of the prehistoric caves of Altamira, Lascaux and Trois Freres,

the shift in both the aims and appearance of Western art and the discoveries of depth psychology indicated the 'stirrings of a fundamental shift in attitudes towards matters of consciousness and creativity: a shift towards shamanic ideas of the relation between life and art'. Tucker specifically examines the 'return of the Western mind to the ancient shamanic idea of the artist as visionary healer' and the 'extent to which twentieth-century artists of the industrialised West have helped to prepare the way for…the shift from mechanistic, rationalist modes of thought to what has been called a sense of *participation mystique* in life'.[28] Erich Neumann, a Jungian psychologist who has written extensively on aspects of the creative and who coined the term *participation mystique*, advocated this desirable state of consciousness as 'containing the constructive creative elements of a new world vision'[29] — again, a new vision or perspective rooted in ancient ground and perception.

Manifesting aspects of the shamanic spirit, however, does not necessarily make a shaman — who is not self elected. The conscious and devotional vocation of *service* that is the way of life of a shaman — a holy wo/man — is quite specific, demanding the highest respect, and is an honour not acquired or accorded lightly. Whilst the subject of shamanism is compelling in many ways, concomitant with the rise in interest in this area has come an increasing co-option of the use of the word in ever loosening definitions and ascriptions — as is the way of the west. Some of this co-option-a behaviour rife in twentieth century contemporary culture-whilst clever, is very commercially and/or egoistically based, which is in diametric opposition to the shaman healer's value system. In our culture, words and categories can acquire fashionable coinage or suffer institutionalisation, thus being divested of their original power and meaning and losing contact with an authentic basis, being or experience in the process — much the same as has frequently happened in twentieth century visual art with the co-option of early cultural art 'forms' without the connection to their inherent religiosity.

At the same time, I think there is great value in a general awareness of the subject of shamanism and of the greater potential richness of a perspective of the artist, where valid, as manifesting aspects of shamanic cosmic consciousness — here meaning the full spectrum of the arts. We, as individuals, also have the potential to glimpse the imaginal realms utilised by the shaman through visualisation and technical information available from anthropologists and others who have had contact with shamans and shamanic cultures. In so doing, we are able to explore aspects of the shamanic universe and cosmic consciousness for creative and healing purposes.

PAST PRESENT INTO THE FUTURE

We as a species are again at a crossroads. We are in that in-between place, the limbo of unknowing between an old order decaying and a new order still in gestation. This place in-between worlds is the shaman's familiar ground and also the working place of the artist. We are also a wounded people, living on a wounded planet, and above all, the archetypal shaman is recognised as the visionary *wounded healer*. Perhaps the notion of the artist-as-shaman is gaining ground today because true artists, as conduits, have long reflected their cultural times and by journeying into seamless time have often signposted the future. Also by reaching into the depths of self and soul and by articulating and communicating that experience, they serve society by assisting us to understand ourselves and the underlying ways in which we are all connected regardless of time, race, gender, class or creed.

Perhaps also the archetype of the shaman and the notion of the artist-as-shaman has resurfaced at this time as a symbolic and actual process for addressing society's need to restore balance, to move us towards the sought-after reintegration and reconciliation of perceived opposites such as female and male, feeling and thinking, light and dark, inner and outer, physical and spiritual. The androgynous shaman, this 'technician of ecstasy' or 'technician of the sacred' who bridges time and space, embodies this reconciliation of polarities. Perhaps the archetypes of the universal Great Mother/Goddess, in all her many and varied aspects in

women's art and psychology, and the primal shaman have erupted at this razor's edge in time in response to civilisation's 'cri de coeur' of lost soul.

The Great Mother is about re-souling the body of self and re-establishing our connection to Earth, about healing the split between flesh and spirit, about alerting us to the inherent beauty and divine nature of Earth and cosmos and the finiteness of our own biological being within the continuum. The work of the primal shaman, as discussed earlier, is about retrieval of ancient and forgotten knowledge; about cosmic energy patterns; about retrieval of the lost soul; about locating dis-ease and healing the individual and the tribe/community — it is about how to walk in balance on the Earth in harmony with the cosmos, as first nations peoples advise us to do, and know our place in the universal scheme of things. The shaman, with her/his intrinsic integrity, is the wise guide to awaken and lead us away from our madness, which threatens to extinguish all life, and, together with the Great Mother, show us ways that can nurture and protect life, in healthy and fair relationships of energetic exchange for future generations.

Perhaps the contemporary resurgence of the shaman, the archetypes of Venus, Psyche and Eros, Orpheus and Dionysius also represent a return to group or communal thinking as against the crushing freedom of individualism that has characterised the ages and archetype of Apollo. The inimitable Jane Harrison brilliantly revealed the historical division between the essentially religious Dionysos (her spelling) and the cerebral Olympian in her classic work *Epilegomena to the Study of Greek Religion* and *Themis*, 1925. She elucidates her ideas (amongst many others) that Dionysos, with every other mystery-god, expresses the underlying oneness that is characteristic of instinctive life, whereas the rest of the Olympian pantheon expresses the action of conscious intelligence, which reflects on and analyses life. '…among primitive peoples, religion reflects *collective* feeling and *collective* thinking,' says Harrison. 'The mystery god arises out of those instincts, emotions, desires which attend and express life; but these emotions, desires, instincts, in so far as they are religious, are at the outset rather of a group than of individual consciousness.' She adds:

'The whole history of epistemology is the history of the evolution of clear, individual, rational thought, out of the haze of collective and sometimes contradictory representations. It is the necessary and most important corollary to this doctrine, that the form taken by the divinity reflects the social structure of the group to which the divinity belongs. Dionysos is the Son of his Mother because he issues from a matrilinear group.'[30]

The 1990s has brought, and continues to bring, rapid and tumultuous change as we come to the end of a millenia and enter yet another (or — depending on your viewpoint — come to the end of the fourth world and enter the fifth world). As the eminent poet Judith Wright says it:

'…time and the world that faster spin until
mind cannot grasp them now or heart take hold.'

The Moving Image

Paradoxically, the advancement of communication technology has shrunk geographical distance, making the web of global connection more visible and accessible. The unique multicultural melting pot that is present-day Australia, whose distance from the northern hemisphere was once seen as a liability and the source of a sense of inferiority manifesting in a peculiar 'cultural cringe', is now developmentally and creatively 'coming of age'. This is particularly evident in the long overdue recognition of the Australian Aboriginal as original inhabitant of this continent, as one of the few remaining ancient living traditions on this planet and in the far-reaching excitement and respect accorded to 'Aboriginal art'. That geographical distance once perceived as isolating has allowed an experimentation and creative emergence unhampered by the weight of history which dominates and inhibits other more 'developed'

nations. Never in recorded history has the 'canvas' of the artist embraced so wide a scope or has the 'palette' utilised been so diverse. Artists now move between and meld media in an unprecedented freedom of expression.

Much has changed since 1962 when H.W. Janson's widely influential textbook, *History of Art*, was first published and did not mention either the name or work of a single woman artist. Norma Broude and Mary D. Garrard state that: 'From the sixteenth through to the eighteenth centuries, women artists had worked in relative cultural isolation grouped together by men's classification rather than by choice.' Even up to the 1950s and 1960s women artists suffered professional isolation not only from one another but also from their own history in an era when women artists of the past had been virtually written out of the *his*tory of art.[31]

Much has and hasn't changed since 1968 when poet Muriel Rukeyser said: 'What would happen if one woman told the truth about her life? The world would split open.' ('Kathe Kollwitz' in *Speed of Darkness*) — and since the 1970s when Anaïs Nin, in her lectures, urged women to unmask themselves, to break out of their silence and to become articulate in expressing their *authentic* experience.

In 1979 Germaine Greer, in *The Obstacle Race*, advised readers that as a first step to under-standing art history and the art of women, they should acquire specific rather than general knowledge of women artists and art works and 'the men's work to which it relates'. A knowl-edge of women's painting, regardless of whether or not it is great female art, reveals a lot about past history, personality and the pathology of the oppressed, says Greer, but '[what] it does not and cannot show is the decisive evidence of female creative power, for by far the greater proportion of that was never expressed in painting but in the so-called minor arts'. Greer advo-cated that it is in the interests of those who are not artists themselves to become an art audience to 'offer the kind of constructive criticism and financial, intellectual and emotional support that men have given their artists in the past'…'If we look fearlessly at the works of dead women', says Greer, 'and do not attempt to erect for them a double standard in the mistaken notion that such distortion of the truth will benefit women living and working today, we will understand by analogy a good deal about our own oppression and its pathology.' Many women in history did not survive oppression and those that did were, as Greer said, astonishing and gratifying. The defeats of those who did not survive, says Greer, 'can teach us about the nature of the struggle; their successes assure us that we too can do it.'[32]

Since 1979 when Greer's book was published there has been a considerable increase in the visibility of women's creative power — in all art media — as evidenced in this book and else-where, and women have been gaining increasing public institutional and private support for their art practices.

In 1995 almost 150 galleries, museums and other venues throughout Australia participated in a massive collaborative effort to stage the *National Women's Art Exhibition* as part of Inter-national Women's Day, celebrated annually on 8 March. A celebration of art made by women of a magnitude such as this would have been inconceivable even as little as twenty years ago.

Art *is* essentially about *communication* and it is through experience and by articulating and communicating experience that we come to know ourselves and consequently others. That more than *half* of the world's experience has been suppressed from public awareness since the documenting of Western 'civilisation's' historical records is outrageous even to contemplate.

Much has been written and continues to be written in redressing the devastating biases, omissions and fictions of Western history. Much continues to be written and expressed in works of art about the co-option and related denigration of women's creativity by husbands, lovers, fathers, brothers and institutions, not to mention women's cast role as muse rather than creatrix. The fates of Woman, the universal Great Mother/Goddess and Nature are inex-tricably linked. In trashing M/Other Nature, we have not only trashed the female principle in all of us (male and female) but also our awareness of our primary connections, both in relation to

our biological, finite basis of being within the infinite and to the interconnectedness of all life forms. We are now witnessing the costs of our disconnections in such phenomena as the looming finiteness of all manner of natural resources we are accustomed to taking for granted, in the annihilation of thousands of species, in the 'greenhouse effect' and its attendant climatic ravages, in the arising of unforeseen pestilence and new, merciless diseases, in the relentless insistence on continuing to produce lethal weapons of potential obliteration of all life. One of the most chilling things I have ever read related to our blind, mindless, relentless destruction of Nature's beauty and diversity. It was a story told by an Iglulik shaman reported in the journal of Danish explorer and anthropologist, Knud Rasmussen (1879–1933):

> 'The greatest peril of life lies in the fact that human food consists entirely of souls. All the creatures that we have to kill and eat, all those that we have to strike down and destroy to make clothes for ourselves, have souls, souls that do not perish with the body and which must therefore be pacified lest they should revenge themselves on us for taking away their bodies.'[33]

We are using our creativity to unconsciously call forth death and destruction — our greatest fears — in increasingly imaginative ways. Out of our *fear* of Nature, of death and therefore of life, we have attempted to control the uncontrollable and tampered with forces whose relationship to the whole we have little understood. With the glut of 'the information age' we no longer seem able to discriminate between data, essential practical information, knowledge and wisdom. We continue to erect barriers between human beings and Earth, robbing ourselves of essential vitality. One of the most disturbing aspects of the increase in computer-generated *virtual reality* is the de-sensitising of experience. We experience the interconnected life of the body and spirit through our senses — absent our senses or become more and more eye and brain dominant and we become increasingly cold and mechanistic, leading to accelerating cruelty. We become the prisoners of someone else's reality and our own severed heads. The Great Mother as the principal archetype of the Great Goddess is a re-assertion of the necessity to honour and respect that actively receptive, life-generating and nurturing creative female principle. She is the female aspect of the primordial union — half of our divine feminine nature. She will remain silent no more. She has risen from the tomb of history, shattering the walls of her imposed banishment and interment and is now seeking her rightful place alongside her male partner in a relationship of complementarity rather than conflict. Ignore her and we all face the terrible, wounded, raging dark, avenging M/Other.

 We now live in a world perilously out of balance. Never in recorded history has the imperative been so great to heed these warnings… Perhaps *now* is the optimum time to reconsider how we perceive the Earth and the cosmos and consider, for example, what philosopher Martin Buber called the *I–Thou* relation of complementarity between self and all other in one's world. This numinous way of being and relating was echoed in the words of an Aboriginal woman elder, Maisie Cavanagh, in a moving talk I attended recently. This way of being and seeing is in contrast to the I (active) subject and other (passive) object encoded in present day language and perception. In other words, it is seeing the other, and indeed all of animate existence, as essentially sacred. The alternatives are now becoming clear — Nature had the first and will always have the *last* word.

 As a Cree Indian saying expresses it:

> 'Only when the last tree has died
> and the last river fish been caught
> will we realise we cannot eat money'

Or as Michael Tucker eloquently says it: 'For life — whether we call it "mother earth", the Great Goddess or as Beuys did, the "Great Generator"[34] — may soon have no other choice than

to remind us forcefully that the symbolism of the *Tree of Life* is founded on the surest of facts: *no trees, no life.*'[35]

The hope and work for today into the future is that our lives and history will reflect a balance between the feminine and masculine principles and outlets for the diverse multitude of 'mixed-blood' voices-which characterises vast numbers of people today in varying degrees-in our cultural expressions. An idea which potently expresses this notion of energetic union between the masculine and feminine principles in life is the ancient spiritual technology of Tantra, which means to yoke together.

Perhaps art, and life, will one day no longer have to be primarily considered on race or gender bases and biases and in terms such as 'insider' and 'outsider' art or on some imposed aesthetic of acceptability. Perhaps one day it will simply be considered in terms of different people having different things to say and different ways of saying it, which constitutes either well-considered art which is effective and affective, or basically deficient art which misses the mark. As artist Eva Hesse once said, 'The way to beat discrimination in art is by art, excellence has no sex.' And in order for that process of sifting and sorting the good from the bad seeds, so to speak, to occur, an art of 'pluralism and diversity' needs to be seen and assessed. A utopian vision? Art is based on visions and dreams and we all need dreams on which to base our reasons for existence — why not ones which offer benefits to more than just a few human beings who arguably only offer a path to nihilism? Also, those who are prepared to devote their lives to *the dream* or to proceed from the dream, as Carl Jung said, help us both to connect with our own experiences and dreams and to counterbalance the rampant rationalism and materialism that characterises Western culture. It has been said that only if dreams are made public through art can they have any real impact on the nightmares we continuously enact in everyday life.

CREATIVE PROCESS

As well as celebrating the individual voices of Australian women artists, the feminine principle in Nature and diversity in life and art, *New Visions New Perspectives* is also a book about exploring the creative process. Hence a few reflections on this aspect of the enclosed material are perhaps in order — hopefully without impinging too much on the freshness of initial discovery in the body of the text itself. Let me preface this by commenting that a treatise on creativity and the creative being is beyond the space and scope of this introduction; however, noteworthy facets seem to jump out of the text. Firstly, if, in Western terms, there is a 'creative personality', so to speak (and this moves beyond gendered grounds — where gender comes into play is in the intention and content of the work), it seems to be one which is focused and driven in a fixated, *obsessive* way, feeding off its own obsessions — everyone and everything becomes fodder to the artist to enable that particular reconstitution, transmutation and transformation that becomes the 'art work'.

In the artists' own words: 'I am driven by my obsession — the obsession of a "voyeur" only ever momentarily satisfied as I approach those fleeting moments of fulfilment realised by the finished piece. Then I am compelled to begin again' (*Annette Bezor*); 'I find it impossible to say what my art is about — I just do it when the compulsion/vision comes over me...' (*Anneke Silver*); 'This is an age of self examination and self obsession... I think my work is a reflection of this in that it "appears" to find new meaning in new perspectives through its own obsessive reworking of visual information. However...it only discovers that which is already self evident' (*Joan Letcher*); 'I am eclectic in the sources I draw from, and when I have a passion, everything seems interconnected and I naturally reorder the universe around that passion' (*Mandy Martin*).

Art does not feed off itself alone: 'A poem, a tune, a dialogue, a journey. A cognition that kindles a creative passion. Every aspect of my life is a source of inspiration...' (*Hannah Kay*); 'Until recently, the somewhat driven imperative behind my work has been the question of loss and

redemption… The struggle with loss and redemption expanded into a philosophy of imperma-
nence' (*Lindy Lee*); 'For many years my work has been concerned with the day-to-day feeling of
human experience — mostly that of the female experience. It is more that unspoken area —
internalised feelings — conscious or unconscious' (*Vicki Varvaressos*); 'The developments
within late twentieth century feminisms remain the primary source of stimulation for my work'
(*Merilyn Fairskye*); 'The body of my work is about woman, man and child and the relationship of
each to each — the pleasure and pain of life in the family' (*Mona Ryder*); 'In my work as a sculp-
tor, the use of technological processes has allowed a deeper probing into the nature of exis-
tence' (*Joan Brassil*); '…despite having a lot of raw material, when I start to paint, my vision of
the painting is very primary. I discover it as I paint and this never changes… It is more like the
discovery of a hidden structure' (*Aida Tomescu*).

The fundamental process, in a contemporary context, is something like someone picking at
an itchy sore, not content to leave it alone until the scab lifts off and the raw, seeping wound
underneath is revealed, providing momentary satisfaction and relief before the cycle of making
whole begins again. Scratching with the right amount of sensitivity and persistence, however,
is crucial. Added to this — or, rather, integral to the creative function — is an artist's *compulsion
to express* their particular inner and outer experiencing in a manifestable form, albeit in widely
divergent ways. Other aspects within this — whether or not you subscribe to either the view
that art in a microcosmic way is making something out of nothing or making something 'new'
out of many existing things — are the need to experiment, *play with* and explore ideas, materi-
als, elements and identity: 'The entire process vacillates between a serious attempt to question
meaning itself and a playful game with words — between the intellect and the sensorial' (*Lezlie
Tilley*); 'Art, for me, has been a place to explore, a place to play, creating and exploring an iden-
tity…not so much in an egoistic way, but rather in finding a place to fit and a reason for being…'
(*Joan Letcher*); 'Within my work, there is a fine line between the humorous and the serious and
also the need to express the child within' (*Judi Singleton*); 'When I was nine years old, I used to
stalk the bush…dressed solely in a hankie, with shield, and spear painted in ochre, burnt
sienna, black and cream. Things haven't changed much. I use earth colours constantly, instinc-
tively. I have always made fetishes, always loved costume. I have always responded to the
ground, the forest floor, earth' (*Inga Hunter*).

Art is a way of preserving herstory, the culture, addressing environmental conservation and
to educate: 'My work today is driven by my custodial responsibilities to my land… I see the
function and purpose of my work as performing an educative role towards redressing the imbal-
ance of Australian dominant history' (*Fiona Foley*); 'The artist manages the deep places, main-
tains them against oblivion — now and then illuminates them' (*Heather Ellyard*); 'My granny
bin tell me [points to painting of Wallupanta snake], yeah, "You can do 'im Wallupanta. That do
'im, and hunting… I not forget for that culture, you know?… Granny bin say la me, 'I know,
I can't forget for that ceremony. We got that Law. We gotta hold 'im, we can't lose 'im. Hold 'im
tight" (*Matingali Bridget Matjital*); 'Awelye is proper one for women looking after country'
(*Gloria Temarre Petyarre*).

Much comment has been made on the sublimation of energies in the creative artist — art as
substitute for direct engagement with life — and I do not wish to comment further on this
aspect except to say that art, as conflict, can serve a function in resolving conflicts in the artist,
healing trauma and to release or stabilise energetic states (and potentially effect catharsis in a
viewer): 'For weeks I lived amongst thousands of decaying blooms while grieving for my
mother and her unadorned grave. The memory of this experience has been particularly influ-
ential in my creative development' (*Anne MacDonald*); 'I began working specifically with
female imagery as a result of a very traumatic personal experience… Sometimes I think that
trauma is one of the most incredibly formative things that can happen to you, that a negative
thing becomes a positive thing' (*Annette Bezor*); 'Art is sort of a therapy and a sorting out of the

chaos of life' (*Judy Singleton*); '…I have been interested in the synthesis of diverse ranges of often conflicting colour, structures, textures, ideas and views. When I look back, these often create an almost surreal effect, each element fighting for survival on the picture plane' (*Gabriela Frutos*); 'I am interested in the impolite rather than the courteous or the rude; I am interested in the friction of opposition rather than the smoothness of consensus; I am interested in that uneasiness where things just flatly refuse to fit' (*Pat Hoffie*); 'A particularly influential turning point…occurred… As a result of a car accident, recurring health problems forced me to look at my work and life…it was during that time I felt a strong desire to pursue this interest [to travel]. The strongest messages I have ever felt, in regard to specific works, came during this [resultant] trip overseas — in countries that were experiencing racial and religious conflict' (*Lucille Martin*); 'I had a happy childhood that was torn apart by war when I was ten years old…Being a "war child"…I felt I wanted to do an exhibition for the Fifty Year Anniversary of the end of the Second World War — paying a tribute…to all the children of all denominations who have died in the last fifty years during wars' (*Jutta Feddersen*); '[The] purpose of my art expresses the stranger that I am. I and my art are uniquely myself. Without it, I would be broken' (*Inga Hunter*).

The importance of *ritual* is a significant motif of some artists' work and creative practice, linking the idea of art and work as spiritual practice: 'The most pleasurable part of the ritual of painting is mixing up the sand and pigment I use. Preparing *everything* is a ritual. The mixing is a meditative process… Ritual is terribly important, but in our society it is something we forget — where our original, pleasurable, joyful rituals come from' (*Kate Briscoe*); 'Before I can paint, I go through a clearing out process — an emptying of all the collective sort of rubbish that is in my head from wherever I may be at the time — to get back in accord with the language I am dealing with' (*Marion Borgelt*); '…the ritual dimension to my work is becoming more an attitude to my life rather than being isolated incident. In my previous work, I would produce something at a specific time, such as during an equinox or solstice, and attempt to endow it with a particular meaning. At the same junctures, I would also try and move something within myself so that I was structuring my own life stages of growth and development and the work became not just about producing a question' (*Lyndall Milani*).

For some artists, their work is intended to provoke the viewer into new perceptions in the search for truth and meaning: 'The images I use are taken from all aspects of everyday life. Their placement and scale is non-hierarchical… I hope to make these mundane, familiar images profound in their eloquence and simplicity, to provoke the viewer to look beyond the everyday and to think about the meaning of life' (*Elizabeth Gower*); 'The installations are designed as works that attempt to provoke people to interact with symbols that they normally accept at face value and do not consider' (*Lyndall Milani*); 'I create my work to challenge my own and the community's preconceptions and perceptions of acceptable behaviour patterns and social rituals and ceremonies within society. I hope to create debate about the nature of the ceremonies we, as a community, take for granted' (*Lyn Plummer*); 'If I think of my work as having any purpose, it would be to raise doubt in the mind of the beholder' (*Merilyn Fairskye*); 'Truth and beauty are the most important words. In a sense they are highly religious paintings — dealing with wholeness, awe and a celebration of the mystery of life' (*Anne Judell*).

Another very significant and compelling need of the artist is to gain an element of surprise and/or pleasure in the finished work so that a new element of self is revealed, and thus art practised in this way becomes a journey of identity and self knowledge: 'The "heroin" of making images, through paint, through words, through celluloid, through collage, through clay, through music, ballet etc etc…is to be able to surprise yourself — the creative genius breathes on this addiction!' (*Davida Allen*); 'My aim will always be to surprise others and myself with the installations and large works I produce' (*Jutta Feddersen*); 'I have to be able to surprise myself in a work at the end and I have a way of measuring it. It is as though I go out of a story and come

back, and if the story has the ability to grasp me inside when I come back, then I think, OK it has "it". If not, it doesn't matter if the whole world thinks a painting of mine is wonderful…I don't think the image has really worked…' (*Hannah Kay*); '…when I walk into a room and see that the work has its own persona and it feeds itself back to me — it's not just a painting any- more, it's a shock element. If a work can take me by surprise — but I'm ready for it — and also if I don't feel any disappointment, then I know the painting works. It has to *live* and it has to "happen"…' (*Kate Briscoe*).

Having realised their visions, the artist then strongly desires to communicate those visions and receive feedback (a desire not unmixed with trepidation); there is the hope of receiving applause for their effort and ingenuity and to make some kind of an impact on a viewer's/soci- ety's perception. In other words, the artist hopes to be seen, heard and to make a difference. *The artist's vision is her voice*: '…where the artist is creating because she has a need to speak' (*Barbara Licha*); 'Art has served as an extended voice for me, a very specific extended voice' (*Marion Borgelt*); 'To make objects which sing remains my challenge' (*Liz Williams*); as Mirlkitjungu paints, she, like other Aboriginal artists, sings the songs related to that story — 'singing the story' keeps the 'Dreaming' alive, as do the accompanying dances and, together with the art, forms a sacred act (*Mirlkitjungu Millie Skeen*); 'The artist's job is to stay awake, to notice both details and patterns, and to use visual language as though it were a dialogue with the infinite, rather than a demented soliloquy on some sordid plateau halfway between heaven and earth, perpetually stunned' (*Heather Ellyard*).

Having said all this, no matter how much we analyse, talk about and dissect art and the creative process, art and its creation is essentially about magic, mystery and the ordinary, like the dance of life itself. As above, so below; as within, so without — the mask and the mirror and vice versa. In the wealth of material in this book, the artists allude to this living mystery in a variety of ways. In each hard act of grace that is a creation is a small echo of the primary Source of all Creation, in the same way as each time we see an exquisite sunset, a radiant flower, a fury of lightning or a suffering child, we are reminded of this penultimate Mystery — enjoy it, explore it, be it.

All in One
One in All
One in One
All in All

ANNA VOIGT

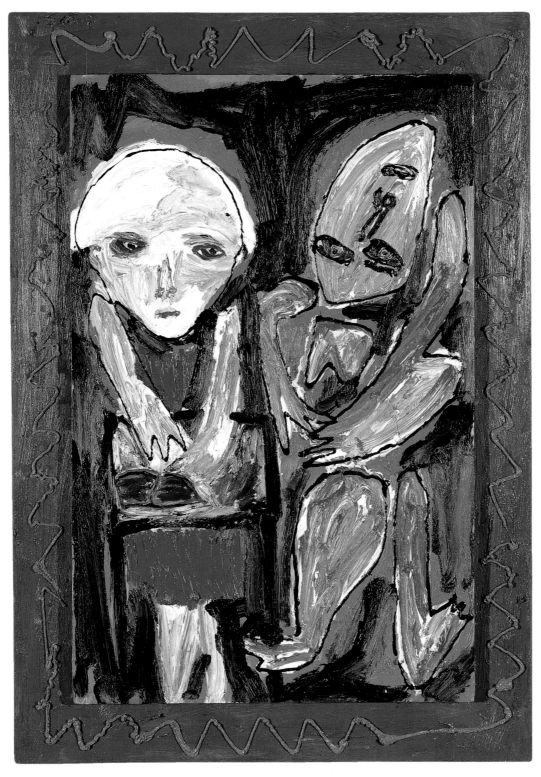

PLATE 1

Davida Allen

Obsessed with her roles of Woman, Mother, Housewife, Wife,
Lover, Fantasiser, the artist squirms, frolics, cries, laughs,
screams, giggles, despairs, exults ...

AVIDA ALLEN was born in Charleville, Queensland and attended Stuartholme Secondary School, Brisbane, where she studied art under Betty Churcher from 1965 to 1969. She then trained at Brisbane College of Art from 1970 to 1972 with Roy Churcher.

Davida Allen's figurative paintings reflect the centrality of her domestic relationships, emotions, fantasies and intimate personal concerns. These form the largely experiential, raw subject matter for her boldly gestural, primary coloured, passionately expressionist art.

Allen has held numerous one-person exhibitions in Brisbane and Sydney since 1973 as well as participated in many group exhibitions throughout Australia since 1969. A major survey of her work was held at the Museum of Contemporary Art, Brisbane in 1987 and in the same year she also featured in a survey of painting and sculpture at Saitama, Japan. She is represented in many Australian state, regional and private collections, as well as in notable overseas collections such as the Metropolitan Museum of Art in New York.

To begin, could we discuss the influences that have been particularly important in your creative development — the people, experiences and places that have been inspirational?

I find answering questions difficult, because there is never a right answer...and what is seemingly sensible to me today can be stupid tomorrow; this is because of the influences that can play on the vulnerability of creativity. I speak now as a middle-aged artist in my forties — being so bold as to think I am mature enough to reflect on my art career and afford to be a little deadpan about its future.

I was extremely lucky as a young student at high school to have Betty Churcher as my teacher. It was her enthusiasm and encouragement that enabled my parents to cope with my going to art school, which was the last straw in regards to their plans for me. At art school I was

PLATE 1
HOMEWORK, 1993
Oil on marine ply, 108 x 77 cm
Courtesy of Australian Galleries, Melbourne

'*Homework* is an image depicting the child holding an exercise book and standing beside the mother. The child is holding the book *authoritatively* whilst the mother's head is upside down to represent her feelings of angst and sheer frustration. No doubt, the mother is attempting to help, but there is a conflict of belief in who is right and who is wrong re the information being discussed. If ever there is a self portrait, this is it.

I find homework the worst time of the day — on the one hand I want to help the child, but I am constantly faced with the frustration that what I believe is the right answer the youth tosses out the window. And so, on the other hand, when asked, past experience warns me *not* to want to help. Some days I ask, "Why did you ask me to help if what I have to offer is so stupid?"

Of course, it is a wonderful exercise in the mother–child relationship. I am wise now, knowing that it doesn't have to be a quiet, soft, enjoyable time to be beneficial — but more likely, the domestic fact is that times of frustration, awkwardness, anxiousness are part of the richness of the relationship.

Homework is one of a series of small paintings I did in 1991, where the frame is a continuation of the energy of the image. In this work, the colours of the frame are hot, stifling, choking…well, I hope this is the feeling that emerges.'

PLATE 2
MAN AND WOMAN, 1993
Oil on marine ply, 120 x 161 cm
Courtesy of Australian Galleries, Melbourne

'*Man and Woman* has a floating nude woman — calm, tranquil, in control…in her Olympian way, seemingly all-knowing — looking out at the world with a sense of *satisfaction*, because there is knowledge of the man behind her, camouflaged in her background, as *part* of her life. She has full knowledge that her pleasure will be given her from the man; she is smiling, smirking her power as woman, but with the man lurking in the back of her head as well as in her body. He is not the aggressor, but is still aggressively male in terms of his genitalia.

This is a complex image and one that deserves to be lived with to experience the psychologically sexual subtleties!'

taught by her husband, Roy Churcher, who gave the would-be artist her essential food — admiration! The art dealer Ray Hughes gave me my first exhibition. I was twenty-one and pregnant with my first daughter, and for the next twenty years I was nurtured, tossed about, spurred on, cherished and inspired in an artistic comradeship.

My life's shackles are different now: grown-up children, no longer babies at the breast; Ray Hughes and I have parted company, and I am now involved with Australian Galleries. Being forty odd is quite different from being the young artist — the people I am involved with are different; the artists I admire are different; my family is different; but one thing remains exactly the same: the lust of an artist — 'The hound of heaven', as T.S. Eliot put it — to make images.

When I was young, *everything* I did was wonderful. I can remember ringing Betty up quite late one night, saying, 'I've just done the best painting… You've got to come and look at it' — the implication being, right now! And the same happened with Ray for so many years. Ray would put his arm around my neck, and say, 'We will change the world…'

The older I become, the more aware I am of how hard it is to do something pretty amazing, and yet that need of an artist to have an audience is still the same.

Could you give a general outline of your creative processes?

The 'heroin' of making images, through paint, through words, through celluloid, through collage, through clay, through music, ballet etc etc…is to be able to surprise yourself — the creative genius breathes on this addiction. Davida Allen's art is extremely cathartic. Her novel *The Autobiography of Vicki Myers: Close To The Bone* explains quite aptly this cathartic element and more. Davida Allen's imagery is intrinsically about her life — about having sex, about a man and a woman loving each other, about children sleeping and playing and growing up, about children feeding guinea pigs, about filling up a dishwasher…about fantasies…

Obsessed with her roles of Woman, Mother, Housewife, Wife, Lover, Fantasiser, the artist squirms, frolics, cries, laughs, screams, giggles, despairs, exults. Her medium for this release of mixed emotions is paint and more recently — *words*.

Your iconography of woman, the experiences of domestic relationship and your fantasy life are well-known images in your work. In what other ways do you perceive your being a woman has influenced your work — positively and negatively?

A mountain climber painting a picture of the mountain he/she has climbed will undoubtedly paint a different image to the crippled child in the story *Heidi* who looks out from a tiny bedroom window to a very blurry bit of blue in the very, very far horizon, being told, by images in books, it is a mountain.

The very meaning of 'artist' is individual:

> Each artist as a person has his/her own intonation of voice.
> Each artist as a person has his/her own breathing pattern.
> Each artist as a person has his/her own peculiar laugh.

I happen to be a woman, and so consequently my visions are intrinsically from this viewpoint.

As a woman with a child fast asleep in her cot, Davida Allen the mother, tired/Davida Allen the artist, relieved at the sleeping time — time to paint it!

As a woman with the same child now grown up and luxuriously angst in her adolescence, Davida Allen the mother tortured with new demands, new parental territory. Davida Allen feeds off the angst — *Jimmie the Punk* came out of this painting and is included in an anthology of short stories entitled *Family Portraits*.

I am perhaps a true feminist in the specific sense of the word — to believe the woman is as good as any man, to be truly liberated in the household and work place and not be inferior — but I am not painting or writing these issues. Rather, I am more interested in shining a

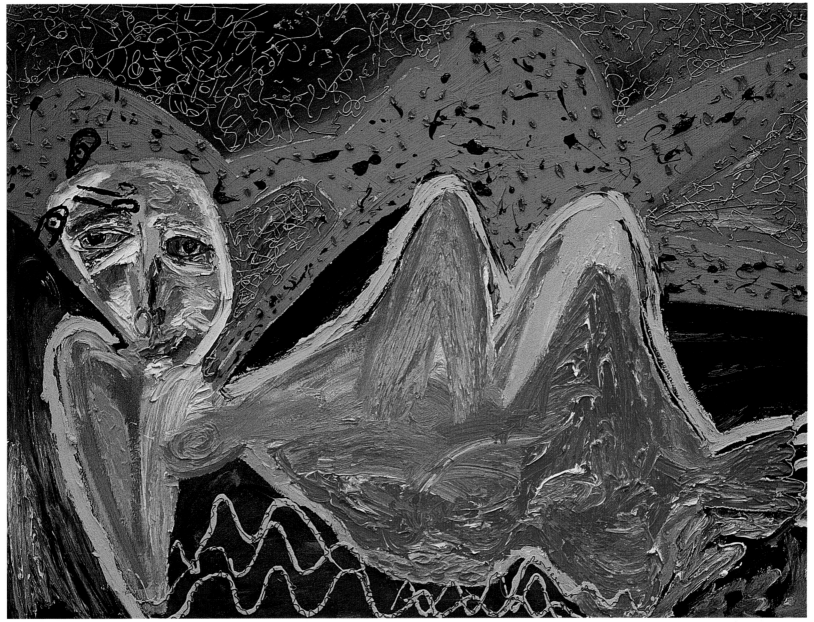

PLATE 2

congratulatory light on the woman in the house doing the nappies…on the woman struggling to maintain some sense of sexual self in her tired marital bed…some sense of worth at her demeaning day's housewifery.

Could you discuss further the meanings and significance of pictorial and symbolic elements in your work?

In some of her early images Allen used crows as a symbol for evil…for danger…The child in school sports uniform…on the cliff of puberty…on the cliff of adolescence. Davida Allen the mother aware of the new dangers lurking for her child — Davida Allen the artist paints these threats as black crows. The threats are really threats to the mother as much as to the daughter: fear of boyfriends, fear of her daughter becoming a young woman and no longer her baby…fear of bad influences in society. Indeed the crows are the mother's fears — and Davida Allen the artist uses the crows to evoke a sense of danger lurking in the schoolgirl's landscape.

And to further answer this question, Davida Allen does not want to be too abstract in her imagery — and to compensate for any possible misunderstanding of an image, she will often write over the image in words what the image is about.

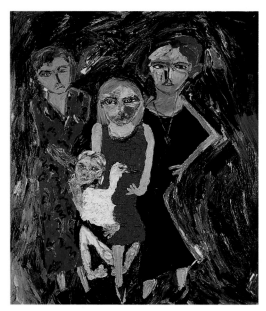

PLATE 3
SISTERS, 1991
Oil on marine board, 235 x 210 cm
Courtesy of Australian Galleries, Melbourne

PLATE 4
WOMAN (detail), 1993
Oil on marine ply, 122 x 122 cm
Courtesy of Australian Galleries, Melbourne

'*Woman* is *part* of the landscape. She is part of the *earth*.
Her feminine vitality speeds through the atmosphere as
does the F1-11 aircraft shape — which could as easily
be a vagina shape. I love this self portrait.'

How do you see your role as an artist and how do you perceive the function and purpose of your art?

I imagine an audience thinking: artist in studio…blind with vision…unaware of who the audience will be…not caring how people will receive the image…totally absorbed in the execution of the image. However, it is very important who is in the audience…who is clapping/supporting/congratulating or *criticising*. The artist must listen, assess and take a stance over what is being said about the art work now that the art work is public…has been born…is now being looked at by an audience!

Obviously no matter how much of an egomaniac an artist is, public opinion has its effect…I utterly believe an artist must be ruthless in the studio; if for one minute I was to think of people looking at what I am painting — my mother…mother-in-law…my husband — I would perhaps make the tree look more like a tree rather than a green abstract wriggle of a line.

But it is all very well to be so pure and ideological… I can remember painting a horse once, and asking my husband what he thought of it. He said the tail was all wrong. So I scraped the tail off (like a child wanting the mother-minder to applaud — it's instinctive). Listening to his instructions, I painted a tail which would be more readable, more normal. Needless to say, it was a disaster. It was the most stupid looking tail imaginable… It took me weeks of anxious attempts to try to reincarnate my original tail!

I have never asked his opinion since — well, not in the studio, that is — not while the image was being 'born'… I am happy to hear his and my friends' opinions when the baby has been born — sometimes I feel like screaming at their ignorance, sometimes I am warmed by their delight in my images, sometimes I feel devastated that they cannot enjoy them.

One critic wrote about Davida Allen: 'She paints about life, death, sex without shame…' This was aimed at being a derogatory review. It is probably the most apt thing that has ever been written about my work. Indeed, I paint and write imagery that I know, that I want to share, that I need to have escape from me. If after this, there is a *sympathetic* audience, it is a bonus, like the smell of rain on parched earth…

Over the twenty years I've been painting, it has become as plain as day that my audience either loves or hates my work. I am happy enough with this. I find it interesting that in what I paint and now write, *the imagery causes a reaction of some sort.*

Annette Bezor

PAINTER

The work is my conflict, the image my battlefield. It demands both physical and emotional involvement, as I manipulate the resistant surfaces, provoking a sometimes violent act of creation.

ANNETTE BEZOR was born in Adelaide, South Australia and from 1974 to 1977 studied under the auspices of the South Australian School of Art, graduating in Fine Art with a major in painting. In 1986 she was granted the Power Studio, Cité Internationale des Arts, Paris for a six month period — the first of two study/work trips to France. Bezor travels extensively and currently lives and works in Adelaide.

Annette Bezor's sensuously wrought paintings are all about the imagery and identity formation of women, using the iconography of Western ideological constructs of beauty and sexual desire. Her fragments of women — autobiographical images, photographs of friends and women who interest her, images from popular culture and history — float languidly within the temporal space of the canvas. They emphasise surface — both the ferociously worked surface of the canvas and the 'surface' of subject/object in the stereotyped imagery of women and male-constructed notions of feminine identity and desirability. Dualities, ambiguities and contradictions permeate these works, which are designed to seduce and ensnare the viewer in an uneasy alliance by engaging our senses of pleasure, beauty, voyeurism, sexuality, eroticism, perversity, alienation and frustration. We are met by the heavy-lidded, beguiling, challenging gaze of a beautiful female face and/or a voluptuous naked or semi-clad body encased in a richly embossed background, a background reminiscent of beds of flowers or satin baths of blood where innocence is invariably despoiled.

Bezor has had several one-person exhibitions since 1983 in Adelaide, Sydney and Melbourne as well as participated in many selected group exhibitions since 1977. The artist had a major showing of her work at the Contemporary Art Centre of South Australia in 1991 and an Adelaide Festival Exhibition in 1994. She is represented in the collections of the Art Gallery of South Australia, the Art Gallery of New South Wales, Artbank, Auckland City Gallery and the Smorgon collections as well as in other public, private and corporate collections.

—·•·—

PLATE 5
A QUESTION OF UNITY, 1989
Acrylic and oil on linen, 285 x 212 cm
Courtesy of the artist

'*A Question of Unity* furthered the idea of intuitive painting that was begun with the *Entanglement* series as I had absolutely no idea of what I wanted to say. A fascination with a different kind of landscape on which to begin led me to photographs of outback Australia and realistic renderings of night and day "scapes" painted horizontally to form a mirror of each other. After sanding and glazing, the work was turned vertically and began to suggest the imagery that would eventually emerge.

Obviously this is another painting about identity and its formation, about the fragmentation of self, which can lead to destruction. Also, it is about the belief in the reality of surface appearance and superficiality as representative of identity, and the inability of many individuals to overcome this response to the "appearance of things".'

Could we discuss the important influences on your formation as an artist — the significant experiences, people, places, inspirations, seminal works and writings or other? Could you also include any premises you may have formulated about art in the course of your journey?

Basically, I think we were all influenced by Jung in some way. I was never quite a hippy, but certainly went through part of that 1960s period, and I also did a lot of experimentation with dream therapy, astral travel and all that sort of thing in the late 1970s, after I had been to art school. I probably didn't start painting or consider myself to be an artist until 1980–1981, so there was a period — when I had my first overseas trip — where I was experimenting with life situations and substances that probably led to my developing a very personal symbolism that then came into my work. I expect that some of the symbols I use will naturally relate and communicate to some people, though I don't go out of my way to make my symbolism universal.

Artists are *myth-makers*, and if you explain too much, you can destroy your own mystery. I feel a bit loath to talk about what some things in my work really mean to me, because when people look at art work, they should be able to put their own meaning into the picture. If they actually know what each piece means, it stops them from relating to it in a spontaneous way. This was once brought home to me very strongly. I had a very old painting in the Art Gallery of South Australia and one day I went and gave a talk to the gallery guides. One of these women gave me her interpretation of the picture and told me what she had been saying to visitors looking at the painting in the gallery. I thought that what she said was amazing, and when she asked me what the painting *really* meant, I said I would never tell her because her reading was so incredible and that she had put more into the painting than I ever had. So I think it's important not to be too specific about what it is you mean in a work, because so much of it is an immediate emotive response to something — in the use of a colour, for example — and it might not be what you intend at all.

Most of the time I don't mind if people see my work quite differently to me…though it is sometimes upsetting when people don't bother to look below the surface, and the work is judged on a superficial level — which often happens. For example, a person might comment on a work being soft, when in actual fact, if you look into it, it is quite a harsh picture.

I am influenced by other artists and, quite strangely, they are usually male artists: Sigmar Polke and Julian Schnabel, for example. It is not so much that I look at their work and think what I can take out of it; it is something to do with the bravery of their work. I have seen a lot of their work, and although Schnabel's work doesn't seem to be popular with many people, I sometimes think his work is *huge* in its gutsiness and courage. Sometimes I may not even like the work itself, but I like its statement. So I am responding to the encouragement to take risks, rather than the conceptual elements. Susan Rothenberg's work, which I like, encourages risk-taking as well. I also like artists such as Anselm Kiefer, but I don't find his work so brave — in some ways it is actually more decorative.

Can you describe your ways of working — your creative processes? What moves you? How do you feed into and structure your work ideas, time and space?

One of the devices I consciously employ to draw people into looking at my paintings is the use of many beautiful elements in the works. Most people are drawn to beauty, have an aesthetic to do with beauty, and will want to look when something beautiful is presented to them. My design is often luxurious and sensuous, defining and framing a distinctively personal fantasy, a pornography, which reaches beyond the power play of relationships based on exploitation — to make objects that reflect an inherent beauty in the face of impending, and inevitable, disaster. I believe in the myth of beauty, in striving to obtain those things that are unattainable. The main factor for me is that people look and make an attempt to see what is in front of them.

I am driven by my obsession — the obsession of a voyeur only ever momentarily satisfied as I approach those fleeting moments of fulfilment realised by the finished piece. Then I am

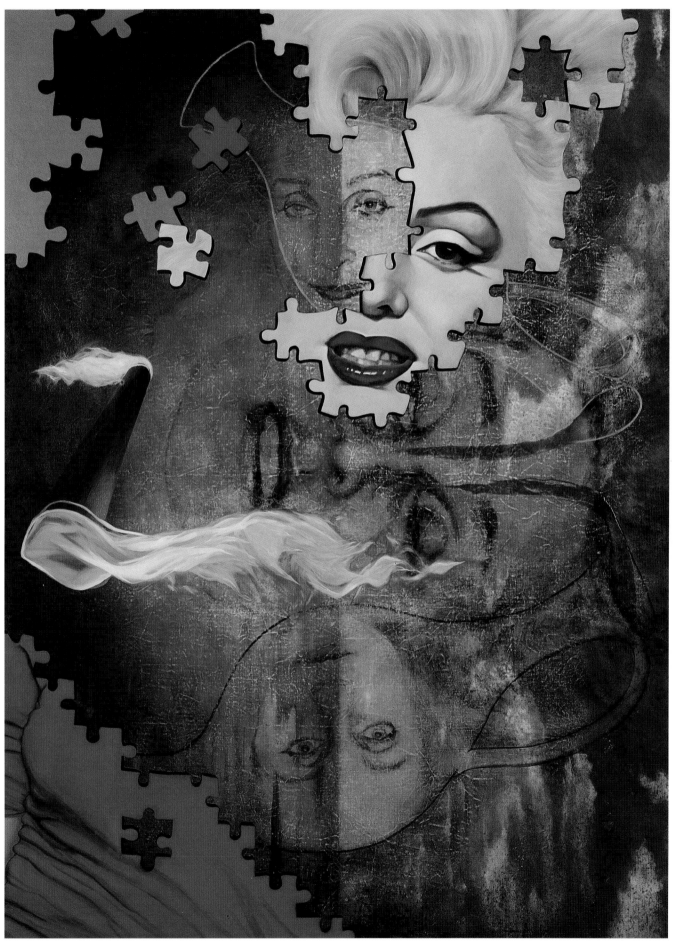

PLATE 5

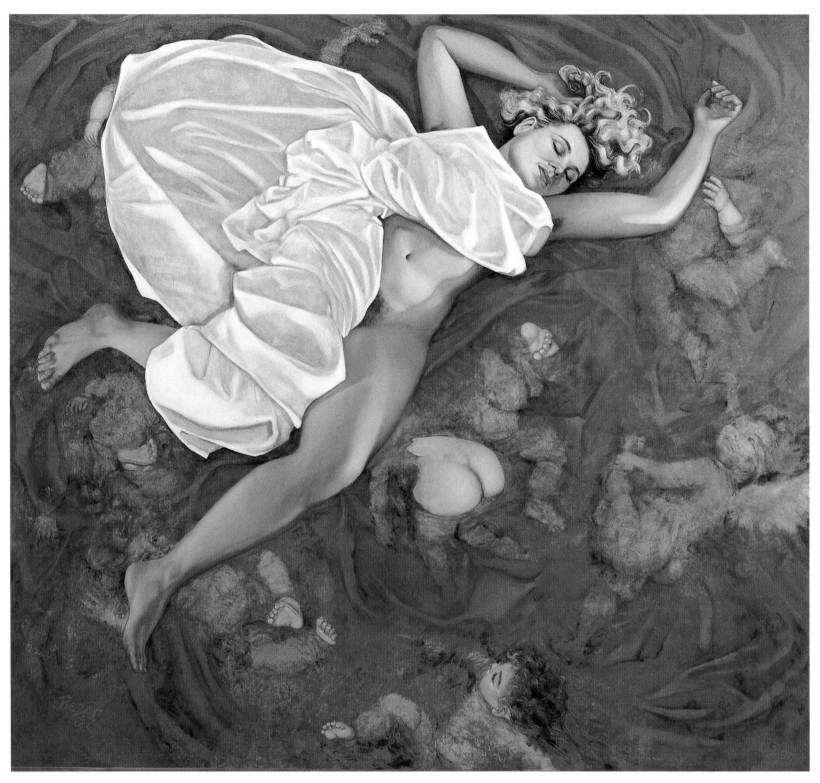

PLATE 6

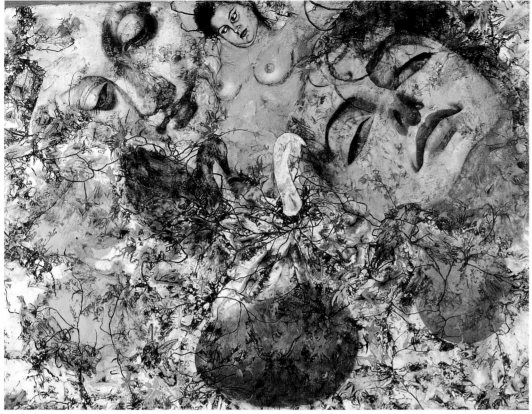

PLATE 7

PLATE 6
GABRIELA, 1987
Oil on linen, 220 x 220 cm
Courtesy of the artist

PLATE 7
ENTANGLEMENT LANDSCAPE — INVERSION, 1990
Acrylic and oil on linen, 220 x 295 cm
Courtesy of the artist

'The *Entanglement Landscape* series is an ongoing series of works relating to singular experiences in events in my life. Entanglement, coils, knots and interlacing lines form a symbol related to that of the net, i.e. bonds, with a multiplicity of meaning: restraining, holding, catching — a trap. They are also a reference to the uncontrollable, the unconscious, the repressed, the forgotten. The entanglement is the map over the landscape — a reference to one's own life.

Technically, the *Entanglement* series began in Paris in 1987 — during a residency at the Cité Internationale des Arts — with a painting called *Romance is in the Air*. My proposal was to find and explore ways in which I might sabotage my ability to paint in a classical, realistic style that had become obsessional and inhibiting. It was also to allow the subconscious to play a more important role in the construction of a painting through accident and play.

Apart from starting with a loosely formed idea of what I wanted to talk about, the painting is allowed to move laterally as each "accident" happens. Subsequent layers may show more clearly formed beings — objects composed consciously to communicate more literally the idea, and to provide contrast.

The initial background is formed through crushing and staining the canvas with various colours and substances. The use of such subversion is an ongoing exploration, and has recently led to a series of large oil monotypes, the resolution of which relies very much on the successful manipulation of accidental mark-making to express a conscious theme. Bearing this in mind, the meaning of the two *Entanglement* paintings, i.e. *Inversion* [Plate 7] — on becoming something else — and *Identity* [Plate 9], become self explanatory.'

compelled to begin again. The work is my conflict, the image my battlefield. It demands both physical and emotional involvement, as I manipulate the resistant surfaces, provoking a sometimes violent act of creation. In short, it is a process of catharsis. In this way, identity, desire, frustration and alienation are liberated, only to be seized by the surface and transformed, a mirror of the inner self.

One of the major symbols in my work is woman herself — which women relate to because they are women, whereas I have never understood whether men relate to this or not. For me, it's a bit like being a vegetarian, which I have been for twenty years. It's a strange thing, but I always want to make works that talk about vegetarianism, but it's a really hard thing to do without being seen as a 'sissy'. There is still a huge overtone of a lack of power, and it's the same with doing images of women. I think it's somehow seen not just as female, but as weak.

I treat my work like a job, and I love it. My home is the studio. It sounds really corny, but it's true. When I work in there, I feel incredibly comfortable. I work at least five to six hours most days, which perhaps isn't a lot, but it's really all I can manage. I still work in a collective, which, although it has its difficult times, is something I still enjoy. Currently there are eight people — both men and women — who share the rent in this collective, and there is no theoretical basis on which everyone works. Our work is totally different; unlike most other studios, we don't seem to influence each other's work, which is good.

We have a huge space (with proper walls this time), and when we need money we just have a fund-raiser. Sometimes there is difficulty in getting the privacy you want, but the studios are all separate, and people get used to being told, and telling others — without offence being taken — that they don't want to be disturbed. I have been with some of these people for three or four years now and think it preferable to working in isolation at home and not having any understanding of where your work is fitting in. I now like the idea of people seeing my work in process — you become less precious about your work in a collective environment, because *all*

work goes through some incredibly ugly, ugly places, and I know there's a huge freedom in my not being too protective of that. Also, it is the only way I can afford to have the space I need and want.

Most of your paintings to date have been about female imagery and woman as object of beauty and sexual desire. How else has being a woman influenced your career as an artist?

I have never come to anything in my work from a feminist perspective, although, without any doubt, I actually am a feminist in the overall way in which I live. Feminism informed my experience and provided me with a creative independence I had not previously known — concerns which seemed particular to women in the process of change. However, despite my feminist consciousness, I have never required my work to be politically correct or to justify its objectification or voyeuristic qualities — it is other people who have wanted that.

I am obsessed with women, in an intellectual sense, and have been surrounded by them all my life, having been brought up by women — with no men around (a factor about which I had no choice). Having a fabulous mother and great women friends, whose company I enjoy, has had an incredible influence on my life and work. So in some way, it is being a woman and how that has influenced my life that has been the subject of my work. I think that this is both positive and negative, because I haven't always wanted to work with female imagery. I think that was because I thought, at times, that my being a woman and being obsessional and so on was a negative thing. Then I would want to move away from female imagery, and found that I couldn't — I kept thinking of things to do. Now I am also working with male imagery, and I'm happy to be doing it, which hasn't always been the case. Today my concerns incorporate a broader interest in the shared challenges faced by both women and men.

Although I say I don't come to my work from a feminist perspective, when I think about it I was very influenced by the women's art movement in South Australia in the 1970s. It was happening around me, and when I chose to work with female imagery, my works were very quickly accepted in some way, which was very encouraging. Whereas if I had started to work with that kind of imagery in any other period, the work wouldn't have had the support that it did. The 1991 painting *The Snake is Dead* was one of the first paintings I did that gave me a lot of attention — people really loved it — and still do apparently, as it is doing the round of politicians' offices and has a list of people waiting to have it. It is a very amusing painting and takes the mickey out of all kinds of things.

Was the close proximity of the women's art movement in Adelaide the major reason you specifically chose to work with female imagery or was there some other catalyst?

I began working specifically with female imagery as a result of a very traumatic, personal experience. Prior to that work I had been working with portraiture — faces and so on — but had not thought of using the female body in a more political sense. I think that I did use the imagery politically after this experience, and it became more politicised because of the support I received from women. Now, however, I do not see the work as being so political. Sometimes I think that trauma is one of the most incredibly formative things that can happen to you, that *a negative thing becomes a positive thing*. Also, a result was that I couldn't work at art school — so I worked at home and, for me, that was incredibly healthy.

So there was a double thing happening. I think that because of my background, I felt incredibly stultified working within the art school environment. The department I was in at art school was totally male oriented, so working in my bedroom at home, without having the inhibition of someone looking over my shoulder, I came up with things that perhaps I might not have done otherwise. I felt I could be myself.

The lecturers came and assessed my finished work at home and, being sensitised to my circumstances, wouldn't say anything (either positive or negative) to me and were predisposed

PLATE 8

PLATE 8
No, 1991
Acrylic and oil on galvanised iron,
two pieces: 120 x 150 x 10 cm
Courtesy of the artist

'*No* was the first in a series of three-dimensional "words",
although the only one so far with specific imagery (i.e.
flowers) painted on the surface. The roses were painted
realistically on to gessoed galvanised iron, sanded, then
treated with a varnish to look old. As with most works,
this piece is open to the interpretation of the individual
(and I have heard some good stories). For me, the word
is a monumental denial of ageing and death. This futility
means the word becomes simply a monument to denial.'

towards my succeeding in my work, which was really good. This experience was somehow
extremely formative, as well as giving me a sense of freedom. I won a prize in my final year at art
school, which also helped — the little pats on the back are fabulous in spurring you on to do
things. This also gave me the approval I needed at that time, which made me feel stronger.

Have their been any other pivotal experiences or formative influences in your life and work?

Another formative thing that happened took place in 1978, at the end of art school — ten of the
final year painting students got together and formed one of the first artists collectives in
Australia. This was a fantastic thing to happen — and a wonderful experience.

Travel has had a considerable influence on my development as an artist. A fascination with
all things European became the impetus to travel. Travel enabled me to circumvent the per-
ception of isolation that continues to plague the efforts of Australian artists. In two residencies,
covering a period of eighteen months, at the Cité Internationale des Art in Paris, I found some
of the beauty I had been seeking. Parisian artificiality — the seduction of the surface — is,
however, the glittering mask that has always concealed the grim realities of urban life.
Paradoxically, the joy of my discovery revealed a conservatism I might otherwise describe as
the 'weight of history' — a cumbersome load carried on the bow of the French psyche. I also
became aware of the *invisibility* of women involved in the arts.

Prior to getting the Paris Studio for the first time in 1976–1977 (for six months), I had floun-
dered around for quite some time. I decided to stay a few months longer and made a really big
breakthrough in my work. I had been painting these minute montage type of things — like the
Notre Dame gardens and so on (which I'm not too fond of now) — and then began painting on
a large scale. In Paris I felt incredibly free to explore technically and experiment with different
things.

The overseas journeying is essential to me now, because I can't see the work of people that
I like here very often. At least if you can live for a time in Paris once a year, you can go to
Amsterdam or somewhere else and see such incredible exhibitions — although, the work you
see in the small galleries is mostly conservative.

Having had two brief stays in New York, I want to go to the New York School for the same
reason. I have looked at those artists whose work is produced in the stimulating milieu offered
by New York City and found inspiration. They have communicated an intense excitement
influencing not so much the way I work but the way I think. The energy I saw in the work in
New York was just wonderful and consequently I would like to find a way to be able to live and
work there for a while.

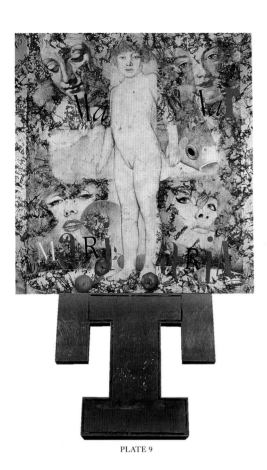

PLATE 9

PLATE 9
ENTANGLEMENT LANDSCAPE — IDENTITY, 1991
Acrylic and oil on linen, galvanised iron letter base,
overall dimension 330 x 220 cm
Courtesy of the artist

How do you see your role as an artist and the purpose and function of your art?

At the moment something strange is happening in my consciousness in that I used to feel totally justified in being a full-time artist and felt absolutely positive about what my work meant to people. I mean I have had a lot of positive reinforcement from people coming up to me and telling me what my work has meant to them and so on, but at present I'm going through a bit of a 'whoops' about it all — a loss of faith, really, in the meaning or justification or whatever. Hopefully this is only a temporary phase and will pass.

I don't think I ever saw my work as bringing about any kind of social change, or anything like that, and I don't think it is having that kind of effect. I don't know that I really believe in the capacity of art to do that, but I believe in its importance. I believe that we need to have visual artists and writers and so on, but I suppose, for me, it was the fact that I was working as a woman, and at one point I did see myself as working for *women*, and I believed in that. As I am part of the larger community of women, it was mostly women who came up to me to say that the work meant a lot to them — to be able to see some female imagery. To be 'one of the women' in this sense meant, in some way, being recognised as an artist, when it has taken a really long time for *all women* to be recognised — especially visual artists. So it felt good to be in there. Now that I've done quite a lot of things, I am going through a period of questioning my work and I don't feel so sure of anything anymore, which on one level I think is kind of normal.

Despite my current questioning about the purpose and function of my art, it is still the only thing that I want to do, so I don't question the fact that I still get up, go into work and do it. It is just that sometimes I look at an image and ask 'Why?' Adelaide also seems to go through cyclical periods, where sometimes it's really buzzing and fantastic and other times it seems to go through a down period.

It is difficult to get honest feedback on one's work from the public. Most people don't talk about your work to you — especially if they don't like it, they tend not to say anything. If they really like it, they may come and tell you, but without telling you the reasons. So, just receiving positive feedback doesn't give you much of a picture of how your work is really affecting people. An artist needs to understand how they are communicating, and I think most artists don't get anywhere near the feedback they need. It is also interesting that even one's agents don't comment much on the art work. I can't recall ever being asked even one question from two of my major dealers about what my work meant or any other detail about a particular painting. Maybe they don't look at art work on that level, but mainly see the works as saleable objects, and therefore don't need to understand them as long as they can be sold.

On those occasions when people do ask me about a work I have done, and there has been a time lapse between the question and finishing the work, I often think, 'What on earth was I thinking when I did this!' I find talking about past works difficult because, apart from particular works that you may be exceptionally proud of — and perhaps still own, you are hugely involved in the work that you are doing in the present. Consequently, I always like my most recent work the best.

Despite all the difficulties, I do believe art is important to culture, otherwise there is a huge danger of people becoming incredibly and overwhelmingly pragmatic — especially in a world with such enormous technological development. Without the more creative elements of life, you would not be allowed to be a dreamer anymore, and that is an essential part of the human spirit. People need to dream, and often people feel they can't do it themselves (even though everybody does dream to some degree), so they use people who can tap into their creative processes as another part of themselves.

Marion Borgelt

PAINTER

*I see my role as an artist being to bring us back to our primal selves
where we exist more in accord with our instinctive, intuitive natures.*

MARION BORGELT was born in Nhill in the Wimmera region of Victoria. She attained a Diploma of Painting from the South Australian School of Art in 1976 and a Diploma of Education at Underdale College, Adelaide in 1977. In 1979–1980 Borgelt undertook post-graduate studies at the New York Studio School. A period of extensive travel through Europe and Asia followed, after which she became tutor-in-residence at Canberra School of Art in 1986 and tutor in drawing at City Art Institute, Sydney, from 1987 to 1989. Since 1989 Borgelt has lived in France, making periodic visits to Australia to exhibit.

In her career to date Borgelt's abstract paintings have moved from weaving, flowing, amorphous images and vortices and tunnels as *motifs of transcendence* to more structured compositions. The latter emphasise the dynamism of colour and combine the dualities and contrasts of simplicity–complexity, coarseness–refinement and female–male principles. They attempt to suggest and integrate both physical and metaphysical realities in the ongoing exploration of the constitution of personal, human and universal identity.

Borgelt has had a number of one-person exhibitions in Adelaide, Sydney and Melbourne since 1976 and since 1975 has also participated in numerous selected group exhibitions throughout Australia as well as overseas. Borgelt won the Muswellbrook Open Prize in 1988 and the Campbelltown Purchase Prize in 1990. She is represented in the National Gallery of Victoria, the Art Gallery of Western Australia, the New Parliament House Collection and in other state, regional and private collections in Australia.

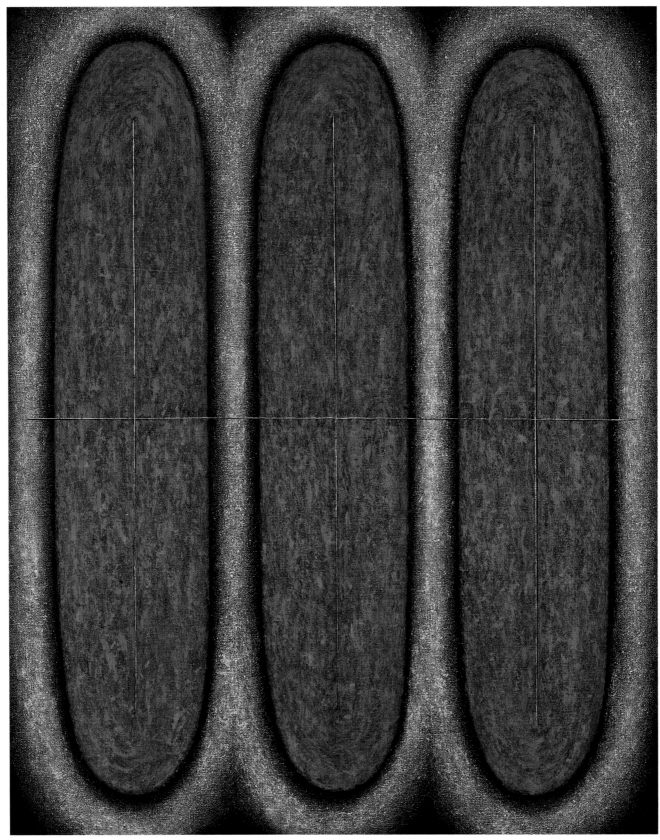

PLATE 10

Could we begin by discussing important formative influences in your art career — the people, places, inspirations, seminal art works and writings, pivotal experiences or anything else you consider significant?

In the course of my career people have wanted to know where I came from and have wished to understand this odd thing of an Australian farm girl travelling the journey she's travelled and why. So I started to feed in information that I hadn't examined, that I had taken for granted, and as I began to examine it, each picture became clearer and each scene had some intrinsic value within the story — like the way people are brought together in cities.

The most influential place for me is where I grew up. It was very isolated in some ways, and the things that were important to me were walks and little journeys, having my own little garden to tend and going out on the verandah at night and looking at the stars — seeing that vastness. Those formative years were so powerful in determining who and what I am now — how I think, the art I create — and especially in giving me first-hand knowledge of nature.

Being on a farm where income is governed by seasonable change makes one so rooted in that unfathomable link to the earth — and the way in which the earth acts as attractor for all sorts of other energy formations around it — phenomena like auroras, storms, animal life, grain life, our lives. In the last few years it has more consciously become a ritual for me to maintain the link with the family farm.

When I was growing up, I remember reading about Brett Whiteley in some woman's magazine, and somehow he symbolised something incredibly exotic to me, and something about Sydney — the harbour, the life of an artist — which became something I set my sights on. It was so far away from what I'd grown up with. It wasn't so much Whiteley's art that attracted me, but what he symbolised — the artist's lifestyle and Lavender Bay somehow epitomised Sydney.

When I was eighteen years old, I knew my life on the farm was going to terminate, and I wanted it to, as I felt that I was missing out. We didn't have television until I was fourteen years old and I felt disconnected from the world, which seemed rich and extraordinary to me. After leaving Victoria, I lived first in Adelaide — to attend art school — then New York, then Adelaide again, then Sydney for eight years — which I loved at the time, but which eventually drew to a close for me. I come back to Sydney from time to time, but not to be an inhabitant/participant on a full-time basis here anymore — I don't need it anymore, like I did in the past. Now I live in Paris, which is very inspiring, very difficult and closed — but very exciting.

Paris acts as a centre — drawing other cultures into it. It draws everything and everybody at some stage or other, and I'm there witnessing this drawing in of material, which in turn draws me in and material in to me, and I'm there sifting and sorting it out. In processing so much input, it becomes necessary to choose a clear position to take. With the complexity of stimuli around me, I've had to become simpler in my visual language — it may be a reaction to the stimuli, I'm not sure. I can't see complicated visual images sitting well in Paris, so my work comes out of a sense of place.

Who or what other influences and sources of inspiration have you drawn from as an artist, and in what ways?

My sources of inspiration are very diverse — different people, different art, seeing my favourite artists' best work. I have mentors from whom I request this role — to help me with this or that, to help me get into gear about something. If I see that certain people have strengths that I admire and/or I'm trying to develop, I seek them out to advise me and counsel me. There have been a few men who have fulfilled this role for me.

In terms of people I have drawn from as an artist, there are three sculptors who have influenced me, in an indirect way, in that I watch how they process things and observe the progress they make in their lives and careers. There is Anish Kapoor, who is a British sculptor with Indian and Iranian roots. I was reading about him in a catalogue recently and he says he creates

PLATE 10
LIGHT AND BODY SERIES NO. IX, 1991
Pigment on jute, 210.5 x 171 cm
Courtesy of Sherman Galleries, Sydney

PLATE 11

ANIMA/ANIMUS: SPLITTING INTO ONE NO. 111, 1993
Pigment on jute with woven jute threads, 197 x 182.5 cm
Courtesy of Sherman Galleries

'This work deals with sexuality — and not only sexuality, but the two sides of being male and female and the unification of male and female in the one human being. The allusion to sexuality is in the sense of the sexuality in all of us — the male and female forces in us. In India, Tantric sexuality is celebrated on a daily level with the female and male forms — the yoni and the lingam — being admired, touched and revered each day, which is wonderful.

There is no outward, ritualised expression in Australian/Anglo-Saxon/Western culture of the female and male in our society *at all*, which is something I am perhaps addressing in my work. Also, what this work is really emphasising is the female in us — in both men and women — and I would like it to be about heightening the awareness of the female in all of us. It's not just about women as women and it's not an agenda for a feminist viewpoint; it's a symbol of the feminine as a way of activating that aspect in us. It's not about the erotic — that is not my form of communication. The erotic is another language that stems from sexuality and the energy of sexuality and from who we are as sexual beings — and gender is part of it. Somehow that's tied up in the complex area of knowing about ourselves.

The "red" works I was doing at the time, of which this painting is one, came from a sense of a split in the self, where there is the female and the male — the Yin and the Yang — and there is the duality where we are two as much as we are one. I saw this on a formal level as much as a spiritual level.

This image is incredibly poised. Facing you is a geometrical image, this incredibly refined shape. Now, in the centre is an illogical rash, a humorous bit — all the stringy bits of the woven jute — it's outrageous. Then there is this broken, red shape that's also refined but is a very coarse, painted material — so we are dealing with contrasts that seem to have no logic. They have an inherent logic when the completed work is there, but when you pull the pieces apart, there seems to be no inherent logic at all. It is in that seeming lack of logic that I form a new logic, a new language, and I say, "Okay, in comprehending this piece, try and assimilate it into your being and, in so doing, assimilate new parts of your self."

To strip it back down, what you have is just a circle with a deeper space — which I might have used as basic elements. Sometimes, though, it's just too obvious, so I'll add something that gives the work another dimension and keeps it alive. But it has to work, it has to sit — which has to do with sensibility — I can't analyse that. It has to exist as fully formed with nothing superfluous, but knitted together even if its humorous.

I don't fully understand the work; it is something I have created in the process of creating and sometimes I am in the dark myself about where the images are coming from — I can't fully explain it. I'm often better at knowing how my works function on a resolved level from a formal point of view than knowing exactly what they mean on the level of the psyche. I'm looking more at the source area of where the sexual energy forms as one of the most intense energy levels/experiences we have. It's a primal thing and there are many things which spring from that, such as sex itself, but, as I said, that is not my area. ➤ p.51

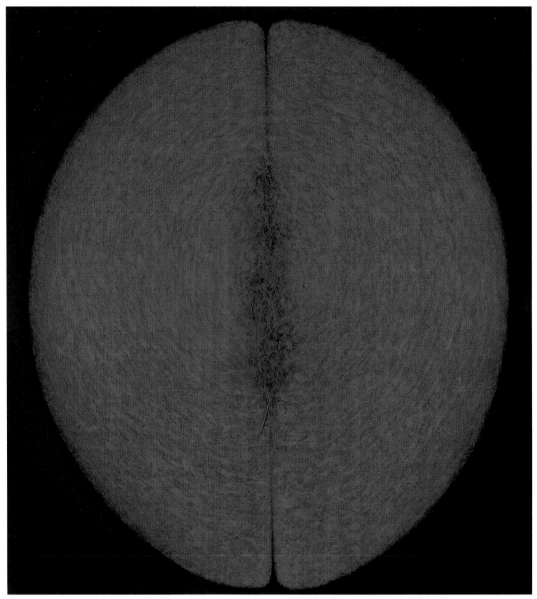

PLATE 11

from the female within himself. He obviously understands the concepts of *animus* and *anima* from a natural perspective. Here is a man who has made it to the top of the international scale of artists and sculptors, and he is speaking in a way that you just don't hear men speaking — *I have never heard men in the visual arts speak that way* — I was amazed!

His work is really about the primal. By primal I mean being stripped back of all the complexities that the socio-technological world has recreated within us — going back to the being where instinct, perception, intuition are powerful aspects of knowing — where we don't have to have things proven on machines and scientific processes. We know because our primal being has been allowed to know — we know what's going on, we know about communication with our fellow persons when they are not even in our presence — the *prima materia*. It's raw, but it's not coarse — it's extremely refined — perhaps our most refined level — and extremely sophisticated in its attunement to our inner sensibility and knowing what that is. For example, knowing when a plant is crying out for food, knowing at the time what our real needs are as human beings rather than saturating ourselves with forms of covering up. This is about communication, about affection, about understanding each other, about perception of our universal needs and our individual needs — the primal being knows what those needs are. I think that in this

clumsy atmosphere, these very fine wavelengths are being bombarded and overridden with heavier, more cumbersome patterns and wavelengths most of the time. We think that technology is so extraordinary, but technology is just trying to hone in on acute patterns of nature where refinement already exists.

Another sculptor that has influenced me is Magdalena Abakanowicz, a powerful, *powerful, extraordinary* artist. She is working with this masculine/feminine thing all the time — and her masculine is so strong. It's not that she is trying to make the art of a man, she isn't — she makes work that sits alongside the toughest, most powerful work of any strong, international artist, and yet it's also got the woman in it — her work from the 1970s in particular. Her big, hanging *Void and Vessel* works were so powerful in their womanliness, and she moved more and more in the direction of being a woman in a man's world. I guess her work became a more balanced thing in a certain way. She has dealt with issues such as war, destruction, regeneration, the masking, the uncovering. Her work is wonderful in my eyes, and in the things she writes, she always speaks about nature and her direct links to nature, her memories in Germany and Poland — so her background is rich and complex, with a lot of destruction and working with the ideas of regeneration. There is a very real, positive thread in her work.

The next person whose work I love is Louise Bourgeois — in a way she's the real scoundrel, the humorous battle-axe of the lot of them. She is quite complicated, extremely diverse, and she is incredibly wily. I hear that she has lapses of memory now, but I don't know how much hinges on memory. To create work, I don't think you need to remember and locate all of what you have done in the past and to hold onto it. Memory often serves us in a dual set of functions. It can sort of hinder us, stop us from being free — if our memory is always recalling where we have come from.

I read a lot, but in bits, and am very scatty, with a lot of books going on at once. For example, I dip into Jung's theories, though I don't want to go into his work heavily — a tiny bit can set me thinking for a long time. I also research areas of interest and have dialogues with friends. My friends are mostly working on themselves in a similar way to me — we don't want to be mundane beings leading mundane lives — life is more than that. So much of understanding ourselves is listening to others.

Could you give a broad account of your creative processes — the physical, emotional and metaphysical dimensions. Could you also talk about formalist elements, themes and concerns within those processes, giving specific examples?

Before I can paint, I go through a clearing out process — an emptying of all the collective sort of rubbish that is in my head from wherever I may be at the time — to get back in accord with the language I am dealing with. But you have to be finely tuned into the self. Sometimes I see that things can flow through me quite easily if I'm freed up — like a channelled thing. But if there are obstructions and confusions, then I either have to avoid painting or release them. So I meditate to find my centre, to bring myself into a state of balance and stillness and to immerse myself in the present.

In terms of the physical aspects of my work process, frequently I have worked my images over very coarse backgrounds made up of sands and resins and pigments in the works on paper, or hairy jutes in the paintings. These coarse backgrounds have emphasised the refined shapes that have been worked over the top of them, thus creating a contrast between coarseness and refined, or primal and refined. This thing of contrasts has interested me for a long time — using extreme contrasts between texture, between a foreground and a background, between colours, whatever. I have chosen simple images that seem to contain and embody an unspoken complexity. I feel the need to live out both extremes and often will have come from, and have worked through, a complex point of view to arrive at the simple end result. That simplicity can only work if there is a richness behind you. There are two kinds of simplicity: the facile and a

Anima/Animus: Splitting Into One is a very active work in the sense that the colour is activating the psyche — it has the most intense pigments of reds and oranges and cool reds and warm reds that I can attain. They are very strong, pure cadmiums. I'm searching for an optimum dynamic of activity within a contained form — within a vessel shape — so when people stand in front of that, the colour resonates within the psyche.

What Anish Kapoor is dealing with, what he is saying openly about creating from his female self/side is relevant here in terms of his courage to speak out, and, in turn, that courage is inspired in other people. I know in *Anima/Animus* I went for a very direct image — no holding back. I basically knew what I was doing here because I'd done two similar works — though they were both horizontal. This was the first vertical one, and I hadn't worked with that scale and hadn't worked with the axis going that way — so there was something new in that, and I didn't know what it's impact would be, but I understood the language from the previous works.'

reductive process to essence. With this latter 'essential simplicity' an audience can read into it many things — whatever they want.

Within individual works, these contrasts mean, to me, contrasts on different sorts of levels. There is that physical level and, on another level, there is the contrast between the emotional and the spiritual, or, expressed in another way, between pain and ecstasy — it seems to me that we need both. For example, I might work with a background on a work on paper and just flood the pigment down the page, and as I do that, I am talking about a stream of emotion, a flooding of pain — that kind of experience. Then over the top of that, I'll work a very singular ball of white light in pastel so that I've got that refinement. So coming off the work, from that background — which is about pain — I've got this extremely refined shape over the top — which speaks of an exquisite moment of ecstasy. Throwing together these two contrasts, these extremes, is so intense that the story of the two can't really be assimilated. I see a confusion between states — a kind of chaos — in the lack of being able to assimilate contrasts like that. Who are we? What are we?

If we think about these contrasts on yet another level, going from one culture to another — where we can't assimilate, say, India in terms of our reference point of Australia — we are thrown into confusion. That confusion and chaos seems like a good thing to me if we can work through it, because all our points of reference are no longer useful to us, so we have to release them and open ourselves up to new ways of seeing. That's what I'm doing on a symbolic level with contrasts in my work — creating the old reference points beside the new when we can't assimilate the two. I'm creating a lack of meeting point — it's difficult to explain. It's like when I see women going out with men and the cultural backgrounds between the two are very different. I know what they're doing — they're exploring the unknown, which creates a new known, and that is the way we learn, and learn very quickly.

There is usually an area of the unknown in my work, which I like, because then I am discovering that potential that we all have. If one's own being has a black hole in it, then one needs to explore that too. So, there will be some works where I know pretty well what I want to do, what I want to say, and there's not much exploratory stuff there, and then in my repeat images I'm working on other things. However, with works in which there is slightly new ground, they will unfold for me in an unknowable way.

There is a strong formalist background to my work, and although I have been able to release that formalism to a certain degree, there is entrenched in me the need to create visual dynamic, visual balance, strong compositional elements, tensions and textures, and all these ingredients give a work its presence. The formal level is really important as an ongoing language for assessment, but still it is imbued with something greater and deeper to me, which is the content of personal and spiritual understandings.

I can't bear purism. I like a bit of the unexpected to jolt one's perception, one's realisation of what's going on — to keep the senses sharpened. I will bring unexpected things into play with each other in whatever form I am working on. I do that in my painting as a kind of important ploy to sharpen awareness, to sharpen perception, to keep one's eye keen.

The image itself dictates the scale of a work — some images can't be scaled down or they don't have the same impact, or if they are, they have to be scaled down differently. It comes down to how I want the images to live, to speak. The works on paper are smaller, but I can see myself making bigger works on paper in the future.

All the preparatory work in the paintings is slow, and can be irritatingly so — organising the jute, laying down the preparatory ground. In time I would like other people to do this work for me, as I would rather be researching or doing something else and then painting the images as my work. The fast part for me can be knowing if an image is right — and that can take just a few hours — then refining it is slow again. Fine tuning a work can take days — moving in and out. Some works can be labour intensive and some are not, though they are becoming more of the

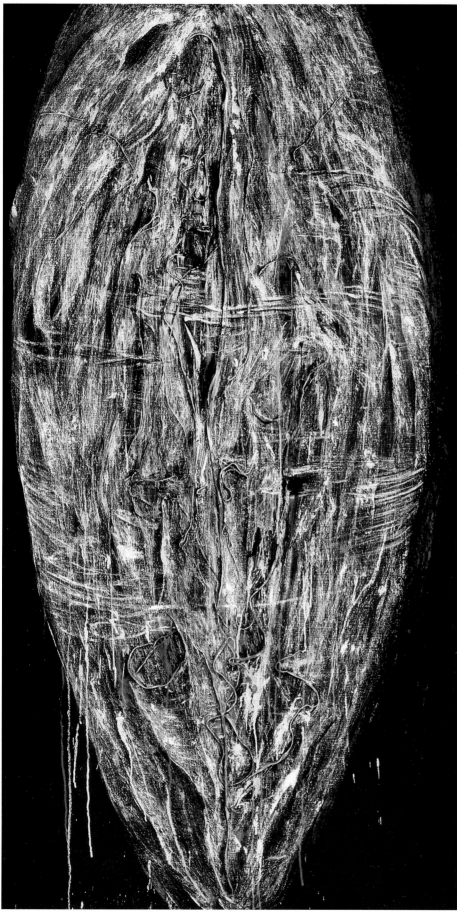

PLATE 12

PLATE 12
VESSEL SUITE NO. 1, 1991–1992
Pigment and collage on jute, 195.5 x 102.5 cm
Courtesy of Sherman Galleries

'I began this suite during the Gulf War in 1991. I came back and reworked it a bit a year later. When I began, I felt there was so much destruction going on in the world and wondered what was happening. I somehow felt this harsh, cruel, confusing event was going on that nobody really understood. I don't know why that suite coincided with the Gulf War, but somehow I could feel the fear that was in Paris — of bombs in the street and in garbage bins. There was a threat that the war was going to escalate out of all proportions, beyond the Arab territories into other countries and we didn't know how. There was a very strong element of fear in me. We would go to bed listening to the radio and wake up listening to the radio, and we didn't know if the Americans were going to bomb or what they were going to do.

I can't say this work is a direct result of that, because it came out of previous works that had a natural linkage, but I think the tension, the suggestion of bloodiness, of matter contained in some nebulous form and all these cacoon-like shapes — which I have called vessels — vessels for containment, vessels for carrying thought, unformed matter, unformed forms — could have something to do with the death that prevailed at the time. In Paris we were all aware of this at that time. So the story, the timing of those works, now exists as some sort of symbol or experience of a deeper consciousness, a deeper moment.

The five series — cocoon-like, diaphanous yet filled with something — are collaged and are sort of three dimensional as well as two dimensional. Those works suggest matter in a state of becoming and dissolving. As I evolved the form, that was what it was about. The idea wasn't a totally formed idea. I did one work, then realised it had to be a suite — I had to reinforce this one with others.

Around that period, my work was loose — diaphanous veils and a lot of layers — and what I was doing was layers of experience. The limited colour palette I use, what that means — the variations of white, red and black — is a basic range of choices in order to have the least distraction from the form itself. That means I cannot see other colours in there without them being anything other than decorative. My work is not decorative other than the fact that it is hanging on a wall. Decorative art serves an important function, but mine isn't decorative. For me, those three colour choices and the nuances around them, like cool reds, warm reds, oranges, warm whites, cool whites, blue-blacks, green-blacks and brown-blacks is enough; I don't need anything more. I like the idea of, say, red on black to make simple direct statements.'

former, even though I thought the process would become simpler. To get the intensity there is a lot of work. The end looks very simple and looks very simply contained, but there is a lot of layering and building up, and sometimes taking back, which makes the work richer.

I tend to work on one or two paintings at a time because of the size of the images. Sometimes I have been working on a series that I couldn't assemble together in the studio and will only see in its completed stage as a series in a gallery, and I've thought, 'Will this work or not work?' And they have worked. I couldn't photograph them either, so there's a need in this situation to be a super visualiser. A friend and I have recently taken a nine year lease on a new space in Paris that we are converting to two studio spaces that we will share, which will give us more space.

I like to keep the first few works in a new series and have held onto all the really refined ones — I think years later they are going to be speaking about something that is not evident now. But with the current works, where I'm working on repeating a motif, working in multiples or on strong developmental lineage, I'll keep the rawer pieces — which I need as symbol pieces — and I'll put out the more refined works.

Your work appears to be noticeably informed by scientific language and understandings. Could you comment on this?

I'm looking more and more at scientific and computer language because it's arriving at a similar point to the one I have come to through an experiential and intuitive knowing and discovery. It is very important that we realise this knowledge is endless otherwise our situation becomes quite nihilistic. Whether it is a mystery or we need to create mystery is another question, and if we want to create hope to give us hope, then that is okay.

Would you elaborate on the significance and symbolism of colour in your works?

Over the last three or four years I have worked with a limited palette consisting of three main colours and variations thereof. This has not come from any particular point of view and has emerged as thus:

> *White* or a pale, creamy, light colour may represent a skin, a covering or a membrane that protects the inner life. This range of pale colours can also represent light itself.
> *Red* represents the inner matter, an unformed, fleshy state, a life force energy, a pre-life essence and a primal experience.
> *Black* represents deep space or infinity and allows paler forms to exist as representations and formations of light.

Colour is amazing — you are working with energy when you are working with colour.

What are the meanings and significance of other pictorial and symbolic elements in your art?

As far as the symbolism in my work is concerned, the title of my 1994 exhibition at Sherman Goodhope Gallery in Sydney, sums up a lot of my images:

A FIELD A STREAM A POOL A THOUGHT
A TEAR A SHADOW A SKIN A SCAR

The words mean as follows:

> *Field* — of energy
> *Stream* — of emotions
> *Pool* — of light
> *Thought* — used in a lateral manner, an abstract sense, rather than literally — thought of what we are going to become before we become it

Tear — of release
Shadow — proof that we physically exist
Skin — of containment
Scar — scars as a marking of life experience

I once did an image that was like a big scar. I also created pools of light that are in the form of ellipses or in the circle as a field of energy. With regard to other shapes and elements in my work:

- The *circle* is a beautiful form and though totally unnatural in the sense of producing it — you have to think about it to make it — it is natural in the idea of cycles as a totality and an eternity.

- The *ellipse* and *spiral* have, in a sense, a greater dynamic than the circle, which is a fixed state of balance where every dynamic is counter-balanced. An ellipse and spiral have really strong unbalancing dynamics, and to keep them balanced/poised, you have to repeat the same curvatures up and down, so they suggest more momentum.

- The *oval* is like an ellipse, in a way. It is slightly more organic, is formed some-what more by a free-flowing movement. The circle is the perfection, but it doesn't occur naturally. All these distortions of nature that create other things like ovals and also the ellipse are something that could be a perfect circle flipped over on its side. The science of fractals works with these ideas.

- *Skin* is a tactile, suggestive thing rather than a shape. It is membrane: strong and yet vulnerable.

- *Blood* is something I'm totally freaked out about — in terms of it appearing in front of me oozing from another human being. I find myself suddenly remembering when I was a child, and my is father making us watch him slit a sheep's throat.

He thought it was good for us to see where our food came from. So this sheep was tied in an old wheelbarrow thing — I think he still does it the same way now — with its legs tied up together in pairs. He then forced the sheep's head over the edge of the wheelbarrow and slit the jugular and drained the blood. I remember watching in numbed horror as the blood was soaked up by the earth. (This is an incredibly strong image now.)

Grass fed the animal and the animal's blood goes back into the earth. Earth gives us this and then it soaks it back up — just takes it. When I think about this now…I see there are elements of this in the skin piercings in the *Slit* series (1994) I did — all the interventions creating a new image from the piercings…

So when I paint the colour red as blood, it is as a symbol, a material as such, a representation of the life force in the physical. There was/is a German painter, I can't remember his name, who used real blood in his paintings — I don't know whether or not I would try this. It is very evocative — the idea of bleeding and pain in a beautiful image. I feel that true beauty has something painful in it — I don't know why. As I think about it, if I am really moved by something — say a beautiful face — in that same moment, that's both painful and ecstatic. So blood is in there as a sort of remembrance.

The art is a product of the way the artist thinks, feels, senses and responds to the outer stimuli processed by self, which is itself an inseparable component of the world at large. Painting arouses the imagination and takes you on a journey. It can be like a waking dream: suggestive, elusive and obsessive. My images are themselves symbols and metaphors of the process of

growth and becoming — as if this process is about a perpetual state of arrival. The images speak of life cycles and the cycles within cycles, which themselves manifest from personal life experiences.

Could you talk more about the relationship between spirituality and art in your work and how that specifically manifests in your imagery?

Spiritual experiences have been with me all my life: I 'knew' that there was more to life than what we see, hear, touch — what our senses tell us. I have a familiarity with what is beyond the physical, and the next word for that is 'spiritual'. This spiritual dimension, which is the basis of everything, of all seeing and being, is what informs my visual language, and art is the experiential dimension through which I express that understanding. My daily life experiences — where I may be dealing with death, with love, with hatred, on an emotional level — also informs my spiritual understanding. I express these emotional states through the use of colour in my work. Being open to the image and the visual impact of colour, rather than cerebral notions, is what primarily leads to communication.

Another aspect of this in my work is the concept of cycles within cycles in nature. The infinite also has had a lot to do with my work. Infinity is an extraordinary part of experience and language. The more we uncover, the more we discover how much there is to uncover — expansionist theory. This is a spiritual idea that along our journeys, we uncover a piece of knowledge that is appropriate to us at that particular time — and find that with this newfound piece of knowledge is the realisation that there is so much more to be tapped — the 'great mystery'.

There is perhaps a God notion here — in the idea that it is fathomable only in as much as it is unfathomable. The mind can get it, but it is beyond our intellectual range — it can only begin to be explained to certain degrees. Somehow I've sought to express that idea, that image, in my work. The image that expresses that is the spiral, I think. Fractals touch on that — scientists are trying to express this theory in image on computers. This is what I believe the void is about, the black hole is about. Scientists understand this indirectly. I have found it difficult to put into words.

In the black hole, where there is no such thing as time, what there is, I believe, is the potential for being and becoming. I'm not sure what that potential is — it can be information — but in that void, it is not that nothing exists: it's the unknown that exists. I know that there are artists who are aware of this because I see images about this coming up in their works — there are certain shapes being expressed. Some artists are working now with computers and making absolutely beautiful forms. I know they are getting close to cosmic consciousness theory, which is about the infinite.

How has being a woman particularly influenced your work and career?

As I said earlier, an aspect of my work is the concept of cycles within cycles in nature. A woman's body is subjected to those, and therefore she knows the link to her own body and is brought back to body consciousness through those cycles — that is a fundamental, natural law. She is also imprisoned by circumstances to some extent. We also have a mind, and we want to explore the parameters of that mind.

Being a woman at this time in history has meant that certain concerns about life and being, and the cycles of nature, can be expressed more freely and directly than in the past. We do not have to concede anymore to a male language of painting, sculpture — art in general — nor to its outmoded emphasis on formalism, which has created barriers on all sorts of levels. Now we are more free to be personal, and in being so, we find we can touch on issues of commonality. We are as much a part of nature as the nature we see around us — it is one and the same thing. We are physical beings — this is our means — and sexuality, which is very much misunderstood and maligned, is a powerful form of energy. This sexual energy force leads to a life-forming

force and to procreation — and has to be the most powerful energy form that there is.

For many women their creative process is about creating another human being, and that is not a path I have chosen. But, in a way, I see the images I create as my children, and I do set them forth to do their own work in this world on their own. They are out there acting on various people's psyches. If I can make a parallel, in a way I am possessive and not possessive. It is about directing one's creativity.

My work has such female or 'femina' tones to it that people think I am a feminist, but I absolutely am not. The fundamental issue is that I am a humanist and paint as part of a general voice — it's also individual, but it comes from a greater source — the source of the Whole from which we all spring and with which we all, in our egoless needs, want to merge.

I am now at mid-life, which means to me a releasing and letting go of all sorts of fears and anxieties associated with a younger, less formed self. It means being empowered as a woman and knowing it is me who chooses to succeed or not to succeed. It is me who chooses to communicate or not, me who chooses each step/level of my success. This period, for me, is about attempting to bring to an end — in any form or feeling — the sense of being a victim, feeling helpless against any massive, weighty circumstance. In the past I might have felt the top heaviness of the male — of men in the visual arts and elsewhere — but now I have a different focus, a different alignment in thinking. I don't align myself with those men; I look to have my own art stand on its own, and allow it to do so.

It is interesting to watch and see a growth in overall content prevailing in different artists' work, though I now don't feel the need to compare my work with theirs. I'm just doing what I'm doing, and it is me who answers to me — though I am not yet fully there, because there are stages in this process.

It's happening more and more that women are feeling they don't have to hide their female side in terms of the bigger art world anymore; they feel their sensibility can emerge. Increasingly I have met men who don't feel so repressed either, don't need to be just so 'old school male self', and feel that they can let go, too.

How do you see your role as an artist and what do you see is the function and purpose of your art?

I see my role as an artist being to bring us back to our primal selves, where we exist more in accord with our instinctive, intuitive natures. All that we have created — science, technology, art and language — is meant as a means to improve our essential needs.

Art has served as an extended voice for me, a very specific extended voice. There are multiple selves that exist in each of us and it is complicated now, in the choices available and roles we can play — in relationship, as a creative being, as a business person — and each one requires a great deal of you. I somehow keep the roles separate: the creative part, the marketing part — which is a delicate area and an aspect of myself that I work on strengthening. I want my work to be seen, to be viewed, for it to enthuse people to take it into their lives somehow.

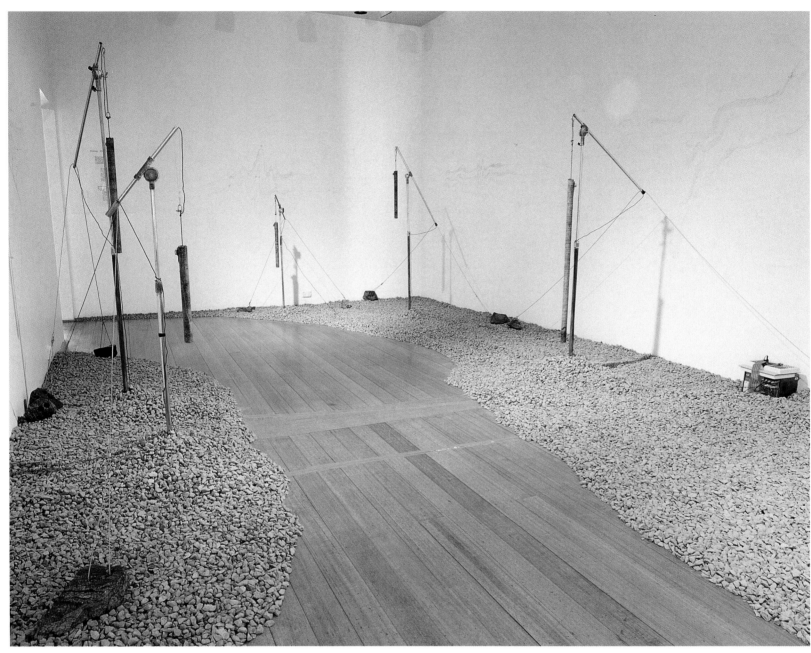

PLATE 13

Joan Brassil

SCULPTOR, MULTI-MEDIA AND INSTALLATION ARTIST

*…electronic energy within the sculpture and installation provides
a dimension of time that radically extends the process possibilities.
Here sculpture may become an instrument of art, with the dissolution
of the object into light, and the work then assumes an ephemeral
condition as in music or spoken poetry.*

JOAN BRASSIL was in her early fifties when she began her full-time practice as an artist, following a career in art teaching and raising a family. She was born in Sydney and attended Sydney Teachers College in 1937–1939, followed in 1940–1945 by studies at East Sydney and Newcastle Technical Colleges. In 1969 she attended the Power Institute of Fine Arts and in 1981–1982 completed post-graduate studies at Alexander Mackie College of Advanced Education. In 1988–1991 she received her DCA from Wollongong University.

Joan Brassil's extraordinary sculptures and multi-media installations poetically focus on physical and metaphysical aspects of 'time, space and energy within unseen forms' using light and sound. They embrace complex ideas within seemingly simple constructions that indicate her very sensitive and refined attunement to delicate forms and subtle levels of perception and intelligence.

She has had numerous one-person exhibitions since 1975 as well as having participated in many selected group exhibitions throughout Australia and overseas since 1974. Brassil had a major retrospective of her work titled 'The Resonant Image' at the 4th Australian Sculpture Triennial at the Australian Centre of Contemporary Art in Melbourne in 1990. She received the Australia Council VAB Emeritus Award in 1988 and is represented in the Museum of Contemporary Art, Mosman Council Collection, Campbelltown City Art Gallery and Orange Regional Gallery in New South Wales, the Araluen Art Centre, Alice Springs as well as in other regional institutional and public collections.

———•◦•———

To begin, could we perhaps talk about your development as an artist and your art practice, elaborating on themes and concerns in your work?

In my work as a sculptor, the use of technological processes has allowed a deeper probing into the nature of existence. The penetrating view through the electron microscope has revealed

'Firstly I chose to make icons as a trilogy of assemblages alluding to unseen waves, each being contained by a black box faced with grey glass; the viewer is thus presented with a reflected image of self, and the vision has to proceed beyond this image to focus on the abstract icon beyond.

> *Sound Beyond Hearing* (1970) is the silent visual representation of a wave.
> *Light Beyond Seeing* (1971) is made up of centrally placed subtle violet chords of light using optical shift.
> *Memory Beyond Recall* (1974) uses slow kinetic single light pulses within a grid.

These works set the path for my vision and the methods to be used. I wanted to address aspects of time, space and energy within unseen forms through the use of light and sound, using poetic tensions and randomness.'

PLATE 13
RANDOMLY NOW AND THEN, 1990
ACCA retrospective, 1990 and MCA, Sydney, 1995
Courtesy of the artist

'The eight primal sample cores of diorite were salvaged from geological explorations, then each was electrically stimulated to resound at its own resonant frequency, as a random Song of the Earth. Set in a field of gravel, rocks were covered with carbon to emphasise the time factor and the connection to life.
 This work and *Can It Be That the Everlasting is Everchanging* are two of my most important works.'

PLATE 14
CAN IT BE THAT THE EVERLASTING IS EVERCHANGING, 1978
Courtesy of the artist

(In the foreground) from the retrospective *The Resonant Image* at the Australian Centre of Contemporary Art in Melbourne in 1990 and at Campbelltown City Bicentennial Art Gallery in 1991
 [On the rear wall of this exhibition (as seen in the colour plate) was the *Trilogy of the Unseen*, 1969–1974. These were the works *Sound Beyond Hearing*, *Light Beyond Seeing*, and *Memory Beyond Recall*.]
 '*Can It Be That the Everlasting is Everchanging* was inspired by SUGAR (Sydney University Giant Air Shower Recorder), which registered cosmic rays from outer space as they bombarded the earth. The installation contains spark chambers salvaged from SUGAR; patterns of light emitting diodes were then placed underneath the spark chambers, using four circuits to a panel. These circuits were activated from a central apparatus using Geiger tubes that responded to the radiation of cosmic showers on Earth thus different circuits at different times. Thus the work was randomly operated by the natural unseen forces of radiation from outer space that constantly surround us.
 The ochre-painted sapling aerials in the installation suggested the myths of the stars according to Aboriginal lore, which was true in its Dreaming time. The scientific truth of registration and measurement is true in its current context. However, who knows whether in another century it may be said that all the twentieth century was about Dreaming.'

PLATE 14

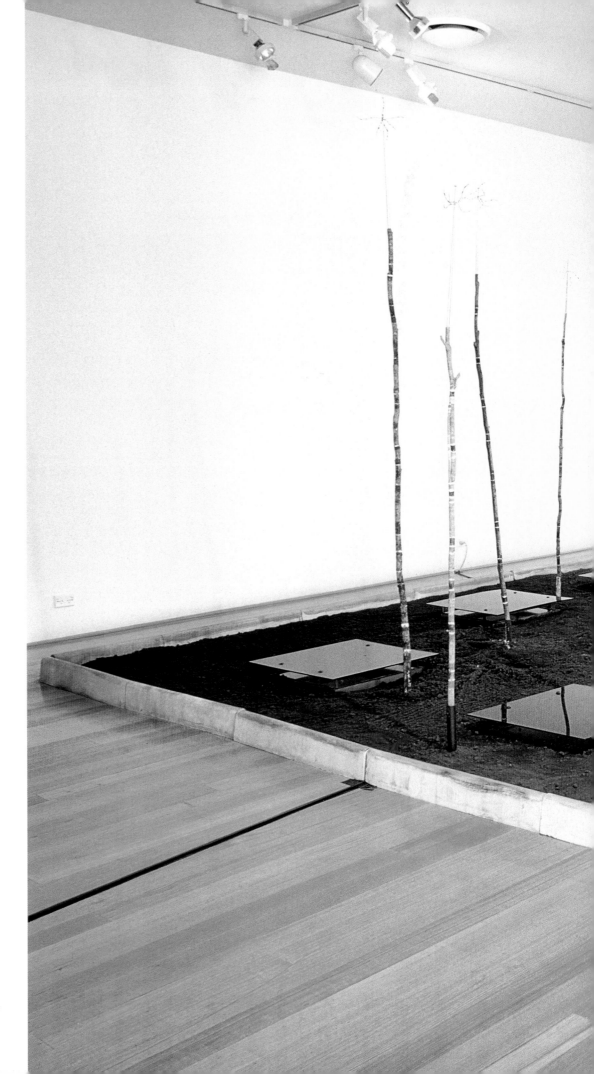

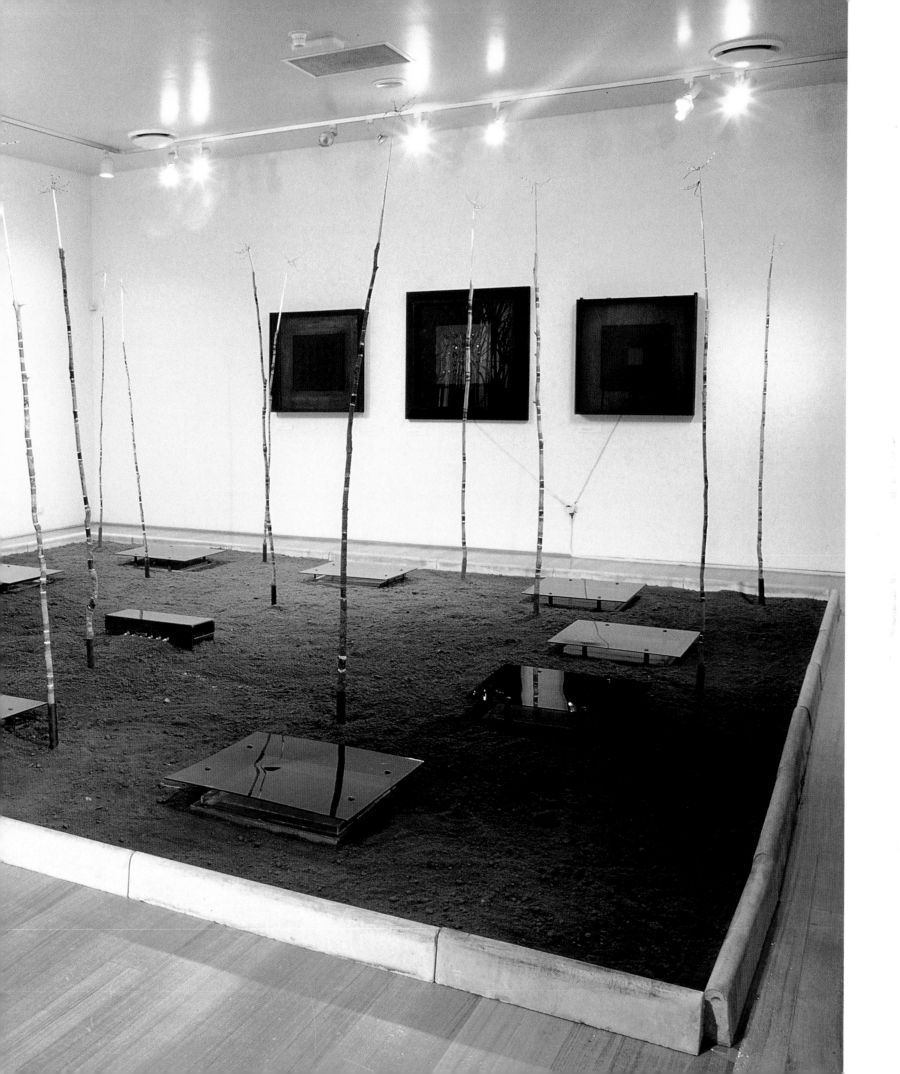

hitherto unknown processes of nature on Earth's inanimate crust. The vast expansive view provided by the telescope and the transmission of information by radio waves, or satellite, have demanded new considerations of Space itself. In sculpture, a form of installation has evolved where space was the pervading element, with the interaction of process, object and viewer becoming the work of art. This spatial and experiential dimension of the installation, together with the use of time-based electronics, revolutionised the attitude to sculpture.

During this century, scientific and technological explorations and discoveries have over-turned concepts and values of past ages. The cultural reorientation with respect to time presents undreamt of possibilities so rapidly…

> I wish to pause and wonder on
> the magnitude of Nature.
> Processes of symbiotic adjustments
> energy transfers
> the 'chaos' of change
> to absorb into the culture, the scientific
> implications of subtlety discovered
> in Nature
> to take inspiration from the survival
> processes of millions of years, with
> the insights and revelations made
> possible by technology.

Over the past two decades, the direction of my sculptural practice has been a development from object to process. Whilst not denying the three-dimensional object, the electronic energy within the sculpture and installation provides a dimension of time that radically extends the process possibilities. Here sculpture may become an instrument of art — with the dissolution of the object into light — and the work then assumes an ephemeral condition as in music or spoken poetry.

Poetic process for me was a way of addressing revolutions in sensibility and forms of sculptural practice. T.S. Eliot maintains that:

> 'Poetry may effect revolutions in sensibility such as are periodically needed…
> [Poetry] may help break up the conventional modes of perception and valuation
> which are perpetually forming, and make people see the world afresh or some
> new part of it. It may make us from time to time a little more aware of the deeper,
> unnamed feelings which form the substratum of our being, to which we rarely
> penetrate; for our lives are mostly a constant evasion of ourselves, and an evasion
> of the visible sensible world.'
>
> *The Use of Poetry and the Use of Criticism*, 1933

The need to see the world anew is of prime importance in creative thought. This avoidance of ourselves and the visible, sensible world leads to the consideration of phenomenology. Phenomenology is a study of what is already there in existence, and is also a study of essences. Commencing with maxims on the twentieth century visions of space, time and energy, I have approached the phenomenology of landscape by exploring these unseen energies together with existing codes that affect the nature of consciousness and perception. In the interaction between these aspects, it was hoped to inspire wonder and reflection in the observer.

Resonance and reflection have been used as important interactive agents; in the video works, the image itself is apprehended through its reflection. The image of the viewer may be reflected from a glass or perspex surface, yet the viewer's choice of position changes the reflected image. The position of the listener determines how the random, ever-changing reso-

nances within the installations may be perceived.

Whilst most works are concerned with processes, the object has not been denied, and appears in the installations as found object, as sculpture, as mirror of natural object, or as symbol. The works are conceptually open-ended and contemplative. In the extended space of the installation, the viewer may participate in the establishment of relationships with the concepts and elements of the work. Viewers position themselves within the kinetic and random elements of time-based works to experience the great enigma of existence.

In 1989 I participated in Ars Electronica in Linz, Austria with *Time Warp Reflection*. The statement in the preliminary brief said:

> 'According to diagnoses, hypotheses and forecasts of scientists and the media-theoreticians, modern mass media and technologies of communication will lead to a profound transformation of our culture, to a new codification of how we experience the world and ourselves, new codes which will determine our perception and our action.'

In the face of these revolutionised codes, communications and perceptions, the documentation of my work during 1988–1990 demanded a form that was consistent with the processes.

Have there been other particular influences or inspirations in your work?

It seemed to me that Kasimir Malevich was addressing the inner necessity of getting beyond the surface, referring to his use of Suprematist elements in his painting as: '…expressing the notions of flight…the sensation of metallic sound…the feeling of wireless telegraphy…magnetic attraction…white on white, expressing the feeling of fading away…conveying the feeling of movement and resistance, the feeling of [a] mystic "wave" from "outer space".'

I felt that visual arts had been given a more profound way of proceeding into the twentieth century. Inspiration also came to me from listening to research scientists and their revelations of universal processes of existence in nature. I found the elegance of these processes stimulating and profound.

Could you talk about the significance of signs and symbols in your installations?

In the journeying, 'signs and symbols' became important.

Time is symbolised by the use of the hourglass:

- *Have You Metamorphosed Lately?* (1977) contains high, sapling hourglasses. Each hourglass bowl contains a stage of metamorphosis in the life cycle of a moth — time is encoded in a minute insect egg.
- In *Stranger in the Landscape* (1983), colonial letters are contained in laboratory-blown hourglasses that are set among xanthorrhoea as representatives of primal Gondwana plants.
- In *Time Mirages*, desert landscape and fossils are viewed through the shards of a broken hourglass.

Carbon also symbolises time, being used as a time dating agent, and also forming a vital element in rocks and life. In *Randomly Now and Then*, rocks are rubbed with carbon, and carbon is in the core of the poem:

> 'Carbon Moon-moths
> Listen to the sounds
> of a million years singing
> for just one nocturne'

Aspects of randomness that are contained in the works are as follows:

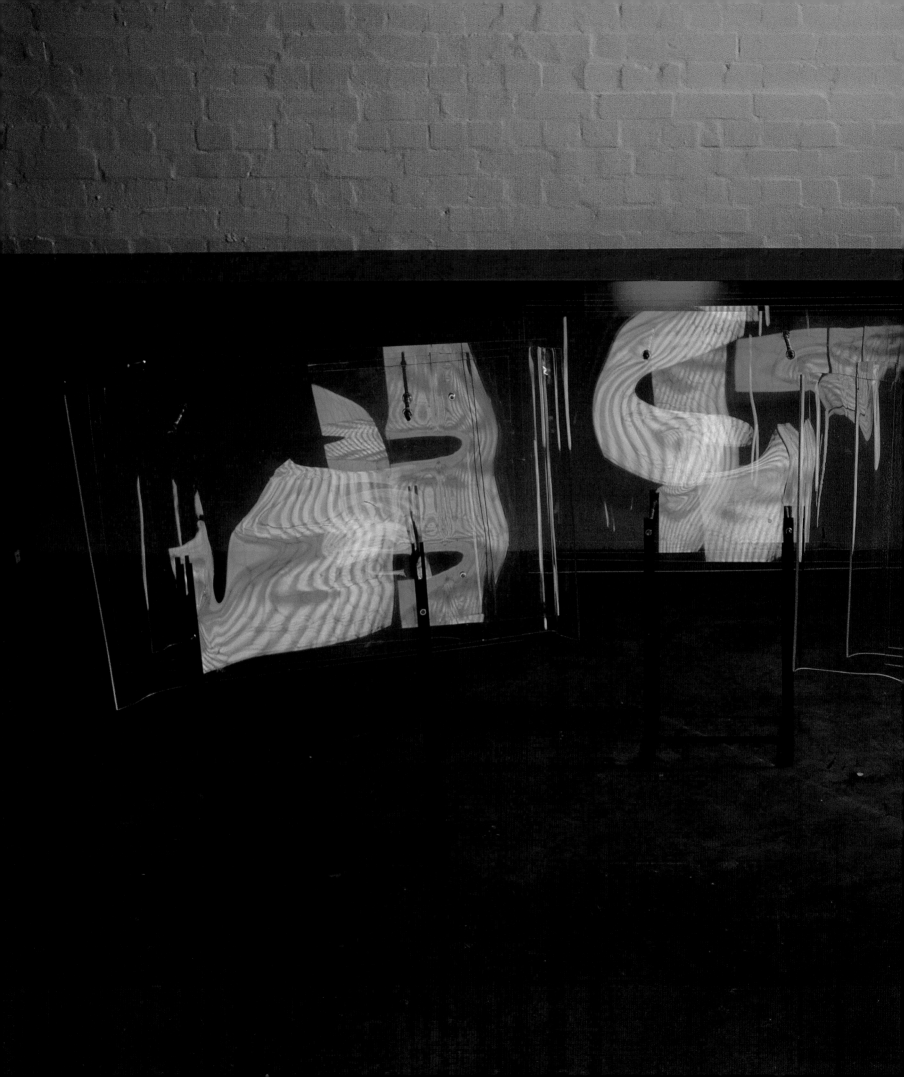

PLATE 15

PLATE 15
KIMBERLEY STRANGER GAZING (detail), 1988
Installation at Roslyn Oxley Gallery, Sydney, 1988
Photograph: Jill Crossley, Courtesy of the artist

'In pursuing this journey to discover the primal sources of existence and the primacy of the land, I wished to explore the way in which we, the observers, see what is there. I chose to focus on sense of place, and on the attempts of migrants to come to terms with displacement — memory, measurements and charts, bones in the earth, cultural expectations, or a recognition that the land makes decisions — and this resolved itself into a mirage of what there is in existence. To portray the many processes of perception, a series of video landscape images were transferred from a monitor on to multiple overlapping reflective surfaces, to hover as light images in the space.

To chart the journey of my work:

In *Stranger in the Landscape* (1983), landscape is viewed through archival family letters from the 'homeland' to Hobart Town (1833–1855) that have been placed in a stand of xanthorrhoea (grasstrees). The installation became:

> "The stranger is the memory
> that does not apply"

Stranger Charting (1984) continues the struggle in the observation of an unknown land. In this video installation the coastline of 'Terra Australis Incognita' is accurately observed and mapped using Western cultural measurements and grids, but the Dreaming remains the "Incognita".

In *Stranger Companion* (1985) the companion becomes the bones gone to earth in a new land. The view of the landscape is one in which the frame of reference is overlaid by bones, drawings and X-rays from all parts of the body, implying "the whole body" consciousness of the land.

The next trilogy, *Landscape in Four Dimensions*, concerned the cultural difference in viewing the landscape.

In *Time Mirages*, landscape is viewed through the shards of a broken hour glass and divisions of territory, whilst a section of a prehistoric fossil image floated over the video screen.

> "Dust and Shards
> overlaid by shadows
> from wire-fence grids,
> a temporary definition,
> on a primordial land."

In *Time Warp Reflections*, the landscape is mapped using Papunya-style dots or in a form of aerial mapping using the dots of a computer circuit.'

> "Psychic Terror
> Time Warp fright,
> Pause for Reflection
> On a silicon byte."

PLATE 16
KIMBERLEY STRANGER GAZING (detail), 1988
Installation at Roslyn Oxley Gallery, Sydney, 1988
Photograph: Jill Crossley, Courtesy of the artist

'In *Kimberley Stranger Gazing*, the stranger for the first time appears as a shadow — with pastoral animals — over the land, whilst the existing energies appear as charts of winds or magnetic fields; the invisible elements of air and land become the mirror gaze of the landscape in which the stranger arrives.

"We passing shadows,
fired by the Sun,
as pressured pulses
from alien climes,
Memory programmed
to change the land
and,
…Gazing,
The Land
to change the Memory,
With the random precision
of measured winds."

The sound work was made by Alan Lamb in Western Australia, on a modified stretch of abandoned telegraph wires 600 metres long. The music is made by the wind, which causes the wires to vibrate. Because they are so long, the patterns of vibration may shift along an infinite range of possible harmonic combinations. In the visuals, the effect of the wind also dominates the rhythms of the movement and timing.'

Light:
Memory Beyond Recall (1974)
Can It Be That the Everlasting is Everchanging (1978)
The Fall from Pond Light in Two Phases (1992)
Sine Waves/Harbour Waves (1993)

Sound:
- The sea waves in *Consider the Fungi at the Interface* (1986) and in *Sine Waves/ Harbour Waves* (1993)
- Recordings of the sounds of the random harmonics of the wind in telegraph wires by Alan Lamb, used in the three desert pieces: *Time Mirages* (1986); *Time Warp Reflections* (1988); *Kimberley Stranger Gazing* (1988)
- In *Randomly Now and Then* (1990), rocks were stimulated to their own resonance; the random sounds of rocks 'singing' unknown 'program' switches for 'on' and 'off'
- Random timing of the piano 'plop' compositions by Ross Edwards in the installation *Pond Light in Two Phases* (1992)
- Sounds of rocks — five rocks were collected for their resonance and were placed using a spectrometer to measure their radiation. Michael Askill made a composition using the sound samples of rocks and a spectrometer in *Energy Mirages* (1987)
- In *Body Weather Erosions* (1994), samples of sand and ash collected from Lake Mungo were placed on a square skin drum used as a palette; then a feather was used as a brush on the drum surface to draw the substances in visual rhythms of the dunes and outcrops, resulting in a continuous sonic scroll of 12 minutes — video soundtrack (assistance from ABC Broadcasting Corporation).

Interactive light and sound:
In *Sine Waves/Harbour Waves* (1993), the experience of random changes in the natural light and interactive movement within the gallery was created using infra-red cameras, positioned according to a computer-generated design, to sensitise particular areas; the accompanying sound was a composition created by Warren Burt using tuning forks that have been made according to a Dorian scale.

How has being a woman specifically impacted on your work and art career?

In regard to being a woman artist, I came to being a practitioner after a career in art teaching, so my work has been done in old age. The 1970s saw the encouragement for feminine recognition within the arts, and I was fortunate in receiving much support. I find that what I have to say appeals especially to young women artists and students. I found this also on a recent exhibition tour to Taipei! 'We want to be where you are. How do we get there?' I realised how fortunate we were, with the networks available being women inclusive.

How do your see your role as an artist — and the purpose and function of your work?

Perhaps being an elderly woman gives me courage, but what have I to lose? So there is a freedom…the nature of the world in which we exist is already there — and I exist in this time.

Kate Briscoe

PAINTER, MIXED MEDIA ARTIST

*I'm at a point now where I am clearly using death… The body and
the container are part of this work — the elliptical form, based
on the basket or the bowl, is holding the body and the body is
buried in the soil. These are all burial paintings.*

KATE BRISCOE was born in England and from 1960 to 1964 studied for her National Diploma in Design at Portsmouth College of Art, where she majored in painting and also explored photography, printmaking and ceramics. Between 1964 and 1965 she studied for her Art Teachers Diploma at Leicester College of Art, specialising in printmaking. In 1989 she attained a Master of Fine Art from the College of Fine Arts at the University of New South Wales. Briscoe has held a number of teaching positions, including lecturer at the National Art School, Sydney from 1969 to 1976, and since 1992 has been a part-time lecturer at the College of Fine Arts, University of New South Wales.

Briscoe's abstract paintings, with their richly layered and textured surfaces, have an earthy, primal quality that suggests not only a personal and archaeological 'her-story' — as represented in her archetypal Goddess paintings — but also that which is timeless in nature. A glowing volcanic energy underlies an embalmed-like containment in her compositions — particularly in her more recent 'burial' paintings — suggestive of an alchemical crucible below the surface and of life within seeming darkness. The canvas thus functions as metaphor for Earth's surface, which contains both death and potential rebirth.

Prior to emigrating to Australia in 1969, Briscoe participated in several group shows in Britain and also had an individual exhibition at the Harnham Gallery, Salisbury. Since 1971 she has also had several one-person exhibitions in Sydney. She won the Cathay Pacific Prize in 1975 and the Maitland City Art Gallery Purchase Prize in 1979 and 1989. She is represented in the Parliament House Collection, Canberra as well as in other regional and public collections and in many private collections both in Australia and overseas.

PLATE 17
CONTAINERS, 1995
Pencil and crayon on paper, 35 x 42 cm each
Courtesy of the artist

Could we begin by discussing important formative influences and pivotal experiences in your development as an artist?

My experience of using photography as a student at art school in England became a strong influence upon the way in which I deal with the visual in that it became very valuable to me as a type of sketchbook. I never wanted to become a photographer, but I was excited by the way you could use photography to select visually — initially through the lens, and then through the enlarger. So I spent much of my time as a student photographing pebbles, sand, rotting old boats on the beach and in estuaries.

Form, texture and composition were the key elements in this selection process. This process then fed into my painting — even when I was working with a broader landscape scene. I was never interested in the view as such, but in the elements that were the essence of place. I couldn't just paint any old landscape — it had to have a particular symbolic feel, a relevance to me.

The other important influence on me was the strong emphasis placed on drawing in my early student days — drawing as a tool, as research, as well as a form of expression. I was only sixteen years old when I went to art school — you were supposed to be eighteen but I nagged my way in on the strength of my work, which was mostly drawing. I was quite romantic then and I think that my enthusiasm probably had a manic edge. Although I was very strong in drawing, I was not so in art history or in any area where I had to write.

I also spent a lot of time in the British Museum in those days, not so much for academic research but to be surrounded by all that stuff — it became quite addictive. I also loved historic architecture, particularly cathedrals and churches and the paraphernalia inside them, and ancient constructions such as Stonehenge. I think the strongest artistic influences on my work then were Ben Nicholson and Brancusi.

When I arrived in Australia in 1969, I travelled to some fairly extreme locations, like the Birdsville Track, Fraser Island and the Tasmanian coast. I also did a series of works on the Glasshouse Mountains. I think I was looking for visual equivalents to Menhirs and Stonehenge. When I went to Fraser Island, I was absolutely enraptured by the sense of place there — the formations of the sandhills and lakes gave me a way of using a landscape that I could tune into directly, without a view. What I was doing was looking down onto forms as I had done on the south coast of England (the cliffs, rocks and ocean) and I could visually manipulate the forms and get that essence of place. After this experience, I started to look at landscape from a totally aerial viewpoint. I went to Fiji in 1977 and from an aircraft I took hundreds of photographs of the reefs, islands and formations that could be seen through the water. I combined these images with forms viewed close-up underwater, such as clam shells and coral formations, and I started sticking objects to the surface of my works.

A pivotal experience took place for me in 1986 when Elwyn Lynn came to my studio one day to see some of my paintings and collages. We also looked at my New Guinea artefacts, which I had been collecting since the early 1970s. After Elwyn had looked at my work for a while and we had talked about underwater forms, he said, 'You haven't mentioned all the New Guinea things you have in the context of your work, but I can see them all over the place!' He was right: there were all sorts of forms coming into the work — zigzags, beak shapes and hook forms. For me, this comment opened a door — I suddenly realised I no longer had to be locked into particular landscape or landforms; I could combine images from a variety of sources. The content was mine to play with however I chose. This was a turning point in my development.

How and when did the Goddess series initially emerge as subject matter for your work?

The *Goddess* series emerged in 1990. It arose from looking at very simple forms — triangles, splits, containers — and looking at books such as the writings of Maria Gimbutas. I was researching ancient cultures, where the goddesses were important in rituals — as part of the

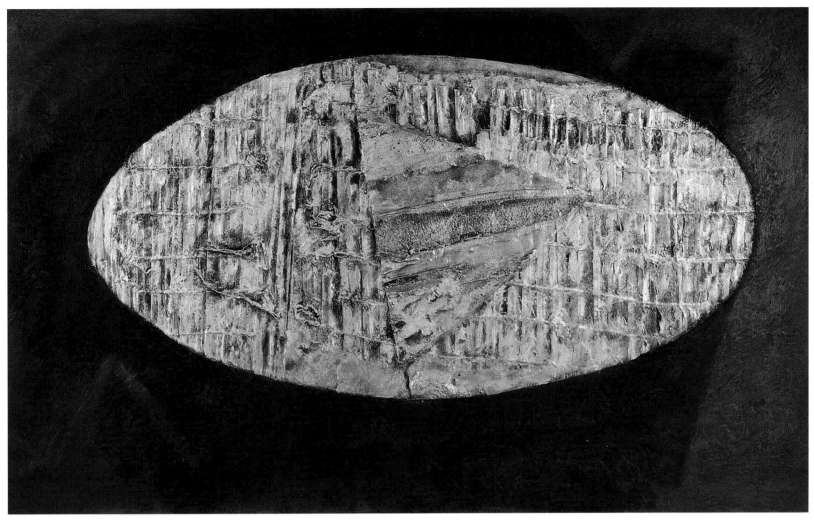

PLATE 18

process of looking, part of the journey. I was working with the body form and with earthy, sandy materials and putting the two together. I learned a lot by exploring these ideas. I don't know that the goddess as a belief or as a form is as important to me now and I'm not specifically focused on that anymore — it may come back again. If it does, that will mean I have absorbed the experience and meaning of working with those ideas. Once you have processed something as an artist, it remains with you, and bits will come out here, there and everywhere. I'm still very earth fixated, however — it's to do with the materials.

Could you talk about your creative processes and the specific importance and function of the materials you use in your works?

The most pleasurable part of the ritual of painting is mixing up the sand and pigment I use. Preparing *everything* is a *ritual*. The mixing is a meditative process and everything has to be absolutely right or else I can't do the painting. I prepare everything, including the fabric that will have the metallic paint and collage applied. I draw the shape until I'm happy with it. The painting goes on the floor, and I mix up the sand and pigment mixture, which is quite a long process. I have to think hard how that is all happening — the relationship between the soil and metallic elements, for example, and whether I want holes in the earth to imply depth.

I buy a lot of dry pigments and the sand I'm currently using is a very soft clay sand that a friend of mine brings up from Gunning. So I have a special type of sand, and other sands as well if I want something coarser. I am actually 'burying' when I do the painting — I'm *burying the body* — I know whether the container is going to contain 'bones' or have a more skin-like surface.

PLATE 18
SARCOPHAGUS, 1995
Mixed media on canvas, 91 x 152 cm
Courtesy of the artist

'The drawings *Containers* [Plate 17]: These are some of the working drawings for the burial series. They are experiments with the container — I wanted to see how variations on a spiral or spring would work on the ellipse. The spiral originated from ribs. Apart from a way of pushing the container around in my mind, I find drawing a very seductive process and I enjoy the concentration and focus required and the clarification that emerges out of the doing of it.

The painting: *Sarcophagus* is one of a series of burial paintings in which the elliptical form implies the opening in a container — 'container' being a metaphor for "body".

These burial paintings follow on from works like *Fish Tent*, in which the body is apparent but not contained in such a specific form. The ellipse is a glimpse at the contents, so what I put into it has to carry the allusions and meanings of the work. *Sarcophagus* has references to shields, armour, medieval tombs and Celtic artefacts. The use of the bamboo window blind is a reference to earlier works where a basket or fishtrap represented the body/container. The triangular shape is cut out of another painting; it has the edge of a garment embedded in sand and paint, so this form is like a body fragment.'

PLATE 19
FISH TENT, 1993
Diptych, mixed media on canvas, 175 x 244 cm
Courtesy of the artist

'*Fish Tent* came from the images of the flattened bodies of
the Bog People. It has the structures of the bodies hidden
in the golden triangle. The triangle obviously symbolises
"body" anyway, but inside there are two bodies facing
each other, with the shape of bent knees. Although they
are buried in the earth, I wasn't dealing with a burial site as
such but with bodies that had gone through ritual burial.
I wasn't trying to reproduce the burial but to get into the
ritual process — a way of understanding that comes to you
when you see the photographs of those bodies that are
three thousand years old.

 The bodies are not clear. The gold refers to something
precious — something important has happened here. The
central split within a triangular form, as with earlier works,
relates to the female body. There is a moon form on the
left, which refers to cycles of nature and fertility, and a sun
form on the right — but here the moon is warm and the
sun is cool. The surface is a history — it's a building-up
process.

 Sometimes I take things away, sometimes there are bits
from older paintings that are put on. There is a cloth
collaged on to the base canvas to provide a skin, and there
are structural elements from other paintings. Then there
is the sand — the earth element — and the gold in the
central triangle, which provides a contrast with the earth.
The pigments are like burnt soil — I use burnt umber and
handle the materials a lot. I have to work on that a lot to
get a spatial feeling, because I still want a structure that
goes back into the layers. I stain the gold so that it looks as
though something has burnt it. I utilise an acrylic gel
medium with everything I stick on and have never had
any problem with things falling off or cracking. I work over
the gold with transparent colours — reds and blacks —
otherwise the gold would look very glittery.'

PLATE 19

PLATE 20
BODY GODDESS, 1991
Diptych, mixed media on canvas, 152 x 222 cm
Courtesy of the artist

'*Body Goddess* was one of the first in a series of "body" paintings that have a specific reference to the female body. I didn't pick the female body consciously or with the intent of being gender specific. These works developed from a series in which the forms had associations with Melanesian artefacts and symbols, combined with references to reefs and underwater forms.

I was cutting up and reassembling some of these earlier works and the body, in the form of a basket, began to emerge. So it had to be a female body with its connotations of "container". The actual idea for this work came from two of these fragments of body that I placed together; I then decided that the work itself should be large and monumental. The surface was gradually built up using pieces cut from earlier works — these structural layers can be read through the subsequent layers of sand and paint. This process of cutting, layering and building using old paintings, sand, earth and metallic pigments is essential to the development of the image. It is important that the pieces I "cannibalise" from other works have the correct references. The work gradually acquires a history in the process. The process also imbues the work with references to ritual, alchemy and magic.

The body in this series is a magical symbol of transformation, various bodies turning into containers — baskets, fishtraps, vessels — that are universal and lasting forms implying survival. The painting is intentionally royal and rich — evocative of a goddess image. I wanted this work to exude a sense of power and strength, and to be mysterious as well as monolithic.'

I've thought about all that beforehand. I have to know, for instance, whether I want a skeletal feeling or a fleshy skin in there.

By preparing and planning as much as I do, this doesn't mean that the painting is totally fixed at an early stage; it can change dramatically from its foundation — more substance, bits or stuff can be built in and buried. If the painting is not working, I can cut it up and re-use some of the pieces. I always feel at a bit of a loss if there isn't a pile of canvases in the corner of the studio that I can 'cannibalise'.

For me, the process is another way of dealing with the body. The body is my particular interest. But for me it encompasses the seductive and sensual aspects of soil and the ritual. Ritual is terribly important, but in our society it is something we forget — where our original, pleasurable, joyful rituals come from. If you can go back to being a child — all children love to play with soil and sand and to bury people in the sand. Drawing on the sand is also a useful process for thinking. I can make an image, add to it and then let the tide distort and finally dissolve it. I document this metamorphosis with the camera and add these images to my sketchbook, which in turn becomes part of what I rummage through in my studio.

This way of working with the body — exploring the way people deal with the body and the forms that represent the body, such as the basket and the container — is a meaningful thing for me. In the last three years I have been going into how people bury bodies. Some New Guinea tribes, for example, put their bodies out on a trellis to be picked over. I also get enthused about the Bog People. Going into European and Celtic backgrounds means looking at these Mound People — in Ireland and Scandinavia. These bodies, which have been dug up, are two or three thousand years old and are visually so exciting.

I grew up in England near Stonehenge looking at those things, so it seems I've gone in a circle back to things that in Australia I didn't really think about for a long time. It was actually looking at New Guinea burial practices which got me into this current enthusiasm — looking at bodies, the way people deal with materials, with earth and colour such as the black, red and white earth pigments that are so important to New Guinea tribes. I have also appropriated and absorbed a variety of documented rituals of rites of passage.

I am putting myself in the crucible when I am going through this ritual process in my work — I am burying the body. I am trying to find a personal way of having the alchemy happen — though I want to stay away from consciously defining it as such, because everyone seems to be using the alchemical metaphor, which kills it a bit for me. What I am hoping is that this will be the place where I will understand the transformation process.

My process takes me right into the work, but there also has to be a standing back. You have to look with a very hard eye at the formal elements and consider whether those elements are going to function for other people. You can't expect people to see all of what you're doing, and perhaps you don't really want them to. But you can give clues to indicate the mystery — and there is a mystery that we are dealing with.

How do you know when the ritual is complete, when a painting is finished?

The way I know when a painting is finished and whether it works is, basically, when I am able to walk into a room and see that the work has its own persona, and it feeds itself back to me — it's not just a painting anymore, it's a shock element. If a work can take me by surprise — but I'm ready for it — and also if I don't feel any disappointment, then I know the painting works. It has to live and it has to 'happen' — it has to give me back what I have put into it.

What are the meanings and significance of pictorial, archetypal and symbolic elements in your work?

I'm at a point now where I am clearly using death — which I wasn't a few years ago. The body and the container are part of this work — the elliptical form, based on the basket or the bowl, is

PLATE 20

holding the body, and the body is buried in the soil. These are all burial paintings. Within that theme, I am exploring structures to do with bones and bits of bodies. The triangles and splits refer to the female body, and even the works in my *Skate* (1985) series were metaphors of the female form. The works are really referring to archetypal symbols — throughout history, all simple forms have had a variety of symbolic applications.

For me, the container has become a very personal symbolic form, which dates back to about 1986 when I had references to sacks, fishtraps etc. The basic development in my work is from the basket/body paintings to the body/fishtrap series, and now the elliptical container forms. The materials are also symbolic, as are colours and pigments. The earth — sand and pigment — contrasts with the gold metal to symbolise the emergence of light from darkness — transformations. The gold enhances connotations of magic.

How has being a woman impacted on your journey as an artist?

In terms of being a female artist, as a student/young artist in England, I didn't have a particular awareness of any gender bias — there seemed to be female artists exhibiting and teaching. It was only when I came to Sydney that gender bias hit me, and not just in the art world either. In 1969 I was offered a position as a full-time lecturer at the National Art School at East Sydney Technical College, and there was *huge* resentment expressed towards me from the men at the college. Here I was, a *woman* — the only one on full-time staff — and, from their point of view, a 'Pom' who painted with acrylics and 'did' photography! My way of coping with this hostility

was to keep out of the way of the more unpleasant males but, of course, anyone who wasn't 'one of the boys' wasn't part of the scene. I also felt an enormous sense of displacement — interacting with other artists meant back-slapping with the boys at the pub and I thought it all very parochial.

So, in those early years in Sydney, I experienced acute loneliness and a lack of artistic exchange. Few of these artists showed any interest in what I did, boasting only about what *they* did. None of the females I met who were part of this scene were practising artists — they were too busy working to earn a living to support the males. I found this all quite depressing and chose to live at Woronora — outside the Balmain/Paddington nexus — where I bought a cottage in the bush by the river.

At my first exhibition in Sydney, at Bonython Gallery — then the largest commercial gallery in Sydney — I showed works with sand and enamel paint on aluminium where parts of the metal were exposed and polished. My co-exhibitor at the show was a male Queensland landscape painter. He strode into the gallery on hanging day — complete with cowboy hat and boots and bronco-busting oil paintings to match — and promptly refused to show in the same space with a 'Pommy sheila shit abstractionist!' This man's candour was breathtaking! However, Kym Bonython was very supportive towards me, and a good diplomat, so the show went on regardless.

This preference for male artists, and the way that many male artists in Sydney still see themselves as the 'male artist as hero' is now more pervasive in the institutions than in the galleries. There are still precious few role models for female students in most places running fine art courses. So there are many social and cultural aspects of being a female artist that are negative.

I don't use my work in any conscious socio-political way or conceive of it as being used to push any gender-based ideas. This doesn't mean that I don't like, or disagree with, gender-based work or works that are designed to have a socio-political context. It's just that this is not what I am about. I do believe, however, that being female influences the subjective choices I make in my work. I follow ideas that are pertinent to me. I don't believe in using gender like fashion in my work — any gender content is there in the core.

Also, I don't want to be tied to using only female symbols. I may in the future decide that I want to use male symbols — I want to draw upon whatever interests me in the course of my work. The objective and formal elements of art are the same for everyone.

How do you see your role as an artist and the function of your works within this role?

I like to think that my works have an initial visual pull and that the image has sufficient power to hold the attention so the work can give — can start to reveal itself. There is a mystery in which to engage and I see this as the start of a meditative process. The works are containers of history, personal as well as appropriated, and what I call biological memory. Inevitably the work contains the artist. I find the job of being an artist exacting, painful and sometimes incredibly exciting. There have been periods in my life when it has been difficult to keep working — for various reasons — but somehow I never chose to stop.

I think that most artists live in their own private world and often do not relate easily to others. I find words a difficult medium and usually end up discussing the process rather than content in discussions of my work. The artist is an interpreter and transformer of ideas, emotions, the visual world, politics — whatever they have chosen to work with.

Heather Ellyard

PAINTER

*Creativity is a readiness to go to the edge. To wait there, still and
burning — neither consumed by the flames nor the emptiness…
Art is an indestructible passion for 'finish'…I mean going all
the way, not stopping in the comfort zone or the bliss trip.*

HEATHER ELLYARD was born in Boston, Massachusetts and grew up in Cambridge. In
1961 she obtained a Bachelor of Science degree in English Literature and Education
from Simmons College and from 1961 to 1963 studied at the Boston School of the
Museum of Fine Arts. Otherwise, she sees her art education as having been self-taught. In
1970 she migrated to Australia with her young daughter and during the 1970s lived in
Canberra. She then spent three years living in Papua New Guinea before moving with her
family to Adelaide in 1980. Here she joined the artist's collective, Roundspace. Ellyard has
held a number of teaching positions, among them teacher of design, drawing and modern art
history at the Canberra School of Art from 1971 to 1973 and lecturer in painting at the Victorian
College of the Arts in 1993. The artist currently lives and works in Victoria.

Ellyard's work, whether image or text, has always been about journeys. These are journeys
of the psyche as well as physical journeys — of memory, of female experience, of healing, of
spirituality, of identity — archetypal voyages delving into deep waters to bring knowledge to
the surface. Insights gleaned are then constructed intuitively into elemental, non-narrative,
organic fragments of experience and inquiry, searching for physical and metaphysical balance
between the light and the dark of human beings in nature.

Ellyard held her first one-person exhibition in Canberra in 1974, followed by several others
over the years in Adelaide, Sydney and Melbourne. She has also participated in many group
exhibitions from 1975 to the present. Among her prizes are the Canberra Art Club Prize in 1974
and the Whyalla Prize in 1987. She is represented in the collections of the Art Gallery of South
Australia, the Parliament House Collection, the University of South Australia and Artbank as
well as in other public and private collections in Australia and the United States.

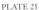

PLATE 21

Could you outline your journey as an artist — the significant influences and inspirations in your creative development?

> 'An hour ago there had been no poems
> and now they came like rain and were real.'
>
> <div align="right">A.S. Byatt, Possession</div>

This is the gift. I call it soft-looking. Seeing unintentionally while doing everything else. I put it first, in gratitude, remembering that a gift is nothing until it is first accepted.

I put second the premise that making art comes from an urgent combination of not being able to do otherwise and being possessed by a vision pulled out from the trajectory between chaos and culture (though some will argue that this is romantic attitude).

Concerning creative development, I assume that *everything* influences and inspires it: it's a process of participation. Creativity is a readiness to go to the edge. To wait there, still and burning — neither consumed by the flames nor the emptiness.

> 'Every creative act must pass through
> a moment when it is neither seed nor
> flower, through the abyss, which the
> (Hebrew) mystics call AYIN, that
> nothingness which is the hidden
> source-spring of everything. Such a
> passage is fraught with danger, however,
> for the pull of the abyss, of anarchy,
> formlessness, and chaos, is strong as death.'
>
> <div align="right">Herbert Weiner, 9 1/2 Mystics: The Kabbala Today, 1969–1992</div>

Could you elaborate further on your creative processes. What moves and motivates you? How do you feed into and structure your work ideas, time and space?

Art is this conjuring trick. You come back from the void, from wherever your limits are, with enough primary material to make it feel like a holiday, and then you have to figure out how to transform matter into image. It takes intelligence, an alchemical inclination and daring, especially as there is the awkward realisation that art is illusion; that, in fact, life may be quick and ordinary, and preoccupied; that immortality is mythic advertising; that art changes nothing but itself (usually in the marketplace); that art matters only because soul matters (a fragile nexus). But underneath is the realisation that creative expression is a way into soul; that believing this,

working at it in arguments and dreams, is accepting the covenant with soul. It is an agreement to remain with the self a long, hard time, under all manner of circumstances, even in the wilderness, even in love, even in extremis. To know who you are.

It is the courage/madness to reach into the body of self, to pull out substance, slot it into the human condition, codify the layers, from the bones to the skin of identity (structure and surface), and then begin with absurd determination to coerce the findings into art.

It is also trying to get hold of historical truths and secrets. I am prepared to listen to the whispers of the luminous, the texts of the archetypes, and the erotic discourse where mind and matter are indistinguishable and learning is intense. Gatherings in such zones are personal. How they are used requires insight more then eyesight, *initially*, but eventually, converting this substance into art demands hard work. What you need is a good mirror (which is mnemonic), tough friends (some of them invisible or imaginary), a fabulous library with which to engage in debate and re-invent options, and an indestructible passion for 'finish' [Juliana Engberg used this word in reference to conceptually resolved work].

By 'finish' I mean going all the way. I mean not stopping in the comfort zone or the bliss trip. I mean digging down beneath the ego. I mean planting the seed, weeding, watering, mulching. All that earth stuff. I mean singing the crop up. I mean the true harvest. Don't pick unready fruit; don't eat what is green and hard and call it a feast. I mean go each time to your limit. Know where you are, and be poised to start out again (persistence and faith).

Go alone, but with everything that matters from before *in* you. Alone, but with other voices: the mystics, the scholars, the poets and the pioneers. Go by yourself but memorise 'the dream of a common language' [Adrienne Rich] and carry it with you lightly, lightly. Be weighed down by nothing, absolutely nothing, but do not neglect the losses, the scars, the blood letting, the descent and the matrix.

The artist must know and exhort her limits. She must use them to learn the names and shapes of things and measure the depths. The artist manages the deep places, maintains them against oblivion — now and then, illuminates them. This is the 'finish' I mean, nothing less.

Women work from where we are, from where we can reach and touch. The personal is the starting point. We do not separate. We thrive on the 'permeable boundaries' [Helene Cixious]. We make connections; we make allegiance to nature. Women know the cycles. We know how to wait the gestation out; how to prolong the kiss; how to relive the orgasm (and translate it); how to wipe tears and shit; how to clean wounds and bathe in soothing waters; how to share and how to dance and sing when alone).

This knowing is organic without betraying the intellect, and resonant because it is both intimate and open. I write down the knowing to remember the excursions and document the responses. What comes back to me from my journals, lecture notes, poems, commentary and exhibition statements is like a songline:

- A desire for the spiritual through the body's abundance (sensory truths activating timeless ones)
- A clinging to the idea that art, in its grappling with 'inner necessities' [Wassily Kandinsky], claims a spiritual purpose
- A confirmation that the pattern of my work and life is deliberately open rather than narrow
- A recognition that the search for balance between the light and the dark is my primary motif: whether dealing with variations of love or war and decay, the Holocaust and my cultural roots, or more recently, the composition of my identity
- An assumption that the artist, as maker, works with integrity as her first tool, curiosity as her second, persistence as her third, and otherness as her fourth — and best and most challenging equipment

A SELF-PORTRAIT IN PIECES, 1993

PLATE 21
MNEMONIC MEASUREMENTS (detail), 1993
Mixed media on canvas and board, each panel 30 x 30 cm
Photograph: John Brash, Courtesy of the artist

PLATE 22
THREE GRACES / DESCENT AND RETURN (detail), 1993
Mixed media on canvas and board, each panel 30 x 30 cm
Photograph: John Brash, Courtesy of the artist

'The works illustrated (all details) are from two versions of *a self-portrait in pieces* (1993): the first, at Luba Bilu Gallery in Melbourne; the second, later, at Greenaway Art Gallery in Adelaide. One was the evolution of the other. In both exhibitions, the grid was the structural basis of the work. Its logic was interrupted and subverted by gaps and intuitive associations within the content, which opened up non-linear narratives.

The self portrait is a natural progression from the preceding work, which explored (with considerable inner turmoil) the destruction of culture and identity in the Holocaust. That work, in 1991, took me into the landscape of my own roots. This work takes me to notions of identity within the feminine.

each piece is self-contained
and part of something else.
identity develops by association.
everything is both connected and alone.

the self portrait is a process:
accumulating definition,
moving between the singular and the mythic
carrying both memory and observation,
which are incomplete, always.

I am working towards, not against,
a whole vision.
the systems have gaps.
and intrusions into the gaps.
and overflows from one thing to another.

there are:
family matters and labyrinths.
triangles, circles and the square-of-home.
desire and the mortal coil.
personal pronouns and mythic equivalents.
interrupted narratives and sub-texts.
equations and the solo equation
of descent-and-return.

the root is in bedrock
far beneath the bloom.
down there the root-home
has no name.
the language must be imagined
memorised and heaved into art.'

Heather S. Ellyard, 1993

'Tomorrow, whenever it comes, I need to look at the intersection/s between my cultural origins and my feminist concerns. Maybe I will be the eternal wanderer, female version, rendering the soles of my feet differently. Maybe I will embroider secrets with silken colours or derange exquisite alphabets that move from right to left. Maybe I will take the first soil to the third condition, reworking the seed, the bloom and the botany.'

"Art must recreate, in full consciousness, and by means of signs, the total life of the universe, that is to say, the soul where the varied dream we call the universe is played."

Teodor de Wyzewa, 1886
from Annie Dillard, *Living By Fiction*, 1982

PLATE 22

In what other ways has being a woman specifically influenced your art?

Much has been written and acknowledged about women and the margins. Much is being rewritten as we reclaim our principal territories. The feminine 'writing itself' [Helene Cixious] requires engagement with different strategies that come from working those margins, the roots, the blood, the birth, which finally, must be located in the imagination. The result is an astonishing heart–mind–body hallelujah of acceptance and creative energy: I know who I am and how to use my strength to add something to the culture of my time.

My own marginal geography made me critically 'unmapped' during some pivotal developments, but this dislocation gave me freedom to extend and trust my own resources. I work from the inside out, from autobiographical material that condenses into the symbolic and shifts into larger recognitions of collective root matter. I work, increasingly, with fragmentation, not to empty out, but to accumulate a whole vision. The body is source not gaze. I take it to the edge, consciously.

> i'm tired said Eve of fucking around.
> my time has limits, god knows that's true.
> who told me to accept this role?
> who sucked me in with myths of immortality?
> who gave me lust disguised as ecstasy?
> and crimson fruit, still moist, to eat?

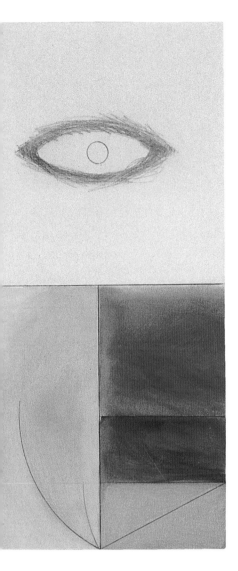

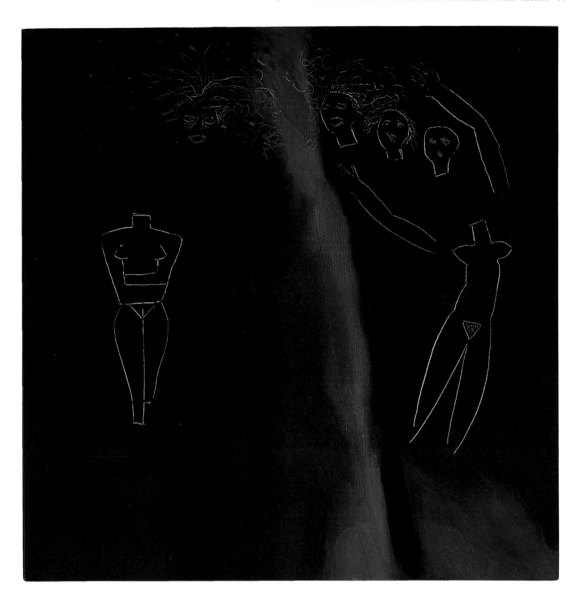

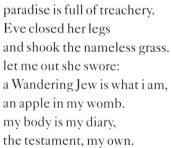

paradise is full of treachery.
Eve closed her legs
and shook the nameless grass.
let me out she swore:
a Wandering Jew is what i am,
an apple in my womb.
my body is my diary,
the testament, my own.

Heather S. Ellyard, *A Woman's Manuscript*, 1981, from *Preface*

This much I know: women's way is inclusive. We subvert the artificially imposed conflict between nature and culture. We accept the personal as origin and the outer limits as workable terrain. Somewhere I read: 'Feminist art is not a trend, a style. It is a shift in consciousness.' This cognitive shift is where I locate my own creative process. It is very simple.

I need metaphor, sensation and idea, together. My syntax, my politics and my centre are in the qualities of the poem. I need layers and associations:

nothing stays empty.
nothing stays unchanged..
nothing is eternally dis/un-connected.

PLATE 23
SELF PORTRAIT IN PIECES, 1993
Oil on canvas/board, each panel 30 x 30 cm
Courtesy of the artist and Greenaway Art Gallery,
Adelaide

whether we care or not,
whether we try or not,
everything is part of something else
and accumulates meaning.

<div align="right">Heather S. Ellyard, 1993</div>

I need a process that sustains the collaboration between inner and outer views, and a structure that facilitates that process.

'Art which is unrelated to the person who made it and the culture which pro-
duced it, is no more than decorative.'

<div align="right">Lucy Lippard, *Overlay*, 1983</div>

Picking my way between the personal and the universal to find the tuning between them is risky and self conscious. Knowing what to keep, what to discard and when matters. Deciding how to live with abundance and its possible contradictions matters. Also, learning what to do with repetition and the core material within it.

'Spirit yearns with limitless aspiration;
matter imposes limitations on spirit.
Soul mediates between them.'

<div align="right">Marion Woodman, *The Ravaged Bridegroom*, 1990</div>

For me, nothing is either/or. I cannot sacrifice the idea for the paint or exile the paint for the concept. Colour, forever, means more to me than the rules and conditions of temperature.

The way I manage content and process is through the structure. This is where I model my aesthetic, where I deliberately (though sometimes obliquely) push my limit in an effort to integrate the source and the result, responsibly.

Talk about the meanings and significance of pictorial and symbolic elements in your work?

I have constructed butterfly collections (about eros and global frailty), soft walls (about life force principles from sex to language), scrolls (for my time that worked with 'ripe mandalas against the chill, the dying of dreams' [Heather S. Ellyard]), iconic and shaped figures (as ideative ancestors), sacred boards/doorways (in sanctuary zones), the unfinished grid, to emphasise the blasphemed record of living for the Holocaust victims, and most recently, the open-ended grid, to extend the meanings of my, or anyone else's, identity.

I am not satisfied by the rectangle or the canvas or the single rendered image, per se. I need to go to the edge of these constructs, and take my content with me — perhaps because I am mostly self-taught, or terminally stubborn, or because I have empathy with too many distinctions; or maybe its my equal addiction to word and image, or my love of detail that is both restless and tender. I look for alternatives and find them outside the conventions.

What are your thoughts on your role as an artist and the function and purpose of your art?

The artist's job is to stay awake, to notice both details and patterns, and to use visual language as though it were a dialogue with the infinite, rather than a demented soliloquy on some sordid plateau halfway between heaven and earth, perpetually stunned.

PLATE 23

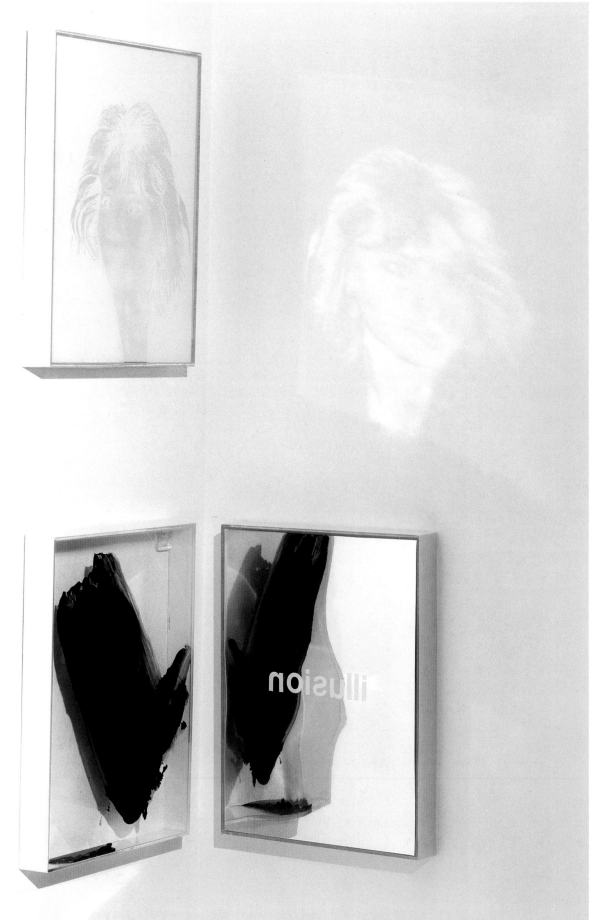

PLATE 24

Merilyn Fairskye

PAINTER, MULTI-MEDIA AND INSTALLATION ARTIST

every artistic practice is inscribed with a multitude of intersections,
not always conscious, between many things ...the complexity of
these intersections can rarely be measured in their entirety and
the visual density of art making can't be conclusively accounted
for with language or through theory.

MERILYN FAIRSKYE was born in Melbourne and studied at the National Art School from 1970 to 1972, then completed her art studies at Alexander Mackie College of Advanced Education between 1974 and 1975. She then worked in a rape crisis centre and became involved in grassroots art activities such as poster making, graffiti writing and mural painting. From 1977 to 1978 she travelled in Europe and the United States, and following her return to Australia in 1979, she worked on the Woolloomooloo Mural Project in partnership with Michiel Dolk between 1980 and 1984. She currently lives and works in Brisbane and is a lecturer in visual arts at Queensland University of Technology.

Fairskye's art practice has always been informed by feminist expositions, but her more recent works have extended their gaze to the nature of perceptual realities and ambiguities. They have looked at the ways in which images and messages are socially constructed and communicated in the areas of mass media, contemporary theory and discourse, optics and vision, and the constructive, rather than absolute, nature of space. Using abstract, figurative and gestural referencing, the ephemeral, finely tuned, distorted anamorphic images in Fairskye's installations were initially drawn from mass media photographs of influential, famous and infamous people. (Anamorphosis — a painter's device from the Renaissance — is where the form is distorted from a particular viewpoint, and this distortion can then be rectified by a change of viewpoint.) Her filmic, elusive images flutter on the edges of perception — fluidly dissolving, fragmenting and resolving, according to the position of the viewer, who thus becomes woven into the range of perceptions elicited and is induced into a state of open-ended self/other reflection.

Fairskye has had numerous one-person exhibitions/installations since 1980 across Australia and in New York. She has also participated in several selected group exhibitions, both nationally and overseas, since 1982. She has received two residency awards — the Cité Internationale des Arts, Paris in 1985, and the PSI Studio, New York in 1989–90. In addition, Fairskye is producing a series of 676 (26 sets of 26) handmade books made between 1991 and 1999 titled *Alphabets of Loss for the Late 20th Century*. She is represented in the collections of the National

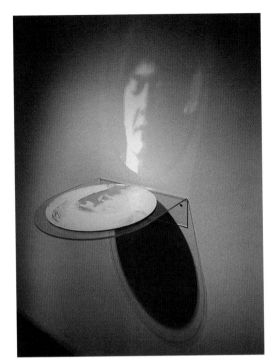

PLATE 25

'In late 1990 I had an exhibition of large diptych paintings in New York. The images I used were those of three nursing assistants from Vienna who, in 1988, had been arrested and charged with the murders of over forty-nine of their elderly patients, and of Gudrun Himmler, photographed at a public rally in Berlin as a child of eight in the arms of her father, Heinrich Himmler.

In the middle of the gallery, there were two columns that were quite imposing, and so, rather than ignore them, I decided to use them as the surface for another diptych, a painting of Sigmund Freud just after he escaped Vienna for London in 1938. The image came together or fell apart depending on the movement of the spectator's body through the gallery space. I wanted to continue with this development, but felt constrained by the necessity to find spaces that had suitable columns.

In May 1991 I needed to pack some large, unstretched canvases to go to an exhibition at William Mora Galleries in Melbourne. I had ordered wide cardboard tubes to roll the canvases in for the journey from New York to Melbourne. The tubes were delivered and were laying on the floor of my Tribeca studio. Someone was coming to look at some work, and the studio was in a mess. When I was tidying up, I placed the tubes upright to get them out of the way. They coincidentally reached from the floor to the ceiling, and I realised that I could use them as moveable columns. This lead to the series *Proposals for Rooms with Columns*, which I then started to work on, firstly as a series of maquettes. Later, at the Institute of Modern Art, Brisbane [*sleep* exhibition, 1993] and at the Christopher Leonard Gallery, New York [*Death Wish* exhibition, 1990; *sleep 3* exhibition, 1993], I installed room-sized column works.

In each of these installations, three large sonar tubes, which builders use for pouring concrete, were placed diagonally in the room, with some distance between each one. I determined the position at the entry to the room where the columns momentarily formed a single visual element, and then, where their combined shadow fell on the wall behind, painting a block of complementary colour, which you couldn't see until you abandoned the ideal vantage point for viewing the columns.

Gallery of Australia, the National Gallery of Victoria, the Queensland Art Gallery, the Getty Center, Santa Monica, USA as well as in other public, private and corporate collections in Australia, New Zealand, USA, Britain, France and Japan.

---•--

Could we discuss your development as an artist — the various influences, resources, experiences and inspirations that you have drawn from in the different stages of your work?

Over the past fifteen years my artistic practice has variously taken the form of large-scale mural projects produced collaboratively, photo works, film, installation, painting, and more recently, book works. It has always been image-based. From the early 1980s on, my work has specifically addressed representations within the social body, and the fictions that sustain them. It has been produced with reference to, and acknowledgement of, issues of contemporary theory and discourse such as the articulation of gender and sexual difference, and the condition of 'woman's speech'; representations of power and authority, questions of representation; the poetics of materiality; vision and opticality; and the representation of space.

Various forms of literature, both fiction and non-fiction, in areas as diverse as science and technology, sport, medical texts, pornography, advertising, journalism and popular culture, philosophy and sociology, have been mined over the past decade for their associative potential. At different times the writings of Marguerite Duras and Claude Simon, and the work of Lomar and Melamid, Gerhard Richter and Bill Viola have been a stimulus, as have certain conversations over the years with other artists, filmmakers and writers, especially with Juan Davila and Michiel Dolk. The developments within late twentieth century feminism remain the primary source of stimulation for my work. In relation to this, the writings of, and conversations with, Australian philosophers Moira Gatens and Elizabeth Grosz have been of particular interest. I see a lot of films. And every exhibition I take part in provides an opportunity to rethink what I am doing.

In 1986, on my way home after six months in Paris at the Power Studio at the Cité Internationale des Arts, I discovered that all the work I had made during this period had been lost in transit back to Australia. This was at the time of several terrorist-inspired bomb explosions in Paris, and in the panic at Charles de Gaulle airport, the large tube containing all this work was taken away by the airport security people, and subsequently disappeared. The trauma I experienced at the loss of my work — as if six months of my life had disappeared — propelled the development of the *Conducting Bodies* series that I worked on between 1986 and 1988 and which, in overall terms, could be viewed as an extended investigation into representation and sexual difference. The title of this body of work came from a novel of the same name by French novelist Claude Simon, whose methodology provided a platform from which to explore differences in technique, media, strategy, representations and meaning.

Have there been any other significant or pivotal experiences related to your work?

In late 1989 I was feeling boxed into a corner that I had to get out of, and I wanted to reduce the labour intensity of the work I had been doing. I also wanted to simplify the relationship between space and image somehow. After a period of experimentation and a few false starts, I began to make large diptychs that featured the faces of various people taken from the print media who had become involved in events or relationships that in some way threatened the stability of social organisation — such as treason, exile, bad blood, mass murder. I painted the faces in monochromatic, nocturnal tones and placed them on a minimalist, non-descriptive ground.

One panel was anamorphically distorted, the other immediate and literal. The viewer is unable to compress the image and capture it in its natural, undistorted form by locating a

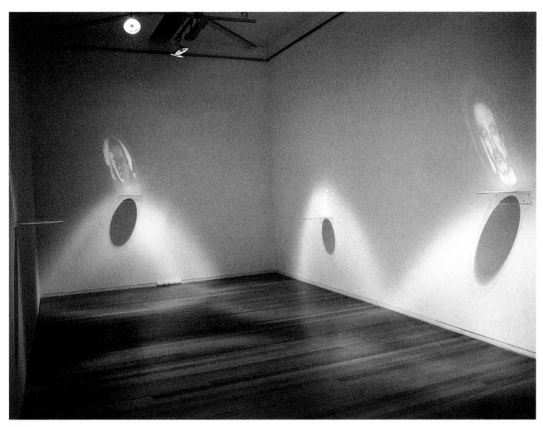

PLATE 26

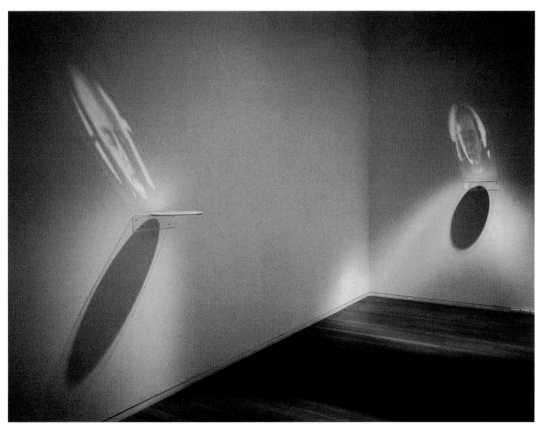

PLATE 27

On the columns themselves, I painted a single, nocturnally monochromatic image of a face. Once you moved into the space, the image started to fall apart and dissolve. The first one used an image of Borislav Herak, the young Serb who came to media attention in late 1992 when he was arrested for the multiple murders and rapes of Muslim women in former Yugoslavia. The second installation, *valerie, writer, north america*, used an image from the series of photographs I had started to take of non-media figures, posed with their eyes closed. Like the earlier diptychs, these works make me think of the space between waking and sleeping.'

INVISIBLE PAINTING, 1993

'With the *Invisible Paintings*, I had imminent deadlines to meet for two exhibitions. I decided to make an exhibition of invisible paintings for New Zealand, and to take the *sleep* paintings to Melbourne. I figured I'd make twenty-six, with three parts and a shadow to each one — twenty-six because I was using a set of twenty-six books I had already made as the structural and textual departure point for this work.

They were quite small in their individual components. I worked out what two of the three boxed components of each individual work would be, and made them up, still not having a clear sense of what was going to happen with the third and crucial box, but knowing that something would. I was working with aluminium cylar, which is a very thin but resilient, mirror-like surface.

One day I decided to tidy my workbench. I picked up one of the mirrored boxes, which had a word in reverse permatype stuck on its surface, and hung it on a nail that happened to be situated about 30 centimetres out from the corner. It was a bright sunny day, and the sun was streaming in the window. I happened to glance up and was struck by what I saw — the sun hitting the reverse white type on the mirrored surface threw the type's negative image onto the adjacent wall, and the image formed itself in light in reverse. I immediately saw how I could make it work with the face.

Since then, I have been playing out different permutations with this work, trying different hanging options in different exhibitions, discarding, in the end, everything except the image, and making it much more private. I withdrew all overt political keys, although my work remains intensely political in its concerns. The media figures were replaced by images of relatively unknown professionals whom I photographed with their eyes closed. The titles have been simplified, and now refer only to the 'subject's' first name, occupation and place of birth. They suggest a sort of mapping of different people, systems of knowledge and geographies. I have moved from the rectangular shape to a circle, from the wall to a transparent shelf. During this time, the other projects continued.'

SLEEP PAINTINGS, 1992

'The four paintings in the *sleep* series relied only on a monochromatic representation of the face against a non-descriptive background (respectively, Flight Lt Jon Peters, the British airman shot down in Kuwait during the Gulf War; Anita Hill, who had taken on the US Supreme Court during the appointment hearings for Clarence Thomas, over Thomas's earlier history of sexual harassment; the Rumanian Nadia Comaneice, former Olympian gymnast now fallen from grace; and Tom Moran, whose image had been extensively documented in the media as he lay dying from AIDS complications whilst connected to a life support system) and the titles of each individual work.'

particular position. I titled the works with the colour used, the name of the persona whose image was used and the place and year where the person was photographed. My interest was in the way in which facial features have moral meanings for us — especially when we read a story or caption that claims to identify the person in relation to some actions — and what it means to encounter such a face, and how the flatness of news photographs makes these faces perfect surfaces for one's own projections. I carried this concern over into *Proposals for Rooms with Columns* and the *Invisible Paintings*.

Could you further elaborate on your creative processes in these specific works or series?

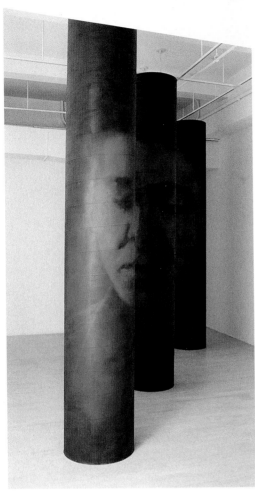

PLATE 28

Since 1988 my work has incorporated anamorphic perspective — development of an earlier interest in anamorphosis, which Michiel Dolk and I first explored in the mural *A Disposable Mural Positions Vacant — Painters and Decorators — Refs. reqd.* at the Art Gallery of New South Wales in 1983. With anamorphosis, through the prescription of a spatial vantage point from which it's possible for the image to 'make sense', the viewer, in being relegated a position, becomes self consciously complicit in manufacturing the meaning in the work. It also reveals space as an ideological construct rather than as an absolute.

In 1991 whilst living in New York after spending a year at PSI Museum on a Visual Arts/ Craft Board Fellowship, I was curious to see what an 'invisible painting' could look like. At the time I was unaware of the invisible and secret painting of various members of the Victorian Art = Language group in the 1960s. The next year was taken up with a series of experiments in my studio, when I made various prototypes. During this time I was also working on three other projects: a series of *Proposals for Rooms with Columns*; *Alphabets of Loss for the Late 20th Century* — a project of 676 handmade books, which can be seen as one account of the last decade of the twentieth century, produced during 1992 and 1999; and the writing of *Out of Place*, a feature film script.

With the 'invisible paintings', I wanted to somehow get a variable shadow of a painted image onto a wall with minimal technology and without an intrusive material presence — I couldn't picture the result, but I had a sense of how it could look. At the time I was working a lot with the image of the face, and playing out different permutations of encountering it. I was reading the philosopher Emmanuel Levinas second-hand, going to a lot of movies, and thinking about invisibility. I was having occasional conversations with a friend, Canadian artist Michel Daigneault, and also with Liz Grosz — who was a frequent visitor to New York — about a previous body of my work, the *smoke* series of anamorphic diptychs, upon which the evolution of the 'invisible paintings' idea was heavily dependent.

The phenomena of breathing began to interest me more and more, as did the non-scientific idea of smoke being unverifiable, incalculable, loose in the air, something unable to be seized — sort of what I had in mind for what I later called *Invisible Painting*. Continuing, as in my previous work, with media images, I started to look for media representations of people with their eyes closed.

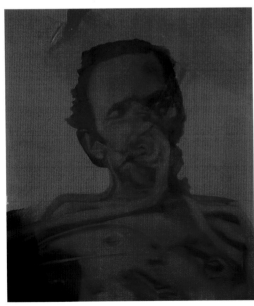

PLATE 29

This interest, and the *sleep* group of paintings that I was working on, led Michel Daigneault to show me Jacques Derrida's *Memoirs of the Blind*, a meditation on vision, blindness and self representation. It made a strong impression on me at the time and further encouraged my interest in images of people with their eyes closed.

How would you describe your approach to your art making generally?

In general, art making can be considered as research into how we are situated in the world, what our concerns are and how we are thinking at a particular time. Methodical processes can't be separated from content. Intuition is dependent on experience and knowledge. Critical seeing, not what is seen, is important. Every artistic practice is inscribed with a multitude of intersections, not always conscious, between many things, including:

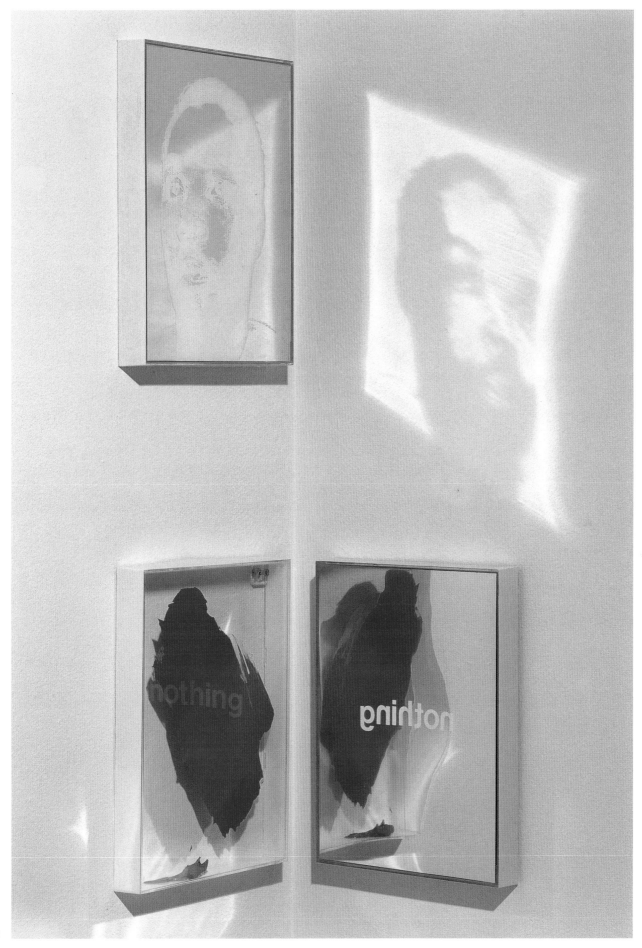

PLATE 30

PLATE 24
ILLUSION (ALESSANDRA MUSSOLINI, MILAN, 1992),
1992
Acrylic, mylar, perspex, light, dimensions variable,
Photograph: Fred Scruton, Courtesy of the artist

PLATE 25
INVISIBLE PAINTING: (KARIN, LAWYER, GERMANY),
1993
Installation view (detail), Cell paint, perspex, light,
dimensions variable, Photograph: Sandy Edwards,
Courtesy of the artist

PLATES 26, 27
INVISIBLE PAINTINGS, 1993
Installation views (detail), acrylic, mirror, perspex, light,
dimensions variable, Photograph: Sandy Edwards,
Courtesy of the artist

PLATE 28
SLEEP (VALERIE, WRITER, NORTH AMERICA), 1993
Acrylic, oil paint on sonar tubes, wall, 335 x 425 x 425 cm,
Photograph: Merilyn Fairskye, Courtesy of the artist

PLATE 29
SLEEP (TOM MORAN, N.Y., 1989), 1992
Acrylic, oil on canvas, 137 x 122 cm, Photograph: John
Brash, Courtesy of the artist

PLATE 30
NOTHING (RODNEY KING, L.A. 1991), 1992
Acrylic, perspex, mylar, dimensions variable, Photograph:
Fred Scruton, Courtesy of the artist

the content of materials
the content of the image
the content of the style
the content of the genre
the artist's prior work
other artists' bodies of work
systems of knowledge
the artist's personal history and experience
the broader cultural, social and political milieu in which she or he practises
the experiences and histories of the audience
economics

The complexity of these intersections can rarely be measured in their entirety, and the visual density of art making can't be conclusively accounted for with language or by theory.

You talked about late twentieth century feminist discourse as being central to your work. Are there any other ways that being a woman has impacted on your art career — positively or negatively?

I am a woman, at this time, in this place. Whatever I do is framed by that fact, and by the experiences that come from it. I don't think of it as being a positive or negative influence on my work — it is simply what I am, and these are the circumstances in which I find myself. I try to make the most of them. Over the years, I have received financial support for my work from the Australia Council when it was really needed. Since returning from North America in mid-1992, I have been lecturing in the Visual Arts Program of the Academy of the Arts at Queensland University of Technology in Brisbane. QUT welcomes practising artists on the staff and actively encourages my professional development as an artist.

How do you see the purpose and function of your art?

My work is intended to be seen within a political spectrum, but not to function as a didactic account of certain theoretical or political positions. If I think of my work as having any purpose, it would be to raise doubt in the mind of the beholder.

Jutta Feddersen

SCULPTOR

On a technical level, I am never frightened to
tackle what I set out to do and I am also generous
with whatever materials I may choose to use…

JUTTA FEDDERSEN was born in Germany and arrived in Australia in 1957. From 1953 to 1956 she studied textiles and restoration at the Handwerkskammer, Bremen, gaining a Diploma in Fibre Art and in 1974, on an Australia Council grant, she studied textiles in Africa. She was a lecturer at the National Art School, East Sydney from 1962 to 1967, at Alexander Mackie College of Advanced Education, Sydney from 1977 to 1980, and at Hunter Institute of Higher Education, Newcastle in 1980. She gained her Master of Arts (Visual Arts) degree from the City Art Institute, Sydney in 1988. She is currently Lecturer and Co-ordinator in Studio Area Fibre Art in the Department of Fine Arts at the School of Visual and Performing Arts, University of Newcastle — a position she has held since 1981.

Feddersen has attained a national and international reputation as a leading exponent of fibre sculpture. Her earliest works were organic, totemic-like forms using bones, feathers and twigs, which were 'suggestive of the birds and horned animals of Eastern European mythology'. Her interest then moved to polyurethane pigs symbolic of human forms and then to circular stones with 'trapped' hands, legs or feet emerging from the centre, which were constructed so that they could not roll forwards or backwards, and also simplified humanoid, bird and animal forms reminiscent of embryonic aliens, spirit or ghost creatures.

Her most recent works have been of dismembered toy babies in wire cages, assembled in ritualistic installations, vibrating the horror, pain and alienation of war and untimely, violent death. Feddersen's existentialist works, which always emphasise light and shadow, have an intriguing, compelling presence and are powerful in their elegant simplicity, which embraces physical, spiritual, cultural and environmental relationships. In the crowding, repetition and anonymity of the figures, with their haunting, artificial eyes, we feel the effects of over-population in the wider world. In the simple construction of her 'spirit' shapes, which move in and out of form, an echo resounds of a mythic, interconnected, primal world that is constantly eroded and lost to our everyday awareness amid conflict and material and technological 'advancement'.

Feddersen had her first one-person show in Sydney in 1967 followed by many others over the ensuing years, with the most recent at Coventry Gallery in 1995. She has also participated

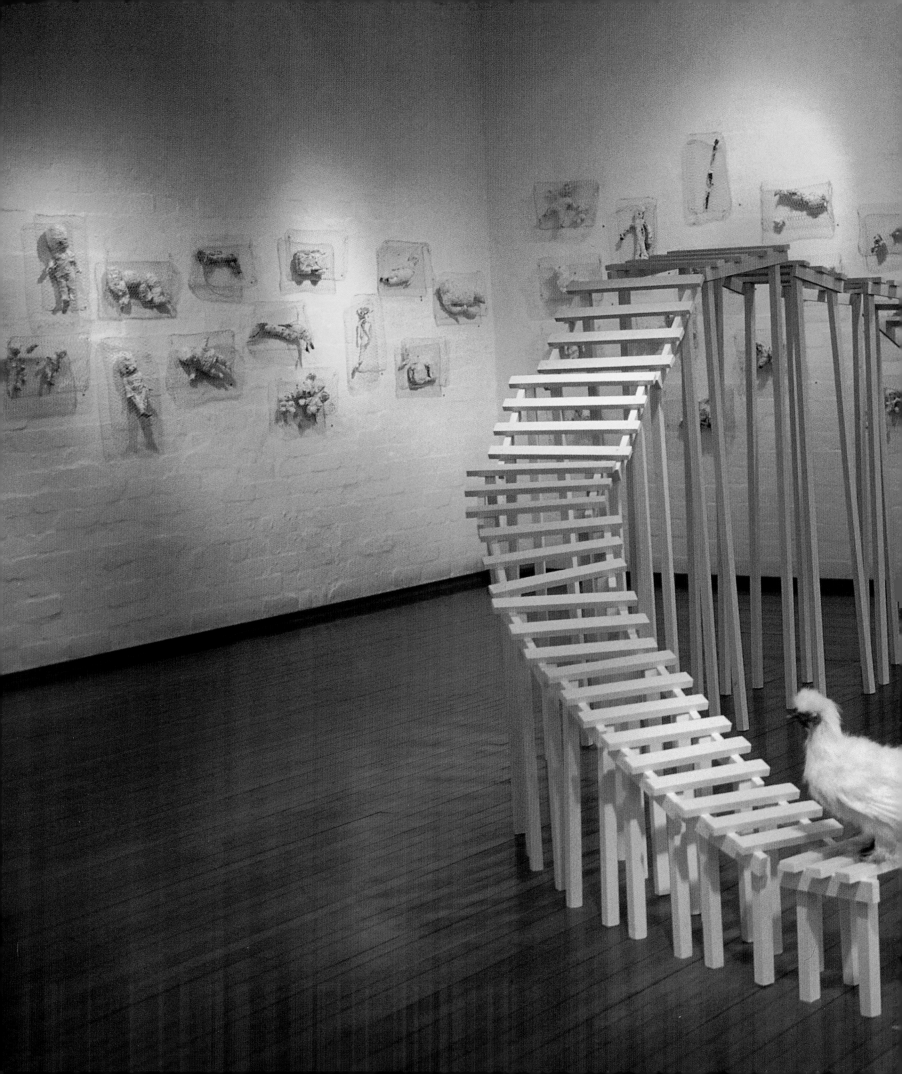

THE FORGOTTEN TOYS, 1995
Sculptural installation at Coventry Gallery, Sydney, 1995

PLATE 31
CLAUDE, 1995
17 forms, wood, chicken, paint
Courtesy of the artist

'Being a "war child" and having had a very happy
childhood until I was ten years old, I felt I wanted to do an
exhibition for the Fifty Year Anniversary of the end of the
Second World War — paying a tribute to the time since
then.

In 1943 my mother died and in 1944 my father went
missing in Russia. In 1945 the Russians overtook us whilst
we were attempting to escape. From then on we five
children were looked after by a remarkable aunt. We were
interred and shifted from camp to camp until 1947, having
no idea that the war had officially ended in 1945. My aunt
of course hoped that the war was finished, but we were
south of the Baltic Sea, closer to where our property
had been, and had no contact with the west until my
grandfather found us through the Swedish Red Cross
in 1947.

The basis of this installation stemmed from childhood
memories of the Second World War: the Russian Army,
when they invaded us, overtook our carriage with the few
belongings that we had, and in the process our horses
were killed; I remember walking in our town, Schivelbein,
and twice in one day stepping over a human arm — and
no-one removed them. Not far away, and soon after this
experience, I frequently observed toys left behind by
children who had been killed or who had died because
they had lost their parents. Ever since (and as recently as
two weeks ago) I seem to see lonely toys in war pictures.
So I thought I would dedicate my fifty wire "parcels" —
with found toys or parts thereof — to all the children of all
denominations who have died in the last fifty years during
wars.

The installation piece of seventeen objects with *Claude*
represents the process of life — graduating from very
small to tall, and ending somewhere in the future.

The over-sized chair with eighty candles, *Comfort versus
Discomfort*, is, I guess, a homage to all the children, as
well.'

PLATE 31

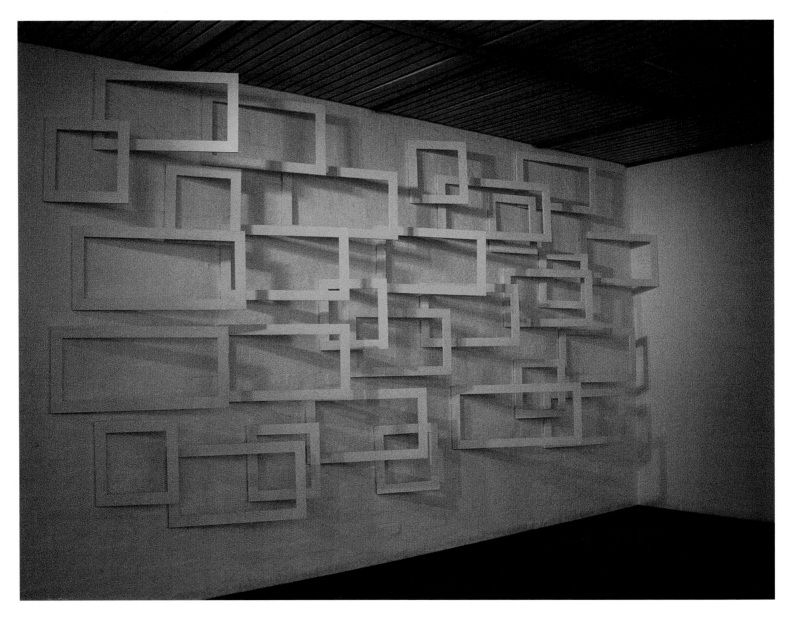

PLATE 32
SUBSTANCE OF SHADOWS, 1993
Courtesy of the artist

in a number of group exhibitions between 1969 and 1992. She is represented in the collections of the National Gallery of Victoria, the Queensland Art Gallery, the Art Gallery of Western Australia and the Ballarat Art Gallery as well as in other institutional and corporate collections in Australia and overseas.

Could we discuss formative influences in your development as an artist — the significant experiences, places, people and inspirations?

A while back I found a statement I made that I think says quite accurately where most of my thoughts come from: 'I am what I am from long way back.' Obviously the art one sees has influenced certain beliefs or even art works and techniques, but I cannot quote a particular person who has influenced me.

My frequent travels to Europe — to keep me informed worldwide — have surely broadened my view (not having been born in Australia). I rather look at myself as an international person and my art is a reflection of that. Certain countries have influenced me: my travels in Africa and New Guinea; outback Australia, where I worked with Aborigines; Korea and Japan; and always my own country Germany, particularly its country life and heritage.

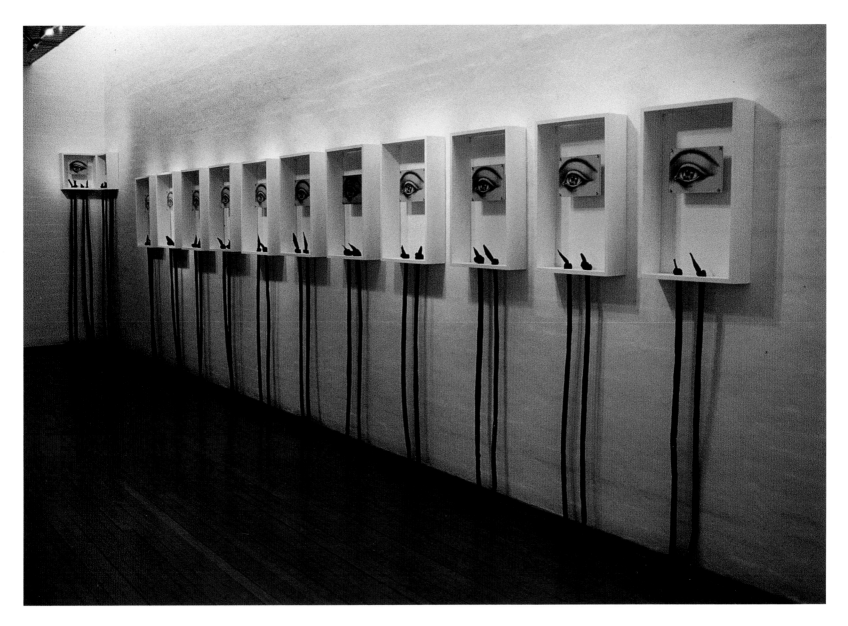

PLATE 33
HOMAGE TO LOUISE BOURGEOIS, 1993
Courtesy of the artist

The freedom to go beyond the discipline of traditional weaving allowed me tremendous scope for exploration and experimentation. With this found freedom, I sought out many different types of materials that would allow me to build more positive forms. Also, where I live I am surrounded by bushland, which allows an immediate and constant reference to nature.

I had a happy childhood that was torn apart by war when I was ten years old, then *everything* changed. Aspects of these war-torn experiences in Germany are etched in my memory and emerge in my sculptures, and though the works can appear sad to other people, to me they are more like a homage to the children of the world.

I felt displaced for many years following the experiences of war and migration, and it was my relationship with nature that eventually enabled me to 'rediscover' myself.

Could you give an outline of your creative process and the most significant elements in your work?

Simplicity, minimalism, progression and repetition of forms would be my trade marks, otherwise I defy classification, I think. It bores me stiff to do the same thing all the time. My installations nearly always portray humans — even if they are 'Mummy-Pig' or empty frame forms. Shadows and light, on or off the wall, within space are very important to me and my work.

In one of my recent installations, *Perceptions Of Time*, lighting was all important, but I found the space at the gallery was not quite suitable for the effect I wanted to achieve. As a result of this, I have decided, for the next installation of the same work, I will get a professional lighting expert to help with my shadow imagery — where the empty frames are fixed at an angle to the wall and will, if the lighting is right, open and close like a book.

The other installation, *Homage to Louise Bourgeois* (1993) was a follow-on of my work, but I met Louise Bourgeois — whom I admire greatly, and who at age eighty-two is still doing wonderful and very important work — so I decided to dedicate the installation to her.

When I plan the next work I will do, it is never easy. I am interested politically — and as a human being — in other human beings, so some actual political situations — for example, the opening of the Berlin Wall — may appear as a statement in my work. On a technical level, I am never frightened to tackle what I set out to do and I am also generous with whatever materials I may choose to use — such as wood, stone, steel, natural fibres, sand, water etc. Although I usually predict the people/figures that are formed — even my 'mummies' appeared when nuclear war was imminent — I cannot predict exactly what will come out!

I have a passion for collecting things — from the streets, second-hand shops and nature. My studio is filled with found or bought objects that I feel may one day come in handy.

How has being a woman influenced your career as an artist?

Being a woman is not an issue for me in my work as an artist. I work in art because I am a person and happen to be a woman. To my mind, all too often less important artists go along the path of the women's movement. I know it often is not easy — I educated and brought up two daughters alone for fifteen years — but for me, as I said, it is not an issue. I think it is rather passe to still drum on that one.

How do you see your role as an artist and the purpose and function of your art practice?

I have always been interested in human beings: how they function, their sufferings, their basic needs and their intellect. Consequently, these feelings play into my work. My aim will always be to surprise others and myself with the installations and large works I produce.

I would like my work and installations to be in public and private places, but it is not easy to place them in a comparatively small society such as Australia, which has few funds available for sculpture, compared to the money available for such works in Europe.

Fiona Foley

INSTALLATION ARTIST, PAINTER, SCULPTOR, CURATOR

*The public parts of religious ceremonies I have attended
at Ramingining and Maningrida — held out in the landscape —
were awe-inspiring experiences in the same way, to me,
as the chanting in Buddhist religious ceremonies in Japan and
the things that are talked about in the Book of Genesis.
These are stories from the beginning of time...*

FIONA FOLEY was born in Maryborough, Queensland and at eleven years of age moved with her family to Sydney because of the community's hostility towards her parent's mixed marriage. In 1982–1983 she studied at East Sydney Technical College, obtaining her Certificate of Art, and, also in 1983, was a visiting student at St Martins School of Arts, London. After her return to Australia, she studied for her Bachelor of Visual Arts degree at Sydney College of the Arts from 1984 to 1986. In 1987 Foley also gained a Diploma of Education from Sydney Institute of Education. In 1988 she was a guest at the Barunga Festival in the Northern Territory and also worked as artist-in-residence at Griffith University, Brisbane. In 1989 she coordinated a silk-screen printing workshop at Ramingining and in 1990 returned to New South Wales to become artist-in-residence at the Cleveland Street Intensive Language Centre. After a period of living and working in Sydney, Foley is currently considering a return to Fraser Island.

Foley's installation works use natural and culturally iconographic objects that are gathered from her nomadic walks and travels and are then assembled in various compositionally contained arrangements. They have largely been concerned with personal and cultural memory, the location and dislocation of Aboriginal people, culture and art, and cultural reclamation within the dominant white European colonialist culture. Continuing her interrogations into the complex issues surrounding past and present indigenous peoples of the world, her most recent works have examined the particularities of Caribbean 'indigena' and the lost identity of the aboriginal people of Cuba.

Foley's work is motivated by a range of concerns. These concerns include her historical search into her personal origins and Aboriginal cultural heritage, together with her custodial responsibilities to her Badtjala people's land, Thoorgine (now Fraser Island); her political existence as an indigenous person of Australia; and her ongoing search for artistic identity within mainstream art practice.

Foley has had a number of one-person exhibitions in Sydney and Queensland between 1988 and 1994 and has participated in numerous group exhibitions throughout Australia and in

PLATE 34
SAND SCULPTURE, 1991
Sand, varying dimensions, Courtesy Roslyn Oxley9
Gallery

'This sand sculpture was part of the *Moving Sands*
exhibition at the Adelaide Arts Festival in 1994. Basically,
the two main images in the piece evolved from an
experience one evening when I was sitting on the
verandah back home on Fraser Island and, in between two
tree trunks, I saw a full moon rising. The centrality of the
work also relates to an image of an island or female
genitalia.

There is a little painting at the top with a diamond shape
in it that has a few references — one is the diamond-scaled
mollusc, which was a winter source of food for my people,
and another is the strangler fig vine. The actual
inspiration of the fig vine came from a photograph in a
book by Kevin Gilbert. It has roots going all over this fig
tree and forming a diamond-shaped pattern. A further
reference is to a dilly bag — which is over a hundred years
old — that comes from my area and has a diamond shape
woven into its design. The dilly bag has many criss-
crossed layers of meaning and there are also a number of
men's paintings about women's dilly bags. It is an object
that can, at times, be deeply religious and so it has a lot of
associated significance. Men can also make dilly bags and
these are used in conjunction with ceremonies. Some dilly
bags are very secret and sacred objects created specifically
for ceremony.

The yellow is the moon, and the red lines going through
the sculpture are the actual tree trunks that were cutting
across each other. The full moon rising between the two
trees represents the mystique of the feminine.

Sand sculptures were used in traditional Badtjala
culture. This type of art form would have appeared all
over Australia in a similar way to how it is represented
here. You also sometimes see them in photographic
references, where the actual ground was etched into for
ceremony. They also appear in the rock engravings around
Sydney and along the coastline of New South Wales. If
you go to Central Australia, you will see there are sand
paintings done in conjunction with women's business and
men's business — this was a part of the overall installation.
Sand sculptures are still being made today in places like
Arnhem Land, but mainly in conjunction with funerals
and the rites of passage of the deceased person from this
earth plane into the spiritual world.

From my limited research on aspects of our culture from
Fraser Island, there is a ground sculpture called a Dora
Ring, which was used in conjunction with the initiation
of young boys. This is what I understand from attending a
part of a young man's ceremony — there are public parts
of the ceremony in which women participate, and in
which men participate, and it's not until the final stages
that the women are asked to leave and then the young
boys are handed over to their mother's brothers, or
maternal uncles, and taken care of. So there is a balance
to the performance and the ceremony.'

Europe, Asia and the United States between 1984 and 1995. She has had considerable project
and curatorial experience, which includes curator of Boomalli Aboriginal Artists Co-Operative
in 1991 — of which she was a founding member. She has recently completed two terms as guest
curator at the Museum of Contemporary Art, Sydney between 1991 and 1994. She has served
as a member on various Aboriginal boards, including a directorship of Bangarra Dance Theatre
in 1993. Foley is represented in the collections of the National Gallery of Australia, Canberra,
the Art Gallery of New South Wales, the Art Gallery of Queensland, the Australian Museum,
the Robert Holmes à Court collection as well as in other public and private collections.

———— ·•· ————

*Could we begin, perhaps, by discussing some of the important formative influences,
significant experiences, memories and inspirations in your life and work as an artist?*

The significant aspect of my cultural identity was formed at a very early age growing up in a
small town in Queensland. I was made aware that my family was different from the other kids
because my mother was Aboriginal, therefore I was Aboriginal, which meant 'less than' white
people. Consequently, I encountered racist comments like 'abo', 'bong', 'koon', and with the
constant rejection, my life became a 'sink or swim' experience. When a child, you don't know
why you are different from the other kids — you have two arms and two legs just like them. And
to add further to the confusion, we were taught at school to fight against racism! However, in
that youthful fighting — both verbal and physical — I became a stronger person. I also became
curious to learn more about my history and to question why I was placed in the position of being
part of an underclass in my own country.

I wanted to learn about traditional culture because I could see that there were things that
would have taken place in my community but we didn't have the documentation to say that
they had occurred. In these investigations into my origins, which is integral to my work, I draw
on many sources — recorded history in museums (which is very complex), lots of aspects of my
own culture and other traditional Aboriginal contexts, where I link up with my own traditional
culture. So as a young person, I was thinking, 'Oh, this is what would have happened back
home on Fraser Island; this is part of a tradition, a custom that we also would have had, because
I have remnants of that culture.' Henry Reynolds's book *The Other Side of the Frontier* has helped
to fill in a number of gaps for me and for others.

One of my earliest memories is winning fifty cents in a drawing competition at Urangan
Primary School. I was in grade one and the multi-coloured crayon drawing was of Jane skipping
rope. I have never won an art competition since.

Another strong memory whilst growing up in Hervey Bay was of a book written by my Great
Uncle Wilfie and illustrated by my Great Aunty Olga. Uncle Wilfie wrote short stories and
poetry and made sculptures, and although he had many creative gifts, he did not receive much
recognition in his lifetime. The book was a series of creation stories from Fraser Island titled
The Legends of Moonie Jarl, published in 1964 — the year I was born — and so was a cherished
piece of cultural history. He also collected stamps, which has become a part of my life also and is
why it was really great to have an image of mine on an Australian stamp recently. Aunty Olga is
still alive and has a lot of really good oral history. She is also important in the lineage of my fam-
ily today — which is matriarchal as opposed to patriarchal — it begins with her, descends to my
mother, then to me.

*Have there been other significant people and events that have influenced your art? If so, in
what specific ways?*

Lectures by Geoff De Groen and Bruce McCalmont while attending East Sydney Technical
College were very important in my development as an artist. These teachers had quite a

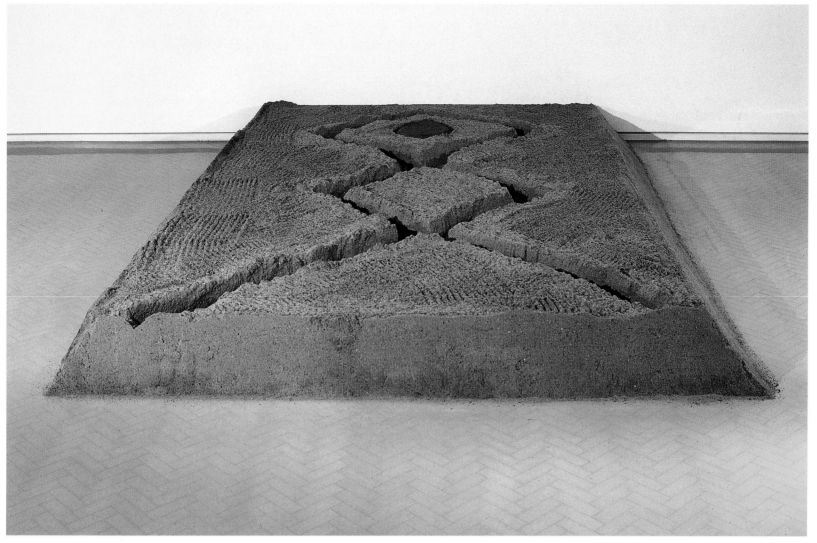

PLATE 34

humanitarian approach to teaching and related to me as an individual. They took a more holis-
tic approach to art education — which is something you don't necessarily receive now from our
art institutions in Sydney.

We were encouraged to explore and read more about individual artists whose work we
liked. Here I was introduced to artists I may otherwise not have discovered — people like Paul
Klee, Joan Miro and Richard Long amongst others. They would also bring in objects for us to
draw, repeatedly — usually a feather, a rock or an avocado seed — always something very sim-
ple. Through the process of drawing, you also learned a lot about yourself, like how to be
patient. We would spend anywhere between three and twelve hours on the one drawing and
we would often work on the same object over a period of weeks.

Some of the students in my classes were quite gifted as draughtspeople but I was hopeless
— I just didn't have great drawing skills (I probably still don't), because I tended to flatten out
the image. However, we students were just made to persist with that one object — to keep
looking at it, looking at it, looking at it — to draw and extract different qualities from it.

I don't see things three-dimensionally; I think, though I am not entirely sure, that it has
something to do with the different way Aboriginal people perceive the landscape. It took me
until after art school to work this out, and — based on having looked at a lot of Aboriginal art —
my general opinion is that we tend to perceive things more from an aerial and a flattened-out,
two-dimensional perspective. There is also an expansive, spatial quality in Aboriginal art. By

PLATE 35
A QUESTION OF INDIGENA, 1994
Canvas, acrylic, glass bottles, honey, milk, snake.
Installation, 72 x 197 cm overall size, Courtesy Roslyn
Oxley9 Gallery

'This work came about as a result of my recent travels to
Cuba and Canada. I attended a conference when I first
arrived there and encountered people from the African
Caribbean talking about themselves as the new
indigenous people because the indigenous people of
Cuba no longer existed — nor did those of the Caribbean
Islands. These Afro-Caribbean people were wanting to
usurp these extinct indigenous peoples, but to the
indigenous people at the conference this was absolutely
absurd. You can *never* 'replace' an indigenous people, no
matter how long you have lived in a place or how much
you have suffered. If the traditional people have gone,
they are gone and that is how it is. I mean, what is the
definition of "indigena"? How are you going to judge it?
Is it a time-line thing or how brutally treated you were —
like the slaves going to other countries in ships from
Africa? These were the questions I was asking.

The first object that triggered the work was an old milk
bottle I found in an antique shop in Canada that had "Old
Colony" written on it. The snake that I placed behind the
bottle also came from Canada, where I found it squashed
on the road one day. I dried it out and managed to get it
back to Australia. I started working on the golliwog pieces
whilst I was still in Canada and there are lots of layers of
meaning in these. I don't think black British people
necessarily like the golliwog, because it is derogatory to
them. However, for me, when I was growing up, the
golliwog was the only black doll I had and it was made by
my mother, so I tend to think of golliwogs affectionately as
part of my childhood. I think it was the same for a lot of
Aboriginal children who didn't have access to black dolls
in this country. And it probably wasn't until the 1960s that
black plastic dolls were introduced here.

This old bottle became the central image and
represented "old colony", and the image of the boat
represented the new colonies being created and the idea
of "a supreme colony" and people's notions of what
"supremacy" is. Also the boats represent those that came
from Africa taking slaves to the Caribbean. I was also
looking at the notion of the "promised land" of "milk and
honey". The oar represents honey, as in this "promised
land".

The other strong element in the work is a profile of
Kohiba, the only remaining reference to an indigenous
person that can be seen in Cuba; it is an image found on
cigar packets and on beer cans. I wanted to know what had
happened to the indigenous people of Cuba and quickly
learned that they were subjected to genocide by the
Spanish invaders who conquered and occupied Cuba. So I
was looking at the African diaspora and indigenous people
from different parts of the world.

The egg shape is an actual ostrich egg that I bought
while I was in Canada and there's also a [spear] that relates
to an old man, an Aboriginal artist named [Jack Bunner
from Garmidy outside Maningrida], who I heard talk one
day about how indigenous people are the yellow part of
the egg and how the British people who came here in
boats are the white part of the egg and how we will never
be able to send them back. I think that is how the story
went. ➤ p.99

contrast, European landscape artists tend to paint the image from an upright, forward-looking
viewpoint and effect a three-dimensional quality. Aboriginal people know their country inti-
mately, like the back of their hand, and this has been reflected in stories I have heard about
Aboriginal women who have gone up in an aeroplane for the first time and have easily been
able to point out familiar sites. It is almost like they have astral travelled the land many, many
times.

Other important influences were Georgia O'Keefe and Frida Kahlo, both strongly indepen-
dent women with their own careers who, despite being married to well-known artists in their
own right, managed to retain a separateness and single-minded focus on their own art making.
The strength of character they must have had to do that is impressive — particularly Georgia
O'Keefe with her individualistic lifestyle, travelling into parts of the New Mexico desert to col-
lect bones and remnants of things and sitting in her car painting the landscape. I, too, like to
collect bones and use them later in my work, so I was particularly drawn to her series of bone
paintings.

Ana Mendieta — a Cuban artist who did a lot of environmental sculptures — interested me
both in her use of her own body in her sculptures and the body of the female figure in the envi-
ronment in her works — which were dealing with female sexuality in an earthly, spiritual way.
Mendieta died quite young — in her thirties — so she is not well known internationally. Her
work, to me, contrasted with British and Australian environmental sculptures, which were
more male based. I find environmental sculpture fascinating and it is something I would like to
explore further, but you have to have other people involved to document the work as it takes
place in the landscape. It is through this documentation that the artist's works survive.

I very much like the work of the novelists Isabelle Allende, Gabriel Garcia Marquez and
China Achebe, who all have this capacity to create dreamlike states with characters weaving in
and out, which sparks my imagination and emotions and gets me going.

Rover Thomas has been inspirational in terms of the honesty and integrity of his work. I
relate to him strongly in the way I perceive landscape, because I understand where he is com-
ing from and understand the two-dimensionality of his work. He is representing some heavy
material — such as massacres in his own country and the cross-roads of life — in the most mini-
malist terms, yet the work is very powerful.

Anish Kapoor's works have also been influential in terms of the sculptural shapes, textures
and colours (the oxides) he makes, and Joseph Beuys, who is defined as a conceptual artist, is
fascinating in the materials he has used, such as fur and felt.

I like the work of Tommy McCrae and Butcher Joe, who were lesser known Aboriginal
artists. Tommy was doing sketches on paper around the late 1800s and Butcher Joe has work in
the National Gallery of Australia — but I don't know much about him. I find Butcher's draw-
ings very lyrical and comical, with a good sense of line. His humour is expressed through
human figures with birds tails, dancing around the landscape. I don't know the depth of the sto-
ries, but they relate to me in almost the same ways as May Gibbs's drawings for children — in
their playful, fun-loving qualities. Also both used Australian flora and fauna and Aboriginal
spirits in the landscape. Once again, this is work that is very honest, very unpretentious.

*Could you discuss spiritual dimensions that have had a particular impact on your
consciousness and work?*

The public parts of religious ceremonies I have attended at Ramingining and Maningrida —
held out in the landscape — were awe-inspiring experiences in the same way, to me, as the
chanting in Buddhist religious ceremonies in Japan and the things that are talked about in the
Book of Genesis. These are stories from the beginning of time, and the significance of that con-
tinuum of culture and people abiding by their custodial law impacts on you and demands
respect, both for the sacred space and the ceremony held within it.

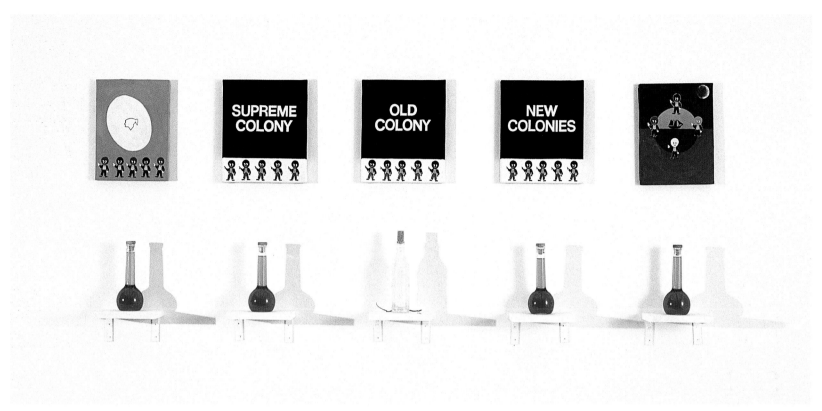

PLATE 35

Sacred sites on Fraser Island have the same importance in that they are all highly religious places with highly religious ceremonies. The ceremonies are cyclical in nature and, in some, there are as many as sixty songs in a set order going from one to sixty. This is a similar formality to that which I have seen enacted in ceremonies from other religions. Commandments are also practiced. You can see the overlaps in lots of different art forms: through the song cycles; through the painting; through the sand sculptures.

The painting *Ophelia* by Sir John Everett Millais is a haunting image that stayed with me for a long, long time. It is something about the combination of beauty and death — this beautiful woman whose spirit has departed, but she is still lying there in the calm of death. There is something in this work about the spirit being there and not being there simultaneously. I get a strong sense of that when I am walking on Fraser Island — my spirit being there but not there and a sense of 'the old people' who I know are there, watching, but there is no physicality about them. I would like to do something similar to *Ophelia* using one of the lakes on Fraser Island.

Describe the important cultural aspects, for you, of being a woman and an artist.

There is a gender equality in the performance of Aboriginal ceremonies that makes the experience very satisfying and powerful for everyone. I think there is more of a gender balance in Aboriginal culture than we were led to believe by the research of male Anglo anthropologists. There is also an equality between the different skin groups — Yirritja and Dhua, in my people's case — everything is divided into two halves like the Yin/Yang concept. There are the people who own the ceremony and the people who manage the ceremony, and everyone participates. Culture is dispersed amongst everyone — it doesn't matter about your financial situation or status in the community, you are responsible for a certain part of a ceremony.

I think that in a lot of Aboriginal work there are underlying symbols of sexuality and there is a lot of association with sexuality, but people aren't necessarily aware of it, because women's and men's business is separate. For example — not necessarily in relationship to any particular piece of mine — there are female Creation spirits who have gone through the landscape naming

I haven't entirely fathomed the work yet, but it is also looking at how people are classified, such as white, black, yellow and red. I have difficulties with pigeon-holing, particularly with the so-called "urban artist" category in this country. It is too simple for people to lump you into either the urban artist category or the traditional Aboriginal artist category. I think it is necessary to break away from these categories and look at developing a new way of representing the complexities that exist in cultures here. I came from a rural community where there were Chinese people, and Ian Abdullah, as another example, is Afghan mixed with Aboriginal, and all that complexity is not discussed. [Gerald McMaster and Lee-Ann Martin's book catalogue *Indigena* (1992) is useful in this area of breaking down stereotypic ideas of indigenous peoples.]'

PLATE 36
COLOURED SAND, 1993
from the Australian Centre for Contemporary Art
exhibition *Lick My Black Art*
Sand, tin, wax, glass jars, wooden boxes, varying
dimensions, Courtesy Roslyn Oxley9 Gallery

'In my final year at art school, I made boxes similar to the
shapes in these works, but I never really knew how I
was going to use them. I always had the boxes sitting
on the floor and initially painted them with yellow ochre,
but they didn't look that good because rather than
highlighting the colours in the sand, the ochre made
them look washed out. So I then had to use either white
or black to highlight the colours of the sand in the bottle.
Somebody talked about all these objects being contained
— like the sand being contained within the glass and the
glass bottles being contained in these wooden boxes —
the same with the candles and the sardine tins.

When you make a work, it's very new, and I find it quite
hard to articulate that work because I don't know some of
the symbolism myself. It's not until I look back, after a
period of time has elapsed, that I think, Oh! that's why I
did that, that relates to such and such…

The coloured sand is from Fraser Island and makes
reference to its commercial value — for example, for
tourists and previously in sand mining for rutile. Coming
before such uses is the knowledge contained in the
Aboriginal women's Creation story that told how the dunes
formed their colours. I also have memories from childhood
of filling bottles with coloured sand accompanied by my
mother, siblings and maternal grandmother — so I already
knew how to do it. We would go to different sandhills up
and down the beach and collect the different colours and
spend some of our time filling these bottles. My mother
really liked doing this, as did people preceding her. I
remember this old black and white photograph of one of
our people selling a bottle of coloured sand to tourists on
Fraser Island as a source of income.

The candles represent sacrifice and what my own
people from Fraser Island endured over the years from
1904 to 1988 — when they were given back land, but only
six hectares, on the island — and how hard they had to
fight the Joh Bjelke-Petersen Government even for
that. I also equate the lighting of candles with the same
spiritual reverence and religious significance as when you
go into a cathedral and pick up a candle and put it before
the altarpiece.

The sardine tins are a loose metaphor for the fishing
industry and the destruction of fish habitats in the
Hervey Bay region.'

PLATE 36

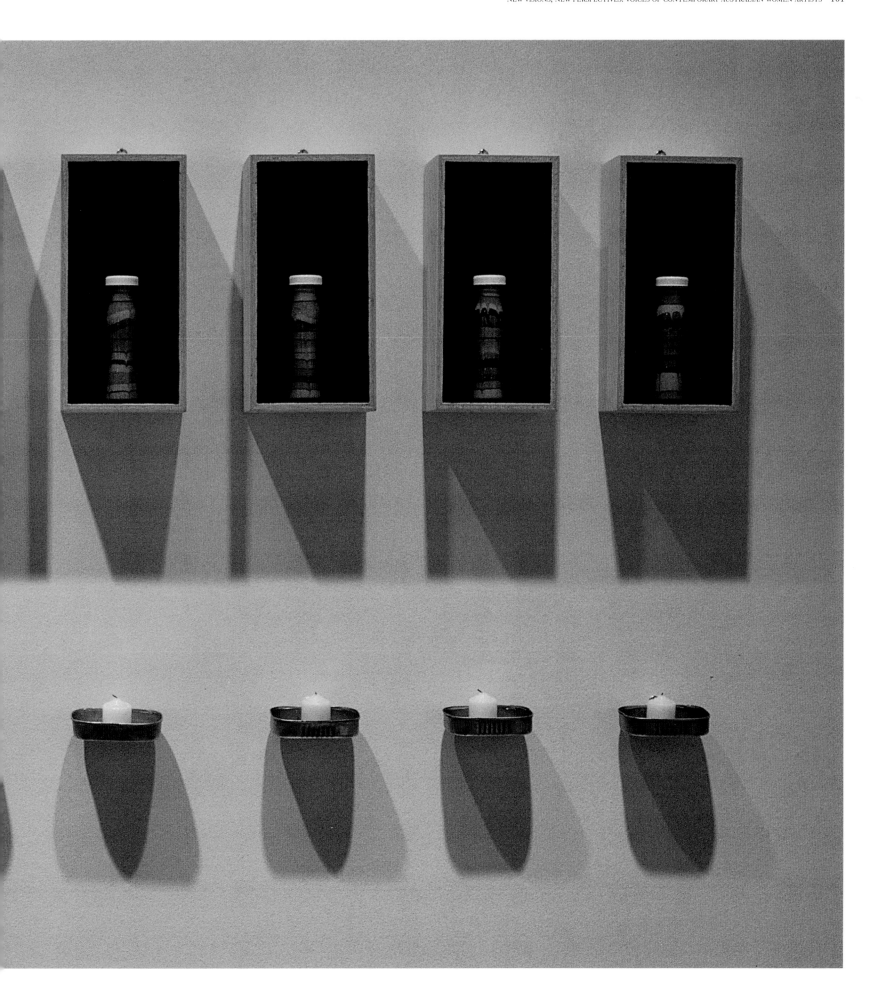

features and aspects relating to cycles and bodily experiences of the feminine, and there is an element of sexuality in our experiential works that is not necessarily written or talked about publicly, but which gives a deeper layer of meaning. There is a seasonal aspect also to these cyclical things, particularly in relationship to the moon — the effects that it has on water and on the world as well as on female bodily nature. I think that when Aboriginal people are painting the details of these stories, there are these depths of meanings to them — like women's power and men's power tied up with their own sexuality, but I think we don't read that into the experience because people don't have access to that knowledge.

How do you approach your work — what sparks and feeds your creative processes?

Everything I have mentioned feeds into my creative processes. I often start with an image or an idea somewhere in my head. I then ponder it, write a few words or do a brief drawing about it in a sketchbook to remind me to keep thinking about it. In A *Question of Indigena*, for example, I wanted to do something with honey and glass bottles, so I just kept working on it — how to refine it, what did I want to say etc. My mood, when I am working on a project, is generally quietly contemplative with undertones of solitariness and other ephemeral feelings such as loss.

Sometimes objects will come before the idea, and other times, particularly with the drawings, the clear composition of the image will come before the materials — whether I will do it in pastel, for example. In one work, I knew I wanted to draw diamonds with bush string from Maningrida and then came the question of how it would all come together. If I know I'm working towards a show, I start to realise I have the power within me to take a certain direction in my work. Sometimes that's tied up with a political power, which can be quite confrontational, and at other times it is connected with a sense of my Aboriginal spirit and a rejoicing in my own culture (which is a focus I have had for a long time now) — images, objects and experiences that I have had — so here the work is less confrontational. However, sometimes running concurrently with this latter work there is the political aim of trying to get people to think about things.

I don't like to set limits upon myself. It is important to keep educating yourself and to pull in from lots of different sources. I get inspiration from theatre sets, from reading novels, from seeing films, from looking at other artists' works from different parts of the world, from going to ceremonies in Arnhem Land — if I am that privileged. It takes a long time for these influences to work on you or to internalise them, but I think that there is enough strong imagery out there — in fact it's hard to escape it. I'm finding that as time goes on, I can say what I like and I'm not limited to 'an aspect' of a particular Aboriginal art tradition. I can move in and out of different media, different realms, different levels. So I feel an immense freedom.

Do you have any other particular concerns as an artist?

I feel it's important to address the way Aboriginal artists are seen as something less than their white counterparts, as ethnographic curiosities or are viewed with an emphasis on Aboriginal social issues rather than the individual artist's work.

I understand that in the late 1980s and early 1990s a lot of Aboriginal artists have come to the fore and been given recognition, but I still think a step further needs to be taken in looking at these Aboriginal artists in their own right and respecting them as great creators — as master drawers and master painters. Also their life stories and their contexts should be written about as the *primary* focus, instead of the social issues surrounding them.

There is the opinion around that leading Aboriginal artists in this country are being ill served by people who have access to writing articles on art and are forming 'Australian art history' — which is a grave injustice. These people are still alive, so why isn't, for example, Rover Thomas held in the same regard as Arthur Boyd or Brett Whiteley. When Rover Thomas is being talked and written about, why isn't the emphasis on his being a great artist rather than on

his lifestyle, lack of money and dependency on alcohol. With Brett Whiteley, it was his art first and his addiction second. I can see this happening across all age groups, all geographical locations and I'm seeing it start to happen with my own work. Our work is important to us, and under such circumstances it is easy for our development as artists to slip. Too often I am having to talk about social issues pertaining to Aboriginal people — and I certainly don't have all the answers — rather than talking about my life as an artist. It seems that often when someone is confronted with an Aboriginal and a non-Aboriginal artist, the line of questioning is quite different and separate.

It's important to move us up out of that realm of just being Aboriginal artists and attempt to equate the art more on an intellectual level, because Aboriginal art in this country is far more sophisticated than the credit it's being given. I say this from having observed and participated in the contemporary art arena and from reading art journals — which are formulating opinion — and I am still seeing that people are very frightened to write about Aboriginal art. I think this is due to a number of factors, including the fear of the unknown, a fear of being labelled a racist if they get something wrong or are critical, instead of diving in and working with the artists and talking to them about their work.

Another concern relates to sand sculptures in Aboriginal culture and my work *Moving Sands* (1994). I was reading a recently published book that talks about performance art in Australia as having a history of twenty-five years. However, if you look at performance art in its entirety in this country, and the integrity of that sort of work, it has been going on for well over forty thousand years, because performance and ceremony is held in conjunction with these sand sculptures. Also, looking at sand sculptures as conceptual pieces of work — as Djon Mundine and I say at the Museum of Contemporary Art — they should be considered as installations, but installations that are mostly created in the landscape. Again it is that notion that only Westerners have an intellectualism that can create 'installation art', instead of looking at the richness and diversity of Aboriginal culture in the same vein when assessing this history — as having conceptual pieces of work made by artisans in their own right.

How do you see your role as an artist/educator and the purpose and function of your art?

In Aboriginal culture, quite a few people are given responsibilities in different areas and are forced to articulate things from an early age. I think that happened to those of us who were involved with Boomalli in 1987. We were all relatively young, given a lot of responsibility and were thrown in at the 'deep end'. It was tough but it also opened a lot of doors.

My work today is driven by my custodial responsibilities to my land, Fraser Island (the largest sand island in the world), and by my political existence as an indigenous person of Australia. I see the 'function and purpose' of my work as performing an educative role towards redressing the imbalance of Australian dominant history. To me it is a predestined path already mapped out for me.

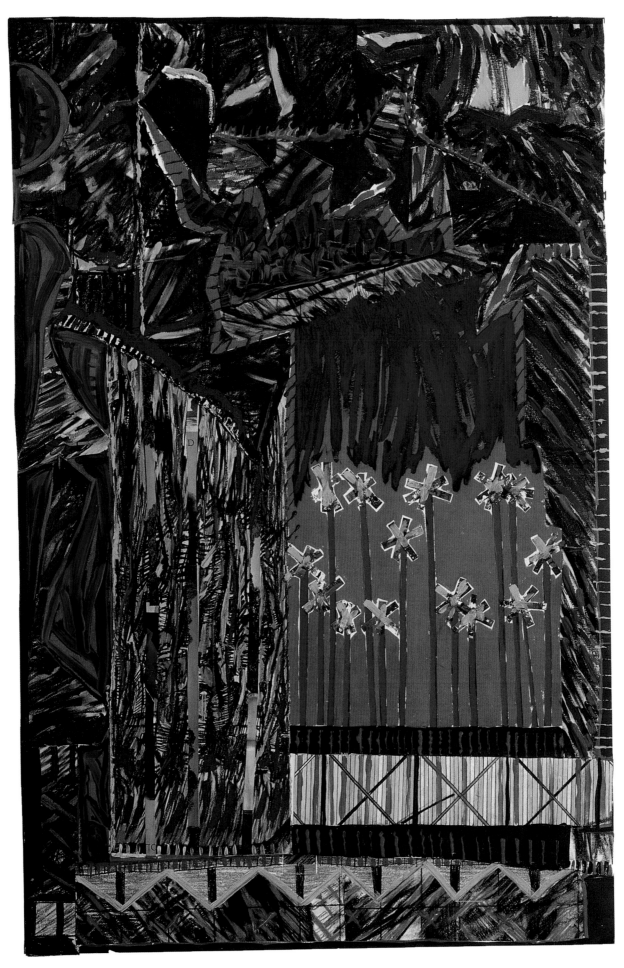

PLATE 37

Gabriela Frutos

PAINTER, COLLAGE ARTIST

*There is always, for me, conflict in reaching a middle ground between
feeling and intellect. But it is in the challenge of trying to keep
everything in check without killing the work that gives me energy
and keeps me intrigued in working creatively.*

*But…if for some reason I could not paint or draw any more, the
creative part of me would impose its will on other parts of my life.*

GABRIELA FRUTOS was born in Uruguay and arrived in Australia in 1976. Between 1984 and 1986 she studied for her Bachelor of Creative Arts degree at Wollongong University, where she also completed a Graduate Diploma in Education in 1987.

In recent years Frutos has moved from painting to exploration of different collaging techniques, using her works as spatial ground upon which conflicts between nature and the structural impositions of industrial man are played out in contests of survival. Frutos draws from her immediate physical environment, her inner imaginings and intuitions as well as recycling earlier works in her pattern-play compositions of divergent materials, textures, colours and ideas — all of which jostle for place and struggle towards a visual synthesis, if a somewhat uneasy resolution.

Frutos began exhibiting in group shows in Wollongong in 1985, followed by several others from 1986 to the present. She had her first one-person exhibition in 1987, with her most recent individual exhibition in 1996. In 1987 she was commissioned by the City of Wollongong to design a mosaic — *City Echoes* — for the city centre, as a gift for the bicentennial project. She is represented in the collections of Wollongong University and other public and private collections.

*Could we discuss the formative influences in your creative development — the important
people, major experiences, philosophies, inspirations — and your concerns as an artist?*

It is almost impossible to pin down exactly what it is that inspires me, and if I have a personal creative philosophy, it is one of love and fascination for imagery that almost doesn't fit together but somehow does, and the desire to invite from the viewer exploration and inquiry in my work. I also cannot say that there has been anyone or anything that has influenced my creative development. My cultural background and my life experiences are what I believe have made

PLATE 37
RECYCLED LANDSCAPE 7, 1993
Collage on paper, 98 x 63 cm, Courtesy of the artist

PLATE 39
RECYCLED LANDSCAPE 5, 1993
Collage on paper, 98 x 63 cm, Courtesy of the artist

RECYCLED LANDSCAPE SERIES, 1993
'The title of my most recent body of work, *Recycled Landscapes*, was inspired by the collage techniques I used throughout this series of works for my exhibition in 1993. The title was meant as a pun upon my working process and techniques. I had accumulated a lot of works that were successful in parts, so I decided to use them as the base for new works. These old works were cut and collaged together and then worked on top with various materials. Even though I started with some set images, the final compositions were arrived at through the working process rather than through preconceived ideas.

I approached these works largely on an intuitive level, but also introduced, once again, my perception of my immediate environment and surrounding landscape, using a combination of real and imagined space. The most challenging and exciting part of working this way was how to marry varied materials together without losing their particular characters. Sometimes the works would be successful, other times not, so some works would be recycled several times. Each image that I put down, along with the various materials, was chosen throughout the working process for its contribution to the integrity of the finished work. Spatial organisation, colour and the juxtaposition of disparate elements were very important in the working process.

I feel that this body of works signify a personal victory in reaching some degree of middle ground between feeling and intellect.'

an impact on the character, mood and views expressed in my work. I have always been drawn to other artists whose works extend my own perceptions about art, and evoke in me some kind of emotion, idea or memory.

One particular aspect that I have been struggling with is the difficulty in approaching creative work on a purely intuitive level, as I, like everyone else, am surrounded by a multitude of questions and answers. There is always, for me, conflict in reaching a middle ground between feeling and intellect. But it is the challenge of trying to keep everything in check without killing the work that gives me energy and keeps me intrigued about working creatively. Since being able to work in my own studio, I have discovered that it is important for me to give tangible form to my feelings, emotions and views. But, at the same time, if for some reason I could not paint or draw anymore, the creative part of me would impose its will on other parts of my life. Above all, I strive for personal integrity, because without it my work is dead.

And other aspects of your creative process? What moves you from the initial spark into the work?

To me, the most important and exciting part of my work is the initial idea or spark; intellect then comes second to feeling during the working process. I do not usually work towards a predetermined point, but rather my will reacts and blends with what is happening on the second surface. Each work becomes part of the next, but all are also separate entities.

During the last three years I have been interested in the synthesis of diverse ranges of often conflicting colour, structures, textures, ideas and views. When I look back, these often create an almost surreal effect, each element fighting for survival on the picture plane. The *Recycled Landscapes* series reproduced here exploits these themes, plus other areas of interest to me. Old pieces of works served as surfaces onto which I built new structures. These works also convey my personal views and observations and my relationship with my immediate environment and landscape — in particular, it is from where the ocean meets the land that I have drawn inspiration. The contrast created by manmade structures and the natural landscape dominates these works, made up mainly of contrasting and complementary colour schemes, structural relationships, and a mixture of real and imagined space and personal symbols arrived at both by accident and predetermined designs.

I do not think that my work deals with only one particular aspect, but rather grows out of my interest in the contrast and friction existing in our environment between that which is manmade and that which is not. I usually respond to that in an intuitive and semi-descriptive manner. It is the friction and playful contrast created by the two that I enjoy in my work — when they fit together and work as a whole.

It is always exciting to exclude narrative or external references in order to explore the unknown, but it is also exciting to explore preconceived ideas, pictorial and/or symbolic elements that evoke in me memories and a sense of place. I use the materials at my disposal and the creation of personal symbols and structures to evoke spaces and environments rather than to describe them and hopefully to provoke a response from the viewer. It is also important for me that my work not just be easy to understand but rather that it conveys and evokes many and varied emotions and intellectual interpretations.

How has being a woman influenced your journey as an artist?

When I think about how being a woman has influenced my creative development, again a lot of contradictions and conflicts come to mind. There is the side of me that has always related to 'art' on its own merits — not whether it is/was created by a male or female. But, on the other hand, I am conscious of always making my own personal and deliberate choices where my life and work are concerned. I always strive to work from within my self rather than following trends or fads. This, I believe, makes my work distinctive more than anything else.

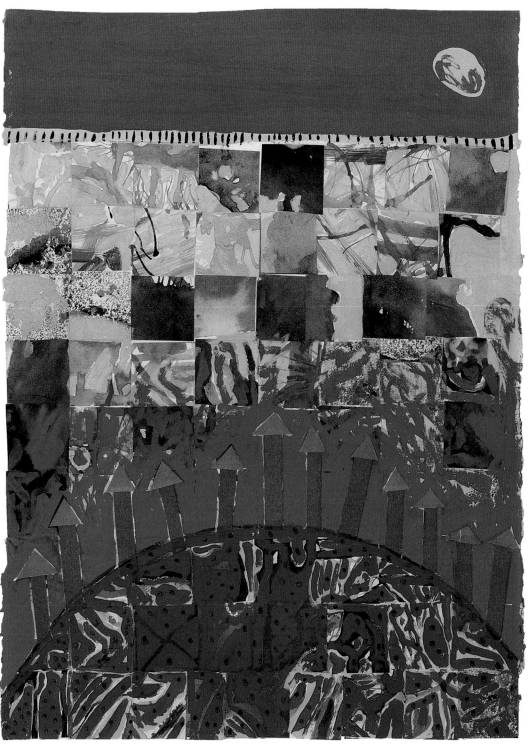

PLATE 38

PLATE 38
WATERFRONT SERIES 2, 1993
Collage on paper, 38 x 28 cm, Courtesy of the artist

'In the *Waterfront Series*, spatial organisation and the juxtapositioning of disparate elements were exploited even more than in the *Recycled Landscape* series, as I aimed at intensifying the contrast between the waterfront and industry at Port Kembla, Wollongong. I wanted to capture the almost surreal visual impact of nature against manmade in the work — that feeling that even if everything seems to work together, there is still some uneasiness, which is what I feel when I'm in that area of Wollongong. I wanted to create a sense of friction and a sense of things that flatly refuse to fit but somehow work as a whole, and to reach a middle ground between feeling and intellect.

I still prefer, and probably always will, to work from within myself rather than follow trends or traditions. My last piece of work in a series is the beginning of the next, making the working process one of continual recycling and discovery.'

At this stage of your creative development, how do you see the function and purpose of your art?

At this point in my creative development, I find it difficult to formulate concrete opinions on the function and purpose of my work. My work now serves to satisfy and express my feelings and views about what is around me every day. I can only hope that other people can relate to the pictorial structures and symbols I create. In one way I am striving for personal ends, but at the same time I want to give the viewer a way in to my work, to leave a lasting impression and a desire to explore and to take a second look. But I am very aware that I am still at odds where philosophies are concerned. They can be very dangerous in robbing the work of its own identity. In the words of David Munro: 'Work humbly, put up or shut up…'

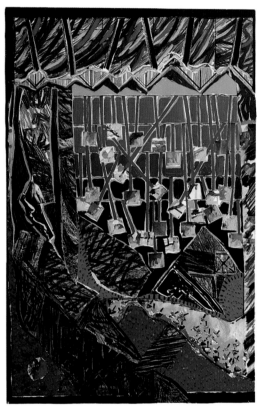

PLATE 39

Elizabeth Gower

PAINTER, COLLAGE AND INSTALLATION ARTIST

*Meaning and understanding comes from a belief in God, the
letting go of self, male/female relationship, parenting, immortality,
reflection on one's life so far and the transient nature of
individual plans, activities and achievements.*

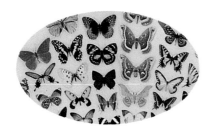

ELIZABETH GOWER was born in Adelaide and from 1970 to 1973 studied at Prahran College of Advanced Education for her Diploma of Art and Design. She attended Mercer House Teachers College in 1974, gaining her Diploma in Education. Gower was awarded the Alliance Francaise Art Fellowship for study in Paris in 1980 and was artist-in-residence at the Paretaio Studio, Italy in 1983. She was a lecturer in painting at the Victorian College of the Arts from 1978 to 1984 and at the Centre for the Arts, University of Tasmania from 1985 to 1986. She is currently Senior Lecturer and Head of Painting at the Victorian College of the Arts — the first woman to be appointed to this position — and is also in the process of completing a Master of Arts at the Royal Melbourne Institute of Technology.

Gower's process of creating her intriguing collages, 'paper quilt' paintings and installations — formed by weaving, layering and assembling items selected from the plethora of objects and mass media iconography that daily invades our lives — itself replicates the mundane reality of most urban dwellers' life experience. This occurs in the continuous sifting and sorting of a 'fall-out' overload of informational material in order to bring some sort of editing and arrangement to what can reasonably be contained in the spaces we occupy — at the same time, retaining time for reflection and inner peace amidst this everyday barrage. In its seesaw between the figurative and the abstract, Gower's art also has philosophical and spiritual underpinnings. These are evidenced in the way it structures a sense/no-sense dialectic and a dialogue between the tangible and the intangible, the enduring and the ephemeral, the material and the spiritual — which reflects back to us the layers of clutter and demand that veil what is essential and meaningful in our existences.

Gower held her first one-person exhibition in Melbourne in 1976 and has exhibited regularly over recent years at major galleries in Sydney, Melbourne and Brisbane. The artist has also been included in several important group exhibitions in Australia and overseas since 1977. She is represented in the National Gallery of Victoria, the National Gallery of Australia, the Art Galleries of New South Wales, Western Australia and South Australia, Artbank and several major regional galleries.

PLATE 40

PLATE 40

THINKING ABOUT THE MEANING OF LIFE, 1990
Acrylic on drafting film, 288 x 287 cm,
Photograph: Henry Jolles, Courtesy of the artist,
Collection: Queensland Art Gallery

In this image Elizabeth Gower juxtaposes coexistent experiences of the chaotic and fragmentary in life — represented in symbols of material concern and advertising-generated consumerism — with that which is still, eternal, fluid and unchanging — symbolised by the transparent, membranous, background 'cross'. The cross is both a symbol for the crucifix and an aesthetic device to denote order, stability, strength, stillness — the place of contemplation amid the seemingly endless barrage of worldly concerns.

'The familiar everyday imagery I incorporate in the works is collected, traced, drawn or cut out from junk mail, magazines, newspaper, children's encyclopedia's, science and nature books etc. So while I select imagery that reflects my experience, it is not drawn from personal memory or imagination. I use the images as symbols and metaphors of contemporary life. I construct the works in collage fashion from these selected elements, sometimes leaving them as actual collages, as in *Cycle* (1993) and *Forever* (1993), or enlarging and painting from them as in *Thinking About The Meaning Of Life* (1990).'

Could you describe for me the formative influences that have been inspirational and pivotal in your creative development?

The constant state of flux in contemporary life — the ephemeral, the transient — has been the source for all my works, and the search for meaning and understanding within this flux is my current concern. The inspiration that has come to me from the ephemeral and transient includes daily life experiences, television, junk mail, advertising and packaging materials, fabrics, patterns and repeated imagery, domesticity, urban culture and so on.

Important influences, to name but a few, have been: Matisse's large collages; Jackson Pollock; Mondrian; the Russian Constructivists; Braque; Leger; the women's art movement in the 1970s; Eva Hesse; Delaunay; quilts; woven fabrics and carpets; mosaics; illuminated manuscripts; primitive art; Seurat. The art influences are constant and subliminal, so it is difficult to say what has had the most profound effect. Art seems equally as relevant as the above-mentioned advertising influences.

As I outlined in the Moët et Chandon exhibition catalogue in 1988, my paintings are synonymous with the information explosion experienced in this latter half of the twentieth century. The images I record, cut out and trace are drawn from junk mail, popular magazines, science and history books, children's books etc, and are presented in random juxtapositions or are jigsawed together to create an overall pattern. They are often multi-layered on drafting film and nylon.

There is no hierarchy of images. They all vie for attention, coming in and out of focus in what at first appears to be a confusion of lines. With each object and image fragmenting into another, and carrying with it a range of meanings, the immediate effect is that of visual overload. However, our ability to sort out, interpret, analyse and edit a daily barrage of information and emotions is highly developed, so that even amidst great confusion, one can still find solace and reflect on one small aspect of life.

Some of my works have been described as 'paper quilts' — a term I found irritating at first, since physically the works reflect different aesthetic concerns. However, the *process* of accumulating, sorting, and piecing together small repetitive units to make a whole is a ritual related to that of quiltmaking, and an important recurring aspect of my work. Quiltmaking, as a source of reference, and skills such as sewing and weaving, have traditionally been put down as

PLATE 41

PLATE 41
WORLDLY CONCERNS, 1994
Acrylic on drafting film, 205 x 330 cm, Courtesy of the
artist

PLATE 42
**ALL THINGS PASS AWAY BUT GOD ENDURES
FOREVER**, 1993
Acrylic on nylon, 250 x 113 cm, Courtesy of the artist

'This image has discs of painted fragments from everyday
life floating on the central nylon panel. These, too, come
from a collage source. The use of transparent materials
enhances the ephemeral and transient nature of the
things depicted. I also prefer the process of constructing,
rearranging and layering the elements, which again
reflects a collage methodology. The conceptual process is
more difficult to articulate as it is an accumulated process
spanning twenty years.'

'women's work' and not considered 'art'. In looking back, I found that these elements became
incorporated more obviously in my work as my consciousness and growing identity as a woman
developed. They became not only a process and means of construction, but a *major part* of the
content.

*Could you further elaborate on your creative processes — your typical ways of working —
with specific reference to the materials in your collages and assemblages and the stages in
your work?*

I have now been involved in making free-hanging works for nearly five years as the flat surface
of the stretched canvas was too restricting and uninspiring. I prefer to work into the surface and
initially began weaving paper and sewing scraps of canvas together to create a textured ground
on which to paint. This freedom led me to experiment with diverse materials — tissue and wax
paper, twigs, resin, etc — in order to build up transparencies and contrast of texture. By hanging
the works in layers, I could further emphasise the transparency and fragility of the materials.

My studio is full of paper fragments, off-cuts, test sheets (and is now full of collected images
from junk mail) and so forth. Many of my works are extensions of, or have originated from,
these otherwise discarded materials. As I am dealing with collage and found objects, most of
my aesthetic judgements are intuitive: chance combinations are inevitable. I work best when
my studio contains a sense of pending chaos.

In discussing the developmental aspects of my work, Hannah Elliot [in *Tension* magazine,
1990] spoke about my images better than I can express it:

> 'During the 70s, Gower experimented with a range of found materials such as
> leaves, fabric scraps and various paper, producing non-representational works.
> Later, she worked with images cut from magazines and advertising material,
> shredding them to make collage "quilts". Where earlier works had been con-
> cerned with opening up the pictorial space, the quilts made from magazines were
> symmetrical, rectangular, inward-looking and confined. In the 80s, Gower's art
> went through a similar cycle, that of "breaking out" — asymmetry, movement,
> and then a reaction of confinement of the pictorial space, a return to the rectan-
> gle. These works are (were) non-representational, avoiding recognisable objects.

PLATE 42

PLATE 43
CYCLE, 1993
Collage on fabric, 61 x 30 cm, Courtesy of the artist

PLATE 44
FOREVER, 1993
Collage on fabric, 61 x 30 cm, Courtesy of the artist

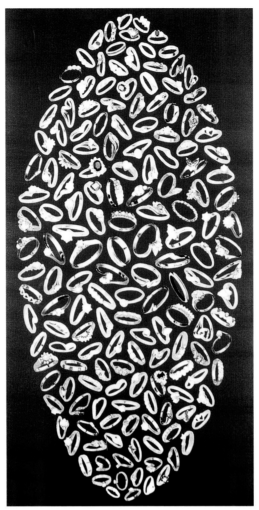

PLATE 43

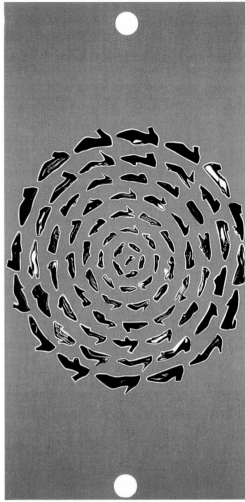

PLATE 44

They are (were) harsh, glittering impressions of an existence overloaded with modern life: clutter, objects, chaos. With titles like "Setting Up House", "Consume" and "Visual Overload", they are very much akin to the recent work.

'Gower's latest works seem to embody nearly all the tendencies evident in her earlier work. Her use of draughting film parallels earlier experimentation with different papers and her fascination with the translucent and fragile. The absence of a frame opens up the work and the delicacy of the draughting film allows the edge of the pictorial space to merge subtly with the wall. The depiction of everyday objects represents a step beyond finding the images and appropriating them for art. The artist has synthesised the materials and images of her earlier work into a vocabulary of expressive lines.'

When I moved briefly to Hobart in 1985 I experienced suburbia after being used to inner city living. In this situation of comparative isolation, the ubiquitous junk mail advertising, television and talkback radio became the links to the outside world. Figurative elements began to enter my work. With my collages, acrylics on paper and sometimes on the canvases, I began outlining the found images, then broke up these lines to create a scattering and dislocated effect — with each discrete entity fragmenting into another. Out of this process, recognisable objects began to emerge from what initially appeared as a field of chaos.

In recent works, the images of everyday life are sometimes barely discernible — fragmented, separated — and often appear to float and move across the plane, giving the appearance of an

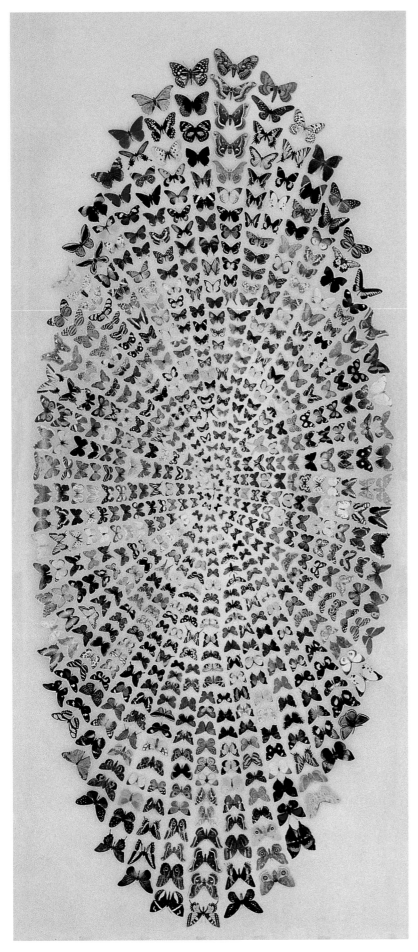

PLATE 45

PLATE 45
CHANCE OR DESIGN, 1995
Collage on drafting film, 250 x 100 cm, Courtesy of the artist

'One of 26 works from the exhibition *Chance or Design*, originally at Ian Potter Gallery, the University of Melbourne Museum of Art, and then touring Victorian regional galleries throughout 1996.

As I have expressed in the catalogue that accompanies this exhibition all the images I collected for the exhibition are reproductions of other artist's or naturalist's drawings, diagrams or photographs culled from secondhand books and magazines. These illustrations are not generally acknowledged in aesthetic terms but on their ability to service and enhance theological and scientific research. I have, however, selected and arranged the images according to their visual compatibility. Searching, accumulating, cutting out and sorting the images into categories is a sustaining methodology of my work. The underlying aim in presenting this collection of natural imagery "en masse" is to bring into focus the meaning and intention of its existence, or more specifically, the question is it *Chance or Design*.

The title *Chance or Design* has a double meaning, referring both to the content of the works and to the nature of the processes involved in their fabrication. The methodology used relates directly to the conventions of collage and assemblage. As all the images are found, there is an element of chance involved. However, as no image is ever repeated, a process of control or design is apparent. The final form of each panel is determined by the available collected material. The ephemeral nature of printed images glued to drafting film is such that there can be no additions or subtractions once a work is completed. If additional material is chanced upon later, it cannot be included in the design. The nature of collections is such that they are rarely, if ever, complete, and this inventory of images is no exception.

Many cultures develop theories regarding their origins based on observations of nature. Our human identity and place in the world is formed by these notions and determines the course and structure of society. It is important, therefore, to continue to examine the two dominant theories of our time, evolution or creation: chance or design, as scientific evidence can be selected or interpreted to best "prove" either hypotheses.

In the process of researching and collating this body of work, it has been evident to me that the natural world is a manifestation of precision, order, design and beauty of such complexity and ingenuity that it could have come about through millions of chance accidents and random mutations.'

PLATE 46
CHANCE OR DESIGN, 1995
Installation view (detail), comprising 26 individual works, paper on drafting film, each 240 x 102 cm, Courtesy of the artist

All of these works are from the exhibition *Chance or Design*, originally at Ian Potter Gallery, the University of Melbourne Museum of Art, and then touring Victorian regional galleries throughout 1996.

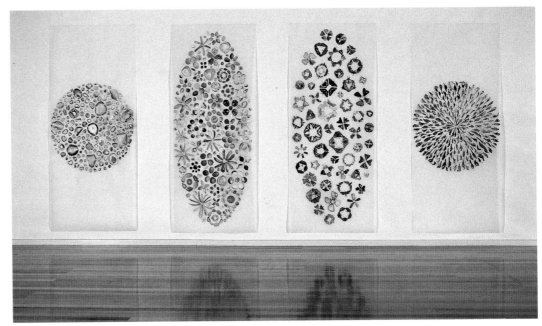

PLATE 46

abstract field. The vertical and horizontal panels and squares of solid colour are strong, bold and solid in comparison, often underpinning the work or implying a cross.

How has being a woman influenced your art — positively and negatively?

After my first show, a critic warned me that my work looked 'feminine'. I was horrified at this description, and felt very vulnerable and angry at myself for not hiding my 'femaleness' better — but I was also incredibly relieved that now the secret was out, I wouldn't have to pretend anymore. My work reflects my life experiences, emotions and intellect. If it shows a female sensibility, it's because I was born female, educated and brought up accordingly, and find it extremely difficult to leave my life experiences outside the studio door.

When I experienced the death of my mother, and the birth of my daughter soon after, I began to re-evaluate the nature of my imagery. From the end of the 1980s broad Christian principles have tempered the reference to materialistic obsessions and an over-abundance of visual stimuli.

What do you see is the purpose and function of your art work?

Meaning and understanding comes from a belief in God, the letting go of self, male/female relationship, parenting, immortality, reflection on one's life so far and the transient nature of individual plans, activities and achievements. The images I use are taken from all aspects of everyday life. Their placement and scale is non-hierarchical, collectively forming an overall pattern or haze. Individually or in juxtaposition, however, they read as metaphors, triggering a range of meaning and analysis. I hope to make these mundane, familiar images profound in their eloquence and simplicity, to provoke the viewer to look beyond the everyday and to think about the meaning of life.

Pat Hoffie

PAINTER, MIXED MEDIA AND INSTALLATION ARTIST, CURATOR

For me, some of the best work has happened in spite of myself. It might
be full of shortcomings and misjudgements, but somehow it seems to
work — it seems to have an energy that is sufficiently commanding
to demand your attention. It's with work like this that it almost
seems like you yourself have had very little to do with it.

PAT HOFFIE was born in Edinburgh, Scotland and arrived in Australia in 1957. From 1971 to 1973 she studied at the Kelvin Grove College of Advanced Education, Brisbane, gaining a Diploma of Teaching, and from 1974 to 1975 attended the Queensland College of Art, where she was awarded a Diploma in Fine Art. From 1980 to 1987 she was also a lecturer in painting and drawing at QCA. In 1986 Hoffie gained her Master of Creative Arts degree from Wollongong University, where she is currently enrolled in a PhD program. She has curated a number of art exhibitions and was associated with the Australian Flying Arts School from 1982 to 1990 — acting as academic adviser. She currently lives and works in Queensland.

Hoffie's more recent imagery and installation work has emphasised collaborative effort and juxtapositions of unlikely materials, media and subject matter — and their associations — with the fundamental aim of challenging existing hierarchies, definitions, artificial separations and power bastions in such areas as notions of gender, culture and identity. Hoffie's work, which is manifold in meaning and frequently has a humorous edge, is art about art and locates its ground in those tense arenas of cultural convergence and clashes of opposites. It seeks to reconnect and re-establish the validity and importance of art and the creative imagination in everyday life.

The artist has had numerous one-person exhibitions from 1974 to 1995 and has also participated in many selected group shows since 1979. She is represented in the collections of the Queensland Art Gallery, the Art Gallery of South Australia, the Art Gallery of Western Australia, the Saitama Gallery, Japan, the Dobell Foundation, Sydney and in several major regional galleries.

PLATE 47

VESSEL, 1991

from the installation *Frames Of Reference* — a feminist survey exhibition organised by Artspace at Pier 4/5, Walsh Bay, Sydney. Champagne glasses, plastic tubing, deck chair, air pump, oil and honey, computer generated images, Courtesy of the artist

'The materials I used in this installation were champagne glasses, computer-generated images, a deck chair, an air pump, plastic hoses, oil and honey.

I chose the word *Vessel* because of the connotations the word has in association with women — that is, everything to be filled…something that needs to be filled. I wanted instead to suggest other connotations — there are four dictionary meanings and the location of the feminist exhibition was a *pier*, which suggested little vessels or crafts — as in boats. The other thing I wanted to suggest was the potential of women to act as "vessels" in terms of conduits — joined to each other like a matrix of connecting tubes. So I drilled all these champagne glasses and inserted wee little phallus-like spigots into them, then joined them all together with plastic tubing. Half of the glasses were filled with oil and half with honey and all the tubes were joined to an air pump so that a slow stream of viscous bubbles moved up through the golden fluid.

I had intended that the whole installation gradually seep and leak — like women do — all over the pristine white floor I had created. However, I hadn't thought fully of the implications of the content. It was only when I had flown home to Brisbane — after I had installed the work — that I realised I had provided a free feed for all the dockland rats of Sydney Harbour! So the seeping and leaking had happened quicker than I thought!

Looking back, though, it was kind of nice in the way you could trace the tracks of the rats — little pads of honey and oil leading into Kathy Temin's furry *Duck/Rabbit Problem* — where they had slept off their feast. The rats had gnawed a little hole into Kathy's sculpture between the head and the beak!

In the end, my installation looked like a wreck — thanks to the rats — but it all seemed quite appropriate, really. In one way or another, rats are always going to be around, and I guess the lure of crashing and trashing a feminist party was always too strong for the vermin.'

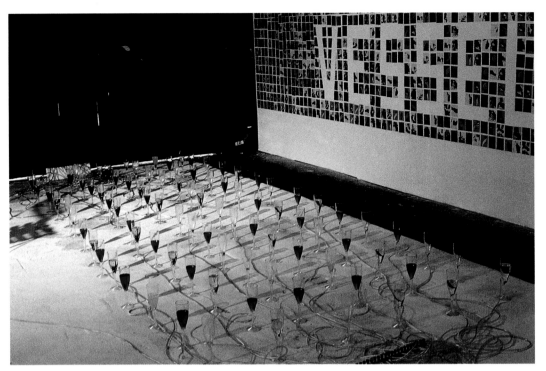

PLATE 47

What have been the predominant formative influences in your creative development and art practice?

Lots of things have influenced me. In terms of art writing, I guess that, to me, Ian Burn has made the most sense. I mean, there has been so much good analytical and critical writing over the last two decades, but Ian's voice came through with an integrity and clarity that made the best sense right here, right now. I guess that if I believed in heroes, I'd pin an image of Ian to my cupboard door.

Some of the writing that's come from the Third World has also been influential. I did a subject in Third World literature the year after I graduated from art college, and I don't think I realised how influential it was — until some of the recent postcolonial writing theorised those diverse texts and art works. Of course, feminist critique has also played a particularly influential role in the formation of my ideas and practice. In particular, feminist critiques of power have fed in to so much of what I've dealt with in issues that aren't necessarily directly associated with gender.

One of the biggest influences on the development of my ideas has also been travelling. The time I spent in various parts of Asia and South-East Asia is now feeding into the present cultural and political climate in productive ways. I mean, all of a sudden 'Let's Asia' is status quo stuff — though I still find it problematic, as any thinking person does. However, there's no solution in staying outside of the whole thing — there's no point in being such a stickler for political correctness that you refuse to engage at any level. So I work through the issues as I go.

How would you describe your typical ways of working — your creative processes? What moves you, how do you structure and feed into your work ideas, time and space.

As I said earlier, often the ideas are being generated within a number of areas at once. What 'moves' me? you ask. Ideas, places, people, passion…all the usual stuff. Sometimes it's just that urge to stop making sense in the sense of 'sense' that the everyday world demands. Making art is appealing in its basic perversity. I mean, it really doesn't make sense in terms of the 'sense' of spending so much time and money on this kind of obsession. So much goes to the wall — too much sometimes! But that kind of perversity has its own appeal — despite the price. Which

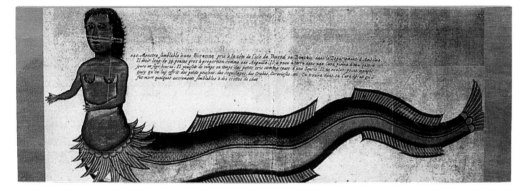

PLATE 48

PLATE 48
THE VENEER, 1991
Computer generated imagery, oil on canvas, photograph
on plywood, Collection: Museum of Contemporary Art,
Sydney, Photograph: Brett Goodman, Courtesy of the artist

'This image was included in *The Veneer* exhibition at
Coventry Gallery, Sydney in 1991 where I was looking
at the way early representations of Australia were
modified according to the assumptions and materials of
the artist/explorers. The materials I used in this work
were oil on canvas, a computer-generated image and a
photograph on ply.

In this image, I included a computer-processed image
of the 'little mermaid' that sailors discovered in the waters
of the southern hemisphere. The mermaid is a stocky
and focused little creature above the sinuous lines of her
magnificent scaly tail. But it did her no good. According
to the records, the sailors fished her from the ocean
and unceremoniously dumped her in a tub on shore.
Her doughty disposition — evident in the set of her
determined little mouth — kept her alive in this ghastly
incarceration for four days after which she simply left
"a few faeces (sic) similar to those of a cat". This story
— an official account — has a certain appeal: that little
"figure extraordinaire" seems an appropriate metaphor
for the women of the southern hemisphere — you will pay
a high price for being admired as a curiosity, so it is a much
better idea simply to shit and leave, no matter what the
consequences!'

leads me to your question about how I 'structure my time and space and work and ideas'.

I live alone now and all my rooms and all aspects of my life involve art in some way — mak-
ing, writing and talking about it. I've got a studio at home — it's there because I tend to be a bit
of a hermit when I'm working and it makes more sense to me to have everything in one place so
that I can potter in the garden while I'm mulling over the next paragraph or the next aspect of
the work. Anyway, the odd thing is that more seems to be done in other parts of the house than
in the officially designated 'studio'. I generally work on a number of things at once, and have
bits and pieces trailing all over the place. And then I'll tidy them all up into something cumula-
tive. The whole process is a bit like foraging — it all seems so disconnected and bitty, and that's
both the weakness and the potential strength of it.

The other part of that doing everything around the house/studio environment thing is that
I'm gone for so much of the time as well. I've tended to travel a fair bit, and the exhibitions I
have had in the last few years have been pretty dispersed. That's been fun, but it's probably
pretty dumb in terms of official professional practice habits. I mean, no one except me gets a
chance to see the work's development from one piece to the next. Anyway, the house becomes

PLATE 49

a kind of charnel house where all the bones of past art exhibitions come to rest — sad, really, but funny too. If I had any brains, I'd burn it and call the whole process truly ephemeral and conceptual! But sometimes you can use the elements of previous work again, and I tend to become such a hoarder — the accumulated work might be of some further use in the future! So you start realising that your environment is stacks and stacks of work produced for other places and times, that it all comes back to haunt you and that you keep making more of the stuff anyway.

What are the meanings and significance of pictorial and symbolic elements in your work? Could you also discuss thematic concerns and abiding interests.

Most of my work is temporally or spatially specific, so I tend not to use elements that simply keep recurring like floating absolutes of personal symbology. But meaning is always important, and it's always attached to the particularities of the context — where and when the work was done — generally, surrounding textual references, groups of ideas, current issues etc…

I guess a lot of what I've done is really ephemeral in that it has been so tied to the particularities of the situation in which it was created. Often I'm writing about the same issues I'm making art about at the time. This used to be a kind of problem for me. People were often saying things like 'You'll have to make up your mind whether to write or to paint', and things like that. But now I don't worry about that so much. A lot of the writing feeds into the painting/installation and so on, as well as the other way around. It's just that when you start getting interested in something, you'll keep at it and at it in a whole range of ways — doodling, writing, playing, painting, reading, talking on and on and on until you've somehow internalised it, worked it through or something.

Sometimes I look back at old stuff and recognise certain continuities — like an enduring interest in the decorative and in animals — both things that don't hold much weight in the serious-art brownie-point lists. In defence of this off-hand observation, I hope that there might also be an enduring dedication to ideas, to the polemical and to humour. I am interested in the impolite rather than the courteous or the rude; I am interested in the friction of opposition rather than the smoothness of consensus; I am interested in that uneasiness where things just flatly refuse to fit.

As you said earlier, feminist critique, particularly that which deals with power relations, has played a very influential role in the formation of your ideas and practice. Are there other ways that being a woman has specifically influenced your work — positively and negatively?

Being of the female gender is absolutely pivotal to everything I do. I mean, how can you be an artist at this point in history and think that your gender doesn't affect the way you come at things? For a start, it just doesn't make sense to be involved in a practice that for so long has excluded your gender from its official accounts. You're aware of this, and so you are also aware of the deep irony of your own drives. Why be so involved in playing the same game — the culture game that has been used as an instrument to marginalise and dispossess and control anything other than the dominant status quo? It's a dangerous dance. You continually risk falling into step with the frameworks that you began by intending to critique. There's also no use falling into the equally dangerous trap of being easily labelled. Once that happens, you're equally as easy to deal with as if you play the complicitous role. So you risk being mercurial or perversely contradictory to the point where you can't be recognised as having a fixed identity.

Lacking a 'fixed' identity is a definite negative point within the art world. The infrastructure works better for those who negotiate a fixed position and then consolidate that position — just look at themselves over the age of thirty. In a culture that is so identity fixated as Australia, it makes much more sense to develop your identity strategy and bastion it. It's no better now than it ever was — just do the statistics on the dropout rate between women enrolled in tertiary art institutions and those who are represented in commercial galleries etc. Have a look at who is

PLATE 49
HEROWALK, 1994
Oil on canvas, 9.75 x 6.75 metres, on Adelaide Cathedral,
Courtesy of the artist

'This image was one of four banners produced for the *Herowalk* series at the Adelaide Festival in 1994.

To produce this image, which is an enlargement of a painting by J.M. Crosslyn (an Adelaide artist) of a local Aboriginal pastor, Samuel Konduillan, I employed the skills of the Galicia family in Manila, who make giant billboards for a living. Members of this family are trained in fine art and are highly talented, yet their enormous and skilful billboard images are not considered "art". However, if I, as a white, Western, "first-world" artist, commission them to produce a work as part of a prestigious international festival, the work is awarded status as "fine art". The irony and the contradictions of the entire system of hierarchist definitions in the art world became part of the content of the work.

The image and text related to the role of the church and the role of agriculture in overwhelming the original (Aboriginal) cultures of this country. The materials I used were oil on canvas on Adelaide Cathedral. The whole process was one of teamwork: working with the Galicia family; getting permission from the Cathedral to hang the banner; the hanging of the banner from the Cathedral using a whole team of people. My own role as "artist" was very problematic — the work would have been impossible without cooperation and collaboration.'

PLATE 50
THE TYRANNY OF APPEARANCE, 1989
Oil on canvas, 183 x 183 cm, Courtesy of Coventry Gallery,
Sydney

PLATE 50

most represented in overseas exhibitions from Australia. Those artists (mostly male) who persist in reifying their own position within art history (often via appropriation or via referential symbolism) and the existing framework of practitioners are far more easily encapsulated in reductive curatorial briefs.

I'm not just talking about a numbers game here. I'm talking about the potential for an alternative politics, where identity is far less rigidly articulated and where a culture learns to value other ways of negotiating states of identity. Traditionally, and practically, women have had to configure their roles in a mercurial number of ways. Women artists still have to grapple with a myriad of ways of negotiating time and space to engage in art practice. This fight of continual renegotiation is not necessarily simply negative — it is never easy — but is the sort of stuff that forges work in a particular way. On the whole, such ways of working are still not sufficiently valued within the visual arts, even though business and the corporate world now seem to be calling for sustainable practices that work across and between disciplines.

Talk about how you perceive your role as an artist — how you see the function and purpose of your art.

Despite the prevalent mood of scepticism on all fronts, I think most artists still believe that art *can* make a difference. I do. I believe that it makes a difference on a whole number of levels.

You give up so much of your life in order to give as much time to doing/making/learning about art as possible, so that it would be almost impossible to be that obsessed without some belief in the worth of the activity you're engaged in.

I believe that art can make a difference to people's lives on a very personal level. I still think that you can have a moment when you see a piece of art that seems to have just jumped straight out of your insides, and there it is, hanging on the wall, or on the floor, or whatever. At that moment, you feel like gasping, 'How did you get outside of me?' and at that moment there seems to be a thread of connection between you and the art and the other person who made it. You can sometimes be surprised at being *connected* to the world in this, actually very mysterious, way.

Of course, it's not always like that. Sometimes art can be powerful in an opposite way to this — it can be so grating. However, even though you may turn away from it, it still seems to have wormed its way into your system. Or it might have gotten caught just under the skin, like an irritating splinter — it just hangs around there until you acknowledge it. And when you do, sometimes something unravels — like a part of yourself that you hadn't recognised before or an underside of a thought that you hadn't turned over for a while.

I guess I'd like some of my art to work in this way. For me, some of the best work has happened in spite of myself — it might be full of shortcomings and misjudgements, but somehow it seems to *work* — it seems to have an energy that is sufficiently commanding to demand your attention. It's with work like this that it almost seems like you yourself have had very little to do with it. This kind of work reminds you that there is something in the art making process that is so far away from making sense and being accurate, which is one of the most powerful things that holds your interest and fascination with the whole process.

I still believe that art can make a difference at a more communal level also. The world of the imagination adds a dimension to life that makes life a far more rewarding experience. For some cultures, it is only this world of imagination that makes the day to day hardships tolerable. This is not a minor thing — it is an absolutely fundamental part of being human. Art is not a 'leisure time' activity — it is an *essential* activity in the process of becoming human. Even so, authorities persist in failing to acknowledge this essential aspect of children's development and include subjects that are considered 'non-essential' within the curriculum.

So I guess this is a long-winded way of saying that, for me, my art is an attempt to keep my faith in those aspects of life that are non-quantifiable and essentially elusive. I guess its like that lower-heart-beat sort of stuff that really keeps driving you, even though it's the surface stuff that appears to listen and hold your attention. In a way, it is to do with the politics of caring. *Care* is such a small word — and it's so unhip — but unbutton it and it is to do with passion and commitment and faith and all that kind of stuff. And even though — on a rational level — you realise the ultimate futility of everything, I guess this little thing of 'caring' keeps the bell jar of futility from descending permanently.

PLATE 51

Inga Hunter

MIXED MEDIA ARTIST

I always feel that the creative mind is a little like a primordial sea.
There are all those things swimming around, and one day something
crawls up onto the bank and grows legs. I find myself throwing a lot
more of them back these days, poor hapless things.

INGA HUNTER was born in England of an English mother and a father of Jamaican and Scottish descent. In 1963 she graduated with a Bachelor of Arts degree, majoring in anthropology, from Sydney University; she was a teacher in fibre studies at Sydney College of the Arts in 1981 and was a lecturer at the City Art Institute from 1981 to 1984. She was instrumental in establishing the Batik and Surface Design Association of Australia and also introduced *shibori* — a complex Japanese tie-dye art form — to Australia. The artist currently lives and works in Sydney.

Inga Hunter's richly imaginative work has covered a wide spectrum from drawing, fibre art, painting, printmaking, photography, small sculptures and mixed media assemblages to talismans, small shrines, jewellery, book illustration and writing. Her most recent works utilise and combine a vast array of media and materials with an emphasis on found objects such as beads, clay, shells, bottles, pins, feathers, blood, bones, bits of animals and various fragments of society's discards. Hunter has created a unique and extraordinary cosmology and mythology called the *Imperium*. It consists of at least five discrete societies (with a sixth in progress), complete with detailed histories — including religion, government, history, geography, astronomy and so on — and art lineage, including designs of magnificently ornamented costuming, such as ceremonial robes, which she has exhibited. Her skilled and intuitively constructed work has a distinct totemic and ritual feel that is more akin to indigenous art and culture but has a contemporary visual culture overlay. Currently she is exploring her African/Caribbean ancestry — particularly its spiritual aspects — in developing her own syncretic religion that combines Christianity with her cultural mixed-blood background into a hybrid 'Afro-Christianity'.

Hunter has had numerous one-person exhibitions from 1975 to 1995 as well as having participated in many selected group exhibitions in various regions across Australia. She is represented in the collections of the National Gallery of Australia, the Queensland Art Gallery, Darwin Museum and Art Gallery, the Victorian National Craft Authority, the Power House Museum, Sydney, the American Craft Museum, New York as well as in many corporate and private collections in Australia and overseas.

PLATE 52

PLATE 53

To begin, could we discuss the most important influences in your becoming an artist and how your creative impulse has developed and manifested in the course of your life?

Like any artist, my creative life has spread over the years and undergone changes as I have grown and as my circumstances have changed. What I see as the most important for me is the division between the years of not knowing who or what I was and the subsequent discovery of these aspects of myself. I was born in England and came to Australia when everyone was Anglo and I obviously wasn't. I suffered constant and often violent criticism in both places for my appearance, dress, attitudes and personality, and to some extent, my work. People do not recognise me as any particular race; they just know there is *something*, and it is wrong (or interesting, depending on the person). This attitude was so effective that for about fifty years I felt I was some sort of Martian, though I knew (or so I thought) that I was English/Australian.

The discovery of my Jamaican family and my ultimately West African background has been a revelation: a division point in my personal and, naturally, my creative life. From being an artist whose work fitted into no known movement or category in the world in which I live, I have found that I am a typical artist of the African Diaspora. There are hundreds of people like me — people who belong nowhere — on the outside, perhaps, too pale to be black; on the inside too different to be white. My use of mixed media and found objects, assembling them largely with thread, bones, feathers, blood, and all the things that people throw away — or find disgusting, the lack of understanding of what is appropriate are common to artists of my background all over the world — we just don't really see them in Australia. And most Australians do not know that they exist.

What and who have been other significant influences and inspirations to your art and how has being a displaced person of 'mixed-blood' or multicultural heritage particularly impacted on your creative expression?

The most powerful influences on me prior to this have been museums, the ancient past, other, strange cultures — anything other than my own, and preferably no actual people. For a long time all my work was completely empty of people, perhaps because they caused me nothing but distress. I studied anthropology and have always been fascinated by the fragments of cultures that we see. We only ever see tangents to the circle of any culture, either in museum displays or in historical and anthropological studies. We deduce conclusions from the flimsiest of evidence: the accidental detritus of the world. And, of course, we lie.

I began to invent my own worlds, revealed to others as museum exhibits, and made in the form of costumes, artefacts, fragments of documents, naturalists' notes. I was God, in a sense, and could create and destroy at will. This was immensely satisfying both artistically and intellectually, and looking back in the light of what I now know, it is obvious that I needed to invent worlds in which I belonged. As a descendant from the wildly contradictory backgrounds of slaver/enslaved, black/white, I belong to neither. I will always be an outsider. Ariel Dorfman says it for me. He was talking about political exiles, but it is just as applicable to the half-breed/mixed-race/mixed-blood (there isn't a proper single word for the concept in English): 'The distance kills you, but it also fertilises you. In exile you are forced to recreate culture. You are forced to surround yourself with it as a weapon and defence.'

I've always done that, but now I *know* I'm doing it, and there's a vast difference. I carry my own world within me. I recreate my own culture.

As you have said, discovering your Afro-Caribbean roots has had a profound impact on your life and work. Have there been other artists, art works, movements or writings that particularly resonate within you?

I have always admired the work of other artists, without having been personally inspired by them myself, with exceptions — Joseph Cornell, in particular. However, the fact of seeing how

all others work is inspirational in itself, even if they don't resonate within me specifically. I do love to hear artists speak about their work, and I loathe critical discussion by others, however good. I want to respond, not to analyse.

Since I have discovered the world of Afro-American art, I am much more personally and spiritually impressed by individuals like Renee Stout, Bessie Hervey, Houston Conwill. I am deeply influenced by the writings of Robert Farris Thompson, who is the most sensitive exponent of African and Afro-American art and philosophy I have ever read. These people resonate within my spirit in a way nobody has before. It is enormously exciting.

What about your actual ways of working — your physical and psychic creative processes?

I would like to be able to say I know where I'm going, but I can't. I only know where I've been — like seeing footsteps in sand, or snow. Because I enjoy intellect as well as intuition, I am prone to fall into that awful creative trap of thinking too much. When I started the *Imperium* series, I tried to create the works to reflect their cultural patterns at the same time as I was making them. This was difficult because I would become all clogged up with anthropological meaning and the visuals wouldn't work. Finally I just did the piece of work and invented its place in the culture later. This is equally important now. I am doing a great deal of reading on African religion, in particular the various syncretic developments of the Yoruba faith combined with European Christianity (Obeah, Candomble, Vodun, Santeria, etc), their altars, and Kongo spiritual Minkisi figures [Minkisi is plural of Nkisi, a vessel with a spirit, made by the Nganga or shaman].

For the past ten months I have been sorting out my feelings about my ancestry, the lies I've been told, the lies of European history, the monstrous treatment of Africans by Europeans, the completely Anglo-centred world view that still prevails. I have had to forgive my ancestors. All this sort of thing stopped my creative process stone dead, and I have been half crazy as a result, even though I normally love research.

I cannot *not* work and still stay relatively sane. Normally I work, and think, or research, all the time that I am not ill. Discipline is something I have developed over the eighteen years since I have had severe Chronic Fatigue Syndrome together with all its attendant opportunistic infections and allergies. I never know when I will be well or flat on my back. (Contrary to popular perceptions one is *not* 'just tired all the time'; it is much more debilitating than that). And I lost the years of my forties almost completely. At this point one learns how to work, and how to choose. I don't see as many exhibitions, movies or theatre as I would want, and my social life is not very active. I choose what is most valuable to me. Sometimes I can only do a very little in a day; sometimes I can go till I drop.

As I get older, it becomes harder, not so much physically, but spiritually. I should be more skilled and fluent, but I'm not. It is increasingly more difficult to have and to realise ideas. That is not to say that I don't have hundreds of ideas, but that I have more requirements. I always feel that the creative mind is a little like a primordial sea. There are all those things swimming around, and one day something crawls up onto the bank and grows legs. I find myself throwing a lot more of them back these days, poor hapless things.

Essentially, I suppose I feed stuff in, let it sit there and rearrange itself, and then wait and see what emerges. Fishing the sea isn't very viable. I quite often have conscious ideas that never work — thinking too much again. Sometimes ideas that I feel are maybe one-off, like the Imperium, which was developed for a particular exhibition subject, turn out, to my surprise, to be years long. I guess you don't have to know how you start, but you must know when to stop — before everything becomes slick. This is where the pressure of the marketplace becomes very hard to bear. People don't seem to realise that artists change. And I change radically, because I get bored easily, and because I am addicted to learning new skills, which I then add to all the others. I sometimes wish I could devote my life to say — landscape in oils — but I can't.

'*Figure of the Bird Goddess* is clearly based on the various Venus figures of Old Europe and has much the same function. She is companion to the dreaded Bird God — the Life function to his Death, the Earth to his bone. She is made with a wire armature and bound with fabric strips, not unlike the way Kalahari Bushmen make their doll figures. Her collar is copper sheeting; she is wrapped in handwoven mummy cloth given to me by a friend; and her pubic area is covered with brass filings (from a locksmith). The stick and paper structure is recycled from some past work.

The Bird Goddess (Iboriis, 12th century Post Imperium) is the mother of all creation, the womb of life, give of life, sustainer, wife to the Bird God, the Destroyer, who takes life and hands it over to his lady to renew as part of the fabric of existence. She is the centre of a cult who worship the Egg of the Bird Goddess — a symbol of ultimate renewal. The goddess represents the fruitfulness and steadiness of the earth, a hope of stability for the terrible unpredictability of the Iboriisi seasons. These fertility figures are widespread all over Iboriis. This is a larger one than is usual — generally the figures are tiny and able to be carried in the hand.'

PLATE 52
FIGURE OF THE BIRD GODDESS, 1995
Drawing. Courtesy of the artist

PLATE 53
FUNERAL BOAT OF THE BIRD GODDESS: IBORIIS, 9TH CENTURY POST IMPERIUM, 1995
Courtesy of the artist

'Every year just before the Hatching ceremony, the people of the Goddess celebrate her death and resurrection. She is the symbol of life's renewal and must be seen to die and be reborn. The ritual death takes the form of a mass launching of little boats all with their tiny mummified figure of the Goddess. Mummies signify rebirth from the egg, so the Goddess figure is always portrayed in this form on her funeral boat. People have developed all sorts of extra myths and beliefs centred round the funeral launchings: prediction of the future depending on where the boats land or if they break up and sink; identification of future lovers etc.

PLATE 54
AFRICA III, 1995
Mixed media: painted wood triptych, canvas, clay,
bottle, herbs, blood, feathers, beads, bamboo, roots,
30 x 34 x 12 cm, Courtesy of the artist

'This is the fifth work in my current body of work. So far
all the current works draw inspiration from Bakongo
Minkisi images. Some of my Minkisi express my own
journey; some simply come from my unconscious. The
altar-like triptychs are painted with patterns either
consciously or unconsciously based on African textiles.
The containers have magical herbs and ingredients sealed
inside.
 Each triptych is made in Jamaica from local Mahoe
wood, so the African–Jamaican–Australian link is
expressed, in a sense, in both materials and concept. Some
of the magical ingredients are local; some come from
Botanicas — shops that supply materials used in
Afro/South American and Caribbean religious practices.
None are prohibited imports and can be bought in Sydney
if you know what to look for. The way I put them all
together is entirely my own.'

Ideas, for me, are a kind of feeling. I never 'see' ahead. If the finished work satisfies the feeling a little — fine. Generally, it only does for a time, and then the itch starts again. I am never very happy with what I have done except during the first flush of completion. Really, I am only in love with what is to come.

My work area is limited: one back verandah, one dirty little shed, one drawing board, and a sheet on an apartment floor — and all the cupboards, shelves, boxes I can lay my hands on. Everyone always covets a large studio, but I know that if I had one, I would fill it up with things picked up off the street, and then I would end up with a tiny little space again. It is just as well that I work small.

Looking at your work and creative life to date, what discoveries have you made, what essential characteristics or insights are revealed about your work?

Over the years I have discovered several things: I am generally a miniaturist. I love detail. I must have texture. I am incapable of working solely in one medium for long. I work in layers on layers; hate to work flat. I need a palette of materials to choose from, which means everything from paints, to old bottle tops, to pastels, to thread, to clay, to whatever. I alter everything; any found object will be painted or altered; I am incapable of using it as is. To hold me for long, I need my work to have a meaning other than just visual. I am drawn increasingly to the spiritual/ ritual/magical. I need disciplines as a sideline — I go to a sketch club once a week for life drawing, and recently I have been drawing flowers, but not satisfactorily, I might add. The regular discipline of work that is not fraught with emotion is satisfying; consequently, I do produce a lot of varied work, which I need to get up the courage to destroy, more than I already do. I like to work fast when I draw, but I have enormous patience for things like beading, where necessary. A lot of my work requires me to sit down and do tedious things to get the effect I want. I do not accept rules or conventions — that is, I do not see why light in a painting shouldn't come from all directions if you want it to — stuff like that.

I don't necessarily know ahead of time whether a work will need particular materials or skills. It happens additively, or maybe geometrically. To take as an example one of the *Imperium Robes*: I think of the concept, a title, create a shape from a basic material and wash it with a dilute acrylic colour to set a kind of guideline from which to work. I make a lot of papers once a year to get qualities I cannot buy. I don't actually like doing it, any more than I really like printmaking; I just want the results. Once the basic shape and colour are established, with the concept in mind I go through my material shelves with a basket and pull out a lot of things I might want to use — fur, feathers, bones, claws, threads, gold etc. I only select from what I can see. Then I take it to a next stage. Then I paint again or work in pastel. I keep going, working in layers until I feel it is finished, line it, colour background papers, mount and photograph it — if I am being disciplined. I tend to work on one or two pieces at once, with occasional drawing on the side as a sort of relaxation.

The very essential and characteristic way I work is to create a layer, then regard it as a completely fresh ground on which to work — repeatedly. I like building up and breaking down. It is collage, except that I either create or alter all the elements. Increasingly, I am limiting my materials to the few things I actually find on the ground or somewhere in the process of making the work, together with joining materials (glue, thread, wire) and colouring agents. I like hunting and gathering, so to speak.

Frequently work I do for fun, or discipline, i.e. life drawing, will move into my main body of work — when the time is right. For instance, at Julian Ashton's, where I go to a sketch club, for a huge number of weeks one year, we had a model I called 'The model with four poses'. I went nuts till I decided to stretch myself better by taking one sheet of paper for two and a half hours and drawing a sort of collage: layers of body parts. It turned out to be fascinating, and led to a series of *Slave Drawings* about the close packing of slaves in the ships that took them to the

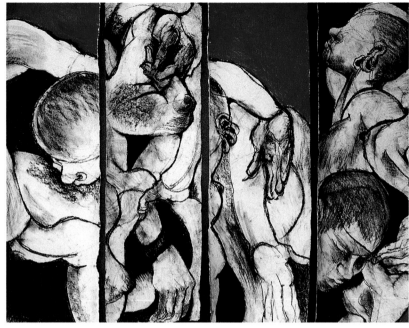

PLATE 55

PLATE 55
SLAVE DRAWINGS, 1994
Charcoal and pastel on heavyweight Indian handmade paper,
sealed with acrylic medium and knotted onto canvas,
approximately 1 x 1.5 m, Courtesy of the artist

'I have always loved drawing, and I invented this means of
presentation because not only are frames expensive, but I love
the shape of the paper as object — and hate seeing it
squashed under glass.

 This is one of a group of drawings done for the last group
exhibition at the Blaxland Gallery in Sydney, called
Passages, in which artists were to choose a piece of text
and make works inspired by their choice. I chose a
passage about the close packing of African slaves in ships
transporting them across the infamous Middle Passage to
the Caribbean islands. It was only relatively recently that
I had found out about my African slave ancestry, and I had
done some reading and was totally horrified to find out
about the vastness, cruelty and horror of a three hundred
year long holocaust, which, amazingly enough, not only
dwarfs the Nazi treatment of Jews in the Second World
War, but has been effectively hidden from most historical
records. I had to come to terms with the fact that I was
descended from both sides. It is a theme that obsesses
many artists of the African Diaspora, because of its power
and horror, and I guess I too shall draw from it for the rest
of my life, in one way or another.

 I am perfectly aware that the syncretisim in my work is
not terribly "accessible" as art — particularly in Australia
where the spiritual tends to be embarrassing, and where
I am virtually alone in my background. Here you really
have to blend in with the crowd. However, I have to be
responsible to what drives me, rather than to an imaginary
clientele. I am an artist, not a performer.'

Caribbean. The creative process is not unlike a sort of loop — you have an idea, do research that
leads to more ideas, and so on. Actually it is probably more like the double helix of DNA —
very complex.

 Sometimes personal life completely changes my work; sometimes not. I've always been
fairly cool till recently, and now (probably since my children left home) I am becoming increas-
ingly emotional and expressing it in my work. The less I think, the more I feel — left vs right
brain, I guess. I have become less adult and responsible, and closer to what I was as a child. I
think it is better and more true, even if I lose and break things all the time and alternate
between despair and elation.

Would you elaborate on the mythic, totemic, symbolic and spiritual aspects of your work?

When I was nine years old, I used to stalk the bush in Turramurra dressed solely in a hankie,
with shield, and spear painted in ochre, burnt sienna, black and cream. Things haven't
changed much. I use earth colours constantly, instinctively. I have always made fetishes, always
loved costume. I have always responded to the ground, the forest floor, earth. These images
and variations keep emerging in my work again and again. The forest floor appears as piles and
rows of diagonal lines. I colour everything with earth and blood. I still do masks, ritual costume.
I found an interesting thing the other day: I have been working in a particular colour palette for
a while — yellow oxide, terracotta, grey, cerulean and ultramarine blues, black and white, and
pink. I suddenly saw the exact colours and my diagonal patterns in a book on West African
painted houses. It was quite eerie.

 For some years now, I have been finding a sort of arrow/tepee/boat shape recurring. After all,
for generations I and my family have been stuffed into boats and sent to places where we didn't
want to go; it is not surprising that the image is there. What I find interesting is that I have used
this sort of thing long before I knew my background. I feel that cultural bonds must go very,
very deep. I paint in patterns rather than forms — triangles, diagonals, spirals, crosses, spots.

 Consciously, I am coming to use some African symbols, in particular a form of writing called
Nsibidi. I've always used crosses, too, only now they symbolise African cosmological concepts
as well as Christian ones. Anyway, when you tie two sticks together, they end up as a cross. I
think that is how I started. I feel entitled to appropriate West African imagery and concepts —
they are mine by right of descent. They were stolen from us. In a sense it is reappropriation,

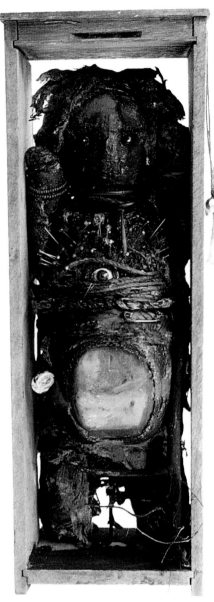

PLATE 56

PLATES 56 AND 57
NKISI FOR MARGARET GIRVAN, 1995

'An Nkisi, as I said earlier, is a significant African object of Bakongo origin — a vessel with a spirit, the outward and visible sign of an inward and spiritual relationship with God — a hiding place for people's souls, a receptacle for sacred medicines given to humankind by God. Minkisi [plural form of Nkisi] are not simple festishes, but highly complex means for healing, honouring ancestors, protection and/or judgement.

My origins are Afro-Caribbean-European, and my Minkisi express the displacement I have always felt, my pity for those of my family who have had to pass for white to survive, the double nature of my descent from enslaver and enslaved and the consequent need for healing.

The Bakongo say that "the man in touch with his origins will never die" and I suppose that in one sense, this is true. It is said that 40 per cent of the downsteram descendants of the African Diaspora came from the Bakongo, and, like the Minkisi that survived the destruction of the French and English slavers, are the relics of a complex and spiritual culture. ➤ p.129

restitution. I could and would not do the same with any other cultural imagery: it would feel wrong. Some African things resonate within me and some don't. There are no existing Jamaican records of where in Africa particular slaves originated, so I am currently responding purely by instinct, and using concepts that appeal to me at a very deep level.

The figures from the Kongo called Minkisi have impressed me deeply ever since I saw my first one many years ago. When I was in Jamaica, I found one lonely in a gallery, and brought him home. You have to be in a relationship with these. An Nkisi is a spirit-embodying figure — as Robert Farris Thompson quotes from a Kongo writer, Nsemi Isaki: 'A hiding place for people's souls, to keep and compose in order to preserve life.' My Nkisi is a little like me — long time out of Africa, out of Jamaica, living in Australia, a creature of no place, with no spiritual relations. I decided that we should create our own relationship anew. And we have. And I am making my own Minkisi. They aren't African, nor anything else, but mine.

Could you describe the cosmology — the Imperium — that you have created?

The Imperium is a politico-economic grouping of the three planets Irusaq, Nrat-Tuan and Iboriis and originated about 1500 Irusaqi years ago. In the distant past the Irusaqi were a nomadic people who put all their wealth into costume, weapons, textiles, jewellery — portable goods — and all their energies into petty warfare, duelling and various sorts of armed combat. The Nrati-Tuan were the first to develop space travel; indeed, it is reasonable to suppose that they had developed it many centuries before, but, for religious reasons (the Wave Dance), at that particular time decided to share their own sophisticated technology with their more primitive neighbours. The influx of hard technology, including space travel, had its predictable effects — Irusaq changed dramatically. Much remained, but a hereditary monarchy was established, the petty warfare ceased and became transformed into formal drama; groups of dissidents fled the more populated areas and set up in the highland forests — to become the Forest Peoples. There was a complete shift in society, and a flowering of talents, as the previous social strata and family nomadic groups changed and reformed.

The changes were too numerous to list, but the greatest of these was the formation of the Imperium, and its great Court, centred at the city of Intuk, on Irusaq. In time Irusaqi society settled back into even more rigid structures, with emphasis on extreme formality, and strictly stratified roles, based on both hereditary status and Imperial positions at Court. Anthropologists still do not know why the Nrati-Tuan, with their obvious superiority, allowed the Irusaqi the enviable position of heading the Imperium. It can only be supposed that the well-known Nrati-Tuan desire to remain secret had something to do with it.

The entry of Iboriis into the Imperium came late into the Sixth Century Post Imperium. It was considered politic to keep an eye on the planet and its warlike inhabitants. Nrat-Tuan, in addition, wanted a monopoly on the trade in wave stones, which they valued highly for religious purposes. The Iboriisi themselves claim that they originate from those free-thinking individuals who escaped off-planet away from the rigid stratified society of Irusaq; however, there are rumours of a great off-planet dumping of dissidents shortly after the first agreements were made between Irusaq and Nrat-Tuan. It is not known which, if either, story is true. It is certainly true that both peoples are human in origin, whereas the Nrati-Tuan are definitely non-human, so the Iboriisi cannot have originated from there.

Absolutely nothing is known about the origins of the Nrat-Tuan. When asked, all they say is, 'The water knows'. Nothing more can be learned, despite the attempts of investigators.

The planet Irusaq is formal, ex-nomadic and includes elements from Elizabethan England, Imperial China, Japan and the Arabs. Iboriis is primitive, animistic and addicted to human sacrifice, using elements of New Guinea, Africa and (white) Australia. They, like Australia, originated as an outcast society, founded by social and political dissidents from Irusaq. They show many of the characteristics of our own people, only set in a 'primitive' framework. Nrat-

Tuan is an alien water planet, with elements of Polynesia, space-travelling Swiss lake villagers, Australian Aborigines, and more. If creativity is taking already existing elements and combining them in new ways — I have done this with social groups, appropriating from everywhere. And at last, I have had the chance to use my hitherto useless degree in anthropology.

Irusaq, Nrat-Tuan and Iboriis orbit two stars. One is an F5 type star, the Voidstar, a bit brighter than our sun — more like Sirius. The other is a small, red star, about one-fifth the size of our sun, known on Irusaq as Inturan, 'The Jewel's Eye', and on Iboriis as Iisa, 'Womb of the Wave Stone'. Irusaq and Nrat-Tuan orbit the Voidstar 150 million miles out and are relatively unaffected by Inturan. On Irusaq and Nrat-Tuan, a year is equivalent to two Earth years, otherwise their planetary climates are very similar to ours. Iboriis, on the other hand, orbits the red star erratically from 14–22 million miles away. The planet goes around the red star in a two-month year, which varies from extremely hot summers and very cold winters to mild winters and very cold summers, depending on the relative positions of the planet and the two stars — this is called the Wave-cycle and it repeats in its entirety every twenty-seven two-month years (about five years of our time). It is this Wave-cycle that causes such havoc with the Iboriisi seasons, so that weather prediction is almost impossible. It is during one of the more severe winters when 'the White star is eaten by the Red star' that debris from the outer asteroid belt falls on Iboriis in the form of 'wave stones'. The land on Iboriis varies from bare, arid desert to lush jungle. Little is known of the planet except its barbaric religion, though young men from both the other planets journey there to prove themselves and to test their fighting skills — mostly to their doom.

Irusaq is a mountainous, rocky planet, much of the known surface area being taken up by steppes and bare plains, with some desert and rich, impenetrable pockets of both temperate and rain forest in the highlands. It is rich in minerals and precious stones, but deficient in agricultural soils, so that the inhabitants must trade for food with Nrat-Tuan, which produces more than it needs. Nrat-Tuan is thought to be 95 per cent water, both salt and fresh, separated by permanent islands, which are the breeding grounds for the giant amphibians and a source of the little timber available on the planet. All the population live on constantly moving, floating islands, from which the rich waters are farmed for food and are electrolytically mined for minerals, particularly silica, used to make the glass houses and boats for which Nrat-Tuan is famous. The whole place is something of an enigma, because the inhabitants are totally unwilling to cooperate with people from outside. Much of the information is guesswork.

How has being a woman affected your career as an artist?

Being a woman, and one of my particular generation and appearance, has quite naturally affected my life profoundly. For instance, I was forbidden to go to art school. I resented this for years till I finally realised that not only was I not strong enough then to fight for myself and would have been coloured by the particular 'style du jour', but also I would not have had as good a training as I have given myself. I have gone to classes not inimical to me, taught by extremely good teachers, and have done so when I was ready for them. I owe a great deal to the various extra-curricular schools, in particular the McGregor Summer School in Toowoomba, where I have learned everything from botanical drawing to taxidermy.

Women of my time were pre-Pill, only a few of us on the verge of feminism. We were all heavily pressured to marry. We had children. We had few labour-saving devices and not many of us had independent transport. We had to get our husbands' permission for medical procedures, credit — you name it. It was like a different planet. I studied, I became a cartoonist, I took up various fibre crafts, I cooked. I used my creativity in all sorts of ways that were not mainstream fine arts and consequently were not seen as valuable in any way.

I was a feminist, indeed still am, but I don't hate men. Men and women are different, but we should be treated with equal rights at all levels. It was the attitudes then that were wrong — and still are — not the creative activities. I don't regret it — although, for many years I felt like

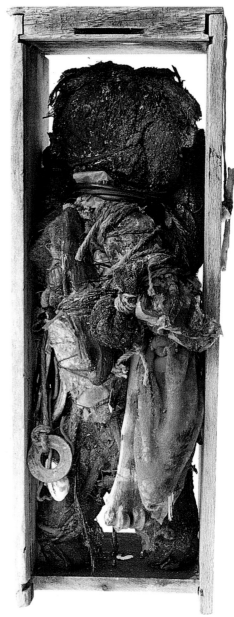

PLATE 57

They are dangerous: "The way of every Nkisi is this — when you have composed it, observe its rules lest it be annoyed and punish you. It knows no mercy." [Contemporary source from Congo]

My first original Nkisi, *Kongo Christ*, reflected both parts of my background — Afro-Caribbean and Scottish Christian. *Nkisi for Margaret Girvan* was my second Nkisi for healing the three Margarets Girvan in my family, who for one reason or another have had to be white. In the belly (which is a vessel) of this Nkisi is contained: photographs of my great-grandmother — the first Margaret Girvan I am aware of, earth from the Darling Downs where she was born. Also inside this Nkisi's belly were little dolls representing the generations, from Black to White, in my family.

I see what I am doing now as a working from my enormously rich spiritual heritage — a kind of Minkisi parallel — composing figure/objects for healing, honouring ancestors, to visit consequences and God's judgement upon those who would do evil, for protection.'

PLATE 58
TALISMAN FOR DIFFERENCE, 1994
Mixed media: collage, paint, beads, thread, pastel, sticks
on paper, 40 x 57 x 6 cm, Courtesy of the artist

'This was one of a series of talisman pieces from my last
one-person show at the Blaxland Gallery in Sydney.
I made it to more or less exorcise the difficulties I
experience in having an extremely colourful personality
and appearance in a country that seems to frown on such
things. It also expresses visually the frivolous part of my
nature — there is a place for frivolity; people tend to be
too serious these days. This exhibition marks the first
time I ever worked directly from deeply personal
emotions. Each talisman marks some specific emotion,
i.e. pain, guilt, healing etc.'

PLATE 59
ROBE OF THE FIRST SHAMAN TO THE BIRD GOD:
IBORIIS, 12TH CENTURY POST IMPERIUM

'The major religion on Iboriis is the worship of the savage
Bird-God. Sacrifice to the God is believed to ensure some
sort of regularity in the harvest (the planet's position and
orbit make prediction of seasons virtually impossible),
so that a series of shamans control the sacrifice and,
therefore, the planet. Delegates to the Imperium wear
Robes of hide, feathers, and a sort of felt — decorated
with amulets, shell knives, trade currency, and other
objects of magic. The first shaman usually wears, on his
back, a huge mask of the God, but in this particular Robe
he simply uses the Sign Disc of the God — very sacred
representations of the practise of 'Stranger Gift'. This
custom, originally thought to be the giving of gifts to
strangers, was later discovered to be, in fact, the giving
of strangers to the Bird God, for the purpose of augury —
predicting the crops.'

a second class citizen without accreditation. You could call it time wasted if you discounted the richness of life as the underpinning of creative expression. I have done everything back to front in one sense, but I am ineffably richer in skills and attitudes than if I had been trained only in painting and drawing and nothing else. It would not have suited the kind of artist I am. And I still haven't gone to art school.

As I said before, you have to forgive your ancestors, and not only that, respect and honour them — whatever they were like. You also have to forgive some of your male (and often female) peers. I do find some of those egos who are too scared to be seen either still learning or doing politically incorrect activities a bit pathetic, because they lose out on all sorts of amazing skills, and an enormously rich life. One painter of ability once said to me: 'You know, if you just did the one thing, you might get to be quite good.' He is wrong.

I am lucky in that I have a single-minded obsession, even if not a single technique. It makes up for the early years, in the end. And I am not handicapped by being too nurturing, so I have been able to work, despite having a number of children over a period of thirty years. I am able to work single-mindedly now they are grown.

People do still often discriminate against women artists. You would have to be Blind Freddy not to see that. And they do use the skills traditionally practised by women (textile techniques etc) as insults against them. But men have problems, too. I have said before that I have been constantly, and still am, attacked for my personality, the way I look and dress. It makes you tough. My family in Jamaica have a saying: 'What don't kill, fatten.' I feel just now that I do not have the time to bleed about the past or the present. I have fought as hard as I could in the past. What I want to do now is to work the best way I can, regardless of whether I am a woman or a man. I cannot think of gender as relevant, any more than fame or vast wealth.

Basically, I've stopped seriously caring about whether people recognise or even see my work or not; and I don't care what people think — although I have to confess I do like some appreciation and/or feedback. But I don't actually seek it out. It is my journey that matters to me. And I either have the next second or up to thirty years left. When I was belatedly starting out at thirty, I felt I was too old. Paradoxically, nearly thirty years on, I don't.

In addition or concomitant with your perception of your creative life as a 'journey' are there other ways you see your role as an artist, and what to you is the function and purpose of your art work?

Other people have also said to me: 'Just what exactly is it that you do?' And I cannot explain, because I'm not anything immediately recognisable — such as a painter. So…I am an artist who works in multi and mixed media, a typical example of artists descended from the African Diaspora, except that most of them live in the USA, South America and the Caribbean. I make drawings, prints, small sculptures, paintings, collages, talismans and small shrines, using dozens of different materials that I buy or find on the ground. I like to assemble detailed, textured works out of what people discard: those objects seen as valueless. I use paint, pastel, thread, beads, clay, blood, shells, bottles, pins, feathers, bones, bits of animals, whatever seems to be right. So far, my ideas are taking the form of small hinged icon-like painted shrines, sheltering painted boxes, bottles, spirit and animal figures, and amulets. I like to think I might make boats, but I truly don't know where I am going in the future.

It gives me great pleasure if my work gives joy, inspiration, instruction or enjoyment. I know that lately some people find it repulsive, strange, aggressive and threatening, because of the imagery and the materials I use. I find this weird, but these are the various ways in which people also see me, so it shows that I am, at the very least, working true to myself. When it comes down to it, I work because I cannot not do otherwise. I am compelled. So I suppose the purpose of my art expresses the stranger that I am. I and my art are uniquely myself. Without it, I would be broken.

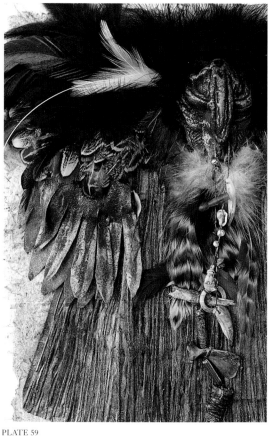

PLATE 59

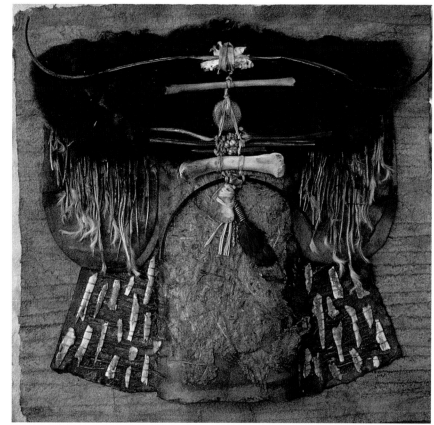

PLATE 60

PLATE 60

AUGURER'S ROBE: IBORIIS, 9TH CENTURY POST IMPERIUM, 1987, Miniature paper costume, mixed media: handmade cotton and plant papers, fake fur, chicken bones, thread, protea stamens, feathers, beads, paint, pastel, 36 x 36 cm, Courtesy of the artist

'This artefact comes from a much larger body of work called *Robes of the Imperium*, a group of miniature costumes and artefacts from several fictional societies. Each item reflects a small piece of the interrelated societies — if you had the complete set of works, you would have a comprehensive picture of this particular world, inasmuch as a museum exhibit gives a comprehensive picture of any society. I am trying to recreate the evocative fragmentary quality one experiences on viewing an anthropological exhibition — the apparent randomness of the discovery of artefacts, and the speculation mixed with hard fact that makes such exhibits so fascinating.

To make the robes reflect their societies, I first had to invent customs to be reflected, and worlds in which there were cultures that had such customs. I chose three different cultures — for contrast — and invented geographical settings for them (I have since added more groups). My son is a scientist and helped me with the astronomy, such as it is. I would say to him: "What sort of a planet would have such erratic seasons that the people couldn't predict the climate?" And he would work out the orbits of various-sized stars and their planets for me. I wrote everything about my world down in a notebook — what, in film, is called subtext — the information that the writer needs to create the work, but that may never actually be seen. So I wrote about art, religion, government, history, geography and so on.

On the planet Irusaq, the individual is subordinate to the role he, or she, plays in society. The Robe is the role; the role is the person. Everyone who takes office at Court is assigned a specially designed, unique robe, which symbolises the position held by its wearer. Because the robe itself is destroyed (returned to the Void) when the wearer dies, it is customary to create a miniature replica for the archives — a portrait, as it were, of the office bearer. This and the name of the incumbent are the only records; no personal likeness is taken.

Delegates from Nrat-Tuan and Iboriis adopt the Robe system for ceremonial purposes and attempt to keep a similar style, if at all possible. These robes, too, are kept in the official archives, deep in the mountains around the city of Intun. The Court and the archives, together with the delegates' quarters and ancillary offices, are probably the only permanently occupied buildings on Irusaq. The populace have, to a great extent, kept to their old nomadic habits, and the cities consist mostly of inns, and rental quarters. The delegates are in residence as long as their period of office lasts — usually about five Irusaqi years.

To make the robes, I first make paper in sheets, from cotton linters, Japanese kozo — the inner bark of the paper mulberry tree — or other plant fibres. The cotton paper is pure white, flexible and unsized, with a rough surface. Kozo paper is transparent; it looks delicate, but is really very strong. My other plant papers tend to be rough textured, hairy and rather brittle. I make all the paper in my garden. It is not sophisticated, but I have full control, and can make paper whenever and however I want.

Each robe is cut out of the handmade paper from a paper pattern and stitched up on a sewing machine, just like any normal garment. The three societies have very different cultures, so their particular robes must show both the differences between the three cultures and the similarities within the one culture. For instance, Iboriisi Robes are primitive, coarse and barbaric, decorated with the trophies of hunting and sacrifice. Here is where the plant paper makes its appearance, mostly masquerading as animal skins, though I do also use fur. Iboriisi Robes themselves are made from cotton paper painted in browns, sepias and ochres. Any bones used come from roast chicken, gifts from friends, very old dog-bone splinters found in the street and sometimes dead birds killed by the cat next door. I clean and dry the bones and smear them with Venetian Red paint, which looks exactly like dried blood. I have a collection of beads, dried plant materials, bits of metal, wood, feathers — anything that seems appropriate. I make fetishes out of threads and bits of stick and hair and feathers, then I dunk them into paint. I spend long hours sewing on the beads and bones, usually in front of television.

Next to the Shaman to the Bird God, the Augurer is the most feared official on Iboriis. His function is to predict the future of the crops at the seasonal Bird God sacrifice by analysing the position and condition of the bones of the sacrificial victim after the birds have had their fill. His magic is complicated and takes many hours to complete on the actual day of the sacrifice, not counting the days of preparation before the event. Because his job is so terrifying, and his magic is so potent, the Augurer lives alone and is shunned by all except the shamans and their helpers. The sacrificial victim must not see him till the actual moment of sacrifice, because the gods demand it; if she does, the prediction will be invalid, the crops will certainly fail.

The Augurer's Robe features a heavy cloak-like collar of beast hair and horns. The body of the robe is hung with the tools of his trade — blooded bones. The central fetish is very important in the ceremony, but anthropologists have not been able to study this more closely because of the secrecy surrounding the whole event.'

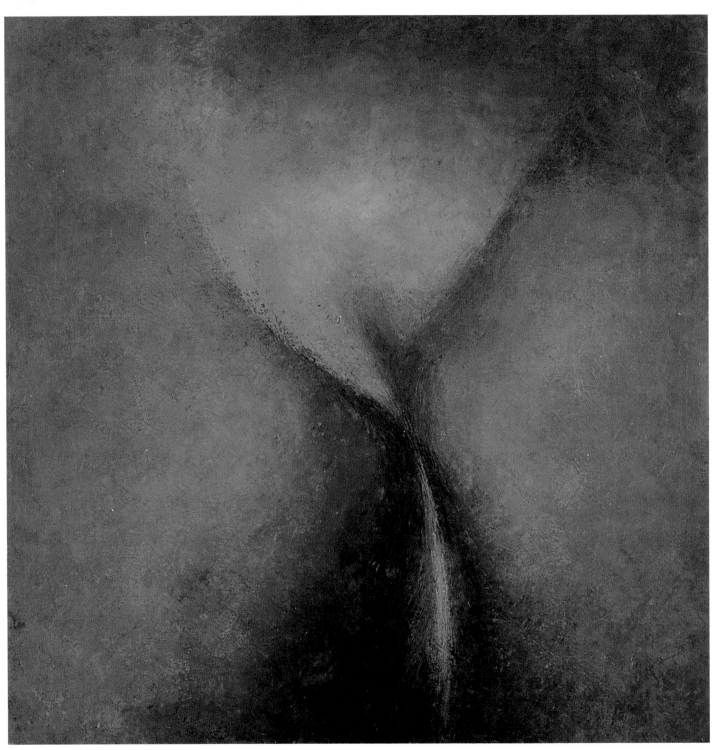

PLATE 61

Anne Judell

PAINTER

*Art, for me, is the mystery itself,
as well as being the means
to explore the mystery.*

ANNE JUDELL was born in Melbourne and studied at the Royal Melbourne Institute of Technology from 1959 to 1962, graduating with a Diploma of Design. She has travelled widely and lived for many years in Europe and New York. After a long period of living and working in Sydney, she recently moved to the Southern Highlands region of New South Wales. As a painter she is largely self-taught.

Judell's intriguing, meditative, abstract pastel and painting works on paper and canvas shimmer and glow with an inner-light intensity that resonates with a spiritual and mystical presence. These deceptively simple and minimal compositions veil the sheer hard labour involved in the intense layering and stripping back process necessary to give a painting a history, to extract essence and to reveal the light held between the layers of pigment. Her art is primarily concerned with light and that other reality that lies behind material existence.

Anne Judell has had numerous one-person exhibitions in Sydney and Melbourne since 1976 as well as having participated in several selected group shows since 1983. She is represented in the Art Gallery of New South Wales, the Parliament House Collection, Canberra, the Latrobe Valley Regional Gallery, the Australian Broadcasting Corporation as well as in other public, corporate and private collections in Australia, Britain, Europe and the United States.

———·•·———

Could we begin, perhaps, by discussing the cardinal influences and inspirations in your creative development. Talk also about your philosophies and concerns as an artist.

My influences come from the east rather than the west, and from poets and writers more than from painters. I find that the influences change, but I have recently been reading the poets Octavio Paz, Jorge Luis Borges and Emily Dickinson and I am always affected by T.S. Eliot and Rilke. C.G. Jung continues to be an enormous influence on my life and, to a lesser extent, Erich Fromm, Chogyam Trungpa, Joseph Campbell, Shunryu Suzuki and Lao Tsu and many

PLATE 61
DREAM 1, 1990
Oil on canvas, 51 x 51 cm, Photograph: James Ashburn,
Courtesy of the artist

'This was one of a series of transitional works that came out of a period of great change in my personal life. There were around fifteen in the series, worked over approximately a twelve month period. All these paintings were done on thick paper and then stretched onto canvas. I love working on paper, as it has great flexibility.

I had just taken studio space in Darlinghurst with two other artists, which was the first time I had worked away from home. It was a positive experiment for a while, but then I realised I preferred to work alone and so returned home. It was during this period that I consciously began attending to, and working on, my dream life. I also became interested in light and matter and light in matter.

As I said earlier, all of my works are about emotional states and when I was doing this "twisted" picture, I felt twisted. Looking at the work now, I see the wrenching, the twisting more clearly, even though it is not an object. It reminds me of the Yin/Yang of experience and the necessity to have both, as in Dostoyevsky's quote: "The awful thing is that beauty is terrible as well as mysterious."

It is only possible for me to think later about a picture, perhaps on occasions before, but not whilst making it. I work very obsessively and I am sometimes surprised by how intense the pictures are. This may seem to contradict what I have said before, but the images just come and I work intently with the materials and they manifest under my hand. However, there has to be some connection with my psychic state.

Up to the time of this series I had been unable to have my paintings similar to the pastels in terms of the layering effect, but the wax medium allowed me to achieve this layering. I could use it as a glaze, using only a very minimum amount of colour. I don't paint in the traditional manner as I never formally learned to paint. I paint with my fingers and use only paint, wax, a rag and a palette knife to scrape back. I think the reason I paint with my fingers is because this was my method with the pastels and I just continued on from there.'

other writers in the areas of psychology, science, philosophy and religion… The Old Master painters Rembrandt and Vermeer have influenced my approach to my work, as has Rothko — though more so in the past than the present. Music is an important part of my working life, particularly Baroque.

The following quotations reflect my attitude to my work:

'Greatness in art is measured not necessarily by how much ground is covered, but how deeply, how fully and movingly it is explored.'

Thomas Albright

'The creative impulse springs from the collective; like every instinct, it serves the will of the species, and not of the individual…it remains the function of art to represent the archetypal and to manifest it symbolically as a high point of existence.'

Erich Neumann

The natural world gives me the deepest stimulation, and frequent trips to the bush are essential. I have been documenting my dreams for a number of years… I like to let my subconscious know that I take it seriously! I discuss them with another person who has a Jungian approach — it's not exactly therapy, as we discuss the imagery in the dreams and we don't analyse them. Like dreams, my images come from the subconscious. I see that the body and the psyche are interconnected and I believe that the *evolution of the soul* is the *purpose of life* and that the 'new consciousness' is perhaps our only chance of survival.

My work is at once an explanation and an exploration of myself. I am driven by the *need to know*. I am fascinated by the idea that we create our world — you find this in the 'new physics', which also relates to what the mystics have said over the centuries. I am fascinated by the way the 'new physics' and mysticism have come together.

My deep interest in Tibetan and Zen Buddhism, as well as my practice of Tai Chi over a number of years has also, no doubt, strongly influenced my work. I don't follow a specific tradition, rather a hybrid of my experiences and natural inclinations — gurus are an anathema to me since having been told what to do by Pope throughout my Catholic upbringing. However, I do meditate and use a mantra — doing different kinds of meditation such as reverie in the bush and near water. The sky is my very favourite thing.

I live alone and I'm finding it much easier than in the past, when it was very difficult. I find more and more peace in solitude. I am forging my own way, I can do no other — that's all there is. My work does not fit into the broader art scene in Sydney. I look at the pictures and they are me. At times, I wish they were different, but I have to accept myself and face the truth that these are who I am. We are alone with 'It' — that is, the human condition — we don't have a lot of company. It is an illusion that we have closeness. Part of the journey is realising we are all One — that we should love the self and hence love others.

Tell me about your typical ways of working, your creative processes — what moves and motivates you and how you feed into and structure your work ideas, time and space. Could you also talk about the physical aspects of your work and your relationship with the materials you use — particularly your special affinity with the pastel medium?

I regard my reading as very much part of my process, as is my personal writing. My time is divided between painting, *staring* at the painting (hoping it will reveal itself to me), writing and reading, and *praying* on the very despairing days. The time given to each of these pursuits varies from day to day and week to week depending on my state of being, which itself depends on which book I'm reading, or the weather, or my dream of the night before. I usually spend the morning collecting my wits, and begin painting in the afternoon — but some mornings I wake with my wits intact… I always work in series, and work on more than one picture in a day. The

PLATE 62

PLATE 62
STILL POINT NO. 27, 1989–1991
Oil and wax on paper, 57 x 43 cm, Photograph: James Ashburn, Courtesy of the artist

'This work is evidence of the struggle to reconcile the finite with the infinite — the image hovering between "being and unbeing". The paradoxical state — the apparent solidity of matter and our knowledge from quantum physics that matter is pure energy. Life is an illusion, as is art — the truth of existence contradicts our vision. Everything is a *process*, constantly moving and changing, and we are part of that evolution that I understand as consciousness.

The works in the *Still Point* series were all done in oil and wax on paper. I mix wax medium with oil paint. As with the pastels, the shape changes a million times. The picture was worked on over a period of eighteen months — layers of wax medium mixed with oil paint, repeatedly applied and rubbed back with a rag, until an image emerged. I don't paint with a brush, I use my fingers. I used to dig in, but it's a softer process now. Colours can change from dark to light. I only relate to the absence or presence of light. The image changes its form many times during this procedure and I stop when I feel I have achieved a measure of…truth?…harmony?…beauty? — never because it is "finished", because there is no finishing, just a continual process.

My life at the time was similar to the pictures. This image has very little light — soft light. I guess you need strong confidence to come up with strong contrasts. I do find the connection between life and art fascinating — what is the art saying? The mystery. I count myself very fortunate to be an artist, because it is so fascinating to produce an image.

All of my paintings are really one painting.

> All in One
> One in All
> One in One
> All in All

adjustment of one enlightens me about another and then I can't wait to adjust it. I always work on a small format, and prefer to use either pastel or oil and wax on canvas.

I started painting in New York in 1979 — I had painted before this, but I date my maturing as a painter from this time. I had only a small room to work in, and a small table. I asked people about the easiest way to start, and as a consequence, I began working with pastels and loved it. I saw the Degas exhibition at the Metropolitan Museum of Art and it excited me. His use of pastel was an inspiration — it enabled me to see what I could do. Also, I had the time just to think and work. I had pads of paper, twelve very ordinary pastels, and I just did hundreds and hundreds of drawings. I covered my walls with them. It was a wonderful experience.

PLATE 63

PLATE 64

PLATE 65

PLATE 66

PLATE 67

PLATE 68

Pastels are a very soft and forgiving medium, so I can let myself go more and work and rework more quickly. They are like magical bars of pure colour, pure light. Translating these elements is, for me, a very intense process, involving the remaking of the image many times over. I like the work to develop a patina — evidence of the evolutionary layers as it emerges from the paper — a sense of history in that time has passed during the making of the images as time has passed during the making of the person and the land. My search for that elusive quality of light is central to my working with this most sensuous medium.

I use a very thin layer of pigment of different colours over each other. I end up with a very complex colour that looks simple but is actually made up of many, many colours. This colour is very dense and the only way to get that density is to use all those colours — blue, but all colours. Every colour is in every other colour. The works are like layers of membrane with the light held within, like enveloping membranes — incredibly subtle.

I need a hard surface, so I work on unstretched canvas and need good quality paper. I work physically hard on the surface, also painting with my hands. I take as much time with pastel on paper as painting on canvas and in both cases I like the history to show through. I like the surface that is emanating light to fluctuate, so that you cannot actually fix your eye on one point without another area coming up — a molecular structure in constant movement, so that light is hitting different things. I work and work to get life and light into the surface, so when light hits it, it lives and breathes and no point distracts. I want each point as dense and as alive as another and I want equal complexity in each point — as in nature.

Because I find it impossible to face a blank canvas, I usually just put any marks on it that I can, to give me something to bounce off when I start to impose some kind of image on it. I then try to expand the imagery, use a different medium, work very quickly and intuitively. I work very, very hard and work on many at once. Then, over a period of weeks, I revise and revise and come back to a very familiar image that I am much more comfortable with. But I seemed to need to go that long route to get back to where I started from 'and know the place for the first time' (T.S. Eliot).

I need to bring the drama in and then tone it down and down and down. I always work like that. Colours are much stronger in the beginning and then are worn away, worn down, sort of matured or mellowed. I like my drama very, very subtle. I like the changes to be so infinitesimal that the faintest nuance of a mark is heavy drama within the context. I can't bear the obvious. Some paintings are worked over eight years, some one year. I give the works lots and lots of time, quiet time, because it also takes a bit of work to let them come to you. I will not be easily seduced. Contemplation of issues of life does lift the soul but slowly. So time and effort is needed.

I have a constant and long battle between *what I am thinking I want to say* and *what it is telling me it needs me to do to make it whole*. It is a long procedure of will and trust and faith and despair and exhilaration, and on it goes in a cycle — until, at some wonderful point, you realise there is nothing more you can do. Painting is exhilarating when I am not in despair with it. It is sustaining like food. If I don't do it for a while, I feel unconnected with myself.

On the surface, so to speak, your paintings are all essentialist abstractions with a central emphasis on light. Could you talk about the underlying meanings, intentions or aims in your works, including personal and transpersonal or spiritual/metaphysical details if possible?

All the paintings are about energetic states, emotional states, and it is difficult to separate the personal from the transpersonal. The images are metaphorical and symbolic and deeply felt. I am interested in essence…the 'is'ness of things. The contradictions of simplicity/complexity; energy/stasis/entropy; the inevitable paradox; the tension of holding the opposites; the attempt to give form to that fleeting reconciliation; holding time in timelessness; *the illusion of creating and holding order and balance within the chaos*…the sheer agony and ecstasy of it.

Truth and beauty are the most important words. In a sense, they are highly religious paintings — dealing with wholeness, awe and a celebration of the mystery of life. Having a Catholic upbringing made me confront death very early — knowledge of the soul, the part of me that is connected with the whole, ritual, sacrifice, the 'otherness' of life.

Who is the I? It is a process of allowing myself to be a vehicle for expression rather than having my ego get in the way. On a bad day the ego still gets in the way and the image becomes *my* expression and I become really precious about my work — but it is the sacredness that is really precious. I am changing, though — I am now getting more detached from the work as I go along, and by the same token — perhaps paradoxically — it is becoming more and more important to me. I take it far more seriously and far less seriously at the same time. I now look forward to what I am going to make — it is like an inspiration. In some way, the images aren't made by me but are made by some archetypal force.

PLATES 63–68
THE DANCE SERIES, 1980–1991
Plate 63: *The Dance 14*, pastel on paper, 36 x 29 cm; Plate 64: *The Dance 6*, pastel on paper, 35 x 28 cm; Plate 65: *The Dance 10*, pastel on paper, 30 x 24 cm; Plate 66: *The Dance 13*, pastel on paper, 37 x 28 cm; Plate 67: *The Dance 7*, pastel on paper, 30 x 24 cm; Plate 68: *The Dance 4*, pastel on paper, 36 x 28 cm, Photographs: James Ashburn, Courtesy of the artist. Part of an exhibition with James Gleeson at David Jones Art Gallery in 1991.

'I had worked on many images at once and over a long period of time. When I found one that felt strong and complete, in the sense of having an equilibrium, a clarity and strength of light, enough form and substance — but not too much — I would try and bring all the others up to that level. This is how I work on all my series. It is a constant readjusting of one against the other; I keep working and working until I feel they are in an even state. Light is the major concern and colour comes after that. If I have a colour in mind — say a strong blue — maybe another picture would become grey to give that life. So it's a question of lowering and reworking and reworking until there's some sense that it's "right". It is not an intellectual or rational decision.

Some parts of the series I worked on years before the exhibition. I had worked on them periodically over some years; though, there was always some element of the original work left that I recognised. This series, as in all of them, bounced off itself. Again I built up the layers and then pushed right back, and then built it up again. Sometimes the paper gave up on me. I suppose it is sort of a continuum. Sometimes you need to push something to an extreme to capture something else. It's the pattern of my life. I don't always work like that, but there is always the putting on and the taking off, putting on and taking off. I never just build up and up and up.

No. 14, dated 1991, is a very old pastel. I started this work in 1980 and it only just survived. The paper is very thin and fragile and, because of this fragility, the surface is very fine and vulnerable. The changes are very subtle. It is like an old friend — we've been through a lot together. The colour is like a skin. I like the colour to become one with the paper — then it is like a skin rather than like something sitting on top of the paper.

The Dance refers to the dance that T.S. Eliot describes — all the pictures are about the cosmic dance — the fact that everything is in constant flux; there's no solidity or solid matter, it is just an illusion. I try to show this by alluding to a solid form, but it is not — the layers show the movement.'

My aim is to develop *a sense of light emanating from the pictures*, which is attained by the tones I use and the juxtaposition of tones. I achieve the effects by using oil paints mixed with the wax medium, and I use many, many layers, one over the other. The light only emanates from the work when it feels as if it is *held between the layers*. Obviously it is not just an optical illusion. I like the image to look as if the light is coming from within it — that it's not cast from the side or the front, casting a shadow. The light is not strong, it's refulgent. I also like the light to be blocked out by the form and to emanate around the edges.

Elaborate further on the symbolic and archetypal aspects of your pictorial spaces.

I am intensely interested in edges, where one thing hits another — very sexy — the transference from one area to another, that leap, that change. There is a softer, strange light on them — ambiguous, definitely there, but hard to define exactly. Where the earth meets the sky or the sea meets the sky has always fascinated me. Out in the desert where the earth meets the sky, it is always white. And the flatness of it and the emptiness behind it and the night sky, the sense of the huge emptiness compared to the solidity of the earth, the worn-down rock. I love that juxtaposition of the hard and the soft, or the unyielding and the yielding. The earth is so solid and hard. One could see the image in terms of the earth and the sky, or the sea and the sky. The image of the object in the landscape or the object on a table.

I have tried to make a picture of a place that does not exist — a place deep in the psyche — *a secret hidden universe*. But I also strive to evoke a sense of place — the empty, old, worn-down landscape that is Australia, which has a unique sense to it. There is a brutality here as well — a very black sky and a very old land that has been exposed to blinding heat and all the ravages of nature — worn into a beautiful state through the pounding of time. The land has survived and there is a peace gained through the ravages and trials. My work is informed by being out in the desert. The light out there is indescribable. I guess you cannot divorce the light from the emptiness and the sound of the silence. It goes together to create an ambiguous mood, alienating and enveloping at the same time. I try to get this into my work with the other paradoxes: joy and sadness, light and dark, agony and ecstasy. There is balance and order, mystery and clarity and light in the darkness. The light is never natural — it doesn't come from any particular source. I like to feel that the light is emanating from the object itself — the moon is a mirror with an eerie quality of light. The light is a metaphor for knowledge and understanding and black is ignorance and the darkness.

I keep coming back to the cross. It is something that is unavoidable to me. A block on the horizon — a cross. I can't bring circular elements into my work, no mandalas.

Shimmering light was a departure — organic shape not geometric, not edges. It has now become a glowing ember rather than a flame — a quieter, more deeply burning light rather than a flash of light. Sometimes I think the images look very lonely and alienated. Sometimes they look very grey. Sometimes they look very secure and very much a part of their place. I like them to have all these qualities — for each of these things to be valid.

How has being a woman specifically influenced your work — positively and negatively?

The negative aspects of being a woman and a painter are far outweighed by the positive. I started taking myself seriously as a painter relatively late as I had spent so many years seeing my primary role as that of wife and mother, which precluded the intense concentration necessary and the solitude and space to think. Though, these years gave me the necessary experience and a degree of maturity to bring to the work (not to mention two wonderful sons). Women are able to bring to the subject those particular feminine attributes of receptivity, nurture, deep connection to the earth. I see the spirit as masculine and the earth as feminine. I think that it is imperative for both male and female artists to take on the task of developing this

feminine principle. For far too long the balance has been tipped in favour of the masculine, with disastrous consequences for the earth and a great deal of soul-less art.

How do you see your role as an artist and the purpose and function of your art?

My concerns have been the same since I started painting seriously in 1979 — not to entertain but to confront us with life and death. I reflect things that a lot of people will not want to look at: death, the paradox, the condition of humanity — to bear it, deal with it and accept it.

I used to think I was painting to show people something, but I have since realised that the purpose of art is the doing of it. My relation to the art is the only reason for its being. My responsibility is to me and to it, not to anyone else. The work itself is the reason and the purpose, it's part of my development. My responsibility is to myself and if it mirrors my own psyche, then it is teaching me.

I would ask the viewer to spend time contemplating the images — to use them like a candle flame and be aware of what responses and feelings the pictures engender. I think making art is *a sacred act* and my hope for my work is that it resonate in the soul — that I communicate my awe, reverence and love of this mysterious life.

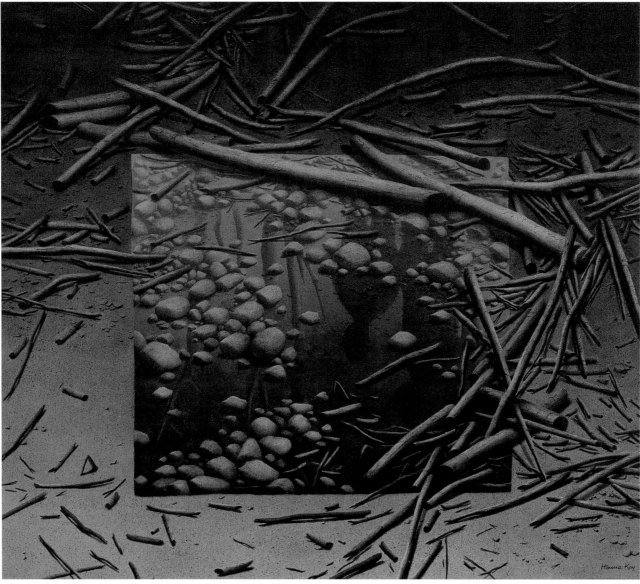

PLATE 69

Hanna Kay

PAINTER

The moment I approach a painting, I think — where is my source of light. All the volume, all the composition and the form depends on the light source and the place of that source — without light we have nothing…

HANNA KAY was born in Tel-Aviv, Israel and in 1971, following her first one-person exhibition there at the age of twenty-three, moved to Europe and studied at the Academy of Fine Arts in Vienna to further her painting technique. She was also the co-founder of the Centre of Art and Communication in Vienna and produced stage and poster designs there for various theatre and dance companies. After a series of successful painting and drawing exhibitions in Austria and Germany, Kay transferred her studio to the Soho district of New York. She moved to Sydney, Australia in 1989 — where she currently lives and works — and received her Australian citizenship in 1992.

Hanna Kay's exquisitely detailed and skilfully executed images use fine draughtsmanship and a special technique derived from studying works of the Old Masters. At a cursory glance, some look like photographs or photo-realist works and only on deeper investigation reveal intricate complexities of perception and perspective. This technique she then applied to landscape painting, with particular emphases on time, movement, stillness, alternative dimensions, colour relationships and extending the work's narrative beyond the confines of the pictorial space.

Essentially, her quite powerful works are addressing the workings of universal laws and the vitality and inter-connectedness of all life forms — whether expressed in a work on the human body, an archetypal goddess image, a tree or a mysteriously depicted and somewhat foreboding shadow figure subtly juxtaposed in a richly coloured, earthy — usually autumnal gold-brown — landscape featuring sand, puddles of water, stones, twigs or bones. If a viewer openly spends time with one of her works it is possible to begin to feel a disorienting, perceptual re-organisation on the subtle levels of one's being. Kay is concerned with transforming complex ideas and imagery into seemingly simple but strong images which, with contradicting and paradoxical perspectives, are constructed to attract aesthetically and then jolt the perception of the viewer into seeing anew the familiar natural elements that constitute our everyday lives.

Kay had her first one-person exhibitions in 1970 and 1971 in Tel-Aviv, Israel and during this time also illustrated a book of classical erotic poetry. She had several other solo exhibitions

PLATE 69
JUXTAPOSITION IV, 1994
Oil and tempera on board, 120 x 165 cm, Photograph: Sage, Courtesy of the artist

'This painting is basically about light. *Without light we have nothing* — we have no shadows, no objects and we are unable to see anything at all.

In *Juxtaposition IV*, there is this one branch that goes in between the two landscapes — one landscape around another inset one. It is actually coming from the back of one landscape onto the back of another. The back of the middle landscape has a deeper space than the one around it, and there are two different light sources — one in front and one in back. The light source on the branch that overlaps both landscapes cannot be in either space because it wouldn't be convincing in many situations, so it is a totally different light source. Also, the way it comes into focus is by coming closer, but it still has to go back as well. The kind of complexities to solve in painting such a picture is where the difficulty arises — which makes it arduous for me to paint and also satisfying when I succeed.

I did the painting *Juxtaposition IV* three times because I needed to correct it. Definitely I know how to paint certain things, but this is in a way a problem, because I know — in every painting that I paint — I can reach a certain technical level and that it will look good. However, my question is — is this really what I am trying to do? Having a good deal of technical skill also has elements of a curse, because I can get carried away with the technique and the sheer ability of knowing how to paint. I recently destroyed a painting because of this wonderful ability to paint — when I looked at it I thought, "It doesn't work". Every element in it, every part of it, was beautifully painted, but the whole thing together, to me, was horrible. So I can have a finished painting and look at it and see that it is technically wonderful and nobody would ever know that it is not what I wanted to do — that is something between me and the painting only. However, if I know it is not what I wanted to do, the painting looks horrible to me, even if everybody else thinks it looks wonderful.'

between 1974 and 1984 in galleries, museums and universities around the United States and Europe, returning to Israel for further exhibitions between 1986 and 1987. During this time she was also deeply involved with environmental projects that took her to a number of cities in the northern hemisphere, including New York, Frankfurt, Heidelberg, Amsterdam, Vienna and Toronto. The work included extensive lectures and slide shows. She was also co-founder of the Computer Art Foundation, New York — research and development, in conjunction with both New York and Massachusetts Institutes of Technology. Kay has also participated in numerous group exhibitions in many of the above countries from 1970 to the present — establishing herself further in international contemporary art. She had her first solo exhibition in Australia in 1989 in Sydney followed by others in Adelaide, Melbourne and Queensland. She is represented in the San Francisco Museum of Modern Art, in the IBM, Warner Brothers and Omni collections, and in numerous private collections in Israel, Austria, Germany, the United States, Mexico and Australia.

———◦•◦———

Could we begin by talking about formative experiences and influences that have been instrumental in your creative development — significant places, seminal works or writings, the key people, philosophies and inspirations?

> A poem, a tune, a dialogue, a journey
> A cognition that kindles a creative passion…

Every aspect of my life is a source of inspiration: a fusion of biographical experiences, inner reflections and drive and the spark of the creative moment that ignites the artistic process. Personal experience feeds the overall direction and the images.

Growing up in Israel was an endless confrontation with social, political and emotional issues — fears of war, a daily struggle for both collective and personal survival and the joys of interludes that triggered a quest for comprehension. The 1967 Six Day War, in which I served as a soldier, shook my beliefs and brought about a desire to understand and express the puzzling nature of human behaviour. Images of unclaimed corpses on the endless desert dunes prompted me to turn to art as my salvation. The potency of these impressions have underscored my use of painting as a language — though the impact of these images does not diminish other events and people that have influenced me.

My first encounter with paintings by the Old Masters (the originals), in the museums and galleries of Europe, resulted in a strong desire to perfect my skills as an artist. And the works of Bacon, Goya and Monet inspired a wish to create works of art that would bear witness to my inner strife and would give birth to a new pattern of emotions and thoughts in the viewers of my works. Dialogues with artists, writers, poets and musicians have been an essential part of my creative development. Some, such as my teacher Ernst Fuchs, have influenced my artistic decisions, whereas others have set clear examples of how not to be.

A fence or a broken branch can provoke an image. An essay by Sartre can spark an idea. A poem by Octavio Paz can send me to the easel, such as:

> 'I walk behind the murmur,
> footsteps within me, heard with my eyes,
> the murmur is in the mind, I am my footsteps,
> I hear the voices that I think,
> the voices that think me as I think them.
> I am the shadows my words cast.

Octavio Paz, from *A Draft of Shadows*

PLATE 70

PLATE 70
FORESHORE, 1993
Oil and tempera on board, 92 x 122 cm, Photograph: Jill
Crossley, Courtesy of the artist

'In *Foreshore*, there are two separate perspectives — one is
the shadow that is cast on the man holding the stick and
the other is the landscape upon which the shadow is cast.
The pebbles are much bigger and the shadow would not
normally be cast like this — it would be much bigger or
the pebbles would be much smaller. So here I had to
solve one perspective of the landscape and the other
perspective of the shadow. Then there is the solving of the
colour relationship between them — where the light is
and the way that it falls. So this is quite a complex image,
and although you can see a lot of details, the details are
the fun part compared to the rest of it.

In terms of my perspective, I am standing above.
Actually, in all of my paintings since the trees, I am
standing above and looking down, and I hope whoever
looks at the painting also has this feeling. For some reason
I find it very disturbing and limiting to have a horizon line
in my work these days, and I don't know why. I think the
way I paint definitely creates more space — the painting is
not closed and you can travel wherever you want in the
image; you can imagine whatever you want with no
finishing point.

The shadow — especially the man and the stick —
introduces the figure. With the stick, there could be a
continuation to somebody who stands outside and is
doing something. That is, you have the stick that is in
the painting and you have the figure, who is holding the
stick, outside the painting. This conception gave me the
opportunity to extend outside the painting and at the
same time have a whole environment inside the painting.
I wanted the effect of an installation without actually
having to have the people standing outside the painting.
I was very happy when this image emerged, because I
thought I was successful in achieving what I wanted to
create.

In an attempt to jolt the mind, I have about three or four
different points of view and three sources of light in a
painting, and you don't *know* their sources. Then there are
all these dimensions and situations that are impossible —
but they look very possible. So I really want to deal with
all these impossible spaces. Again I can have two shadows
being reflected, but for me it was more the relationship
between the colours and the space than whether there
is a reflection or whether there is not. It is the same with
the shadows, because it is a different situation when
something is reflected than when something is being
cast upon.'

The desert — with its arid mountains and crevices — the forest, the gorge and the puddle, to
name just a few of nature's phenomena, as well as poetry, mythology, science and literature are
my primary sources of nourishment. I don't make a conscious effort to use the impressions I
acquire in my work; rather, I let them ferment in my imagination. I find that distance gives me
a better understanding of a particular perception, and this provides me with a less subjective
affinity with the idea. 'What seems like sudden insight…may be misleading, and must be
tested soberly when the divine intoxication has passed' (Bertrand Russell).

Over the years people, as well as adverse social and political events, have helped to define my
philosophies and objectives. Rather than depicting ideologies or conflicting situations, though,
my interest lies in fostering an alternative and focusing on the core of sensory expression.

*As you have said, a fleeting image, a poem, a natural spectacle can kindle a spark for you.
Can you further elaborate on your creative processes in your typical ways of working: what
motivates you to move from impulse, idea or feeling to form; what are your pre-eminent
concerns and how do you feed into and structure your work concepts, time and space?*

If I could easily outline in words my creative processes, the moving forces, or the nature of cog-
nition, I would have taken up writing — it is this very lack of vocabulary that made me turn to
painting. The creative moment is kindled by a conscious survey of those options available to
me that have certain analogies with the images I want to paint — through this process, I make
my decisions. My inspiration can come from a natural spectacle — scenic or human — that I
will then translate, organising my impressions in the studio. I don't need contact with the
object, as my modes of expression follow inner reflections and patterns of thought.

I'm not interested in painting the human figure, depicting landscapes or still life —
although I use them in my work. It is my curiosity with the nature of our existence, with the
timelessness of space and the nature of light as a filter of time, that dictate my preference for
particular elements. The scenic fragment, the disproportional shadow, the reeds, the pebbles
and the logs congregate in a frozen moment to imply different points of view. The image is not
a reflection of what I experience while painting it. When painting, my concerns are simply
aesthetic — balance, composition, colour relationships, tension between forms, movement,

PLATE 71

light and shade. It is a process of amalgamation, where everything contributes — even the size of the canvas.

In Vienna, I studied the techniques of the Old Masters, and later modified them to suit my needs. I use drawing as an *immediate* medium, a direct transcription of my perceptions, which enables me to develop my convictions. Using pencil or ink, I search for the shape, consider the quality of the light and decide on the characteristic atmosphere. Drawings and watercolours will serve either as an end in themselves or as a groundwork for oil paintings.

How do you initially approach a painting?

The moment I approach a painting, I think where is my source of light. Is it going to come from the back or elsewhere, because this factor changes the whole composition of the painting. For example, the moment I want to paint a figure, I think — if the light comes from behind it, you can't see the face — and I work from there. All the volume, all the composition and the form depends on the light source and the placement of that source. Now, every object has its shadow, so the moment the light comes from the side, the shadow falls onto a particular place. I then have to take into consideration what objects I will put in that space, how the composition will go with the shadow and if that will create too much tension there or not. So basically, this is the first decision that I make after I decide what subject I am going to paint. After these two decisions are made, I decide where I will place the subject according to the source of light and if, for example, the shadow falls in front, that means I need more space on one side and so on.

In painting, my choice of colour follows no preconceived plan, the shades dictate themselves instinctively. I apply the first layer of colour with broad brushstrokes guided and contained by the outlined features. To achieve the illusion of real situations, I use an elaborate method of oil paint alternating with white tempera — which, rather than being an exercise in dexterity, is an important factor in the search for harmony. As the painting progresses, the colours change: from monochromatic yellows to primary-colour abstractions, through to the final consolidation of detail. The surface quality of the colours is essential — I give them a transparency, superimposing them so they can act together. The resulting hues are probably the best indicator of my aesthetic and emotional state at that specific time.

All of my works have fundamentally the same process. I start with a dark canvas and I build the composition — the major elements that I decide to use — basically drawing the elements in white…well, I don't actually draw them, but rather, I put a light on them, thus illuminating the image. I then start putting colours on the surface, followed by applying a yellow all over the canvas. I then start 'throwing' colours. I become so absorbed in the process that I don't remember all that I did afterwards.

The moment I put the first details down — like the dark, then the white or light — I frame in my mind what I am going to do in that instant and start throwing colours quite wildly. You don't see this process later — even I don't see where I have been. I already know where I want to go, so I give myself the guidelines — the light in the dark — then I start building it, and in that process I begin finding 'it' again. When I am doing a work, it is always changing and, because the decisions are momentary ones, I never really know what the final colours are going to look like. The final stages of a work are really when I figure it all out and then go into all the details that you see — which is the fastest part of the entire process and is the bringing of ideas, image and processes together.

People ask me all the time how I have the patience to paint all the fine detail in my works. Although it is a conscious decision to have fine surfaces in my paintings, and it looks like there is a massive amount of detail, this doesn't take me as much time to complete as the earlier complexities, which are not visible in the completed work.

I always work in the studio and I don't have models. I work with the imagination, but with elements that are familiar to all of us. I don't have the stones or reeds or sticks, or whatever

objects I am working with, in front of me whilst I am painting them. I collect some of these things, but I don't paint them. I will also take photographs when I start to become interested in something, but the moment I press the shutter, it is like the image is then in my mind and I don't have to look at the photographic image again. It's funny, too, because there have been many times when I'll start painting something and I'll think it is totally fresh in my imagination and I have never even thought of it before and then I look back in my journal and can see the origin of the idea sometimes years before — which I had forgotten on a conscious level. My journal/sketchbook is the most accurate record of where my mind is/was at any given time because I will usually make a sketch of an idea the instant I have it, then let it go.

When I start doing a work and it doesn't flow and I try to force it — even if I know the idea is good (and it has to be good, otherwise I am not interested) — and the end result looks controlled or contrived and not what I am trying to achieve, I will leave the work and forget about it. I can get very frustrated and even after years of practice and being very skilled as an artist, I can feel very incompetent at these times and think that I'm not very good. All these doubts come in and then I recognise that the whole experience is about learning that I can't push some things — I have to just let them be — even if it is the most wonderful idea. It is better to write it or sketch it a little bit, and then a few years later it will come out and there it is, ready to be completed. This process happens all the time. I should feel very comfortable with my technique now, but I am not, because every time I pose a new challenge, I experience the same problems all over again — going through the doubt, the feelings of incompetence and so on, because I'm not able to achieve something I set out to do at the time. This experience is never ending and is always part of my painting process.

Could you discuss the metaphysical/spiritual dimensions in your work?

There is the symbolic meaning of light — wisdom, for example — but I am very cautious about defining my work in a spiritual sense. Everywhere you go, in every country, the moment you start talking about the origin or the source — especially the spiritual context of things — you immediately get resistances and antagonisms. Or you can get interpretations that are very phoney, because you are entering realms where words can't really be applied and things are difficult to pin down. The moment I start defining my work spiritually, I lose the whole thing. I love it when people come to me and say 'your work is very spiritual', because I then understand that they know where I am going — but I do not want to put words to it. It is similar to another thing I do not like saying, which is related to the concept of artistic talent as *a gift*.

Some people, who have read things I have said about my work, have asked 'Why don't you say anything about the "creative gift", because art is basically about having this talent, this big gift!' I reply that I can appreciate that it is a gift, but from whom? So saying it is a gift is, on one level, shedding responsibility. It is like saying I am not responsible for my achievements — somebody gave it to me — and thus you can become very arrogant. On another level it implies a 'chosen' person. A lot of artists tend to have this attitude of being 'gifted' and I'm not so sure we are such chosen people, except perhaps that many artists seem to suffer a lot. So the implication is that you are given this gift because you are a chosen person to God — or a certain energy. It doesn't matter if I believe in it or not, but these are areas of caution to me.

The work I am doing now is much more difficult because the concerns are basically aesthetical — that is, the relationships of colours, of form, of composition. What I'm doing with the different perspectives in my current paintings is really like I am trying to paint the impossible. I actually have five or six dimensions going on sometimes and it should be impossible to do, but somehow I'm succeeding in doing it.

Can you tell me more about the meanings and significance of pictorial, archetypal and symbolic elements in your work?

PLATE 71
AFTERMATH, 1992
Acrylic and ink on board, 78 x 93 cm, Photograph: Sage, Courtesy of the artist

'Being an earlier work, *Aftermath* was a different technique than *Concave–Convex* or *Juxtaposition IV*. It is perceived as being only black and white, but actually there is no black and no white in it — only shades of grey. Also there is cross-hatching in fine ink in this work. Black and white has been a love of mine since I started working. I did only black and white works for years and I constantly go back to working with it because, somehow, when I achieve a certain image, I can see all shades of all colours in it. It is more difficult to attain a black and white effect using only shades of grey, so it is very satisfying to achieve this. Generally speaking, though, people find it more difficult to respond to black and white art works. For me, however, working in black and white is often more fulfilling than working in colour — even though I love colour. I think this is because it is more challenging to get the spaces and the colours using only greys.

I can feel the space in this painting and I can really feel the heat of the log, although technically it is just white. I can also feel the warmth of the landscape with the rays of the sun, though again, it is a kind of contradiction — working with an apparent coldness in the absence of colour. There are no colours whatsoever in this work, yet I can feel all these colours. If somebody else can also, it is another story. Somebody actually came to me once (referring to another black and white work) and said, "It is very clever the way you put the pink halo on the log", and I told them that there was no pink or any other colour in the painting, only shades of grey.

The cross-hatching is really painstaking — in a way, it is almost like automatic writing. However, it is not like therapy and not like meditation, because I am not relaxed. I go at it, sometimes quite wildly, until I am finished. I cannot stop, it is like an obsession and I cannot think of anything else while I am doing it. It is not like mechanically doing one line after another — I do follow a certain texture in the painting and try to bring out certain details in the technique of the surface underneath, so the concentrated effort required is very absorbing. I have not figured out why I am so obsessed with cross-hatching, other than perceiving a need to go to pen and ink.

I also continually have a need to pose myself challenges to be resolved, and I'm not always successful in solving them. Sometimes it drives me crazy when I look at the works and think, "What does it all mean!"'

PLATE 72

I know the work has symbolism, and it is there because it is representative and has a sort of story behind it. People question me about this symbolism — what did I mean and what is its relation to what I'm doing now? I don't want to specifically say what my symbolism means, but with the recent Juxtapositions works, for example, I know what I am intending to do and whether I am successful in that or not.

Would you elaborate further on the philosophical underpinnings of your works and how you weave these into or arrive at particular images?

The images I paint are a direct result of my interests and concerns, which in turn are based on a wish to understand the forces that act upon us, and their manifestation in successive moments — moments that cause the tangibility of beings and things, moments that are evident on surfaces in front of us. What fascinates me is to watch — on the white paper or canvas — the emergence of a process that attempts to capture the complex system of natural laws, laws that initiate movement and tranquillity, that create matter and light, and are evident in knowledge and in myth. I work without concepts and am motivated by a thought that I only understand as it evolves with the image, or after its conclusion.

I can't explain, exactly, why I choose certain elements rather than others. Every element is deliberate — they are not explanations, justifications, or even solutions — they represent sensations and a mode of thought at a particular moment and are governed solely by my artistic interests. For instance, the use of a shadow cast upon a landscape enables me to introduce an action that is taking place outside the canvas. There might be various explanations as to why I'll choose to imply a motion rather than portray it. When painting, I'm absorbed by the movement of the brush, preoccupied with colour relationships, and reluctant to think upon the meaning, for fear of not finding any.

With the work *Concave-Convex* (1981) came the beginning of my 'personal truth' in painting. By this I mean trusting myself and the work to emerge rather than always consciously directing it — which I had been doing up until then. Now that I am painting shadows, for instance, I usually have a preconceived idea of where the majority of the work is going or of the elements that I'm choosing. However, I do ask myself whether I'm dealing with the shadow because it really

interests me or not, or do I care if the shadow falls across the pebbles or not, or am I bored with it. This is my dialogue with truth. It is not having this immense 'truth' as a philosophical statement — this probably comes through somehow anyway, because I have my beliefs, but I am not trying to paint them.

I have to be able to surprise myself in a work at the end and I have a way of measuring it. It is as though I go out of a story and come back, and if the story has the ability to grasp me inside when I come back, then I think, OK it has 'it'. If not, it doesn't matter if the whole world thinks a painting of mine is wonderful and I can say, intellectually, it works technically and is very good — I don't think the image has really worked if it doesn't have my *inner response*. Some of my works may look like variations on a theme or repetitions of certain elements to a viewer, but I know there is always some new challenge in every work and it is ever-changing — there are new colours or different perspectives or paradoxes are introduced.

While contemplating the alternatives available to me is an integral part of the process, it is not an end in itself. I wish to stimulate continuity from that moment of reflection through the images, to the observer's senses. Although I don't consciously set out to paint objects that signify anything, I hope that my paintings, as a whole, have a meaning that will inspire the viewer to reach beyond the portrayed symbols, that will trigger a dialogue between the image and the spectator's experiences.

How has being a woman influenced your career as an artist?

I grew up in a country that didn't give women any special consideration and I took it for granted that, as an artist, I would be judged on merit. At the beginning of my career, ignorance and naivety were my saving graces. Later, I was guided by intuition and determination. As I grew more aware of social attitudes and trends, I learned to be more careful, and not let them hinder my aspirations.

It is difficult to pinpoint how my being a woman influences the choices I make as an artist. As my work is a reflection of who and what I am, the female energy is manifested, somehow, in whatever I do. When I try to define the manifestation of this energy aesthetically, the terms that spring to mind are: mystery, sensitivity, levity, nourishment, honesty, subtlety and grace. I can only hope that one can find these qualities in my work. I believe the fact that I insist on ephemeral authenticity in my paintings stems from my innate female qualities, and the constant search for balance and serenity from the matriarch in me.

It's easier to see how external forces have acted upon my resolutions as a woman artist. I have lived in Israel, Germany, Vienna, New York and Sydney and have experienced comparable, adverse attitudes towards women in all of them. In the years before 'sexual harassment' and 'women's lib' became household terms, the fascination with a woman 'doing her own thing' — especially an 'artist', with all its mythical connotations — led to great confusion between freedom and permissiveness, resulting in endless, aggravating encounters with the opposite sex. In addition, the prevailing condescension towards women artists made me feel that I was not taken seriously, that I was being given a chance to play until I found a male who could tame me.

I found one. Being an artist himself, I received understanding and support as long as I stayed within a woman's domain. I heard many remarks, coming from men and women alike, regarding my obsession with my own work instead of taking care of my family.

In New York in the 1970s, when women's liberation was on the agenda, I heard the same criticism hidden behind politically correct language. The art community was generous, to a point — as long as you understood that women were not destined to make a deep impression on the history of art. After the end of my marriage and subsequent divorce, I lived with my daughter in a loft in Soho. Having acquired, unintentionally, the image of a '70s woman' — single parent, independent, with an established career — I found it a hindrance and sometimes

PLATE 72
CONCAVE–CONVEX, 1981
Oil and tempera on canvas, each panel 127 x 139.5 cm,
Photograph: Bob Sasson, Courtesy of the artist

'This work came directly from my earlier "tree" paintings, which I had consciously decided to paint in an effort to make a statement — because I could do things that I couldn't do with figures (which I had been painting prior to the trees). *Concave–Convex* emerged primarily from the inside and as such represented a departure from that earlier work, which was stimulated from the outside. With this image, I more or less broke through to a new level in that I could never really explain why I was doing it — why I chose this image, why those elements. I mean, I have a hole in the ground and a hill, and from these little twigs is made a huge mound/mountain almost like an anthill. So the image contains a paradox between the two different levels of relating to it — the feeling of being very big and very small at the same time, depending on how close you are to the image. All through my work, especially since this painting, I have been creating these unidentified situations. The elements I am using are very familiar — a stone, a twig, a puddle — but what has driven me to create the art works all these years is trying to get people to stop, look and think about the things they see every day and to suddenly see the familiar from a different angle.

I never really know what the meaning of a work is while I am painting it — it is only later that I can look at it and say, "Oh yes …" So when *Concave–Convex* started coming, I began to go with the flow and not make arbitrary decisions like — I'll do a hole in the ground because it means this and that. I began to have more faith in what I was doing and that I could trust the work to come through, and it did (the "personal truth" I spoke about earlier).

Talking specifics in this work, the image is constructed from twigs (which fascinate me and which I am still painting), but in a way it's not really the twigs — what it's basically about is almost like having an atom, multiplying it and creating something out of it. I do this also with the pebble. I just feel very comfortable with painting these things, not because it is easy; on the contrary, I find it problematic, which is why I haven't stopped painting them. There is continually this factor in my work of multiplying the same one element.

When I was painting *Concave–Convex*, I was very intrigued with the fact that I was dealing with a positive and a negative — maybe the hill came out of the ground or maybe it didn't. Technically, I was very interested in resolving this space that had a hole and a hill and creating it from one element. I also wanted to create the feeling that the hill could be a little hill or it could be a huge mountain. The time-consuming part in the work is the building of the image and the problem solving — the details themselves come at the end, they are more defined and are not as time consuming, even though that may not appear to be the case in the finished work. With the layering process in the work, I layer colour and texture and will have first solved the volume of it, the space and the form — only later will I go into the details. The details are the easiest part in the work in that I have got to a point where I can basically relax.

At a basic level, the image, to me, is of a hole in the ground and I am trying to explain to myself this need I have to get everything out of the way and just find out the core of it all. That is happening to me now in my study of philosophy.'

felt it was simpler to do nothing rather than paint. As a woman artist I might have been praised for just being that — for performing the role — and, at the same time, criticised for exploring, no matter how genuinely, new aesthetic territories.

Although I can't say my frequent moves from country to country have been motivated by the social attitudes directed towards me as a woman, they have certainly played an important part. As a result, new places have given me a detached outlook towards my past experiences, enabling me to appreciate the diversity of vistas and cultures that have enriched my aesthetic and intellectual options.

At this stage of your development, what do you see is the function and purpose of your art?

In this age of ready-made images and media-generated emotions, I believe art can play an important role in focusing our experiences in this culturally complex world. For me, painting is an aesthetic imperative, crucial to my survival. My art is a result of endless conversations with myself, where the questions posed are rarely answered. I can never be sure if I achieve my objectives, nor what impact my work has, or even if it serves any purpose beyond my own needs.

For me, being an artist is an ongoing battle. Ideas, feelings and imagination are the weapons. Colours, shapes and texture are the ammunition. I aim at the seams of reality, targeting the neglected cracks and crevices, challenging that which is taken for granted, using contradictory spaces and paradoxes. In this age, when beauty is of little value, I strive for balance, trying to create images that leave the door open to the imagination — encouraging the viewer to transcend the obvious. Each of us has this need to go inside ourselves, to see what is there, and to break down all the levels to the core — to the primal core — of wherever we are or whatever things are.

It is so difficult for me to explain what I am doing, because I don't want to make a final statement. I want to leave it all open, because I myself do not know the extent of it — I just know that all the paintings are driven by a need or an urge to make people stop and think. So I am trying to create works that are strong enough to jolt people into remembering them and to start some sort of process in their thinking. I don't want to tell people what to think, because in a strange way, I'm still naive in believing that art can still make a change. But I also know that if you set a direction in which you want a change, you provoke exactly the opposite. So I think art works on a level that can't really be defined and we don't really know what it does.

If you are coming from a certain truth, you can still have this truth, which may be different to that of other people. I mean in the images you have; for example, two shadows cast upon a stick, and you have this stick and you have a log, and it can be belonging to one of them or not belonging to one of them — you can connect this to what I am doing. However, if somebody else sees just this painting and says this reminds me of my friend, one that I like or I hate, it starts an association that I cannot control. So I don't want to give a definitive meaning — as long as it starts an association in people. Many people get stuck or hooked on the techniques and technicalities of the art work, which is okay, as long as they are looking. It doesn't matter to me why people stop and look, whether it is because of the details or the technique or they like it or they don't, as long as they *stop and look and think* and it stimulates some sort of process.

The process of making art is really about making marks and don't we all want to make 'marks' in the world.

Lindy Lee

PAINTER AND PHOTOCOPY COLLAGE ARTIST

…the most persistent questions in my work…are: If I am not exactly this or that, then what am I? What is authenticity? What is the relationship between the copy and the original? I question the nature of presence — and the necessity of finding a way to understand loss and redemption against loss.

LINDY LEE is a first generation Australian of Chinese descent and was born in Brisbane. In 1973–1975 she studied at Kelvin Grove College of Advanced Education, Brisbane, attaining a Diploma of Art Education. In 1979–1980 Lee studied at the Chelsea School of Art in London and in 1981–1984 completed her studies at the Sydney College of the Arts, gaining a Bachelor of Arts (Visual Arts) and a Post-Graduate Diploma in painting, later returning there to teach. Lee is currently living and working in Sydney amid periodic trips to China.

Lindy Lee's work is art about art: about art history and its discourses; about the formation of personal and cultural identity within the constraints of distance and second-hand informational resources. Lee utilises and inverts these constraints to provide a framework for her art practice — whether she be working with reproduced images of beloved Old Master European painters and their mud-thick, encaustic chiaroscuro works on canvas or manipulating photocopied facial portraits of anonymous people in moody, monochromatic, minimalist works of repetition and seriality. Lee's portraits and figures are enshrouded, furtive, melancholic — usually ultramarine blue or vermilion in black, suspended in a field of carbon deposit or dim limbo space. They emerge from and disappear into the void, in gradations within the compositional 'grid' structure (with all its modernist and post-modernist associations). Her twilight images mesmerise, mirroring the ambiguities and confusions in the processes of time, memory, vision and reflection in eternal cycles of loss and redemption.

Lindy Lee has had several one-person exhibitions since 1985 in Sydney, Melbourne and South Australia and has also participated in numerous group exhibitions since 1982 throughout Australia as well as in China, Germany, New Zealand and New York. She is represented in the collections of the Art Gallery of New South Wales, the Art Gallery of South Australia, the National Gallery of Australia and Wollongong Art Gallery as well as in other public, corporate and private collections.

PLATE 73

Could we start by discussing what have been the cardinal influences, experiences and inspirations in your formation as an artist?

The primary experience that has formed my life is that of *difference*. It was not just about being Chinese, but realising that I was somehow different from everyone around me. I didn't feel at ease within my own ethnic group — most Chinese in Brisbane, where I grew up, had been born either in China or Hong Kong and so had different frames of reference to mine. I was born in Australia and felt more Anglo-Australian, but of course I didn't look it. Nothing fitted me and so I began questioning the nature of my existence at a very early age. This experience played a formative role in shaping the most persistent questions in my work, which are: If I am not exactly this or that, then what am I? What is authenticity? What is the relationship between the copy and the original? I question the nature of presence — and the necessity of finding a way to understand loss and redemption against loss.

I think that it must have been very painful and shameful to feel this sense of difference so acutely, and I'm not sure if it accounts for the overwhelming sense of grief I have felt since I was small. I was always searching for a system or philosophy that would make sense of suffering — not just mine, as my own distress made me sensitive to the distress in the world around me.

That helps in understanding the strong motif of presence and absence in your works. Have there been other profound influences in your life and work?

There is a Japanese film called *The Burmese Harp* that was made in the decade just after the Second World War. It is a passionate anti-war film. The main character in the film is a Japanese foot soldier who is stationed in Burma. While on his tour of duty, he learned to play the Burmese harp and speak a little of the native language. He is often requested by his superiors to make reconnaissance trips disguised as a Burmese.

On one of these trips, he puts on the robes of a Buddhist monk. During the course of his mission, he literally comes across mountains of unburied dead — both Japanese and Burmese. In his anguish, he begins to bury the corpses. He accomplishes his military task but realises that his Buddhist monk's disguise has penetrated him too deeply and he can't discard it. The war ends and he knows that he can't return to his homeland. He feels he has to stay in Burma, in his Buddhist robes, and his job is to honour the dead by making graves for them.

I saw this film in the early 1980s — it had a very powerful effect on me and has stayed with me for a very long time. For me, the most deeply perplexing question has always been why we exist. We are born, we have some joy, also some suffering, and we die, and in the living out of this, there is something both poignantly absurd and deeply honourable. We develop systems and laws to help us to exist, to protect ourselves from uncertainty, but in the end, life always proves to be too big and messy to be contained by anything we impose on it.

Until recently, the somewhat driven imperative behind my work, has been the question of loss and redemption. In very small part, I use overwhelmingly European faces to exercise a process of identification and make a declarative statement that my tradition is Western: it is, after all, the dominating culture on my horizon, despite my Chinese appearance. Mostly, however, their use describes a different purpose, one that is more difficult to speak of because it is more personal and relates to *The Burmese Harp* — something in me requires that I remember and value what it is to be human.

Describe for me your typical ways of working, the creative processes involved in your photocopy collages — including the themes in your images.

The photocopies are all portraits, mostly anonymous people — the details of their existence dispatched to oblivion. The insistence of loss comes up again and so does the concept of redemption. I don't necessarily mean in the religious sense, but in the reclaiming or retrieving of each moment before it dies. Within each photocopy work, there is repetition of the same

PLATE 73
HEARTBEAT AND DURATION, 1992
Photocopy and acyrlic on stonehenge paper, 176 x 127 cm,
Courtesy of Roslyn Oxley9 Gallery, Sydney

'The heartbeat is a tiny measurement of time, uncluttered by notions of past or future or even the present. This instant is without limit. The image is derived from a northern Renaissance Dutch painting by Jan Van Eyck called *The Altarpiece of Ghent*. The faces are Adam and Eve. The colours are the ultramarine blue that is very characteristic of my work and a very vivid orange that has only recently appeared within the iconography I use. Ultramarine is introspective and very deep. The use of this blue indicates a life of the spirit. The orange is god. It is the luminosity in each and every thing which becomes apparent when given proper attention.'

PLATE 74
**ALL SPIRIT IN THE END BECOMES BODILY
VISIBLE**, 1987
Oils and wax on canvas, 180 x 160 cm, Courtesy of Roslyn
Oxley9 Gallery, Sydney

'Often the early reason for appropriating other artists'
images was a way for me to assume somebody else's
existence. There was usually something I envied that I
wanted for myself. In the case of El Greco, I envied his
belief. From his work I think you can tell that he was a
fervent, perhaps mystical Christian. There is great passion
in his work. I was intrigued/attracted to the idea of faith.
I envied his intensity.'

PLATE 74

image with varying degrees of clarity and obscurity. This practice of redemption, expressed in
my use of art reproduction, paralleled my own sense of existence. Our culture is based on the
proliferation of images, and with so many images, how is it possible for any one image to survive
— to have meaning. It seemed also the case for any individual life and for every single second
that constituted that life. How does any one life have meaning? Every single moment of our
being will ultimately be lost, and that, for me, was the cause of great grief.

There seemed such a pointlessness to life, so my task was to somehow find a way of being
generous to each moment, to redeem it before it was lost. In my photocopy work, I use a lot of
repetition. Each unit represents a single instant in the history of the image and the life of indi-
viduals now disembodied from the substances that constituted their reality. It's not important
that their images can be placed with any historical accuracy; rather, there is an evocation of
familiarity and a sense of commonality. When I make these works and look at those faces, there
is a sense of recognition — a meeting and measuring of the nature of existence. I am very con-
scious of the paradox that exists in these pieces — they are fundamentally copies, but there is a
sense of singularity about them.

Would you further elaborate on the philosophical and metaphysical bases in your life and work?

There has been a huge shift in myself and my work recently, which culminated in doing Jukai, a ceremony wherein I formally undertook to embody the precepts of Zen Buddhism. It was probably not before time and it was utterly predictable in retrospect. The struggle with loss and redemption expanded into a philosophy of impermanence. Prior to this shift, my attitude contained something that alluded to the heroic quality of the individual struggling against indifference and ultimate death to have meaning. The individual rails against the inevitability of loss and death — life and the individual were somehow separate.

When I became a Buddhist, my position changed completely — I understood that life is enacted and manifested through the individual. They are not separate. I read Dogen Kigen, who was a Japanese Zen philosopher during the twelfth century. This period was called the 'Heian period' and it was almost mandatory to write exquisite, wistful and sentimental Haiku lamenting the impermanence and passing of all things. These poetic speculations missed the fundamental point — there was still a sense of separation from life; the individual was locked into a position of an onlooker watching as life fades. Dogen's point is completely unsentimental — the individual is life, is impermanence. This was very liberating, because there is no need to struggle. What is required is simply to be faithful to the ever constant stream of change that happens to be what I am. Zen practice is infinitely subtle and beautifully precise.

This is the essence of Zen practice, which is now the core of my life. One of the first books I read about impermanence was Thich Naht Hahn's *Heart Of Understanding*. It is a commentary on the Heart Sutra, and is a text central to Zen Buddhism. He writes that there cannot be life without impermanence, for then a child could not grow into adulthood or a grain of corn cannot grow into a cornstalk. This was the beginning of my emancipation from this perplexing and often extremely painful need to redeem life. When you need to redeem in this sense, there is a steeling of self against the pain of eventual loss, which prevents us from actually being totally present with life — with being life. Impermanence is understood as the absolute nature of all things.

Another aspect of the nature of things is that nothing exists only by itself as a discrete entity. Everything exists in relation to every other thing in the universe. In the experience of Zen, this is called Emptiness. It is the space of potentiality activated by its relationship to form. Emptiness is in fact exactly form and form is exactly emptiness. It is said that from the beginning there was nothing but the void. Everything about and in this life is an expression of that void. It is not that when we die we return to nothingness, death itself is an expression and activation of nothingness. In this sense, life is beautifully and most powerfully empty.

Talk about any attitudes, philosophies or concerns you hold about art generally and how you see the purpose and function of your work?

Most of the art that interests me has a way of compelling it's own spatiality and temporality — forcing the viewer into the work's own presence. My paintings are often very dark and the images are fugitive. Images become clear only if time is invested and even then, if small shifts in light occur, the image is lost and a new perspective needs to be realised. My images are copied from other sources but they are themselves extremely difficult to photograph. This has been very important to me, because it returns us to the necessity of being in some kind of relationship to the work itself — to be actually and entirely present with the moment that is the work. By renewing contact and understanding from second to second, we are returned to a state of authenticity and originality. Until I began to study Buddhism seriously, I had no notion that the questions I was asking had been formalised into a serious religious practice. The practice of Zen requires a constant opening to authenticity. The outside is internalised and returned to the world again — self is actualised by a myriad of things. Authenticity of self is gained by unity with whatever is being actualised, the experience of what is happening 'now'.

PLATE 75

PLATE 75
SOUNDLESS FATE, 1992
Photocopy and acrylic on stonehenge paper, 168 x 173 cm,
Courtesy of Roslyn Oxley9 Gallery

'The grid has appeared in my work in various forms for as
long as I can recall. It embodies two very significant and
seemingly opposed ideas — the boundless and the
particular. It is a matrix which in potentiality stretches to
infinity and represents the underlying unity between
things. The intersection of lines within the grid represents
a very specific moment in time. The face is a now-
anonymous burgher painted by Jan Van Eyck.'

PLATE 76
NELL AND EVERY LITTLE THING, 1995
Photocopy and acrylic on stonehenge paper, 2 parts: 25 +
25 panels, each 205 x 143 cm, Courtesy of Roslyn Oxley9
Gallery, From the exhibition catalogue 'Because the
Universe Is':

THE COLOURS

BLACK — underlying mystery: invisible,
unseeing, unseen and silent, motion of non-
events, utmost causation, causeless, ceaseless,
indeterminate, an awareness of hidden things,
pervasive presence, darkness and excessive
brightness, illumination, loss of illumination, loss,
death, forfeiture. Black is not as Black as all that.

RED — blood red vitality, passion, fire, life,
fortuity, actuality, carnal, corporeal, matter
substance. This instant — without limit!
Heartbeat and duration. All Spirit in the end
becomes bodily visible.

BLUE — deep, vast and introspective, the life of
the spirit, translucent and silent, my utopia.
Appearance Shines.

PURPLE — the direct mix of blue and red, of
spirit and matter, dark murky and rich, uncertain,
neither choice nor chance, grit, endurance,
reluctance, hesitation, sedulity, perseverance,
struggling in the Ocean of Yes and No, of fear and
exultation, virtue in the process of becoming.

ORANGE — the black stone at the centre of the
universe, pure transmission, gold, the luminosity
in each and every thing when given proper
attention, the true mystery of mercy — to honour
the black.

In 1992 Bill Seamlan directed a short video about my work, called *Loss and Illumination*, for
SBS Television. The script was elaborated from a list of the titles from my work. The titles
themselves are gleaned from various philosophers both Western and Eastern. It was interest-
ing to tie them all together because it gave me the opportunity to articulate the ground that the
work comes from. It's not meant to be poetry but an evocation of different aspects of the same
set of questions. The following is a version of that script.

Invisible
Unseeing
Unseen
Silent
Motion of Non-events
Event Without Moment
Utmost Causation
Causeless
Ceaseless
Indeterminate
Uncertain
Grit
Endurance
Reluctance
Hesitation
Sedulity
Perseverance
Recognition of Will
Resignation of Will
Abdication of Will
Neither Choice nor Chance
Volition
Remembrance
Evocation
Separation from Love
Separation from Error
Separation from Appearances
Binding
Unconsoling
Pitiless
Relentless
Disconsolate

Without Hope
Unmerciful
The True Mystery of Mercy
The Psychology of Some Pure
 Event
Awareness of Hidden Things
Translucent and Silent
Movement Beyond Itself to
 its Idea
Struggling in the Ocean of Yes
 and No
Fortuity
Pervasive Presence
Actuality
Nothing to Take Hold Of
Darkness and Excessive
 Brightness
Clarity
Obscurity
Illumination
Loss of Illumination
Loss Death
Forfeiture
Redemption
Transformation
Of Fear and Exultation
Appearance Shines
To the Limits of Beauty
Carnal
Corporeal
All Spirit in the End Becomes
 Bodily Visible

PLATE 76

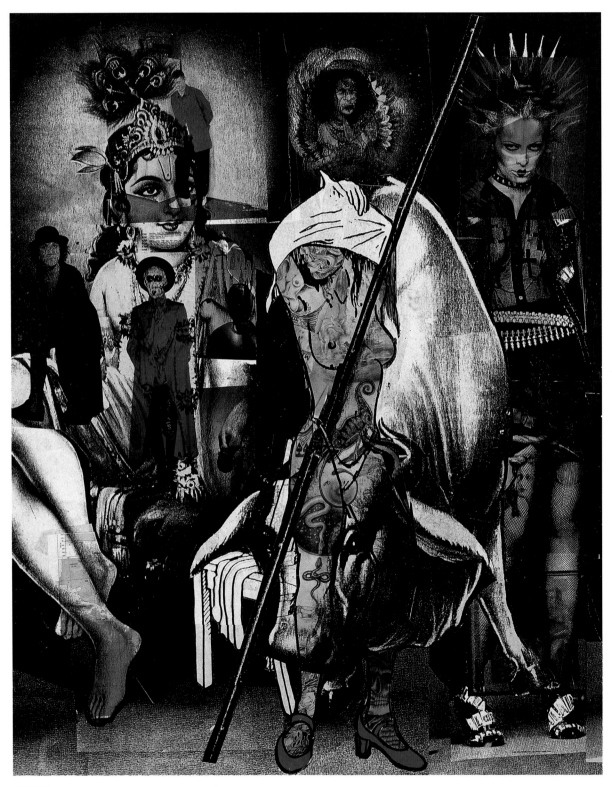

PLATE 77

Joan Letcher

PAINTER AND PHOTOCOPY COLLAGE ARTIST

*The struggle to comprehend a world of fleeting impressions and moods
by grading and classifying is not the only option. To look at an ink blot
and see a butterfly is one thing. Turning it upside down in order to
see a vision of God gives it greater value, but limits its possibilities.
It is necessary to break it down into equal parts, to reshuffle
and rearrange in order to see both at the same time…*

JOAN LETCHER was born in Melbourne and from 1976 to 1977 and again in 1980–1982 studied at the Prahran Institute of Technology, gaining her Diploma of Fine Arts and also an Award of Excellence from the Powell Street Gallery.

In Letcher's career to date, her paintings and montage-type collages deal almost exclusively with imagery of women — intuitively selected torn-out pages of books, magazines, television images and photographs — that is fed through a black and white photocopier. She uses different kinds of paper, overlaying and breaking down the imagery into equal parts and freely experimenting with composition and aesthetic. Letcher consciously works with imagery that she considers to be both impersonal and collectively shared in everyday contemporary life. She allows that imagery to free form in a play between image, technique, fantasy, personal obsessions, perceived realities, that which is conscious and public and that which is unconscious and private. In so doing, Letcher attempts to personalise this imagery, to rearrange existing genres, hierarchies and boundaries and to allow new perceptions to emerge in journeys of cultural and self knowledge, identity and recognition.

Letcher has had several one-person exhibitions at 13 Verity Street, Melbourne since 1987 and has participated in numerous group exhibitions in Victoria, Queensland, Canberra, Sydney and Tasmania. She is represented in the collections of the National Gallery of Australia, the National Gallery of Victoria, Artbank, the Gold Coast City Art Collection, Queensland as well as in corporate and private collections in Australia and West Germany.

———•—•———

Could we begin perhaps by discussing particular influences, inspirations and significant experiences in your creative development?

As far as creative influences are concerned, I try to avoid them at all costs. I merely gather together seductive reproduced images and allow them to develop their own relationships.

PLATE 77
UNTITLED, 1994
Mixed media, 112 x 91 cm, Courtesy of the artist

'This work concentrates on "fashionable" magazines. Though, I didn't want only to combine fashion statements but to look at the whole idea of decorating yourself as a way of saying something about who you are. The idea was almost to combine those sorts of outward philosophical statements with religious expressions — like with the Indian Hindu princess. I suppose it's basically about wanting to be seen as regal, and creating that sense of yourself through fashion tattooing and sexuality — again using images that attract me and reorganising them.

So the overall statement is about outward appearance and how people express themselves and the connotations that go hand in hand with altering one's natural appearance. It's also about putting all these expressions under the one roof, so to speak, in that each one is as valid as the other — that basically each has equal value and interest. I suppose my work is about levelling, about pulling down hierarchies. Reading Camille Paglia, that's what she talks about. I like the idea of rearranging "the accepted" and I use magazine images to do that — which is a personal thing.

A lot of the works are just experiments in different effects and processes and sometimes they come out looking very different to how I initially imagined. I cringe a bit looking at them, but then I think I had to do them, because one has to try different things — even though basically my work is about the same thing. It is always collage, but within that, I try to stretch out different ways of going about it. The works are really quite important in their context and you have to keep reminding yourself of that, otherwise the tendency is to want to throw them away and forget about them.

Generally, I'd rather someone else take the responsibility for interpreting my work. I think part of the concern about committing to words/writing something yourself is that you feel totally responsible for it, so having someone else do it takes the weight and responsibility off. I went through a stage of reading a lot of art magazines and so on, and I found that to be really stifling. I had so much going on in my head and then realised that that was not where my work comes from. The work comes from the actual physical process and that happens all at the same time — eyes, hands, materials and thoughts working together in unison, rather than one dimension dominating another, though sometimes it can get quite intense.'

Although I cement them together physically, it is up to the viewer to mediate the paradoxes that may occur through any opposing concepts.

Influences can be anything for me — everything I look at, everything I read, anything and everything — rather than being major experiences or people. I can say I really enjoyed Camille Paglia's book *Sexual Personae*. I enjoyed her complete honesty in revealing certain personal biases, her intellect, her general knowledge and her ability to use her knowledge in a really practical way. To actually say *something* and not just what is expected, and the passion that she reveals in doing so, I find very inspiring.

I have been attracted to artists like David Salle and Cindy Sherman, as I see their work as rearranging existing genres to include their own obsessions. While the Dadaists also used recycled sources in their search for an alternative order, theirs was a public statement denouncing public assumptions. I, on the other hand, see my work as an attempt to fuse the boundaries between that which is conscious and public and that which is unconscious and private.

As far as taking art as my particular direction is concerned, it has been a gradual evolution. Being an artist happened mainly because other avenues were closed and art seemed the only area that was open to me. Because I grew up in a repressive family, art became like an escape that gave me some sort of pride I couldn't find anywhere else. I would like to be able to say that there were major artists that I looked to — and there are people that I could identify with — but I think that you always try and move away from anyone you feel too close to, as far as your work is concerned, in order to find and develop your differences and identity. I suppose this is an area I like to keep mostly to myself.

I went to Prahran Institute of Technology as a mature age student and tended to lock myself away — there were these tiny rooms like cells that were given to the students and I tended to stay in my little room and go my own way. Art school was good in the sense of finding out what was possible — I mean the fact that everyone there had total freedom. At the same time, I also found it intimidating, because everything was questioned. Not that justification for everything that you did was demanded, but you felt that there needed to be some sort of rationale behind what you were doing.

I actually started art school in 1976–1977, then deferred, then returned. So my work emerged bit by bit. It is very difficult for me to take control of things — like exhibiting in other Australian states — for when I do, I find it doesn't work. This is not necessarily a good thing, but I feel I have no choice — which is a wrong way of looking at things, but I have to do what feels right to me.

Art was a way to play and make things and you were given a lot of freedom to do that at art school, which was what I really enjoyed most of all. You had certain subjects that you had to do and certain projects that were presented to you (like your questions for this book!) but I found those sort of things difficult because I always felt that there was some sort of expectation — some kind of original idea that you were expected to fulfil. There is probably a certain part of everyone that rebels against giving everything that you have inside and that shuts off and maintains a sort of secrecy. I suppose I feel that fear of being completely exposed, as much in thoughts as in words or anything else. I don't have as much fear about exhibiting paintings as I do trying to divulge ideas, probably because I feel insecure about articulating the content, in that your thoughts are constantly changing — you say one thing at one time and it's okay, and at another time it's not, so you don't want to be pinned down.

So art, for me, has been a place to explore, a place to play, creating and exploring an identity, which is a big thing — not so much in an egoistic way, but rather in finding a place to fit and a reason for being, especially when you haven't had one, which women haven't. I speak here as an individual person as well as a woman.

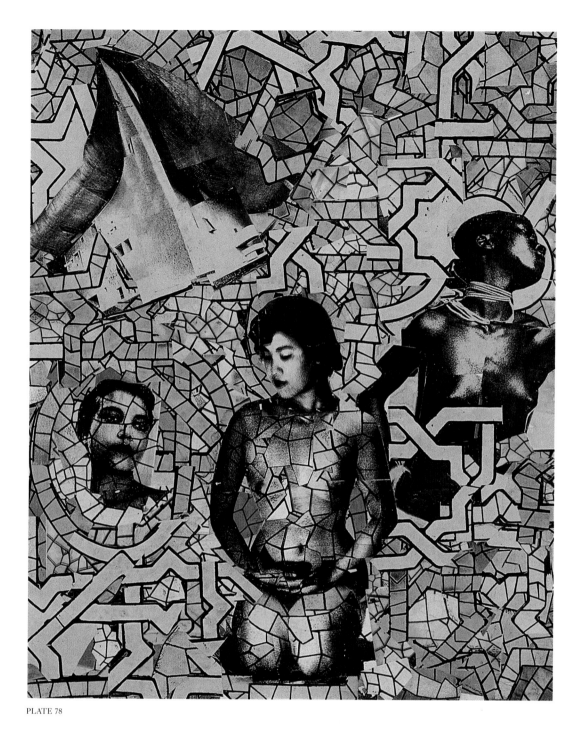

PLATE 78

PLATE 78
UNTITLED, 1992
Oil and xerox collage on canvas, 167.6 x 137.2 cm, Courtesy of the artist

[Given a working title: *The Fine Art of being Different*]
'With this image, I started off with the Islamic patterns and then wanted to put some figurative images into the patterns. The fact that these are images of women is a type of statement about fundamentalist thinking and the refusal to acknowledge — and the attempt to squash — the power that women have as far as their sensuality and sexuality is concerned. This terrible repression and restraining of women's natural inclinations is basically what originated the work. I can't remember using that patterning again except in *Palace of the Winds* (featured in the *World Art* article), which was basically the same concept.'

Talk about the different aspects of your creative process. Include key motifs in your montages, emotions, music — if applicable, dreams or fantasies and thoughts as well as technical and physical details.

The actual process of making my works is basically bound up with experimentation on a xerox photocopying machine — taking apart images and putting them back together again in new ways and finding out what's possible in playing with images and colour. So the works are basically collaged xerox images. The fact that the photocopier can reproduce detailed images without hampering that detail means you can play with it and have a freedom that you wouldn't have in drawing and painting. It's like what you do in kindergarten, the cut and paste. There is

PLATE 79

UNTITLED, 1994
Xerox collage on linen, 106.5 x 86.3 cm, Courtesy of the artist

'The faces in this work are all romantic photographs of women; they are overlaid upon magazine images of dolls and pretty young boys. They are just fantasies — images about daydreaming and fantasising. Though, thinking about it now, it is actually more about romanticising — almost like a little girl thing. There is something irresistible about the romantic image to me. On one level I know it's kitsch and sort of revolting, but at the same time these notions of the romantic are part of me. I didn't start out with the intention of doing the image this way, it just came together. It is done with the faces almost on a sort of grid and I like the fact that it is made up of these images that are really cutesy and romantic, but as far as contemporary art goes, it has that almost abstract thing about it, which brings those two opposites together.'

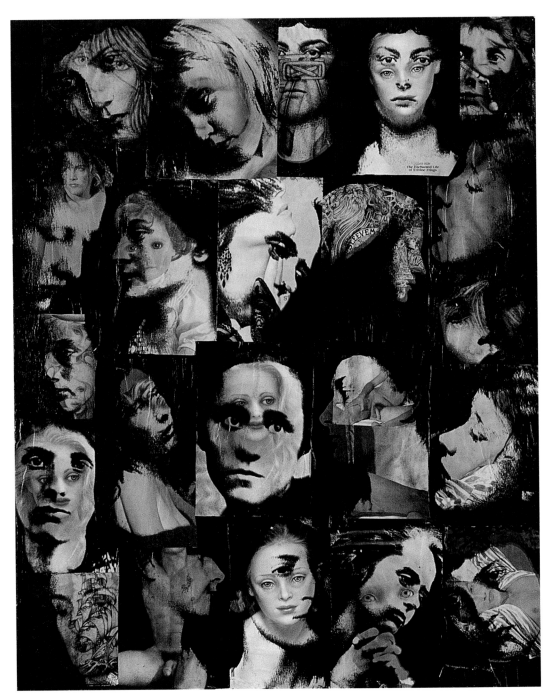

PLATE 79

something very satisfying about just drawing, pasting, reconstructing without having any responsibility — like images.

The paper and photocopier actually dictate how the picture will be. You might have a direction in which you want the work to go, but if the actual materials don't allow for that, you just have to accept that fact and try and find another direction, another way around it, even though sometimes it seems like you have exhausted all the possibilities. However, there is always some sort of way, whether with the actual materials, the images or whatever, to come to some sort of resolution. I think this is because it is a matter of layering, not one sort of attack or one spontaneous expression. You develop small parts, so it is one creation on top of another over a period of time. You try and maintain the original starting point and just keep adding to it. While I may initially choose a single image for its particular significance, its placement and/or repetition on the work will also depend on aesthetic, even decorative values.

I work with a black and white photocopier and feed different types of paper, torn-out pages of books, magazines and photographs through it. I haven't used any of my own photographs, but I've started to take some more and I intend to use them in the future. Mainly I've been trying to explore different uses with different sources. I overlay images with other images and in the past I used paint as well, though I haven't used it for a while now — possibly I will again in the future, because I like the works to have another dimension.

The images I work with are quite flexible and are a lot tougher than you would imagine. You can feed the imagery through the photocopier, and when, sometimes, things get stuck, they always come back to life. Also they sometimes refuse to do things that you want them to do, but eventually something gives in the battle of wills. Some images get you with their energy, strength and flexibility and the possibilities of going beyond its actual aesthetic.

I tried using wax and bleaching paper as I found out that you can bleach the colour dye out of paper but the photocopied image remains. It's like a printing process in that if you are a print-maker, you explore all the possibilities of using paper and inks in different ways. I am thinking about trying some printmaking soon, just to see what happens.

I usually work on a couple of works at once over a fairly long period of time — up to a couple of months. Some works come together very quickly and others take a lot longer. Some look like they have been wrestled with, which I don't really want. I don't mind the struggle, but I don't want it to be obvious.

I tend not to show anyone my work in progress, because although I can see and know how a work is going, and I have an image of how it's going to be — whether it ends up that way or not — and I am able to see possibilities that to me are obvious, they are not necessarily obvious to other people. So I don't want this confusion of expectations. Also the work is changing and I'm not sure as yet which way it's going to go. However, I do try to work with what is part of every-one's world.

How do you approach the mass media imagery that is characteristic of your photocopy collages?

Mass media is such a powerful force and I want to sort of participate in it on a physical level. It takes over your thoughts, what you are looking at — its impact is so strong. If you just walk into a newsagency, for example, there are all these images that you just melt into and I kind of want to 'own' them in some way, because they sort of own me.

I've used images from films, though film itself doesn't influence my work. There are a lot of film-makers whose films are them, but it's filtered in a way, it's not as direct as writing or paint-ing. The work is really somehow separate from literature or painting and so on.

Does music play a role in your art-making?

I like to listen to a lot of different types of music. I share a studio with two other people and one of them has quite extreme musical tastes. He searches out a lot of music, which I then get to hear — and have to adapt to — in sharing the studio space. In a way, this is also indicative of the way I work in that I work with what is there, what is readily available and easily accessible — like the photocopier. Anything that is too detached or separate from my world, and most peo-ple's everyday world, I'm not so interested in.

The imagery in your works is mostly about women. In what other ways has being a woman specifically influenced your career as an artist?

My images are mostly about women because I am one. They are not consciously political; they just happen to be about women because that is what I am exploring, hence my work has that bias. No matter how hard I tried — or if I were to try, which would be pointless — I cannot escape this orientation. Sometimes it makes me cringe, in that this bias is so overt and I wish it

wasn't so that I could go beyond that and find some space where the work conceptually passes that. However, I can't see any point in forcing myself to do other imagery, because it would be false.

As far as being a woman artist creating imagery about women and affecting opportunities in the wider art world is concerned, I haven't really noticed as I tend to take things on a more individual and personal level rather than on a gender level. Although, I am aware that women in the arts have been neglected in the past. I have also had male artist friends who have recently commented that it is better politically to be a female artist than a male artist today — though I know that this observation is very limited.

Art has to find its own place. It is good to be able to see other women artists work today, which is something that was denied in the past. Sometimes, and without making too much of a generalisation, I think women's art is quite different. I know I tend to be more passive towards my actual work than male artists I see, who tend, I think, to have to dominate what they are doing, and the ego is more strongly involved. I'm not necessarily saying that this is a negative thing, but I think it's a big part of what they do, whereas I don't feel that in my own work. I also cannot speak for other women. Nor do I know if that way of working lessens the work's power — hopefully not. The way society works, one has to have ego to survive, but ego can get in the way — it can be blinding and distorting. Andy Warhol once said he didn't have an ego, though I believe the ego is necessary in getting by in life, but sometimes I think you have to get rid of the ego to be completely honest.

At this stage of your development, how do you see the function and purpose of your art?

In the search for some sort of answer, nearly all human experience today is 'worded', grouped and then placed within a sequential pattern. However, I feel this is repressive, as our naked perception of the world allows systems to interact freely and with equal value and is therefore more exciting and expressive. The struggle to comprehend a world of fleeting impressions and moods by grading and classifying is not the only option. To look at an ink blot and see a butterfly is one thing. Turning it upside down in order to see a vision of God gives it greater value, but limits its possibilities. It is necessary to break it down into equal parts, to reshuffle and rearrange in order to see both at the same time, a sort of free association of subliminal impressions. Everything can be pulled in any direction.

As a visual artist, I feel more comfortable with visual modes of communication than with the written word. In my paintings, I select images and then by isolating them and taking them out of context, I personalise them and so incorporate them into my own visual vocabulary. In so doing, I am attempting to create a form of visual poetry.

This is an age of self examination and self obsession, based on the belief that self knowledge is the key to self control, which is the key to happiness. I think my work is a reflection of this in that it appears to find new meaning in new perspectives through its own obsessive reworking of visual information. However, like most art and most self-help books, it only discovers that which is already self evident. It is this recognition that brings reassurance and momentarily relieves self doubt.

Barbara Licha

PAINTER

In the process of painting, I open 'drawers of my brain' and I use knowledge together with imagination. Sometimes it surprises me to see what is happening on the canvas, but I'm very happy that I can mix reality with dreams, past with present knowledge about visual structure together with experiments in looking for my own structure.

BARBARA LICHA was born in Rawa-Mazowiecka, Poland and from 1979 to 1981 studied painting, lithography, graphics and sculpture at the State Academy of Fine Arts, Wroclaw. She then travelled to Bulgaria, Hungary, Yugoslavia, Austria and Germany, lived for a year in Italy in 1981–1982 and arrived in Australia in 1982. In 1985–1988 she attained her Bachelor of Art degree from the City Art Institute, Sydney, where she also gained her Graduate Diploma of Fine Art in 1989. Between 1990 and 1993 she travelled again to Poland, France, Italy and Germany from her home base in Sydney.

Licha's figurative paintings are reminiscent of dream states where physical and imaginal experiences, emotional and symbolic realities are fluidly expressed in poignant, multi-layered visual statements. These evocative images of simultaneous realities, with their emphases on exaggerated human gesture, line, space and stylised form — often in a palette of blue, gold, black and white, are executed in a manner resonant of German expressionism with a hint of Chagall. Licha stresses, however, that her paintings are inspired by daily contact with different, individual people and a desire to express something unspoken and spiritual, thus melding the visible and invisible worlds. In combining such complexities in simplified form, her images celebrate a here-and-now experiencing of life whilst at the same time moving beyond it and, as such, evoke a sense of liberation.

Licha had her first one-person exhibition of paintings, drawings and prints in Wroclaw in 1979, and her first solo Australian exhibition at the Holdsworth Galleries, Sydney in 1984. Since then she has had further exhibitions in Poland and at Access Contemporary Art Gallery, Sydney — the most recent in 1992 with her next scheduled for 1997.

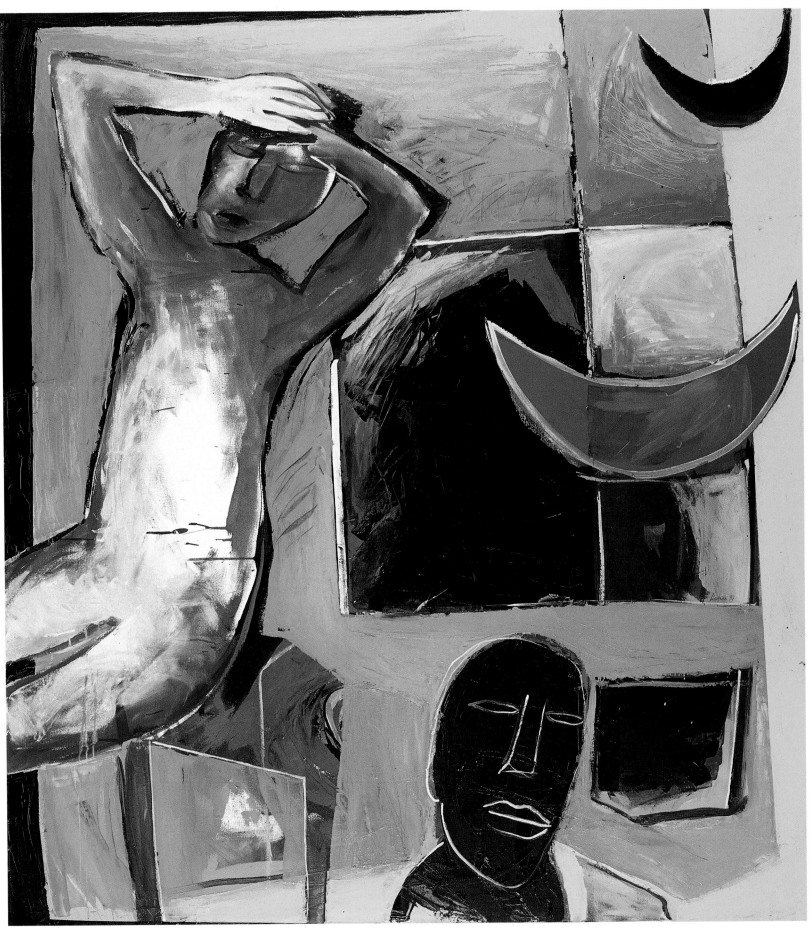

PLATE 80

Could we begin by talking about your formative influences as an artist. What are the key experiences, significant people, inspirations, dreams, emotions, music, natural elements and spiritual orientations that feed into your creative development?

Everything that is around and surrounds me has an effect on me — *everything*! Reality and dreams, past and present, good and bad, anger and love inspire me. I like to 'feed' myself with different feelings, and, apart from the everyday, where we meet new people and see new shapes, what you can call 'food for the soul' — music, literature, theatre, films, visual art — can have an effect on me. Music, for example, can deepen my feelings, can build up an image that I have at a particular moment and can activate something past or a dream.

When martial law was proclaimed in Poland in 1981, I was travelling in Italy with my then boyfriend, now husband, and we decided not to return to Poland. I wanted very badly to go back because I hadn't finished my art degree, but I also knew the best thing for my art was to stay away from Poland. I needed more freedom and the ability to travel, because that is such an important thing for me. I knew that if I went back to Poland, I might not have the chance to travel again. We thought about which country would be the best place in which to settle down and make a new life, now that we knew we were not going back to Poland. Australia, in our minds, sounded a very exotic country; it was the country where we believed we could do everything for ourselves that we wanted.

In Poland, I was studying lithography, poster design and painting all at the same time. However, I see the three things as very different. In painting, I express myself with colour, but in lithographs, I am mostly calculating and using very detailed work to express myself. In design graphics, it is a very specific way of thinking about a topic. What I'm trying to do now is combine the three things. That is maybe why in my painting there is an element of drawing — where I scratch on paint, as if searching for something.

I'm afraid of becoming predictable in my work, of getting to a point where I have my method of painting and then sticking to it. That is not very creative. Not knowing where I am going is exciting. It opens up possibilities and gives me, and my art, freedom.

For me, the body and psyche are intimate topics. Every day we see hundreds of people with different appearances, characters, experiences and points of view on life. We are all so different, but what unites us are our raw emotions and feelings. The figures that I paint more or less represent someone, but at the same time they also cross over and are changed into symbols of emotion that represent all of us.

Tell me more about the different aspects of your creative process — giving specific details of the compositional elements in your images and your major interests or concerns as well as how you approach your work.

Contrast always fascinated me a lot. The biggest contrast to me is what we people contain within ourselves. That is maybe why people play the main part in my works. Contrasts make life more active. We all have these ups and downs — I have ups and downs and try to use these very characteristic moments in my works. I don't want to damage my feelings, but I would like to use them in search of my individual expression.

Because of the contradictions I use in my work; for example, quietness–aggression, my colours vary from very intense to very calm and my lines are more or less specified — stronger or lighter, sharper or delicate. It is me at a particular moment creating a particular work. So I allow myself to be very myself and also to control the process of painting. I try to fight for what I believe is very important, which is artistic individuality — where the artist is creating because she has a need to speak.

The process of painting, for me, is associated with a conscious and unconscious state of mind at a particular time. Throughout our lives we store an individual vision of the world and we record what is around us — both knowledge and emotion. In the process of painting, I open

PLATE 80
MUSTARD NIGHT, 1993
Oil on canvas, 167.5 x 152 cm, Courtesy of Access Contemporary Art Gallery, Sydney

'As mustard has its specific taste, some moments in our life have specific tastes. It can be sweet or sour, or can be as mustard.'

PLATE 81
AFTER, 1991
Mixed media, 100 x 75 cm, Courtesy of Access Contemporary Art Gallery, Sydney

'This image just "happened" after someone's death was announced to me. It was in the morning and my neighbour told me about a dead body in his place.'

PLATE 82
DART, 1993
Oil on canvas, 152 x 167.5 cm, Courtesy of Access Contemporary Art Gallery, Sydney

'Past and present, dreams and reality sometimes combine on one piece of canvas.'

'The shapes, lines and colours that appear in all of these paintings usually show my own expression at that particular moment.'

PLATE 81

PLATE 82

'drawers of my brain' and I use knowledge together with imagination. Sometimes it surprises me to see what is happening on the canvas, but I'm very happy that I can mix reality with dreams, past with present knowledge about visual structure together with experiments in looking for my own structure.

Everything from the beginning of our life to the end of it has an effect on who we are and what we do. All this — where we were born; what experience we had in our childhood and throughout our life — can't be forgotten. Also I am a woman who has built herself. I can't avoid some situations and all this experience — for me to be a woman, to be a Pole, to be European, to live in Australia — what has 'happened' makes me as I am.

I never regret what has 'happened', as I always see it as the possibility for constructing myself and of becoming richer through any situation that has happened to me. I also believe that, in the end, what really matters — particularly in artistic creativity — is to use this 'I am as I am' in search of your own language with which to communicate.

Could you discuss pictorial and symbolic elements in your works?

Perhaps a work I did called *Three Moon Night* recollects the three moons and the three different skies I have experienced during my time in Poland, Italy and Australia.

My figures themselves are symbols of human emotions. Everything else that appears on the canvas is related to that particular state of emotion that arises on canvas.

I don't want to explain the significance of separate elements in my works. They usually work together with other shapes, lines and colours to construct one image. They often come from my unconscious and I let it be in the conscious thought of the whole structure. Also I prefer to give the viewer the possibility to be creative, to interpret the work in their own way.

How has your journey as a woman affected your career as an artist?

I don't think that art should be seen as male or female. It has happened that, as a woman, I have this personality and not another. First and foremost, I am an artist — I am already a woman, so it is not a consideration. I am not born an artist; I am making art. I feel more as a human being when I work in the process of painting and, in the end, I hope to be understood by other human beings, not just by a particular group of people. I want my work to be appreciated and understood in a universal way.

What do you see is the purpose and function of your art?

I want to talk and I do feel that I have plenty to talk about. The thoughts come from my inside, and outside it is canvas and paint that helps me to talk. If my works can be read by others, and if I can be understood, I can see it as my success, I am then satisfied. I see my works as communication.

PLATE 83

PLATE 83
COMPUTER WORK, 1996
Courtesy of Access Contemporary Art Gallery, Sydney

'I started to treat the computer as a sketch book about ten years ago. It opened up other possibilities of working and thinking. Recently I returned to using the computer and was again excited by the shift in working and thinking process. The computer offers a kind of second studio, a working place where you can quickly retract mistakes, speedily adapt a new idea, and extract new ways of solving problems; it offers a mobility that you simply cannot get with conventional painting.

On the computer I can continue to rework images searching for new shapes, colour and lines without losing particular stages of work.

I try to combine the new work of the computer with the old methods of painting; they coexist in my work. I can store ideas on the computer and work with images in different directions. Some of them become finished works, some are just ideas for works on canvas. In addition, new discoveries on canvas are adapted during work on the computer.'

PLATE 84

Anne MacDonald

PHOTOGRAPHIC AND INSTALLATION ARTIST

*Much of my imagery comes from the graveside. For many
years I photographed memorial sculpture at the cemetery. I was
particularly drawn to small funerary ornaments, emblems and
ceramic wreaths. I like to think of those brittle, fossilised flowers
as erotic symbols of passion which have been turned toward
the cold and rigid form of dead but unforgotten love.*

ANNE MACDONALD was born in Launceston, Tasmania and from 1978 to 1983 she studied at the Tasmanian School of Art, gaining a Diploma of Visual Art Teaching in 1980, a Bachelor of Fine Arts degree in 1981 and a Master of Fine Arts degree, majoring in photography, in 1983. In 1984 she worked as a tutor in photography at the Tasmanian School of Art and in 1986 to 1987 was assistant director at Chameleon Contemporary Art Space in Hobart. In 1988 she returned to the Tasmanian School of Art, where she is currently employed as a lecturer in photography.

MacDonald's darkly moody and hauntingly beautiful photographic compositions and installations have, for a number of years and within a Western cultural context, explored themes of bereavement, alienation, the denial of loss, the funereal and the role of sentiments such as idealisation, romantic love and obsession in human life. Her leitmotif is the flower, object become image — symbol of feminine beauty, of fragility, of fleeting life, of memento mori — usually tinged ice-blue on a black background, isolated, frozen and captured in the frame like death itself.

Anne MacDonald has had several one-person exhibitions from 1983 to 1993 and has participated in a number of selected group exhibitions over the same period with her most recent in 1996. She is represented in the collections of the National Gallery of Australia, the Tasmanian Museum and Art Gallery, Hobart, the Art Gallery of Western Australia, Artbank and in other public and private collections in Australia.

PLATE 84

UNTITLED NO.1 FROM THE INSTALLATION 'OPHELIA',
1993, chromogenic colour photograph,
120 x 120 cm, Courtesy of the artist

'This installation — at Roslyn Oxley Gallery in Sydney in 1993 — was, in part, a development from the *Inconsolable* series, by highlighting the symbolic importance of flowers. My aim was to photograph flowers that were freshly cut and yet already tinged with the aroma of death and decay.

I began by photographing the bouquet. This was to be the largest work in the installation. The bouquet consisted of an excessive abundance of roses, irises, gladioli and lilies — all chosen for their form and colour. I photographed the bouquet arranged on black velvet on my studio floor. I chose to crop the image closely so that it appeared compressed within the frame of my large format camera. It is Ophelia's bouquet and, at the same time, it is the drowned Ophelia. The bouquet lies in a horizontal position, cut down, fallen. Depending on the values attributed to positions of the feminine (beauty, vulnerability, inferiority), the bouquet is by implication a female corpse.

I then photographed each individual flower from the bouquet, including full stems, single heads, buds and petals, this time using a medium format (6 x 7 cm negative) camera for the smaller images and large format (20 x 25 cm negative) for the larger works. The format size was varied from large to medium in order to maintain a consistency of image quality and sharpness throughout the installation. Each flower was placed against black velvet and carefully arranged to appear as if tumbling, floating, or sinking in a black void.

Shooting, proofing, editing and reshooting took place over several months until I felt I had strong images of each one of the flowers depicted in the bouquet. I have access to a colour processor and choose to proof my own images as I shoot them. This way I gain immediate feedback on the images I produce, allowing a great deal of opportunity for experimentation and refinement during the developmental stages of the work.

I also find it is important to print my own final images in order to maintain total control over image quality, scale, colour balance, tonality and cropping. Even at this final stage of the work, decisions are made and changed. I chose to print the bouquet approximately double life size in order to overwhelm the viewer. The large format negative allowed me to do this without loss of image quality. The individual flowers, buds and petals were printed to equivalent size in order to emphasise their relationship to the bouquet.

In the darkroom, I manipulated the colour images by using an unnatural blue cast and dark tonality, echoing the mood of the painting *La jeune martyre* (the initial inspiration for the installation). The use of heavy black frames further emphasised the funereal quality of the work.

Based on Botticelli's device of compressing and scattering flowers, the description of the drowning Ophelia in *Hamlet* and the depiction of flowers floating downstream in Millais's *Ophelia*, the installation comprised a large, single image of the bouquet, from which the other individual photographs dispersed and flowed across the gallery wall in an arrangement that appeared both rhythmic and random.

The heavy wooden frames I use isolate my photographs from the real world. My images of flowers become untouchable, immaterial, ideal. This glorification is another kind of death.

In the final installation, the bouquet of Ophelia lies abandoned, bathed in a cold, dim light. Scattering and drowning in darkness, isolated and tender blooms pay tribute to that which is lost but not forgotten.'

PLATE 85

Your photographic images and installations have a lot to do with ideas of mourning, the memento mori and symbolic depictments of the 'beautiful, captured and frozen flower'. Are you able to talk about the significant developmental experiences and influences behind these ideas with respect to the formation of your creative life as an artist?

On the day of my mother's funeral, flowers were transformed for me into potent symbols of love and loss. I retain a vivid memory of being led by my aunt into a room that housed my mother's coffin. Wreaths, bouquets, floral tributes of all kinds filled the room. The scent and colour of this superabundance of hothouse blooms was at once exquisite and sickening in intensity. They were also a sign that my mother had many friends and relationships, a whole history, of which I had no part. This was a double loss.

My grandmother, insisting that such expense should not go to waste, had the floral tributes transported to our home. For weeks I lived amongst thousands of decaying blooms while grieving for my mother and her unadorned grave.

The memory of this experience has been particularly influential in my creative development. Much of my imagery comes from the graveside. For many years I photographed memorial sculpture at the cemetery. I was particularly drawn to small funerary ornaments, emblems and ceramic wreaths. I like to think of those brittle, fossilised flowers as erotic symbols of passion that have been turned toward the cold and rigid form of dead but unforgotten love.

Recently I have photographed freshly cut flowers bought from the florist. My house is filled once again with the unmistakable smell of fresh and rotting bouquets.

I read a great deal. I find I am continually drawn to writers who concentrate on the subjects of unrequited love and mourning. The tragic figure of Miss Havisham in Charles Dickens's *Great Expectations* provides images of time and decay that are a constant reference in my own work. Gabriel Garcia Marquez's *Love in the Time of Cholera* and short stories such as 'The Other

PLATE 86

PLATE 85
No.1 FROM INCONSOLABLE SERIES, 1992
Colour photograph, 34 x 38 cm, Courtesy of the artist

PLATE 86
No.5 FROM INCONSOLABLE SERIES, 1992
Colour photograph, 34 x 38 cm, Courtesy of the artist

PLATE 87
No.9 FROM INCONSOLABLE SERIES, 1992
Colour photograph, 34 x 38 cm, Courtesy of the artist

'During an Australia Council residency in Paris in 1990, I photographed the interiors of crypts at Cimitière Montmartre and Cimitière Pere-Lachaise. These monuments for the dead often contained altars displaying small statues and vases of artificial flowers. Opening ornate iron and glass doors that appeared to have been closed for years — leaving the objects they contained in an advanced state of decay — released a cold, poisonous air. I felt like a thief as I trespassed into these claustrophobic enclosures in order to photograph disordered arrangements of disintegrating ornaments and tokens, symbols of inconsolable loss, derelict memories of the anonymous dead. Bathed in a dim, yet lurid light filtering through the coloured glass windows, only the artificial flowers remained deceptively bright and fresh, despite their layer of cobwebs, dust and grime.

Since photographing in the cemeteries of Paris, objects symbolic of beauty, freshness and purity — yet tinged by death, decay and loss — have continued to hold a compelling significance for me.'

Side of Death', 'The Third Resignation', 'Eyes of a Blue Dog' and 'Artificial Roses' have shown that an obsession with mourning, and the denial of loss, are powerful subjects to work with. *Camera Lucida* and *A Lover's Discourse* by Roland Barthes, *The Second Sex* by Simone de Beauvoir, and the poetry of Sylvia Plath and Margaret Atwood have also provided a rich source of ideas and imagery.

I travel quite often and spend much of my time away visiting museums, to view a wide range of historical and contemporary work. Museums such as the Louvre, Paris; Uffizi, Florence; Alte Pinakothek, Munich; the Tate, London; Prado, Spain; the Guggenheim and Metropolitan, New York have provided great inspiration. I am particularly moved by the work of early Renaissance painters such as Giotto, Simone Martini, Fra Angelico, Hugo van der Goes and Sandro Botticelli. The work of these artists has been directly influential in much the same degree as certain books and memories of personal experiences. Elements of these paintings — such as skilled craftsmanship, a heavy reliance on symbolism, use of colour, decoration and composition — have been reinterpreted and utilised in my photographic work.

Certain aspects of contemporary photographic work such as the eroticism of death and beauty portrayed in Robert Mapplethorpe's photographs of flowers, the exploration of annihilation and abjection in Cindy Sherman's recent photographic self portraits and Christian Boltanski's installations on the theme of death and mourning are also of great interest to me.

Could you give a general description of your creative processes: what moves you; how you feed into and structure your work, ideas, time and space.

My first thoughts of producing a work on the theme of *Ophelia*, for example, occurred while standing in front of a painting at the Louvre museum, Paris, on a hot summer day in July 1990. The painting was titled *La jeune martyre* and was painted by Paul Delaroche in 1855. Amidst the

heat, noise and traffic of the Louvre, this painting was intensely cold, silent, still — a memento mori. The corpse of a beautiful young woman — 'the most poetic topic' according to Edgar Allan Poe — floats on the surface of a lake or sea. Her pale hair and pale ice-blue gown form gentle undulating folds as they sink into the dark, rippling water.

Some time later, the fascination that this work still held for me led me to search for other images of drowning women. I found an image of *Ophelia* by John Everett Millais, 1851, in which a beautiful young woman drowns while clasping a few stems from a bouquet of flowers. The rest lay scattered across her gown or floating downstream. In this painting, the fusion of a narrative of death, with its symbolic representation in flowers, was of particular fascination to me.

In the planning stages of a work, I collect relevant images and texts. It is usually a combination of elements rather than any one image, or one text, that forms the direction of the work. I like to complete the research for the work before I begin to make photographic images. The collected texts and images are pinned to my studio wall, along with my own notations and diagrams, providing a constant source of reference during the production of the photographic works.

The following passage from Shakespeare's *Hamlet* — describing the moment of Ophelia's death — became the central theme of the work. It provided an appropriate vehicle for expression of a particular instance in which death and flowers are bound together:

'There is a willow grows aslant the brook
That shows his hoary leaves in the glassy stream.
There with fantastic garlands did she come
Of crow flowers, nettles, daisies, and long purples,
That liberal shepherds give a grosser name,
But our cold maids do dead men's fingers call them.
There on the pendent boughs her coronet weeds
Clamb'ring to hang, an envious sliver broke,
When down her weedy trophies and herself
Fell in the weeping brook. Her clothes spread wide,
And mermaid-like awhile they bore her up.
Which time she chanted snatches of old tunes,
As one incapable of her own distress
or like a creature native and indued
Unto that element. But long it could not be
Till that her garments, heavy with their drink,
Pulled the poor wretch from her melodious lay
To muddy death.'

William Shakespeare, *Hamlet*

I place the flowers in an unnatural darkness. They are isolated against a black backdrop. They appear to fall or float in a blackness. It is the black of velvet (seduction), the black of damp earth in a freshly dug grave (suffocation and decay), the black of a deep, dank pool (coldness and isolation). I arrange the flowers before the lens of my camera. They lay silently on the black velvet backdrop of my photographic studio — beautiful, fragile offerings, wilting and dying in the heat of the studio lights, captured forever as latent images on film. They are further dislocated from the realm of the living. I print the photographs with a blue colour cast. It is the cold blue light of moonlight, of the mortuary, of bruised skin, the first tinge of colour on a decomposing corpse. The image is separated from life by a veil of corruption.

Simone de Beauvoir in *The Second Sex* uses a metaphor of the flower as feminine, and the photographic process as love, to describe a sense of loss, waste and disillusion:

PLATE 87

'There is nothing more bitter than to feel oneself but the flower, the perfume, the treasure, which is the subject of no desire: what kind of wealth is it that does not enrich myself and the gift of which no-one wants? Love is that developer that brings out in clear, positive detail the dim negative, otherwise as useless as a blank exposure.'

In 1992 I visited the Uffizi in Florence. I returned to the Botticelli room several times to study the artist's rendering of flowers. I was particularly moved by the tightly bunched, red bouquets in *Madonna of the Pomegranate*, in contrast to the pale, delicate, isolated flowers floating across the surface of the *Birth of Venus*. This sense of compression and confinement in the image of a bouquet — rich red in colour and expressive of intense moments of passion — contrasted against a scattering of individual blooms — faded pinks, reminiscent of loneliness, loss and vulnerability — became the basis of the arrangement of the installation.

The opening sentences of 'The Other Side of Death' by Gabriel Garcia Marquez links the aroma of fresh flowers with that of the mortuary: 'Without knowing why, he awoke with a start. A sharp smell of violets and formaldehyde, robust and broad, was coming from the other room, mingling with the aroma of the newly opened flowers sent out by the dawning garden.'

Your work is often symbolic and archetypal. Could you further elaborate on these elements in your work?

In Camera Lucida, Roland Barthes writes:

'In the photograph, Time's immobilization assumes only an excessive, monstrous mode: Time is engorged (whence the relation with the Tableau Vivant, whose mythic prototype is the princess falling asleep in Sleeping Beauty). That the photograph is modern, mingled with our noisiest everyday life does not keep it from having an enigmatic point of inactuality, a strange stasis, the stasis of an arrest.'

When making a photograph, the object before my lens is fixed, frozen forever in the moment taken to release the shutter. The object becomes an image and enters what Barthes describes as 'flat death'. This is just the first of a number of symbolic acts I undertake in order to separate my work from everyday life.

The symbolic usage of flowers is a recurrent subject in my work. Their close association with romantic and funerary rites provides their most obvious symbolism of the sentiments of love and loss. Flowers are beautiful, fragile vessels symbolic of femininity; however, above all else, I find flowers to be symbolic of death. Cut flowers already show the faintest hint of corruption and decay. In an otherwise perfect bloom, embalmed by the florist, faint bruises are already visible. Petals are beginning to droop, their edges about to curl and discolour. As well as entering death when submitted to the act of being photographed, these flowers are in the process of undergoing actual death. Like many of the objects I choose to photograph, flowers are memento mori (literally 'remember you must die').

I place my photographs in heavy wooden academy style frames to isolate the photographs from the real world. My images of flowers become untouchable, immaterial, ideal. This glorification is another kind of death.

In *Framed; Innocence or Guilt*, Germano Celant states:

> 'Initially the frame was a simple ornament appended to the work of art. Then it began to play a role in one's perception of the art, finally becoming itself an autonomous sign. The frame is an enclosure which isolates art and identifies its 'separate' reality. Its introduction in the representation of images is tied to a process of solemnisation of the subject. As the frame takes on this decorative disguise, the area it defines is glorified.'

There is a distinctly feminine sensibility to your work. Could you discuss this and in what other ways being a woman has influenced your work — positively or negatively?

My work is imbued with the traditionally feminine qualities of beauty, fragility, suffering and sentimentality.

I choose to make highly personal statements. I believe the content of my work is more meaningful, and the resulting imagery more powerful, when drawn directly from my own experience. It is therefore inevitable that my work expresses ideas pertaining to the feminine.

My experience of life as a girl, growing up in an atmosphere of the sick room — as one after another of my family suffered terminal illness, has been extremely influential on my development as an artist. It has insinuated a dark, morbid quality into my artistic expression:

> '…melancholia is, according to Freud, failed mourning, an inability to accept the death of a desired object. Melancholia involves a denial of loss, which emerges from initial acknowledgement of this loss and provokes its perpetual articulation.'

Elisabeth Bronfen, *Over Her Dead Body: death, femininity and the aesthetic*, 1992

I find it acceptable in our culture for women, rather more than men, to openly display their emotions, to be sentimental, to mourn. Sylvia Plath in her poem about dying writes:

> 'Dying
> Is an art, like everything else
> I do it exceptionally well.
> I do it so it feels like hell
> I do it so it feels real.
> I guess you could say I've a call.'

Collected Poems of Sylvia Plath, 1981

PLATE 88

As a woman I feel free to perpetually articulate feelings of loss as highly personal statements within my work. This could be seen as a negative act of denial (as in the case of the melancholic) or as a positive attempt to make powerful statements about important aspects of life.

PLATE 88
INSTALLATION VIEW OF THE ROMANCE, 1986
George Paton Gallery Melbourne, Courtesy of the artist

Could you discuss your current thoughts on the function and purpose of your art?

The purpose of my art is to create skilfully wrought photographs of great beauty and deep personal meaning.

> 'The creation of beauty allows us to escape from the elusiveness of the material world into an illusion of eternity (a denial of loss), even as it imposes on us the realisation that beauty is itself elusive, intangible, receding. Because it is created on the basis of the same elusiveness it tries to obliterate, what art in fact does is mourn beauty, and in so doing it mourns itself.'
>
> Elisabeth Bronfen, *Over Her Dead Body: death, femininity and the aesthetic*, 1992

We fear our own death. With equal intensity, we fear the loss of those we love. The result is a denial of loss. I hope that by creating beautiful images, symbolic memento mori, my work functions to illuminate this denial and analyse the role of sentiments such as love and loss in our own lives.

PLATE 89

Lucille Martin

MULTI-MEDIA INSTALLATION ARTIST

*Often I am triggered emotionally by something I read, see or hear —
it is as if it somehow becomes destiny to follow certain paths of
information… Frequently the same symbols evolve consciously and
unconsciously from one series of works to the next. It is as if they have
a force of their own…yet technically and materially they begin to take
on a new identity and the next program of work is born.*

LUCILLE MARTIN was born in Perth, Western Australia and in 1980 gained a Diploma in Design from James Street Technical College, Perth. In 1988 she received a Diploma in Production Design from the Australian Film, Television and Radio School in Sydney, and in 1992 attained her Master of Art in 4D Computer/Photography from the College of Fine Art, University of New South Wales, Sydney. In 1989 she was a tutor at the Fine Art College, University of Western Australia. Martin has travelled widely and her project grants have included an Australia Council studio residency in Tokyo in 1993. She currently lives and works in Western Australia.

Martin's work has straddled advertising art, design, film, painting and more recently video with computer assisted and generated imagery, all of which she now combines in collages of image and idea through multi-media installation works. Martin uses the colour red in all her exhibitions as a visual evocation of its associations and as a binder to hold together elements of object, image, video — 'even sound and text'. The focus of Martin's works has been on issues of gender and the imagery of women; identity — with the body and self portrait as a 'practice of resolving, healing and growth'; racial conflict; and environmental concerns. In all of these themes, her aim is to confront 'complex discourses of social and cultural representation to find new ways of thinking in culture and art'.

Martin has had a number of one-person and group exhibitions in Australia and overseas and is represented in the Art Gallery of Western Australia, the University of Western Australia, the Lawrence Wilson Art Gallery and in private collections.

What have been the most significant formative influences in your development as an artist?

I believe strongly that we are guided by the experiences, information and people we interact with. I have known since I was a young child that art and the making of art would be the

PLATE 90

PLATE 91

PLATES 89, 90, 91, 92
**METAPHORS FOR MEMORY — A PARADOX OF
ORDERING**, 1992, Courtesy of the artist

'The project *Metaphors for Memory* was a body of four
installation pieces that specifically addressed the
exploration of identity using self portrait, to discuss
cultural and social constructs such as gender, sexuality,
class, race and colour. The choice to work with self
portraiture assisted the development of the communication
process within the imagery. In the course of storyboarding
research, I found a reference relating to the first account of
self portrait — interestingly it referred to the model being
a woman, an artist, who had drawn herself for lack of other
artistic models. Women were forbidden to use models at
that time (the fourteenth century) and, above all, were not
to depict men or women in the nude. Paradoxically, I was
working with the self portrait to make visible the hidden
speech about such taboos. This view of watching myself
in an image of life, became a form of discovery. It was a
way of dealing with issues and asking questions through
the body.

Part IV in the series *Metaphors for Memory — A Paradox
of Ordering* is created with five main images. Each of the
five pieces has a chrome stand, each is placed on a shelf,
each holds a perspex mount with the mirror as the central
theme. Within these images, the mirror became the main
focus for the communication process, as if to somehow
invite the viewer inside to share in the journey/narrative.
It is presented in such a way as to ask the viewer to look
inside the imagery for other meanings. In other words,
each image has points of direct similarity and difference.
However, upon looking closely, the topic is unique on all
accounts, yet still pertains to the theoretical issues relating
to women. All of the images are directed towards self
portrait, through the body. ➤ p.179

strongest passion in my life and that eventually this would lead to visual and oral communica-
tion and writing.

Although my work and drawing journals were always encouraged in my younger years,
being brought up in a working class family meant that money — and how to earn it — was the
priority. A career as an artist seemed like something one could do when one retired. Added to
that, the prospect of a solo career as a professional artist did not seem a well-paid occupation,
especially for a woman.

It wasn't until my third year at art college that I was introduced to a more expansive view of
art by a teacher and now mentor Paul Thomas. He was from a group of young avant-garde
artists that had arrived in Perth from England to teach drawing classes. The relationship we
had grew over many years and in those years, during which I was developing my career working
as a commercial artist and art director, I still fought with the idea of how a woman artist would
survive, let alone exhibit or be acknowledged for her work. It just wasn't something I had seen
or experienced during those formative years.

A particularly influential turning point in my life and work occurred during 1984–1985. As a
result of a car accident, recurring health problems forced me to look at my work and life. Travel
to other lands always seemed fascinating and it was during that time I felt a strong desire to pur-
sue this interest.

How have these influences flowed into specific works?

The strongest messages I have ever felt, in regard to specific works, came during this trip over-
seas — in countries that were experiencing racial and religious conflict. These countries were
South Africa, Israel and border settlements of Lebanon as well as parts of Northern Ireland.
South Africa was the most shocking and revealing. It was mid-1984, the anti-apartheid riots
were surfacing and it was here that I faced my own identity and truths of what equality and
freedom of colour and race meant. I just didn't understand why I couldn't walk or talk with ease
to another human being if their skin colour wasn't white. My view of life seemed so protected
in Australia and any work I had created for magazine advertising paled in significance. It was
one of the most important times in my life — I was enraged for fellow human beings who were
being persecuted because of their skin colour.

Every country I went to was surrounded by war. There was a lot of conflict happening and I
thought that somebody had to say something; there is more to life than advertising — art can
talk. There was really no choice — I had to speak out about the injustice and I began recording
my encounters and interactions with people in black townships like Soweto and Alexandra,
which resulted in my first solo exhibition in 1986, *Blind Spots*, at King Street Gallery in Sydney.

My life/work has continued in much the same way — being faced with human and environ-
mental situations that I am compelled to talk about and, naturally, they are expressed in my
work. Another example of this inter-relationship was in 1994 when I was living in northern
New South Wales, working toward a major exhibition in Perth in June. Whilst I worked, I was
confronted by large earthmovers flattening ancient plants — hundred-year old melaleucas,
grasstrees, culvert — because of a housing development bungle carelessly passed by an inept
council. This was a sacred and beautiful site, threatened by human greed and progress.
Progress for what? I ask — we can't be progressive when we destroy nature. These experiences
then infiltrate my work and this work is my reality.

Talk about your typical ways of working — the creative processes involved in moving spark
or impulse to form.

Thought, discussion and dreams tend to guide me to meetings and interactions that in turn
help define a structure. Often I am triggered emotionally by something I read, see or hear — it
is as if it somehow becomes destiny to follow certain paths of information. I read heavily during

the early stages of a program or a new series for a show. Notes, cuttings from magazines, video, thumbnail sketches and storyboarding are important processes in the documentation of the new work.

During the late 1970s I concentrated on the photocopier, using it as a camera to record or rework information previously collected. This work continued until the mid-1980s when the colour photocopier was offering interesting effects. David Hockney, influential English artist of the 1980s, inspired my early experiments with this methodology. In his book *Retrospective*, he describes the works: 'They are not reproductions in the ordinary sense but the original work. New technologies have started revolutions that need not frighten us. They can be humanised by the artist. The office copier has opened up commercial print as a direct artist's medium.'

In the series of works to follow, the body became a relative theme for exploring this information. This process required the model to lie on the glass of the photocopier and be photographed. Each image was collaged into the final pattern and the whole piece was modulated with acrylic paint.

Particularly important during the period when I was exploring the merging of image and text (which resulted in the installation *Metaphors from Memory — A Paradox of Ordering*, 1992) was the association of a theory class 'Art and Cultural Difference', by lecturer Dr Diane Losche. In this stimulating class that threw the doors open with new information, Losche encouraged a freedom of expression, artistic and oral, within the set parameters of the theoretical discourse. As a result, I created another series of words and images in book form entitled *Structures of Identity*.

Recently I completed a Master of Arts degree, expanding my dialogue and theoretical practice. This newfound voice and sense of place in my work prompted a change of tools. I set aside the brush, paint and canvas for new technology — primarily video with computer assisted and generated imagery. Initially, I had to face this cold piece of machinery, whereas prior to this I was using my whole body to paint, which was very tactile. However, with persistence came competence, and it became very liberating. Computers have been a very male-dominated area and it is now time for people to use this technology to express other viewpoints, so women should be encouraged to participate. As a woman and visual communicator, I felt challenged to expand my work on new levels, confronting complex discourses of social and cultural representation to find new ways of thinking in culture and art.

This relationship between painting and photographic work has been uneasy for many artists who have used photographs as functional, and sometimes formal, equivalents to drawings. For example, Max Ernst — whose work has always been inspirational — moved between many mediums to achieve the juxtaposing of his mediums, collage and realities: '...he believed by doing this he would generate dissonance — an aesthetic disharmony with social overtones.' (Carter Ratcliff in *Aperture* magazine, No. 125)

During this change of medium, I worked specifically with self portrait as a practice of resolving, healing and growth. The choice to work with self portrait also assisted the development of the communication process within the imagery. Jo Spence, a psychotherapist, shared a similar response related to her work: 'It is a kind of dialogue from within the theatre of the self in which the psychic and the social finally meet.' Interestingly, it seemed that from that point, the role models in my life had primarily changed from men to women.

As well as Jo Spence, I became especially interested in the work of Lorna Simpson, Cindy Sherman and Helen Chadwick, because they too worked specifically with self portrait and the body in expressing a narrative. Spence, Sherman and Chadwick focus on the stereotypes of women, while Simpson works with parts of body and word to confront the viewer with issues about race and people of colour. Women writers were also influential during this period, like Black American writer Audre Lorde, American writer Gayartri Spivak and Vietnamese-American writer Trinh Min Ha (*Woman Native Other* and *Framer Framed*) who shared other

Initially, on *Metaphors*, I worked using a filmic approach, concentrating on the camera principles of the extreme close up, the long shot and the mid shot, using a professional Hi-8 camera with a still camera. Using a Macintosh CX computer and a NU Vista frame grabber, I captured single frames and reworked the chosen images with a combination of software: Colour Studio, Photoshop and Quark Xpress. This formula became the technical basis for the ongoing series.

The colour red is used in all my exhibitions as a visual point for holding elements of image, video, object, even sound and text, together. It relates to a subliminal approach similar to the feelings evoked when looking at Christian Boltanski's work. The colour radiates heat and fire, femininity and sexuality — the power from which combines all of these elements to touch the senses. Interestingly, Vicki Noble, in her book *Motherpeace*, describes the mythical background of the colour red as also being associated with circles and discs. She explains: "In stone caves, archaeologists have found hollowed out circular breast mark cupolas in the walls, circular perforations and coloured spots or discs (usually painted red) that surround hands, breasts or animals or stand alone."

This series marked the beginning of my explorations into merging image and text. My first approach to this merging was by working with Chinese and Japanese text and symbol. They were beautiful in appearance, structure and movement — representing the unknown, the outward and the diversion. Contextually, this process was significant within the recurring theme of language and the body, because it joined the research in visual communication, language, material/computer function, performance and theory together.

As well as working with oriental text, I explored the visual/written rhetoric of Joseph Kosuth and Barbara Kruger, Christian Boltanski and Sophie Calle. Boltanski and Calle really interested me because their language works subliminally, implicating the viewer. Their installations combine image and text, minimal in approach, working in very particular systems and organised grids, often beguiling the viewer to provoke response. One of Boltanski's installations, *Archive: Detective*, involved a wall of images, with a tin holding articles that relate to that image underneath each one — meaning that the written information is not visible, all we know is that they are linked to the story. This explanation of the language/story is not directly defined as we know it "to be read or written".'

PLATE 92

PLATES 93, 94, 95, 96

EXPOSE: THREE STORIES FROM TOKYO. PART I, II, III, 1995, Plate 93: *Three Stories from Tokyo Part I* (installation), 1995, Multimedia, Hi8 video, suspended futon, soundscape, projected image, Photograph: David Dare Parker; Plate 94: *Generation Series: White Rhythm*, 1995, Hi8 video, computer manipulated photograph, 20 x 35 cm; Plate 95: *Generation Series: Taste of Forbidden Fruit*, 1995, Hi8 video, computer integrated image, photograph, 20 x 35 cm; Plate 96: *Generation Series: Super Girl and Astro Boy*, 1995, Hi8 video, computer manipulated photograph, 20 x 35 cm; Courtesy of the artist

'In 1994 I was awarded an Australian Council professional development grant to take a studio residency at their VACB studio in Tokyo, Japan. Whilst there, I developed the images for this installation. All the images had a separate theme and each theme related to situations I encountered during this time as artist-in-residence, and to my attempts to understand the relationship of 'me' in that dislocation — as a woman in such a patriarchal society, trying to be sensitive in my cultural understanding of that; where did I fit in and how would I share/relate to this or that if it affected me.

In *Part I*, the video installation piece has a circle six foot (180 cm) in diameter of painted red wood over which hangs a matrimonial futon bed. In *Part II*, the centre column structure — supporting the seven images and objects — is an eight foot (240 cm) circular column and also in *Part II*, underneath the suspended underpants installation, is a four foot (120 cm) in diameter mirror reflecting the controversial text screen printed to the gusset of all sixty pieces — *Tolerance comes at a price*. To me, the recurring theme documents cycles in life: as an abstract feminine symbol; in a woman's body; as a complete whole; the joining of two points. It is balance, which then extends into many philosophies and religions throughout the world — the most common of these is the Yin/Yang symbol. It is related to personal, global and environmental interconnectedness. The circle is a grounding form and, working within this frame, creates a sense of security, a protectiveness that encloses you during the process of making the art and speaking from that point of view.

The image *Expose: Between Worlds* in *Part II* of the installation, talks about a cultural theme known as *Ko itten* (A Touch of Scarlet) that Kittredge Cherry describes in her book *Woman's Word* as relating to the linking of females in ruby hues. In this particular work, the red background linked (what I had experienced from many interviews with women) roles and ideals that they seemed to be currently questioning. Within the image are three central themes — the face of the housewife, the traditional kimono and the graphic outline of the costume of the Western bride. Traditionally — in the past — women have worn red underneath their kimono to ward off menstrual pain and keep the female reproductive system running smoothly. In Western culture, the red undergarment is looked upon as being very erotic. The use of the colour red is culturally driven and I have used it in diverse ways within many works. Red then becomes the linking device between construct, culture and country. Within these works, red was specifically associated to Japanese culture as a means of understanding the struggle and changing role of Japanese women. Many icons and fetishes are described around the use of red/scarlet.

Through the use of the magnifying glass, the idea was to renegotiate the perception we have of vast cities and vast technological centres like Tokyo. I found the senses were being violated, desensitised — too much noise ▶ p.182

representations of women working through and with their bodies, using language and writing. Trinh Min T Ha explains how, socially and culturally, women have been forced to be 'outside their bodies, outside them-selves' and 'women must write through the body. Must not let themselves be driven away from their bodies. Must thoroughly rethink the body to re-appropriate femininity'.

The influences of travel and nature outside my own country of Australia — which constantly reinforces the notion that we are all interconnected — continues to be a primary direction for the cultural and political discourse I engage in. From 1990 until recently, each residency has precluded the early processes of storyboarding and collection of visual data. When I go overseas I photograph stills and shoot images on a Hi-8 video camera. The video becomes a portable sketchbook of encounters and discussions with interesting people and places.

Back in the studio I run the video footage through the computer program to create new imagery enhanced with sound and text. Having been transferred to the computer, the information is integrated with scanned images, photos and collected data, together with graphics manipulated by software. It is later printed in a variety of ways and finally combines with a surface object to take part in the final display/presentation. With the use of computer-assisted image technology, the video scenes can be altered and reworked to create an endless number of new images. New printing processes mean I can print out new work in a variety of ways. These applications have led to installations and exhibitions in Sydney, Perth and Melbourne that have combined photocopy collage, computer imagery and soundscape displayed on any static surface.

Could you discuss the pictorial, archetypal and symbolic aspects of your work?

Frequently the same symbols evolve consciously and unconsciously from one series of works to the next. It is as if they have a force of their own in describing a narrative.

The developmental and theoretical process of working towards these elements is continual from one series of works to the next. Within each new body of work, the planning process has similar threads, yet technically and materially they begin to take on a new identity and the next program of work is born. It is as if cyclical patterns form and reform in different contexts; for example, *the circle* operates very much like that in my work. Unknowingly, it has revealed itself in many forms — as part of the solar system in *Metamorphosis Series* (1990); the shape of a mirror in the series *Metaphors for Memory — A Paradox of Ordering* (1992); the frame of some 140 pieces of work in the show *Hoop* (1994) from the series *Exposed through Language* (1994); and recently in the major installation pieces for *Expose: Three Stories from Tokyo. Part I, II, III*.

It wasn't until returning from a 1993 residency in South-West USA, in the regions of Taos and Arizona, where I had worked with the indigenous peoples of the region, that I realised the rich mythological and historical significance of the 'circles'. Whilst there, I experienced ceremonies like the Sweat Lodge, which was constructed in the form of a circle with hoops (the 1994 installation *Hoop* was the result of these experiences). Inside the hole, in the centre of the Sweat Lodge, is contained hot, fiery rocks suggesting the core of Mother Earth.

It is about remembering and linking what we know to our cultures, to our elders and really having a look at our identities. Within the series *Hoop — Reflecting Reflections* (the name is borrowed from the writer Trinh Min Ha in her book *Woman Native Other*), the *mirror* became a source of reflecting, seeing ourselves seeing ourselves — never quite content with the view, as if dependent on the image and yet wanting more. For me, as a communicator and artist, this is the point of exchange. I often use multiples in my works — sets, patterns and orders of things — to give an intensity to the way the image is seen within the object, or to find some common ground in discussing timely situations that may often arouse conflict or emotion. Trinh Min Ha explains — 'Mirrors multiplied and differently disposed…constitute a theatre of illusions within which countless combinations of reflecting reflection operate.'

LEFT: PLATE 93, TOP RIGHT: PLATE 94, MIDDLE RIGHT: PLATE 95, BOTTOM RIGHT: PLATE 96

pollution, visual pollution. And even when away from that bigness and over-abuse I found we sometimes lose sight of seeing what is, and was, important in our lives again — like the need to see, hear, smell, communicate, touch again — and to accommodate these needs in our lives and, most especially, to speak out to the greater organisations and governments to support these needs. What continues to amaze me is the power of the mass media, presenting one single program from one country and beaming this information — good or bad — to millions and millions of people every day! What control!

The second of the two projects influenced by this residency was presented in the group exhibition *Generation* in Perth in 1995. This series works by way of a similar process relating to cultural identity, describing short narratives in a collaged form created on the computer. Each panel is set in an oval shape with themes relating to the juxtaposition of the very public and private face of Japanese life. On the left of each panel are scanned combinations of realistic photographic and video imagery depicting women in various roles. On the right of these reworked and integrated computer-drawn images are cartoon caricatures of women stylised according to the look of the well-known Manga comic books. Reading *Manga* is a common daily activity for thousands of Japanese people. I especially chose this type of graphic because of the well-known history of these comic books, which present women in scenes of bondage, rape and refer to them as helpless victims to be preyed upon. In all four works from the series *Junketsu kyoiku* (Purity Education): 1) *Tuna and Women*, 2) *Myself in You*, 3) *Women's Stories* and 4) *Ask Marilyn*, I wanted to present the view of women breaking out of these constraints and exploitations — seeing them/us as in our reality — as strong and equal.'

At this point in my work and career, I am interested in celebrating difference, the diversity of voices and individuality. Being a woman and a woman artist is difficult at the best of times — juggling career and lifestyle in the most normal way possible. Change is evident, with government organisations such as the Australia Council supporting equal opportunity and balanced ratios for grants and awards.

Could you further elaborate on how being a woman has impacted on your career as an artist — outlining the perceived positives and negatives?

It wasn't until I returned to university that I really recognised difference. It began as a feeling of heaviness, as if I had somehow recognised and heard something familiar that had burdened me for years. It felt similar to the seeing/feeling of injustice I had experienced in South Africa, but now it was here, inside me, something not quite right. The more I studied, the more I recognised it was 'I' caught in the ideals of an institution. This was a 'difference' I felt in words, language and vision. Monique Wittin, an American writer, speaks of this in relation to language. She said language is an 'important political field where what is at play is power' and how that power acts in our social reality, for we have all been raised in a society where the influence of socially 'institutionalised knowledge' and its distortions are endemic within our living. Writer Audre Lorde said, 'We either block difference or pretend it does not exist' — often those recognising these 'differences' are from 'outside the normal' such as 'woman of colour and culture'.

To renegotiate this new understanding of identity — as an artist/woman — meant to move beyond patterns that, up until this point, were not recognised as oppressive. It also meant renegotiating the art identity in society, past and present, one without the historical baggage of a patriarchal order that weighs it down today — that is, the view that most real art was created by men, and mostly white. Russell Ferguson says in the introduction of *Out There: Marginalization and Contemporary Cultures*: 'for artists and writers who have been brought up in a system entirely based on belief in great geniuses who produce great works, it is not easy to reject those concepts, even if that very system has consistently excluded works by members of their own race or sex'.

At this stage of your development, how do you see your role as an artist and the purpose and function of your art?

As an artist and visual communicator, the choice of technology, philosophy and word is central to the nature of my work, in which complex ideas and layers of information are frequently drawn together. This interwoven methodology is like a duplication of the technique and discussion of my work — the collaging of image and idea through the multi-media function.

I live my work each day — it is a source of discovery, constant challenge and pleasure to me, whether it takes the form of a mark on paper or the written word. It is often provocative, opening dialogue for discussion, presenting situations that are often personal but which affect us all. It is the awareness of the human condition that often provides compassion and understanding and I believe that we, in the time of the 'information revolution', must all speak out. As Audre Lorde said, 'Silence will not protect you.' *We must, as women in a changing society, feel empowered to claim us, to re-establish an identity, in our lives and work, to rewrite 'the History'.*

At this stage, my work continues to document this exploration of identity. The intention is not to provide answers, but to support the diversity of voices by examining functions of visual communication and personal interaction to find new ways of thinking — in culture and art. During the entire period of my work — and most especially during the preparations of new shows — I look to nature, my partner and close relationships for grounding from my other world.

Mandy Martin

PAINTER

On each trip I have taken in recent years, I have read the relevant explorers' journals, and other associated material, which provides me with an eclectic assortment of notations on the geology and the fauna and flora of a place. Poetic allusions or operatic phrases work their way in…and I often throw in my own words as well.

MANDY MARTIN was born in Adelaide and studied at the South Australian School of Art from 1972 to 1975. Martin was actively involved with women's art issues in South Australia and the related socio-political concerns prior to moving to the ACT in 1978 when she took up the position of lecturer in painting and drawing at the School of Art, Institute of the Arts, Australian National University, Canberra — a position she still holds.

Mandy Martin became known in the early 1980s for her atmospheric landscape paintings — informed by the eighteenth and nineteenth century Northern European Romantic sublime and executed in a manner reminiscent of Turner — which depicted, both aesthetically and impactfully, the intrusion of industrial construction and pollution upon the natural environment. Martin's recent work is intensely concerned with the nexus of artist and historian/explorer — not only in terms of her own paintings, drawings and mixed media works, but also retracing (historically, physically and artistically) the journeys of early Northern European artists who accompanied the early colonial explorers of 'Terra Australis'. In so doing, she is attempting to understand these artists' perceptions of this land as 'terra nullius' (viewed as being without legal owners), which in turn has shaped Australian cultural and landscape identity and has led to industrial and agricultural exploitation, the attempted annihilation of Aboriginal culture, and contemporary white Australian spiritual questing.

Like some of the colonial explorers who kept detailed diaries as a documentary record of their ventures, Martin draws and records in words some of the details of the locations she is depicting. Her response to the landscape is also intensely personal: her discovery of the landscape is also about discovering aspects of herself in relation to the environment.

Martin has held numerous one-person exhibitions since 1977 in Sydney, Adelaide, Melbourne, Brisbane and Canberra and in St Louis and Washington in the USA, and she has also participated in group shows in Paris, New York and Nuremberg. She won the McCaughey Prize, National Gallery of Victoria, Melbourne in 1983 and the Alice Prize, Alice Springs in 1990 and is represented in the Guggenheim Museum, New York, the Los Angeles Museum of Contemporary Art, the National Gallery of Australia and in most state gallery collections.

PLATE 97
SUNRISE AT LAKE JULIUS, 1994
Oil, ochre and pigments on linen, 152 x 550 cm, Courtesy
of the artist

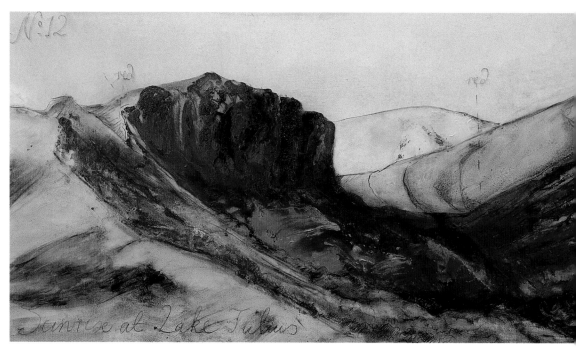

PLATE 97

*Could we discuss the experiences, the people, the places, the seminal works and writings that
have been particularly influential and inspirational in your creative development?*

It is difficult to make a simple personal statement about influences that have been important in
my career, as it spans quite a few different periods and manners of work.

I guess the first major period of my work, from my perspective, was after the years of politi-
cal screen printing when I first exhibited canvases at Powell Street, Melbourne in 1981 and
1983. The underlying concern — to talk about the human condition in contemporary
Australian society — was evident in these two series. They were paintings of elliptical water
tanks beneath threatening thunder clouds in a barren, somewhat apocalyptic landscape. They
were in part about the drought, redundancy, bushfires and despair in Australia. They were also
about death and dying (autobiographically). The other dominant motif was the sawtooth fac-
tory — the male symbol of industrialisation.

Industry and landscape have remained central concerns in my work since then. The
Romantic industrial sublime informed my work, then and now, and I have always researched
Romantic landscape art and artists who deal with the sublime. This led to my current interest
in the nineteenth century artist/explorer in Australia, which I primarily see as a metaphor for
the spiritual quest in Australia by the non-Aboriginal population and for misplaced priorities. I
have a continuing concern with the Australian landscape and the cultural, industrial and agri-
cultural colonisation of that landscape.

There are many books that have been very influential upon my work. Among these are
Ludwig Becker: Artist and Naturalist with the Burke and Wills Expedition by Marjorie Tipping and
The Volcano Lover: A Romance by Susan Sontag — particularly the passages:

> 'He has escaped the dungeon of thought. He feels elated. He is climbing. It is a
> laborious ascent. But now the mountain no longer has to be climbed. He has
> climbed, by a kind of levitation. He was looking up for so long and now he can
> look down from this high place. It is a big panorama. So this is dying, thought the
> count' (p. 352); and:

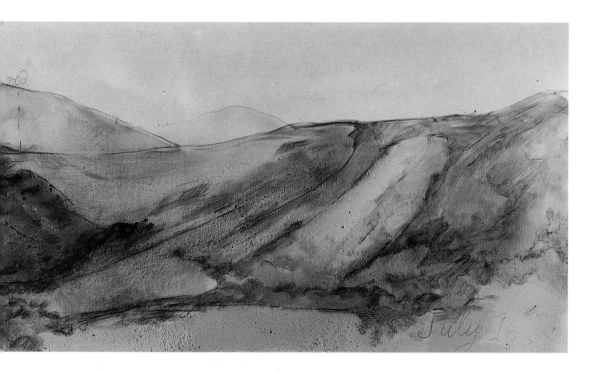

'But I cannot forgive those who did not care about more than their own glory or well-being. They thought they were civilised. They were despicable. Damn them all' (p. 419).

Another is *Reading The Landscape: Country — City — Capital Rd* by Simon Pugh:

'In the post industrial world, all "country" becomes "city". The archetypal site of modernity today may no longer be the metropolis with its shanty-towns and barricades but the desert. As Estragon says in Samuel Beckett's *Waiting for Godot*, 'Recognise (the place)! What is there to recognise? All my lousy life I've crawled about in mud! And you talk to me about scenery!' (p. 6, Introduction: Stepping out into the open)

A few of the many influential artists and paintings have been: *Border of the Mud-desert near Desolation Camp* by Ludwig Becker; *The Flood in the Darling 1890*; *Sydney from Sketches on the Darling* by W.C. Piguenit; 'The Flying Dutchman' by Albert Pynkham Ryder (1890) and the works of Turner.

What are the creative processes involved in your art making?

Usually the first stage in my process is accompanied by rough thumbnail sketches made in my diary. In the studio, I work from these drawings to make paintings. I also make mixed media works in the landscape.

An example of my process is the suite of drawings *Narribri — Moree*, which resulted from a drawing trip I took around Bourke, Narrabri and Moree in the far north of New South Wales. I had been researching the sketchbook drawings of W.C. Piguenit, who drew in the same area during the floods of 1890. From these drawings he produced *Flood on the Darling*, which hangs in the Art Gallery of NSW — and which Daniel Thomas describes as the first modernist painting in Australian art.

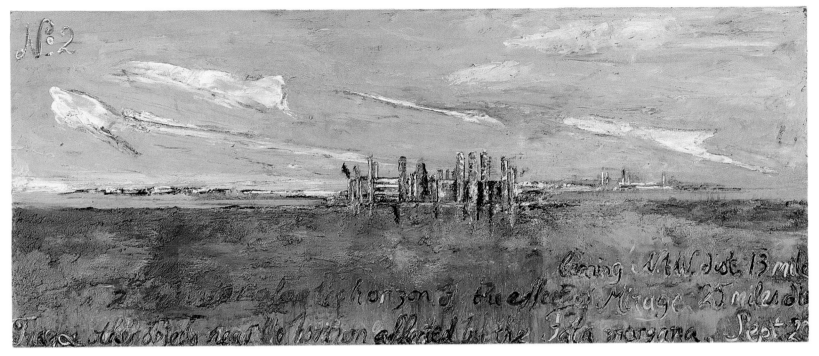

PLATE 98

My drawings refer to devices Piguenit used in his work — including his handwritten notes on drawings. They also refer to the current land use of the area for growing cotton and sorghum. The suite is an overall reflection on the agricultural and concomitant cultural colonisation of the Australian landscape.

I have used watercolour, pigments — including ochres — that I have collected and graphite pencil as media and have grounded stretched paper with an acrylic medium tinted with gold lustre to simulate the off-white paper of Piguenit's sketchbook. (His sketchbooks are in the Mitchell Library.) I used quotations from many of the cited sources in the drawings and often chose a word as text for my paintings. This concept is similar to the concept that shapes my current work.

I have worked a few times in the ochre pits north of the Flinders Ranges in South Australia — the third of such sites in which I have worked. Drawing here and in other Aboriginal quarrying sites interests me as the scene of Aboriginal industry and part of Aboriginal trade routes, which, for red ochre, extended as far as the North-West Cape.

The Northern European Romantic sublime shaped our vision of the desert. Ludwig Becker, the German artist who painted on the Burke and Wills expedition, searched for the 'vast' of Caspar David Friedrich. I feel that Becker foresaw his own sublime death. That same Northern European Romantic sublime vision is a constant conditioner in my work. The sublime is a useful tool to approach the degradation and exploitation — however 'necessary' — of the environment.

On each trip I have taken in recent years, I have read the relevant explorers' journals, and other associated material, which provides me with an eclectic assortment of notations on the geology and the fauna and flora. Poetic allusions or operatic phrases work their way in and I enjoy reading parallel literature from archaeologists, Australian studies and humanities researchers, and I often throw in my own words as well.

Charles Sturt, who was one of the more erudite explorers, wrote: 'We were as lonely as a ship at sea and as a navigator seeking land' (Sturt, 26 August 1845). It occurred to me that the spiritual quest in the 'Rime of the Ancient Mariner' struck resonant chords with Sturt's journal. There is little doubt that Ludwig Becker was aware of his journey into the desert in sublime terms — in fact he did publish a strange little parody in Victoria that has a sea voyage in it. I would hazard a guess that Sturt may have read the 'Ancient Mariner' himself.

I am sure it was in Sturt's mind as he travelled north looking for the inland sea. Camille Paglia, writing in *Sexual Personae*, on Coleridge said: 'The Ancient Mariner transports its Gothic tale out of the historical world of castles and abbeys into the sublime theatre of desolate nature.' We find the place of Eurocentric spirituality in the face of the circle of 'paranoic eyes' (Coleridge) — that is, in the face of Aboriginal spirituality.

What Camille Paglia says of the Mariner could apply to Burke: as 'the male heroine by operatic self-dramatisation [he] is a prima donna triumphing through exquisite suffering watched by the all knowing ring of eyes' (Paglia). Burke — like the Mariner — searches for redemption. Contemporary white Australians search for their own sense of spirituality in Australia. This cannot happen until there is a reconciliation with Aboriginal Australia.

S.T. Gill's *Horrock's Expedition* (1846) is a seminal image and presented the possibility for reconstruction that I had found in Becker and Angus previously. In a series of work I did following a trip to Tibooburra, two underlying ideas meshed: Coleridge's 'Rime of the Ancient Mariner' and Sturt's journal. In 1994, shortly after the first Tibooburra series, I produced the second of two Lake Torren series. Alan Moorehead's book *Cooper's Creek* introduces the myth of the inland sea, saying of Sturt that: 'His hopes for an inland sea had revived and it was with bitter disappointment when once again they struck the Stony Desert' — '…coming suddenly upon it,' Sturt recorded, 'I almost lost my breath. If anything, it looked more forbidding than before; herbless and treeless.'

On recent trips to the north-west of New South Wales, I have visited the sites Becker worked, including 'Mutwingie' and the 'Goningberri Ranges' (his spelling), which he depicted in 1861. The image encapsulated in 'The sun's rim dips, the stars rush out, in one stride comes dark' from the 'Ancient Mariner' seems to capture the consistent melancholy theme in nineteenth and twentieth century artists' work, including Becker, who, in my opinion, knew he was going to his death.

I am eclectic in relation to the sources I draw from, and when I have a passion, everything seems interconnected and I naturally reorder the universe around that passion. I have had a strong interest in Albert Pynkham Ryder's work for years and I tend to use him as a hallmark for the possibilities of what can be achieved in landscape painting. I had been thinking about him in Alice four years ago. Naturally I was very receptive when Bernard Smith brought to light in *Imagining the Pacific* some new research on Coleridge and the 'Rime of the Ancient Mariner', which is another version of Ryder's 'Flying Dutchman', 1890 — a seminal work to which I often refer.

During my past three drawing trips in 1994 (June–July to Lake Gairdner; July to Cooper's Creek; September to Mt Isa), I have been more open, allowing narratives to flow into my work in an attempt to find a voice.

How has being a woman specifically impacted on your life and career as an artist?

I helped to produce the women's art movement in Australia in the 1970s and in turn I am a product of the feminist revolution. I have always demanded equality and access to the structures and placements that I wanted. I have managed this and, within a politically balanced marriage, have also managed children and lectured at art school as well.

I have been able to travel interstate and overseas, but not to work there — except for very brief periods and very rarely without family commitments. Possibly this has held back my career somewhat, but I do not regret that. Certainly having children adds to the massive financial burden of producing art.

My work is obviously autobiographical, although deeper analysis is needed to reveal this aspect. In the 1970s to 1980s my work was all gender oriented — i.e. about the condition of women in society. The gender issues are now submerged in the overall work rather than revealing themselves in issue-based images or themes.

Martin's current interest is to examine art-historical renderings of the Australian landscape in order to express her own insights on the human condition. Martin made a trip in late 1992 to Lake Mungo in south-western New South Wales — an important site associated with Aboriginal culture — but her recent paintings also amalgamate details from historical research trips to other locations. As an artist, Martin is interested in acting as an explorer — to venture into 'unknown' territory in the same way that the eighteenth century explorers documented Australia's open terrain — an 'alien' landscape in need of interpretation and understanding.

PLATE 98

FATA MORGANA, 1992
Oil on linen, 100 x 244 cm from *Strzelecki Desert: Reconstructed Narrative Series*, Courtesy of the artist

'In 1991 I had just completed a grim suite of paintings of Kuwait and — unable to persuade Red Adair to take me to Kuwait — had finally been allowed to go to Moomba Gasfields, as the first post Gulf-crisis visitor. The paintings I had made in Alice were formative for the series that followed — from my trip to the Moomba Gasfields shortly after. I made this series over the next year, and the reconstructed narrative referred to was that of Ludwig Becker's — the artist on the Burke and Wills expedition who also perished.

The Ludwig Becker painting, *Border of the Mud-Desert Near Desolation Camp* (1861), is a seminal reference in my work. The irony of flying over Burke and Wills's Dig — even in a company helicopter, even if by some devious collusion — and hacking through the sandhills in a 4-wheel drive did not escape me. Sturt wrote in 1844: "here as in the Sahara mirages floated on the horizon and oases like Cooper's Creek were a promise that they could be real".

I imagined Becker struggling over the interminable sand dunes and seeing in the mirage, on the horizon, a castle — the stainless steel gas refinery with its "sci-fi" chimneys — the effect of refraction!

Fata Morgana is more commonly known in European folktales as the Queen of the Faeries — the queen of trick and illusion — the same one Michael Ondaatje refers to in *The English Patient*. In recent work, this name has been simplified to F-A-T-A.

The vertical ellipse is the effect of refraction recorded by Ludwig Becker and is readily apparent to any migraine sufferer. It is also a Shakespearian symbol for orgasm, being the woman's chin thrown back in ecstasy. In Man Ray's *Anatomies* (c.1930), the same image of ecstasy is used.'

PLATE 99
N-O-T-H-I-N-G, 1993
Oil on linen, 152 x 274 cm, Courtesy of the artist

'This image is again based on the research I undertook at the Mitchell Library on Piguenit's suite of sketches. As I said earlier, the suite is an overall reflection on the agricultural and concomitant cultural colonisation of the Australian landscape. My thumbnail sketches of his work are a continuing reference in my work, as is his painting *Flood on the Darling* (1890). *N-O-T-H-I-N-G* is also based on the European explorers' idea of "nothing" being in the Australian landscape — the "Terra Nullius"! It is also influenced by my experiences of Lake Mungo.

Lake Mungo is a vast burial site — it amazes me it is not recognised as a sacred site as yet. In less than 100 years, 40 000 years of culture has been almost eradicated in this western part of New South Wales. The cotton industry has irrevocably altered the water courses of the Darling Basin, adding final insult to injury. This landscape was *invisible* to Europeans, seen alternately as hostile, worthless or — in good seasons — often inappropriately as wonderful grazing land. The Europeans had no way of seeing the country: "They saw it as if it had been conjured up for the first time by the explorer, by his choice of route, his naming, his camp sites, his distress" (Paul Carter).

In 1993, in the Lake Mungo suites, the same references to Piguenit and Becker emerge to deal with themes of agricultural colonisation and subsequent overgrazing. John Mulvaney refers to Aboriginal trade routes, saying that:

> "…these items travelled much further than the length of the stockman's Birdsville track, along which forlorn European ruins testify to the destruction of this land within a generation of pastoral exploitation. For thousands of years, people lived fulfilling lives in this region, where the fate of Burke and Wills foreshadowed the consequences of ecological ignorance. In a sense, the much vaunted Stockman's Hall of Fame at Longreach is a monument to environmental ignorance and futility."

The past six drawing trips I have taken have all been in and around the site of 'the inland sea', which, in the early Cretaceous period, was very extensive. This is the site of Aboriginal and European-Australian myth. When the Spanish first explored north into North America, they heard similar myths of the inland sea and, like the Australian explorers, associated it with wealth and luxuries. The Australian explorers were not to know that when the Aboriginals waved them onwards to the inland sea, they were casting a frame of reference forty thousand years old.'

What are the meanings and significance of pictorial, archetypal and symbolic elements in your work?

Symbols that recur in my work are as follows:

> The ellipse: yoni — egg; female; ascending side — evolution; descending side — devolution
> The shaft of light: symbol of hope or — as in The Danae — fertilisation
> Use of gold: reference to eighteenth and nineteenth century Romanticism
> Heavy impasto: earth, erosion: forces of time
> Staining and cracking: as for heavy impasto
> Text: use of romantic ornate text; deliberate reference to Romantic topographic art
> Factory, sawtooth: industrial Western structure/male
> Smokestack: phallus, male!

I prefer the devices of ironic allegory and calling to task high seriousness and farce. These are the appropriate tools to expose the folly that attended early Australian exploration. These devices need to be accompanied by the honest search for redemption that also typifies Australian exploration — actual and metaphorical.

Could you discuss how you see the function and purpose of your work as an artist/educator?

Exploration myth in Australia has been dominated by male, Eurocentric myth. I want to reconstruct that narrative, to look at the consequences of little more than 100 years of cultural, industrial and agricultural colonisation.

My investigations of land use, whether the mining of gas at Moomba in the Strzelecki desert or the overgrazing of Lake Mungo and lands near Sturt National Park, pose the question as to what sort of M/Other Nature contemporary Australians want. We no longer have a pristine landscape and carry the guilt of its destruction.

I continue to investigate the sublime and other legacies of Northern European Romanticism brought to colonise Australia culturally in the nineteenth century. I am also interested in the influence that Charles Darwin had on early Australian art. Skinner Prout met Darwin aboard the *Beagle* and as a result of that meeting he became acquainted with Darwin's theories. Other artists I am interested in — Von Guerard, Becker, Angas — were also exposed to Darwin's ideas through Prout and the Melbourne Geological Society. Therefore, I return often to the idea of the artist explorer as naturalist, meteorologist, geologist, ornithologist and so on. Often these positions enmesh, which I particularly see as being relevant to my own art practice, which relies on hybrid vigour.

Maybe working within the imaginal, it is possible to address some of the big issues like where did we go wrong? And why? Was it some half-cocked notion of manifest destiny, which underlies the colonisation of Australia? Was it impetuous vain-glory that blinded explorers to the land and the people as we would now wish to see them? Nineteenth century landscape becomes a metaphorical site to examine where we are in the late twentieth century.

PLATE 99

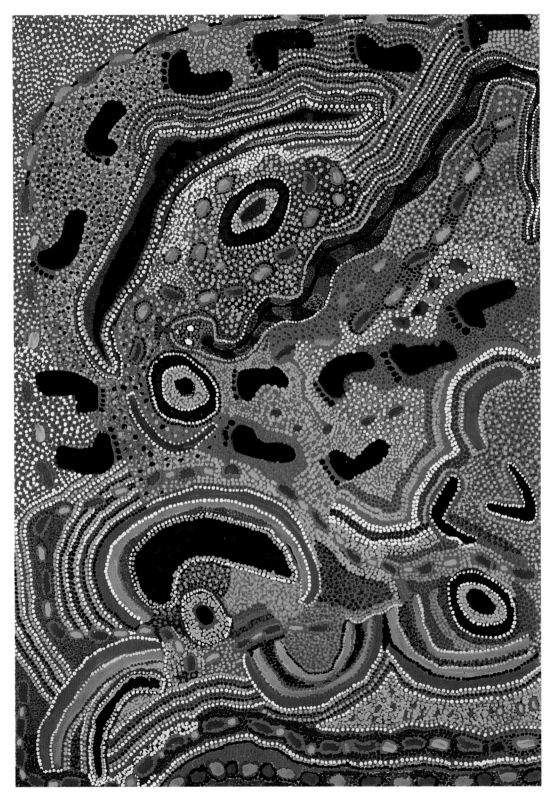

PLATE 100

Matingali Bridget Matjital

PAINTER, SENIOR LAW WOMAN,
LEAD SINGER FOR SONG CYCLES

Start painting, Ngarti country. From my grandmother, and from grandfather…I not forget for that culture, you know?…Granny bin say la me, 'I know. I can't forget for that ceremony. We got that Law. We gotta hold 'im, we can't lose 'im. Hold 'im tight.'

MATINGALI BRIDGET MATJITAL (MATI) was born between 1935 and 1940 at Wurru, south of Yaka Yaka, on land owned by the Ngarti language group. She grew up in the area between the present-day communities of Yaka Yaka, Wirrimanu (Balgo) and Kururrungku (Billiluna), encountering Kartiya (white people) for the first time between ten and twelve years of age. She and her cousin, Tjama (Freda) Napanangka, talk about their early memory of Mati's father having been accused by a local station owner of stealing a bullock. He was taken on foot, in chains, to Halls Creek, followed by his distressed family, and was eventually released. Her family group spent time in the bush at Mintirr waterhole, along with a group of other families, rather than 'sitting down' all the time at the mission settlement. Mati worked as a domestic at Sturt Creek Station before moving to the Wirrimanu (Balgo) community in the Eastern Kimberley, Western Australia in the 1950s to raise her family.

The training in traditional Law and culture that Mati received early in her life, together with knowledge she has received through her more recent participation in ceremonial exchanges with other desert communities, and her abilities as a lead singer in the song cycles, means that Mati plays a considerable role in maintaining traditional culture in the Balgo area. Song cycles for which she has responsibility include the *Nakarra Nakarra, Palgu Palgu, Tjarrata* and *Tjipari*.

Knowledge of the song cycles for Dreaming tracks passing through the country is not complete without a knowledge of the visual signs accompanying them. Mati and all the other women who have been similarly trained as custodians of their country, therefore have a wide repertoire of designs that they can draw upon for their painting.

The Balgo men started painting their traditional designs on canvas earlier than the women. The women transferred the designs they learned from sand drawing onto canvas by experimenting with acrylic paint and canvas, learning about the new media as they went along. There was a young woman by the name of Gracie Greene Nangala who liaised with the older women, but there was very little formal training with the new materials.

PLATE 100
NAKARRA NAKARRA, 1993
Acrylic on canvas, 110 x 80 cm, Photograph: Phillip Castleton,
Courtesy of Manungka Manungka Women's Association

This painting shows two Nakarra Nakarra women going
hunting for Wallupanta snakes. They travelled around the
crountry collecting bush tucker but they couldn't find that
snake.

NAKARRA NAKARRA (SEVEN SISTERS) DREAMING TRACK
The Nakarra Nakarra Dreaming Track celebrates the
journeys and actions of a group of women mainly from
the Nakamarra kinship or 'skin' group in the Tjukurrpa
(Dreamtime). At times women from other skin groups
appear in the narrative. Women from all eight of the local
skin groups are involved in ceremonies recreating the
events of the song cycle: Nampitjin, Napanangka,
Nungarrayai (classificatory grandmothers, mothers
and daughters of the Nakamarras) and Napurullas,
Napaltjarris, Nangalas and Napangartis (aunts, sisters-
in-law, mothers-in-law and cousins respectively).
The Nakarra Nakarra Dreaming Track travels from south
to north, from Parakurra (Point Moody) to the Yaka Yaka
area, where it crosses the Wati Kutjarra (Two Men)
Dreaming Track. The doings of the two men, their
mother, and various other ancestral beings also feature
in the narrative.

The aspect of the Nakarra Nakarra story that has
received the greatest attention is the pursuit of the
women by men who are in 'wrong skin' relationships
to them and who must therefore be rejected. In the
Wirrimanu version of the Dreaming, the women's suitors
are Tjakamarras, or classificatory brothers.

The full story of the women's travels covers far more
than their relationship with men, celebrating elements
of the women's lives from food gathering and preparation
to their participation in ceremony and role in their sons'
initiations. The Nakarra Nakarra ancestral women are
believed to have been transformed into features of the
local landscape such as hills and trees.

The incident depicted by Mati in her painting of
Wallupanta concerns two of the Nakarra Nakarra women
— a mother and her daughter — who went hunting for the
Wallupanta snake. They searched and searched, but the
snake had gone underground to a site called Tarlapunta,
where it still lives today in a large claypan. These events
are commemorated by local women in ceremony.

The women painted under the Catholic Church staff of the St John's Adult Education
Centre in Balgo from about 1982 until the *Aboriginal Art from the Great Sandy Desert* exhibition in
Perth at the end of 1986–early 1987, when the Church decided it should hand over responsibil-
ity to a professional art organisation. They advertised for an art coordinator — Andrew Hughes
arrived a few months later and Warlayirti Artists was formed. Hughes worked from the Adult
Education building, but was separate from it organisationally. The art centre stayed in the
Adult Education building until it got new premises in the old mission dining room.

Mati began painting on canvas in 1987–1988. Her versatility as an artist, her experimenta-
tion with different techniques and her prolific output of paintings have made her a significant
Balgo artist. A number of aspects of her painting style echo the way she forms icons in sand
drawing; for example, the freedom in the way the forms are drawn, and the angular V-shape she
makes to show people standing up or sitting down. She is innovative in dotting techniques and
dotting fields, including her own style of dots, which become small, curved strokes evocative of
vegetation or flame. Mati's works have been exhibited widely in Australia as well as in Europe.

———·•·———

INTERVIEW WITH MATINGALI BRIDGET MATJITAL NAPANANGKA
SYDNEY, DECEMBER 1993

Anna Voigt Nakamarra*: When did you do your
 first painting, Mati?
Matingali (Mati) Matjital Napanangka: Before
 Tjakamarra [Michael Rae, coordinator of
 Warlayirti Artists from 1988 to 1992].
Christine Watson Napanangka: Andrew
 Hughes's time, so that must have been
 1987–1988.
MM: [Nods] Yeah.
AV: And which people were teaching painting to
 you?
CW: Did somebody encourage you when you
 began painting on canvas?
MM: Tutju [women]? Yeah, we bin painting, Mati and
 Margaret [Bumblebee] and Dora [Napaltjarri,
 from Lajamanu — another Aboriginal
 community] and Nancy [Nyangirnarra] and
 Tjama [Freda Napanangka] and Manaya [Sarah
 Napanangka]. Whole lot. We bin start painting,
 now. Yeah, we bin start. Nyangirnarra mob and
 Tjama. Still we bin doing 'im. All bin painting in
 the Balgo centre. We bin la [at] old one, first
 time. We bin paint 'im la that centre. That one
 new one. That new centre, you know, that time
 we bin start painting. That Andrew bin go. We
 bin still painting la [with] Tjakamarra.

 I bin look for the women, you know, painting.
 I bin start painting. Start painting, Ngarti
 country. From my grandmother, and from
 grandfather.
AV: So your grandmother taught you?
MM: Yeah, she bin tell 'im about me. She bin tell

'im before she bin pass away. She do 'im
 anything, you know. She bin do 'im painting
 [Indicates her breasts]. Ngapurlu [breast]. That
 one she bin tell me: 'You want to [ought to] look
 after 'im painting.'
AV: She taught you through the body painting and
 the sand?
MM: Yeah. My granny bin tell me [points to
 painting of Wallupanta snake], yeah, 'You can do
 'im Wallupanta. That do 'im, and hunting.'
CW: So your grandmother gave you that story?
MM: Yeah, and mother. She's stopping [staying] in
 Balgo, that Nampitjin, my mother.
AV: Did they give you the story when you were
 little?
MM: No, no. We watch 'im dancing, you know.
 Dancing. Mother and granny, auntie. All bin
 dancing that Nakarra Nakarra. Proper
 important. Long, long time before we never bin
 born yet, nothing. All the women bin keep 'im
 [the Nakarra Nakarra Law]. Nungarrayai [Mati's
 grandmother] and Napaltjarri and Nangala,
 Napurulla. Alright, we bin born. Little bit, we
 bin grown big. Now we watching all the dancing.
 Granny too. Granny and mother.
CW: So when you were a child, you watched the
 dancing of your grandmother and mother?
MM: Yeah. Then when we bin go school, you know,
 Kartiya [white people], we bin talk, Kartiya, you
 want to go to school now. We bin watching. We
 never bin leave 'im culture. Teaching culture.
 We bin learn [from] watching, you know,

———

* The 'skin-names' — Nakamarra and Napanangka were given to Anna Voigt and Christine Watson by the senior Law
 women from Wirrimanu in order to be in 'right relationship' in accordance with traditional Aboriginal culture.

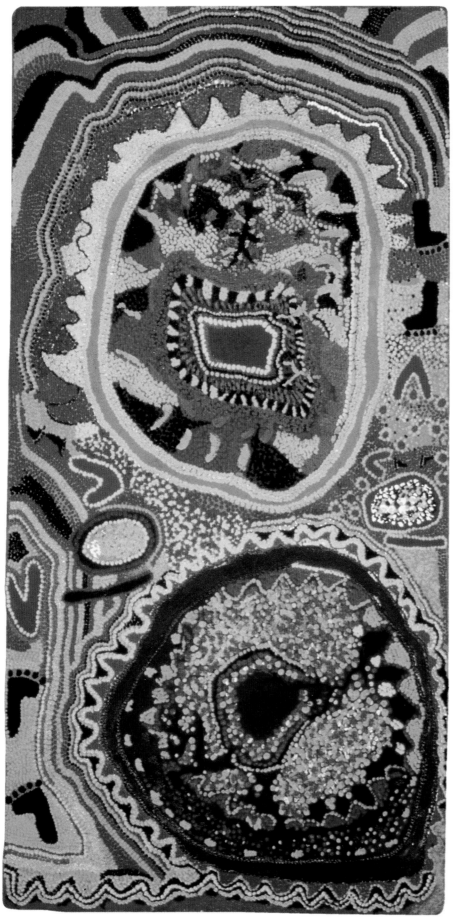

PLATE 101
PALGU PALGU, 1991
Acrylic on canvas, 100 x 50 cm, Courtesy of Warlayirti
Artists Aboriginal Corporation and Coo-ee Aboriginal Art

This painting recounts part of the local Dreaming myth
about a mother and her daughter who were travelling
about here. They have left signs in the land and their
actions are celebrated in songs and dances. There are
many foods to be found locally including yulumpurru,
palkar, warkatji, lukararra, kumpupatja and tjirrilpatja.

PLATE 101

PLATE 102
PALGU PALGU, 1993
Acrylic on canvas, 110 x 80 cm, Photograph: Phillip
Castleton, Courtesy of Manungka Manungka Women's
Association

In this painting, Matingali depicts an incident where an
old woman, weak and nearly 'finished', was left behind by
her two sons, who travelled to a billabong in the Palgu
Palgu region. The painting shows bush tucker from that
area — kunti (bush potato), carrots and onions, which the
woman is too old to gather or find for herself. The river
and billabong record the presence of living water in this
arid desert region. The goanna shown is really an old man,
a devil spirit.

dancing. School, nothing. We bin watching.

CW: Aboriginal school?

MM: Yeah.

AV: When did you do the dancing?

MM: Dancing little bit big one. Before this one
[Indicates breasts]. Before got milk. Dancing
now alright. Mother take 'im dance.

AV: So you were watching, watching, watching,
and then when you were a big girl?

MM: Big girl go work. Still thinking for ceremony,
for Nakarra Nakarra. Still thinking. We bin
work.

CW: Was that when you went to Sturt Creek
Station?

MM: Yeah. All been singing too, there. Singing and
painting [body painting].

CW: All those other women were there, weren't
they? Mayan [Kathleen Paddoon]…?

MM: Yeah, yeah. All the sisters, all the
Napanangkas. Three grannies, three
Nungarrayais. Three sisters.

CW: Three important Nungarrayais — they were
grandmothers for Tjama, and who else?

MM: Kathleen.

CW: They lived together?

MM: Yeah, all the sisters. They bin teaching too.
Grandmother and mother.

CW: At Sturt Creek Station?

MM: Yeah, all around [different places]. You know,
I bin take 'im you. We bin little girl that way.

CW: So you travelled when you were young, too,
did you?

MM: Yeah. And we been at Sturt Creek. We never
bin forget for Ngantalarra, for Nakarra Nakarra,
for Yaka Yaka, nothing.

AV: Travelling through the country?

CW: While you were at Sturt Creek Station being a
domestic, still you were able to leave and go to
Ngantalarra and dance the Nakarra Nakarra?

MM: Yeah, Yeah. Palya [good]. I not forget for that
culture, you know? Still we bin work around.
Granny bin take 'im about me. Granny bin say la
me, 'I know. I can't forget for that ceremony. We
got that Law. We gotta hold 'im, we can't lose
'im. Hold 'im tight.'

AV: So, she teach you not to forget?

MM: Yeah, We can't lose 'im. Hold 'im tight…

AV: So, did your mother and grandmother say
when you could dance?

MM: Yeah. They say, 'Now you can dance' — we
dance' im. We look at 'im mother. My mother
dancing, my granny too.

CW: And you followed on behind?

MM: Yeah. And ochre. All around ochre.

AV: Did you paint up [ceremonial body painting]?

MM: Yeah.

AV: And the little girls, are they painted up too?

MM: Yeah, we paint 'im too.

CW: Like Carmen [One of Mati's grandchildren, a
two-year-old granddaughter]. You paint
Carmen. You painted her for Mina-Mina [a
Dreaming songline and ceremony]. She was
sitting in ceremony a year ago at Christmas
time. You remember? Mati was saying, 'Clap, clap,
clap!'

MM: Yeah, I teaching that one. He [she] gotta stop
la [with] me. He gotta stop my grannie
[granddaughter].

AV: Carmen is two years old and she is already
painted up?

MM: Napurulla, Napurulla. From my son
Tjakamarra. I teach 'im.

AV: So, the teaching starts right from the
beginning of a child's life?

MM: Dancing.

AV: And singing?

MM: [Claps]

AV: Are you teaching other children too?

MM: Two. Granddaughter from my daughter,
Nungarrayai. Dancing. Granddaughters from
my daughter and from my son, his daughter. And
that one from my sister, Nakamarra.

AV: From your daughter, Nungarrayai?

MM: Nungarrayai, teach 'im dancing. School him
[her] dancing.

AV: How many children you teaching?

MM: That one from my sister, Nakamarra, and my
granddaughter from my daughter, Nungarrayai,
and from my son, Tjakamarra, him daughter.

AV: So that's three, three girls you're teaching.

MM: Yeah, That Nungarrayai, other one. That's all.
Two Nungarrayais and Nakarra, like you.

AV: Two Nungarrayais.

MM: And Napurulla, daughter from your brother,
Napurulla, your daughter. Daughter for you,
from your brother. [Laughs]

AV: From your brother?

MM: You brother.

AV: My brother?

CW: Yes, Carmen is a daughter of Tjakamarra, your
brother, so she is your niece. So, you are teaching
Geraldine?

MM: No, Carmen and Loretta [another
granddaughter — Geraldine's sister].

CW: Oh — she is what, six or seven?

MM: Yeah, Loretta.

AV: And the daughter of your sister?

MM: Angeline. Angeline Tjooga, teaching.

CW: She's a daughter for Mati's half-sister.

MM: Sister from grandfather, kulu [as well], Inji.

CW: Inji's daughter. She's kind of niece.

MM: Yeah, like you, Nakarra. Same you two

Nakarra. Two Nakarra.

AV: Right, so you've got three — three girls.
Teaching three girls?

MM: Yeah. I teaching.

AV: One is two years and one is six or seven?

MM: Yeah. Teaching. Still teaching.

AV: And Angeline, how old is Angeline?

MM: Little bit bigger one.

CW: She's what? She might be ten, or eleven, I
think.

MM: Yeah, big girl.

CW: She's in high school… No, she hasn't got
ngapurlu [breasts] yet.

MM: Nothing yet.

MM: Still I tell 'im Nakarra, that little girl, now.
Yeah, I teach 'im you my niece, you know? I can
teaching you dancing, Nakarra Nakarra.
Nothing. You can't chuck it away. I telling my
granddaughter, Loretta. You gotta dancing,
dance 'im from your granny. Me. Right la [with]
me you can stop [dance]. Like 'a me, you can
sing 'im.

AV: Like you. Dancing from your grandmother.

MM: Yeah. Right la [with] me you can stop. Like 'a
me you can sing 'im.

AV: Are other women teaching children, too?

MM: Yeah. Everyone, every woman teaching.

AV: Every woman is teaching the children?

MM: Yeah. Nancy. Nyangirnarra teaching too.
Napurulla. And Ruby [Darkie]. Two Napurulla.
Yeah, everyone. Yeah, we teaching that lot. All
the grandkids. We going la school. We dancing.
We take 'im hunting. Get 'im bush tucker. Kill
'im goanna. And teach. We go hunting.

CW: So you're teaching a lot of your grandchildren?

MM: Only teaching my children, you know? From
my daughter, from my sister, and from my
daughter-in-law. Not everyone, only from mine
self, you know. All want to learn. I teaching. 'You
gotta dancing,' I talking, 'You not want to stop
dancing. Still you gotta learn. When you big, you
can keep dancing.' Yeah. I telling my
granddaughter, you know, Nungarrayai, and my
niece.

AV: Are other women teaching the three children,
or just you?

MM: Napurulla teach 'im. 'Nother lot take 'im —
this one I teach 'im, me.

AV: You do most of the teaching?

MM: You've got to ask 'em, that lot. And after,
'nother lot. This one I call 'im daughter from me.

CW: Other women are teaching their own relatives.
That's intensively, but as much as the women
can, they come up to the school in culture time
and then they teach a whole lot of kids together.
The men teach the boys dancing. And the

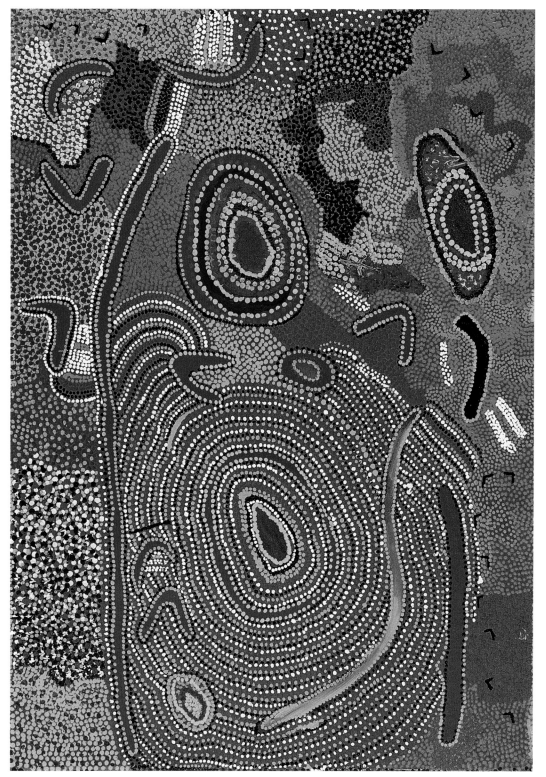

PLATE 102

ANNA VOIGT WITH MATINGALI BRIDGET MATJITAL

women teach the girls.

MM: Yeah.

AV: OK. And the dances are particular songlines. You teach your children the songlines. Are there different songlines for the different children or the same?

MM: Same. Sometimes Mina-Mina, sometimes Nakarra Nakarra.

AV: Everybody shares the songlines?

MM: Yeah, just two.

AV: And do you teach all the different parts of the songlines or the same parts?

MM: Same one.

AV: Because songlines are a big journey?

CW: With the little [lampan] ones, just one song, one dance is taught.

MM: Yeah. Little bit.

AV: A little bit at a time. It's beautiful. It's very palya [good].

MM: Before, from [going to] Sydney, I bin teaching my granddaughter, my Napurulla-Napanangka [Carmen]. You want to see 'im. Dancing all around. That home for you in Balgo. She bin dancing la the lawn, Napanangka, she bin dancing.

CW: Little Napurru? She's really clever.

MM: Na [yes], she not shame la culture. I tell 'im. Napanangka gone la Canberra. I meet 'im [in] Sydney. And with daughter go, Geraldine. You remember Geraldine?

CW: Yeah, Geraldine's another granddaughter, Nakarra.

MM: No. Nungarrayai.

CW: Nungarrayai. Of course she is… Because she's Nakamarra's daughter [and big sister to Loretta].

MM: Yeah, Nakamarra's daughter.

AV: You bin teach her too?

MM: Yeah. I bin teaching. Big girl now.

AV: What's her name? She's a Nungarrayai?

MM: Yeah. Geraldine Nungarrayai.

AV: Geraldine Nungarrayai. And she's bigger still…

CW: She's Geraldine Matjital and she is about twenty.

MM: Geraldine Matjital. Second name la me, all the Matjitals. Son and daughter.

CW: The only non-Matjital is Angeline. She's a Tjooga.

MM: Tjooga, that one, Angeline. My niece.

AV: Where does the painting fit in with the dancing, the singing, the sand painting?

CW: Mati, when you were a little girl, did your kaparli [grandmother] teach you to draw in the sand? And teach you to do the footprints? [Mati uses these in her paintings.]

MM: This way la ground — soakwater and tali [sandhill] and puli [hill]. [Mati makes marks with her fingers on the floor.] Yeah, I bin keep 'im. I bin do 'im like 'a that. I think about first for painting. I thinking, my mother tell 'im me I can do 'im, Ngarti. Ngarti country, that's all.

CW: So you think first about what your mother taught you, what your grandmother taught you, and then you do that painting?

MM: Yeah. The mother and that two tutju [women]. Snake. Drag 'im and take 'im. Take 'im. Ayone tell 'im. 'Nother two. Nampitjin. And that snake bin go la Tarlapunta now. He bin sleep. Those two women were digging. Nothing. Wiya [no/nothing].

CW: They couldn't find him? Underground?

MM: La [in] the water. La that big warran [claypan], you know. That's all. That's all. I bin learn from my mother, she bin tell me. Soakwater, Kra, you know, Krakutjarra.

CW: Mati is talking about the Wallupanta painting — how she started off thinking about things that her mother and grandmother taught her, how they taught her to do at that place.

AV: In the sand?

MM: Yeah. And tell 'im too, la the soakwater. This one, two fella [ancestral women] bin take 'im. That's true. Women bin take 'im. Nothing. Can't find 'im, only hunting around, telling story. That true. Only I put 'im, me, now, put 'im la canvas, you know. Yeah. We bin living there las sanke…soakwater. We bin living there, all around. Where I bin little girl.

CW: Which country?

MM: Yaka Yaka, Ngantalarra and Krakutjarra, that Yaka Yaka; and Palgu Palgu and Parayipil. You bin see 'im all around. Not for the Warlpiri [another group]. Not for the Kukatja. No. Ngarti country. We all bin start to Law. Yawulyu [women's ceremony], you know. Watching. Dancing. We bin watching, dancing.

AV: So, Mati was moving around with her people when she was a little girl. When did they stop and stay in one place?

CW: You went to Sturt Creek Station then?

MM: Yeah. From there, now, we bin living there. We go Sturt Creek, now. Work round there now.

CW: And then Patsy and Marie [Mati's daughters] were born?

MM: Yeah.

AV: Did your mother or grandmother live at the station?

MM: No, grandmother bin finish.

CW: Where were Nampitjin and Nungarrayai [Mati's mother and grandmother]? Did they go to Sturt Creek?

MM: Sturt Creek, yeah. We bin come from Yaka Yaka living there. Yeah. Working. Nampitjin bin work there too. Cleaning rubbish. Milking goats.

CW: Milking the goats.

MM: [Laughs]

AV: Milking the goats and cleaning, eh?

CW: And grandmother, an old woman — just sitting down, eh?

MM: Yeah. Sitting down telling stories. [Laughs] She bin say, 'Don't forget for Law. You want to look after 'im.'

AV: And you would go out from the station to do dances?

MM: Yeah. We bin alright. We want to teaching all the kids. Big girls now, you know. We bin dancing round there. Palya [good].

AV: And when you do painting, each time, do you think about what your grandmother taught you?

MM: Yeah, yeah, I know.

AV: Each one? Every painting?

MM: Yeah. I think about. That, my mother tell 'im about me. I got 'im mother one. Him [her] telling me.

AV: Mother?

MM: Yeah, Nampitjin.

CW: She is still alive.

MM: Him telling me.

AV: Yeah? Is she…

CW: She is really knowledgeable. Tjama's mother and Mati's mother are sisters. Both are really knowledgeable about the Law.

MM: Ninti [Law] — fellow.

AV: Is that boss for Law?

MM: Yeah. All the singing, singing, you know, we ask 'em, two fella.

CW: They are still watching, aren't they?

MM: Yeah.

CW: And when we went out Nakarra Nakarra way…

MM: Yeah, he bin tell me, you can do 'im [Nakarra Nakarra dances] la [with] Napanangka. Where we bin camp. Yayiyarr. Yeah, we bin do 'im la you. All bin dancing…we bin camp. From there we bin to Ngantalarra. Where we bin. Where we dancing, all the women. Two Napanangkas [Mati and Tjama].

CW: Mati, when you're sitting down in Balgo, do you sometimes think about Tirrin or sometimes think about Tarlapunta? And think, maybe I might do a painting about that one or a painting about that one?

MM: Yeah. I think. I not forget.

CW: So you remember that place and then you paint that place?

MM: Yeah. I not forget from my mother and grandma and daddy from long way. Poor bugger

my father from Kintore. Yeah…country. Only grandpa and uncle, and mother and auntie, Ngarti side. My father from…I bin tell you.

CW: Ngarti [language group] is your mother, grandmother?

MM: Mmm.

CW: And father's side is Pintapu [Pintupi].

MM: Pintapu. My mother bin get 'im no kid [no children from her husband's other marriages]. He come up from Kintore. They were married at Ngantalarra… Yeah, all around. All around, go to Warlkarli, Mangamanga, all around, my father. All bin show 'im la you. You look 'im country. Tirrin all around, and Tarlapunta. Yeah…that's all.

CW: And are you teaching Manuel [one of Mati's sons] about his country?

MM: Yeah, talking. I telling my son Ngarti country, talking Ngarti. He gone Yaka Yaka. Gone look 'im country. Little bit we look 'im Yaka Yaka.

CW: Who took him around when he was learning country? Did you take him around?

MM: No, we gotta give 'im might be own car. He gotta go. All around. I'll show 'im la [with] him.

CW: You'll show him?

MM: Yeah. My daughter-in-law, too. Napaltjarri. Sister-in-law for Nakamarra [Anna] — really daughter, you know.

CW: But you've been showing Manuel how to do Wallupanta [snake], haven't you?

MM: Yeah.

AV: What's Wallupanta?

CW: That's Tarlapunta. It's on the Nakarra Nakarra Dreaming Track where the snakes came in and they ate up all the people in ceremony.

MM: Yeah

CW: Canvas painting. I remember that one. What, two snakes coming down from the top and two snakes coming up from the bottom.

MM: Yeah, that's a Wallupanta.

CW: In Adrian Newstead's show in Sydney [May 1993].

MM: That's Tarlapunta. You seen that one? Put 'im that 'nother, Wallupanta, that one bin go Tarlapunta. Him stay.

AV: Yeah, I really liked that one.

CW: So it was the same snake, wasn't it? It was a Wallupanta snake and Tarlapunta [place].

Yeah. You tell 'im 'nother one, you know, la big board [canvas]?

CW: Yes. Really big one.

MM: Same. Ngarti snake. I bin do 'im [Wallupanta canvas in the exhibition] la Women's Centre. This lot [for the Yinkinpaya Turlku Yawulyu exhibition in Sydney] we bin work la Women's Centre. Not la house. There no. Special one.

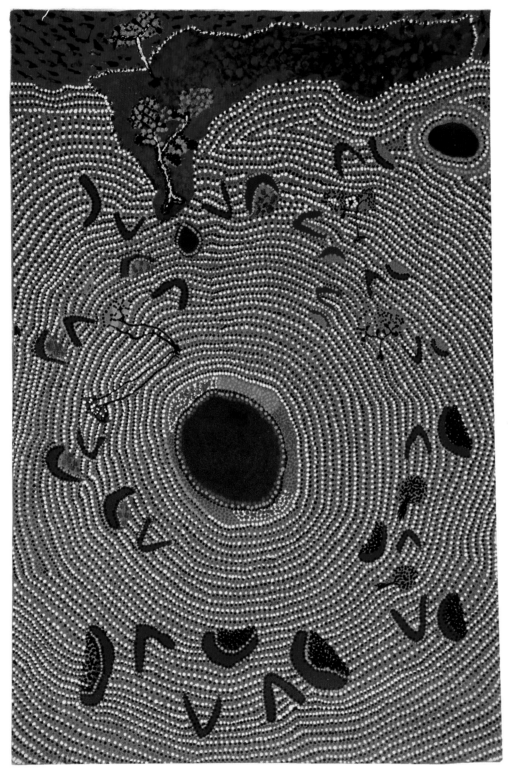

PLATE 103

Special one for here. I bin singing and dancing. Whee!

CW: All this exhibition [Sydney, 1993] was produced at the Women's Centre in Balgo. It was special. The women sang the stories of the paintings as they worked.

AV: For these paintings, you sang the story? To make these paintings, you sang the story?

MM: Yeah.

AV: This painting. It is a Dreaming. Which Dreaming?

MM: Nakarra Nakarra Dreaming. Nungarrayai and Nakamarra. 'Nother one daughter. No, mother, daughter, Hunting round. Yeah. Nyaku kaparli [my grandmother] and my daughter. Mother and daughter.

CW: So they are grandmother and grandchild to each other. So they are hunting around. Are they following that Wallupanta snake?

MM: Yeah. They sat down la that hill and dug for that snake.

CW: Were they wearing those ininti [bean] seed around their necks?

MM: No, waist. I bin put 'em bead, ininti. Like that big tree, you know. Tree, little, little one.

CW: Is there an ininti tree here in the painting? Where is it?

MM: Yeah, middle one here…This side. Bottom. Up. That's the tree now. Here, ininti tree.

AV: And that's where a lot of them walked, following the snake's trail?

MM: Bush tucker there when we go… Coolamon. Bush fruit, tjunta [bush onion], kumpupatja [bush tomato], tjirrilpatja [bush carrot]. Hunting. Seedpa [seeds]. Ininti seed.

CW: Ininti. Are they here on the women [indicating on body] or fallen down on ground?

MM: Yeah. Ininti. Ground. Everywhere. Seed, ininti seed. [Starts singing, beating time to herself.] You got 'im painting [Wallupanta]. You can have 'im painting.

AV: It's good, this painting.

MM: From my mother… Ah, you gotta talk, you.

AV: Me?

MM: Yeah. From Napanangka, yeah. Mother for you. From mother, Napanangka [Mati, in this instance]. From Nakarra Nakarra you can think. Him [her] daughter for Mati. Daughter for me. You.

AV: Me?

MM: Yeah. Nakarra. Uwai [yes]. Yeah.

AV: You look after country?

MM: From my mother.

CW: It's taught from grandmother.

MM: Grandfather.

AV: Grandfather too?

CW: Yeah.

MM: From Mother. Grandfather. Uncle. From auntie.

CW: And they teach you all how to look after the country?

MM: My mother tell 'im about me: 'You look after 'im country. Don't forget for country.' Still we make 'im…I still stopping la Yaka Yaka from my country. From mother country. From my grandmother.

CW: So your mother says, 'Don't forget your country. Don't forget those songs?'

MM: Yeah. Nakarra Nakarra.

CW: And what else did she teach you? Did she teach you Tjipari [song cycle] or no?

MM: Yeah. Still Tjipari. One now.

CW: Right, and you dance 'im?

MM: Yeah. We bin dance 'im before. My mother and granny, grandmother.

AV: And did your grandmother take you hunting and show you your country?

MM: Yeah. Camp. Walk around. Take me from mother. Take it away from big fire and sleep. Mother and daughter.

AV: Mother and daughter.

MM: [Laughs] Grandmother.

AV: Your grandmother, mother and you go together in the country? And she'd show you…

MM: Yeah. Show me soakwater, and river, and creek, you know. What for all bin do 'im Dreaming Time, and telling me story from Dreaming Time. Where bin hunting, tell me. Huntin round. Get 'im tjirrilpatja [bush carrots]. Yeah, and bush onion and mulupuka that tree.

CW: Mulupuka — desert oak?

MM: That tree where I bin singing corroboree.

AV: That part is in the song cycle, too, isn't it? The going out and the hunting and the gathering. So those sorts of everyday things come into the song cycles with the stories and mythology and everything, so it's a combination, isn't it?

CW: Yes, it's a combination, of dancing at special places and the food. But the food isn't just food. It's been created by the Ancestors as well. That man, that puntu [man] left those yams, didn't he? Near Tirrin. He fall down?

MM: Meah, fall down, yeah.

AV: Everything is from the Ancestors, isn't it?

MM: Yeah. Mangarri [food]. That tree… That little one [coolamon] for us.

AV: So you go out eating bush tucker, mother, grandmother, kiddies as well?

MM: Grandmother. [Pause]

AV: Can you tell me a little about that…

MM: We not put 'im long way. We bin stopping round there. Ngantalarra. Nakarra Nakarra and

Tirrin, Priljipanta, Palgu Palgu, all around. All around. And Tarlapunta, Tirriparri, and Wangkaji.

AV: All over.

MM: All over. Parriharri.

AV: Walking, walking? — And you stopped and slept?

MM: This time Mati go muticar [in a car].

AV: Muticar!

MM: No, truck. That teatime? Where we bin go on big…Get 'im fire. You know, driving. Where we bin little girl. No muticar. Walk around. Walk around. Soakwater. Let 'im go… Desert country, desert.

AV: Desert country?

MM: [Sings] We bin take 'im bush food…all around. He never bin find 'im. Nothing…Nampitjin, Sonia [a former coordinator of Manungka Manungka Women's Association] and car, Napanangka. That Napanangka from Sydney, tall one.

AV: I don't know her.

MM: I bin la Kumantjayi [Alice] Springs, that Nampitjin, Napanangka la Kumantjayi Springs. That Napanangka, she bin tell me. Go Sydney. Work on language, you know. Language story, hunting…

PLATE 103

UNTITLED, 1994

Acrylic on canvas, 120 x 80 cm, Courtesy of Warlayirti Artists Aboriginal Corporation and Coo-ee Aboriginal Art

In this Tjukurrpa (Dreamtime) painting from Mati's country she has shown Ngarti women out in the desert hunting for food. They all have their luwantjas (wooden dishes) to carry back to camp the food that they find. Many different foods are available including lukararra (grass seeds), yakatjirri (mistletoe berries) and the fruit from the wiltjilki tree.

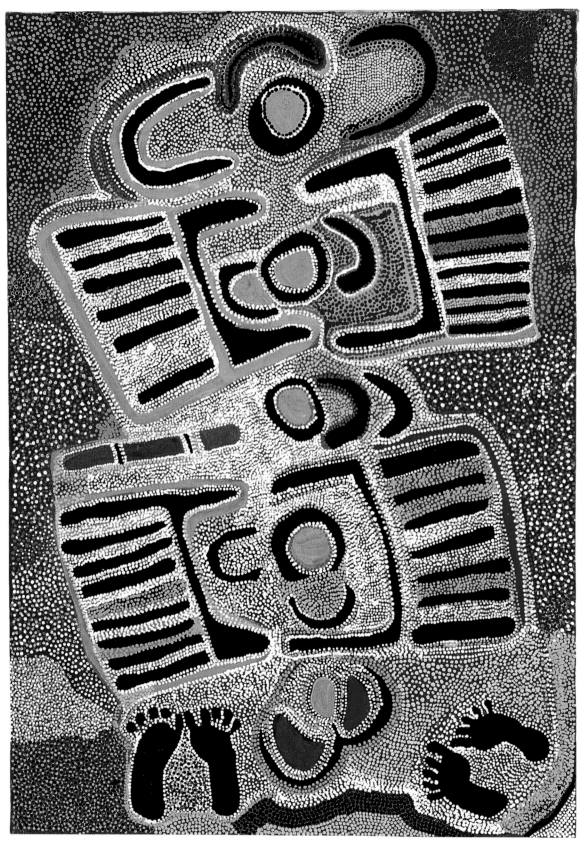

PLATE 104

Mirlkitjungu Millie Skeen

PAINTER, SENIOR LAW WOMAN

[Millie began singing, and as she sang, she danced (sitting down).
She was remembering the story; it is contained in the chants].
[Singing] Kampiny [egg] one, kampiny one, all the way. Like
Ngarangkarni. [Millie drew an Emu Dreaming paint-up design,
a kuruwarri, singing while she drew. Designs of emu tracks
represented the Yawulyu, Women's Law.]

MIRLKITJUNGU MILLIE SKEEN is a senior Law woman of the Ngarti and Kukatja peoples who lives at Wirrimanu (Balgo) in the Tanami Desert, Eastern Kimberley, Western Australia. She was born at Intiwakuwaku, north of Kiwirrkurra, and came as a young girl to live at the Pallotine Catholic mission at Tjumurnturr, subsequently moving with it to the old mission site at Wirrimanu (aka Balgo). Like many others in the area, she lived at Mintirr rockhole and worked at Lake Stretch station at various times as an alternative to mission life. It was at the old mission that she met her husband, artist Tommy Skeen, and raised her family.

Mirlkitjungu has connections through her grandparents with the Kiwirrkurra area to the far south of Balgo and through her parents and her own youth with the Mangkayi–Yaka Yaka area immediately south of Balgo.

Mirlkitjungu belongs to those desert people who lived in the last indigenous territory on the continent now called Australia to be encroached upon by Europeans. As late as 1967 the desert peoples — still living a traditional lifestyle — were being rounded up and moved into missions and reserves such as Wirrimanu (Balgo). The desert, say the people, is 'alive', and they insist there are people — their relations — living out there who keep to the old way. Although the desert is now largely depopulated, it has been estimated that there were between 10 000 and 18 000 Aboriginal people living there before European contact.

Because the European impact is so new in this region, the Kukatja and other Western Desert peoples have retained their culture, language and land in a way that has not been possible for many other indigenous people. Even so, Wirrimanu is not without problems as a result of the impact of Kartiya (white man) culture. However, the elders, Mirlkitjungu amongst them, keep hold of their Law and the memories of their life before the Kartiya (white man) came. The senior Law women and men are a bridge between worlds. They are the gatekeepers for the young ones, the keepers of their culture.

Art has a major role to play in this process. The canvas is the vehicle that allows the stories to be 'written down', retained and utilised as a teaching tool in education of their culture — primarily for the younger generation in the community but also for the outside world. As

PLATE 104
TJIPARI, 1993
Acrylic on canvas, 110 x 80 cm, Photograph: Phillip
Castleton, Courtesy of Manungka Manungka Women's
Association

In the Ngarangkarni (Dreaming), two Nangala (skin
name) sisters left their mother to travel across the country,
learning the land and growing up as women. The two
sisters travelled far, having many adventures along the
way. They stopped at soakwaters where they dug for
water and found food. In carrying out the ceremonies
sacred to those places, they painted themselves with
pilytji (red) and karntawarra (yellow) ochre and adorned
themselves with the white headdresses used today by
women in Tjipari ceremonies. As they travelled, they
changed the country about them. They hid from a storm
in one place, and in another, they ran away from a
bushfire. Those places are marked by land formations
today. By the end of their journey, they had become
women.

Mirlkitjungu paints, she, like other Aboriginal artists, sings the songs related to that story.
Singing the story keeps the Dreaming (a European terminology) alive, as do the accompanying
dances and, together with the art, forms a sacred act. She and Matingali Matjital (Mati) would
also break out in song when telling the Dreaming stories associated with the particular art
works.

Through parental and grandparental instruction and her own participation in cultural
activities, Mirlkitjungu has the right to produce the designs for a wide range of sites and
Dreaming tracks. These include *Nakarra Nakarra*, *Tjipari*, *Wati Kutjarra*, *Tingarri Women* and
Wartunuma (Flying Ant). In Mirlkitjungu's words:

'My mother [*whispers because her mother is dead*] learn me bush way. From mother. You know?
Dreaming. "You gotta put him this way, Law way." Me fella ready for dance, might be Law
time. Me fella gotta go bush, walkabout. Dance. Learn 'em all the words, kids. Sit down in Law
way. Learn 'em kids.

'Me painting story for country. Me fella Kukatja. My father he Kukatja, Alright, my mother
might be Warlpiri, mother. Kaparli [mother's mother], Mandjindja. Different language. I can't
use 'em that one. No. Bush way. I can't do 'em painting from mother, la [from] kaparli. Long
way Kaparli country. Long way. Different way. Can't do 'em painting. Nothing. 'Nother
country for my grandmother. My mother leave 'em that country young fella. I don't know that
country. Different. Different. Lake Carnegie country [800 kilometres south of Balgo, east of
Wiluna]. Mummy country. Kulyui [can't do] country. Can't do 'em painting. Me fella mummy
bin find 'em me [I was born], Parakurra, sandhill. This side. Where Wati Kutjarra [ancestral
beings] bin walk around. Long way my Mummy country.'

Mirlkitjungu's art work has been exhibited widely in Australia and also in France. Her story
of her life and her people weaves in and out of Ngarangkarni (Dreamtime) and Mularrpa
(Truetime), the two interacting through a timelessness that creates a living Dreaming, defying
Kartiya (white man's) concept of reality. It bears witness to the fact that the desert way remains
strong and that the people of the desert retain their dignity and identity despite the impact of
the Kartiya.

Mirlkitjungu recounts the stories of *Parakurra* and *Yapuru* Dreamings of which — in addition
to Tjiparri, Yurrututu, Nakarra Nakarra and Lirrwati Dreamings — she is custodian:

PARAKURRA DREAMING
Two fella, Tjungarrayai [skin name] bin travelling. Tarlapunta. Alright. Warlupanta — big
snake. Big one. He fella like rainbow in river. Yuwayi, shhh! He cut cross country, put 'em story
everywhere. Alright. He going to Tarlapunta. Stop. Having dinner halfway. After finish he
come back, Tarlapunta. Have 'em chicken and bullock, in Tarlapunta. After that he go on.
Right up to Wati Kutjarra [two men]. Two men they bin look for camp.

'Hey, we camp here'

'No, we keep going, to Parakurra.'

Two fella bin go to Parakurra. That snake bin sit down in Warrangarni. Two fella bin camp,
have mangarri [food]. They bin find mother, Nakamarra [skin name]. She bin crying for them.
They bin sleeping. Kurtitji [shields] for pillow. They bin sleep by Puntu Wanya [kadaicha
men] claypan. That home for kadaicha men. Some sitting down, some standing — they ready
to fight. They gonna spear Wati Kutjarra while they bin sleeping. Kurnkuta-kuta [spotted
nightjar bird] come. He messenger. He wake up older wati [man], tell him, "Hey, don't you two
sit down there. You gotta get up. You fella in big trouble. You better run for your life!" He tell
'em wanya men getting ready to spear 'em. That wati he wake up brother. They too frighten,
can't stand up. Crawl away. Shhh! They frighten.

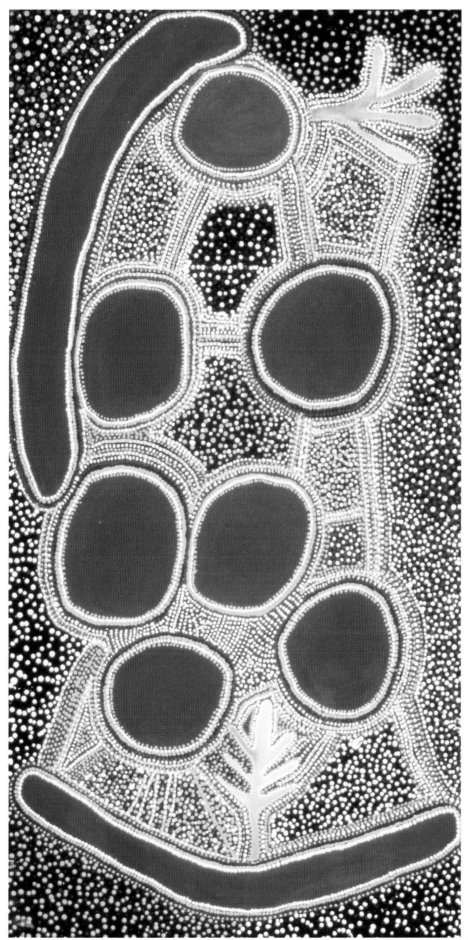

PLATE 105

PLATE 105

PLATE 105
YURRUTUTU, 1991
Acrylic on canvas, 120 x 60 cm, Courtesy of Coo-ee
Aboriginal Art

PLATE 106
NAKARRA NAKARRA, 1993
Acrylic on canvas, 80 x 80 cm, Photograph: Phillip
Castleton, Courtesy of Manungka Manungka Women's
Association

In the Ngarangkarni (Dreaming), seven Napaltjarri
(skin name) sisters descended from the sky and travelled
through the land. They were the first women on earth.
They would come to Earth to hunt and gather bush tucker
and to paint themselves and dance ceremony. The
painting shows the women sitting down painting up
before they danced at Parakurra and went on to Wangkaji.
One day this old man, Tjakamarra (skin name), was
walking past and saw them near the Nakarra Nakarra hills.
He crept up on them and grabbed the youngest woman
and took her away to be his wife, although he was son-in-
law to the sisters. The other sisters ran away and ascended
into the sky with their digging sticks. The younger sister
fought back against Tjakamarra and got away. She
followed her sisters up into the sky. The sisters are still up
in the sky today. You can see the six sisters with the
seventh sister following behind. Tjakamarra followed
them and became the Morning Star.

PLATE 107
LIRRWATI, 1992
Acrylic on canvas, 100 x 75 cm, Courtesy of Coo-ee
Aboriginal Art

'Kuninyi [Mirlkitjungu's eldest sister] bin tell 'em me that
story. That one, and Tjama. Bin tell 'em me that story
because I am from Lirrwati [near Stanmore Ranges, south
of Wirrimanu]. I bin growing up la Old Balgo [Tjalyuwan]
long time. Big mob been sit down. Me bin little girl. Little
one. Lamparn, lamparn [baby]. Youngest one me. I
remember from kid. I bin go Tjalyuwan. That story la
Ngarangkarni [dreaming]. My father country. Two fella
bin cousin-brother la me. Tjapanangka and Tjangala.
Lirrwati my father land. Kamirarra.'
 'Me fella bin go, walk around. La land meeting. All the
womens. Me and Tjama and Patricia Lee. Alright. I bin
tell 'em story 'long microphone la video cassette. From
father. Tjama bin tell 'em about me, "Millie, you number
one. Your father country." Me fella bin talk on microphone:
"This one country my father [Tjangala] and Tjapanangka
uncle cut 'em about knives, white one knives, tjimarri
[stone knife]. All the way, all the way. Me got to look after."
Ngarangkarni story. Tjangala, Tjapanangka. Two fella bin
fight 'em about Ngarangkarni. My father, Tjangala, bin
make 'em that one. Tjangala. Law. Ngarangkarni.
Tjukurrpa. Tjangala, my father, bin see him shadow, two
fella. 'Somebody might be coming,' my father bin say.
"Might be somebody coming up. Watching." Tjangala bin
hide 'em, long manytja warta [mulga tree]. Mulga tree.
Look. Somebody bin coming. Two fella, Tjapanangka and
Nangala, sister foe Tjangala. That one Tjapanangka my
uncle. Two fella bin walking. Two fella bin fight 'em
because that Nangala bin find 'em [gave birth to] baby,
Napaltjarri [skin name of baby]. ➤ p. 205

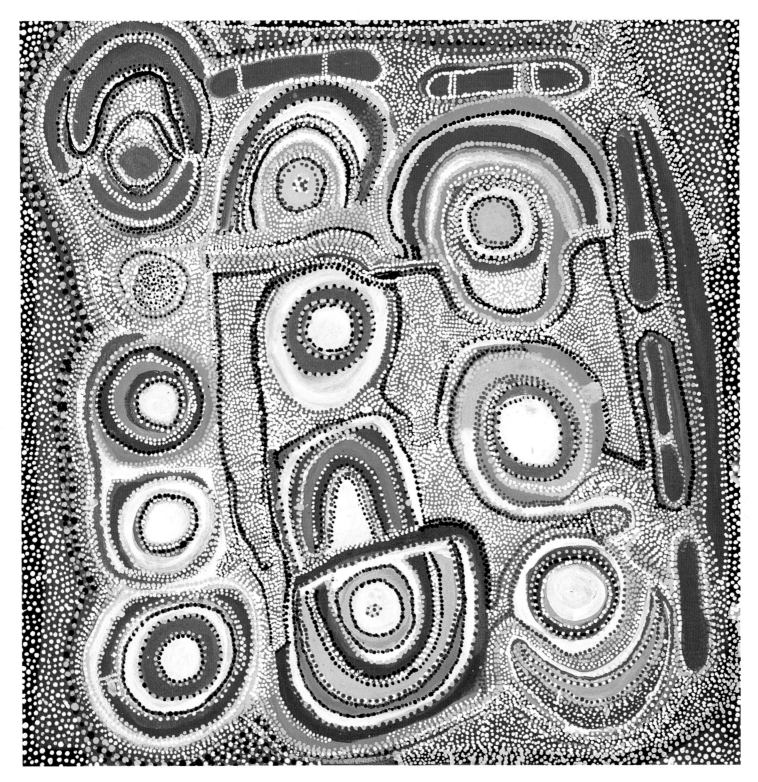

PLATE 106

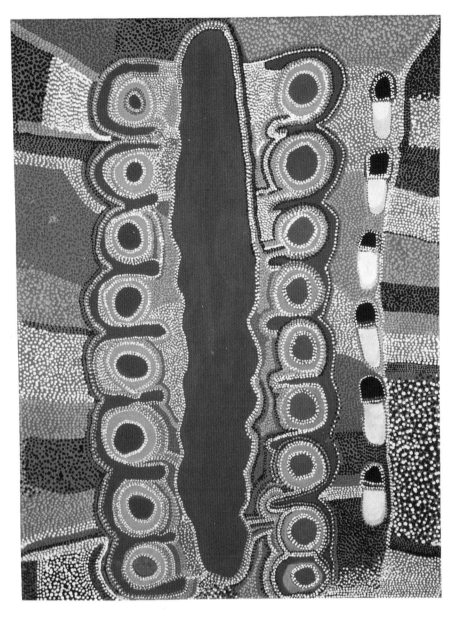

PLATE 107

Nangala bin talk like that, "No father. Gotta chuck 'em this one baby. Chuck 'em away. No father." Nangala bin talk 'em, "No. No father. Me got to chuck him away." Got to throw him. Kill him. That Tjapanangka bin come up and tell him, "We got to go warta [trees]." Tell 'em about that, Nangala now. "Come on, we got to go warta." That Tjapanangka he not father. Two fella bin kill him, Napaltjarri [baby]. Chuck him. Throw him. Tjapanangka bin grab Nangala and two fella bin run away. Leave 'em baby. Big storm. Tjilkarrpa [lightning]. Where that baby bin fall that place big rockhole. Tjangala bin watching. Getting angry for that one, sister, Nangala. Bin get 'em stone. Fight that Tjapanangka. Cut 'em, cut 'em. He bin fight 'em Tjapanangka, cousin-brother. Bin cut him about all the way. Long way. Got 'em knife, cut him, cut him, like that. Tjapanangka and Tjangala two fella bin fight. Get 'em knife, white knife. Old way, no knife. Stone. White stone. From Lirrwati. Fight long way, 'long river. Big river. Make 'em that river those two fella. Cut 'em about all the way. Bin cutting that river and come back to Lirrwati Law.

That stone he make 'em knife la marlu [kangaroo], wallaby, turkey. Bin cut 'em and eat him. Kuka. But this time he use 'em fight. If you go to Lirrwati you gotta look. Stone, pamarr [stone], like knife, everywhere. You gotta look. Nothing. Only knife. That's all. Sharp one, sharp one. Knife. Yellow one too, and white one. That pamarr [stone] one.'

'Me bin painting long time. Long, long time. When I bin going meeting to Lajamanu [a community in Warlpiri country, Northern Territory]. Me fella bin go Lajamanu for land meeting, kamu [and] Yaka Yaka. Bush way meeting. Warlpiri and Ngarti and Kukatja. Looking after Yaryarpa, Nakarra Nakarra and Parakurra. All around. All over. Before Manungka Manungka [an organisation set up by senior Law women in Wirrimanu and surrounding communities to protect and nurture women's culture/ Law]. Long time. I bin work for school, la Brother Leo. Make 'em good mangarri [food]. Big mob. Me and Susie Bootja Bootja and Patricia Lee, Napangarti. Me fella help 'em all the teachers, mussus, you know. Kukatja, Warlpiri, language. That one I bin helping. I bin do 'em Yapuru, but I never get 'em something. Prize. Nothing.'

One time I bin hunting with Tommy [her husband] and little bird come. Tommy say, 'Hey, we gotta run.' We run away. I bin cooking snake. Just leave him here. Mularrpa — true one. We bin run. If you hear 'em bird you keep going. Them two fella they bin grass. Stand up, grass, them Wati Kutjarra. Big one, big one. Tjukurrpa, Dreaming — and mularrpa. You find 'em there right now.

YAPURU DREAMING

Yapuru, la [belongs to] Tommy [Mirlkitjungu's husband]. No women's Yawulyu [Law]. Tommy's father bin cut 'em out woman [a term adopted from mustering days, meaning to direct people to do different things].

'Nyuntu [you], Napaltjarri, gotta go this side, Wangkali. 'Nother one, Nakamarra, gotta go that way.'

For dance. Napaltjarri, Napangarti, cut 'em out, cut 'em out. Tommy Skeen father he singer, sing 'bout Law.

Thomas Skeen's [Mirlkitjungu's husband] brother bin tell me, 'You can do him. You can make him that canvas. You can tell 'em that story. Everybody.' That story for Nampitjin, Tjangala, Nangala. That story 'long my father. Land my father. Long time. That why he gotta

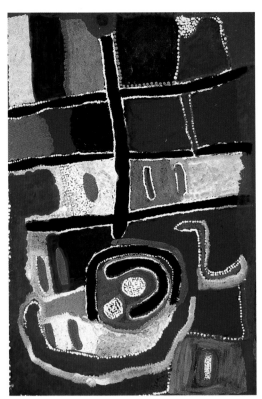

PLATE 108
Yurrututu, 1991
Acrylic on canvas, 120 x 60 cm, Courtesy of Coo-ee
Aboriginal Art

tell me. I look after that story now. When me fella bin go to culture meeting. Broome. Me fella got to dance him for mama [father]. Women gotta come — million thousand million. Me fella gotta dance, bush way. Only tutju [women] can look that dance [*Mirlkitjungu whispers because it is secret*]. Yawulyu [Women's Law].

Yapuru. My father land. That one for Nampitjin, Tjampitjin, Kanankanytja [emu] bin walk around. Two fella, mother, father kanankanytja. Bin sit down. Dig hole. Kampiny [egg]. That one kampiny bin leave 'em little kanankanytja. He bin put 'em down long hole, the kunaka-palpa [emu egg]. Keep going. Dig hole. Kampiny. Walking. Dig hole. Kampiny. Walking little bit. 'Nother one kampiny. That kampiny make 'em kanankanytja lamparn [emu baby], lamparn. That egg bin make 'em lake, Yapuru.

Mother, father bin walk away. Two fella keep going. Desert. Long way. Little kanankanytja walk around, walk around. Little one emu. Bin go in la underground. All bin go in, whole lot. Underground. Bin go inside for good. Sitting down. Mother, father, bin walk away. That mother emu bin say to wumpunna [wallaby], 'You got 'em two boomerang. I give you two kampinya, give me two boomerang. I got to walk that way, got to take em to Tjikiar.' Wallaby bin give him two boomerang and he bin take that kunakapalpa for Law. [*Millie began singing, and as she sang, she danced (sitting down). She was remembering the story, it is contained in the chants.*]

[*Singing*] Emu one be walk, nothing, got no kunakapalpa. Emu bin say, 'I bin sink down, sink down la ground.'

One time me fella bin go to culture meeting — bush way, tiwa [long way]. Manungka Manungka [Women's Association] too. That time me fella bin sing him. All the Nampitjinpa and Nangala dance. [*More singing*] Nampitjin in front, Nangala behind a little bit. For dance time, you know? Dance time. Culture time. If no Nangala, two Nampitjin got to sing him mother one [emu].

Father one [emu] he bin walk around, different way. [*More singing*] Father emu, mama [father] one, bin come out. Keep walking Ngarangkarni. He walking outside now. True one, not Ngarangkarni. Mularr [true] one. Walking outside. Find 'em kampiny. Look at him like that, bust him, kampiny. Finished. All the way, all the way. Father one, not mother one. Little emu come out, poor bugger. Walk in creek. Mularr story, true one. He walk around all the way. Kinti [near] Yaka Yaka [community] road. All around. All over. Desert. I bin go find him, kanankanytja. All over. Long way. Take him away. Kampiny one. I bin find him everywhere. I bin go hunting. I bin go.

[*Singing*] Kampiny one, kampiny one, all the way. Like Ngarangkarni. [*Millie drew an Emu Dreaming paint-up design, a kuruwarri, singing while she drew. Designs of emu tracks, it represented the Yawulyu, Women's Law.*]

You gotta look. Might be Nampitjinpa, innit? Yuwayi, Nampitjin one, might be.

[*Singing*] Yuwayi. Yapuru one, this one.

I bin painting that one. 'Oh, really good!' That one be white man bin talk. 'Really good you bin do him that one now. Really good. Ought to give you five hundred.' He bin telling me.

Lyndall Milani

SCULPTOR, MULTI-MEDIA INSTALLATION ARTIST

The art work is the artist — is the process — is the function.
In acts of finiteness, I quest to touch the infinite.

L YNDALL MILANI was born in Brisbane, Queensland and has had a diverse educational background beginning with studies in physiotherapy at the University of Queensland from 1964 to 1967. She attended various workshops held by the Society of Sculptors in the 1970s, completed a plastics course with Harry Hollander in 1973 at the Kelvin Grove College of Advanced Education, Brisbane and learnt wood lamination with Michael Cooper at the Robert Dunlop Furniture Factory. From 1980 to 1982 Milani was artist-in-residence in the Sculpture Department of the Queensland College of the Arts. She has held teaching positions at Queensland College of the Arts, in 1993, and at Kelvin Grove College, in 1994.

Milani's early formalist sculptural work utilised wood, stone, metal and plastics and, after a fortuitous association with John Elliot at the Queensland College of Art, her work changed to sculptural installations that incorporated documented ritualised performance. These were followed by intentionally ephemeral works and dismountable 'nomadic' sculptures. During this time Milani was concerned with issues relating to personal identity and process and the transformative power of ritual as well as an interrogation of belief systems. Her most recent work has involved a critical shift into technology using video and computer graphics, with the lens as 'third eye', to produce work from a body oriented perspective — putting the body back in the picture by exploring woman as a transactive subject — to 'humanise and personalise the public experience and perception of technological art' and to challenge the dominant male perspective in this field. All of Milani's work has been concerned with the nature of transience of all manifested forms in the universe. It pertains to her need to connect with the ongoing cyclic nature of life and death and the continuum in expressions of the moment as part of an overall interest in the evolution of the human consciousness.

Milani has had a number of one-person exhibitions since 1984 in throughout Australia as well as having participated in many group exhibitions since 1979. Her work is in significant private collections such as that of Lord McAlpine.

PLATE 109

PLATE 110

To begin, could you outline your journey as an artist — your key influences and inspirations and also what central understandings about art and life underpin your work?

In 1984–1985 I wrote that my journey through life has led me to the understanding that the only constant is change — no absolute truth — no absolute reality — only one's perception of a given moment at a particular time from a specific perspective. All is arbitrary. As well, there was an awareness of an underlying constancy — an intrinsic rhythm within the nature of things. This attitude is central to my work and governs my need to consider time/space — the fourth dimension; to recognise the altered perspective and realise the importance of orientation and location (time/space/personal and cultural perspective). I believe art is not only the product, but also something that exists within the individual — the product is the manifestation of the artist's being. The product is inextricably bound to the artist's personal state of growth/awareness and their orientation/location within the total. The art work is then seen as a continuum, a growth, a reflection of the individual and the culture.

Talk about your creative processes — giving psychical as well as physical and thematic details, with reference to particular works or installations…

The art work is the artist — is the process — is the function. However, if one projects, stamps, the personal idiosyncratic nature of the artist too heavily upon the art work, there is an imbalance created that warps the orientation/time factor — the relevance of the work; it can then only reflect the limitations of the individual rather than release personal awareness. While seen as a continuum, I realise there are moments of resolution of the preceding process/function. The art work is the process — the resolution is the product. The cycle is continuous, but should be that of the spiral rather than the self-perpetuating circle.

My earlier works — for example, *Landscape no. 1: Mandala* (1984) and *Landscape no. 2: The Sentinel* (1985) — represent moments of resolution in my working through concerns about the situation of humanity. We have lost the roots that bind us to the earth. We have lost the sense of our dependence upon the earth and our responsibility in the maintenance of the natural order — the perpetuation of the balance. We are the caretakers of the future. We must understand our terminal nature in relationship to the eternal. This work is about transience, unity and continuity. Once the universe is seen as a whole, as the manifestation of the temporal ongoing nature of existence, we cannot fail to recognise our responsibility as guardians and caretakers of the continuum.

> Mana from the heavens
> Fire from the earth
> The well nurtures and is
> nurtured in return
> The cycles repeat, confirming their nature
> — and ours.
> And all is one.

Originally, the process was almost more important than the outcome. Over the ensuing four years, the methods of processing the work became more structured, more perfunctory. While the work became more overtly permanent in nature, it maintained a link to the earlier ephemeral work through its nomadic quality. *Landscapes No. 3* and *No. 4* were demountable and capable of re-erection. This mode of being reflects my ongoing interest in the potentiality of transience within the notion of the eternal — the continuum — and is part of my overall interest in the evolution of the human consciousness. Later works retained an ironic monumentality through a parodic use of im/materiality and facadal devices.

PLATES 109 AND 110
THE FLOATING SHRINES, 1989
Performance in the landscape,
Photograph: Stephen Crowther, Courtesy of the artist

'In *The Floating Shrines*, one of my main concerns was how our capitalist society breeds voracious consumers and how we are complicit in this rampant materialistic process. The television commercial is a symbol of this capitalist society. By using a TV monitor to play a previously recorded ritual enactment in a slower time frame, I was in a sense using society's own tools to invert that materialist process.

I suggested a need to restructure our spiritual world by building on the best of what the past has to offer rather than casting it aside. This work was the acting out of this principle. I used the cross and the Gothic arch — which was also the keel of the boat — to make the skeletal form. The boat is burnt and its remains — the keel and legs that supported it out at sea — are transformed into the shelter and the altar respectively. The sculptures illustrate the process of restructuring. As in the past, it is through the development of the work that I continue to explore my own process and that of the external world.'

PLATE 111

VIAGGI, 1993
Installation, Queensland College of Art Gallery,
Photograph: Peter Liddy, Courtesy of the artist

'In 1992 I was awarded the Australia Council Studio in
Besozzo, Italy for a four month period. I decided on a
critical shift of my art practice into technology. In 1993 I
was awarded a fellowship by Arts Queensland and, in that
fellowship year, concentrated on an intense developmental
phase. This included skills of a technical nature relating
to video and computer graphics as well as addressing the
development of a particular philosophical and conceptual
basis to the work. My intention was to produce intermedia
installations that used technology to explore conceptual
issues and to challenge the lack of philosophical depth I
found in a lot of technological art, which I believe has a
particular "look".

I wanted to challenge myself to develop a unique and
particular approach to subvert this stereotypical style,
producing work from a body oriented perspective that
placed the body back in the picture as a subject, a sentient
character and as an interactive processor. I wanted to
humanise and personalise the public experience and
perception of technological art and to experiment with
video projection in order to use various technical devices
within the installation to produce an evolving art work
that brought itself into being in front of the viewer. I
wanted to challenge the male perspective that has
dominated this field and explore cyberspace sentiently,
as a woman, and to address and challenge myself into the
world rather than be called forth.

I was working then with a video camera, exploring life
itself like a found object. With the lens as a "third eye", I
had the ability to frame, reframe and reposit meaning and
had begun to develop a female gaze, seeing the potential
to forge, with life itself, an analytical tool of exquisite
irony. To give conceptual depth to that process, I felt I
had to take this material further and to intermix computer
generated and facilitated images with this "found"
footage and other footage fabricated "in studio". I
intended to juxtapose this material and present a
multiplicity of segments contemporaneously and cause
them to reorganise themselves continuously in relation to
one another, using differences in duration or the more
interactive process of video disc. In the same way, I
wished to be proactive in calling myself into being. I
also wanted the interactive user of the art product to be
responsible for shaping their own experience of the art
work. I felt that there was a lack of women directing their
gaze, critically and analytically, at male culture, or
interrogating cyberspace as a male construct.

Viaggi was the outcome of this period of intense
exploration. I had taken control of the camera. I was able
to reposition myself in relation to the lens and to frame
and reframe my viewpoint of myself and the world in a
powerful way. The camera replaced my eyes, often
looking at my body, down my body, from my body.

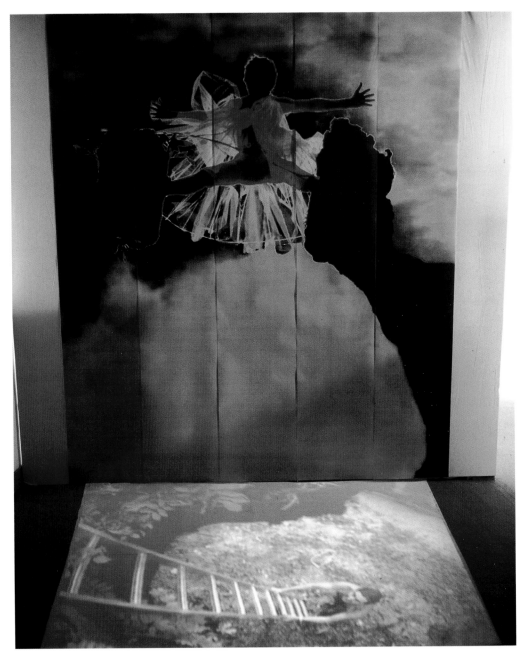

PLATE 111

All the *Landscape* works required continuous maintenance, either through the daily lighting
of the oil lamps, the maintenance of water cycles or through the later inclusion of plants. The
repetitious activity added a ritual element to the work.

Running parallel to these were the performances that accompanied each of the *Landscapes*.
They occurred at specific times of the year (e.g. Solstice or Equinox) and generally took place
at the beach, at the water's edge, utilising the incoming tide. When possible tidally, they coin-
cided with sunset or sunrise. They indicated my need to connect with the ongoing cyclic
nature of reality and were more overtly ephemeral and poetic than the *Landscapes* themselves.
They revealed the essential, spiritual nature of the works.

In my work in the 10th Mildura Sculpture Triennial in 1988, the ritual performance and the
sculptural installation came together for the first time. The event took place at sunset, the day
of the opening of the Triennial. It was, in essence, the same as the beach ritual conducted at the
Spring Equinox in 1987. This was documented and was presented as part of the work. In these
acts of finiteness, I quest to touch the infinite.

The sculptural installations reflected my understanding that architecture is the physical manifestation of our culture and society and that it embodies both our physical and spiritual attitudes towards ourselves and our environment. Thus they present a physical reality that looks both monumental and fragile at the same time, symbolising the ways in which we construct and institutionalise social and cultural beliefs. The architectural facades thus act as framework, shelter and prison, which in turn are dismantled and re-constructed, and are thus part of a transformative and evolutionary process. The installations are designed as works that attempt to provoke people to interact with symbols that they normally accept at face value and do not question.

In my early works I used mostly natural, ephemeral and recycled materials in my works and the pieces were designed to be easily assembled and dismantled and to be portable and thus are in a sense 'nomadic'. They also required assistance from others in these processes and, as such, are collaborative efforts in construction and deconstruction.

The idea for my show in *Installation* in 1991 was developed during 1990 after I had been listening to several Radio National broadcasts on the state of the environment by David Suzuki. About the same time I became aware of the work of Paul Davies, then Professor of Physics at the University of Adelaide, through discussion of his book *God and the New Physics*. This information, linked in with my reading of Hawkings's *History of the Universe* and the excitement generated by Chaos theory, led to my working with these ideas and their relationship to a change in our perception of our physical reality and a corresponding shift in our concepts regarding a metaphysical reality.

Would you further elucidate the concepts and themes relating to the melding of physical and metaphysical relationships in the areas of science, nature, culture and religion that are relevant to your work?

I have for some time been interested in perception, how it is formed, maintained and modified. Consequently I am interested in our anthropocentric Christian heritage and how it influences our perception of nature and science. I have observed how the Eastern philosophies have modified our Western monotheistically based culture and how we are becoming increasingly affected by the Aboriginal Dreamings and their relationship to the environment.

I am fascinated by our Western cultural lineage and its basis in the adversarial and democratic culture of Ancient Greece, with its city states maintained by the heroic soldier; and by the influence of language and learning, both in its usage as a carrier of meaning and as a tool that modifies the user. This fascination encompasses the modern philosophers and psychoanalysts: Wittgenstein, who changed the emphasis of philosophy from the mind to language and established the difference between saying and doing; Freud, whose psychoanalytic theory linked sexuality and repression to neurosis and later developed this into a general psychology; Jung, Freud's pupil, who established the importance of the subjective experience and explored dreams and the phenomenon of the collective unconscious, describing its archetypal symbology as revealed in dreams; Nietzsche, who pronounced 'God is dead' in an attempt to influence humanity into a position of personal responsibility; and Lacan, whose work has reassessed the whole Freudian legacy and suggested that if psychoanalysis is a science, it may be surprisingly similar to linguistics.

These people, amongst others, have revolutionised the way in which we think about ourselves, as have the mystics such as St Augustus, who first named the idea of original sin; the Abbess Hildegaard of Bingen — scholar, musician, composer; Meister Eckhardt, who was tried for heresy and stated that the inward man is not at all in time or place but in eternity; and Teilhard de Chardin, who foreshadowed the shift from an anthropocentric perspective to a world interested in a holistic view of the universe, with its attendant interest in ecology and the environment. Charles Birch spoke not so long ago of a publication that includes comments on a

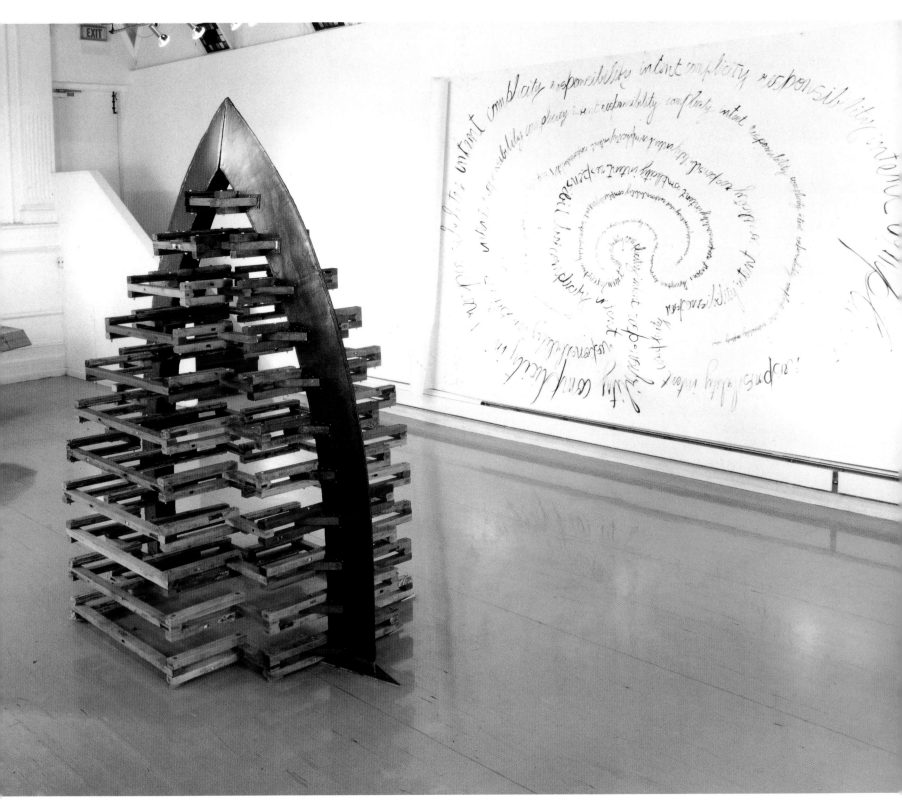

PLATE 112

pantheistic view that relates to the notion of God present within all nature as an interactive component of an unfolding universe.

When one considers how our understanding of science and the natural world has influenced our paradigms of reality, one can understand the arising of the mechanistic, external, judgemental God of the industrial era and the changing notion of gods throughout the evolution of our species. From this, one may draw the inference that our gods (or lack of them) reflect our own image of ourselves and our status quo (vis à vis communism). In other words, it would seem that we construct our gods in our own image rather than the biblically versed opposite. Seeded within such notions is the negation of determinism, the promotion of personal responsibility in both a local and a global sense and the recognition of the interconnectedness of all things.

What have been the significant changes or stages in your work throughout the course of your career to date?

My outlook, concerns and what has informed my work has not fundamentally changed since I made those earlier statements except that the ritual dimension to my work is becoming more an attitude to my life rather than being isolated incident. In my previous work, I would produce something at a specific time, such as during an equinox or solstice, and attempt to endow it with a particular meaning. At the same junctures, I would also try and move something within myself so that I was structuring my own life stages of growth and development and the work became not just about producing a ritual. I have always had these two parallel journeys — of the dialogue that occurs within the work, which then becomes exhibited publicly, and the other, personal journey. Now, I believe the two journeys are becoming more intertwined in that I have always sought to have control over my art work — the way it was shaped and formed — and this same purpose, I am now becoming aware, is what I am applying to the ritual of my life.

I am also investigating the personal, autobiographical realm — and where this is narcissism and where, in its relational concerns, it becomes relevant to making art.

How do your see your role as an artist — and as a woman within that role — and also the function of your art work at this stage of your creative development?

For me, the journey is one towards liberation of the self. As a human being I am a subject — a colonised and a gendered subject. I desire autonomy but now see it as undesirable to be separated from society. What I am seeking is an integration of my own being, my own self, rather than, say, the role play in a couple relationship, where one person acts out one dimension of me and I act out another. In other words, I would like to have the satisfaction of being a 'complete' being by taking on the responsibility of integrating my masculine and feminine aspects. Thus, I continue to explore some way in which I can see the world and see myself and see reality.

I have reached an age and developed an attitude towards life that will hopefully facilitate an effective and compassionate cultural discourse that is capable of looking at myself — the observer — looking at life — the observed — and in the process sentiently interrogate contemporary experience and the meaning-making process.

'Even if the form disappears the roots are eternal'

Mario Merz

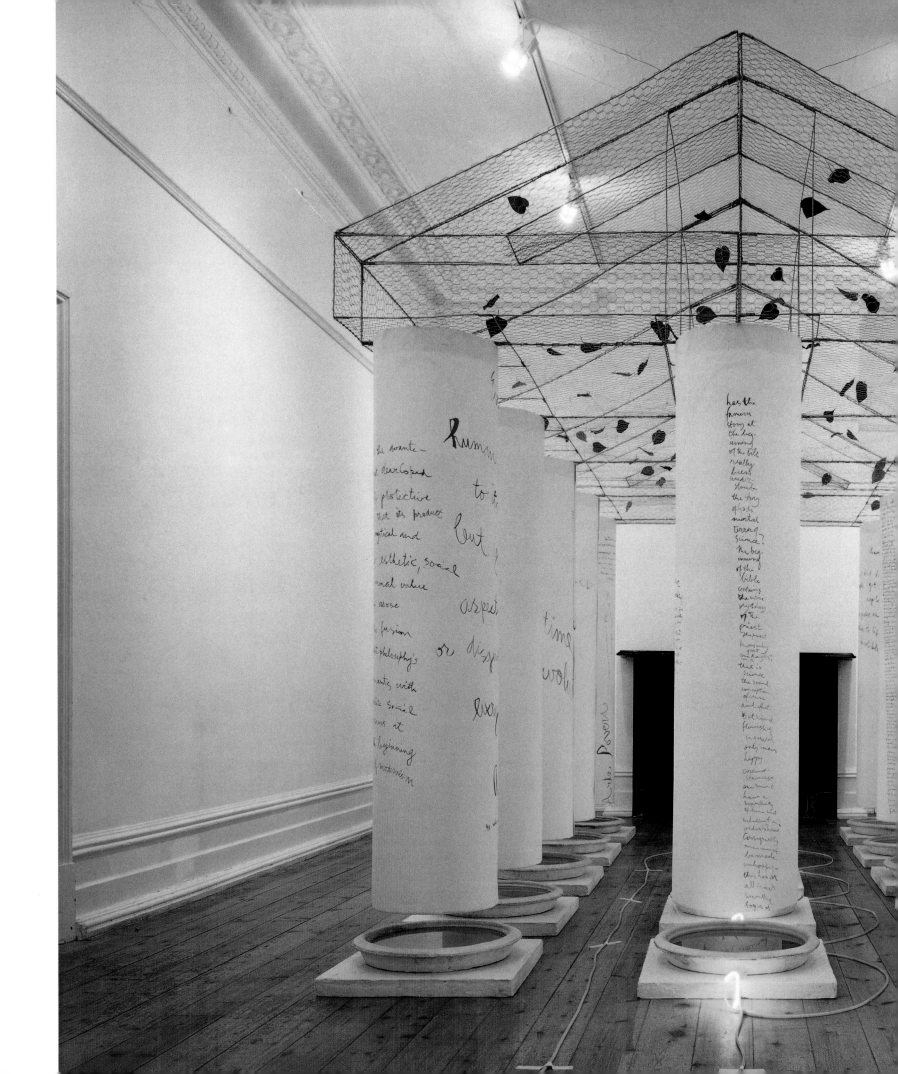

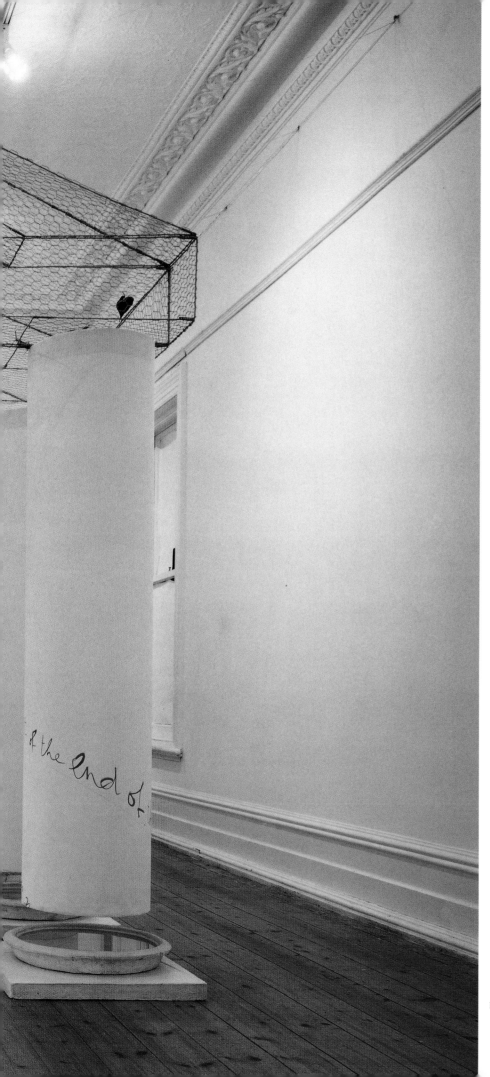

PLATE 113
INSTALLATION, 1991
Wire mesh, wire, paper, wax, plaster, water, neon, text
(gouache on paper), artificial leaves, electrical cords,
Photograph: Garry Sommerfield, Courtesy of the artist

PLATE 113

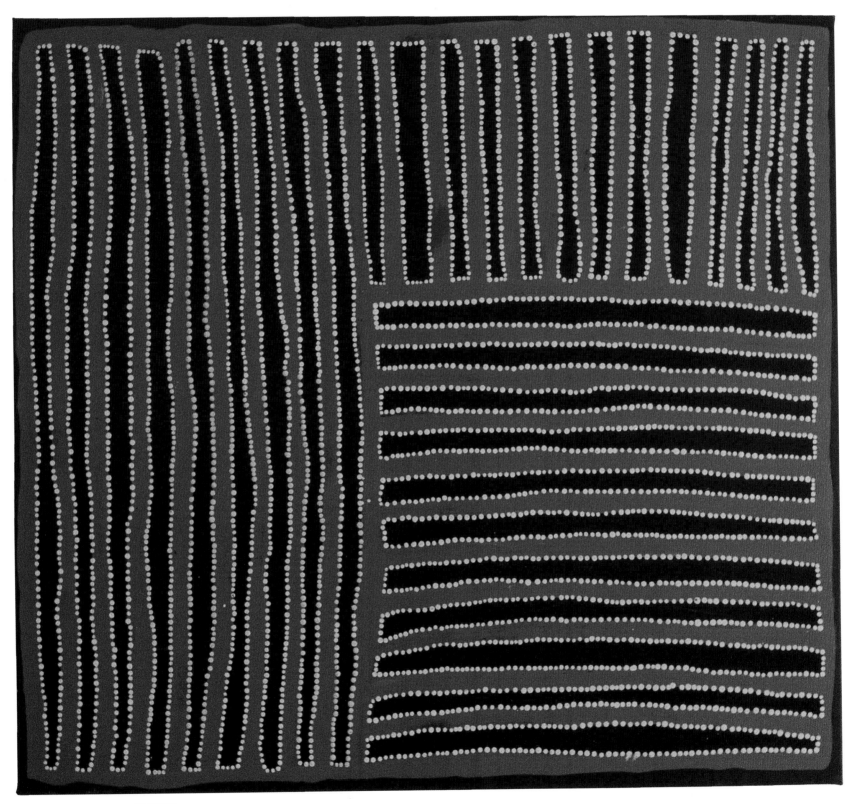

PLATE 114

Gloria Tamerre Petyarre

PAINTER, SENIOR LAW WOMAN

*'Awelye' might be whole mob of women…might be body paint…
might be little hills…might be little rainbows.*

GLORIA TEMARRE PETYARRE was born between 1938 and 1945 (according to various sources), her country is Atnangkere and she is an Anmatyerre speaker. Gloria is amongst the senior Aboriginal Law women of the Utopia community in the Northern Territory and she lives at Mulga Bore (Akaye soakage). She is the niece of, and is in close relationship to, the legendary artist Emily Kame Kngwarreye and she has four sisters who are also artists: Ada Bird, Violet, Myrtle and Kathleen. Gloria, like many of the Utopia artists, first gained recognition in contemporary art for her work in the medium of batik, which was exhibited throughout Australia and overseas between 1980 and 1987. It was immediately following this period that Gloria began working with acrylic on canvas. Although in western art terms this appears a relatively brief career as an artist, Gloria has been 'creating art' in the forms of her ceremonial life for many years prior to her first batiks.

Gloria's art work is entirely based on her 'Dreamings' and 'Awelye', which refers specifically to women's ceremonies. Until recently, the hallmark of her art work was the geometric 'paint-up' body designs that are applied during ceremonial enactment. She is an instinctive, intuitive artist and her powerful minimalist works radiate an electric energy that both embraces and transcends its form. In 1988–1989 Gloria, with other Utopia artists, participated in her first works on canvas exhibition in Sydney and in 1993, together with Lyndsay Bird Mpetyane, designed and executed a large mural for the Kansas City Zoo in the USA. This mural depicted animal tracks, pathways and traditional territorial maps commemorating the ancient culture of the Aboriginal peoples and also celebrated the kinship of all living creatures and the unity they form with the land from which they originate. In Gloria's work there is always the traditional cultural referencing and clarity of spiritual purpose. This is expressed in central themes of the unity of reality in diversity, the unity of life in its cycle and return to origin, the unity of reality in its emanation from the one creative principle and celebration of all that is — visual manifestations of truth in beauty and beauty in truth and simplicity. Her works in this sense are like visual prayers.

PLATE 114
AWELYE, 1993
Synthetic polymer on linen, 75 x 81 cm,
Courtesy of Utopia Art, Sydney

This work was one of Gloria's key paintings in her 1993
Sydney Exhibition at Utopia Art, Sydney. During the
period leading up to this exhibition, Gloria produced a
number of dark and austere paintings, resulting in the
majority of works in the show comprising a black
background with a red ochre linear pattern and yellow
ochre dotting. The reductive system in those works is
particularly evident in this painting — which was the most
minimal and severe of all the works in her exhibition. It
later emerged as a bridge to her current work — this, as
Gloria's most austere work then, would be the least
austere now. In terms of her artistic development, this
work was painted around the time that she was
completing the mural for the Kansas City Zoo. Also during
this time, Gloria painted a couple of big, heavily dotted
canvases for public exhibition to accompany the mural at
the zoo. After completing these major works, Gloria
stepped back, in a sense, to the earlier, more descriptive
elements of the *Awelye* work. The result of this stepping
back was the emergence of works that were also pared
back, becoming very reductive and severe in the process.

Gloria painted her first work for the Central Australian Aboriginal Media Association
(CAAMA) — who in late 1987 had been approached by the Aboriginal Development
Commission to assist in the further development of the burgeoning arts and crafts industry at
Utopia. The result was the first of many national and international exhibitions of Utopia art
organised by CAAMA. Titled *Utopia Women's Paintings: The First Works on Canvas: A Summer
Project 1988–89*, the exhibition was held at S.H. Ervin Gallery, Sydney. In 1990–1991 Gloria
travelled to Ireland, London and India as a representative of the Utopia women, accompanying
the exhibition *Utopia: A Picture Story*. As well as the Royal Hibernian Academy, Dublin, this
exhibition was mounted in Tandanya, Adelaide and Gallery Gundulmirri, Warrandyte,
Victoria. Her work features on the cover of Michael Boulter's *The Art of Utopia*. It has been
included in major survey exhibitions, including the 1991 Art Gallery of New South Wales
touring *Aboriginal Women's Exhibition*; *Flash Painting* at the National Gallery of Australia in 1992;
and The *Body Paint* Collection at Bishop Museum, Hawaii, which toured the USA, as did the
Crossing Borders exhibition initially shown at the Kansas City Art Gallery. Also in 1992 Gloria's
work featured with other Aboriginal artists in the 65e Salon du Sud-Est Exhibition in Lyon,
France as well as in exhibitions in Japan. In 1993 Gloria received a tapestry commission for the
Victorian Tapestry Workshop and another in 1994 for the Law Courts, Brisbane. She had her
first one-person exhibitions in 1991 at the Australian Galleries in New York and at Utopia Art,
Sydney — where she has had other solo shows from 1993 to 1995. Gloria was the recipient of a
Full Fellowship grant from the Aboriginal and Torres Strait Islander Board of the Australia
Council in 1995–1996.

Gloria's work is in the collections of the Art Gallery of New South Wales, the National
Gallery of Australia, National Gallery of Victoria, Queensland Art Gallery, the Museums and
Art Galleries of the Northern Territory, the Supreme Court, Brisbane, the Holmes à Court
collection and in numerous other public, private and corporate collections.

＊

When the borders of the Utopia Pastoral Lease were first drawn across Aboriginal lands in 1927
(the second wave of pastoral development in the area), the Alyawarre and Anmatyerre clans
were forced to move away from their traditional lands and ceremonial sites — the land to which
they were inextricably bound and which they had 'caretaken' as responsible custodians for
over forty thousand years. They had no option at the time but to move closer to the cattle sta-
tion homesteads where the men worked as stockhands and the women as domestics — essen-
tially becoming a source of cheap labour. Wages were paid in the form of second-hand clothing
and food rations such as flour, sugar and tea. With the passing of the landmark 1967 legislation
requiring that Aboriginal and white stock station employees be paid the same award wage,
many Aboriginal stockmen lost their jobs and others continued to be paid on the ration system.

In 1977, under the provisions of the Aboriginal Land Rights (Northern Territory) Act 1976,
the Anmatyerre and Alyawarre Aboriginal people gained a 99-year leasehold to the 1800 square
kilometres of the Utopia Pastoral Lease. In 1979 the same clans made a successful claim to the
freehold title of this lease, thus legally regaining their traditional lands — central to their lives
and 'art' — after fifty years of white control. The Utopia women played a key role in the 1979
land claim hearing, giving their evidence separately from men in the way of 'women's business'
and mostly through the performance of Awelye — women's ceremonies — whereby they
powerfully demonstrated knowledge of their country and Dreamings. Here was evidenced
also the inseparable tie for Aboriginal people between their land and all its inhabitants, their
ceremony, their religious expression and their 'art' practice — land is body and body is land.

Gloria Temarre Petyarre, as has been said, is primarily known for her *Awelye* batiks and
paintings, which specifically derive from the women's ceremonial body paint designs. 'Awelye'

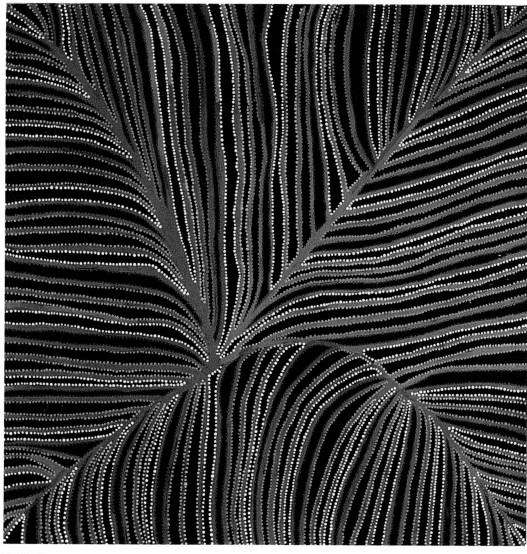

PLATE 115

PLATE 115
Sacred Grasses, 1991
Synthetic polymer on linen, 91 x 91 cm,
Courtesy of Utopia Art, Sydney

All of Gloria's paintings work on manifold levels
emanating from the entire spectrum of her embodied
Aboriginal consciousness. What can be described in her
work can only ever touch the surface of her meanings.
The title of this work is an applied title — descriptive
rather than emotive and lyrical. The work shows a lineage
to later works reproduced here — such as the dark back-
ground and minimal compositional elements. From a
central focus, derived from the feel of a plant form, there
are basically four fronds with many root-like fibres
emerging out of the work. The dark background with very
spidery lines and elements that appear to look like grasses
— in relation to the title — could just as well apply to
the roots of the grasses lying under the ground. So the
painting suggests a number of different (though related)
and simultaneous realities.

also includes the ceremonial situations in which the paint is applied as well as the conceptual
basis underpinning the ceremonial activity. Gloria's Dreamings, which are painted and per-
formed in Awelye, are the Mountain Devil Lizard, Bean, Emu, Pencil Yam, Grass Seed and
Small Brown Grass. Her Christian name was bestowed by those Europeans who moved
through and temporarily subsumed her country. Her actual name is Temarre, which relates to
the red sap that comes out of the trees. Her sister name is Arnkerrthe, who is the mountain
devil lizard, and then there is her skin name denoting her place in the structure of human rela-
tionships within her tribe. There are several levels to Aboriginal 'naming', all of which are con-
nected to their traditional cultural structures, their responsibilities and their kinship ties to
land and spirit — defining their place within that cosmology.

In traditional life, Aboriginal women and men live separately and have separate camps,
each with separate responsibilities to be carried out during the day and in ceremonial activities.
This structure is commonly known as 'women's business' and 'men's business'. Despite their
gender separation practices, Aboriginal women and men are as interdependent and comple-
mentary as they are independent and individually autonomous — two parts of a symbiotic
whole with each needing and defining the other. Each individual, their clan and language
group, is entrusted with the ownership of particular areas, sites and knowledge of the ancestral
journeys which formed the topography of the landscape. It is this knowledge of their Law —

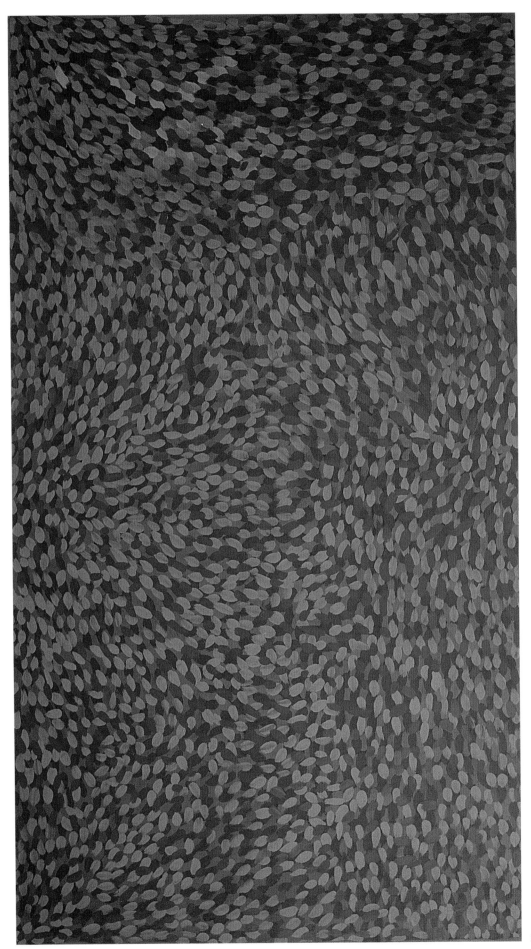

PLATE 116

embodied and continuously re-enacted (as though for the first time) and transmitted through the sacred traditions of ceremony — that is the basis of their art. Aboriginal women's ceremonial life and stories only began to be documented, recorded and more widely communicated in the 1970s due to the fact that they were not being asked about their culture — only Aboriginal men were — and, traditionally, only women can deal with women's business and men with men's business. Senior Aboriginal women are now also keen for their Law to be recorded so that their culture can be preserved and so that the Law can be utilised for educational purposes within their communities and abroad. The Awelye that is women's ceremonial business is described by Gloria's sister Kathleen, who is also a fine artist and Law woman:

'The old women used to [and still do] paint the ceremonial designs on their breasts, first with their fingers, and on their chests, and then with a brush called a 'typale', made from a stick. They painted their thighs with white paint. They painted with red and white ochres. Then they danced, showing their legs. The old women danced with a ceremonial stick and a headdress of feathers. While they danced they placed the ceremonial stick in the earth.

The spirits of the country gave women's ceremonies to the old woman. The woman sings, then she gives that ceremony to the others, to make it strong. The old woman is the boss, because the spirits of the country have given her the ceremony. So all the women get together and sing.

The old women sing the ceremonies if people are sick, they sing to heal young girls, or children. If a child is sick in the stomach, they sing. The old women are also holding their country as they dance. The old women dance with that in mind. they teach the younger women and give them the knowledge, to their grand-daughters, so then all the grandmothers and grand-daughters continue the tradition.'

Quoted in Anne Marie Brody, *Utopia: A Picture Story*

The ceremonial culture of these Aboriginal people is the focal point of life in the community and although ceremonies are held for different purposes, they are generally focused on preserving the well-being of the land and its human, plant and animal life. Visual expression is integrated into ceremonial culture, and each person is taught the designs that describe their land, and how to make and decorate ceremonial instruments. Through sacred ceremonies and adherence to the laws passed down from ancestors since the time of the Tjukurrpa — the Dreamtime — people look after their land.

The rich ceremonial culture contrasts with the austere material conditions and the harsh nature of the desert environment in which these Aboriginal people live. The country has a typically arid climate with a low rainfall, scorchingly hot and long summers and freezing winter nights. At Adelaide Bore, the home of Gloria Temarre Petyarre and her artist husband Ronnie Price Mpetyane, there is a shifting population of about fifteen families. There are 'seven houses, several out buildings, a shed with emergency radio and another that is partly reserved for the travelling medical clinic and, on other occasions, for storing completed works of art' (Michael Boulter, *The Art of Utopia*). The settlement centres around a windmill and a water tank on stilts with the only permanent water coming from bores and soakages. Although it is on the Ti-Tree Aboriginal Lease, slightly to the west of the Utopia Aboriginal Land, the people living here regard themselves as a part of Utopia. Unlike other Aboriginal communities, Utopia has never had or been near a township structure.

The desert topography is flat, sparsely landmarked with boulders, rocky outcrops and some low ranges. The rich red soil frames the landscape and sprouts tough vegetation consisting of kurrajong, bean wood and mulga trees. Seasons are regarded differently in the desert to the characteristic European four seasons. The main seasonal change is from dry to wet and is

UNTITLED (LEAVES ON THE GROUND), 1995
Synthetic polymer on linen, 192 x 110 cm
Courtesy of Utopia Art, Sydney

In this work, Gloria has used the inspiration of leaves on the ground, the motif of a dash of paint which looks like a leaf and a swirling pattern to create a field of immensely energised life. In focusing on this image, one's attention is quickly drawn into its centre and, once there, the eye is thrown around the picture — up and down, in and out. There is a strong sense of movement in the painting — as in the earlier plant form work *Sacred Grasses* — but here the organic, broad-stroked, undulating rhythms become like rapid dance steps in a celebration of colour and form. This painting was the final painting for her 1995 Sydney exhibition.

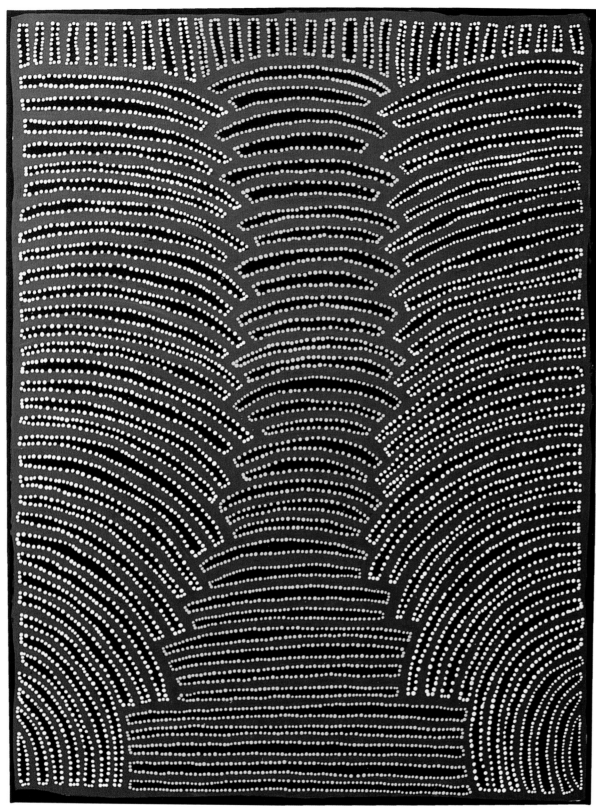

PLATE 117

distinguished by the rapid and prolific appearance of wildflowers and fruits amongst the perennial spinifex and bush scrub. Every feature of this land and the animals it supports — beloved of the Aboriginal clans — is associated with a particular Dreaming and every Aboriginal has their own totem being.

The intractable nature of this particular desert land has also meant that the Utopia community has been comparatively fortunate in the historical encounter between indigenous peoples and white 'civilisation'. There has also been minimal impact of Christian missionary colonisation in this community, so the traditional Aboriginal culture has remained virtually intact. Since the 1970s land reclamation, the centralisation of housing, which reflected white pastoral interests, has been reversed by the outstation movement. Families have moved back to their own country to be nearer to their important sites.

Batiking was introduced to the Utopia community in late 1977 by Suzie Bryce and a Pitjantjatjara woman, Yipati Williams. The art of batik, for which the Utopia women became renowned, was first introduced into the Aboriginal community at Ernabella Mission. At Ernabella, these dyeing techniques had been in use since 1972, building on the achievements in weaving, which had been introduced in the 1940s by missionaries. The Aboriginal women from this mission settlement travelled to other communities to teach the batik techniques and other Aboriginal women came from Arnhem Land, Yuendumu and Western Australia to learn this art in the craft room at Ernabella. In Utopia, the educator, Jenny Green — one of the few non-Aboriginal Anmatyerre speakers and one of the first people to write down a word and phrase list of Alywarre and Anmatyerre languages — incorporated batik making into an adult education program. This was building on other social welfare programs designed to provide women in the community with basic literacy, numeracy skills and commercial knowledge, such as dealing with unemployment and pension benefits, signing documents and handling money for transactions in and out of the community. Most of the group had never received any formal education or training in non-traditional art forms, although they were all accomplished in the practice of their ceremonial arts, primarily body painting.

In 1978 Julia Murray joined Jenny Green in the adult education program and quickly saw the professional potential in the batik work. Murray guided the setting up of the Women's Batik Group, as it became known, and sought to secure public funding to enable the continued buying and expansion of art materials — such as silk — and to sustain the viability of the batik production. Murray also set about commercially promoting the batik artists and their works. Jenny Green describes her initial acquaintance with the women of Utopia and the ceremonies which form the basis of their lives and art:

> 'The country was revealed to me through the performance of elaborate song cycles and dances. Every afternoon the women congregated and prepared for the 'awelye'. They smeared their bodies with animal fat and traced the ceremonial designs on their breasts, arms and thighs, using brushes called 'typale' (made from flat sticks with cotton). These were dipped in powders ground from charcoal, ash, and red and yellow ochre. The paintwork was appraised critically by everyone and mistakes or omissions of detail corrected. The women sang as each took her turn to be 'painted up'.
>
> The singing continued for hours, interspersed with dance. Several women who had been appointed danced together, led on many occasions by Emily, the most senior woman of the Alhalkere clan. She carried the ceremonial painted stick (kwetere). Meanwhile the other women beat the rhythm with their hands, and sang the songs relevant to the dreaming story. These depict the travels of the dreamtime ancestors through Alhalkere country including the mountain devil lizard (arnkerrthe), the emu (arnkerre) and the kangaroo (aherre) and other totemic plants, animals and natural forces.

PLATE 117
ARNKERRTHE — MOUNTAIN DEVIL LIZARD, 1995
Synthetic polymer on linen, 112 x 86 cm

This painting is derived from the *Awelye* body paint works. However, the design in those earlier works — the painted breasts with a line that runs across the chest in the picture (which Gloria still paints from time to time) — has been changed so that the chest line has been transposed into a series of verticals. The curves that would be the breasts in real life have become a series of curvilinear lines that run along the side of the picture. The different dotting on the edge of the canvas is the only thing that changes the colour balance in the painting. What this produces is an enormous exuberance of energy running vertically up the central panel — like the explosion of a fire cracker.

PLATE 118
AWELYE, 1994
Acrylic on canvas, 186 x 186 cm,
Courtesy of Utopia Art, Sydney

The knowledge of songs is shared by many women, including those from different clans. The women are keen to record their songs on tape, and these cassettes are often produced when groups of women are together. There is often much joking and commenting about the quality of recording, and frequency of interruptions, coughing, extraneous dialogue and the barking dogs during the performance.

Contrary to popular belief, women play a vital role in ceremonies for the initiation of boys into manhood. These ceremonies last several weeks, and the women who are classificatory mothers of the boys future wives, play a special role. The dancing associated with the ceremony is enjoyed by everyone. People laugh at each other's mistakes or peculiarities of style. Young girls and sometimes even small boys join with the women, and toddlers look on and clap their hands. If some fall asleep during the long night everyone is woken at dawn for the excitement of viewing the boys adorned with ochre and feathers.'

Quoted in Anne Marie Brody, *Utopia: A Picture Story*

The art of batik occupied Gloria for over a decade — from 1977 until 1987 — when she painted her first acrylic work on canvas, apparently soon preferring the greater freedom and control that this medium offered. Since this time, Gloria's extensive national and international travel has led to a number of changes in her work. With a developing artistic self awareness, propelled by the contact with world contemporary art, Gloria continuously experiments with colour and with subtle variations in the forms of her *Awelye* compositions.

Although her work is always based on her Dreamings, since her early distinctive body paint designs, which clearly showed the designs painted across the women's breasts and shoulders in ceremony, Gloria has developed her painting to higher levels of abstraction. Her work now has several touchstones in contemporary art. Several works in her 1995 Sydney exhibition, for example, had no characteristic dot shaping at all, but bands of brilliant colour whose optical effects have evoked comparisons with the English artist Bridget Riley.

Also her most recent *Leaves in the Ground* works are quite distinctly different from the organic, wide, billowing curves of the earlier plant form works *Sacred Grasses*. In the *Leaves…* works, Gloria has taken the motif of a leaf on the ground, which could possibly have been inspired by Emily Kame Kngwarreye's lush pattern painting covering the entire canvas surface. However, it seems that Gloria is not content just to adopt an idea; she has to work out her own unique way of presenting a motif. It would seem also that Gloria is unable to make a painting without having a strong and clear purpose in her mind's eye for doing so. Consequently, in the experimentation process, she finds within herself her subject — in that uniquely creative marriage between inner and outer vision. The net result in this instance is that her Leaves in the Ground are exquisitely balanced compositions whose colours and rhythms sing and dance in a play of light and life. Whatever Gloria 'finds' in her creative process — here meaning a spiritual engagement with subject — she makes her own. For these reasons of integrity, sincerity and commitment, coupled with her strong traditional Aboriginal core and her natural talent and intuitive vision, Gloria's paintings vibrate a strong life force which can only emerge if one is freely and directly engaging with spiritual essence.

Underpinning all her work, however abstract, is Gloria's consciousness of her sacred traditional responsibilities. Although Gloria does not talk about specific paintings in detail, she says of her overall work: '*Awelye* proper body paint for my country…proper one for women looking after country. *Awelye* might be whole mob of women…might be body paint…might be little hills…might be little rainbows…'

Unlike Western contemporary art, this Aboriginal art is not simply painting a picture, but is each time a total engagement in making a Dreaming. As with the other Aboriginal artists in this

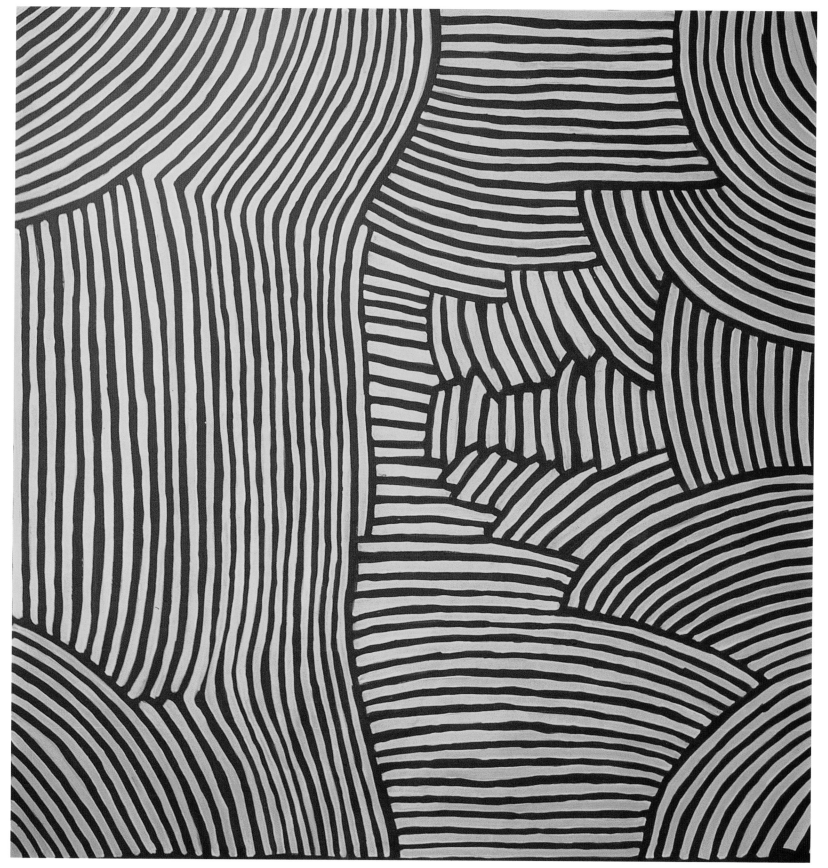

PLATE 118

book (and elsewhere), the accompanying ceremonial songs and dances are integral to the visual statement.

Gloria is widely respected as an artist and Law woman and is often spokesperson for the female artists and in relation to the 'women's business' of the Utopia community, both in Australia and overseas, because of her erudition and language skills, her strength and wisdom, her travel experience and her ability to bridge the worlds of her traditional Aboriginal culture, the white Australian culture and the commercial worlds of contemporary art. She is also seen as the person most able to cope with the pressure of being a frontsperson in addition to being well versed in dealing with the human face of the Utopia community. Indeed, Emily Kame Kngwarreye, who is the most senior of the Utopia law women, is said to have nominated Gloria as her 'Number Two'. This could mean that Gloria is Emily's 'heir apparent', so to speak — the person who will assume the future leadership of the Utopia women's community, given her experience, skills and public confidence, and possibly also to take over Emily's mantle when she stops painting. Utopia, like Wirrimanu (Balgo Hills) and other Aboriginal communities, is extraordinarily rich in artistic talent and creative output given the relatively small numbers of its communal members.

Of all the artists in the Utopia group, Gloria is said to be the most critically aware of her position in the art world. With the rise and rise of interest in Aboriginal art across the planet and the Western 'star' system of personality and assessment has come an interest in individual painters. Also a number of individual Aboriginal artists have emerged — like Utopia artists Emily Kame Kngwarreye, the Petyarre sisters, Gloria Temarre, Kathleen and Ada Bird, and others in this community — with unique and captivating visionary expressions. Whilst the discovery, nurturing and acceptance of Aboriginal art in the Western world has been of incalculable importance to Aboriginal reclamation of identity, economic independence and self esteem, thus changing the face of Australian culture, the fundamental cultural and conceptual difference in the communal or 'generic' basis of Aboriginal art versus the individual 'superstar' or 'artist as genius hero' approach of Western art has not been without its problems. In Aboriginal understanding, each person's expression of a Dreaming is as valid and valuable as any other. This is not the case in Western art evaluation. Consequently, there is now immense pressure on individual Aboriginal artists as well as the creation of the same social and economic inequities that exist in Western culture, which — together with other Western influences such as alcohol and other drugs — contributes to the destabilising of traditional community values. The introduction of hierarchical artist evaluation has also incited some of the same jealousies and rivalries for which the Western art world is notorious. However, Aboriginal artists understandably also seek the same status, acceptance and appreciation as their white counterparts and there seems general agreement at this time that the future of Aboriginal art will concentrate more on individual artists.

While Gloria has a creative vision expanded by world travel and exposure to Western contemporary art and its practices, she has unwaveringly retained her deep roots and close ties to her own country, her traditional cultural Law and Awelye. Gloria and many senior traditional Aboriginal Law women today are aware of the primary importance of producing and recording their art works, their public words and their story texts in their own languages as ways of preserving their culture and of educating their children, grandchildren and others for future generations.

Lyn Plummer

SCULPTOR, MIXED MEDIA AND INSTALLATION ARTIST

*...the creativity and inspiration that brought to religion the reverence
and awe of the public have been reclaimed by art...art has declared
as its own the formations and signs of the overlord which once it
served. From my perspective, the narrative of the development of the
myths and beliefs of the religions of the world can be clearly viewed
through the imagery of visual art.*

LYN PLUMMER was born in Brisbane and in 1960–1961 studied at the Brisbane School of Art. After living in Papua New Guinea for several years, where she exhibited and taught, she furthered her studies at the Canberra School of Art, graduating in 1981 and gaining a Diploma of Arts (Visual). In 1982–1983 she received a Graduate Diploma in Fine Art (Sculpture) from the Victorian College of the Arts and was artist-in-residence at Cheltenham School of Art, England, in 1988. In 1990 she assisted in the establishment of a contemporary art gallery in Albury and in 1992–1994 completed a Master of Arts (Visual Arts) by research through Monash University. Plummer is currently a lecturer at the School of Creative Arts, Charles Sturt University, Albury, NSW, a position she has held for the last ten years.

Plummer's immensely detailed and finely constructed semi-narrative sculptural installations using seemingly fragile, membranous and ephemeral materials explore and deconstruct notions of culturally accepted dogma and representative imagery. She explores themes such as so-called 'high ceremony' and ritual, the imagery of women in art and cultural history, sexuality and the embodied self — layering the surface of her works like a 'skin' into which memory is embedded. The installation is designed to involve the viewer in the play, rite or ceremony and then to question their responses to accepted notions. Another significant aim in Plummer's installations is to change the nature of (the formerly religious) space that the works inhabit for a short time, giving it an energetic charge, and to leave 'afterimages' that stay in the memory of viewers/participants long after the installation has been dismantled.

During her years in Papua New Guinea, Plummer was awarded a number of prizes, including the 1974 Rabaul Art Prize. She has had many one-person exhibitions since 1974 and has also been included in a number of group exhibitions since that time. She is represented in the collections of the Papua New Guinea Government, Port Moresby, Wollongong City Art Gallery, NSW, Charles Sturt University, Albury, NSW as well as in private collections in Australia and New Zealand.

Could we discuss your formative experiences as an artist — the key people, significant places, pivotal situations and seminal works or writings that have been particularly influential and inspirational in your creative development?

I lived in Papua New Guinea for many years during my formative years as a visual artist. This geographical isolation, I believe, was the source of the individual imagery and forms in my work. Rather than seeking out certain artists whose work would act as a goal or inspiration, I found that the rawness of life in a 'Third World' country in the 1960s and 1970s — a country in which I had wanted to live since I was twelve — contributed fully to the many issues on which I had begun to reflect. These issues and experiences were also the catalyst for much of the work I produced then, and for many years later. Not that it was the landscape or the people that I wished to depict, it was more an abstract response to my personal reactions to the physical and social pressures at work within the turmoil of the society. This experience also moulded understandings of space and *plas*, which is a Tok Pigin term that can be identified on one level as expressing a strong sense of belonging that is not evident in the equivalent English word 'place'. For me, it is the sense of the understanding of, and an affinity with, the potency of a place, which I have noted is markedly different for artists who develop in an urban, Western-art conscious environment.

The drama of Papua New Guinea's landscape, people and art works has a strong influence on all its inhabitants. The art work of the people is incredibly varied and original in its forms. My work source for many years remained the wealth of experience I gained from my years in this country. This I combined with research into the wide variety of configurations possible in Papua New Guinean Art, where in-depth knowledge of mediums, experimentation and memory unite with spiritual beliefs. In studying the art of PNG and some of the main myths of the people, I also gained an understanding of how the sacred imagery spilled over into the profane sphere. The utilatarian objects were often decorated with imagery appropriated from the sacred and this then could invest such secular implements with special powers.

During these years in PNG, I studied the history of modern art and began to read works by, among others, Herman Hesse. I was inspired by the contemplative nature of the theoretical journeys that he created, especially *Narzis and Goldmund* and *Klein and Wagner*. I read *The Glass Bead Game* some years later when I had returned to PNG and was working in a sculptural medium using the tissue paper and the polyurethane that I still use today. Although I have not dwelt on the book obsessively, it has been some sort of amazing signpost that keeps surfacing in my memory and has given me a great insight, I believe, into the nature and theory of the postmodern condition.

How did these observations, experiences and interests specifically impact on your work?

I wished to create forms that would hold the same potency as those developed by these indigenous people. Forms which, by the non-referential nature of their configuration, would relate to the primal. During these formative years in PNG, I worked as a painter. It wasn't until about 1975 that I began to investigate sculpture. In 1979 I went back to art school, which began a long inquiry into sculptural forms and space.

The development of 'artless' forms has to do with a concern for aligning primal structures with primitive instincts in humans. The analogy extends to the concept that the shelter and the covering of the body was being developed in the period before sophisticated language communication.

What about other influences and experiences that have flowed into your creative life?

Generally speaking, I have always found much more inspiration for my own work in reading literature and poetry than in studying visual imagery. This is not to say I do not enjoy viewing the great works of art. Quite the contrary. However, when developing my ideas for an exhibi-

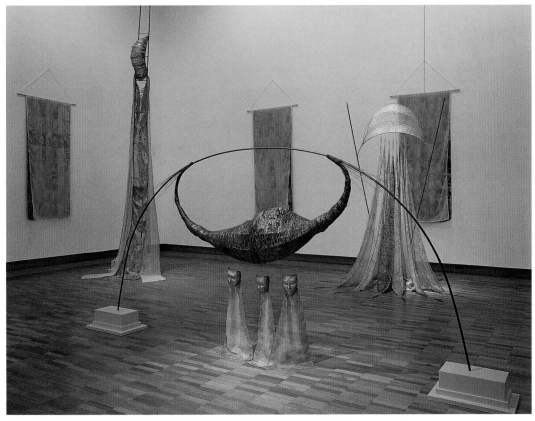

PLATE 119
ENDGAME: A SIMPLE MATTER OF BALANCE, 1990
Steel, cane, timber, tissue, fabric thread, Background:
Attendant Aurum, 5.2 m (h) x 1.2 m (w) x 1.1 m (d);
Right: *Bride of Shahmat*, 3.2 m (h) x 2.5 m (w) x 1.7 m (d);
Front: *Offering of the Thalamus*, 2.0 m (h) x 3.0 m (w) x
0.8 m (d), Photograph: Rodney Browne, Courtesy of the
artist

'In this large installation I explored the relationship
between our culturally developed rituals and the basic
instincts of the self as body/skin. I tried to set up a
dichotomy between the fragility and labour of creating the
gigantic shapes of the skin/flesh/cloak and the precarious
and threatening structures to which they had attached
themselves. The notion of ancient and meticulously
regulated games also dictated the placement of the
elements.'

PLATE 119

tion or, in recent years, an installation, my first tendency is to resort to literature rather than to
scan works of art. While in PNG I read and studied widely on its people and history. I have
always underpinned my work with this sort of background, even though I may not necessarily
refer to it, either directly or indirectly, in the visual work.

A particularly significant incident occurred during February 1976 and seemed, to me, to
elicit recollections of two other episodes that had occurred some years earlier in 1972 when I
was close to death from loss of blood as a result of the birth of my son. At that time I was put
under general anaesthetic for major surgery twice in one night. I had experienced the same
'sense of presence' on both of those occasions. As I was being anaesthetised, I felt and saw
myself swirling down a long, black tunnel. I was getting smaller and smaller, but as this was
happening, my consciousness seemed to be becoming bigger — more encompassing. It
seemed to be taking over the whole of the space around me. Finally, the visual image I had of
my 'self' seemed so far away that it disappeared and then the 'self' filled the whole void, which
suddenly became a vivid white light. I was fascinated by this experience then, but I was too
sick and subsequently too busy to investigate it further.

The experience in 1976 was the same, but much stronger — the sense of being the white
light was overpowering. A friend was with me at the time and we experienced the incident
together. Maybe the sensation lasted around one or two minutes. The experience left a feeling
of lightness, of insight, which seemed to be visible in some way. I felt that I had looked at the
face of God and that at the same time the white light reflected 'self'. This incident was the cat-
alyst for a number of new pursuits that lasted for many years. I began to write poetry seriously,
in an effort to describe the phenomena that we had experienced. Also, immediately after the
event, I embarked on an extensive study of Van Gogh and then the writings of Herman Hesse.
I began to comb the public libraries and those of my friends, looking for something that would
give me a clue to the nature of the apprehension I and my friend had endured simultaneously
on that day in 1976.

PLATES 120, 121, 124, 125

RE ENACT\DIS ENCHANT OPUS #1 AND #2, 1992–94
Installation view, Benalla Art Gallery, Photograph:
Rodney Browne, Courtesy of the artist.
RE enact\DIS enchant: Opus One in the Wangaratta
Exhibitions Gallery. *RE enact\DIS enchant: Opus Two* at
the Benalla Art Gallery.

'With this series of installations — which I worked on for
over two years — I concentrated more on the way that a
code of relationships and behaviour has been created
through organised religion and so too the important
cultural institutions of Western society. I took the raiment
as metaphor for skin. The highly decorated surfaces all
related to flesh/skin. I wanted to highlight the close and
ambivalent relationship between the power of the
religious face of the spiritual in Western culture and the
markings of sexuality and violence that are embedded in
the memory of the skin in relation to the collective
experience of this history.

The surfaces of the elements constantly shift between
image and decoration — which were created by the power
of the human intellect — and the all-embracing sensation
that it is also just flesh, scarred and incised, flesh
embedded with blurred tattoos — that it is flesh/skin
which provides the sensations of sexuality and violence
that are constantly referred to in the myths of Western
religions.

To further give some indication of the symbolic
elements and the layers of meaning in the works:

Humankind has always resorted to body decoration to
denote one's relationship to the power structures within
the culture. Ceremony describes and interprets this
decorative and abstract coding. In the rituals and
costumes of our public high ceremonies can be seen the
relationship with the body, flesh and skin. The skin was
the original precinct of display that indicated the position
held by the individual within the group or society. The
markings could signify initiations into either realms of
power, subservience or rebellion. Flesh as memory is
embedded with the markings and scars of the culture's
past behaviour patterns, lusts, ritual gratifications and
punishments. The skin is the parchment on which the
culture's collective memory has traced and incised a
collection of patterns and images. These relate a narrative
of personal inspirations and public sacrifices that is
inevitably coupled with the instinctive preoccupation
with human sexuality.

The costume has become a metaphor for the skin.
These signs communicate as abstract symbols that
provoke the individual memory and emotions. Woven
into the garments of our rituals are the convolutions of
basic instinctive behaviour which can be related to
sexuality and power. The installations trace the
relationship between costume and power structures, and
the self/the body and skin/flesh. They associate these
ideas with underlying and faint references to sacrifice
and sexuality in our revered ceremonies.

They also question the reference to ritual in
contemporary visual art and make comparison with the
frame of art. How art's production and placement has
influenced the way in which it is now interpreted and
re-invented as religious substitute. They trace a tenuous
thread from the source of our religious rituals to present
interpretations in art practice that set artefacts, forms and
garments in quasi-ceremonial context.

By taking this stance, I then have to discipline myself to
the immense task of totally engaging myself in the process
of making the forms with tiny, regulated strokes and
decorative forms. It feels, in fact, almost identical ➤ p. 231

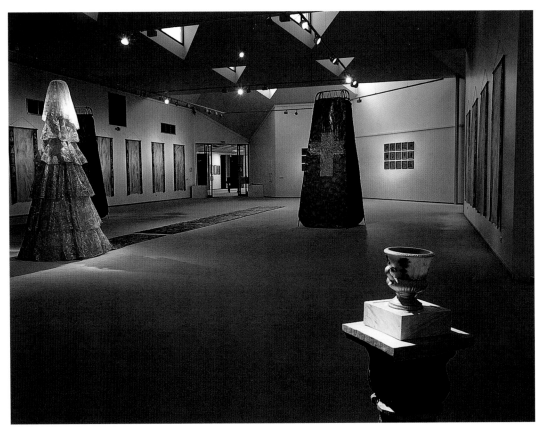

PLATE 120

Carl Jung's book *Man and His Symbols* seemed to me to be a possible first clue to finding
more about what I had experienced. A few months later, a friend produced a book called *Cosmic
Consciousness* by Richard Bucke. I immediately felt that this was the book that I had been
searching for and was quite excited at seeing it. Bucke discussed the lives and work of a long list
of people, writers, poets and philosophers whose work and insight had expanded Western cul-
ture and religions. Bucke speculated that this ability is part of the evolution of the human
mind. After reading about Bucke, I then read extensively on Plotinus, the founder of neopla-
tonism, and began studying mysticism and the early Christian philosophers.

***Can you talk about the consequences of these profound mystical and transformative
experiences on your life and work?***

One of the most disturbing consequences of this encounter was the fact that I seemed to have a
heightened awareness of the importance of time and how each hour intensified the unrelent-
ing vision of a forthcoming violent death. The images and the poetry seemed to emanate from
some other consciousness, one that was connected to my own, but which emerged from a much
deeper level, and one over which I had no control in terms of the initiation of the subject mat-
ter. One of the earliest paintings of this period, as well as the poetry, predicted exactly the way
the friend who had experienced with me that 'moment of enlightenment' was to be killed.

The effects of the experience strongly affected the production of all of my work for nine
years. During that period I spent much of my time studying and questioning the spiritual, mys-
ticism and writings on paranormal events. It is apparent to me that I have always possessed the
need to question and test any such phenomena that I have experienced. I think that this
predilection has led to the presentation of dichotomous positions evident in my work since the
production of that series of paintings during 1976 and 1977.

This incident in 1976 also initiated a new series of paintings. My concern shifted to one
which involved the creation of images that represented the individual, the self-denying

gender, and involved a search through the inner self to release a sensation of light which penetrates and emanates from the conception of the inner void.

How did your work progress after the end of this nine year period?

As the concepts progressed during the 1980s, they continued to present a seemingly total involvement in the rituals of a belief or system and to invite the viewer into that private realm of such an experience of faith. On the other hand, equally and if not more essential, they delivered a barb of inquiry that controverted such involvement and presented a case that challenged the stability and constancy of such a faith. The viewer was invited to imagine themselves into the space and then to question her/his instinctive responses to such beliefs by transferring the emphasis from the mind to the body/flesh.

I also experienced for some years — before I began producing sculpture — the feeling that the work that I produced was being created through me rather than by my own volition. I found at this time that on each occasion when I began a new painting, it was as though I had no experience of producing the body of work that I had already completed in the studio. I remember that I often felt that I seemed not even to know which way to hold the brush. This was also during the period I spoke about earlier — from 1975 to 1979 — when I began producing a considerable volume of poetry, a capacity that appeared suddenly. I had only ever produced one poem before — some time during my teenage years — and I cannot remember any of its contents. I did write quite a lot of poetry in those years, some of which was featured on ABC radio and on FM 2XXX in Canberra.

In 1991 I began reading a little book that I had purchased some years before. I had never got around to reading it because we set off overseas for six months and immediately on our return I began work on the commissioned installation for the Queensland Art Gallery's 'Gallery 14'. The book is called *Iconology and Perversion* by Allen S. Weiss. It was a revelation, as I found here someone discussing, in very complex terms, the concept of skin as memory, which had been one of the central spheres of my own investigations in my sculptural work.

One quote I have found not so much inspirational but so incredibly succinct and relevant to my own work is this one by Weiss:

> 'The body is memory, where the wounds inflicted in initiatory ceremonies and vindictive punishments become the scars that remain the trace of one's own suffering, a suffering that creates both self-consciousness and its ethical double, social-consciousness.
>
> 'The scar turns the body into an icon. The intensity of the knife's passage and the memory of the blood's flow are transformed into a symbol — the mark of passage into society and its regulated systems of value and exchange.'

The notion that the membranes of the work equate with skin and that skin infers memory and refers — through the marks — to scars of memory and past acts has remained a constant area of involvement for me since 1980. In the expansion of this concept, veils, shrouds, cloaks, cloths, banners, letters, parchments have been associated with skin in many different works. I wish to stress the concept that iconography and mark-making relates to the body. The body is reference point.

How do all these experiential effects and concepts merge in your actual ways of working, in your creative processes? Could you also discuss the philosophical or thematic foundations of the works and how you weave image, space and sound in your installations?

I tend to work on closely related concepts over many years. For instance, I have been concerned with the representation of membrane-like elements in my work as metaphor for skin and memory since 1980.

to the task of producing gowns for a ceremony, such as religious, liturgical or university academic gowns or wedding or debutante gowns — the designing of the gowns, creating the patterns and the surface designs for them, and then actually making the garment, which is built up of thousands and thousands of strokes/forms. One small stroke is placed next to the one before, whether it be embroidery, applique, sequins added to the fabric or the creation of the 'fabric' as in lace making. When developing the works for these installations, it was important that the small detail of the large sculptural pieces accentuated the notions of these small, repetitive processes. I did not actually want to use the processes themselves but to draw attention to them symbolically by simulating the so-called "marks".

The exhibitions have been formulated to evolve as they move from one ceremonial space to another. The public experienced *RE enact/DIS enchant: Opus One* in the Wangaratta Exhibitions Gallery, a ceremonial space that was initially conceived and constructed for the observance of religious rites and now has taken on the role of revering art. *RE enact/DIS enchant: Opus Two* was formulated for the Benalla Art Gallery, a modern space that was conceived and designed purely for the contemplation of art.

The works draw attention to the close relationship that art has always had with religion and religious ritual. They indicate how the creativity and inspiration that brought to religion the reverence and awe of the public have been reclaimed by art. The structure of the installations register how art has declared as its own the formations and signs of the overlord which once it served. From my perspective, the narrative of the development of the myths and beliefs of the religions of the world can be clearly viewed through the imagery of visual art.

Regarding the symbolic layering of the sculptures, the name "Novitiate Velate" (which privately I call "The Bride") suggests veiled novice or initiate. I chose this name and also chose to veil her fully so as to emphasise the fact that she is "controlled" and not in control of the procedures at which she is the centre. However, she is the centre of the procedure. Her presence, or the presence of the initiate, especially the sacrificial initiate, is the Other manifest. The knowledge of the existence in the past, or the actual presence of, the sacrificial initiate seemingly confers authority and power on those who control the ritualised ceremony.

The names are important extensions of the nature of the works. I do not choose them to describe the piece. There are always layers of referencing. (Note the "Endgame" and the "Enshrined Spoils" names, for instance).

It is interesting and very difficult to try to put into words the nature of the symbolic layers in the making process. (Probably it is more difficult just to begin, especially in relation to a singular work!) I wanted the dress and the veil to appear as lace on the one hand and yet as flesh/skin on the other — flesh that had recently been laid bare; skin that was flayed or torn with diminutive strokes. For each tier of the bride's gown, the processes recalled the dressmaking skills of drafting, cutting and hand sewing. As I went through the processes — of adhering the tissue paper and then, the next day when it was dry, bending over the table for hour upon hour, wrecking my back, my lungs and my thumb and finger muscles, applying the impasto medium with a cake decorating tube — they recalled for me the countless women who have toiled over garments for centuries. At the same time, I wanted to make the forms and their decoration very beautiful and sensuous so as to draw the viewer into contemplating at close range the surface that, at that close proximity, metamorphosed into flesh. I hoped that at that ➤ p.232

close range the identification with one's own skin would be invoked. I wanted too, to accentuate the connection between highly decorated, sumptuous surface treatments with sensuousness of flesh and the rending of the flesh.

The aspiration is to link the flesh to the sexual act — on the one hand linked to the act of procreation, to the inferred and actual violence and pain of childbirth, and on the other, to the more negative violence associated with the sexual act, that of rending the skin. Both imply that blood will flow and will smear the flesh. They are so closely associated in our psyche, to the tactile, unspoken understanding of our responses, especially for women, that our reactions, so aroused, are complex and confused. The process of producing very sensuous surfaces which, while referring to lace and embroidery, still associate with flesh and with blood and therefore with some form of violence, I hope presents the notion of "woman" (and 'man', by inference, as Other) as complex and ambiguous, rather than as readily definable. These processes are layered in this way to evoke the tactile responses of women, to set up an almost inexpressible understanding and communication between women that empowers them because this "knowing" can be felt through the senses, through the connections between sensuous touching, tearing of flesh, pain, and the feel, warmth and viscousness of blood on the flesh.

Somehow, in the presence of something that arouses this "knowing", women are empowered, even though the image of themselves is that of the sacrificial initiate. Somehow the presence of these elements represents man as the Other — one who looks on, as he invents more elaborate rituals, but the texture of the surface is controlled by women's understanding of the sexuality of sensuousness. She makes the elaborate and time-consuming ceremonial costumes for the offices he holds. So the "chasubles" represent not only the traditional and the new, but the repetitive nature of the decorative process.

The making of these simulacra, for me, represents the full, instinctive nature of woman, and when the works appear in installation, the responses of the women and men who view them becomes the performance, the communication through the work.'

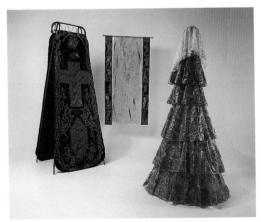

PLATE 121

One of my processes has been to challenge myself and the forms I produce in each new body of work with a new structural format and usually a new process or element. These are added to the vocabulary of forms and processes that I routinely use, and earlier forms or processes that may not have been so successful, or are no longer relevant, are discarded.

The works usually develop out of the concerns of earlier works. The challenges for the new forms and installations have usually been formed within a few months of beginning the current work. My installations usually take around twelve to eighteen months to gestate and around twelve months to deliver or physically produce. They are usually on a large scale, (i.e. 3–5 metres high — although I have made some very small works (i.e. 60–80 cm) — and they are extremely labour intensive. I like the reference that the layout draws to the small, repetitive tasks performed by women in their daily duties and in the domestic artefacts they produce.

The obsessive treatment of the surfaces implies the notion of remaking a known form for a new ceremony/ritual and, in the preparation of the new ceremonial players and their garments, each new rebuilding process analyses the way we assess the products of women's labour — especially in relation to the perpetuation of ceremonies. I have simulated surfaces that emphasise the fragile, the delicate and elegant decorative processes and the sensuous — qualities that have been traditionally aligned with the 'petite' arts. The incessant repetition of small tasks — meticulous and intricate layering — is not seen to have relevance or significance in the world of real production, of real art or real sculpture.

In the last six to seven years, as the concerns of the work have shifted tangent slightly — from skin as transient shelter or hide to the relationship between skin and costume — I have involved myself in a further sector of broad research that I seem to find essential for the creation of the installations and the forms. I like to layer my work with meanings and visual references that can draw the viewer into the smallest detail, even on very large sculptures. At the same time, I want to evoke personal responses to the structure and the surfaces of the membranes that I have created. The luscious and visceral nature of the surfaces — into which has been embedded recognisable imagery from past great paintings and decoration — is an important element of the current work and is designed to help establish the viewer's individual identification with the skin.

So the process of layering and building up the skin-like surface without getting it too bulky and heavy is one of the challenges I have set myself; it therefore requires strict discipline in the timetabling of the different processes required. Otherwise, all working surfaces would end up in a very sticky mess — not to mention the state of my lungs. So I try to plan the day so that the last hours of each day's work are spent with the double mask and the fumes of the polyurethane paint, and the paint can be 'going off' overnight or while I am not in the studio.

I have always associated and accompanied my exhibitions with music, and the series of installations *RE enact\DIS enchant OPUS #1* and *#2* (1994) were the first ones in which I collaborated with a musician, Mark Finsterer, to produce music especially composed and performed for the installations. The music is based on research into medieval ecclesiastical chants and beliefs, and, as well, Mark followed the research I was doing and observed the work developing. The sounds of the score were envisaged as a muted echo to be constructed so as to set the mood of the space. The complex and layered sounds fill the silence of the space with a procession of personal apprehensions. But it has been produced with the aid of, and manipulated on, the computer. Therefore, it relates to the visual work that has also been developed by means of electronic imaging processes, although it conjures up snippets of memories of images from the past.

Would you discuss the materials you use in your work and also the meanings and significance of pictorial, archetypal, symbolic and spiritual elements in your work?

I choose seemingly ephemeral materials for their apparent fragility, for their flexibility and ability to move with the air currents in the space and for their visual lightness. By their very

fragility, they demand more space than they occupy. Also, they will appear in a space for a short interval of time only, but when they have disappeared, the 'afterimages' linger in the memory of those present for a long time. I treat the materials so as to imply not only fragility and ephemerality, but also the concept of vulnerability, violation and deterioration.

I made the choice to continue to develop a medium that is noted as unconventional. As a result of that decision, I found that there were no past set procedures to follow and there still appears to be resistance to the collection of such 'seemingly' fragile work.

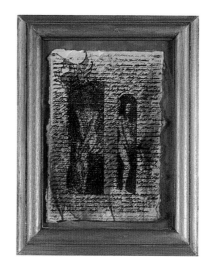

Could you elaborate on the theoretical framework of the portability of your sculptures?

All of my works can dismantle and roll up like a tent or a prayer mat and the component parts are light enough for me to carry. This concept comes from a few different sources. Firstly, the portability of the components in PNG was an important factor in the viability of building in such a mountainous and inaccessible country, and this idea combined with my need to be independent as a woman sculptor. I wanted to be able to construct and erect my sculptures entirely as I dictated, without compromise. There is an interesting 'culture' among male sculptors, especially those who were in control in the art schools of the 1970s: the macho attitude to materials and to the weight, invulnerability and size of the sculptures inferred that only certain initiates were accepted into the 'real' sculpture club. Therefore, the physical strength of the individual and also that of the combined group invariably dictated the nature of the completion and placement of a work.

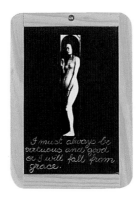

Some women who were students in the late 1970s chose to work in the heavy metal, stone and wood mediums; however, there was constant reference to the unsculptural nature of certain (no, most) materials. It was also presumed that if a person chose to work in a 'soft' material, it was because she was not strong enough to handle the large equipment or the sculptural elements. Also, work that did not have those attributes of large, powerful, massive, heavy was deemed not to be effective or authoritative sculpture. Subsequently, I have chosen to produce works that challenge the accepted and preferred language used to describe and value judge sculpture.

PLATE 122

Would you elucidate on the overall themes in your work and their artistic and philosophical underpinnings?

It seems that I have certain recurrent personal themes that underpin the larger themes of the work. The meanings have been layered in the surface of the works. The placement, structures, surfaces and images each have their own dimension and symbolic reference. I have always been interested in the repetitive stroke, action, form. In some earlier works, the repetition of similar, almost identical, yet individual forms was a very important aspect of the work. My private wish was that when these forms were placed in formal relationship to one another and to the walls etc of the space, the small, individual characteristics of these repeated, often primitive forms would attract close and sympathetic inspection from the viewer. There was the hope that the viewer would identify with these forms, that the small individuality in all of us — which is threatened to be swamped by the sheer numbers of similar personalities that surround us — would be pondered as the viewer moved in closer to inspect the differences in each form.

I feel that the control of the space, the medium, and the principles of aesthetics are important tools by which the artist controls her/his message and subsequently the instinctive reaction and the intellectual responses to her/his work. I wished to question the idea of art production existing in a realm in which it was related closely to the unknown and the unknowable — 'God's gift'. I also sought to analyse closely this idea that many people hold of the artist as a slightly lesser version of the original 'Creator', with similar, if not quite as potent, powers — an idea reflected in such statements as: 'An artist has the ability to transform a medium from its inert state into a form which has the power to communicate with and uplift the human spirit.' The

PLATE 123

PLATES 122, 123

Her Appropriate Sphere, 1991
Art I Studio Workshop, Albury

'This installation consisted of several components:

a. twelve "Stations" — plaque-like components that
 consisted of a framed work on paper on the top; a
 framed slate below; a printed statement pinned to the
 board at the bottom;

b. a pulpit-like lectern form consisting of a book on the
 lectern; a low, flat platform on which to stand to view
 the book; a red rug; a notice;

c. an ornate table and chair set with a folder of readings;
 two ornate candelabra with candles lit;

d. an oblong-shaped low pedestal set with two brass
 candelabra; a wooden bread board; a round loaf of
 bread; a large red capsicum; a large brown pear; a
 knife;

e. taped sound, instrumental and vocal.

In this "exhibition", I developed the notion of the icon,
parchment, illuminated manuscript, letter as skin and as a
signifier of the past experiences and condition of women.
I used slates to reiterate the notion of conditioned
learning — learning by rote as it were, a type of catechism.
Quotes positioned below the slates were by well-known
thinkers and writers such as Georges Bataille and Allen S.
Weiss and they questioned the notions of sensuality,
sexuality, beauty, eroticism and marriage. Above the slates
were placed small, icon-like framed pieces of skin-like
parchment covered with writing and also embedded with
faint and blurred, gum-release print images of the ideals
accepted as great and high — morally uplifting — art.
There were twelve of these "Stations" placed around a
central pulpit that presented a wedding album as a book of
law. The images in the album were also blurred and
presented images from advertising — presenting women
in all of her roles as the ideal mysterious sexual being —
and on each opposite page, images of the provincial
wedding. Each image was overlaid with overhead
transparency film with long quotations that discussed the
history of past treatment of women and theories analysing
the nature of marriage, beauty, rape etc.

Her Appropriate Sphere further explored the ceremony
and rites of society as they referred to desirability in
feminine behaviour, conduct, presentation and
representation. The concern for women's ritualistic
playing out of their perceived roles led to an interest in the
investigation of a more complexly layered concept. And
that is — that sexual instinct, tempered by its relationship
with sacrifice and therefore the threat of death, is cloaked
in rituals that provide it with a sense of legitimacy and a
reason for perpetuating its needs. It also led to my
involvement with the deconstruction of ceremony to
provide a tableau which analyses some of the myths
surrounding the exploits of the modern self.

This work was probably the most overtly theoretical
work that I have produced. It developed from the ideas
that I developed while researching and producing the
"Banners" for *Endgame* (1990). I noted how little the body
language and symbolism in the visual imagery — from
Renaissance paintings to modern magazines depicting
women — had changed throughout the centuries
regarding the "ideal of woman". I decided to explore this
further and try to make visual some of the truisms that
women learn from a very young age and which they
intuitively use to monitor their behaviour throughout
their lives. Against this, I presented a sample of the
history and analysis that has been produced to try to
explain and maybe counter this behaviour. These
writings were presented in small handwriting that ➤ p.236

romantic myths, indulgent ideas and criteria that the general public seem to hold of a 'genuine'
artist I found *very unrealistic*. It has always been my belief that any powerful artistic work emanates
from a sound knowledge and control of the concept, the mediums and the criteria of art.

I am particularly interested in the transformation of the space and the 'process of the mak-
ing'. My interest also lies in the nature of the surface as a means of communicating the intent of
the work to the viewer and eliciting a response that, in a sensory and intellectual way, chal-
lenges their acceptance of, and understanding of, their beliefs. These issues are, of course, cou-
pled with the usual concerns of the artist, which are for the nature of the forms, the colour, the
surface, the scale, the content and the unity of the work. Over the past sixteen years, I have
closely considered the response of the viewer to the process involved in making an art work —
especially when the labour of this process is a visible and also a considered component of the
work. I am interested in how the evidence of the process can lure the viewer into the ambience
of the art work and how they can thus believe that they can experience the toil of its creation
themselves. This somehow relates to the repetitive processes of which all productions of
humankind, large or small, sturdy or fragile, have been fabricated in the past. Also, the works I
have produced combine in installation to charge and change the nature of the space that they
may inhabit for a short period. This is a very important feature of the work.

Since 1979 the nature of the mediums I have used to create art works and the way they may
relate to the self, the body and flesh/skin has been a very important concern for me. For
instance, some artists' works relate solely to the mind, to the intellect and do not reference
these other sensory areas. Amongst Australian sculptors, there is work that hits dominant spiri-
tual cords, that has strong meditative qualities with a 'disembodied' spiritual aspect which I am
drawn to. In my own work, though, I try to involve the viewer in an experience that relates to
the instances and the conditioning of the self implicit as the body/flesh. The installation is
designed to involve the viewer in the play, rite or ceremony. And, at the same time, this experi-
ence is challenged by presenting an intellectual argument that questions that response by
highlighting some form of the cultural conditioning that constructs our reactions and beliefs.

Another aspect of this process is it solitariness — long hours alone — it's not easy to talk. It's
good to think about issues and resolve ideas while you work, but all the time you have to be
checking that you are not straying from the indicated shapes, that you have not missed any
larger forms which need decoration, that the spaces between the strokes remains regular.

In the earlier works and also in *Endgame* (1990), the repetition of fine, linear forms squeezed
in by the pressure of the space they occupy accentuated the vulnerability and resilience of the
form and produced rhythms and beats within the form. Tight, formal placement within the
space and in relationship to the walls and other pieces is a device I have created in order to
make intangible reference to the adherence to strict rituals.

*Could you talk about other important themes and concerns in your art, such as your interest
in religion and high ceremony, ritual, spirituality and the paranormal?*

While overseas in 1988 I began to relate the beliefs and taboos of so-called primitive cultures
and the underlying instincts embedded in the nature of contemporary behaviour, rituals and
high ceremony. The visits to traditional art museums and churches both large and small gave
me much greater insight into the wealth of rituals and their artefacts as well as a chance to com-
pare their origins with that of the Third World societies that I had experienced and studied.

It seems to me that there is a very close connection between art and spirituality and, even-
tually, structured religions. I remember that my earliest thoughts on the essential role of art in
expressing the spirituality of the community lay in its ability to give form to feeling and shape
to ideals. I was convinced then that art and spirituality were inexorably linked.

My interest in the apparent need of humankind for spirituality has led me on an eclectic path
of study that has covered both the history and accounts of paranormal events and experiences

PLATE 124

was overwritten on the parchments and also typed onto the transparencies that were layered over the images in the album. Therefore, this information took much more concentrated effort to take in and to comprehend.

The installation was created to work on more than one level, as are all of my installations. This one used text presented in a manner which, while accessible, demanded much more time to apprehend than the visual component and was therefore more "obscure" than the other, but which is essential to the full understanding of the work.

The ambience created in the space was that it had been recreated as a religious space, and by taking time to comprehend the meaning, the viewer would feel that they had involved themselves in some kind of religious ritual.'

PLATE 124
RE enact\DIS enchant OPUS #1 and #2, 1992–94
Detail from side panels of *The Banners*, from the installation *RE enact \ DIS enchant*, 1992–94.
Photograph: Rodney Browne, Courtesy of the artist.
Image is from a laser photocopy of *Hercules and Deianira*, 1517, by Marbuse (Jan Gossaert) (c.1478–1532), reworked with tissue paper, polyurethane, oil paint glazes, gold and thread.

and also that of religion. I have found that my directions in research and my work has centred around opposites — on the one hand, producing work that evokes a strong spiritual response, and on the other, challenging that response and questioning the cultural conditioning in which it is cloaked.

The Tok Pigin term *plas*, referred to earlier, is a sacred concept to me and has been an important dimension of my life and work. This sense of 'plas' connotes the concept of being part of the 'inner space', the 'radiant space', isolated and surrounded by a vast silent, shadowed space. This radiant space can be revealed and simulated through the core of certain types of music. It can also sometimes be glimpsed through poetry. In the same way that certain locations can present a strong sense of place for many people, for me they promote the private recognition and the sense of retreating into the secluded inner space where an affinity with centredness and radiance is induced.

I have found myself recognising and being enveloped by it in the soaring spaces of some of the great Norman and Gothic cathedrals. I am also sometimes aware of it in the naves or the cloisters of modest churches and monastic buildings. Some geographical places emit a powerful sense of place and often you see that the Christians have erected a church on such a place. Sometimes I have found myself entering into that 'other space' when alone in the rainforest or on the shore, with the sound of the ocean lapping. This sense of place has the capacity to promote a heightened awareness of that inner space which is surrounded by a measureless space.

Experiencing the white light of this space is for me experiencing the sacred. By sinking into this limitless, radiant space and feeling that you are present in the light or pulse, the cacophony of thought is silenced. It reduces, too, the temporal trials that often threaten to ravage our sense of ourselves until they become issues of significance.

At various times over the years, I have attempted, in my work, to represent the notion of the spiritual that seems to suggest a state of understanding and consciousness that is beyond personalities and gender. I find that the representation of a spiritual entity as either male or female reduces its limits and also our perception of its force. By squeezing it into the confines of gender behaviour and narrative sequence, it is reduced forever to the temporal and becomes dogma, repeated endlessly without the assurance of any future recompense or current 'state of grace'.

Art has also claimed many spaces that were originally erected as places of ceremony. We are invited to view art in places that hold historic significance for society, such as town halls, palaces, grand residences and churches. These buildings lend their aura of grandeur and pomp to the works, and the public who enter the space absorb the ambience and assume a demeanour of contemplation and reverence.

How has being a woman specifically influenced your work?

Being a woman has provided me with the experience of childbirth and the resultant near-death experience from massive loss of blood that I talked about earlier. This provided me with the means to reflect on the notion and the reality of the close relationship between sexuality and the penetration and ripping of the skin and flesh, with the associated violation and blood.

The skills and knowledge that were passed on to me as a young girl in the domestic sphere, such as in sewing, for instance, have become for me important tools for referential comparisons. These skills and experiences, I feel, have provided me with the capacity to observe and compare from an objective distance.

I am also interested in the rhythm of lashing and binding and weaving and in the decorative webbing of threads. I am still fascinated by the power of that rhythm in binding that was produced before it became decorative; the incorporation of the binding and the weaving that nearly always involves a rigid warp — such as cane, kunai grass strands or wire — and a fine weft — such as fine threads, usually of gold or silver — as on the small work *Angelico's Vision* from

PLATE 125

PLATE 125
RE ENACT\DIS ENCHANT OPUS #1 AND **#2**, 1992–94
Detail from *The Runner*, from the Installation *RE enact \ DIS enchant*, 1992–94.
Photograph: Rodney Browne, Courtesy of the artist.
Images are details of laser photocopies from old bridal magazines and works by Giovanni Battista Tiepolo (1696–1771) and Raphael (Raffaello Sanzio) (1483–1520). The laser photocopied images are re-worked with tissue paper, polyurethane, oil paint glazes and gold and thread.

Divine Extravagances (1988) and on the large works of *Moon of Mithras* from *Enshrined Spoils* (1986). Even on the very large sculptures, I will often spend hours binding large forms with the finest of yarns — those usually used to weave tee-shirts — or weaving finely detailed segments using kunai grass and thin gold thread. Both of these latter processes I used on *The Offering of the Thalamus* from *Endgame* (1990).

As I have already indicated, I have always felt that the act of producing these large sculptures with such small, repetitive motions re-enacts the story of women's work and their traditional 'petite' art forms. By this I mean the continual and pressing need for cleaning, sweeping and washing, hanging out the washing and then ironing. All of these activities demand repetition of action as well as the need to repeat the process over and over, almost on a daily basis, to the same benches, floors, clothes, etc. The petite art forms of embroidery, petite point, crocheting, knitting, lacemaking and quilting require the same attention to the small, repeated action, an action that also demands creativity, perseverance, constant attention, skill and dexterity of limbs. Such time-consuming tasks visibly relate to the methods traditionally employed when building up a skin of covering. The methods of producing large sculptures with the combination of such small elements develops a rhythm of absorption for me that allows quieter states of mind to prevail.

As an artist and educator, what do you perceive is the function and purpose of your art?

I create my work to challenge my own and the community's preconceptions and perceptions of acceptable behaviour patterns and social rituals and ceremonies within society. I hope to create debate about the nature of the ceremonies we, as a community, take for granted. I hope the work provokes disquiet by questioning the roles that we, the society, has condoned or has undertaken in relation to such ceremonies.

Through the work and its layered surfaces, I have aimed to present a case that exposes the role of the skin/body and of the sense of touch in our knowledge of the self and our comprehension of our spiritual beliefs. I have attempted to create works that articulate with fragile, sensuous, translucent and luminous skins, often with spare, tenuous structures, which are analogous to the human form.

Since 1981 the work that has been developed for my installations has dealt with various aspects of that introspective search. It has also been strongly associated with aspects of the feminine. I also wish the layering of such small elements within the large sculptures to draw the viewer in closer and closer to the nature of the surface of the work and reveal a recognition between the skin/flesh of the work and their consciousness of their own skin/flesh and what could be imbedded in it.

The connection that art production has traditionally had with the notion of the spiritual and with religion, together with the substance of cultural rituals, has resulted in many years of investigation for me. This has led to the creation of work that echoes art's connections with religious rituals, accoutrements and experiences; and while it purports to reiterate the power of those experiences and ritual, at the same time it challenges those connections and reactions and emphasises the notion of the experience as sensory — slitting open the narrative of memory to reveal instinctive response and its responses as flesh/body.

By 1991 I had been focused for seventeen years on this supposition, which had been initiated by that experience in 1976. From that awareness, I had continued to explore and challenge the relationship between the sensations of skin/body to the spiritual self and the manner in which these sensations had tempered the intellectual/cultural understanding of self.

Eight solo exhibitions dealt with aspects of these questions. These have involved revealing and questioning the relationship between the composition of the self as both mind and flesh. It has also led to exposing the dichotomous relationship that exists between the mind and the flesh, especially in our culturally moulded Western religions.

As an artist-educator, I have spent the last ten years exerting a great amount of my energy toward cultural and educational goals for the community. I have been left realising how brittle such aims are when you are working at the grassroots level. The system's worshippers of economic rationalism — who have long since grabbed the reins of power, authority and control — impugn society's aspirations to conceptual goals and belittle those who contribute to expressing the community's cultural needs at the fundamental level. Creative production and criticism of the condition of society by artist-educators is being subsumed by the incessant demands of a hierarchical system that is lurching clumsily toward its elementary comprehension of a corporate model. This predicament necessitates repeatedly filling in time-consuming reports that are designed to substantiate performance indicators and to survey *worth*! These ignore, or seem to be unable to evaluate adequately, the contribution of creative production towards the community's health and strength of vision.

I have noted that I have this tendency to present dichotomous positions in my work and I can see that this is a predilection of my character too. With the annihilation last year of the community goals to which I and others collectively aspired — and which demanded that the pragmatic, organised side of my character should prevail — has come the need to turn inward again. Having experienced that inner space before, you understand that by moving closer to it, you can rise above the paltriness of the system's profane power mongers. I have still tried to allude to or recreate in my installations, this sense of space, in order to draw people into their own inner space and then to challenge the legitimacy, or the origins of this space.

When a number of questions like those presented here are asked, the resultant digging in order to be able to respond uncovers many connecting threads that bond the different solutions and forms into a pattern that presents common motifs. These questions have caused me to stop and reflect on the past twenty years of my life.

Mona Ryder

SCULPTOR, PAINTER, MIXED MEDIA
AND INSTALLATION ARTIST

If I wanted everything to run smoothly, I would choose materials I know well… This is not enough for me. Enjoyment comes from making the seemingly impossible possible.

MONA RYDER was born in Brisbane and in 1976 began studies at the Kelvin Grove campus of the Brisbane College of Advanced Education, gaining an Associate Diploma of Visual Arts (Printmaking) in 1980. In 1989 she was artist-in-residence at Claremont School of Art, Western Australia and in 1991 she attained a Bachelor of Arts (Visual Arts) from Kelvin Grove College, Queensland University of Technology and is currently studying for a Masters degree in Visual Arts at Griffith University, Queensland.

Ryder has explored various media in the course of her art career, such as drawing, painting, sculpture, embroidery, weaving, book illustration and printmaking — all of which she brings, together with a variety of transformed domestic bric-a-brac, to her sculptural installations. All of her works are constructed as evaluations and responses to her immediate physical, domestic and cultural environment. Her assemblages often have a satirical eye directed towards the often 'primitive' behaviour that underscores many family situations, female–male relationships and tensions between cognitions of entrapment and freedom.

Ryder has won several awards, including a Visual Arts Board Studio Grant, enabling her to go to Vence in southern France in 1986. She has had several one-person exhibitions from 1984 to 1995 and has also participated in many selected group exhibitions since 1976. In 1995 Ryder had a major installation exhibition at Queensland Art Gallery titled 'Mother Other Lover'. She is represented in the collections of the National Gallery of Australia, the Parliament House Collection, Canberra, the Queensland Art Gallery, Mackay Regional Art Gallery and the British Library as well as in other public and private collections throughout Australia.

'The body of work presented here is a gathering together and expansion of recurrent themes. For example, it relates strongly to the fountain water sculptures (*Passing On*, Michael Milburn's Gallery, 1987). It relates to previous work in the use of individual sculptures and small installations to create an atmosphere or sense of theatre (*Broken Records*, Michael Milburn's Gallery, 1985). It refers also to my 1983 works, including the ironing board series at the University Art Museum and the *Theatre of Circus Follies*, as well as the iconic mimicry of *Return to Paradise* at the Gold Coast City Art Gallery, 1992.'

PLATES 126, 127, 128
IRONING BOARD series, 1983–1994
Plate 126: lead book, 1.5 m (h) x 0.55 m (w) x 0.8 m (d);
Plate 127: carving, baby head, 2.36 m (h) x 0.55 (w) x 0.48 (d); Plate 128: cot, 2.14 m (h) x 0.62 m (w) x 1.46 m (d)

'The *Ironing Board* series was a reaction to the mechanical problems experienced with my previous project *Circus Follies* — which was a four year, intensive activity. *Circus Follies* resembled a large mechanical music box or small theatre. There were fourteen mechanical figures with accompanying music and curtains that opened and closed, and the entire structure was covered with painting and embroideries. Not having a mechanical background, I lacked the precision the project demanded and major operating problems were encountered.

My wooden ironing board at that time was from the Salvation Army disposals, and needed covering. Traditionally, this involved old sheeting or tablecloths. While stripping the layering of sheeting, I realised the common link with previous generations conveyed by this domestic ritual.

The wooden ironing board, for me, is a beautiful object in itself, and the nail holes from the layering of the coverings give it texture and meaning. Most of the ironing board works used found objects and domestic items, which took on a layering of meaning, as did the layering and covering of the ironing boards themselves. In the end, I found the ironing board to be a very powerful metaphor to represent women's lives, domestic concerns and conflict.

The *Non-Mechanical Woman* was the first of the ironing board series, completed for the 1983 exhibition at the Queensland University Art History Department. There were only seven in the series, and they generated extreme public comment and reaction. I had always intended doing another series, which I eventually tackled in 1994. In the new series of ironing boards I have created, the boards are trolley like and interact with each other, relating as if in the family context. The latest series is called *All My Dreams Come True* and has not yet been exhibited. It explores disillusionment, dashed hopes and the complexities of the family at midlife. I have predominantly used metal ironing boards to examine these issues and the historical context of my own work.'

Could you outline the formative influences, pivotal experiences, inspirations and philosophies in your journey as an artist?

Picasso said, 'I paint the way someone bites his fingernails, for me painting is a bad habit because I don't know nor can I do anything else', and this reflects the way I feel. I like the freedom of thought art allows; it has always disturbed me when art practices have become closed-minded. I dislike categories and I am pleased many artists in the past few years have been brave enough to cross and merge art forms. As for me, I love to criss-cross and learn — to flip art over and look at its underbelly.

As something of an anarchist, I am prepared to look at everything and have at times disliked works intensely only to find subsequently that these are the most rewarding. I feel an affinity towards several art forms and artists: Frida Kahlo, Georgia O'Keefe, Rebecca Horn, Meret Oppenheim, Otto Dix, Jackson Pollock, Anselm Kiefer.

I would say I was influenced by my family; people; my environment; my mechanical toy monkey rolling over and over; the green lights shining on my telephone poles, edged by the dark pine behind them; my dreams and subconscious. I could also say I was influenced by growing up in a small town, having a sick father, a mother who painted, my awe and love of the environment and it's non-human inhabitants and being an observer of human behaviour.

How do you bring these influences into your creative cycle — your actual ways of working? Discuss how you begin to work, the structural and physical details of your working environment as well as emotional and thematic processes within the cycle…

Often I start with a concrete idea and as I am working, this becomes transformed into something more, which is an element of surprise for me. I enjoy this play — my emotions and thoughts, outside reality, mingle and weave until the process goes beyond me. There is always a sense of discovery — a learning process.

Most of my ideas are documented in a diary. Structural details are worked out here and the diary also holds information about technical products, occasionally my shopping list and other relevant trivia. My working drawings are starting points for sculptures or paintings. It is the emotion I am true to, not the materials.

On the practical side, nothing would be gained if everything went smoothly. If I wanted everything to run smoothly, I would choose materials I know well and by now, no doubt, would be in the National Gallery. This is not enough for me. Enjoyment comes from making the seemingly impossible, possible.

My studio is a double car garage with a space around the back and a garden shed for storage. I live in a house full of unwanted art work, with sculptures floating in the pool, and I am still producing large sculptures and paintings. When things permit, I like to work every day. However, over recent times this has not been possible, due to family pressures and demands. My recent sculptures relate to my sons and my emotional responses to the family situation. I have also been working on a series of ironing boards again; these are trolley-like and interact with each other, relating as if in the family context.

When I am working, I like silence — I don't like the intrusion of the outside world. Time evaporates in this situation. Part of me is a very social being and I expect the world to be waiting for me when I am ready, on my terms. In reality this does not work, so the balance between the two worlds is delicate.

Words often allow an inlet to understanding art, but art expresses feelings and emotions that are fundamentally too complex to verbalise. To explain fully is to say the work need not exist. However, in my art, vertical forms reach for meaning, space and freedom — often in a spiritual sense — and long, trailing forms interconnect like veins.

There is a constant dialogue between my current and former works. The body of my work is about woman, man and child and the relationship of each to each — the pleasure and pain of

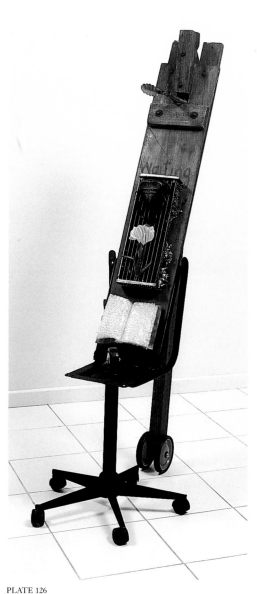

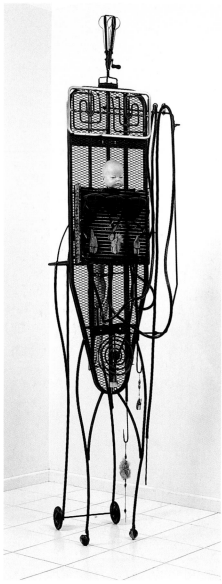

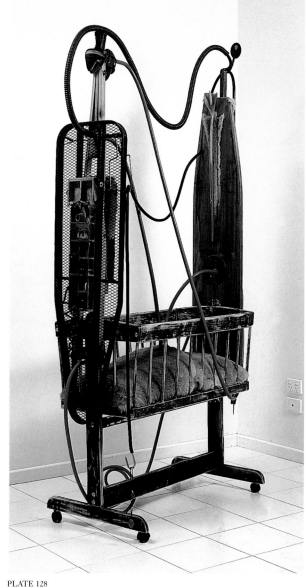

PLATE 126 PLATE 127 PLATE 128

life in the family. It draws on the subconscious to allow the unsayable — and even the unthinkable — to be represented through metaphor and symbol, utilising the concrete paraphernalia of domestic life — objects foraged from the natural world and nostalgic or evocative manufactured articles which, in combination or opposition, create emotional responses to the events of everyday life.

In theory and work practices, I guess you could say I am a maximalist. My themes are minimalist, as I regurgitate my world, its emotions and surrounds (real and imagined) and the myths it creates. The individual pieces are counter-related. While each speaks for itself, they are linked by the continuity and communal memory of family life in its most private and deep structure. Reflected in the work is the concern with the struggle to survive as a family, to nurture and support each element within the group, and the jockeying for space for individual development and identity. Conflict, guilt, pain, sexuality and love are played out across the range of work — emotions that must be repressed for the sake of others. Often the subconscious is linked with the conscious in a symbolism that retains the safety of privacy through metaphorical, or even allegorical, placing and patterning of objects to represent interacting emotion and conflict while, at the same time, a public manifestation of the fragmented and contradictory layers of existence is provided.

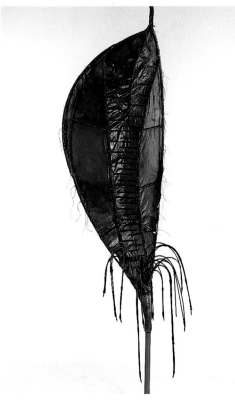

PLATE 129

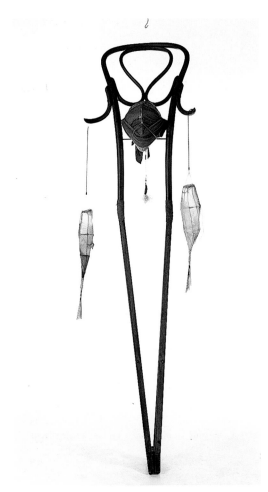

PLATE 130

Whimsy and humour are not absent; life is not all pain and guilt. While life, like broken crockery, can be shattered by events, it can be reconstructed into some sort of order: a load of dirty dinner plates can be washed and piled into a pleasing tower. Cords which tie people together, sometimes unwillingly, can flex and extend outwards, rearranging the shape of the family and domesticity. Family life is not a soft option, an escape from the world. If it can be made solid enough, it can be a base from which the young can try their feathers. Hands can restrain, reach out to support the unsteady or wave good-bye.

Talk about the specific iconography of domesticity that comes into your work.

For woman, the iconography of domesticity — the ironing boards, irons, pots and eating implements — is a two-edged sword. These domestic items are the symbols of oppression and constrained individuality. They conspire against sexuality and self identity. But they also provide the link with children. A mother can only cook for her children and wash and iron their clothes when she is excluded from their identity formation. And her responses to them must be muted by what they will accept from her. So in art, the leap from the private to the public must be mediated, layers of meaning constructed and interwoven, to reveal an essence that courses through many veins and arteries — sometimes tortuously intertwined, sometimes branching separately towards freedom and sometimes seeking to reconnect and flow together.

In what other ways has being a woman influenced your work and career as an artist?

This is the most crucial question for me. In my early career it was difficult being a female artist, as women were not conditioned to promote themselves as serious artists. As a young artist I found it was much easier for males to exhibit, women had to work harder to prove themselves. I remember once walking through an exhibition where one of my works was hanging. It was an emotional work dealing with female roles and sexuality. I was holding the hand of my young son and a voice boomed into my presence: '…and she's pregnant as well!' My work at this time was taking on feminist issues, although at the time I was only aware of my own and friends' experiences and was not familiar with feminist writings. The reviews of my exhibitions always mentioned that I was a mother. It astounded me no male ever had his kids tagging along in the reviews. To make matters worse, these reviews were often written by females.

My work was once refused in an exhibition because of the subject matter, which at the time felt devastating. It also made me hesitant to exhibit work for a while, as I was expecting to be ostracised.

Living in the isolated cultural dearth that was Queensland was problematic, although it forced artists to react to the system and to be more culturally aware. Until relatively recently artists were considered to be on the fringe of society. At least now degrees and universities have legitimised the art world and artists and elevated both to professional status.

Practically, it was difficult juggling my roles as mother and artist. I was forced to form my own opinions and to focus my work habits and resources as well as gaining insight into childhood again. I was also considered an oddity — having children and pursuing an art career at the same time. Applying for overseas grants and being able to allow yourself the freedom to go at will, taking advantages as a woman, was difficult and I still find this so. To acquire further education such as when I did the associate diploma required massive organisation.

Although I am a feminist, I have never been a member of any movement and abhor the way some women in the 1990s play out the power game they resented for so long.

Could you further discuss the themes that characterise your work and other meanings in the material forms and symbolic, archetypal and pictorial details in your images and installations?

I use symbols in the form of ironing boards, hoses, antherium flower bushes, hooks, sinkers and fur — but with subtle variations. For example, the antherium flower can be male or female,

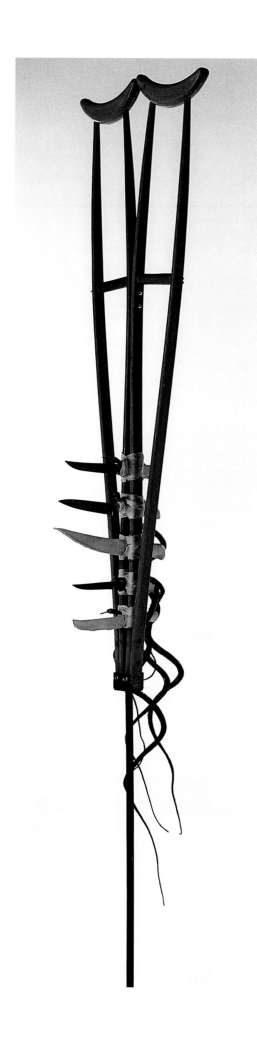
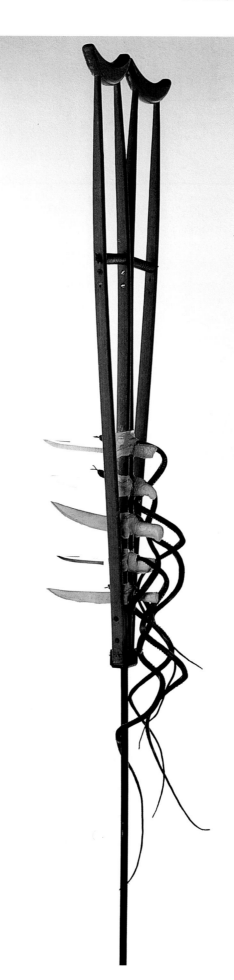

PLATES 129, 130, 131

MOTHER OTHER LOVER, 1995
Installation in the Watermall at the Queensland Art
Gallery, Courtesy of the artist

'This work is a journey into all three aspects of my life
— mother, other, lover — often for me a form of diary.
Reference to previous works runs throughout the
exhibition as a form of resolution and sometimes of
questioning.

The entrance works in this installation are for me the
guardians — the guardians have existed throughout all
my installations and exhibitions. They make reference to
Circus Follies, and the turned pillars, in this instance, refer
to the pillars of society. They are like large fishing trophies
— the hollow, insincere smile and the recorded: "Have a
nice day". They reflect the playing out of roles, often in
childlike fashion, and the pressures that exist because of
the role play. The smile becomes for some "grin and bear
it" — the muffling of real or true feelings. These pieces
and others in this exhibition raise gender issues such as
being physically strong, the body beautiful (both in the
male and female), the crutch of beauty and the
stereotyping of emotional and physical states.

Water has been an important element in my work.
I come from the North Coast of Queensland, and I am
never quite sure whether this is a major factor, though I
am now living at the Gold Coast, not far from the beach,
and in my bedroom at night I can hear the waves — so
water is ever present in my environment. Certainly my
work has always been influenced by both my physical and
emotional environment. Water, for me, is a soother, a life-
giving and cleansing element that is at the same time
capable of taking away life. It also represents our tears and
the flow of life. I wanted to use all the elements in this
installation; however, it was impossible to use fire — I did
try to get around this by enquiring about using theatrical
methods and simulated fire, but the costs were too
restrictive.

In the large *Virgina Dentata* (which were first made on a
small scale using hair combs), I was looking at the way
females are viewed as sex objects, having to adhere to
certain role plays perpetuated by the popular media.
Females are allowed to look sexy, but they must —
according to media standards — observe certain behaviours
— for example, no overt sexuality. Women are considered
to have lesser sex drives than males — but do we really?

The crutches in the work take on a number of meanings
— something that can hold us up, or the need for
something to help us through difficult situations. The
chair is like a lifesaver, the hot seat, ageing, or a place to
rest our weary bodies — all of which are fragile states. In
fact, when humans feel their fragility, often, metaphorically
speaking, they either need a crutch or need to be a crutch
for another.

The swing talks about maybe an abused or unhappy
childhood, or the childhood becoming a crutch, an excuse
for behaviour in adulthood. In religion, the child must be
blessed before it is cleansed. In Freudian psychology, all
psychological fantasies begin in childhood and in Jungian
psychology, the shadow has to be individualised.

Mother Other Lover also includes a number of steel
ironing boards and other totemic sculptures — three to six
metre high neon fountains — creating a sense of play, as
well as auditory sensations. The modern artefacts are a
progression of my ironing board series — single shapes,
figurative and raw.

I suspect that over my career to date, the public has had
difficulty coping with the multi-faceted nature of my
work and its confrontational aspects.'

PLATE 132
SELF PORTRAIT, 1994
Acrylic on canvas, 200 x 180 cm,
Photograph: Studio Sept, Courtesy of the artist

'Effective portraits reflect not the outer manifestations but the hidden self. The painting reproduced here is one of four self portraits, often with reference to the history of portraiture as well as my current and earlier work. The portraits are an unfinished series because painting, for me, is a difficult task. The purpose of the exercise was eventually to obliterate the figurative to reveal the emotional undercarriage.'

aggressive or not, depending on its context. These symbols weave fantasy, myth and reality to form their own worlds and are a vehicle for expressing particular emotions.

My work is hard to categorise and I dislike being boxed and packaged. This is a definite disadvantage, as I do not follow movements and my themes are often forthright and shocking to some. Androgynous themes run through my work. I see this as the soul or inner self laid bare and the struggle of the anima and animus in all of us. Some of the figurative studies are androgynous — using the flower form. This quality of my work relates rather to a state of mind than to purely sexual references. The flower form conventionally pertains to femininity and at times does take on this persona, but it is, after all, androgynous. An example of the hermaphroditic quality is the fur-covered flower with the cage.

The work is also a refraction and layering of everyday life, and the elements water, earth, air and fire form an integral part. My floating sculptural forms, for example, utilise below-water and above-water surfaces, creating textures. Water — which is assumed to be a uni-dimensional, slippery medium — becomes textured through the use of trailing, moving fronds. Some of these sculptures operate as fountains.

The forms reflect both physical and psychological aspects of space in a mix of provocative, bitter-sweet worlds. These apparent contradictions are not only evident in the themes of my work, but also in the way in which I produce it and in the materials I use. For example, the plastic hose is coupled with natural materials such as fur, wood and stones; the cement is embellished with natural beach pebbles and spades. Contemporary society perpetuates these confrontations through the indispensable car and television, or the houses we choose to live in, even the food we consume. The floating sculptures, as an example, may appear to be set free, mimicking and taunting their counterparts, like spirits moving slowly across the surface — markers in the landscape — icons and sexual gargoyles; however, these too are restrained — anchored to the pond's floor — signifying both the temptations, and the illusion, of freedom that our society offers today. A dog on a boogie board creates a surreal diversion.

On a broader level, the artefacts display society's violence towards nature and the human spirit and thereby demand attention. They are spiritual, ritualistic and sexual, and can be seen as sentinels, rigid on the wall. On the other hand, these artefacts become flimsy, whimsical constructions. 'Stone Man', the spade figure, characterises such historic male icons as the all-Australian lifesaver or Ned Kelly — a warrior — but, conversely, alongside this is the softer interpretation — simply that of a figure ready to garden.

The humour in the work has a sense of theatre, 'making strange' a confrontation with feelings that on one hand may be serious statements, but are more easily understood through laughter, irony or satire. Examples of this are the broom heads with electric cords and towel embroidered with 'Mother'; peg dolly and scissors; and the crutches with electric cords and plugs, iron, and flower hands holding scissors. These may be seen as a feminist satire on the necessities of our modern culture — the artefacts of our ever-changing technological world. There is a strong sense of irony in many of these works, such as the Stone Man — the withered strong man with spade head — and the spade-winged, tattooed woman with flower head and hands taking flight on her dog.

The tattooed skins reflect upon society's psychological markings on the subject and on the environment and upon the individual's need to achieve self identity in a world where global shrinkage is creating cultural integration and the knowledge possessed by 'primitive' societies is being given more credence. In Japan the tattooed body is revered and human skins are preserved for museums as national treasures. This led to my thinking of the body becoming an art form and the further depicting of collaborative memories. The skins, in turn, become artefacts, religious icons to the past and records of the present.

The sculpture, because of the diversity and possibilities, has universal relevance and is a maximalist conceptualisation.

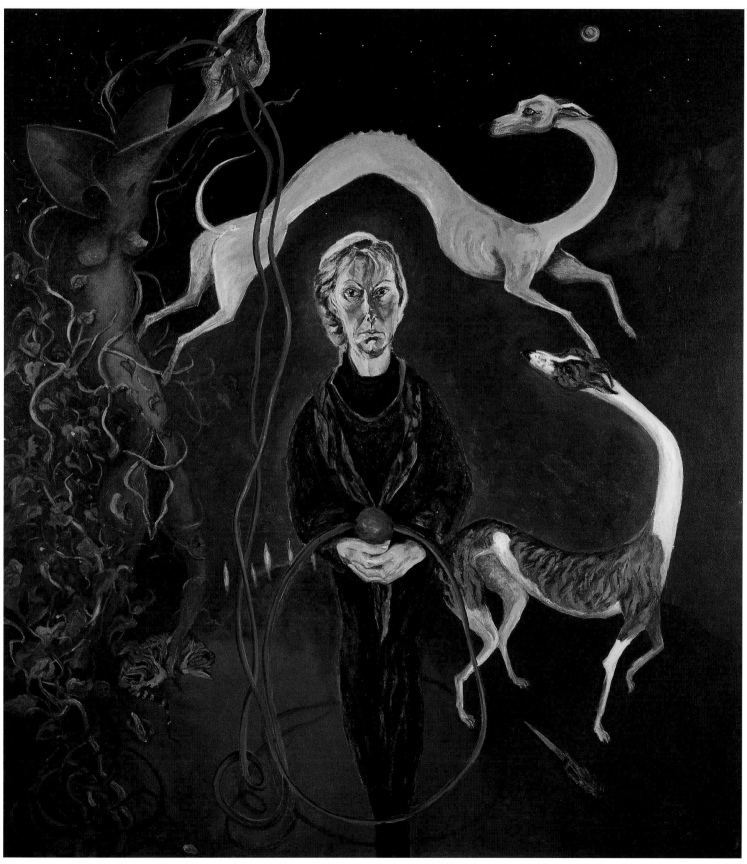

PLATE 132

PLATE 133
UNTITLED, 1994
Acrylic on canvas, 190 x 218 cm,
Photograph: Studio Sept, Courtesy of the artist

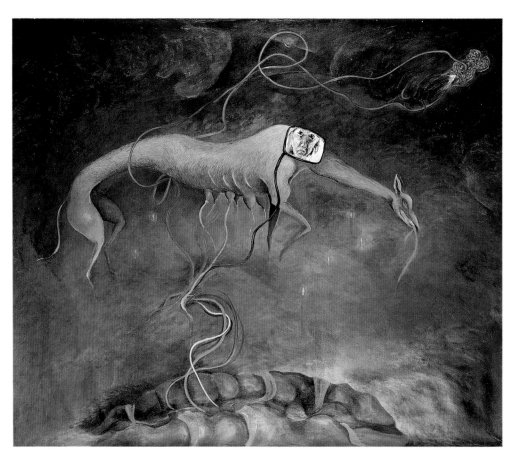

PLATE 133

How do you see your role as an artist and the purpose and function of your art work?

Survival is probably the 'function' of my art. I am not pushing a barrow, a political message or a crusade. I do care about our environment and the way we interact with it and with each other — our basic instincts. I see my work as often hitting a chord with the archetypes within us. I think the purpose here, if I have to have one, is for the viewer to take over from where I left off — to think a little, if they care to, as I certainly do after I have completed a work.

My work is not making definitive statements but instead is questioning my own and society's complex structures. This ambiguous questioning is defined in my sculptures by the use of often diverse materials. The materials used are society's discards — from our culture's ever-increasing throw-away society. The works are multifarious in both themes and materials and the materials are often sophisticated ones such as plastic, fibreglass and steel in combination with natural materials such as fur, drum hide, hair. Society today eludes to sophistication and comfort; however, I question these twentieth century ideals, especially in the face of things like nuclear testing, to give an example. In fact, in many of my works, I am dealing with myths in society.

This is not a statement so much as a process of communication to provide discussion. It is against the nature of the work to impose a final meaning upon it. My underlying aim is for the viewer to find a personal meaning from layers of possible meaning and, in so doing, to produce in the work a 'life of its own'. My recent work particularly takes reality to extremes and in so doing produces its own reality — to allow freedom for other perspectival possibilities.

Anneke Silver

PAINTER, MIXED MEDIA ARTIST

*After this initial stage of committing myself and 'making it visible',
I then start to expand ideas by doing 'homework', such as colour
studies, photography, experiments with surfaces and media,
or research into images or texts more specifically related to the
material on hand. I get a feeling of the worthiness of what I am
doing from the way images keep evolving (or not, as the case may be).*

ANNEKE SILVER was born and educated in the Netherlands. After travelling in Europe, Egypt and Indonesia, she arrived in Brisbane in 1959 and two years later settled in Townsville. Silver gained her Bachelor of Arts degree in 1979, a Graduate Diploma of Education in 1981 and her Master of Creative Arts in 1991. At present, she is a lecturer at James Cook University, Townsville.

Silver's paintings reflect her interest in the relationship between spirituality and the landscape, with particular reference to archetypal goddess figures drawn from early European historical studies — particularly the works of Marija Gimbutas — which she juxtaposes with her Australian experience to produce her own contemporary icons.

Silver had her first one-person exhibition in Sydney in 1972, followed by numerous others in Queensland, Melbourne and Sydney, with a major retrospective exhibition at Perc Tucker Regional Gallery, Townsville, in 1995. She has also participated in many selected group exhibitions since 1975. Silver is represented in the collections of the Queensland Art Gallery, Artbank, the Parliament House Collection, Canberra, James Cook University, Cairns Art Collection and BHP as well as in other public, corporate and private collections.

———•••———

*To begin, could we talk about your formative journey as an artist — the important
experiences, inspirations, seminal works and writings, spiritual dimensions and key
influences?*

I have always sought to imbue the landscape with a certain numinous quality. This was expressed early in my career with paintings that had a strong meditative quality — in the way they were produced as well as the way they looked. I suppose the two really went together. Some of my early paintings were very quiet paintings, almost colourless. I was strongly influenced by Mondrian, whose work I am very familiar with, having spent many of my high school

lunch breaks in front of his works in the Municipal Gallery in The Hague. Then, in the mid 1980s, I exploded into colour and expressive surfaces, really working with the energy I felt from the landscape. I must say that I love the bush and love the powerful, dry, tropical landscape that I am surrounded by in the place where I live — so full of chthonic power and spiritual energy.

It is unique to have such an environment so close to home, where all the natural powers appear to be working as they did when time began. I mean, this includes the placement of trees special to each discrete area — seemingly random but with a superb rhythm and order; the shape of rivers from beginning to end — from source to sandbank, so to speak; the way the wind makes different sounds with different trees. It seems a great secret is going on of which I only every now and then catch a glimpse. This was very much the basis of my work in the past and still is the conceptual framework against which much of my work can be interpreted, though the form of my expression has changed.

During that explosive, high energy period, I started to discover the ancient goddess shapes from many Neolithic cultures but was particularly attracted to the European Mediterranean ones, mainly inspired by Marija Gimbutas's first book on the subject, *The Goddesses and Gods of Old Europe*. I felt an ownership in these, the same way the Aborigines feel ownership with their cultural ancestors; I was at one stage tempted to borrow Aboriginal imagery to express that bond with the natural world, but then I found suitable imagery in my own heritage.

It occurred to me that the ancients had a relationship with nature and the goddess — and nature as the goddess — in a way similar to my interaction with the bush. I started to develop goddess imagery combined with symbols from the natural world, making images that are in a way contemporary spiritual/religious icons. The triptych and diptych formats are prominent in these works. In some I incorporate raw materials from the land itself, in the form of earth, seeds, twigs. Trees replace saints; goddesses become the symbolic representation of nature. At present that is still the mainstream of my practice. As well, I realised recently that really it is also about myself discovering my own strength as a woman — and not only about nature. That is really where I am now. My work is becoming a little more tongue in cheek. At present I am working on an icon in which I reflect on the duality of expectations of the female temperament and sexuality, which I have called *Captive Between the Lily and the Fire*.

Could you give a broad outline of your creative processes — what moves you into production, how do you feed into and structure your work ideas, time and space?

There is often a whole cluster of narratives, ideas, images and interests building up in my head due to reading, talking, working from life, looking, living — but this does not necessarily drive me into production. It is a secret, even furtive, vision that comes to me in a brief, timeless moment — glancing at familiar things in a certain way at a special time of day. Or it may be an impression gained elsewhere, suddenly transformed in my mind's eye, a dream, a reverie or powerful imagery that occurs suddenly as I am driving. (I always have a pen handy, and many ideas are collected from the mulch in the bottom of my handbag.) These can suddenly set off a chain reaction of more or less coherent, but at least workable, ideas. That is when I go to the studio and run with it obsessively until I have hold of it. Then I can leave it for several days without losing momentum and come back to it without having lost my grip.

I use a visual meditation technique when I have to interrupt work. Briefly, it is visualising the ideas, moods and ambiences I am involved with at the time and 'surfacing' through a layer of spectral colours from violet through to red. When I resume working, I reverse the order and, in a sense back, am where I left off. This technique seems to work for me most of the time.

After this initial stage of committing myself and 'making it visible', I then start to expand ideas by doing 'homework', such as colour studies, photography, experiments with surfaces and media, or research into images or texts more specifically related to the material on hand. I

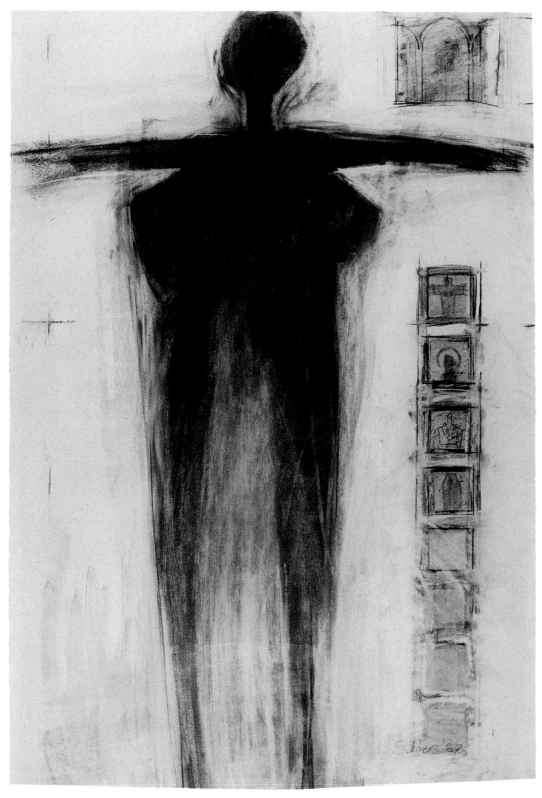

PLATE 134

PLATE 134

THE GODDESS OF CAPE YORK, 1987

23c gold leaf and charcoal on paper, 165 x 114.5 cm,
Photograph: Glenn Abrahams, Courtesy of the artist,
Collection: Perc Tucker Regional Gallery, Townsville

Anneke Silver's inspiration for *The Goddess of Cape York*
was a huge silhouetted figure — about 7.5 metres high —
painted on a rock face near Laura on the Cape York
peninsula that she chanced upon whilst walking in the
area. The figure appeared to represent either a guardian
spirit protecting the entrance to a cave site or a signpost
marking this particular site. Silver was intrigued by the
enigma of the figure's anonymity and her likeness to
some of the early European goddess figures, and she
consequently thought that she must be akin to these
deities in being a forgotten Aboriginal 'goddess'.

Imbued with the powerful presence of this mysterious
figure, Silver wanted to pay her tribute in some way and
decided the only way she could do this was to name her
according to place and situate her in a genealogy of
powerful female spirits and religious representations
of the sacred in our culture. 'When I was ready to work
on this image, I allowed the figure to re-emerge' — in
whatever form it took shape.

Silver's intention was to re-produce and interact with
the image rather than simply appropriate it. She used
lumps of charcoal for the figure and rubbed it back with a
chunk of white clay until she felt the goddess appeared as
if 'rising'. She then introduced a building block series of
small icons of the Virgin Mary — 'the only female deity
our culture knows' — creating a visual play between the
columns on the right and left hand sides of the image. The
lower blocks, representing the Earth Mother aspects, are
obscured images, as if lost in the mists of time, whereas
the higher blocks are more articulated images of the Virgin
Mary and religious figures seen in Sardinia. The blocks
culminate in the iconic altarpiece at the top of the column.
Silver's idea was to portray the natural, free form of the
non-Western figure and the imposed order of the Western
image, equalising and representing both images as rising
female deities in juxtaposition.

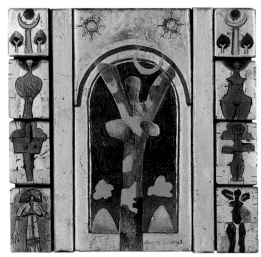

PLATE 135

PLATE 135
EARTH TO SKY, 1990
Oil, 23c gold leaf on gesso on timber, 24 x 25 cm,
Photograph: ProLab, Courtesy of the artist,
Private collection

This is a work based on the concept of the axis mundi —
'probably one of many more to come,' said Silver — and is
a further development of the icon structure employed
in earlier works. Here Silver wishes to celebrate the
miraculous quality of trees with their capacity to transmute
'base substances into other things' like leaves, fruit,
flowers, new growth and, in the deciduous species, to
change form with the seasons. Silver has played with this
idea in the side panels, using pan-cultural symbols of the
central natural image to illustrate the Jungian concept of
the collective unconscious holding the same archetypal
energies — albeit expressed in different symbolic forms
according to cultural and historical determinants. In these
side panels, Silver has drawn symbols from Aboriginal,
Sardinian, Mycenaean and Mesopotamian cultures on the
right and from Matisse, Cyprus, the Caspian and Ishtar
'moon-trees' in the top frames.

The cloud shapes on the tree were carefully worked
with Reckit's blue — 'which I understand Aboriginals
used to attain the colour blue in their paintings' — to
capture the effects of light and shade that Silver had
observed on the trunks of gumtrees. The tree also
provided a very workable structural device in its form and
served as a central reference point for the painting's ideas.
The side panels were intended to have an ascendant
rhythm like the central tree form, which is simultaneously
an upward channel and a downward movement
connecting earth to sky and sky to earth.

get a feeling of the worthiness of what I am doing from the way images keep evolving (or not as
the case may be). Some images have kept appearing over the years — the big, round rock, for
example. One work (*Looking for the Goddess in a City Park*) came to me in a rush of energy during
a stay in Brisbane for an Arts Queensland meeting. I had gone for a magic early morning walk in
the Botanical Gardens and was musing on how a park is not like nature at all. It is an imitation of
nature, a simulated natural environment, and I wondered if the nature spirits would settle
under the shade of the trees or whether they weren't fooled by it all. Then I noticed the reflec-
tion in an artificial pond. The reflection and the shrubbery on the edge combined — the shore
line as its horizontal line of symmetry — had the exact shape of the ancient goddess. I realised
that it is all to do with how you look at things, and with the elements inside one's mind that
dictate the perception of the world. It also seemed to mean that there is hope yet — not to be
so condemning of human effort — and maybe I should be less puritanical about what nature
is. Nature is clearly everywhere. When I came home, I started that work while the vision
persisted.

How has being a woman impacted on your career as an artist?

I think that being a woman, and especially having children, has made me incredibly aware of
the tremendous power and forces within my own body. Childbirth put me physically in touch
with powers well beyond my control, making it both a physical and a mystical experience in a
way — the enormous contractions driving out the foetus, the inevitability of swelling, of bleed-
ing, all those hidden things that our culture does not talk about officially. There seems to be a
certain amount of blinkered vision and obsession with only the clean and nice things, the
things that are easy to cope with, not these strong forces. It is an obsession that in a way sees
nature as untidy too — and leads to us putting up fences and edges, sweeping the leaves, but
also to the debasement of the rainforests and the oceans by dumping toxic waste and car bodies
in them — perhaps because they are untidy anyway and literally out of sight. To me, that is all
interlinked with being a woman, although exactly how is not clear; so, too, is feeling that those
sensibilities are not only important but vital to the survival of the planet. But it is also to do with
the pain of love found and lost and found. Those forces are all so much stronger than our neat
little official world will have us believe.

What do you perceive is the purpose and function of your art?

I find it impossible to say what my art is about — I just *do* it when the compulsion/vision comes
over me — but if I were to hazard an opinion now, I would say that my art wishes to bring about
a refocus, literally to say those things one likes to sweep under the carpet, to acknowledge
those natural forces only too happily made invisible by crawling behind a computer in air-con-
ditioned spaces. In those invisible things lie most of our answers as humans. This is where we
learn about life/death, rebirth; feel real power in certain sites and land masses; experience
peace or extreme distress.

We as humans are in trouble when we cut ourselves off from our earth ancestry. I am worried
that time is running out, bush is disappearing too fast. We must hang on to what we have here:
our climate, our bush, our clean air. I came from Europe, which is a wall to wall simulacrum of
the natural world, and you can hardly see the stars anymore at night as a result of the pollution
haze.

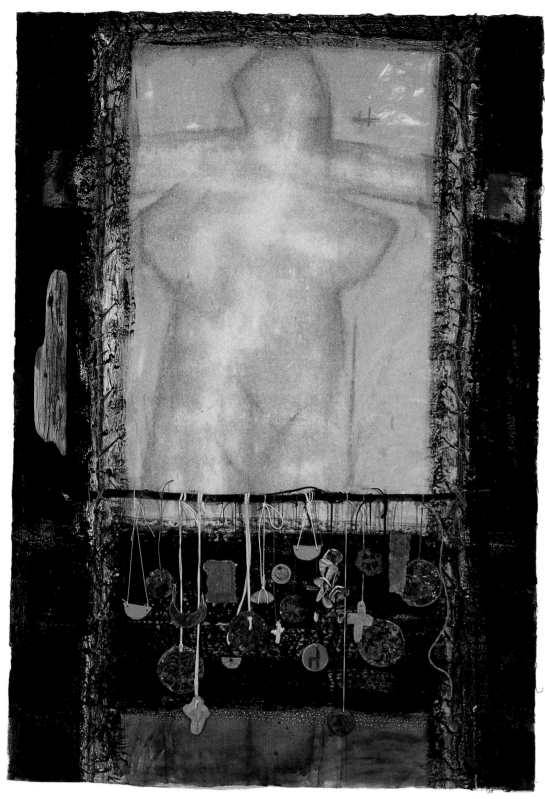

PLATE 136

PLATE 136
ISIS VEILED, 1988–1989
Mixed media on paper, 106.5 x 75 cm,
Photograph: Glenn Abrahams, Courtesy of the artist,
Collection: Dr David Grundmann

The title of this work is an oblique reference to Madame
Blavatsky's *Isis Unveiled* and was the fourth painting in a
sequence of the gradual obscuring of Gaia.

Silver explained that at this painting's juncture, 'some
sort of edifice secluded the goddess from the outside
world' thus creating a demarcation between deemed
sacred enclosures and the relegated secular space of
nature. This desecration of nature 'paved the way for
exploitation of the environment' without fear of her
divine retribution. At the same time, architecture
assumed the place of worship where 'tokens are left as
thanks, devotionals and/or offerings'. These included
images of the goddess herself, coins, moons, banners
and flags.

In this work, Silver wanted to show the simultaneous
obscuring of the goddess presence and her objectification
in the creation of material objects out of aspects of her
essence. These objects are then offered up, dissociated
from their origins, as barter in systems of worship and
trade.

The idea of the mirror-like or emblematic quality of the
'veiled' goddess figure and space came, Silver said, from
'the white rectangular shapes I played with as a child' and
these represented 'the most mysterious form to me'.

In this mixed media work, Silver used earth and earth
materials such as twigs and a worn piece of wood as a
goddess shape; rope and paper worked upon to become
like a hide or skin with stitched surround like a mast; and
wax, tar, gold and earth because of their magical and
alchemical associations. The clay objects that became
offerings had been 'lying around the studio for some time,
as had some of the other materials', as though they were a
precognitive preparation for the emergence of the veiled
Goddess Isis.

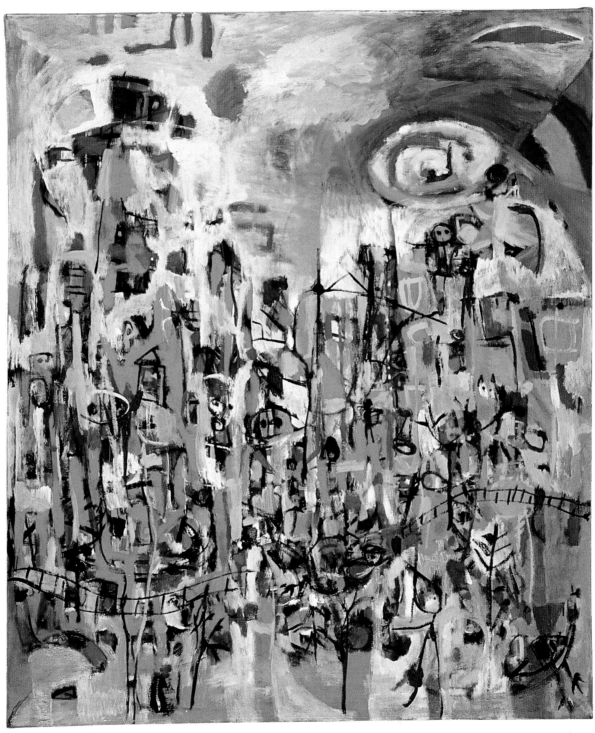

PLATE 137

Judi Singleton

PAINTER, CERAMICIST

Art is sort of a therapy and a sorting out of the chaos of life. This can sometimes be on a purely subconscious level, so I may not realise until a couple of years after I've done a work what it is actually about.

J UDI SINGLETON was born in Sydney and in 1981 studied at Underdale College of Advanced Education in South Australia, followed by work as a craft teacher in 1982. In 1983 she moved to Melbourne and became a committee member of Roar Studios, an inner-city artists' cooperative that had been established in 1982. She regards her art education as being essentially self-taught.

Singleton's abstract paintings and ceramics have a refreshing directness and feeling of vitality that is accentuated in her use of strong and vibrant coloration and freely worked patterning that creates an intriguing and playful visual language.

The artist first exhibited her work in a group show at Roar Studios in 1983, followed by two further shows there in 1984. She also featured in the Roar Studios touring exhibition in 1992 at Heide Park and Art Gallery, Melbourne and subsequently in a number of Victorian regional galleries. Singleton held her first one-person exhibition in 1987, followed by others virtually on a yearly basis up to the present. The winner of the Shepparton Art Gallery Ceramics Prize in 1991 and 1992, Singleton has received several commissions, including restaurant murals for the National Gallery of Australia. She is represented in the collections of the National Gallery of Australia, the New Parliament House, Canberra, Artbank, Shepparton Art Gallery, the Sir William Dobell Collection as well as in other public and private collections in Australia.

———•◦•———

Could we discuss the most important formative influences and inspirations in your journey as an artist? Discuss also any concerns or philosophies that you have developed in the course of your career?

One main inspirational area that has influenced me during my twelve years as an artist is the European group of the 1950s, the Cobras. Their general philosophy and attitudes have given me a sense of security in my beliefs on art. They seemed to have had a general openness and

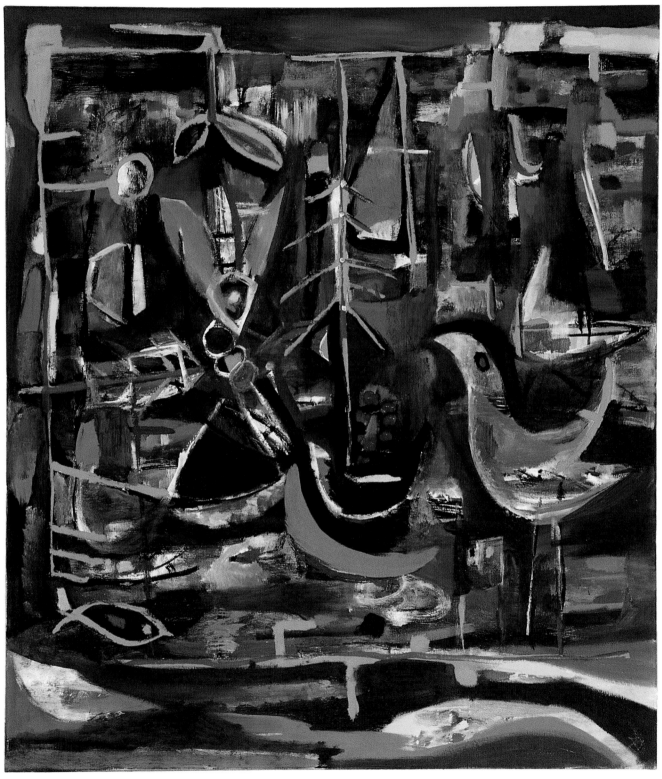

PLATE 138

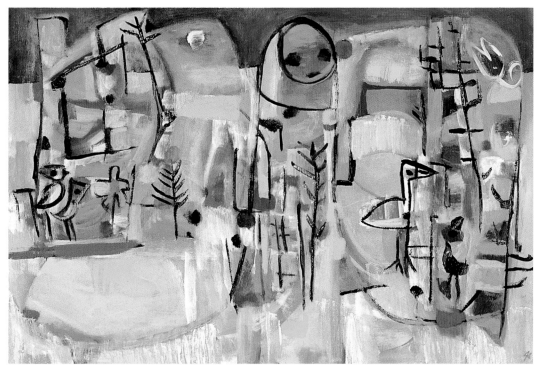

PLATE 139

acceptance of other artists and they were also not afraid to delve into the emotional content involved in art.

When I travelled in Europe, I went to Silkenberg and Herning in Denmark. Silkenberg has the Asger Torn Museum — Asger Torn also worked with ceramics. Herning has the Carl-Henning Pederson Museum and the Kunst Museum, both of which are surrounded on the surface by two huge ceramic murals. Seeing this mural really gave me the confidence to approach ceramic work on a large scale. In 1993 I completed a mural in ceramic tiles at the Shepparton Art Gallery. It measured about 3 metres high by 2 metres wide and is called *Under the Sun*.

Within my work, there is a fine line between the humorous and the serious and also the need to express the child within. Primitive art interests me in the same way as children's art and Art Brut — because of its unselfconsciousness.

I am also influenced by the works of Picasso, Miro, Klee, Munch, Fairweather and Niki Saint Defale.

Could you talk about the different aspects of your creative processes — what drives and feeds those processes? What are the central elements? Also discuss, if possible, the structural and organisational aspects of ideas, time and space as well as emotive and conceptual details in your interaction with your work.

Many things feed into my creative process: my past life, my travels, reading, general life around me. Art is sort of a therapy and a sorting out of the chaos of life. This can sometimes be on a purely subconscious level, so I may not realise until a couple of years after I've done a work what it is actually about. I am fairly emotionally driven and usually find I am unable to use words to describe my processes — let's just say I use 'inter-vision'.

Technically, I actually work very open-endedly. I still use form, shape and colour to try and make the painting work, but I do not know positively, until the day it is finished, what the work is about. I don't mean, in this way, to trivialise the subject; I actually think the subject is most important. This is why I prefer to come at it the hard way — by emotion, the subconscious and gut feeling. Some people comment that this open way of working must be very nerve racking, especially if exhibition deadlines are involved, but I prefer it this way — I am not closed in by

PLATE 137
SEARCH FOR MEANING, 1994
Oil on linen, 174 x 149 cm, Courtesy of the artist

'This image came about from a process of thought. I was doing a context curriculum subject at Royal Melbourne Institute of Technology at the time — the class was called 'Search for Meaning'. It dealt with religion, philosophy, beliefs, morals etc. It was a huge subject and most of the time was spent in discussion, with people sorting out their beliefs through the use of their own lives. Anyway, I thought the same technique of searching, adding and subtracting could be used in a painting. The way I approach painting is in some ways similar — decision making and discipline are used to subtract what isn't needed and replace it with a useful working element.

Search For Meaning took a long time to paint. It does — in its physicality — describe the process of open-endedness I use to find my subject. The titles of most of my paintings happen last and I am always working towards the subject — that is, I really don't know what the picture is about until it is finished.'

PLATE 138
BLUE BIRD SONG, 1995
Oil on linen, 136 x 121 cm, Courtesy of the artist

'*Blue Bird Song* relates to water and space, even though it is still on flat ground — poetic imagery.'

PLATE 139
WOMAN OF THE DUNES, 1995
Oil on linen, 92 x 137 cm, Courtesy of the artist

'*Woman of the Dunes* is a very restrained painting for me. Since I have now been working as an artist for twelve years, I feel I have covered a lot of ground and don't need to destroy the literal subject of the painting as much as I did in the past. This piece isn't as heavily worked as *Search For Meaning* but it still uses the layering effects. Every day is a different day and a different emotion. Painting is like a visual diary. Unfortunately it seems like it's not until years later that you understand what you were trying to say.

The title of this painting comes from a Japanese movie of the same name, where a woman is held captive at the bottom of a sand dune that is perpetually moving so she can't get out. It sounds fairly harrowing, but she does have moments of happiness. Anyway, I think the woman in my painting is part of the environment — she comes from it, but her mind has definitely risen above it.'

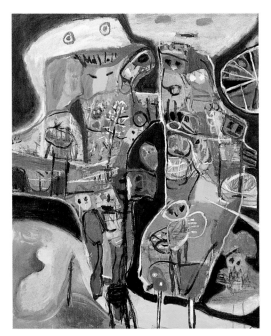

PLATE 140
A COMPLICATED FRIENDSHIP, 1992
Oil on canvas, 167.5 x 122 cm, Courtesy of the artist

my subject when I'm working in a purely abstract way. The painting evolves itself, and after finishing painting, I usually feel that I have been in a meditative state.

Colour is important to me as a mood control. I would like my paintings to communicate on a whole lot of different levels. Ambiguity is also important — I like to leave some things open for the viewer. The viewer can then create their own story and be involved in what they get back from the painting.

I would like my paintings to be more political — they are to me — but many people are still learning to understand my symbolism.

How has being a woman influenced your art — positively and negatively?

I have difficulty answering this question. My feelings about being a woman artist are mixed. I feel very privileged to be in a position where I can express myself and I definitely feel that in this position, I want to say something important. My earlier years were a struggle and art and painting really helped me to examine those sexual/gender inequalities that exist in society. I have found the Melbourne art scene has shifted to some degree and is now not too imbalanced and I'm grateful that I have been accepted by both my male and female peers. However, women generally understand my work more easily, maybe because I do approach things through a woman's eyes.

At this stage of your development, how do you see your role as an artist and the purpose and function of your art work?

It is very important for me, as an artist, to feel that I have something to say. This isn't to say that I expect to be understood by everyone. I use spontaneity and gesture as a driving force in my approach to painting. I try to start my paintings with an openness, so as to allow my emotions and my subconscious to emerge. In using vibrant colours, I wish to surprise and engage. Through painting I aim to reach out and communicate with people. I believe that art is one of the most important points of communication and culture in this over-mechanised world.

PLATE 141
CERAMIC VASE, n.d.
Terracotta, 50 cm (h), Courtesy of the artist

PLATE 142
LIFE TOTEM, 1994
Ceramics earthenware, 58 cm (h), Courtesy of the artist

'Obviously the processes involved in ceramics are very different to those of painting. There are a lot of technical challenges that have to be faced to make the piece work. I usually find that the strong symbols and themes that develop in my paintings become the subjects for the ceramics. Natural elements are important to me, so while working with ceramic, I generally have a strong formal theme and subject to start off with, but I still like to use the natural fall of the clay as an element. I don't want to dominate my medium totally, but to work with it.'

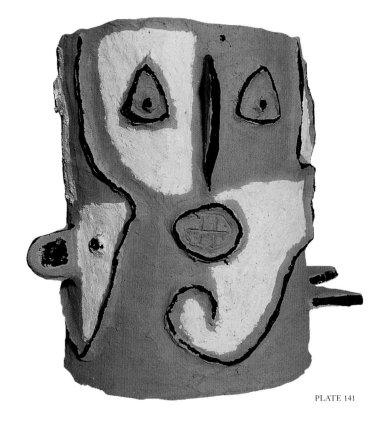

PLATE 141

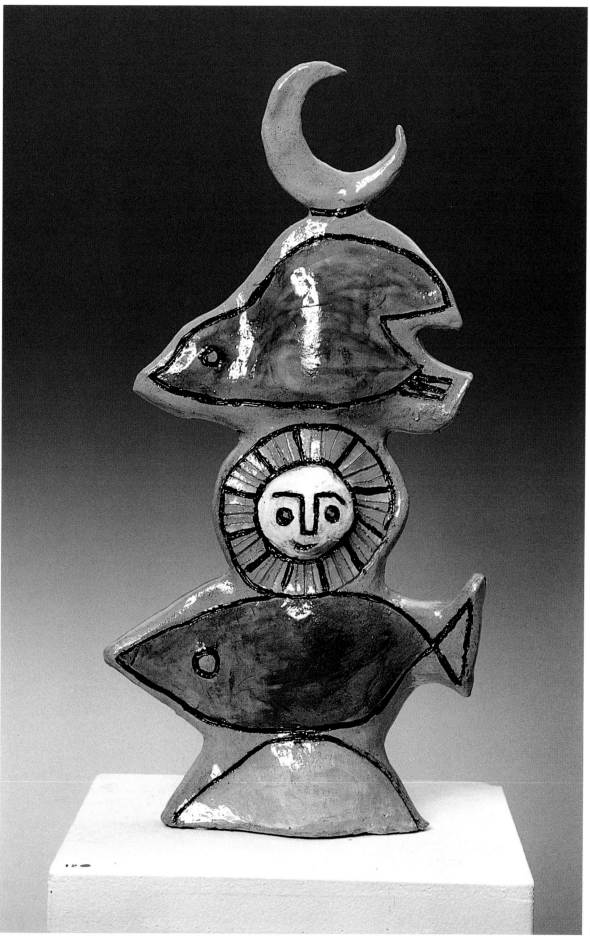

PLATE 142

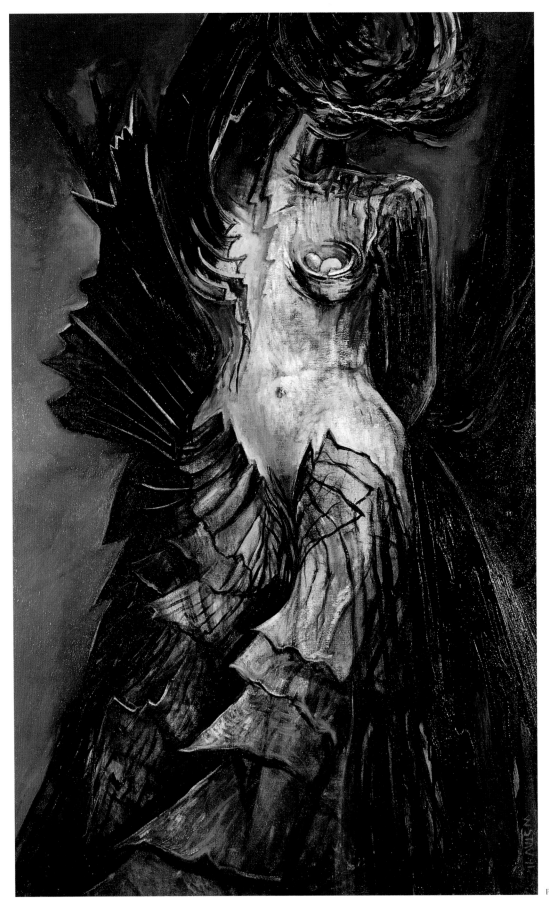

PLATE 143

Wendy Stavrianos

*A lot of art is so highly refined that it almost becomes hotel-foyer art.
I think I would like to bring back the savage quality, the fluttering
quality, that, in a way, disturbs.*

WENDY STAVRIANOS was born in Melbourne and from 1957 to 1960 studied at the Royal Melbourne Institute of Technology, gaining a Diploma of Fine Art. Since 1988 she has been a senior lecturer at the Caulfield campus of Monash University, where she is also currently studying for a Masters degree.

Stavrianos's dramatic and impassioned paintings and ephemerally constructed sculptural installations deal with such universal themes as rituals of fertility, seduction, desire and procreation in timeless cycles of birth, decay, death and rebirth — all inevitably played out in the physical and psychological 'theatre of self'. In the various mythic roles of her archetypal goddess forms, dress — such as 'mantles' and 'skirts of secrets' — is the metaphorical and symbolic speech of the body in the same way that the textures, shapes and shelters of earth forms are the sacred 'cloth' of nature — in both, the dark and the light, the physical and spiritual are intertwined.

Stavrianos held her first one-person exhibition at Princes Hill Gallery, Melbourne in 1967 and since then has exhibited regularly in Melbourne, Sydney and Perth as well as having participated in many selected group shows throughout Australia. She has received several award grants and is represented in the collections of the National Gallery of Australia, the National Gallery of Victoria, the Art Gallery of Western Australia, the Museum of Contemporary Art, Brisbane and Geelong Gallery, Victoria as well as in other regional and private collections throughout Australia.

PLATE 144
DANCE OF THE NESTMAKER, 1992
Oil on linen, 139 x 93 cm, Collection: James and Ellen
McCaughey, Courtesy of the artist

'This image was part of the *Mantles of Darkness* exhibition,
which used *dress as the speech of the body*.

Dance of the Nestmaker is about the dance of youth and
procreation. Young women dance this ritual dance,
trapped into a programming that is biologically built into
them — unaware of what is to come. *Nestmaker* is an icon
for all those young women who are unaware of the
consequences of the act. This is a sexual dance, yet it is
also innocent, joyful, exciting. *Nature is in control* — this is
hard to escape. This is a totemic form, yet one of action
not passivity.

The nest and it eggs are symbols that speak of this
vulnerability. The nest is also a surreal image replacing
the breast as the birth to come. This is a tremulous state —
the eggs, so delicate, are protected by the nest, which is a
universal symbol of home or protection.'

To begin, could we discuss the formative influences in your development as an artist: the inspirations, significant places, key people, important experiences and seminal works and/or writings. Could you also include the spiritual dimensions and philosophies that have affected your work or that you have formulated along your journey?

People who have strongly influenced me are the Spanish painters such as Goya and Velasquez. Giotto was also a very early inspiration and Rembrandt's works have been very significant. Giotto created works in which there is 'the stage of human enactment', where characters stand around in groups acting out the deep human passions of their loves and hates. The contrasts of cruelty and beauty, which is all expressed in their faces, is so amazing and so true. Giotto's works showed me that a painting could also be a stage where characters enacted their human dramas.

It was a spiritual quality in these painters' works that attracted me, a quality that didn't deny the dark but contained the dark and light together — which was something that I had unconsciously been seeking. What is then achieved in such works is a perfect spiritual balance. I think that in all of those painters, it is inspiring the way they hold, compositionally, a psychological character behind all the people they portray in their work. Some of Goya's dark paintings are somewhat frightening, however, in their negative power. Though, you can't just paint a pretty picture and think it is going to work, because that it is not what human beings are about — it is just not real.

Other influences have been cave painting — prehistoric marks and incisions by early man — and Samuel Palmer. Particular works I have gravitated towards are *The Night Watch* by Rembrandt; the perspective in Uccello's *The Rout of San Romano*; Giotto's works in Padua's Scrovegni Chapel and in Assisi. I saw all these works when I was twenty-one years old. At that same age, the robes that shepherds wore in Crete also had an enormous impact on me.

In Rembrandt's *The Night Watch* we see a figure appearing as if part of a dream between the crowd of commissioned portraits. She is like a portent, a message for the future. This picture had a very big impact on me at the time and has stayed with me ever since. It is only this year, however, that I have made my first primitive figure. It is a gatherer figure, *An Image of Holding*, which resembles *Saskia*, the wife of Rembrandt.

I have always related to Dürer and the influence of Soutine, an expressionist, in that very savage thing that I think is missing in art today. I also look back at the women painters: Muriel Schapiro, who works in patterned cloths, and Eva Hesse, who had curtains hanging and cloths embedded in fibreglass.

Greece was a source of great inspiration — the unity of white painted buildings, the ancient sites, the ancient surfaces, the rock faces, seeing the old shepherd's robes. This connection with cloth was very important. As a child, I had a toy sewing machine on which I made small abstract structures that satisfied me greatly. They had no meaning to others, but I treasured them.

Much later, in 1974, I made very large cloth works drawn on with pen and sculptured with the machine. These were the direct result of those early abstractions. However, literature also shaped this work — particularly influential was *One Hundred Years Of Solitude* by Gabriel Garcia Marquez. The major piece of these works, exhibited in 1978, is called *Fragments of Memories of 100 Years Of Solitude*, which now hangs in the Darwin Museum and Art Galleries. This 8 metre long piece in cloth, aged and stained, drawn and sculptured, was all a part of the continuation of the child stage — as well as the literature and the existentialism of Albert Camus. The idea of art being *fragile* — and not lasting — was built into this piece.

Going to Europe and seeing those historic places — the *older* surfaces, textures — and all the great art of the past was immensely important in my formation as an artist. Modern art has never excited or sustained me to the degree as the great works of the past. It is the quality of spirituality that seems to be missing in our own time. A lot of art is so highly refined that it

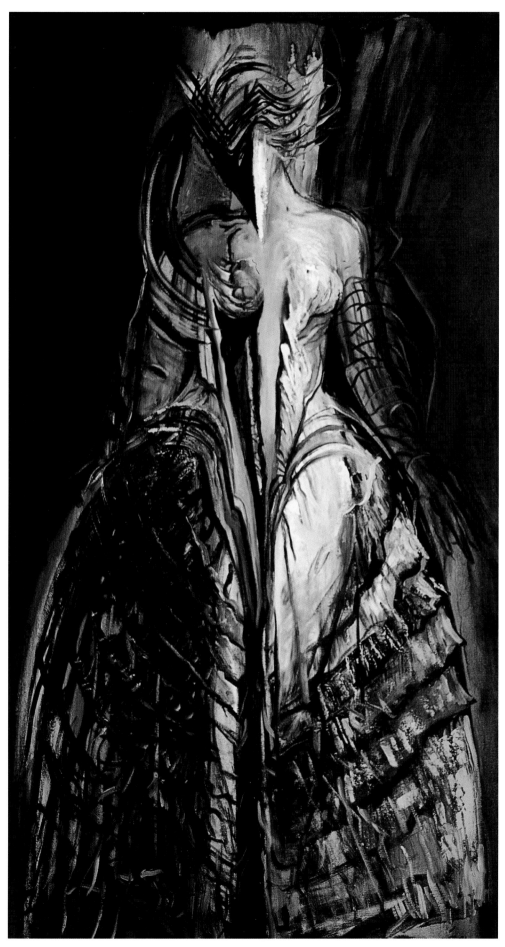

PLATE 144

PLATE 143
AUTUMN MANTLE, 1992
Oil on linen, 184.5 x 108 cm, Courtesy of the artist

'This figure, also from the *Mantles of Darkness* exhibition, originated from *Mungo Woman* — a mythical bird-beaked woman figure that emerged in the 1985 period — after the trip I took alone to the dunes of Lake Mungo. It was at a particular time in my life that I took the *journey* — which, to me, was essential for my inner survival. I had always felt the desert within me and there was a need to meet up with the "real" desert. This had a very special significance. It was as if something that had been apart in myself was joined in the act of facing the fear of being alone in the vastness — taking the journey in my old car with enough petrol for the 300 kilometres there and back, as there were no signs of life or petrol stations then.

The mythological figure of *Mungo Woman* began as a series of drawings in a fury one afternoon. They emerged either encased in earth or half clad, sentinel-like and masked with a sharp yet vulnerable bird beak. I was very surprised at the images — in fact they shocked me, because it was as if I had nothing to do with making them. *Autumn Mantle* emerged in the same way — in fact, all the *Mantles of Darkness* works were the result of the same driving force. I felt I was being propelled by another force.

This image represents a woman with a masked, bird-like head in a dress that is part beehive shelter. Her skirt is split with a dark crevice "entrance" — a *skirt of secrets* — the "ancient secrets" that women hold. This is a woman in the fullness of life — autumn being the mid-life, the time of discarding — shedding of psychological baggage; maybe the shedding of youthful dreams. Her dress, or shelter, is a mantle from which she can act out various human expressions of desire or ritual — it is her protection for her vulnerability, her mantle for reflection or reverie.

This *Autumn Mantle* writhes in its ribbons of organic structure — they are shedding like autumn leaves. She is a landscape. Her dress is her voice. Dress is always used in my work to convey meaning. Cloth has sacred associations for me.

Here the nest on one breast is a symbol of procreation — birth, her spiritual centre — yet the other breast is a flame. So one side is nurture, the other her own inner flame. She is always split between the two sides, torn between those dualities — self and other, dark and light, spirituality and sexuality. The mask is the disguise, the face presented to the world — the outside — consciousness as opposed to the unconscious.

Lately I have seen some pre-history images of goddess figures with birds' heads — I had not seen these when I made my forms, which come from an unconscious source, which is a mystery. The beak is my early shelter reversed and my thorn of the *Rose and Thorn* series. It is also my early tent structures and veil image. So it is a shape that has appeared as shelter, veil, boat and now beak.

Autumn Mantle is really about the birth of inner light held within the shelter of self. Outwardly, the dark mantle and sharp beak of protection, and inwardly, the tremulous aspect of woman. The light is born only when the shedding begins.

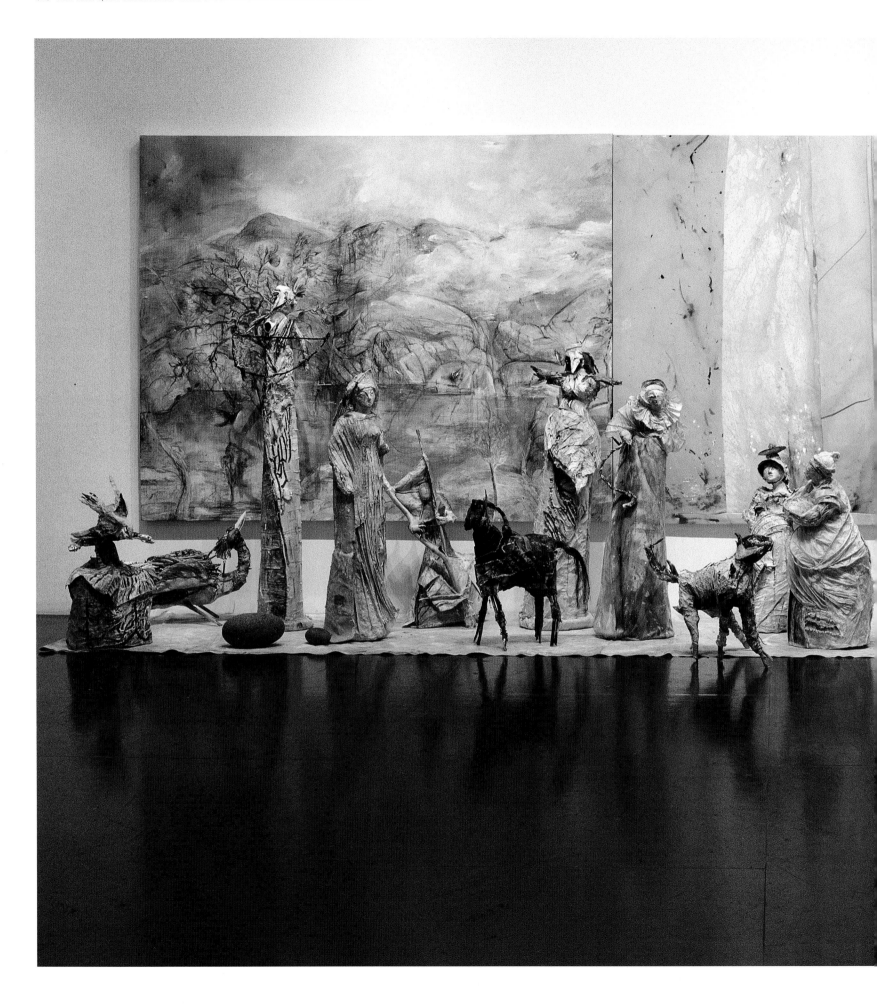

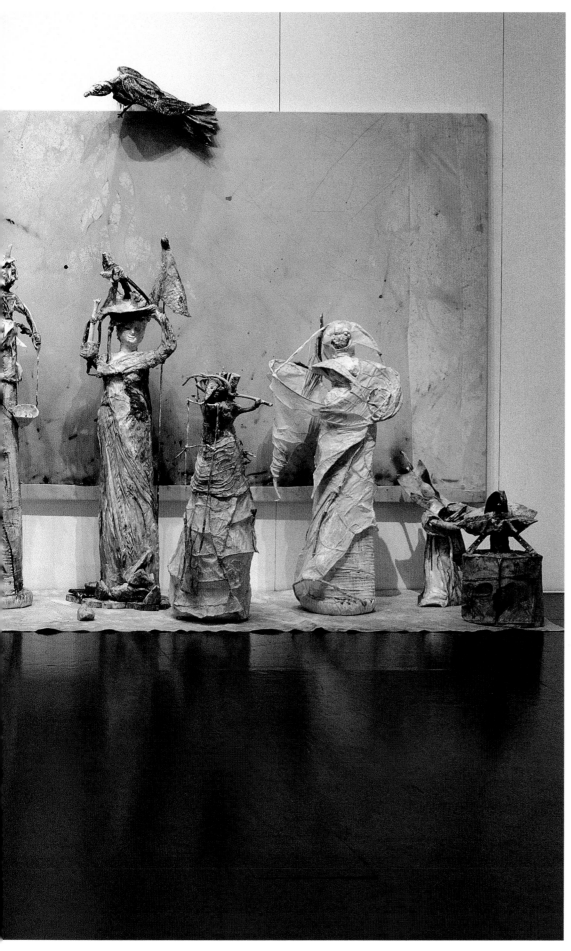

PLATE 145

THE GATHERERS IN A TIMELESS LAND, 1994
Installation, mixed media, 210 x 586 x 130 cm,
Courtesy of the artist

'In the work *The Gatherers in a Timeless Land*, I wanted to
make a spiritual piece connecting it to wall on floor.
(I did a similar work in the 1985 Perspecta.) This is an
installation piece made on my farm at Harcourt, Victoria.
The sculptures are made from found sticks, stones, cloth
and wires.

As a child, I had dolls that I would put all around and
then set them up in a sort of scene. I would then imagine
that they were actually moving and that when I woke up
in the morning, they would be in different positions. So
when I made the figures in this work, I made them like
that, so that they were filled with a spirit that moves.
By this I mean that they don't actually move, but move
within the viewer. I am particularly interested in the
transference of inner reality to outer expression and the
way that expression again reflects back to the inner reality.
To achieve this, the figure has to be still, like a sentinel,
and to sit like a primitive fetish with its power emanating
from it. It doesn't have to say anything — it just is, and you
feel it.

There is drawing behind the sculpture. The figures
are like guardians of the land, yet each one represents a
certain spirit. They are all female in this piece. They have
skirts that hold the secrets. Each figure works as a kind of
fetish. One "gatherer" holds the stone, one holds sticks,
one is part tree, another is Rembrandt's wife Saskia, part
of art history. She is an image of holding, as I feel women
hold and nurture. Saskia holds a spiritual dish, a gift of life.
Two other figures are Velasquez women.

One has a bird symbol on her head. She is a ritual figure,
a white bird of peace. The birds I wrap with my own
psychological binding, my anxieties, whatever, and there
is nothing elegant about the way I work. I sit in the dirt
and can get flashbacks and imagine sometimes that I am
in another life, like an Indian. When I am making like
that, I feel in a primeval state, and those powers come
through in the work, in the bones I use for the heads and
in the stones. I think every object has its own spiritual
power — if I am using a stone, for example, it gives off its
own power, it is all there. This has nothing to do with me
— I am just using it in what I am making. The Eskimos
believe that the image is already in the stone just waiting
to be released.

The other, a big skirted woman, is made of mechanical
parts. She is half in the past and half in the future — and
carries that message. There is also the woman with bow, a
pagan figure — a guardian of trees and earth and the dark
horse of hope.

I have presented here a few examples only.

Always when I visit a gallery I see paintings that are
clever, technically correct, *fashion pieces — surface only,
not felt*. When I drift into the tribal section, I feel the raw
power in the works by tribes — individuals that expressed
very powerful feelings. This is what I feel connected to in
spirit. I identify with the way the Aboriginal feels about
land. Here on my property, I'm aware that it is not mine,
but that I am here for a brief period to make some thing
of this.'

PLATE 145

almost becomes hotel-foyer art. I think I would like to bring back the savage quality, the fluttering quality, that, in a way, disturbs.

Another place that has been inspirational is Australia as it was in the 1950s. It was then an innocent land — though not innocent in our treatment of Aborigines. I also have a strong childhood memory of going by train from the city to the country town of Tamworth in New South Wales, which was a very important journey.

My *huts* were very important places as psychological shelters for the soul. I made them everywhere I went. As a girl of twelve, living in a hotel in Newmarket, Victoria had a very big impact. After living in the relatively quiet and family oriented suburb of Brighton, it was a wrenching reality — the bar, the drunks, the lino, the brass beds, the feeling of not being safe.

Working with my two small children in Darwin was an extraordinary experience. Darwin is a very surreal place — the tropical heat produces some bizarre experiences and behaviour. The changes in nature were so rapid — lush plants that seemed literally to grow overnight — you felt you were on the edge of existence! With its big, wide beaches and mangroves — its more earthy way of life — it opened a way out of the suburbs for me. Then came Cyclone Tracy. I actually saw people's possessions floating in the gutters — all their pornography too — the strangest things were revealed. There were things all over the place — refrigerators wrapped around trees, roofs of houses everywhere — masses of floating shapes. My son collected all these television sets and aerials — which I am now using in my work.

The swift and violent destruction brought by Cyclone Tracy showed me how meaningless possessions were. I also became adaptable in ways of working. Using my knee as support, I drew endlessly. After many hours, days and months of carting around a 6 metre roll of pieces of cloth — mostly calicos — I began the process of building the work — sewing parts on the machine, using the seam as a sculpted line. I would have to stretch this on a frame, rip it off and sew again as many times as it took to make it work. Intuition came first, then play, then exploration, then reassemblage again and again until it worked on a formal level.

In the 1980s I took a trip to Lake Mungo in far western New South Wales. This place had special significance — it was a site of *meaning*. From this place came many of my major works. Also important has been the South Coast of New South Wales — particularly Tanja — where the beach, with its very special rocky coast, was the inspiration of the 1983 *Earth Dresses* series — aspects of which have remained in my work up to the present.

As I mentioned earlier, literature has been very important to me. Often it is just a line from a book or a feeling that inspires so much. One of the most influential books I have ever read is Gaston Bachelard's *The Poetics of Space* — the house and its rooms as image, shelter, hut, nest, the outside-inside. Gabriel Garcia Marquez's *100 Years Of Solitude* not only influenced the Darwin work, it also inspired my first show with George Mora at Tolarno Gallery in 1976. The *Myth of Sisiphus* by Camus was very important to the philosophy behind particular works — making art that itself would decay was part of my way of thinking then and now. I used materials that were flimsy and delicate, that were, as we are, part of the life and death cycle.

The obsession and the *torturous process* contained in Mishima's writings were also found in my work. Working the finest pen line on cloth was 'an act of madness', yet a necessity for me at the time. And again now, I am sewing these new works with the same obsessiveness. Jorge Luis Borges's poetry is a great inspiration: 'Images that are fading as we are fading' — the idea of death being built into all things, making them more wondrous. In David Malouf's book *An Imaginary Life*, there are some exquisite lines, which inspired the 1981–1982 show in Gallery A, Sydney.

Camille Paglia has been a significant influence since 1994, when I read her book *Sexual Personae*. In the chapter on 'Dionysus versus Apollo,' where she clarifies the dualities of this combination, I realised that she had put forward a theory that I could relate to the images in my 1991 show *Mantles of Darkness* — which were pagan figures. I identify strongly with some of her

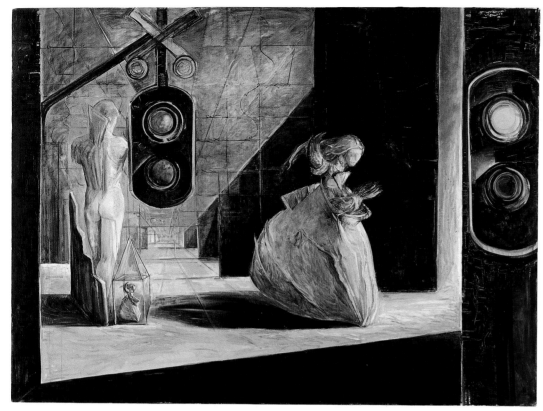

PLATE 146

PLATE 146
THE GATHERER OF THE SHEAF IN THE
NIGHT CITY, 1993
Oil on canvas, 167.5 x 231 cm, Photograph: Neil Lorimer,
Courtesy of the artist

'Camille Paglia's Appollonian versus Dionysian theme
inspired this work. I knew I wanted to contrast the nature
figure with its opposite, put it into a different context
in which the "gatherer's" qualities are heightened,
using symbols of the city — the traffic lights are again
portentous images. To the left, a lone statue is in a surreal
space. The dualities are exposed here. The threat in the
street was also my response to coming to terms with my
own fear of the city as I drive into it each week to go to
Monash where I teach. I had denied this for a long time.
I realised it was because of the time spent in the hotel in
my early youth. It also relates to what I see cities do to
young people and as such also relates to my son. In this
work, I at last placed the city into my consciousness.
The warning lights are part of that feeling.

I feel a true commitment to the old earth values that
have sustained us spiritually for so long. These are *still,
silent guardians of those old earth values*. A need to connect to
what is so enduring, sustaining and simple — as the age
becomes more complex, more out of touch with the
natural flow of things.

The Gatherer was made early on, with its bone arms made
from sheep's horns and its basket carrying the wheat. She
is a small fetish. This idea came from a need to make
images that hold meaning, which goes against some of the
meaningless images of the postmodern era. I worked
inside my house on endless studies in oil of that figure
until I made it work. I also did a smaller painting of that
particular piece. I knew it very well by the time I worked
on the bigger picture. For me, the sheaf is also a symbol of
the Christ part of the Earth Spirit and Heavenly Spirit.'

ideas, particularly because there has been such intense reaction against the overt sexual con-
tent in my work. I also thought that Paglia's book put words to things I had been experiencing
throughout my career. I agree with her comments on the underlying dark sexual powers that
still operate, unchanged, in society and that feminists are being unreal in their messages to
young girls that teach them that they are safe. These dark powers are in all people, especially in
the male, and there are many situations in society where the female is not safe and Camille
Paglia stresses the need to know this.

**Describe your approach to your work and your typical ways of working. What sparks the
creative process into action, what feeds it, how do you structure your work ideas, time and
space?**

All the work I've done is not so much thought out as it is part of a visionary experience. Many
have said my work is Jungian. They said it before I knew who Jung was. I don't create a symbol
before I work. I am not conscious of meanings. The symbols appear and only when I have to
write or speak like this am I aware of the meaning. I'm not sure who said this — I read it some-
where and it is so true for me: *We live life forwards but we understand life backwards*.

As I have grown older, I have been able to see the patterns in my work. This was especially
true last year, when I made a picture — about July 1993 — that related to the death of my son
Peter — hence my description of the 'traffic lights' in those recent works as 'the warnings', for
example.

When I'm working, I draw a lot. I do a lot of preliminary sketching, then lots of small draw-
ings, then big drawings — the sketches, and sometimes the drawings, are in diaries, or on cloth
or paper. I then adjust to the scale of the work and begin the process of making. There's a lot of
process in my work — a lot of collaging, a lot of building up. After they've learnt a bit of skill,
anyone can turn out a painting if they want to. However, I think it is necessary to go through a
suffering process in a way, just as you have to in life. The painting has to have layers of meaning

and layers of paint, so that you're building up the surface. For me, it's important that the age, the time element, the wearing down and the bringing out of certain qualities comes through.

Sometimes I have a long period of thought followed by a very violent outburst of work. I am mostly intuitive and I speak to my inner voice, my subconscious. I dream and listen to my dreams — they never lie. I might have a period of clear thinking, doubting, analysing and formally considering what has been born. I have lots of attempts and yet only on rare occasions do I get out the essence in a short time. I also destroy. I lose faith, and then come back again to the source. I do a lot of recycling, because things in the past can contain the same, or similar, content or feeling to what I am working on in the present. I also remake forms from the past into other things — for example, the other day I remade an early 1980s mask into a primitive bird. It was reborn.

I use my big shearing shed, but heat and cold drives me back to the house, where I can spend weeks preparing details that later go into big structures. When I'm in a flow, the shed is the right place — away from domesticity and interruptions. But often I need to feel the intimacy of the house to work.

The Gatherers in a Timeless Land, reproduced in this book, were made like this. Feeling my way, I made them, sewed them — learned what the materials could do. I knew the *feeling* I wanted in the works but not the *method*. I had never made forms before that were completely self contained. They had always been connected, in some way, to a wall.

How do you see yourself as an artist?

I don't want to stereotype myself as a painter. I want to be what I want to be. I don't want to have things told to me, or dictated to me. This happened to me the whole the time I was in art school — that a painting has to conform to this or that — and I don't believe it.

Your archetypal female imagery resonates with Woman herself in all her various expressions and the feminine principle in Nature. Are there other ways that being a woman has impacted on your work and career as an artist — both positively and negatively?

The most positive impact has been giving birth to a child. This was the richest experience I have ever had. The actual birth experience *connected me to all creation*. I am constantly close to this source. The negative aspect, as an artist, is that I have always been aware of how much my images threatened certain people — occasionally women, but mostly men whose masculinity was fragile. The most negative behaviour comes from these men when confronted with powerful images of women. What I found when giving lectures was that they would ask me questions that indicated I wasn't being nice, and *feminine*. I felt pressure put on me to conform to the stereotype. Their comments aim to *tame the wild aspect I presented*.

One comment — made by a head of painting in an art school about another female artist who uses more conventionally attractive and sexually seductive imagery — was: 'There, why can't you be like that? That is what women's art should look like.' Also, to avoid the real question about my imagery, he said, 'Why are all your skies so threatening?' I wondered if he would have asked, for example, Peter Booth that question, or if there would have been a reaction to Juan Davila's *violent, sexual* imagery.

Would you elaborate on the sexuality in your work?

My sexual content has been met with fear, embarrassment and retreat. The negativity has often come, I feel, because I have been female, and females don't do that kind of thing! Even though they may ogle the images and be sexually attracted to them — such as the big, brutal goddesses I painted — most men cannot cope with strong sexual images being made by a woman. I think it may have something to do with the male anxiety of castration by the female.

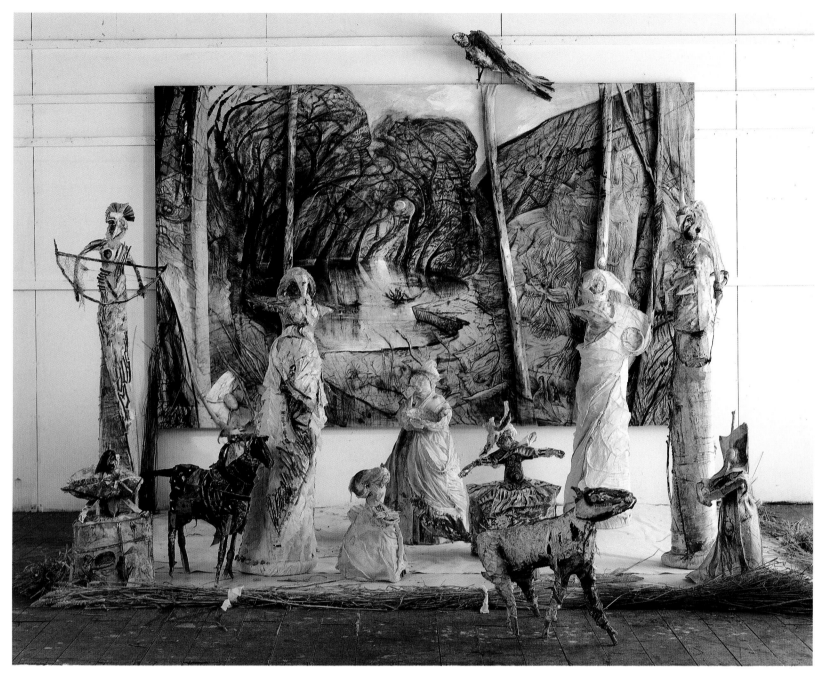

PLATE 147

Talk about the strong 'dark' aspect in your work and how you see the 'light' aspect within that darkness by way of contrast or metaphor?

The 'darkness' in my work has been commented upon as 'threatening' by some people. But, to me, darkness is not threatening — it is 'whiteness' that poses a threat. My white pictures of the little altars, for example, are much more about death. To me, black is the subconscious compost, so to speak, which is rich. Within the darkness lies all the creative ideas and energy, which is one of the secrets that people today don't realise. People are so frightened of any aspect of the dark — they don't want to look inside themselves, don't want to hear or see anything that is depressing — they move away from it in all ways. They don't realise that lying within that dark passage, I think, is the great richness for us in our development as human beings — in our transformation into a higher state. The dark passage is not as difficult when it is confronted; it's when it is denied and/or suppressed that it is made difficult.

PLATE 147
THE GATHERERS IN A TIMELESS LAND, 1994
Installation, sticks, stones, wire, plaster, wax, metal, cable;
The drawing, 167 x 276 cm; Floor, 320 x 334 cm,
Photograph: Neil Lorimer, Courtesy of the artist

There are many different metaphors that can be used for the dark, but, for me, it is the long night journey into the light. On looking back at my exhibitions, I think most of them have been about this night journey, even before I knew about all this stuff. I think now I'm reaching through the dark cave into a little glimmer of light — judging by the recent work — I don't know for sure, though; there may be more darkness to come. However, the work is a reflection telling me what is there.

I believe a woman has a different thing to say, somehow, than maybe a man has. He has something to say, too. It doesn't mean that one idea is better than the other; it's just that female sensibilities are something distinct. Good art is neither female or male. Good art is good art and, in each of us, we have that male–female thing, and we have to have a balance of both. I think a woman can say things about cloth, for example, in a way that a man wouldn't say it, because women are tied up with cloth — they wash, they iron, they're in touch with cloth. I really feel that I'm just starting to understand that now.

As an artist-educator, how do you see the function and purpose of your art?

I have always told my students and myself: it is the journey not the end that matters; forget the fickleness of fashion and learn to listen to the inner voice that informs all; don't cry — work! However, I still notice the difference in the way my male and female art students present their work — the boys often stand proudly and confidently in front of their work, whereas the girls retreat more and are hesitant about the presentation and acceptance of their work. Also, students still defer to the male teacher as 'authority' rather than the female teacher.

I feel the artist is a kind of medium. Through him or her, the universal is filtered. They are the voice and the conscience of the time in which they live. The artist must adhere to the voices and portents that come to them as a result of their sensitivity to what they see and hear internally and externally. Images that are felt deeply can convey *that truth of the artist's time* and can speak to the future generations.

All aspects of the landscape in my previous works were combined in the figures I painted before I went to Spain last year, and they were seen at my exhibition called *Mantles of Darkness* in 1992 at Luba Bilu Gallery in Melbourne. So these figures represent aspects of nature, aspects of the landscape and are the forerunners of the current sculptures and paintings I am doing now. In my current work, I am using the 'dolls' — or 'gatherer' figures — just as I used the tree structures in my past work. This new work is still very close and as yet hard to understand fully, but I see it as being very connected to the Darwin works. The 'dolls' are also like figures from history — from Giotto, from cave paintings, the Spanish figures of Goya etc — and each figure has a certain presence that conveys a feeling or a meaning. They stand like guardians of the land — 'sentinels' — or figures and communications pleading for a return to early spiritual values. In the child part of me, they are the dolls I spoke to as a child that helped with the loneliness. These figures have come at a crisis in my life when I needed their presence to speak to again. They come from the land I live on — they are made from sticks, stones, cloth, fencing wire etc on my property. They are saving me from my own inner isolation, which I feel in today's society is getting worse. Contact with *real* people is very rare. My dolls are the conveyors of meaning for me.

Lezlie Tilley

PAINTER, MIXED MEDIA ARTIST

…there has been a displacement of attention from image to words about the image…for explanation or meaning of difficult or unfamiliar visual experiences. To engage in the emotional or the spiritual is to maintain the mystery — somehow mystery is considered an insult to the intellect. To explain is to demystify.

LEZLIE TILLEY was born in Sydney and in 1967 studied for a year at the National Art School, East Sydney Technical College. From 1973 to 1975 she studied ceramics part time at Newcastle School of Art and Design, where she also gained her Certificate of Art in 1979–1980. Between 1975 and 1979 she studied sculpture part time with a private tutor from University Sains, Malaysia. She attended Newcastle College of Advanced Education from 1981 to 1983, gaining her Bachelor of Arts (Visual Arts) degree and was awarded the Signor A. Dattilo Rubbo Prize in 1984. In 1985 she published an illustrated children's book and since 1986 has worked as a part-time teacher at the Hunter Institute of Technology.

Tilley's formalist abstract paintings and mixed media art works have ranged from miniatures and Biblical paintings based on early illuminated texts through to geometrically woven constructions of recycled found objects and building materials with text from *Roget's Thesaurus*. These latter works focus on word/symbol/object definitions of meaning. By obscuring interpretation, they challenge the viewer to incorporate their own non-verbal, sensory associations into 'accepted' information to locate their own individual response and extend their awareness of meaning.

Tilley held her first one-person exhibition in Melbourne in 1988, and followed it with her *Image and Text* show at Access Gallery, Sydney in 1991, followed by individual shows there in 1992 and 1993. She has participated in numerous group shows since 1980, primarily in galleries in Newcastle and the Hunter Valley region. She is represented in the Warrnambool Art Gallery and Maitland City Art Gallery and in other public, corporate and private collections around Australia.

PLATE 148

Would you outline the most significant aspects — including people, experiences and inspirations — in your formative journey as an artist?

I always had difficulty in attempting to define a specific position in terms of my art, working as I do intuitively. Having discovered the following statements made by Marcel Duchamp, notions of style/place/position and consistency seemed irrelevant: 'You see, I don't want to be pinned down to any position. My position is lack of position, but, of course, you can't even talk about it, the minute you talk you spoil the whole game…'

'Repeat the same thing long enough and it becomes taste…the enemy of art.'

Duchamp

This shrewd philosophy allows one to push personal vision to the edge — offering, as it does, constant surprise as well as the inevitable disappointments. Art would be easy if one could develop a comfortable style and method of working, resulting in consistency, predictability and leading to endless self parody.

Although my influences in the past have been very diverse and have included artists such as Piero della Francesca, Mondrian and Malevich — to name just a few — what has interested me for the past thirteen years is the notion of 'meaning' in art. The catalyst was provided by a local gumtree painter, whose notions of great art remain imbedded in nineteenth century European art. He thrust forward a wonderfully moving abstract image by Paul Klee with the remark that it was an example of 'abstract rubbish, impossible to read'. The word 'read' immediately sprang to mind as a literal device — reading images as in 'words'.

So, in direct response to the word 'read', I began a series of paintings using words, whole sentences and poems. These words were embedded in the surface of the pictures in the manner of Jasper Johns. The result of this experience was a 1983 painting titled *Image as Text*, in which the title was repeated over and over as a pictorial device. This painting then became part of a series for an exhibition titled *Image and Text*. The basic tenet of the *Image and Text* series is that repeated use, or abuse, of words and phrases renders them into meaningless cliches.

The viewer was given something to 'read' while looking at an abstract painting. The painting started out as a joke, but it was also the start of my interest in text. The images developed to include cut-out letters in relief, which enabled me to treat the surface with more freedom. I realised the consequences of what I was doing and the possibilities of extending this work in so many directions. It has been the source of my work ever since.

What are your thoughts on abstraction in art?

I have always considered myself an abstract painter. The *Image and Text* series, whilst being a development, an evolution, of past works, also stands independently as a series, with all contained in the dialectic between image and text. I'm still interested in putting words together with an image and seeing how they influence each other. I don't like to call it playing mind games — it's not a game.

The majority of the general public still consider abstraction to be a totally meaningless pursuit, which points to the fact that nothing much has changed since Kandinsky first struggled with the consequences of the dissolution of image. Abstraction is surrounded by words to explain or justify — the more difficult a work becomes, the more it relies on text, dialogue and museums for meaning and justification.

In an artist's statement several years after the appearance of the initial *Image as Text*, I said:

> In our desire to demystify art there has been a displacement of attention from image to words about the image — focus has shifted from art work to artist. We look to words for explanation or meaning of difficult or unfamiliar visual experiences. While words can powerfully influence the way images are read, they can

PLATE 149

PLATE 150

PLATE 148
590. WRITING, 1991,
Oil on canvas, slate, painted wood, Courtesy of Access
Contemporary Art Gallery, Sydney

This work is from the artist's *Image and Text* exhibition
at Access Gallery in 1991. The exhibition contained
around forty works that were mostly small in scale, but a
few large works were also included. For this series, Tilley
explained, 'I used little scraps from the immediate
environment, such as tiles, corrugated iron, weathered
wood, graphite, slate and lead, and I utilised surfaces
other than canvas, with colour as complementary rather
than a main focus'. The works show clean horizontal
divisions of three colour sections adjacent to a single word.

Tilley has drawn extensively from *Roget's Thesaurus*
dictionary of synonyms and antonyms. In some of the
smaller works, the word chosen by Tilley refers to the
mixed medium in the work. For example, a piece of boat
side has the word '645. INUTILITY', translated in the
thesaurus as: scraps, bits, dead wood, barren, sterile,
worthless, good for nothing, rubbishy, trashy.

For Tilley, the point of departure within the series is a
word or the physical object, whether it be a piece of slate,
corrugated iron or wood. In the latter case, she then looks
for a verbal description of the object's essential
characteristics. In some of the pieces, the corresponding
thesaurus entry is added in computer-cut lettering or
painted onto a ground. The words and letters themselves
then create a non-verbal pattern play. With others, there is
no text on the object, only in the title. The responsibility
is then thrown back onto the viewer to make the
'associations', which in turn make the 'meaning'.

Tilley's concept in weaving lettering with abstract forms
was to emphasise that words and labels in themselves do
not provide meaning. As previously said: 'Words can
simultaneously explain difficult visual experiences as
easily as they can confound/confuse…in art we need to
acknowledge that perceived "associations" are every bit
as important as literal definitions'.

also mislead, misrepresent and misinform. Despite this we would rather trust the
word than our ability to gain meaning through the image itself. To engage in the
emotional or the spiritual is to maintain the mystery — somehow mystery is con-
sidered an insult to the intellect. To explain is to demystify.

*Talk about your creative processes — what moves or motivates you into production? How do
you feed into and structure your work space, time and ideas/concepts? Could you also talk
about the formal and thematic aspects of your art and the dialogue between the painterly,
other non-verbal and verbal dimensions of your works?*

Sometimes a word will stimulate a work, for example, 'Unmeaningless', and at other times a
found material with seductive surface qualities will provide the impetus. The works evolved to
contain both abstract image and panels of text taken largely unedited from *Roget's Thesaurus*.
Placing two entirely separate panels together provided the finished work with simultaneous
and multi-levelled meaning. The entire process vacillates between a serious attempt to ques-
tion meaning itself and a playful game with words — between the intellect and the sensorial.
The words, in a strange way, provide little grabs of information one moment, and in the next,
obscure words leap out like an alien language — to become more obscure than the patterned
surface they sit beside. Words can simultaneously explain difficult visual experiences as easily
as they can confound/confuse. I sometimes present the same works without the text panel so

PLATE 149
SLOTH, 1993
Rubber, cardboard, Q cell, acrylic on board, 152.5 x 154 x
4.5 cm, Courtesy of Access Contemporary Art Gallery,
Sydney

PLATE 150
ENVY, 1993
Copper, cardboard, Q cell, acrylic on board, 152.5 x 154 x
4.5 cm, Courtesy of Access Contemporary Art Gallery,
Sydney

PLATE 151
PRIDE, 1993
Mixed media, 152.5 x 155 x 7 cm, Courtesy of Access
Contemporary Art Gallery, Sydney

PLATE 151

that the noisy verbal banter between image and text quietens to a more contemplative, emotive level.

On a formal level, the text panels offer a visual texture which is often in conflict with the recent and more highly patterned surfaces such as in *ENVY* in my 1993 show *The Seven Deadly Sins*. I often use a third panel of either found material or painted surface so that the entire work reads as text, book spine, the image — like a picture book flattened out. As well, the third panel operates as the arbitrator between two disparate and visually unrelated works. These works sit uneasily between idea and feeling, the conceptual and the ornamental.

Unlike architecture or sculpture, which exist in real space, painting deals with illusion. My work attempts to balance somewhere on the edge between illusion and reality — picture space and the real (found) materials added to it. Surfaces are becoming more important, as they provide the visual see-saw between the two. The constant process of visually editing the real world sees the works as a series of investigations into refinement. How far I can take this process and maintain visual energy is the challenge.

My current works are highly subjective images made within the spartan confines of a minimal structure, allowing the surfaces to be more vocal. The surfaces are both invented and discovered in the process of juxtaposing found objects, memories, impulse and design. Formal aspects such as line, plane, edge, surface and colour are important, but what is crucial is the

PLATE 152

PLATE 152
GREED, 1993
Fabrics, cardboard, Q cell, oil and acrylic on board, 152.5 x 153 x 5 cm, Courtesy of Access Contemporary Art Gallery, Sydney

These works (Plates 150, 151 and 152) were from *The Seven Deadly Sins* exhibition at Access Gallery in 1993. Again, the works included found objects and materials such as wood, fabric, vinyl, rubber; assorted chemical mediums such as acids; tools such as sewing machines, sanding discs and grinders.

The first panels of *The Seven Deadly Sins* series are thesaurus entries; the central panels are painterly interpretations of the sins — for example, spiritual interpretations; and the third panels, through craft, are explorations of the physical worlds of the sins. The words dictated the treatment and order of the panels, so the works were then necessarily constructed from left to right. All of the panels are elaborate plays upon word associations. Tilley found that 'the sins were linked in more than the obvious ways' and thus chose to mine their secondary features and also, in most cases, their ambiguity.

Using weaving, both in construction and as metaphor, Tilley further extends the nuances and subtleties of creating meaning. The physical intertwining of differing materials, from keen-edged brass to lank and pliable rubber gives substance to the mixed media works and makes them haptic sculptural reliefs. Tilley is also making a deliberate pun on the weaving of confusion between the sins themselves and the multiplicity of thesaurus references. In extending the metaphor of weaving into the concepts, she has extended the 'meanings' of the sins. In *ENVY*, for instance, she depicts decay; in *LUST*, impurity, and so forth. Weaving is an ancient art and craft, almost as ancient as the universal 'sins' themselves.

work's ability to evoke dialogue. This 'dialogue' is taken literally in the form of the panel of text lifted from *Roget's Thesaurus*. The text simultaneously offers pattern and multiplicity of meaning in the same way as a piece of architrave or skirting board from a demolished house can provide — among other things — colour, actual texture and a kind of social history.

How has being a woman influenced your art practice?

Whilst I'm concerned with many issues concerning women in general, I do not choose to use my work as a political vehicle. I have never been consciously aware that being a woman has influenced my work in a particular way — I simply see myself as a person who makes art about art, for its own sake, however self indulgent that may seem.

What do you see is the function and purpose of your art?

Through art, we can once again recognise the value of non-verbal communication.

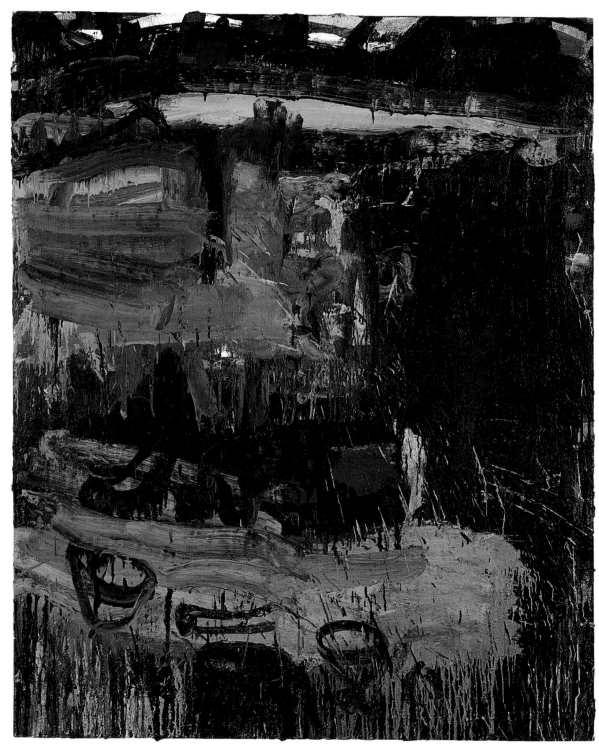

PLATE 153

Aida Tomescu

PAINTER

In painting, nothing is laid down beforehand and,
irrespective of what you paint, you are repeatedly thrown
back upon your own resources.

AIDA TOMESCU was born in Bucharest, Romania and came to Australia in 1980. From 1973 to 1977 she studied at the Institute of Fine Arts, Bucharest, gaining a Diploma of Art (Painting). After her arrival in Sydney, she attended the City Art Institute in 1983, attaining a post-graduate Diploma of Art (Visual Studies). In 1984–1985 she travelled in the USA and Europe and in 1986 worked with the Victorian Print Workshop in Melbourne. She currently lives and works in Sydney.

Tomescu's consummate abstract expressionist paintings brood with the electric tension of holding opposites that are often uneasily resolved. These (usually) large scale and mysterious works have alternating currents between light and dark tonalities, controlled stillness and frenzied movement, subtlety and aggression, simplicity and complexity and are frequently evocative of certain classical or avant-garde musical compositions. Tomescu will not 'present ideas as certainty' and feels that there is always a latent content in the work.

The artist held her first one-person exhibition in 1979 at the Cenaclu Gallery in Budapest, followed by several others in Sydney and Melbourne since 1981. She has also been included in many select group exhibitions since 1978 and awarded the Sulman Prize in 1996. She is represented in the National Gallery, Bucharest, the Art Gallery of New South Wales and in other public, corporate and private collections in Australia.

---·•·---

Could we discuss particular influences and sources — including particular artists, works, writings and composers that were/are inspirational and formative in your development as an artist?

A great number of sources lie behind my work. The list is peopled by hundreds of figures that have fascinated me. Some of the clearest and most memorable experiences are Giotto's *Cappella Scrovegni*, the mosaics of Ravenna, Titian's *Pieta*, Bellini's *Madonna and Child* (Brera),

PLATE 154

PLATE 155

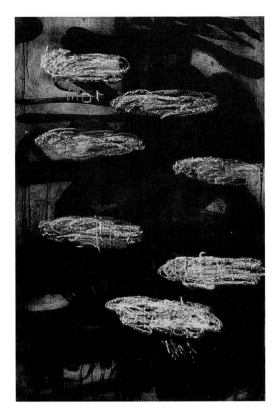

PLATE 156

PLATE 153
BLUE AND OCHRE, 1993
Oil on canvas, 183 x152 cm, Photograph: Paul Green, Private Collection, Sydney, Courtesy of Coventry Gallery, Sydney

'*Blue and Ochre* was the first of a series of paintings completed in 1992. It came at the end of a laborious process and also opened the way to a new series of work. With its building and dissolving of imagery, it allowed for a greater separation between form and setting. Images surged up every day, but were erased again. The melting away of images prepared a more receiving ground where the tension between form and the dense masses of strokes forced a pace in the activity of painting that allowed imagery to find what felt to be its right location. The building and dissolving of imagery also allowed new figural possibilities. Form emerged out of the painting of it.

When a painting results, I no longer have an idea of what is image, what is sign or symbol; everything presents itself together. I don't intend to present ideas as certainty. The painting won't tell a story; it will only suggest one at the end. There always seems to be another content held in the work.'

PLATE 154
BLACK TO WHITE, 1994
Mixed media on paper, 121 x 80 cm, Courtesy of the artist

PLATE 155
WHITE TO BLACK, 1994
Mixed media on paper, 121 x 80 cm, Courtesy of the artist

PLATE 156
WHITE TO WHITE, 1994
Mixed media on paper, 121 x 80 cm, Courtesy of the artist

'I seem to begin a new working cycle almost always with paper. It is the nature of paper, absorbing and reflecting at the same time, that makes it almost an addictive ground for my work. *White to White* was one of a series of works begun at the end of 1993. The result was this suite of works completed in early 1994. In this series, the language became more reflective as the works marked an end to the more dramatic structures of earlier work. There was no more need for great accumulations of forms, but there seems to be an even clearer distinction between form and setting. These works seemed to co-exist rather than to have evolved from one to the next. They became important to me because of their figural associations and also because, in these works, "White" seems to be "winning" over the restricting "Blacks".'

PLATE 157
ALL GREEN, 1994
Oil on canvas, 183 x 152 cm, Collection: University of New South Wales, Sydney, Courtesy of Coventry Gallery, Sydney

'*All Green* was the last of a series of paintings completed in 1994. The work went through daily erasures that gave it a long history and covered its surface with a layer of lost images. I took a lot of space to redo things. It was a daily process of making order and discarding what felt to be of no further use. The disappearance of form became more and more insistent, until it was squeezed out entirely. The work became more narrowly focused, and with it I discovered the difficulty of simple structures. There was no longer a distinction between form and setting.

The painting resulted not from a sum of additions but rather from adding and dissolving. It was a clearing away of imagery. My interest was not in tension that stays within the limits of the mark, but the inner tension of the masses of strokes that took over the form entirely. The painting became, in many ways, a collection of experiences that coalesced and aimed at recovering a simpler structure that felt more direct.'

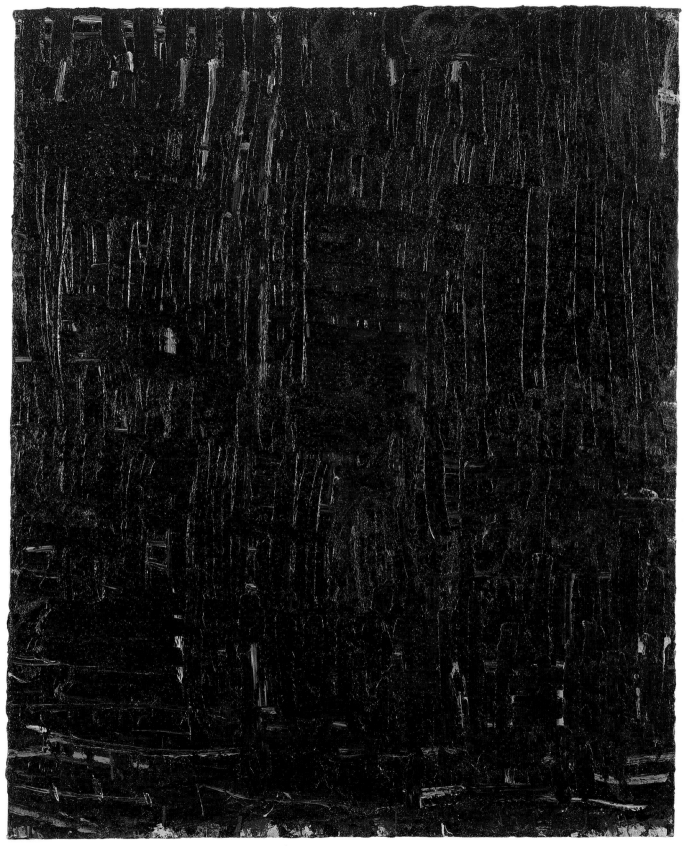

PLATE 157

Goya's *11 Colosso* and the *Black Paintings*, Titian's *Deposition* and Piero della Francesca's *Baptism*. As well, there is the music of Glenn Gould playing the Goldberg variations, the letters of Flaubert, the novels of Thomas Bernhardt, the films of Bunuel. These are some of my enduring and repeated fascinations. When I am painting, I look at almost nothing, and when I read and look, I paint very little. Periods of absolute productivity alternate with others in which I am unproductive.

Almost anything can become the raw material for a painting — everyday things, situations I have lived through, things I have read, other paintings. But despite having a lot of raw material, when I start to paint, my vision of the painting is very primary. I discover it as I paint and this never changes. In painting, nothing is laid down beforehand and quite irrespective of what you paint, you are repeatedly thrown back upon your own resources.

In general terms, could you outline your creative processes — what moves and motivates you into working and how do you structure your ideas/concepts, time and space? Could you also discuss the formalist aspects of your art and your pre-eminent concerns in terms of your works?

The only excuse to make a painting is not to invent another one, but to go through an experience that rings true and make it differently. Although I always start with certain ideas, the painting is something that is constructed as I paint. But I do not have the sensation of having invented anything or that the works depend on my free will. It is more like the discovery of a hidden structure.

My interest is in a found structure, a structure in a continual flux, where form develops out of the painting of it. The question of location or placement of form is vital to me. I have a drawing, it seems, when the structural configuration, taken on its own terms, feels inevitable.

Has being a woman had any particular influences on your work and career as an artist?

I choose not to investigate along these lines — however interesting it may be — as I feel it will take away from the work. A painting might start from situations I have lived through, and in this sense the work reflects the evolution of the way I feel and live, but this can never 'explain' the work. I am interested in painting that goes beyond the personal and includes more. To direct the work into a situation according to a plan would mean excluding too much. It would seem, to me, to be like seeing things only from a distance. I stay with a canvas until it moves into the space of painting, where the feedback I get from the work dictates the pace of the painting. As a painter, you forget about your condition. A painter, at the end, to use Ligia Fegundez-Telles's words, is 'no more than essence'.

At this stage of your development, how do you perceive the function and purpose of your art?

I am interested in painting held together by the strength of its structure. I don't want painting to explain or conclude. The most important function of the work is to impose an order, a structure and to make its experience real.

Vicki Varvaressos

PAINTER

Often the structure of an individual work may come…out of the blue
while I'm sketching… At other times, I just start with a plain board,
with nothing in mind, and work with what emerges spontaneously…
It is important to be open to anything that may happen, and in that
sense, one must be fearless while working.

V ICKI VARVARESSOS was born in Sydney and studied at the National Art School at East
Sydney Technical College from 1970 to 1973. In 1978 she travelled extensively through-
out Europe. She currently lives and works in Sydney.

In the 1970s Vicki Varvaressos became well known for her angst-impelled, broad-brushed
pictorial mockings of stereotyped mass media images of women. In her more recent images,
she focuses on subtle complexities of individual human behaviour, including inner states of
being that influence outer expression.

Varvaressos has had annual one-person exhibitions in Sydney since 1975 and several in
Melbourne since 1980. Varvaressos has also been included in many select group exhibitions
throughout Australia since 1975. She is widely represented in public institutional collections
such as the National Gallery of Australia, the National Gallery of Victoria, the Art Gallery of
New South Wales, the Art Gallery of South Australia, Museum of Modern Art at Heide,
Victoria, the National Gallery of New Zealand as well as in many regional, corporate and
private collections.

———•·•———

How do you see your development as an artist? What have been the most significant
influences, inspiration, threads…?

Being forced to think about changes in one's work makes you reflect on why certain things
emerged in the way that they did. A lot of my early work — done in my twenties — had a satiri-
cal element. On reflection, I've come to think that satire is a young person's thing. I don't mean
this in a disparaging way; it is just that I think that things become more complex (and interest-
ing) in your thirties. So I suppose I could say that my paintings became more intimate, as
opposed to public, in their themes.

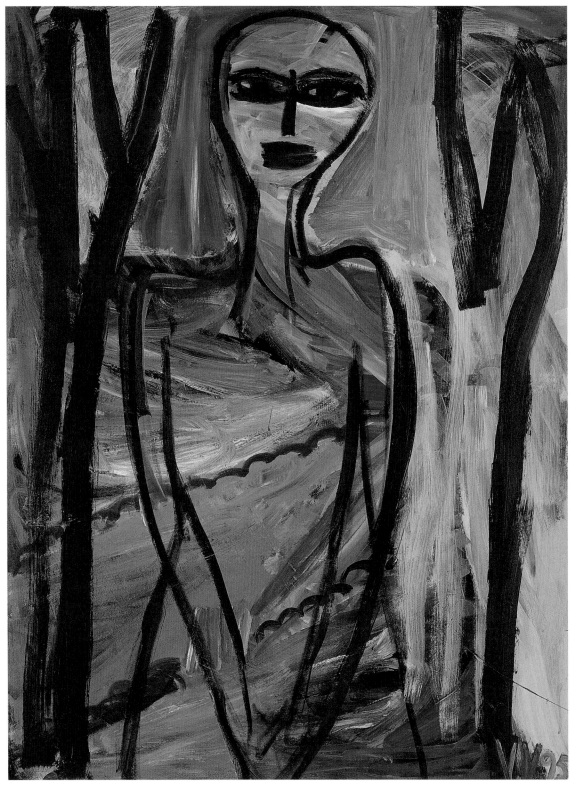

PLATE 158

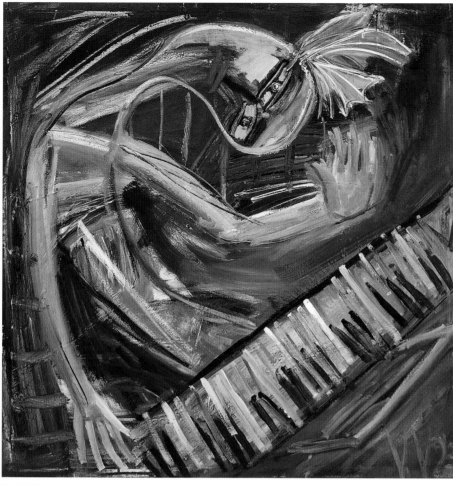

PLATE 159

PLATE 158
WOMAN OVER THE LANDSCAPE, 1994–95
Acrylic on hardboard, 122 x 91 cm, Photograph: Michel
Brouet, Courtesy of Watters Gallery, Sydney

'*Woman Over The Landscape* was an image that just emerged
as I turned the painting on its side — not happy with the
way it was going. I outlined the figure and suddenly saw
the "landscape". I decided not to fill the figure, seeing her
as transparent, yet over the landscape. I find the image
disconcerting and affecting. I feel this painting has many
layers, which I don't really want to discuss for fear of
dismantling her!'

PLATE 159
PIANO WOMAN, 1993
Oil on canvas, 94 x 94 cm, Courtesy of the artist

'*Piano Woman* was a work that emerged while working
with nothing in mind at the start. Round and round she
went, with arms flaying, and it wasn't until almost
completing the work that I had the idea of putting in the
piano, which finally resolved the picture — aesthetically
and emotionally.
 I think it is a joyous picture and in that sense a contrast
to *Woman on Sofa*.'

It's hard to think of 'threads' in one's work, but in retrospect, I think there was a big change
when, in one picture in particular (*Why Dr. Paget…*, 1983), I realised that my figures had a life of
their own — that they interacted on several levels. Following this, came an interest in the ges-
tures and nuances of the way people behave and interact with each other. The paintings from
this period mainly featured one or two figures painted directly on board from 'my head' or from
sketches I had made; while I had often used images from mass media in my earlier work, I no
longer did this. My interests had changed — I suppose as a natural progression of age.

I also felt that because of the nature of these paintings it meant that they could be read on
various levels. For this reason, a lot of the works didn't have titles — just a basic *Two Figures*,
Figure etc — with maybe an identifying thing in brackets for cataloguing purposes. The extra-
ordinary thing was that I felt some people thought, 'Oh, they're not about anything' — because
they had no titles!

For many years, my work has been concerned with the day-to-day feeling of human experi-
ence — mostly that of the female experience. It is more that unspoken area — internalised
feelings — conscious or unconscious. It is hard to express this without resorting to cliches, but
another way of putting it is to say that there was a change from issue-related themes to reflec-
tion upon existence itself — usually using single female figures. Of course, this is just broadly
speaking and reflects just one side of my work, albeit a 'largish' one.

*Talk about how you work in bringing a painting into being. What are the ingredients in your
creative process that move a work from impulse to form?*

Often the structure of an individual work may come out of nowhere, like *Piano Woman* and
Woman Over Landscape, for example. They also come out of the blue while I'm sketching —

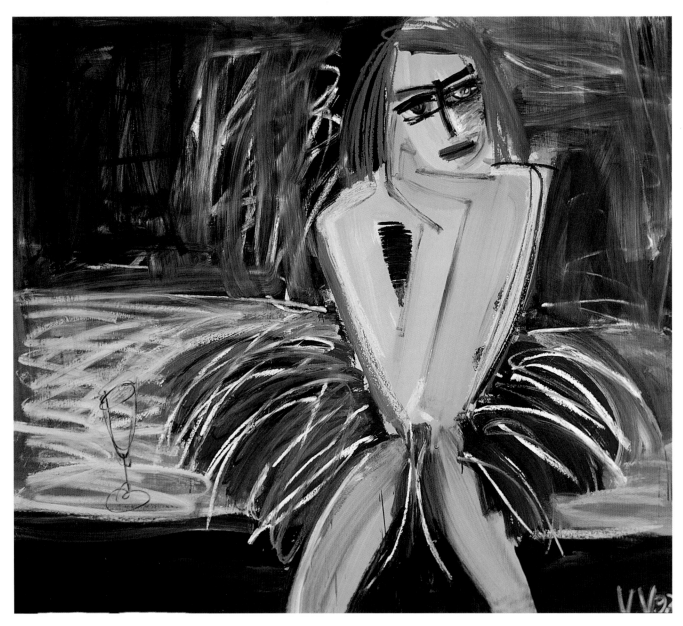

PLATE 160

small sketches which are more like doodles. Sometimes the thoughts and sketches 'marry' — and I'm not sure what came first. At other times, I just start with a plain board, with nothing in mind, and work with what emerges spontaneously — having thoughts along the way. Naturally, many things can emerge, which can be removed or rearranged at any moment. It is important to be open to *anything* that may happen, and in that sense, one must be *fearless* while working. The pictorial elements of my work are about the interrelationship between individuals, their gestures and nuances of human interaction.

I always play music while I'm working — mainly operas. I have realised that I require a lot of energy when I'm working — perhaps music is tied in with this.

You are well known for the female imagery in your works. Are there other ways that being a woman has impacted on your work and career in both positive and negative ways?

This is a little difficult to answer, as it's not possible to compare — not knowing what it's like as a male. A large part of my work could be seen as coming from the fact that I'm female, so therefore I have that source of content for my work, but obviously a male could say something analogous. On the negative side, I feel that people — male and female — when looking at work by females, sometimes view it with presuppositions and assumptions.

What about your role as an artist and the purpose and function of your art?

I don't see my work as having any external purpose or function. Its creation is not directed at anything else — it's not a means to an end.

'Originally there were two people in this picture — a man stood to the left — but I felt the picture was too large, so the man was cut out — literally. The mood remained the same, as did the social setting, which is a sort of party. The woman is on her own in that moment, as I suspect she was later on in the night, as the mood of her seems to be more like some sort of reverie.

I imagine those awkward, anxious moments that can arise in social situations such as parties. These anxious feelings remain internalised and are blunted by a dialogue of inner thoughts, or perhaps even lead to quiet despair. These are the sort of interval meanderings to which I referred earlier — unspoken feelings and nuances that are part of our interior world.'

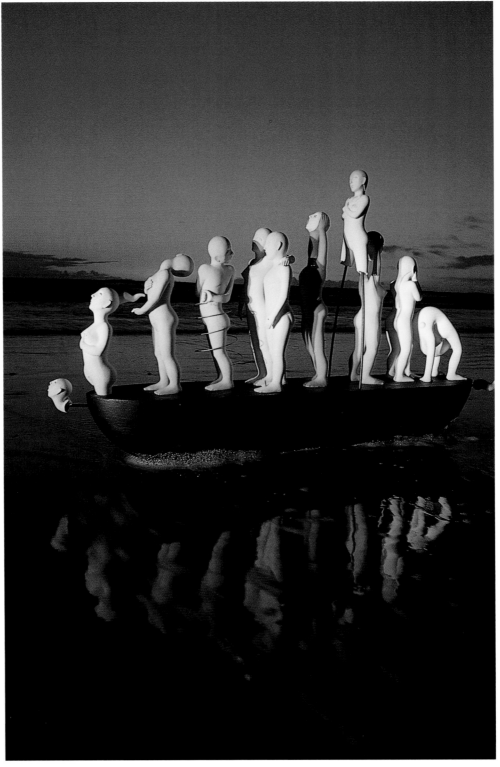

PLATE 161

Liz Williams

SCULPTOR

I don't see making art as separate from or different from any other part of life:
Sometimes it floods me
Sometimes it leaves me
Sometimes it gives me indescribable pleasure
Sometimes it depresses me
It is the same mixture, the same flux as all of life.

LIZ WILLIAMS was born in Adelaide and studied from 1960 to 1962 and 1973 to 1975 at the South Australian School of Art, gaining respectively a Diploma of Art Education and a Diploma of Ceramics. In 1977 she entered into an apprenticeship with Gwyn Hanssen-Pigott, in Kingston, Tasmania and in 1980 enrolled in the Graduate Programme at Goldsmiths College, London, deciding in 1981 to transfer to Scripps College, Los Angeles on a special student basis to work under the direction of Paul Soldner. Williams returned to Adelaide in 1982 and for a brief period taught ceramics at Darwin Institute of Technology. In 1987 she upgraded her Diploma of Ceramics to Bachelor of Design, Ceramics. Williams has held several teaching positions and currently teaches history of ceramics and ceramic sculpture part-time at the University of South Australia.

Williams archetypal figurative sculptures and ritualised installations, whether 'goddesses and dolls', mothers, lovers, cultural hybrids or others, have a serene, timeless simplicity and harmony, with a formal purity of line and enigmatic quality evocative of oriental art and ceramics, religious art, ancient Egyptian art or 'the secrets' that nature holds. Williams has a curiosity and fascination with the mystery of the human condition and its sacred connection to earth, the journey of self knowledge and discovery and the nature of relationships. She is also enchanted by the beauty of form as well as enjoying the interactive qualities of observation, sensuality, reflection and independence in bringing forth works that both celebrate Woman and the liberation of the human spirit.

Williams held her first one-person exhibition at Scripps College, California, USA in 1981, followed by several others in South Australia, Sydney and Melbourne, with the most recent in 1994. She has also participated in a number of selected group exhibitions from 1983 to 1994. She is represented in the collections of the Art Gallery of South Australia, the National Gallery of Australia, the Queensland University of Technology, the Fred Marer Collection, Los Angeles, and in a number of private collections.

PLATE 161
SHIP OF LOST SOULS, 1992
Clay, metal, wood and bitumen, Length: 2.4 m,
Height: 1.3 m, Location: Grange Beach, South Australia,
Photograph: David Campbell, Courtesy of the artist

Could we begin by discussing the important developmental influences in your creative journey as an artist — the pivotal experiences, key people, seminal works and ideas and major inspirations?

It is hard for me to attribute very specific influences to my work. There are obviously preferences, experiences, times, places, people and objects that have been influential. During life one meets a handful of people at the right place and time who are an inspiration and hence become influentially important.

When I was fourteen, I had a botany teacher who so inspired me that identifying and classifying plants became an integrated habit in my daily life, in fact, an obsession. I have also been lucky that two of my ceramics teachers fall into that inspirational category: Milton Moon, my first teacher, and Paul Soldner, my last teacher. I left Soldner recognising that I would never want, or need, another teacher — it was entirely up to me.

Earlier than my time with Soldner, in 1973, I had returned to the South Australian School of Art and enrolled in ceramics and sought a teacher. Previous attempts to throw had left me discouraged, concerned that I was dyslexic and worried about my hand–eye coordination. At this time, I worked under the guidance of Milton Moon and, with his assistance, my fears were quickly allayed. Learning was simple and straightforward — by examples of self discipline, enthusiasm and the creation of personal challenges. There was also the camaraderie of shared endeavour, practice and supported results. There were stories and philosophies — it was an energetic and fruitful time for me.

The Jam Factory was the next destination of most graduating potters, and although it had a rather lunchroom-type atmosphere, it was not without concentrated and consolidated work. Then, grappling with the Leach and Cardew notion that it was going to take all of ten years to really become a potter, I wondered if further study may accelerate the process, so I took up a traineeship with Gwyn Piggott in Kingston, Tasmania. In the shadow of the mountain it was always cold. However, in the workshop, I was warmed by a potbelly stove and lots of milky coffee as I learned about glaze calculation and workshop practice and watched Gwyn's beautiful pots come into being, hoping that, by osmosis, I was absorbing some of that magic — but still it didn't happen!

I returned to Adelaide still with a sense of lacking. I wanted to make a bowl that sang like the Korean rice bowl so revered by the Japanese tea masters and so loved by Bernard Leach; I wanted to make something with the stillness and dignity of the white fluted Sung bowls at the National Gallery of Victoria, which I always visited when in Melbourne. I decided to go to London and look around for a residency. So in 1980 I found myself artist-in-residence at Goldsmith's College — an extension of London University. I embraced raku with enthusiasm — its immediacy was engaging. I enjoyed playing around with that and with other processes and I could make a nice bowl, but it wasn't so different from anyone else's. I wrestled with this problem for a long time.

In the summer of 1980 I took one of those cheap Freddie Laker flights to the USA to visit friends in Aspen, Colorado. In the mountains, as I listened to the music of the Summer Festival, ate, walked and drew, I recalled that Paul Soldner lived in this area. I decided to visit him and the outcome was an invitation to be a special student at Scripps College, Los Angeles in the spring of 1981. And in just the same way as a handful of special people stand out in one's life, so do a handful of unexpected events.

In the Scripps studio, there were no instructions and no aesthetic advice. Soldner refused to participate in decisions unless they were simply technical. The studio was open twenty-four hours a day, seven days a week, and I averaged twelve to fourteen hours a day for the eight month period I was there. Discussion took place over coffee — these endless attempts to define art were vital and often thrilling. I finally found that connection in clay that I had been seeking. I suppose if I hadn't found it then, I would have given up clay, as it had been such a

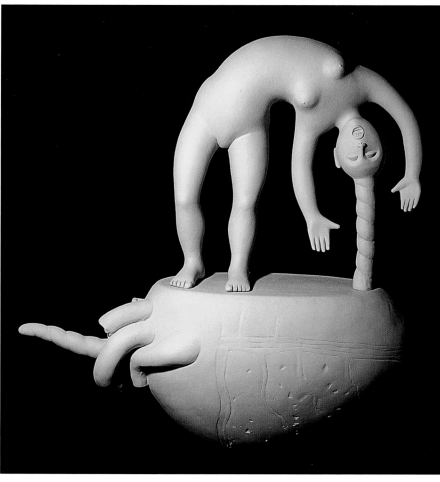

PLATE 162

PLATE 162
WOMAN CAUGHT UP IN HER HEART, 1994
White stoneware, 71 cm (h) x 78 cm (w), Courtesy of the artist

'*Woman Caught Up in Her Heart* came from being surrounded by women friends who, for one reason or another, had lost their primary relationship and were having a great deal of difficulty in resolving their emotional problems. For a brief period, I seemed to be some sort of catalyst to these people. The piece was a result of being amazed at seeing this emotional struggle and suffering in so many women of my own age. These were not my concerns — I made the piece for my friends, as a response to their kind of agony. The heart so often predominates in relationships and at the same time it's like a huge type of irrationality that really takes over people's lives. People lose their judgement in an emotional sense and the whole thing turns into a madness.

Woman Caught Up In Her Heart was my response to that type of madness, observed in several people in a short space of time. I think that they were actually dominated by infatuation, which has nothing to do with the heart or love. The way I feel about my mother, my stepdaughter, my niece or nephew — that is really love. I think this emotional enmeshment is something else. For me, the heart is an emotion, I don't call that love. Emotion is on the surface. People hang onto that feeling desperately for some reason — it's a universal thing. I think it's good to have a big heart, to have a big space in there that feels warm and generous, and to love, but I don't think that that is only the heart — I think it is spirit too. A lot of people lose connection with the spirit.

Woman Caught Up In Her Heart was hard to make. It took me about two weeks to get the figure up, and then three days to get the surface I wanted. The organs of the heart are shown here, and the hair comes through as part of the organs. The piece followed a similar work that I called *Woman Miss Boat*, which was autobiographical in that sometimes I feel that I've missed the boat, and sometimes I worry about not having the security that most people of my age seem to have.

This sculpture is representative of my recent work concerns, which are to do with how we as human beings *actually* are. It is about how we as women often give away our hearts, and in the process of doing that, we often give away our soul. We give up our rights, we even give up our judgements — we give up all sorts of things to someone for some reason we think is more powerful or more important.'

battle. However, I had taken up clay as a means of earning some money, of being independent, having a lot of fun and doing something with my hands.

At Scripps, I started to play around a lot more. Instead of making a pot, as I had been doing before, I started hand-building. This class was responsible for my transferring clay from a domestic context to an abstract or expressionist context. The students there were very interested in the painters of the time — they were working through their own ideas and were very concerned with the immediacy of the expression. This was something Bernard Leach had also been interested in as had the Japanese ceramist, Hamada [Shoji Hamada, 1894–1984, the most celebrated Japanese potter of the twentieth century]. This immediacy of making decisions as you went coincided with the principles of abstract expressionism.

What was the essential inspirational impact of Soldner and this turning point experience at Scripps?

Soldner instilled in me a sense of personal responsibility and the idea that academic study, other than in areas that were really pertinent to what you were doing, was not what ceramics or art were about — it was about *doing*. It was nothing to do with learning things and being clever. The fact that Soldner never gave anybody aesthetic advice about anything was so frustrating, though. At times I thought he didn't even know I was in the class! One evening I said to him: 'What do you think about what I am doing?' He replied: 'What do you mean, what do I think about it — what do *you* think about it? You're doing what you're doing, and the only thing that is important at this moment is the *doing*. I'm not going to give you any aesthetic input — I don't want to influence you in any way at all.' An occasional and quietly spoken word, however, soon made it apparent to me that Soldner was aware of my every move with the clay.

PLATES 163–170

GODDESSES, SELF PORTRAITS AND DOLLS, July 1993 to February 1994

Terracotta, pink earthenware, or white stoneware and mixed media, all clay, 80 cm (h), Courtesy of the artist

'These figures were made for an exhibition at Lyall Burton Gallery, Melbourne in February 1994.

Plate 163 was the first piece in the series of figures that I made. It was influenced by the goddess figure *The Venus of Willendorf*, with her nurturing body, big hips and big belly. I tried to unify the form and find something personal.

Plate 164 was based on my prepubescent stepdaughter, Sarah.

Plate 165 is my Diva doll, who has arms and legs that move, her head swivels and she has a plait at the back. I don't know where she came from — she just popped into my head.

Plate 166 is one of the "portraits" — with superimposed ears. I started this concept of the separation of the head from the body because I sometimes feel like that myself. It's about listening to the senses and not to the "head".

Plate 167 is Prima Vera, based on an Iranian goddess whose name I forget and which looks more like a bird than this figure does. I started to make the skirt and suddenly it became very "springtime" and floral.

Plate 168 is based on an Egyptian goddess. She has little horns in her head and I put a garnet in her navel. She is quite sensuous.

Plate 169 is a China doll, again referenced from a goddess image with childbearing hips and a narrow body.

Plate 170 is based on the Botticelli *Venus* — an image I've used a lot in my work. The position of the hands is about sensuality.'

I had an exhibition at Scripps — at the end of my period there — and Soldner just quietly sat around. We had Australian beer and pavlovas, and all the class was there. Soldner told some of my colleagues that I had gone along well, that he was impressed by my rate of development, but he never ever told me directly — it was always secondhand. This whole experience taught me the process was about going inward — though this was only the beginning!

My first ten years were in part influenced by these two teachers. Milton's knowledge and passion for oriental traditions and Soldner's respect for the directness and immediacy of abstract expressionism.

What have been other significant influences on your work?

Travelling has been very important to me. Travelling alone — to be in the centre of the new and foreign experience, to be disconnected from that which is familiar — to be going into the unknown, not recognising oneself or anticipating one's own responses. I went to London in 1979 and came back to Australia at the beginning of 1982. In that time away I was very affected by the cosmopolitan nature of London and San Francisco, where I spent a lot of time. In San Francisco, the Chinese and Negro faces predominate and it is a strange mix of these two things that finds its way into my work.

I was fortunate enough to receive a visual arts grant to travel to Mexico in 1991. I was excited by the idea of going to Mexico but also thought it might be frightening — but it turned out that it was San Francisco that was frightening to me, with people living on the streets etc. In Mexico, I felt totally comfortable and never under threat. I was impressed by the way the people communicated and looked after each other, the way men looked after children. I also loved the simplicity. These are things that endeared me to that level of the culture.

I like to look at life — I think I am a bit of a voyeur, but it is of real interest to me. Watching people, observing human relationships and human nature are a pastime and are further influenced by my preferences and interests in literature. The writing that has interested me recently is the magic realism of Central and South America, where dream and reality have the same importance and both become illusion and reality.

How have all these experiences and interests fused in your art work in terms of your own creative process — what motivates and moves you from idea and feeling into creating form?

The way I approach my work seems so simple and so logical. If a concern recurs and engages me in the process of dreaming, the form will slowly become clear in my mind, as will the appropriate process and techniques. I actually like the sensation of dreaming and ruminating, and I enjoy the feeling of not really knowing where the idea has come from — that it remain open and a little bit mysterious. Then the resolution and making the work obsesses me. I have always relied on the sensation of my feelings to inform me, rather than my intellect. I tend to simplify and reduce things. I find myself compelled to express in a distilled, succinct, concentrated and resolved form — not that I particularly admire this form of expression, but for me it seems like the only way. I love form — I'm addicted to it. I've always formalised my work. It always looks like I've been involved with it. *It's a sort of ritual* — I dream and think about my work, but I don't always know how it will finish up.

There is a slow motion to my work. I still occasionally dream of a surprising leap into the unknown. And, regardless of my interest in theory and discussion, the fact remains that, for me, the act of working is an experience of its own, somehow separate from the process of thought.

Historically, I have always loved that art which existed prior to high art; it was often anonymous and seems to me more like an act of devotion than a grand statement, somehow more human, more accessible: Pre-Hispanic, African, the early Greek figure, the Kouros figure, early Roman painting and mosaic, Gothic, pre-Renaissance. I am also drawn to forms of folk art because this art permits basic responses to life. Also, much Eastern art has quietly thrilled me.

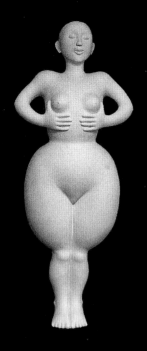

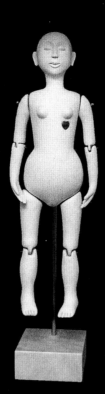

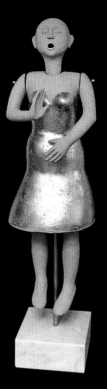

PLATE 163

PLATE 164

PLATE 165

PLATE 166

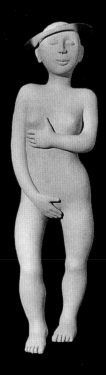

PLATE 167

PLATE 168

PLATE 169

PLATE 170

Vermeer and Modigliani retained that quietness, that stillness — or internalness — in the figures they painted. The same quality can be found in the sculptures of Matisse and Brancusi. Although I admire and aspire to that quality, and there are people who work specifically with that sense (which doesn't belong to a specific time), I've never actually tried to create it — I don't always know consciously what I'm going to do. It is only after having worked like this for eight years that I can look back and see what I've done.

Could you talk about the progressions and transitions in your work?

I had been making bowls in London, then I made bowls in Adelaide that were influenced by fourteenth/fifteenth century Yi Dynasty (Korean) ceramics — my *big, big* passion. The carving was very intricate and I often used the image of the lotus. I developed this obsession with oriental ceramics when Milton Moon was my teacher. For some time, if I had an opportunity to go to a museum, I would choose an oriental art museum as opposed to a contemporary art museum (now it's the other way around). I was, and still am, interested in stillness. After these bowls, I started to make raku bowls and containers, and I started painting with a brush. Then I went to Scripps and stopped throwing pots and started to invest these slab pieces with something a bit more fanciful (for example, I had a thing about dragons for a while).

I returned to Australia with a fragile grasp on the delicate thread of my own expression in clay. It was apparent that I needed to find my own personal way with clay. For two years I worked in relative isolation, in an attempt not to be distracted from my own thread. I exhibited quite a lot in the first year or so, but then I pulled back. I didn't read ceramics magazines or explore what other people were doing — I just worked. Initially, I made bowls, some of which slotted together like jigsaws. I also made shrines — I then forgot about making pots and I didn't think of myself any longer as just a potter. Much too slowly, and what appeared to be much too logically, I left behind the decorated vessels begun at Scripps to make objects of more personal significance. I started to work with the human form, the human torso, and I did some inlaying. Suddenly I was doing things that were magical for me.

Gradually, in 1985, sculptured figures appeared as an appropriate way in which to express my concerns. This has occupied me for the last seven years — after all, I believe that being human is more interesting, mysterious and difficult than anything else — and the figures provide me with vehicles of expression by which to convey my interests in sensation, observation and reflection.

The work is about sensuality. It's also about independence, individuality and a sense of enjoyment of yourself as a woman and being comfortable with that. Not being ashamed, not being shy. I don't know that I'm like that, but one aspires to it, and it comes out in one's art. I guess it's about women having a sense of wholeness and completeness and going through life unhampered by the emotional dross that people carry through their lives. It's about making choices for yourself — the liberation of the spirit.

As is evident in your sculptures, Woman is central to your work concerns. Have there been other ways that being a woman has impacted on your work and career as an artist?

I've never had a strong consciousness that I'm a feminist artist, although I know that on one level I am. I am a woman who is making art and I'm making art about my own personal concerns — about the way I feel. The way I feel must have a lot to do with being a woman and about being a woman now. My first entry into figure making was via the goddesses and I am sure that I was redressing all this oriental work. The imagery in Chinese, Japanese and Korean art tends to be male, and I think I was responding to that. There were enough gods around — I thought there should be some more goddesses! But it was actually quite a long time before this whole goddess thing started to erupt. Although I was doing them in 1985–1986, the latest works are the only figures I actually call Goddesses, and I didn't even call them such in the beginning.

I'm really interested in timelessness and I'm interested in historic periods that are 'anonymous' — the periods that occurred before specific explosions in art. If you look at the Greek quarry figures, for example, there is an internalness to them. They may all look similar, but you can see the internal aspects.

How do you see your role as an artist and the function and purpose of your art work?

I don't see making art as separate from or different from any other part of life:

> Sometimes it floods me
> Sometimes it leaves me
> Sometimes it gives me indescribable pleasure
> Sometimes it depresses me

It is the same mixture, the same flux as all of life.

Making art always remains difficult for me. I work in the isolation of my own understanding, which can be so easily doubted. And yet, it is all I know. I do not entertain or engage in ideas that have no personal relevance to me. I don't want to experience the voice of anyone else in my head and in my decision making. I have an underlying desire not to belong, which is in opposition to the conventional socialisation of my upbringing — to belong. However, I still don't believe that I take full advantage of this freedom, both in terms of myself or my art.

When I made pots, I learned skills and thought a lot about aesthetics but never lost myself in the activity. For some time I didn't recognise this, but felt there was an important element missing. On the outside it looked fine, but on the inside I experienced a gap, a hole. The gap was closed as a consequence of working to the exclusion of everything else — dreaming and making my dreams — discovering a thread, my own voice. I began to disappear into the activity and come out of the other end feeling full of having been alive. It was like travelling; it afforded me the same sense of journey, discovery and even a sense of anonymity — in the sense that I disappeared into the activity.

The visual stimulation of both the natural world and manmade objects is only one aspect of my inspiration. Unconscious promptings interest me a lot. The acknowledgment of weakness and the discovery of personal power are two sides of the same coin and both interest me equally.

In terms of visual art, my current interest has centred around cultural hybrids — for example, the mix of pre-Hispanic, Spanish and recent Western influences in the work of Central American artists. Also, the fusion of Aboriginal and Western art in Australia.

My greatest difficulty as a sculptor is to convey illusion — so much of my concern is to do with that which is internal and not obviously or readily seen. I wrestle with ways of conveying that which is internal. I recognise that such concerns can be more easily communicated in 2-D; somehow by making things 3-D, they become more tangible and less mysterious. My major concerns are with the internal mysteries of life and personal discovery.

My earlier work was about balance, being whole and integrated. These concerns grew not only out of idealistic dreams but also out of the physical practicalities of coiling a figure in clay. However, it is true to say I have been a dreamer but life is not like idealistic dreams — we are separate, incomplete, out of balance, fearful and always yearning. It is these latter concerns that have more recently become the content of my work. All my life I have been more interested in making art than any other activity as a way of entertaining myself.

To make objects which sing remains my challenge. And after twenty years, if nothing else, I consider it an okay thing to be working in clay.

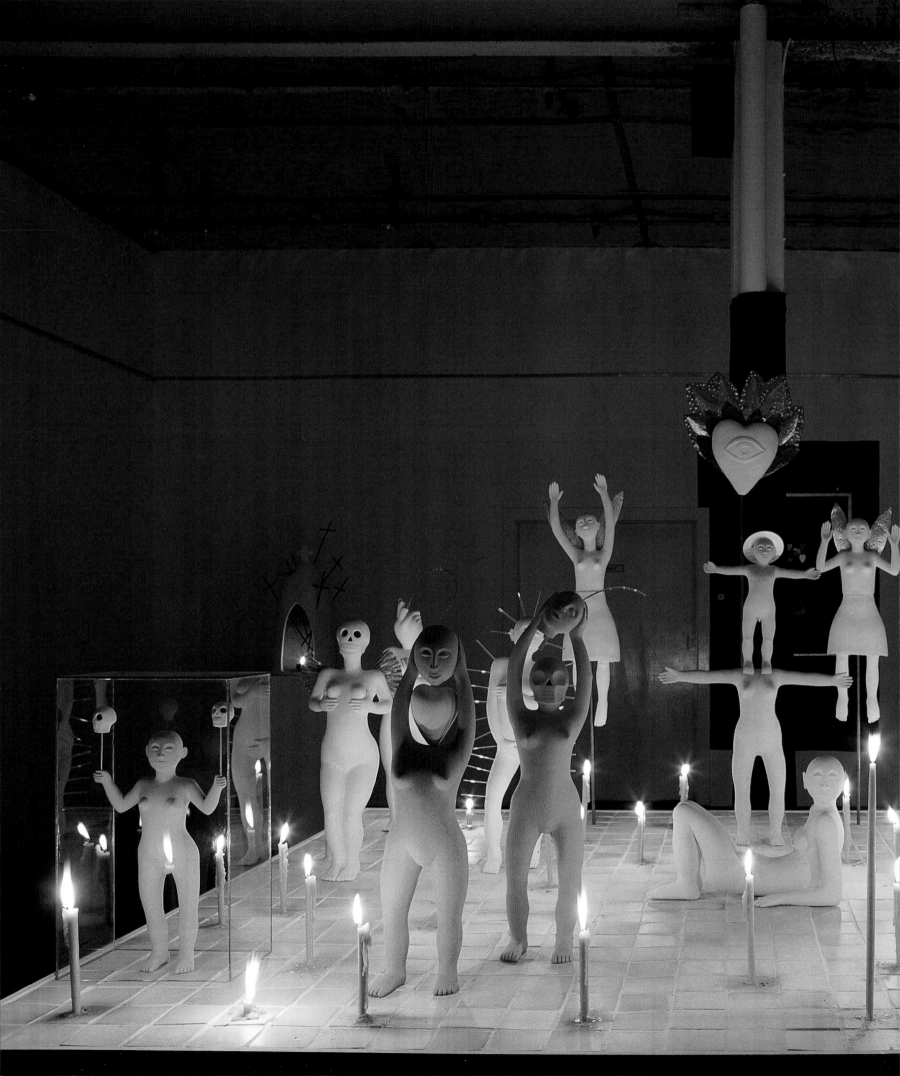

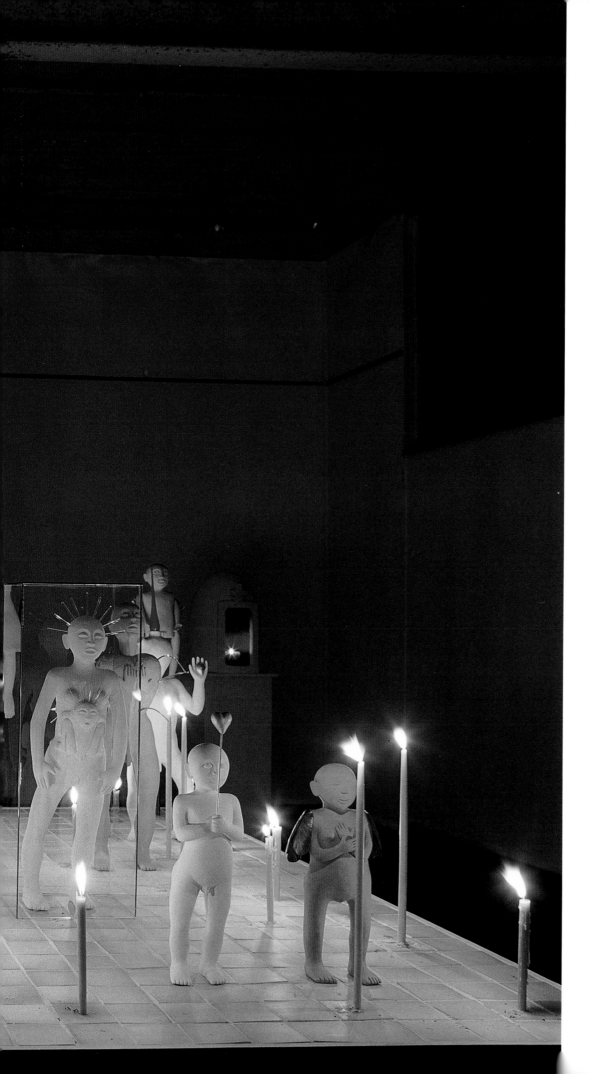

PLATE 171

RECUEDOS, 1993
Sculptural installation, Adelaide Central Gallery, July 1993

'*Recuedos* was one of the only two "multiple" works I have
done. "Recuedos" is the Spanish word for "remembering"
and the show was the result of my trip to Mexico in 1991.
I had been to Spain when I was twenty-four years old
and I was interested in how paganism had crept into
Christianity there. I was so fascinated by it that I knew
I had to visit Mexico.

During that Mexican trip, I was impressed by the
indigenous people and the intensity generated by the
large numbers of people living there. The churches in
Mexico were so beautiful and so embellished with gilt and
paint. In one church I visited, all the figures looked like
indigenous people, but they were dressed up like saints
— my work stemmed out of that. Also striking was the fact
that the Church and the village square were one and the
same — and both were quite commercial. The village
square or "zocalo" is a central meeting place for traditional
Mexican people. I became fascinated by these people
and enjoyed watching them. I was also intrigued by the
marriage between the indigenous and the Christian
elements — that was my starting point. In contemporary
Mexico, they allow the Westernised attitudes to co-exist
with the indigenous and the Catholic. Culture is in
transition all the time, and I found this very exciting.

Another thing I found endearing is that the Mexican
people ritualise and mythologise life in a way that it can be
handled. They accommodate their neuroses and psychoses
within a kind of structure. I love the ritualistic way in which
that is done, even though I could never do it myself, which
I know is a contradiction. I enjoy it, I love to look at it and
try to understand it, but I am glad I wasn't born into it.

Indigenous people have a wisdom that we have no idea
about and have knowledge that we lack. I can understand
why people need to identify their Aboriginality or whatever,
because it gives you a kind of *connection* — a long-established
connection. We live in a culture geared to being the fastest,
the quickest, the biggest and the brightest. Our Western
way of life is structured on individual expression, and
although I admire indigenous ways, I am acculturated to
that individualism.

When I left Mexico, I went to New York and wandered
around the galleries in Soho. I found the art so cold,
calculated and predictable — I felt I'd seen it all before. I
didn't feel that with the contemporary art in Mexico — it
was so exciting, you re-engage with it.

Anyway, for the *Recuedos* exhibition, the figure sculptures
were placed on a ceramic tiled platform that was approxi-
mately 3 metres square and 80 centimetres high. A lightly
shaded, tiled, "cross" was integrated within the square.
There were seventeen figures in the installation, all placed
ceremonially on the square. I gave them names such as
Angel Heart, Erindera, Guardian and *Skull Woman*. Four wall
pieces were each placed in a way so as to extend the image
of the central cross and were given names such as *Cross of
Crosses* and *Cross of Hearts*. The guardian figure, called
Chacmool, was placed in the centre of the *zocalo* at the point
where the cross intersects. The figures placed around the
guardian embodied aspects of the fundamental realities
and struggles of daily life.

Throughout the exhibition, candles were frequently lit
and left to burn, in accordance with the ritual presentation
of the installation. Some visitors elected to place flowers
before the figures and there was a spontaneous closing
ceremony, which was fantastic.

The work was about sensation, emotion and all the
things that were quite tangible for me — materials and
processes. A lot of the work is self referential and about
being a woman — that is just the way it emerges.'

Biographies

DAVIDA ALLEN

1951 Born in Charleville, Queensland

Studied

1970–72 Attended Brisbane College of Art

Solo Exhibitions

1973 Ray Hughes Gallery, Brisbane
1975 Ray Hughes Gallery, Brisbane
1978 Ray Hughes Gallery, Brisbane
1982 Ray Hughes Gallery, Brisbane
1985 Ray Hughes Gallery, Brisbane
1986 National Art Gallery of New Zealand, and
 touring to four other
 New Zealand museums
 Ray Hughes Gallery, Sydney
1987 Ray Hughes Gallery, Sydney
 MOCA, Brisbane (survey show)
1991 Australian Galleries, Sydney and
 Melbourne, and MOCA,
 Brisbane (exhibitions to coincide with the
 launch of the art book *What is a Portrait?:
 Images of Vicki Myers* and its companion
 novel *An Autobiography of Vicki Myers*)
1993 Australian Galleries, Sydney
1996 Rockhampton Regional Art Gallery,
 Queensland
1996 Australian Galleries, Sydney and
 Melbourne

ANNETTE BEZOR

 Born in Adelaide

Studied

1974–77 South Australian School of Art, Adelaide
 Diploma of Painting

Solo Exhibitions

1983 Round Space Gallery, Adelaide
1986 South Australian School of Art Gallery,
 Adelaide

1986 Roslyn Oxley9 Gallery, Sydney
1988 Roslyn Oxley9 Gallery, Sydney
1988 Contemporary Art Centre, Adelaide
1989 Luba Bilu Gallery, Melbourne
1990 Roslyn Oxley9 Gallery, Sydney
1990 Luba Bilu Gallery, Melbourne
1991 Contemporary Art Centre, Adelaide, and
 touring (survey show)
1991 Luba Bilu Gallery, Melbourne
1992 Roslyn Oxley9 Gallery, Sydney
1993 Luba Bilu Gallery 2, Melbourne
1994 Greenaway Art Gallery, Adelaide

MARION BORGELT

PHOTOGRAPH: MELISSA COOTE

1954 Born in Nhill, Victoria

Studied

1973–76 South Australian School of Art, Diploma
 of Painting
1977 Underdale College, Adelaide, Diploma of
 Education
1979–80 New York Studio School, postgraduate
 studies
1986 Canberra School of Art — artist-in-
 residence
1989–96 Lives and works in Paris, France

Solo Exhibitions

1976 Open Studio Exhibition, Adelaide
1978 Bonython Gallery, Adelaide
1981 David Reid Gallery, Sydney
1982 Axiom Gallery, Melbourne
 Roslyn Oxley9 Gallery, Sydney
1983 Roslyn Oxley9 Gallery, Sydney
1984 Christine Abrahams Gallery, Melbourne
1985 Roslyn Oxley9 Gallery, Sydney
1986 Christine Abrahams Gallery, Melbourne
1986 Michael Milburn Galleries, Brisbane
1986 Roslyn Oxley9 Gallery, Sydney
1988 Roslyn Oxley9 Gallery, Sydney
1988 Milburn & Arte, Brisbane
1989 Christine Abrahams Gallery, Melbourne
1991 Christine Abrahams Gallery, Melbourne
1991 Macquarie Galleries, Sydney
1993 Christine Abrahams Gallery, Melbourne

1993 Macquarie Galleries, Sydney
1994 Sherman Goodhope, Sydney
1995 Christine Abrahams Gallery, Melbourne
1996 Sherman Goodhope, Sydney

JOAN BRASSIL

1919 Born in Sydney

Studied

1937–39 Sydney Teachers College
1940–45 East Sydney and Newcastle Technical
 Colleges
1969–71 Power Institute of Fine Arts, Sydney
1981–82 Alexander Mackie College of Advanced
 Education
1988–91 University of Wollongong (DCA)

Solo Exhibitions

1975 Bonython Gallery, Sydney
1976 Sculpture Centre Gallery, Sydney
1977 Sculpture Centre Gallery, Sydney
1978 Sculpture Centre Gallery, Sydney
1982 Roslyn Oxley9 Gallery, Sydney
1983 Roslyn Oxley9 Gallery, Sydney
1984 Roslyn Oxley9 Gallery, Sydney
1985 Roslyn Oxley9 Gallery, Sydney
 Wollongong Art Gallery
1986 Roslyn Oxley9 Gallery, Sydney
1987 Araluen Art Gallery, Alice Springs
1988 Roslyn Oxley9 Gallery, Sydney
1990 Australian Centre for Contemporary Art,
 Melbourne (4th Australian Sculpture
 Triennial Retrospective)
1991 Campbelltown City Art Gallery
 (Retrospective)
1992 The Art Gallery of New South Wales
 (installation)
1993 Australian Sculpture Triennial, CCP,
 Melbourne

KATE BRISCOE

1944 Born in England
Studied
1960–64 Portsmouth College of Art, National
 Diploma in Design
1964–65 Leicester College of Art, Art Teachers
 Diploma
1989–91 College of Fine Arts, University of New
 South Wales, Master of Fine Art
Solo Exhibitions
1968 Harnham Gallery, Salisbury, UK
1971 Bonython Gallery, Sydney
1973 Hogarth Gallery, Sydney
1975 Hogarth Gallery, Sydney
1976 Hogarth Gallery, Sydney
1978 Bartoni Gallery, Melbourne
1978 Art of Man Gallery, Sydney
1979 Art of Man Gallery, Sydney
1981 Bloomfield Gallery, Sydney
1984 Robin Gibson Galleries, Sydney
1985 Robin Gibson Galleries, Sydney
1988 Bonython Meadmore Galleries, Sydney
1988 Gallery Gabrielle Pizzi, Melbourne
1991 The Works Gallery, Sydney
1993 Foyer Gallery, University of Western
 Sydney/Macarthur
1994 Access Gallery, Sydney
1995 Access Gallery, Sydney
1995 Gilchrist Galleries, Brisbane

HEATHER ELLYARD

PHOTOGRAPH: JOHN BRASH

1939 Born in Boston, Massachusetts
Studied
1961 Bachelor of Science, Simmons College,
 Boston
1961–63 Boston School of the Museum of Fine Arts
Solo Exhibitions
1974 Macquarie Galleries, Canberra
1977 Abraxas Gallery, Canberra
1981 Roundspace, Adelaide
1982 Roundspace, Adelaide
1983 Roundspace, Adelaide
1985 Bonython Meadmore Gallery, Adelaide

1987 Bonython Meadmore Gallery, Adelaide
1988 Bonython Meadmore Gallery, Adelaide
1989 Painters Gallery, Sydney
1991 Luba Bilu Gallery, Melbourne
1993 Luba Bilu Gallery, Melbourne
1993 Greenaway Art Gallery, Adelaide
1995 Greenaway Art Gallery, Adelaide

MERILYN FAIRSKYE

1950 Born in Brisbane
Studied
1970–72 National Art School, East Sydney
 Technical College
1974–75 Alexander Mackie College of Advanced
 Education
Solo Exhibitions and Installations
1980 Arts Workshop, University of Sydney
1982 Filmmakers Cinema, Sydney
1985 Roslyn Oxley9 Gallery, Sydney
1985 Union Street Gallery, Sydney
1987 Praxis, Fremantle
1987 Roslyn Oxley9 Gallery, Sydney
1987 Institute of Modern Art, Brisbane
1987 Australian Centre for Contemporary Art,
 Melbourne
1987 Performance Space, Sydney
1987 Chameleon Gallery, Hobart
1988 Roslyn Oxley9 Gallery, Sydney
1989 PS1 Museum, New York
1989 Roslyn Oxley9 Gallery, Sydney
1989 Queensland Art Gallery, Brisbane
1990 Christopher Leonard Gallery, New York
1991 William Mora Galleries, Melbourne
1991 Roslyn Oxley9 Gallery, Sydney
1992 William Mora Galleries, Melbourne
1992 Artis, Auckland, New Zealand
1993 Institute of Modern Art, Brisbane
1993 Roslyn Oxley9 Gallery, Sydney
1993 Artspace, Sydney
1993 Christopher Leonard Gallery, New York
1993 William Mora Galleries, Melbourne
1994 Perc Tucker Regional Art Gallery,
 Townsville, Queensland
1995 Savode Gallery, Brisbane
1995 William Mora Galleries, Melbourne
1996 Savode Gallery, Brisbane
1996 Stills Gallery, Sydney

JUTTA FEDDERSEN

1931 Born in Germany
Studied
1953–56 Handwerkskammer, Bremen, Diploma in
 Fibre Art
1985–88 City Art Institute, Sydney, Master of Arts
 (Visual Arts/Sculpture)
Solo Exhibitions
1967 Hungry Horse Gallery, Sydney
1968 Johnstone Gallery, Brisbane
1970 Bonython Gallery, Sydney
1971 Realities Gallery, Melbourne
1972 McClelland Regional Art Gallery,
 Melbourne
1972 Bonython Galleries, Sydney
1974 Realities Gallery, Melbourne
1975 Bonython Galleries, Sydney
1977 Realities Gallery, Melbourne
1981 Roslyn Oxley9 Gallery, Sydney
1987 Coventry Gallery, Sydney
1988 Ivan Dougherty Gallery, Sydney (two
 installations)
1988 New England Regional Art Gallery,
 Armidale, NSW
1989 Coventry Gallery, Sydney
1991 Coventry Gallery, Sydney
1993 Coventry Gallery, Sydney
1995 Coventry Gallery, Sydney

FIONA FOLEY

PHOTOGRAPH: GREG WEIGHT

1964 Born in Maryborough, Queensland
Studied
1982–83 East Sydney Technical College,
 Certificate of Art
1983 St Martin's School of Arts, London,
 visiting student
1984–86 Sydney College of the Arts, Bachelor of
 Visual Arts
1987 Sydney Institute of Education /
 University of Sydney
 Diploma of Education
1988 Griffith University, Brisbane, and
 Maningrida, Northern Territory artist-in-
 residence

Solo Exhibitions

1988	Roslyn Oxley9 Gallery, Sydney
1988	Griffith University Art Gallery, Brisbane
1989	Maningrida Arts and Crafts Centre, North Territory
1989	Roslyn Oxley9 Gallery, Sydney
1991	Roslyn Oxley9 Gallery, Sydney
1992	Roslyn Oxley9 Gallery, Sydney
1993	Australian Centre for Contemporary Art, Melbourne
1994	Roslyn Oxley9 Gallery, Sydney

GABRIELA FRUTOS

1964	Born in Uruguay

Studied

1983–86	Wollongong University, Bachelor of Creative Arts
1987	Wollongong University, Diploma of Education

Solo Exhibitions

1990	Coventry Gallery, Sydney
1993	Coventry Gallery, Sydney
1995	Coventry Gallery, Sydney
1996	Coventry Gallery, Sydney

ELIZABETH GOWER

PHOTOGRAPH: JOHN R. NEESON

1952	Born in Adelaide

Studied

1970–73	Prahran College of Advanced Education, Melbourne, Diploma of Art and Design
1974	Mercer House Teachers College, Diploma of Education

Solo Exhibitions

1976	Central Street Gallery, Sydney
1976	Ewing and George Paton Gallery, Melbourne
1977	Powell Street Gallery, Melbourne
1980	Axiom Gallery, Melbourne
1981	Coventry Gallery, Sydney

1982	Institute of Modern Art, Brisbane
1984	Christine Abrahams Gallery, Melbourne
1987	Lennox Street Gallery, Melbourne
1990	Luba Bilu Gallery, Melbourne
1991	Queensland Art Gallery, Brisbane
1992	Bellas Gallery, Brisbane
1993	Sutton Gallery, Melbourne
1994	Contemporary Art Space, Canberra
1995	Ian Potter Gallery / University of Melbourne and touring

PAT HOFFIE

1953	Born in Edinburgh, Scotland

Studied

1971–73	Kelvin Grove College of Advanced Education, Diploma of Teaching
1974–75	Queensland College of Art, Diploma in Fine Art
1986	Master of Creative Arts, Wollongong University
	Currently enrolled in PhD

Solo Exhibitions

1974	Cellars Gallery, Brisbane
1975	Kelvin Grove College of Advanced Education Gallery, Brisbane
1976	Design Arts Centre, Brisbane
1977	Design Arts Centre, Brisbane
1980	Kelvin Grove College of Advanced Education Gallery, Brisbane
1983	Galerie Baguette, Brisbane
1986	Long Gallery, Wollongong University
1987	Roz MacAllan Gallery, Brisbane
1988	Queensland Art Gallery
1988	Roz MacAllan Gallery, Brisbane
1989	Contemporary Art Centre of South Australia, Adelaide
1989	Coventry Gallery, Sydney
1990	Institute of Modern Art, Brisbane
1990	Coventry Gallery, Sydney
1992	Coventry Gallery, Sydney
1993	Penguin Gallery, Manila
1993	Australian Centre for Contemporary Art, Melbourne
1993	Australia Centre, Manila
1993	Baguio Arts Centre, Baguio, Philippines
1994	Adelaide Biennial of Australian Art (5-part installation)
1995	Coventry Gallery, Sydney

INGA HUNTER

PHOTOGRAPH: JUDE MORRELL

1938	Born in England

Studied

1963	Graduated from University of Sydney, Bachelor of Arts, anthropology

Solo Exhibitions

1975	Beaver Galleries, Canberra
1977	Distelfink Gallery, Melbourne
1979	Art of Man Gallery, Sydney
1982	Jam Factory Gallery, Adelaide
1986	Australian Craftworks Gallery, Sydney
1986	Noosa Regional Art Gallery, Noosa, Queensland
1989	Beaver Galleries, Canberra
1990	Ararat Regional Art Gallery, Victoria
1991	Breewood Galleries, Katoomba, NSW
1992	Beaver Galleries, Canberra
1992	Blaxland Galleries, Sydney
1993	Breewood Galleries, Katoomba, NSW
1994	Blaxland Galleries, Sydney
1994	Customs House Gallery, Warrnambool, Victoria

ANNE JUDELL

1942	Born in Melbourne

Studied

1959–62	Royal Melbourne Institute of Technology, Diploma of Design

Solo Exhibitions

1976	Manyung Gallery, Melbourne
1977	Barry Stern Exhibiting Gallery, Sydney
1979	Barry Stern Exhibiting Gallery, Sydney
1984	Barry Stern Exhibiting Gallery, Sydney
1985	Solander Gallery, Canberra
1986	Macquarie Galleries, Sydney
1988	Macquarie Galleries, Sydney
1989	Christine Abrahams Gallery, Melbourne
1991	Charles Nodrum Gallery, Melbourne
1993	Crawford Gallery, Sydney

HANNA KAY

1947 Born in Tel Aviv, Israel
Studied
1972 Academy of Fine Arts, Vienna
Solo Exhibitions
1970 New Gallery, Tel Aviv
1971 New Gallery, Tel Aviv
1972 International Gallery, Munich
1973 Spectrum Gallery, Vienna
1974 James Yu Gallery, New York
1975 Hansen Gallery, New York
1977 Hansen Gallery, New York
1977 Yolanda Gallery, Chicago
1978 Spectrum Gallery, Vienna
1979 Graham Gallery, New York
1980 Graham Gallery, New York
1982 Grahem Gallery, New York
1983 A.S.A. Travelling Exhibition:
 Washington, Boston,
1983 Detroit, Chicago, San Francisco
1986 Contemporary Galleries, Tel Aviv
1987 Contemporary Galleries, Tel Aviv
1990 BMG Fine Art, Sydney
1992 Greenaway Art Gallery, Adelaide
1993 Michael Nagy Fine Art, Sydney
1994 Luba Bilu Gallery, Melbourne
1995 Greenaway Art Gallery, Adelaide
1995 Michael Nagy Fine Art, Sydney

LINDY LEE

PHOTOGRAPH: ROBERT SCOTT-MITCHELL

1954 Born in Brisbane
Studied
1973–75 Kelvin Grove College of Advanced
 Education, Brisbane, Diploma of
 Education (Secondary School Art)
1979–80 The Chelsea School of Art, London
1981–84 Sydney College of the Arts, Bachelor of
 Arts (Visual Arts) and Postgraduate
 Diploma (Painting)
Solo Exhibitions
1985 Union Street Gallery, Sydney
1985 343 Sussex Street, Sydney
1986 Roslyn Oxley9 Gallery, Sydney

1987 Roslyn Oxley9 Gallery, Sydney
1988 Roslyn Oxley9 Gallery, Sydney
1988 13 Verity Street, Melbourne
1989 Roslyn Oxley9 Gallery, Sydney
1990 Roslyn Oxley9 Gallery, Sydney
1990 Bellas Gallery, Brisbane
1990 13 Verity Street, Melbourne
1991 Roslyn Oxley9 Gallery, Sydney
1991 Contemporary Art Centre of South
 Australia, Adelaide
1992 Roslyn Oxley9 Gallery, Sydney
1993 Michael Wardell Gallery, Melbourne
1993 Gallery XY, University of Western
 Sydney/Nepean, Sydney
1993 Roslyn Oxley9 Gallery, Sydney
1994 Regents Court Hotel, Sydney
1994 Roslyn Oxley9 Gallery, Sydney
1995 Roslyn Oxley9 Gallery, Sydney
1996 Robert Lindsay Gallery, Melbourne

JOAN LETCHER

1955 Born in Melbourne
Studied
1976–82 Prahran Institute of Technology,
 Melbourne, Diploma of Fine Arts
Solo Exhibitions
1987 13 Verity Street, Melbourne
1989 13 Verity Street, Melbourne
1991 13 Verity Street, Melbourne
1993 13 Verity Street, Melbourne

BARBARA LICHA

1957 Born in Rawa-Mazowiecka, Poland
Studied
1979–81 State Academy of Fine Arts, Wroclaw,
 Poland
1985–88 City Art Institute, Sydney, Bachelor of Art
1989 City Art Institute, Sydney, Graduate
 Diploma of Fine Art
Solo Exhibitions
1979 Lesnica, Wroclaw, Poland
1984 Holdsworth Galleries, Sydney
1989 Access Gallery, Sydney

1990 Salon of Modern Art / Sztuka Polska,
 Wroclaw, Poland
1990 Access Gallery, Sydney
1991 Access Gallery, Sydney
1992 Access Gallery, Sydney
1994 Access Gallery, Sydney

ANNE MacDONALD

PHOTOGRAPH: TERENCE BOGUE

1960 Born in Launceston
Studied
1978–81 Tasmanian School of Art, Hobart,
 Diploma of Visual Art Teaching and
 Bachelor of Fine Arts
1981–83 Tasmanian School of Art, Hobart, Master
 of Fine Arts (Photography)
Solo Exhibitions
1986 George Paton Gallery, University of
 Melbourne
1987 First Draft Gallery, Sydney
1987 Roz MacAllan Gallery, Brisbane
1988 Roslyn Oxley9 Gallery, Sydney
1988 Contemporary Art Centre of South
 Australia, Adelaide
1991 Roslyn Oxley9 Gallery, Sydney
1992 Roslyn Oxley9 Gallery, Sydney
1993 Roslyn Oxley9 Gallery, Sydney

LUCILLE MARTIN

PHOTOGRAPH: DAVID DARE PARKER

1960 Born in Perth
Studied
1978–80 James Street Art College, Perth, Design
 Diploma
1988 Australian Film, Television and Radio
 School, Sydney, Production Design
 Diploma
1992 College of Fine Art / University of New
 South Wales, Master of Arts
Solo Exhibitions
1986 King Street Studios, Sydney
1987 Senchilds Gallery, Sydney
1989 Galaxy Gallery, Sydney
1990 Perth Galleries, Perth

1990	Holdsworth Galleries, Sydney
1990	Perth Institute of Contemporary Art, Perth
1992	Perth Galleries, Perth
1995	Perth Institute of Contemporary Art, Perth
1996	Delaney Gallery, Perth

MANDY MARTIN

1952	Born in Adelaide

Studied

1972–75	South Australian School of Art, Adelaide

Solo Exhibitions

1977	Hogarth Galleries, Sydney
1977	Bonython Galleries, Sydney
1977	Abraxas Gallery, Canberra
1978	Hogarth Galleries, Sydney
1978	Contemporary Art Society, Adelaide
1980	Robin Gibson Gallery, Sydney
1980	Solander Gallery, Canberra
1981	Powell Street Gallery, Melbourne
1983	Roslyn Oxley9 Gallery, Sydney
1983	Powell Street Gallery, Melbourne
1984	Roslyn Oxley9 Gallery, Sydney
1984	Institute of Modern Art, Brisbane
1986	Roslyn Oxley9 Gallery, Sydney
1986	Michael Milburn Gallery, Brisbane
1986	Anima Gallery, Adelaide
1988	Michael Milburn Gallery, Brisbane
1988	Ben Grady Gallery, Canberra
1989	Robert Steele Gallery, Adelaide
1990	Latrobe Valley Arts Centre, Morwell, Victoria
1990	Christine Abrahams Gallery, Melbourne
1990	Monsato Hall, St Louis, Missouri
1991	Ben Grady Gallery, Canberra
1991	Roslyn Oxley9 Gallery, Sydney
1991	Anima Gallery, Adelaide
1992	Christine Abrahams Gallery, Melbourne
1992	Ben Grady Gallery, Canberra
1993	Roslyn Oxley9 Gallery, Sydney
1994	Christine Abrahams Gallery, Melbourne Austral Gallery, St Louis, Missouri (two exhibitions) Australian Embassy, Washington DC
1995	Roslyn Oxley9 Gallery, Sydney

MATINGALI BRIDGET MATIJITAL

1935–40	Born in Wurru, south of Yaka Yaka, Western Australia (exact date unknown)

Solo Exhibitions

None to date, but has participated in several group shows, in Australia and overseas since 1989

MIRLKITJUNGU MILLIE SKEEN

1935	Born in Western Australia (approximate date only)

Solo Exhibitions

None to date, but has participated in several group shows, in Australia and overseas since 1990

LYNDALL MILANI

PHOTOGRAPH: DAVID CAMPBELL

1945	Born in Brisbane

Studied

1964–67	University of Queensland, physiotherapy
1990–91	Monash University, Gippsland Graduate Diploma of Visual Arts

Solo Exhibitions and Installations

1984	Institute of Modern Art Annex, Brisbane
1985	Queensland Art Gallery, Brisbane
1986	Artist's studio, Spring Hill, Brisbane
1987	Bonython Meadmore Gallery, Adelaide
1989	College Gallery, SACAE, Adelaide
1989	Irving Sculpture Gallery, Sydney
1989	Gryphon Gallery, University of Melbourne
1990	Queensland Art Gallery
1990	Institute of Modern Art, Brisbane
1991	Noosa Regional Art Gallery, Noosa, Queensland
1991	Linden Gallery, Melbourne

1993	Queensland College of Art Gallery, Griffith University, Brisbane
1994	Institute of Modern Art, Brisbane

GLORIA TAMERRE PETYARRE

1938–45	Born in Atnangkere region, Northern Territory (exact date unknown)

Solo Exhibitions

1991	Australia Galleries, New York Utopia Art, Sydney
1993	Utopia Art, Sydney
1995	Utopia Art, Sydney

LYN PLUMMER

PHOTOGRAPH: RODNEY BROWNE

1944	Born in Brisbane

Studied

1960–61	Brisbane School of Art
1979–81	Canberra School of Art, Diploma of Visual Arts
1982–83	Victorian College of the Arts, Graduate Diploma in Fine Art (Sculpture)

Solo Exhibitions and Installations

1974	Arts Council of Port Moresby, Papua New Guinea
1976	Arts Council of Port Moresby, Papua New Guinea
1977	Arts Council of Port Moresby, Papua New Guinea
1977	Susan Gillespie Galleries, Canberra
1981	Canberra School of Art Gallery
1982	Gallery A, Sydney
1982	Ray Hughes Gallery, Brisbane
1986	Albury Regional Art Gallery, Albury, NSW
1988	Roz MacAllan Gallery, Brisbane
1990	Artel Studio Workshop, Albury, NSW
1990	Queensland Art Gallery, Brisbane
1991	Artel Studio Workshop. Albury, NSW
1994	Benalla Regional Art Gallery, Benalla, Victoria
1994	The Exhibitions Gallery, Wangaratta, Victoria
1996	RMIT Gallery, Melbourne

MONA RYDER

PHOTOGRAPH: RICHARD STRINGER

1945 Born in Brisbane
Studied
1976–80 Queensland University of Technology,
 Brisbane, Associate Diploma of Visual
 Arts
1992 Queensland University of Technology,
 Brisbane, Bachelor of Arts (Visual Arts)
Solo Exhibitions
1980 Queensland University of Technology /
 Kelvin Grove, Brisbane
1984 University Art Museum, Queensland
 University, Brisbane
1985 Michael Milburn Galleries, Brisbane
1985 Queensland Arts Council Travelling
 Exhibition
1986 Queensland Performing Arts Centre
1987 The Centre Gallery, Surfers Paradise,
 Queensland
1987 Michael Milburn Galleries, Brisbane
1990 Roz MacAllan Gallery, Brisbane
1992 Gold Coast City Art Gallery, Surfers
 Paradise, Queensland
1995 Queensland Art Gallery

ANNEKE SILVER

1937 Born in Holland
Studied
1979 Graduated from James Cook University,
 Townsville, Bachelor of Arts
1981 Graduated from Darling Downs Institute
 of Advanced Education, Graduate
 Diploma of Education
1991 James Cook University, Townsville,
 Master of Arts
Solo Exhibitions
1972 Barefoot Gallery, Sydney
1972 Martin Gallery, Townsville
1973 Barefoot Gallery, Sydney
1974 Young Australian Gallery, Brisbane
1974 Trinity Gallery, Cairns
1975 Trinity Gallery, Cairns
1977 Bakehouse Art Gallery, Mackay

1983 Peter Lane Gallery, Sydney
1986 Martin Gallery, Townsville
1988 Painters Gallery, Sydney
1989 Perc Tucker Regional Art Gallery,
 Townsville
1990 Painters Gallery, Sydney
1991 Perc Tucker Regional Art Gallery,
 Townsville
1991 No Vacancy project, Townsville
 (installation)
1992 Griffith Park Gallery, Gold Coast,
 Queensland
1992 Grahame Galleries, Brisbane
1993 Flinders Gallery, Townsville
1993 Art Expo, Townsville
1995 Perc Tucker Regional Art Gallery,
 Townsville
1995 Gaia Gallery, Sydney

JUDI SINGLETON

1963 Born in Hornsby, NSW
Studied
1981 Underdale College of Advanced
 Education, South Australia
Solo Exhibitions
1987 William Mora Galleries, Melbourne
1989 William Mora Galleries, Melbourne
 Australian Galleries, Sydney
1990 William Mora Galleries, Melbourne
1991 William Mora Galleries, Melbourne
1992 Chapman Galleries, Canberra
1992 William Mora Galleries, Melbourne

WENDY STAVRIANOS

PHOTOGRAPH: MELISSA SHANNON

1941 Born in Melbourne
Studied
1957–60 Royal Melbourne Institute of
 Technology, Diploma of Fine Art
Solo Exhibitions
1967 Princes Hill Gallery, Melbourne
1968 Princes Hill Gallery, Melbourne
1974 Flinders Gallery, Geelong
1976 Tolarno Gallery, Melbourne

1978 Tolarno Gallery, Melbourne
1979 Ray Hughes Gallery, Brisbane
1980 Gallery A, Sydney
1982 Gallery A, Sydney
1983 Tolarno Gallery, Melbourne
1986 Tolarno Gallery, Melbourne
1987 Tolarno Gallery, Melbourne
1987 Greenhill Galleries, Perth
1989 Luba Bilu Gallery, Melbourne
1991 Adam Gallery, Melbourne
1992 Luba Bilu Gallery, Melbourne
1994 Luba Bilu Gallery, Melbourne
1994 Travelling Exhibition, Victorian Regional
 Galleries
1996 Eva Breuer Gallery, Sydney
1996 Lyall Burton Gallery, Melbourne

LEZLIE TILLEY

1949 Born in Sydney
Studied
1967 National Art School, East Sydney
 Technical College
1973–75 Newcastle School of Art and Design,
 ceramics
1979–80 Newcastle School of Art and Design,
 Certificate of Art
1981–83 Newcastle College of Advanced
 Education, Bachelor of Arts (Visual Art)
Solo Exhibitions
1991 Access Gallery, Sydney
1992 Access Gallery, Sydney
1993 Access Gallery, Sydney

AIDA TOMESCU

1955 Born in Bucharest, Romania
Studied
1973–77 Institute of Fine Arts, Bucharest,
 Diploma of Art (Painting)
1983 City Art Institute, Sydney, Postgraduate
 Diploma of Art (Visual Arts)
Solo Exhibitions
1979 Cenaclu Gallery, Bucharest
1981 Holdsworth Galleries, Sydney
1985 Coventry Gallery, Sydney
1986 Design Center, Los Angeles

1987	Reconnaissance Gallery, Melbourne
1987	Coventry Gallery, Sydney
1987	Ben Grady Gallery, Canberra
1989	Coventry Gallery, Sydney
1991	Coventry Gallery, Sydney
1991	Deutscher Fine Art, Melbourne
1993	Coventry Gallery, Sydney
1994	Christine Abrahams Gallery, Melbourne
1996	Coventry Gallery, Sydney

VICKI VARVARESSOS

1949	Born in Sydney

Studied

1970–73	National Art School, East Sydney Technical College

Solo Exhibitions

1975	Watters Gallery, Sydney
1976	Watters Gallery, Sydney
1977	Watters Gallery, Sydney
1978	Watters Gallery, Sydney
1980	Watters Gallery, Sydney
1980	Stuart Gerstman Galleries, Melbourne
1981	Stuart Gerstman Galleries, Melbourne
1982	Watters Gallery, Sydney
1983	Watters Gallery, Sydney
1984	Watters Gallery, Sydney
1985	Watters Gallery, Sydney
1986	Niagara Galleries, Melbourne
1987	Watters Gallery, Sydney
1988	Niagara Galleries, Melbourne
1989	Watters Gallery, Sydney
1990	Niagara Galleries, Melbourne
1991	Watters Gallery, Sydney
1992	Niagara Galleries, Melbourne
1993	Watters Gallery, Sydney
1994	Niagara Galleries, Melbourne
1995	Watters Gallery, Sydney

LIZ WILLIAMS

PHOTOGRAPH: ALEX MAKEYEV

1942	Born In Adelaide

Studied

1960–62	South Australian School of Art, Adelaide, Diploma of Art Education

1973–75	South Australian School of Art, Adelaide, Diploma of Ceramics
1980	Goldsmiths College, London, Postgraduate studies
1981	Scripps College, Claremont College, California, special student
1987	South Australian College of Advanced Education, Bachelor of Design (Ceramics)

Solo Exhibitions and Installations

1981	Scripps College, Los Angeles
1982	Bonython Gallery, Adelaide
1983	Kensington Gallery, Adelaide
1983	Jam Factory Gallery, Adelaide
1985	Devise Gallery, Melbourne
1988	Bonython Meadmore Gallery, Sydney
1993	Adelaide Central Gallery, Adelaide
1993	BMG Fine Art, Adelaide
1994	Lyall Burton Gallery, Melbourne

Endnotes

1 What has come to be known as the *women's art movement* of the 1970s took place when feminism and art joined forces and women artists in the United States and then Australia came together and demanded the mainstream public access for their work, both in exhibition spaces and publications, which had long been denied them

2 Lucy R. Lippard, *Overlay*, The New Press, New York, 1983, pp. 5, 6

3 See Mircea Eliade, *Shamanism*, Princeton/Bollingen, 1972, p. 4: 'Shamanism in the strict sense is pre-eminently a religious phenomenon of Siberia and Central Asia. The word (shaman) comes to us through the Russian, from the Tungusic *saman*, meaning 'one who is excited, moved or raised.'

4 Monica Sjoo & Barbara Mor, *The Great Cosmic Mother*, Harper & Row, 1991, p. 12

5 Marija Gimbutas, *The Goddesses And Gods Of Old Europe*, University of California Press, Berkeley & Los Angeles, 1982

6 Jane Ellen Harrison, *Epilegomena to the Study of Greek Religion and Themis*, original edition, Yale University Press 1925; reprinted by University Books New York, 1966

7 Camille Paglia, *Sexual Personae*, Penguin, England, 1992

8 'Terra nullius' (Macquarie Dictionary): 'Territory belonging to no state, that is, not inhabited by a community with a social and political organisation. In international law, effective occupation is the traditional mode of extending sovereignty of terra nullius.'

9 Lucy Lippard, *Overlay*, p. 69

10 Marija Gimbutas, *The Goddesses And Gods Of Old Europe*, pp. 2, 124, 135, 136

11 Lucy Lippard, *Overlay*, p. 42

12 Fractal geometry was developed by Polish-born mathematician Benoit Mandelbrot. Mathematical formulae of patterns of movement in Nature (derived from equations of universal laws) are fed into a specifically designed computer program. The computer then translates these formulae into visual images. The patterning of these brilliantly coloured images is characteristically, though not exclusively, curvilinear, chain or web like, and spiralling in design, where macro shapes are mirrored in micro shapes.

13 *How can one sell the air?* (spoken in 1855, subsequently published in numerous editions).

14 Revolution in its literal as well as political sense, i.e. 'turning a full circle'.

15 Norma Broude and Mary D. Garrard (eds), *The Power Of Feminist Art*, Thames and Hudson London, 1994, p. 12

16 Ibid, pp. 10, 12

17 It is perhaps worth noting that the word *pagan* is defined in the Oxford Dictionary as 'heathen' and also as coming from the Latin *paganus* or *pagus*, meaning 'rural or country district'. *Heathen* is dictionary-defined as 'not Christian, Jewish, Muslim or Buddhist' and also as 'an unenlightened person', thus deviating from its original meaning.

18 Camille Paglia, *Sexual Personae*, pp. xiii, 3, 39, 96, 97

19 Ibid, pp. 5, 19

20 Daemon is from the Latin f. Greek *Daimon*, meaning deity — not to be confused with 'demon'. Daemons are intermediary apparitional figures who originally populated myth and folklore — from the Celtic fairy people to the Greek nymphs, satyrs etc — and who changed shaped according to cultural times and became entities such as angels, souls, or powers with the Gnostic-Hermetic-Platonic traditions. They are both spiritual and physical, divine and human, arising out of the 'Anima Mundi' or intermediate region. Christianity turned the daimon into a demon — with all its connotations — *splitting* its 'nature', which was neither good nor bad but both benevolent and frightening, i.e. paradoxical in nature. As Plato described them in his *Symposium*: 'Everything that is daimonic is intermediate between God and mortal.'

21 Mircea Eliade, *Shamanism*, pp. 4, 508

22 Helen Gardner, *Art Through The Ages*, Harcourt Brace Jovanovich, original edition 1926 and subsequent reprints, pp. 25, 26

23 Joan Halifax, *Shamanic Voices*, E.P. Dutton, New York, 1979, pp. 3, 4

24 Margaret Mead, *Male and Female*, Gollancz, 1949, p. 182

25 Michael Harner, *The Way of the Shaman*, Harper & Row, San Francisco, 1980, p. xiii

26 Joan Halifax, *Shaman*, Thames and Hudson, London, 1982, p. 5

27 Jack Burnham, *Great Western Salt Works*, George Braziller, New York, 1974, p. 139

28 Michael Tucker, *Dreaming With Open Eyes*, Aquarian/Harper, San Francisco, 1992, pp. xxii–xxiii

29 Erich Neumann, *Art and The Creative Unconscious*, The Bollingen Library, Harper and Row, New York, 1966, p. 125

30 Jane Ellen Harrison, *Epilegomena to the Study of Greek Religion and Themis*, p. 542. 543

31 Norma Broude and Mary D. Garrard (eds),*The Power Of Feminist Art*, p. 12

32 Germaine Greer, *The Obstacle Race*, Farrar Straus Giroux, New York, 1979, pp. 7, 11, 327

33 Knud Rasmussen, *Intellectual Culture of the Iglulik Eskimos*, New York, 1976, pp. 55, 56

34 Joseph Beuys (1921–1986), German performance artist and sculptor

35 Michael Tucker, *Dreaming With Open Eyes*, p. 293

Selected Bibliography

Arguelles, J.A., *The Transformative Vision*, Shambala, Berkeley 1975

Bachelard, G., *The Poetics of Space* (translation Maria Jolas), Beacon Press, Boston 1969, 1994

Bachelard, G., *The Poetics of Reverie: Childhood, Language and the Cosmos* (translation Daniel Russell), Beacon Press, Boston 1969

Boulter, Michael, *The Art of Utopia* Craftsman House, Sydney 1991

Brody, Anne Marie, *Utopia: A Picture Story*, Heytesbury Holdings Ltd, Perth 1990

Broude, Norma and Garrard, Mary D. (eds), *The Power Of Feminist Art: Emergence, Impact and Triumph of the American Feminist Art Movement*, Thames and Hudson, London 1994

Burke, Janine, *Australian Women Artists 1840–1940*, Greenhouse Publications, Melbourne 1980

Burke, Janine, *Field of Vision: A Decade of Change, Women's Art in the Seventies*, Viking, Melbourne 1990

Buber, Martin, *I and Thou* (translation Ronald Gregor Smith), T. & T. Clark, Edinburgh 1937, 1958

Burnham, Jack, *Great Western Salt Works: essays on the meaning of Post-Formalist art*, George Braziller, New York 1974

Campbell, Joseph, *The Masks of God Vol 1: Primitive Mythology*, Penguin Books, Harmondsworth, England 1968, 1976

Campbell, Joseph, *The Masks of God Vol 1V: Creative Mythology*, Penguin Books, Harmondsworth, England 1976

Campbell, Joseph and Moyers, B., *The Power of Myth*, Doubleday, New York and London 1988

Chadwick, Whitney, *Women, Art, and Society* Thames and Hudson, London 1990, 1992

Drury, Nevill, *Images 2: Contemporary Australian Painting*, Craftsman House, Sydney 1994

Eliade, Mircea, *Shamanism: Archaic Techniques of Ecstasy*, Princeton/Bollingen 1964, 1972

Gardner, Helen, *Art Through The Ages*, Harcourt Brace Jovanovich, 1926, 1975

Gimbutas, Marija, *The Goddesses And Gods Of Old Europe: Myths and Cult Images*, University of California Press, Berkeley and Los Angeles 1974, 1982

Gimbutas, Marija, *The Language of the Goddess*, Thames and Hudson, London 1989

Greer, Germaine, *The Obstacle Race: The Fortunes of Women Painters and Their Work*, Farrar Straus Giroux, New York 1979

Guirand, Felix (ed), *New Larousse Encyclopedia of Mythology*, Hamlyn Publishing, Middlesex 1959, 1985

Halifax, Joan, *Shaman: The Wounded Healer*, Thames and Hudson, London 1982

Halifax, Joan, *Shamanic Voices*, Clarke, Irwin & Company, Toronto and Vancouver 1979

Michael Harner, *The Way of the Shaman*, Harper and Row, San Francisco 1980

Harrison, Jane Ellen, *Epilegomena to the Study of Greek Religion and Themis: A Study of the Social Origins of Greek Religion*, Cambridge, 1912 University Books, New York 1962, 1966

Janson, H.W., *A History Of Art: A Survey of the Visual Arts from the Dawn of History to the Present Day*, Thames and Hudson, London 1962, 1970

Jean, Marcel (with the collaboration of Arpad Mezei), *The History Of Surrealist Painting* (translation Simon Watson Taylor), George Weidenfield & Nicolson, London 1960

Johnson, Vivien, *Aboriginal Artists Of The Western Desert: A Biographical Dictionary*, Craftsman House, Sydney 1994

Jung, Carl G., *Man And His Symbols*, Aldus Books/Dell Publishing, London and New York 1968

Jung, Carl G., *The Collected Works*, Volume Five, *Symbols of Transformation*, Routledge and Kegan Paul, London/The Bollingen Foundation USA 1961

Jung, Carl G., *The Collected Works*, Volume Nine: Part 1. *The Archetypes and the Collective Unconscious*; Part 11. *Aion* Routledge and Kegan Paul, London/The Bollingen Foundation USA 1959

Kirby, Sandy, *Sight Lines: Women's Art And Feminist Perspectives in Australia*, Craftsman House, Sydney 1992

Lippard, Lucy R., *From The Center: Feminist Essays On Women's Art*, Dutton, New York 1976

Lippard, Lucy R., *Overlay: Contemporary Art and The Art of Prehistory*, The New Press, New York 1983

Lippard, Lucy R., *The Pink Glass Swan: Selected Feminist Essays On Art*, The New Press, New York 1995

Lovelock, James E., *Gaia: A New Look at Life on Earth*, Oxford University Press, Oxford and New York 1979

Mead, Margaret, *Male and Female*, Gollancz, London 1949

Neuman, Erich, *Art and The Creative Unconscious*, The Bollingen Library Harper and Row, New York 1966

Paglia, Camille, *Sexual Personae: Art And Decadence From Nefertiti to Emily Dickinson*, Penguin Books, Harmondsworth 1992

Rasmussen, Knud, *Intellectual Culture of the Iglulik Eskimos*, Copenhagen 1930, New York 1976

Rowley, Sue (ed), *Crossing Borders: Contemporary Australian Textile Art*, Unpublished article, University of Wollongong 1995

Rukeyser, Muriel, *Out Of Silence* (Selected Poems), TriQuarterly Books, USA 1992

Sjoo, Monica and Mor, Barbara, *The Great Cosmic Mother: Rediscovering the Religion of the Earth*, Harper Collins, New York, 1987, 1991

Tucker, Michael, *Dreaming With Open Eyes: The Shamanic Spirit In Twentieth Century Art And Culture* Aquarian/Harper, San Francisco 1992

Wright, Judith, *Collected Poems* Angus & Robertson, Australia and London 1972, 1987

DAVIDA ALLEN

Baker, J., *Davida Allen: Survey Exhibition*, Museum of Contemporary Art, Brisbane 1987

Hogan, C., 'Davida Allen', *Porfolio* August 1987

Nicklin, L. 'Winning Women', *Bulletin*, Sydney, April 28 1987

Kirker, A., 'Davida Allen, an Introduction', Catalogue essay National Gallery of New Zealand 1986

Mendelssohn, J., 'Davida Allen: My Life Now', in the Biennale of Sydney, *The Australian Painter*, July 1984

Webster, S. 'Six Brisbane Artists', *Art and Australia*, Vol. 18, No.4, Sydney 1981

ANNETTE BEZOR

Fenner, F., 'Sexuality in the Work of Six Contemporary Women Painters', in *Art and Australia*, Vol.30 No.1, Spring 1992

Kirby, S., *Sight Lines: Women's Art and Feminist Perspectives in Australia*, Craftsman House, Sydney 1992

Green, C., 'Annette Bezor', *Artforum*, April 1992, p.112

Morrell, T., Ecstasy/Excess — Annette Bezor 1980–1991, exhibition catalogue, Contemporary Arts Centre of South Australia, Adelaide 1991

Steffensen, J., 'A Desire of One's Own: The Politics and Poetics of Female (Erotic) Representation in Annette Bezor's Paintings', Annette Bezor 1980–1991 exhibition catalogue,

Contemporary Arts Centre of South Australia
Murphy, B., *Australian Perspecta*, The Art Gallery
 of New South Wales, Sydney 1983

MARION BORGELT
Lynn, V., *Marion Borgelt*, Craftsman House/Art &
 Australia Books, Sydney 1996
Loxley, A., 'Poetics of Immanence', *Art Monthly
 Australia*, March 1994
Drury, N., *Images in Contemporary Australian
 Painting*, Craftsman House, Sydney 1992
Chanin, E., (ed.) *Contemporary Australian Painting*,
 Craftsman House, Sydney 1990
Lynn, V., *Abstraction*, exhibition catalogue, The
 Art Gallery of New South Wales, Sydney 1990
Bond, T., and Wright, W., *Mindscapes*, exhibition
 catalogue, The Art Gallery of New South
 Wales, 1989
Bogle, A., *Advance Australian Painting*, exhibition
 catalogue, Auckland City Art Gallery,
 Auckland 1988
Bond, T., *Form Image Sign*, exhibition catalogue,
 Art Gallery of Western Australia, Perth 1983

JOAN BRASSIL
Brassil, J., 'Meandering in Time — a Techno
 Essay', catalogue essay, Next Wave Festival,
 Melbourne 1994
Stanhope, Z., 'Sine Waves/Harbour Waves',
 Photofile, Vol.41
Sullivan, G., *Seeing Australia: Views of Artists and
 Artwriters*, Piper Press, Sydney 1994
Hart, D., *Identities: Art from Australia*, Taipei Fine
 Arts Museum, Taipei, Taiwan 1994
Feddersen, J., *Soft Sculpture and Beyond*,
 Craftsman House, Sydney 1993
Thomas, M., 'Technology of Perception', *Art and
 Australia*, Spring 1993
Scarlett, K., *Australian Sculptors*, Nelson,
 Melbourne 1980

KATE BRISCOE
Drury, N., and Voigt, A., *Fire and Shadow:
 Spirituality in Contemporary Australian Art*,
 Craftsman House, Sydney 1996
McCulloch, S. and A., *Encyclopedia of Australian
 Art*, Allen & Unwin, Sydney 1994
Mendelssohn, J., 'Controlled Passion', *The
 Bulletin*, August 1992
Briscoe, K., *Fetish and Special Things, Ritual and
 Ways of Working*, MFA Thesis, University of
 New South Wales, Sydney 1991
McCulloch, A., *Encyclopedia of Australian Art*,
 Hutchinson, Melbourne 1984
Bonython, K., *Modern Australian Painting
 1970–1975*

HEATHER ELLYARD
Black and White, Issue 4, Sydney 1993
Drury, N., *New Art Seven*, Craftsman House,
 Sydney 1992
Kirby, S., *Sight Lines: Women's Art and Feminist
 Perspectives in Australia*, Craftsman House,
 Sydney 1992
Artlink, Vol.5 No.6, Adelaide 1986

MERILYN FAIRSKYE
Mafe, D., ' Critical Dreams', catalogue essay,
 Smoke, Institute of Modern Art, Brisbane,
 January 1994
Kirker, A., 'Encountering the Ideas and Works of
 Merilyn Fairskye', Queensland Art Gallery,
 1994
Gray, A., ' Gulf War Art', *Art and Australia*, Vol.31
 No.2, Summer 1993
Helmrich, M., 'Merilyn Fairskye', catalogue essay,
 Sleep, Christopher Leonard Gallery, New York,
 June 1993
Ryan, D., 'The Gesture of Her Pose', catalogue
 essay, *Invisible Painting (touch-nothing)*,
 Artspace, June 1993
King, N., 'Illuminating Luminaries', catalogue
 essay, *Luminaries*, Monash University,
 Melbourne 1993
Dolk, M., 'Notes on Anamorphosis', catalogue
 essay, *Death Wish*, Christopher Leonard Gallery,
 New York 1990
Lippard, L., 'Australian Art on the Left', *Village
 Voice*, New York, 19 October 1982

JUTTA FEDDERSEN
Feddersen, J., *Soft Sculpture and Beyond*, Craftsman
 House, Craftsman House, Sydney 1993
Drury, N., *New Sculpture*, Craftsman House,
 Sydney 1993
Drury, N., *New Art Five*, Craftsman House,
 Sydney 1991
Germaine, M., *Artists and Galleries of Australia*,
 Craftsman House, Sydney 1990

FIONA FOLEY
Thomas, M., ' Fiona Foley ', in *Identities: Art from
 Australia*, Taipei Fine Arts Museum, Taipei
 1993
Isaacs, J., *Aboriginality*, University of Queensland
 Press, St Lucia 1992
Crumlin, R., and Knight, A., *Aboriginal Art and
 Spirituality*, Collins Dove Publishers,
 Melbourne 1991
Australian Perspecta, The Art Gallery of New
 South Wales, Sydney 1989

GABRIELA FRUTOS
Drury, N., *Images 2: Contemporary Australian
 Painting*, Craftsman House, Sydney 1994
Drury, N., *New Art Five*, Craftsman House,
 Sydney 1991

ELIZABETH GOWER
Gates, M., *Elizabeth Gower: Chance or Design*,
 University of Melbourne, Museum of Art,
 Melbourne 1995
Williamson, C., 'A Voluptuous Labour' *Elizabeth
 Gower: Beyond the Everyday and a Fragile Life*,
 exhibition catalogue, Contemporary Art Space,
 Canberra 1994
Burke, J., *Field of Vision: Women's Art and Feminist
 Criticism in the '70s*, Viking, Melbourne 1990
Kirker, A., 'Elizabeth Gower Beyond the
 Everyday', catalogue essay, Queensland Art
 Gallery 1991
Elliott, H., ' Elizabeth Gower', *Tension*, Vol.23,
 Melbourne 1990
Holmes, J., 'Elizabeth Gower', *Perspecta 1985*,
 The Art Gallery of New South Wales
Lindsay, R., 'Elizabeth Gower', *Treasures of a
 Decade: 1968–1978*, National Gallery of
 Victoria, Melbourne 1978

PAT HOFFIE
Fern, L., 'Sharp-witted and Comic', *Sydney
 Morning Herald*, 10th April 1992
Drury, N., *New Art Five*, Craftsman House,
 Sydney 1991
McIntyre, A., *Contemporary Australian Collage and
 its Origins*, Craftsman House, Sydney 1990
Sourgnes, M. and Saines, M., 'Pat Hoffie —
 Works in Progress', Queensland Art Gallery
 1988
Hoffie, P., 'Gender/Nature/Culture' in *A
 Contemporary Caste: A Homage to Women Artists
 in Queensland, Past and Present*, Brisbane 1988
Moet and Chandon, catalogue, 1987
Seibert, D., *Seven Queensland Artists of Distinction*,
 Queensland College of Art, 1987

INGA HUNTER
Drury, N. and Voigt, A., *Fire and Shadow:
 Spirituality in Contemporary Australian Art*,
 Craftsman House, Sydney 1996

ANNE JUDELL
Drury, N. and Voigt, A., *Fire and Shadow:
 Spirituality in Contemporary Australian Art*,
 Craftsman House, Sydney 1996
McCulloch, S., *Sun Herald*, Sydney, 9 July 1993
Watson, B., *Sydney Morning Herald*, Sydney, 9 April
 1993

Allen, C., *Sydney Morning Herald*, Sydney, 30 March 1991

Lynn, E., *The Weekend Australian*, Sydney, 15 December 1990

Lynn, E., *The Weekend Australian*, Sydney, 30 June 1990

Cross, E., *The Age*, Melbourne, 15 March 1989

Lynn, V., *Macquarie Galleries Bulletin*, Sydney, July 1988

HANNA KAY

Drury, N., *Images 2: Contemporary Australian Painting*, Craftsman House, Sydney 1994

Omni Magazine, New York 1983

Art in America, New York 1982

Heresies Magazine 1979

LINDY LEE

Elias, A., 'Through a Glass Darkly', *Art and Asia Pacific*, Sydney, April 1994

Baume, N., 'Black is not as Black as all that', *Art + Text*, Issue 47, January 1994

Gregory, J., 'Lindy Lee, black + black +black', *Agenda*, December 1990

Crawford, A., 'Lindy Lee — Redefining History', *Imprint*, Vol.25 No.2, 1990

Crawford, A., 'A Chronicle of Australian Art, 1980–1989', *Tension*, Vol.19, Melbourne, January 1990

Amadio, N., 'Lindy Lee', *Moet and Chandon Touring Exhibition Catalogue*, 1987

JOAN LETCHER

Engberg, J., *The Aberrant Object: Women, Dada and Surrealism*, Museum of Modern Art at Heide, Melbourne 1994

Lindsay, S., *Clashing Fragments*, University of Tasmania, Hobart 1993

McAuliffe, C., 'Joan Letcher: Rip-It-Up', *World Art*, Melbourne, November 1993, pp 52–57

Heathcote, C., 'Joan Letcher', *The Age*, Melbourne, 13 August 1993

Edgar, R., '5th Birthday Show', *The Melbourne Times*, 29 July 1992

McAuliffe, C., 'Joan Letcher' in *Unfamiliar Territory: Adelaide Biennial of Australian Art* (curated by Tim Morrell), Art Gallery of South Australia, Adelaide 1992

Green, C., 'Joan Letcher', *Artforum* Vol. XXV11 No.6, 1990

BARBARA LICHA

Drury, N., *Images 2: Contemporary Australian Painting*, Craftsman House, Sydney 1994

Drury, N., *New Art Eight*, Craftsman House, Sydney 1992

ANNE MacDONALD

Timms, P., *Moet and Chandon Touring Exhibition*, catalogue essay, 1994

Colless, E., 'Sharp displays by the big guns', *The Weekend Australian*, 6 November, 1993

Drury, N., *New Art Six*, Craftsman House, Sydney 1992

McIntyre, A., *Contemporary Australian Collage and its Origins*, Craftsman House, Sydney 1990

MacDonald, A., *Art and Text*, Sydney, No.35, Summer 1990, pp 68–69

Muirhead, B., 'The Romance: A Photography Installation by Anne MacDonald', *Artlink*, Adelaide, Vol.7 No.4, December 1987

Younger, J., 'Anne MacDonald: The Romance', *Eyeline*, Brisbane, Vol.3, November 1987, p.24

LUCILLE MARTIN

Drury, N., *New Art Seven*, Craftsman House, Sydney 1992

Murray, S., 'Myopia: a Far-Sighted Environmental Installation', exhibition catalogue, Lawrence Wilson Art Gallery, University of Western Australia, Perth, 5 October 1990

Bromfield, D., 'Making a Collage of our Origins', *The West Australian*, 6 November 1989

'Lucille Martin: Eclectic', Galaxy Gallery, exhibition catalogue, Sydney, 14 October 1988

MANDY MARTIN

Sullivan, G., *Seeing Australia — Views of Artists and Art Writers*, Piper Press, Sydney 1994

Williams, D., and Simpson, C., *Art Now — Issues in Contemporary Art Post-1970*, McGraw-Hill, Sydney 1994

Mancun, A., *Art Through Australian Eyes*, Longman Cheshire, Melbourne 1993

Heller, N.G., *Women Artists; An Illustrated History*, Abbeville Press, New York, 1991

Smith, T., and Smith, B., *Australian Painting*, Oxford University Press, Melbourne 1991

Haynes, P., 'Mandy Martin', *Art and Australia*, Sydney, Summer 1990

Heathcote, C., 'Martin and Frank', *Art Monthly* 33, 1990

MATINGALI BRIDGET MATJITAL (OR MUDJIDELL)

Kernick, B., Watson, C., and Doyle, O., *Aboriginal Desert Women's Law*, exhibition catalogue, Ballarat Fine Art Gallery, Victoria 1994

Johnson, V., *Aboriginal Artists of the Western Desert*, Craftsman House, Sydney 1994

Cowan, J., *Wirrimanu: Aboriginal Art from the Balgo Hills*, Craftsman House, Sydney 1994

Crumlin, R. (ed.) *Aboriginal Art and Spirituality*,

Collins Dove, Melbourne 1991

Glowczewski, B., *Yapa, Peintres Aborigenes de Balgo et Lajamanu*, Lebon Gallery, Paris 1991

Caruana, W., *Australian Aboriginal Art*, Australian National Gallery, Canberra 1987

MIRLKITJUNGU MILLIE SKEEN

Kernick, B., Watson, C., and Doyle, O., *Aboriginal Desert Women's Law*, exhibition catalogue, Ballarat Fine Art Gallery, Victoria 1994

Johnson, V., *Aboriginal Artists of the Western Desert*, Craftsman House, Sydney 1994

Cowan, J., *Wirrimanu: Aboriginal Art from the Balgo Hills*, Craftsman House, Sydney 1994

Crumlin, R. (ed.) *Aboriginal Art and Spirituality*, Collins Dove, Melbourne 1991

Mayer, A., and Voigt, A., *65e Salon du Sud-Est*, exhibition catalogue, Lyon, France 1993

LYNDALL MILANI

Morrow, C., 'Viaggi', *Eyeline*, Brisbane, Autumn 1994

Scarlett, K., *Contemporary Sculpture in Australian Gardens*, Craftsman House, Sydney 1993

Marsh, A., *Body and Self: Performance Art in Australia*, Oxford University Press, Melbourne 1994

Zurbrugg, N., 'Fatal Attractions: Women and Technology, *Artlink*, Vol.14 No.1, Autumn 1994

Muirhead, B., ' Architecture and Lyndall Milani's Installations', *Artlink*, Vol.11 No.4, Summer 1991

Kirker, A., 'Lyndall Milani', *Art and Australia*, Vol.28 No.3, Autumn 1991

Davies, I., ' Women at the 10th Mildura Sculpture Triennial', *Women's Art Register*, Vol.1, No.2, Melbourne 1988

GLORIA TAMERRE PETYARRE

Neale, M., *Yiribana*, exhibition catalogue, The Art Gallery of New South Wales 1994

Johnson, V., *Aboriginal Artists of the Western Desert*, Craftsman House, Sydney 1994

Luthi, B., (ed.) *Aratjara: Art of the First Australians*, exhibition catalogue, Dumont, Cologne 1993

Boulter, M., *The Art of Utopia: A New Direction in Contemporary Aboriginal Art*, Craftsman House, Sydney 1991

Crumlin, R., (ed.) *Aboriginal Art and Spirituality*, Collins Dove, Melbourne 1991

Brody, A.M., *Utopia: A Picture Story*, Heytesbury Holdings, Perth 1990

Caruana, W., *Windows on the Dreaming: Aboriginal Paintings in the Australian National Gallery*, Ellsyd Press, Sydney 1989

LYN PLUMMER

Drury, N., and Voigt, A., *Fire and Shadow: Spirituality in Contemporary Australian Art*, Craftsman House, Sydney 1996

Women's Art Register Bulletin, 20th issue, Melbourne 1994

Nelson, Dr. R., RE enact \ DIS enchant Opus #1 and Opus #, catalogue essay 1994

Drury, N., *New Sculpture*, Craftsman House, Sydney 1993

Thompson, I., *In Position*, The Exhibitions Gallery, catalogue essay, February 1992

Sourgnes, M., *The Manipulation of Tradition*, Queensland Art Gallery, Brisbane 1990

Richards, M., 'Women on Women on Public Display', *Courier Mail*, Brisbane, 2 May 1990

Ruinard, E., 'Redressing the Balance: Lynn Plummer at the Queensland Art Gallery', *Eyeline*, Issue 13, Brisbane, December 1990

MONA RYDER

Allen, T., and Morell, T., *Mother Other Lover*, catalogue, Queensland Art Gallery, Brisbane 1995

Petelin, G., 'Mona Ruder, Les Kossatz, Art of the East Kimberley', *The Australian*, 23 June 1995

Smith, S., 'A Provocative Look at Tired Old Mothers', *Courier Mail*, Brisbane, 4 July 1995

Drury, N., *New Sculpture*, Craftsman House, Sydney 1993

Standford, L., 'Mona's Art Draws on Personal Experience', *Gold Coast Bulletin*, 15 February 1992

Kirby, S., *Sight Lines: Women's Art and Feminist Perspectives in Australia*, Craftsman House, Sydney 1992

Chapman, A., 'In Mona's Case It's Art for Life's Sake', *Gold Coast Bulletin*, 6 February 1992

Standford, L., 'Mona Ryder', Museum of Contemporary Art, Brisbane, 15 February 1992

ANNEKE SILVER

Magon, J., *Anneke Silver: Images of the Goddess and Nature Mysticism*, Craftsman House, Sydney 1995

Drury, N., *Images in Contemporary Australian Painting*, Craftsman House, Sydney 1992

Sweeney, R., 'Ancient Connections', *Eyeline*, Brisbane, Issue 14, Autumn 1991

Searle, R., (ed.), *Ancestral Wallan*, Perc Tucker Regional Gallery, Townsville, 1989

McBurnie, R., 'Anneke Silver: Totemic Landscapes', *Eyeline*, Brisbane, March 1989

Millington, J., *Tropical Visions*, University of Queensland Press, St Lucia 1987

JUDI SINGLETON

Allen, T., *Roar!*, Craftsman House, Sydney 1994

Drury, N., *Images 2: Contemporary Australian Painting*, Craftsman House, Sydney 1994

Drury, N., *New Art Eight*, Craftsman House, Sydney 1993

WENDY STAVRIANOS

Cree, L.M., *Wendy Stavrianos*, Craftsman House, Sydney 1996

Ellyard, H., and Grishin, S., *Wendy Stavrianos — Mantles of Darkness*, Castlemaine Art Gallery, Victoria 1994

Kirby, S., *Sight Lines: Women's Art and Feminist Perspectives in Australia*, Craftsman House, Sydney 1992

Dysart, D., and Paroissien, L., (eds.), *Eroticism: Images of Sexuality in Australian Art*, Fine Arts Press, Sydney 1992

Walker, R., *Painters in the Australian Landscape*, Hale and Ironmonger, Sydney, 1988

Murray, L., *Wendy Stavrianos — Veiled in Memory and Reflection*, catalogue essay, The Art Gallery, Prahran, Melbourne 1989

Australian Perspecta, catalogue, The Art Gallery of New South Wales, Sydney 1985

McGilchrist, E., 'Challenging the Established Definition of Art and Australian Women Artists,' *Australian Artist*, June 1985

LEZLIE TILLEY

Drury, N., *New Art Eight*, Craftsman House, Sydney 1993

Milestones, catalogue, Newcastle University Contemporary Art Gallery, Newcastle 1992

Germaine, M., *Women Artists of Australia*, Craftsman House, Sydney 1991

Thompson, I., *Lezlie Tilley: Image and Text*, unpublished essay, Wangaratta Art Gallery, Victoria

Stowell, J., review, *The Newcastle Herald*, 16 December 1991

Stowell, J., review, *The Newcastle Herald*, 11 June 1991

Stowell, J., review, *The Newcastle Herald*, 10 December 1990

Eley, M., review, *The Newcastle Herald*, 25 January 1988

Colelough, Y., review, *The Newcastle Herald*, 21 January 1988

AIDA TOMESCU

Lynn, V., *Review*, catalogue, The Art Gallery of New South Wales, Sydney 1995

Lynn, E., 'Primitive Cool Hints at Maze of the Mind', *The Australian*, 21 August 1993

Allen, C., 'Seven at Ivan Dougherty', *Asian Art News*, September/October 1992

Rooney, R., 'Cross-Cultural Icons', *The Australian*, 21 August 1991

Lynn, E., 'Surrender to Dark Powers', *The Australian*, 10 August 1991

Timms, P., 'Fascinating Aida', *Oz Arts*, Issue 1, Spring 1991

Lynn, V., *Abstraction*, catalogue, The Art Gallery of New South Wales, Sydney 1990

McDonald, J., 'Reinvention of Fascinating Aida', *Sydney Morning Herald*, 8 August 1987

VICKI VARVARESSOS

Sullivan, G., *Seeing Australia: Views of Artists and Artworkers*, Piper Press, Sydney 1994

Kirby, S., *Sight Lines: Women's Art and Feminist Perspectives in Australia*, Craftsman House, Sydney 1992

Smith, B., and Smith, T., *Australian Painting 1799–1990*, Oxford University Press, Melbourne 1991

Burke, J., *Field of Vision: A Decade of Change, Women's Art in the Seventies*, Viking, Melbourne 1990

Drury, N., *New Art Two*, Craftsman House, Sydney 1988

Sturgeon, G., *Australia: The Painter's Vision*, Bay Books, Sydney 1987

Burke, J., 'Vicki Varvaressos', *Art and Australia*, December 1982

LIZ WILLIAMS

Selected Australian Works, Queensland University of Technology Art Collection, Queensland University of Technology, 1995

Speck, K., *Pottery in Australia*, Vol.33, No.1, 1994

Drury, N., *New Sculpture*, Craftsman House, Sydney 1993

Drury, N., *New Art Four*, Craftsman House, Sydney 1990

List of Plates

FRONTISPIECE: Gloria Tamerre Petyarre, *Awelye*, 1993, polymer on linen, 75 x 81 cm, Courtesy of Utopia Art, Sydney

DAVIDA ALLEN
PLATE 1: *Homework*, 1993, Oil on marine ply, 108 x 77 cm, Courtesy of Australian Galleries, Melbourne
PLATE 2: *Man and Woman*, 1993, Oil on marine ply, 120 x 161 cm, Courtesy of Australian Galleries, Melbourne
PLATE 3: *Sisters*, 1991, Oil on marine board, 235 x 210 cm, Courtesy of Australian Galleries, Melbourne
PLATE 4: *Woman* (detail), 1993, Oil on marine ply, 122 x 122 cm, Courtesy of Australian Galleries, Melbourne

ANNETTE BEZOR
PLATE 5: *A Question of Unity*, 1989, Acrylic and oil on linen, 285 x 212 cm, Courtesy of the artist
PLATE 6: *Gabriela*, 1987, Oil on linen, 220 x 220 cm, Courtesy of the artist
PLATE 7: *Entanglement Landscape — Inversion*, 1990, Acrylic and oil on linen, 220 x 295 cm, Courtesy of the artist
PLATE 8: *No*, 1991, Acrylic and oil on galvanised iron, two pieces: 120 x 150 x 10 cm, Courtesy of the artist
PLATE 9: *Entanglement Landscape — Identity*, 1991, Acrylic and oil on linen, galvanised iron letter base, overall dimension 330 x 220 cm, Courtesy of the artist

MARION BORGELT
PLATE 10: *Light and Body Series No. IX*, 1991, Pigment on jute, 210.5 x 171 cm, Courtesy of Sherman Galleries, Sydney
PLATE 11: *Anima/Animus: Splitting Into One No. 111*, 1993, Pigment on jute with woven jute threads, 197 x 182.5 cm, Courtesy of Sherman Galleries
PLATE 12: *Vessel Suite No. 1*, 1991–1992, Pigment and collage on jute, 195.5 x 102.5 cm, Courtesy of Sherman Galleries

JOAN BRASSIL
PLATE 13: *Randomly Now and Then*, 1990, ACCA retrospective, 1990 and MCA, Sydney, 1995, Courtesy of the artist
PLATE 14: *Can It Be That the Everlasting is Everchanging*, 1978, Courtesy of the artist
PLATE 15: *Kimberley Stranger Gazing* (detail), 1988, Installation at Roslyn Oxley Gallery, Sydney, 1988, Photograph: Jill Crossley, Courtesy of the artist
PLATE 16: *Kimberley Stranger Gazing* (detail), 1988, Installation at Roslyn Oxley9 Gallery, Sydney, 1988, Photograph: Jill Crossley, Courtesy of the artist

KATE BRISCOE
PLATE 17: *Containers*, 1995, Pencil and crayon on paper, 35 x 42 cm each, Courtesy of the artist
PLATE 18: *Sarcophagus*, 1995, Mixed media on canvas, 91 x 152 cm, Courtesy of the artist
PLATE 19: *Fish Tent*, 1993, Diptych, mixed media on canvas, 175 x 244 cm, Courtesy of the artist

PLATE 20: *Body Goddess*, 1991, Diptych, mixed media on canvas, 152 x 222 cm, Courtesy of the artist

HEATHER ELLYARD
PLATE 21: *Mnemonic Measurements* (detail), 1993, Mixed media on canvas and board, each panel 30 x 30 cm, Photograph: John Brash, Courtesy of the artist
PLATE 22: *Three Graces / Descent and Return* (detail), 1993, Mixed media on canvas and board, each panel 30 x 30 cm, Photograph: John Brash, Courtesy of the artist
PLATE 23: *Self Portrait in Pieces*, 1993, Oil on canvas/board, each panel 30 x 30 cm, Courtesy of the artist and Greenaway Art Gallery, Adelaide

MERILYN FAIRSKYE
PLATE 24: *illusion (Alessandra Mussolini, Milan, 1992)*, 1992, Acrylic, mylar, perspex, light, dimensions variable, Photograph: Fred Scruton, Courtesy of the artist
PLATE 25: *Invisible Painting: (karin, lawyer, germany)*, 1993, Installation view (detail), Cell paint, perspex, light, dimensions variable, Photograph: Sandy Edwards, Courtesy of the artist
PLATES 26, 27: *Invisible Paintings*, 1993, Installation views (detail), acrylic, mirror, perspex, light, dimensions variable, Photograph: Sandy Edwards, Courtesy of the artist
PLATE 28: *sleep (valerie, writer, north america)*, 1993, Acrylic, oil paint on sonar tubes, wall, 335 x 425 x 425 cm, Photograph: Merilyn Fairskye, Courtesy of the artist
PLATE 29: *sleep (Tom Moran, N.Y., 1989)*, 1992, Acrylic, oil on canvas, 137 x 122 cm, Photograph: John Brash, Courtesy of the artist
PLATE 30: *nothing (Rodney King, L.A. 1991)*, 1992, Acrylic, perspex, mylar, dimensions variable, Photograph: Fred Scruton, Courtesy of the artist

JUTTA FEDDERSEN
PLATE 31: *Claude*, 1995, 17 forms, wood, chicken, paint, Courtesy of the artist
PLATE 32: *Substance of Shadows*, 1993, Courtesy of the artist
PLATE 33: *Homage to Louise Bourgeois*, 1993, Courtesy of the artist

FIONA FOLEY
PLATE 34: *Sand Sculpture*, 1991, Sand, varying dimensions, Courtesy Roslyn Oxley9 Gallery
PLATE 35: *A Question of Indigena*, 1994, Canvas, acrylic, glass bottles, honey, milk, snake. Installation, 72 x 197 cm overall size, Courtesy Roslyn Oxley9 Gallery
PLATE 36: *Coloured Sand*, 1993, from the Australian Centre for Contemporary Art exhibition *Lick My Black Art*, Sand, tin, wax, glass jars, wooden boxes, varying dimensions, Courtesy Roslyn Oxley9 Gallery

GABRIELA FRUTOS
PLATE 37: *Recycled Landscape 7*, 1993, Collage on paper, 98 x 63 cm, Courtesy of the artist
PLATE 38: *Waterfront Series 2*, 1993, Collage on paper, 38 x 28 cm, Courtesy of the artist

PLATE 39: *Recycled Landscape 5*, 1993, Collage on paper, 98 x 63 cm, Courtesy of the artist

ELIZABETH GOWER
PLATE 40: *Thinking About the Meaning of Life*, 1990, Acrylic on drafting film, 288 x 287 cm, Photograph: Henry Jolles, Courtesy of the artist, Collection: Queensland Art Gallery
PLATE 41: *Worldly Concerns*, 1994, Acrylic on drafting film, 205 x 330 cm, Courtesy of the artist
PLATE 42: *All Things Pass Away but God Endures Forever*, 1993, Acrylic on nylon, 250 x 113 cm, Courtesy of the artist
PLATE 43: *Cycle*, 1993, Collage on fabric, 61 x 30 cm, Courtesy of the artist
PLATE 44: *Forever*, 1993, Collage on fabric, 61 x 30 cm, Courtesy of the artist
PLATE 45: *Chance or Design*, 1995, Collage on drafting film, 250 x 100 cm, Courtesy of the artist
PLATE 46: *Chance or Design*, 1995, Installation view (detail), comprising 26 individual works, paper on drafting film, each 240 x 102 cm, Courtesy of the artist

PAT HOFFIE
PLATE 47: *Vessel*, 1991, from the installation *Frames Of Reference* — a feminist survey exhibition organised by Artspace at Pier 4/5, Walsh Bay, Sydney. Champagne glasses, plastic tubing, deck chair, air pump, oil and honey, computer generated images, Courtesy of the artist
PLATE 48: *The Veneer*, 1991, Computer generated imagery, oil on canvas, photograph on plywood, Collection: Museum of Contemporary Art, Sydney, Photograph: Brett Goodman, Courtesy of the artist
PLATE 49: *Herowalk*, 1994, Oil on canvas, 9.75 x 6.75 m, on Adelaide Cathedral, Courtesy of the artist
PLATE 50: *The Tyranny of Appearance*, 1989, Oil on canvas, 183 x 183 cm, Courtesy of Coventry Gallery, Sydney

INGA HUNTER
PLATE 51: *Figure of the Bird Goddess*, 1995, Courtesy of the artist
PLATE 52: *Figure of the Bird Goddess*, 1995, Drawing. Courtesy of the artist
PLATE 53: *Funeral Boat of the Bird Goddess: Iboriis, 9th Century Post Imperium*, 1995, Courtesy of the artist
PLATE 54: *Africa III*, 1995, Mixed media: painted wood triptych, canvas, clay, bottle, herbs, blood, feathers, beads, bamboo, roots, 30 x 34 x 12 cm, Courtesy of the artist
PLATE 55: *Slave Drawings*, 1994, Charcoal and pastel on heavyweight Indian handmade paper, sealed with acrylic medium and knotted onto canvas, approximately 1 x 1.5 m, Courtesy of the artist
PLATE 56: *Nkisi for Margaret Girvan*, 1995
PLATE 57: *Nkisi for Margaret Girvan*, 1995
PLATE 58: *Talisman for Difference*, 1994, Mixed media: collage, paint, beads, thread, pastel, sticks on paper, 40 x 57 x 6 cm, Courtesy of the artist
PLATE 59: *Robe of the First Shaman to the Bird God: Iboriis, 12th Century Post Imperium*

PLATE 60: *Augurer's Robe: Iboriis, 9th Century Post Imperium*, 1987, Miniature paper costume, mixed media: handmade cotton and plant papers, fake fur, chicken bones, thread, protea stamens, feathers, beads, paint, pastel, 36 x 36 cm, Courtesy of the artist

ANNE JUDELL

PLATE 61: *Dream 1*, 1990, Oil on canvas, 51 x 51 cm, Photograph: James Ashburn, Courtesy of the artist
PLATE 62: *Still Point No. 27*, 1989–1991, Oil and wax on paper, 57 x 43 cm, Photograph: James Ashburn, Courtesy of the artist
PLATES 63–68:
The Dance series, 1980–1991, PLATE 63: *The Dance 14*, pastel on paper, 36 x 29 cm; PLATE 64: *The Dance 6*, pastel on paper, 35 x 28 cm; PLATE 65: *The Dance 10*, pastel on paper, 30 x 24 cm; PLATE 66: *The Dance 13*, pastel on paper, 37 x 28 cm; PLATE 67: *The Dance 7*, pastel on paper, 30 x 24 cm; PLATE 68: *The Dance 4*, pastel on paper, 36 x 28 cm, Photographs: James Ashburn, Courtesy of the artist. Part of an exhibition with James Gleeson at David Jones Art Gallery in 1991.

HANNA KAY

PLATE 69: *Juxtaposition IV*, 1994, Oil and tempera on board, 120 x 165 cm, Photograph: Sage, Courtesy of the artist
PLATE 70: *Foreshore*, 1993, Oil and tempera on board, 92 x 122 cm, Photograph: Jill Crossley, Courtesy of the artist
PLATE 71: *Aftermath*, 1992, Acrylic and ink on board, 78 x 93 cm, Photograph: Sage, Courtesy of the artist
PLATE 72: *Concave–Convex*, 1981, Oil and tempera on canvas, each panel 127 x 139.5 cm, Photograph: Bob Sasson, Courtesy of the artist

LINDY LEE

PLATE 73: *Heartbeat and Duration*, 1992, Photocopy and acyrlic on stonehenge paper, 176 x 127 cm, Courtesy of Roslyn Oxley9 Gallery, Sydney
PLATE 74: *All Spirit in the End Becomes Bodily Visible*, 1987, Oils and wax on canvas, 180 x 160 cm, Courtesy of Roslyn Oxley9 Gallery, Sydney
PLATE 75: *Soundless Fate*, 1992, Photocopy and acrylic on stonehenge paper, 168 x 173 cm, Courtesy of Roslyn Oxley9 Gallery
PLATE 76: *Nell and Every Little Thing*, 1995, Photocopy and acrylic on stonehenge paper, 2 parts: 25 + 25 panels, each 205 x 143 cm, Courtesy of Roslyn Oxley9 Gallery

JOAN LETCHER

PLATE 77: *Untitled*, 1994, Mixed media, 112 x 91 cm, Courtesy of the artist
PLATE 78: *Untitled*, 1992, Oil and xerox collage on canvas, 167.6 x 137.2 cm, Courtesy of the artist
PLATE 79: *Untitled*, 1994, Xerox collage on linen, 106.5 x 86.3 cm, Courtesy of the artist

BARBARA LICHA

PLATE 80: *Mustard Night*, 1993, Oil on canvas, 167.5 x 152 cm, Courtesy of Access Contemporary Art Gallery, Sydney
PLATE 81: *After*, 1991, Mixed media, 100 x 75 cm, Courtesy of Access Contemporary Art Gallery, Sydney
PLATE 82: *Dart*, 1993, Oil on canvas, 152 x 167.5 cm, Courtesy of Access Contemporary Art Gallery, Sydney

PLATE 83: *Computer Work*, 1996, Courtesy of Access Contemporary Art Gallery, Sydney

ANNE MACDONALD

PLATE 84: *Untitled No.1 from the installation 'Ophelia'*, 1993, chromogenic colour photograph, 120 x 120 cm, Courtesy of the artist
PLATE 85: *No.1 from Inconsolable series*, 1992, Colour photograph, 34 x 38 cm, Courtesy of the artist
PLATE 86: *No.5 from Inconsolable series*, 1992, Colour photograph, 34 x 38 cm, Courtesy of the artist
PLATE 87: *No.9 from Inconsolable series*, 1992, Colour photograph, 34 x 38 cm, Courtesy of the artist
PLATE 88: *installation view of The Romance*, 1986, George Paton Gallery Melbourne, Courtesy of the artist

LUCILLE MARTIN

PLATES 89, 90, 91, 92: *Metaphors for Memory — A Paradox of Ordering*, 1992, Courtesy of the artist
PLATES 93, 94, 95, 96: *Expose: Three Stories from Tokyo. Part I, II, III*, 1995, PLATE 93: *Three Stories from Tokyo Part I* (installation), 1995, Multimedia, Hi8 video, suspended futon, soundscape, projected image, Photograph: David Dare Parker; PLATE 94: *Generation Series: White Rhythm*, 1995, Hi8 video, computer manipulated photograph, 20 x 35 cm; PLATE 95: *Generation Series: Taste of Forbidden Fruit*, 1995, Hi8 video, computer integrated image, photograph, 20 x 35 cm; PLATE 96: *Generation Series: Super Girl and Astro Boy*, 1995, Hi8 video, computer manipulated photograph, 20 x 35 cm; Courtesy of the artist

MANDY MARTIN

PLATE 97: *Sunrise at Lake Julius*, 1994, Oil, ochre and pigments on linen, 152 x 550 cm, Courtesy of the artist
PLATE 98: *Fata Morgana*, 1992, Oil on linen, 100 x 244 cm, from *Strzelecki Desert: Reconstructed Narrative Series*, Courtesy of the artist
PLATE 99: *N-O-T-H-I-N-G*, 1993, Oil on linen, 152 x 274 cm, Courtesy of the artist

MATINGALI BRIDGET MATJITAL

PLATE 100: *Nakarra Nakarra*, 1993, Acrylic on canvas, 110 x 80 cm, Photograph: Phillip Castleton, Courtesy of Manungka Manungka Women's Association
PLATE 101: *Palgu Palgu*, 1991, Acrylic on canvas, 100 x 50 cm, Courtesy of Warlayirti Artists Aboriginal Corporation and Coo-ee Aboriginal Art
PLATE 102: *Palgu Palgu*, 1993, Acrylic on canvas, 110 x 80 cm, Photograph: Phillip Castleton, Courtesy of Manungka Manungka Women's Association
PLATE 103: *Untitled*, 1994, Acrylic on canvas, 120 x 80 cm, Courtesy of Warlayirti Artists Aboriginal Corporation and Coo-ee Aboriginal Art

MIRLKITJUNGU MILLIE SKEEN

PLATE 104: *Tjipari*, 1993, Acrylic on canvas, 110 x 80 cm, Photograph: Phillip Castleton, Courtesy of Manungka Manungka Women's Association
PLATE 105: *Yurrututu*, 1991, Acrylic on canvas, 120 x 60 cm, Courtesy of Coo-ee Aboriginal Art
PLATE 106: *Nakarra Nakarra*, 1993, Acrylic on canvas, 80 x 80 cm, Photograph: Phillip Castleton, Courtesy of Manungka Manungka Women's Association
PLATE 107: *Lirrwati*, 1992, Acrylic on canvas, 100 x 75 cm, Courtesy of Coo-ee Aborginal Art

PLATE 108: *Yurrututu*, 1991, Acrylic on canvas, 120 x 60 cm, Courtesy of Coo-ee Aboriginal Art

LYNDALL MILANI

PLATES 109, 110: *The Floating Shrines*, 1989, Performance in the landscape, Photograph: Stephen Crowther, Courtesy of the artist
PLATE 111: *Viaggi*, 1993, Installation, Queensland College of Art Gallery, Photograph: Peter Liddy, Courtesy of the artist
PLATE 112: *Floating Shrines*, 1989, Photograph: Garry Sommerfield, Courtesy of the artist
PLATE 113: *Installation*, 1991, Wire mesh, wire, paper, wax, plaster, water, neon, text (gouache on paper), artificial leaves, electrical cords, Photograph: Garry Sommerfield, Courtesy of the artist

GLORIA TAMERRE PETYARRE

PLATE 114: *Awelye*, 1993, Synthetic polymer on linen, 75 x 81 cm, Courtesy of Utopia Art, Sydney
PLATE 115: *Sacred Grasses*, 1991, Synthetic polymer on linen, 91 x 91 cm, Courtesy of Utopia Art, Sydney
PLATE 116: *Untitled (Leaves on the Ground)*, 1995, Synthetic polymer on linen, 192 x 110 cm, Courtesy of Utopia Art, Sydney
PLATE 117: *Arnkerrthe — Mountain Devil Lizard*, 1995, Synthetic polymer on linen, 112 x 86 cm, Courtesy of Utopia Art, Sydney
PLATE 118: *Awelye*, 1994, Acrylic on canvas, 186 x 186 cm, Courtesy of Utopia Art, Sydney

LYN PLUMMER

PLATE 119: *Endgame: a Simple Matter of Balance*, 1990, Steel, cane, timber, tissue, fabric thread, Background: *Attendant Aurum*, 5.2 m (h) x 1.2 m (w) x 1.1 m (d); Right: *Bride of Shahmat*, 3.2 m (h) x 2.5 m (w) x 1.7 m (d); Front: *Offering of the Thalamus*, 2.0 m (h) x 3.0 m (w) x 0.8 m (d), Photograph: Rodney Browne, Courtesy of the artist
PLATES 120, 121, 124, 125: *RE enact\DIS enchant OPUS #1 and #2*, 1992–94, Installation view, Benalla Art Gallery, Photograph: Rodney Browne, Courtesy of the artist. *RE enact\DIS enchant: Opus One* in the Wangaratta Exhibitions Gallery. *RE enact\DIS enchant: Opus Two* at the Benalla Art Gallery.
PLATES 122, 123: *Her Appropriate Sphere*, 1991, Art 1 Studio Workshop, Albury. 'This installation consisted of several components: a.) twelve "Stations" — plaque-like components that consisted of a framed work on paper on the top; a framed slate below; a printed statement pinned to the board at the bottom; b.) a pulpit-like lectern form consisting of a book on the lectern; a low, flat platform on which to stand to view the book; a red rug; a notice; c.) an ornate table and chair set with a folder of readings; two ornate candelabra with candles lit; d.) an oblong-shaped low pedestal set with two brass candelabra; a wooden bread board; a round loaf of bread; a large red capsicum; a large brown pear; a knife; e.) taped sound, instrumental and vocal.
PLATE 124: *RE enact\DIS enchant OPUS #1 and #2*, 1992–94, Detail from side panels of The Banners, from the installation *RE enact\DIS enchant*, 1992–94. Photograph: Rodney Browne, Courtesy of the artist. Image is from a laser photocopy of *Hercules and Deianira*, 1517, by Marbuse (Jan Gossaert) (c.1478–1532), reworked with tissue paper, polyurethane, oil paint glazes, gold and thread.

PLATE 125: *RE enact\DIS enchant OPUS #1 and #2*,
1992–94, Detail from The Runner, from the Installation
RE enact\DIS enchant, 1992–94. Photograph: Rodney
Browne, Courtesy of the artist. Images are details of laser
photocopies from old bridal magazines and works by
Giovanni Battista Tiepolo (1696–1771) and Raphael
(Raffaello Sanzio) (1483–1520). The laser photocopied
images are re-worked with tissue paper, polyurethane,
oil paint glazes and gold and thread.

MONA RYDER
PLATES 126, 127, 128: *Ironing Board* series, 1983–1994,
PLATE 126: lead book, 1.5 m (h) x 0.55 m (w) x 0.8 m (d);
PLATE 127: carving, baby head, 2.36 m (h) x 0.55 (w) x
0.48 (d); PLATE 128: cot, 2.14 m (h) x 0.62 m (w) x 1.46 m (d)
PLATES 129, 130, 131: *Mother Other Lover*, 1995, Installation
in the Watermall at the Queensland Art Gallery, Courtesy
of the artist
PLATE 132: *Self Portrait*, 1994, Acrylic on canvas, 200 x
180 cm, Photograph: Studio Sept, Courtesy of the artist
PLATE 133: *Untitled*, 1994, Acrylic on canvas, 190 x 218 cm,
Photograph: Studio Sept, Courtesy of the artist

ANNEKE SILVER
PLATE 134: *The Goddess of Cape York*, 1987, 23c gold leaf and
charcoal on paper, 165 x 114.5 cm, Photograph: Glenn
Abrahams, Courtesy of the artist, Collection: Perc Tucker
Regional Gallery, Townsville
PLATE 135: *Earth to Sky*, 1990, Oil, 23c gold leaf on gesso
on timber, 24 x 25 cm, Photograph: ProLab, Courtesy of
the artist, Private collection
PLATE 136: *Isis Veiled*, 1988–1989, Mixed media on paper,
106.5 x 75 cm, Photograph: Glenn Abrahams, Courtesy of
the artist, Collection: Dr David Grundmann

JUDI SINGLETON
PLATE 137: *Search for Meaning*, 1994, Oil on linen, 174 x
149 cm, Courtesy of the artist
PLATE 138: *Blue Bird Song*, 1995, Oil on linen, 136 x 121 cm,
Courtesy of the artist
PLATE 139: *Woman of the Dunes*, 1995, Oil on linen, 92 x
137 cm, Courtesy of the artist
PLATE 140: *A Complicated Friendship*, 1992, Oil on canvas,
167.5 x 122 cm, Courtesy of the artist
PLATE 141: *Ceramic Vase*, n.d., Terracotta, 50 cm (h),
Courtesy of the artist
PLATE 142: *Life Totem*, 1994, Ceramics earthenware, 58 cm
(h), Courtesy of the artist

WENDY STAVRIANOS
PLATE 143: *Dance of the Nestmaker*, 1992, Oil on linen, 139 x
93 cm, Collection: James and Ellen McCaughey, Courtesy
of the artist
PLATE 144: *Autumn Mantle*, 1992, Oil on linen, 184.5 x
108 cm, Courtesy of the artist
PLATE 145: *The Gatherers in a Timeless Land*, 1994,
Installation, mixed media, 210 x 586 x 130 cm, Courtesy
of the artist
PLATE 146: *The Gatherer of the Sheaf in the Night City*, 1993,
Oil on canvas, 167.5 x 231 cm, Photograph: Neil Lorimer,
Courtesy of the artist
PLATE 147: *The Gatherers in a Timeless Land*, 1994,
Installation, sticks, stones, wire, plaster, wax, metal, cable;
The drawing, 167 x 276 cm; Floor, 320 x 334 cm,
Photograph: Neil Lorimer, Courtesy of the artist

LEZLIE TILLEY
PLATE 148: *590. Writing*, 1991, Oil on canvas, slate, painted
wood, Courtesy of Access Contemporary Art Gallery,
Sydney
PLATE 149: *Sloth*, 1993, Rubber, cardboard, Q cell, acrylic
on board, 152.5 x 154 x 4.5 cm, Courtesy of Access
Contemporary Art Gallery, Sydney
PLATE 150: *Envy*, 1993, Copper, cardboard, Q cell, acrylic
on board, 152.5 x 154 x 4.5 cm, Courtesy of Access
Contemporary Art Gallery, Sydney
PLATE 151: *Pride*, 1993, Mixed media, 152.5 x 155 x 7 cm,
Courtesy of Access Contemporary Art Gallery, Sydney
PLATE 152: *Greed*, 1993, Fabrics, cardboard, Q cell, oil and
acrylic on board, 152.5 x 153 x 5 cm, Courtesy of Access
Contemporary Art Gallery, Sydney

AIDA TOMESCU
PLATE 153: *Blue and Ochre*, 1993, Oil on canvas, 183 x152 cm,
Photograph: Paul Green, Private Collection, Sydney,
Courtesy of Coventry Gallery, Sydney
PLATE 154: *Black to White*, 1994, Mixed media on paper,
121 x 80 cm, Courtesy of the artist
PLATE 155: *White to Black*, 1994, Mixed media on paper,
121 x 80 cm, Courtesy of the artist
PLATE 156: *White to White*, 1994, Mixed media on paper,
121 x 80 cm, Courtesy of the artist
PLATE 157: *All Green*, 1994, Oil on canvas, 183 x 152 cm,
Collection: University of New South Wales, Sydney,
Courtesy of Coventry Gallery, Sydney

VICKI VARVARESSOS
PLATE 158: *Woman over the Landscape*, 1994–95, Acrylic on
hardboard, 122 x 91 cm, Photograph: Michel Brouet,
Courtesy of Watters Gallery, Sydney
PLATE 159: *Piano Woman*, 1993, Oil on canvas, 94 x 94 cm,
Courtesy of the artist
PLATE 160: *Woman on Sofa*, 1993, Oil on composition
board, 122 x 138 cm, Courtesy of the artist

LIZ WILLIAMS
PLATE 161: *Ship of Lost Souls*, 1992, Clay, metal, wood and
bitumen, Length: 2.4 m, Height: 1.3 m, Location: Grange
Beach, South Australia, Photograph: David Campbell,
Courtesy of the artist
PLATE 162: *Woman Caught Up in Her Heart*, 1994, White
stoneware, 71 cm (h) x 78 cm (w), Courtesy of the artist
PLATES 163–170: *Goddesses, Self Portraits and Dolls*, July
1993 to February 1994, Terracotta, pink earthenware, or
white stoneware and mixed media, all clay, 80 cm (h),
Courtesy of the artist
PLATE 171: *Recuedos*, 1993, Sculptural installation,
Adelaide Central Gallery, July 1993

Index